r.

P
i
c

P
Po

(

L

1
1

- 6

THE ENGLISH LANDSCAPE
IN THE TWENTIETH CENTURY

The English Landscape in the Twentieth Century

Trevor Rowley

hambledon
continuum

Hambledon Continuum
A Continuum imprint

The Tower Building,
11 York Road,
London SE1 7NX, UK

80 Maiden Lane,
Suite 704,
New York, NY 10038
USA

First Published 2006

ISBN 1 85285 388 3

A description of this book is available from the
British Library and from the Library of Congress.

Typeset by Carnegie Publishing, Lancaster,
and printed in Great Britain by MPG Books Ltd, Cornwall.

Contents

Introduction

O N THE FINAL DAY of the nineteenth century one of the principal stones at Stonehenge was blown down by a gale. It was an ominous start to the twentieth century for the 5000-year-old monument.[1] The story of Stonehenge, the most famous archaeological site in Britain and now a World Heritage Site, is in many ways representative of the English landscape during the twentieth century. On the death of the 4th Duke of Queensbury in 1824, the 5000-acre estate which included Stonehenge was bought by Sir Edmund Antrobus. The Antrobus family were proud to own the 'premier relic of antiquity in the land', but, when ancient monument legislation was passed later in the century, they were not prepared to allow state involvement in their property rights. Their attitude echoed that of country house owners, some of whom allowed visitors to their houses and parks on a *noblesse oblige* basis, but who were implacably opposed to any government 'interference' in their affairs until the Second World War, when the economics of death duties and the very high cost of upkeep changed many aristocratic minds. As the twentieth century progressed, country houses and many other elements in the historic environment came to rely on tourism for their survival.

The Stonehenge estate had passed to the 4th Baronet Antrobus in 1898, when he offered Stonehenge plus 1300 acres of downland to the Exchequer, retaining for himself shooting and grazing rights, at a highly inflated price. The government refused the offer, but it resulted in a rumour that Stonehenge might be bought by an American and the stones transported across the Atlantic. In the event, following the collapse of the stones, Sir Edmund fenced off the great monument and introduced a staggering one shilling entrance fee. In 1901 the circle was choked with vehicles, horses and carts as the people of the nearby town of Amesbury mounted a mass protest against Sir Edmund Antrobus and his entrance fees. The fences and admission charges endured for another century, as did the tradition of protest at Stonehenge.

By 1900 Stonehenge was already an object of considerable interest, with a steady stream of visitors and events. A favourite excursion was from Salisbury to Stonehenge by way of the hill fort and 'rotten borough' at Old Sarum, in a hired carriage, one horse 15 shillings, two horses a guinea. The upper-class

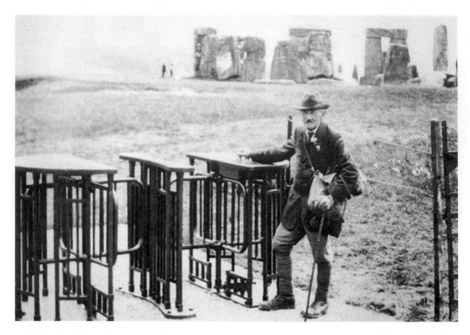

The turnstiles at Stonehenge in the 1940s. The monument was first fenced off in 1901, resulting in mass protest by people from the nearby town of Amesbury. The preservation and presentation of England's premier archaeological monument became an increasingly difficult problem as the twentieth century progressed.

visitor resented the introduction of the 'odious omnibuses'. According to one writer at the turn of the century:

> Waggonette parties are the bane of Stonehenge. To avoid them you must be up with the dawn, or you must wait for the evening shadows. Unfortunately I had stumbled upon it in the early afternoon, and long before I reached the stones I could see that they were ringed with a cordon of waggonettes ... On arriving, you found a good scatter of picnic remains, broken bottles, dirty papers, chicken and chop bones, and what the Victorians called 'litter' ...

Names were scribbled on the stones. Children used the fallen stones for slides and games, while their parents busied themselves with acquiring a souvenir chunk of stone. On a summer day, 'a constant chipping of stone broke the solitude of the place'. One party found their carpenter's hammer was good only for making small chips, and wished they had brought a geological hammer instead.[2]

Stonehenge attracted a wide range of other activities. In 1896, for instance, a concert presented by a travelling company called the Magpie Musicians was attended by an audience of over 1000 people. There was even a cricket ground a hundred yards or so to the north of the stones, which was home to the Stonehenge Cricket Club. A nineteenth-century illustration shows a team of fourteen fielders, wearing top hats, and a large refreshment tent. In the background are the stones, which were also attracting visitors in large numbers. The cricket ground enjoyed a high reputation and local schools from Amesbury used to play other teams, including Marlborough College, here. Cricket continued to be played at Stonehenge until the 1920s, when

Canadian troops passing through Stonehenge during the First World War. The road was diverted around the monument after the war.

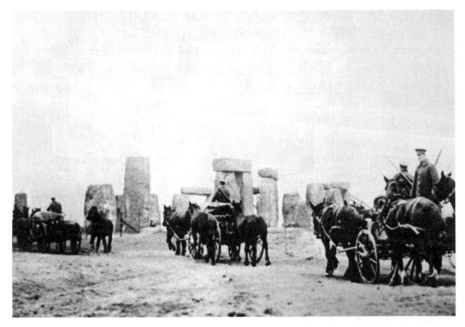

the game had become more sophisticated and more conveniently located grounds were established for local teams in Amesbury.

In the eighteenth century, the antiquarian William Stukeley had wrongly peopled his drawings of Stonehenge (and many other monuments) with Druids. Stukeley created an almost indelible link in public perception between Stonehenge and Druids, a mysterious religious sect found in Britain at the time of the Roman Conquest (AD 43). Stonehenge had been erected in its mature form about 2000 years earlier and had nothing at all to do with Druids. For much of the twentieth century, however, the stones have been associated with modern Druidism. In 1905 the Grand Lodge of the Ancient Order of Druids (founded in 1781 as a secret society, similar to the Freemasons) held a mass initiation ceremony at Stonehenge. The rites were accompanied by music from the 4th Volunteer Battalion, Queen's Royal West Surrey Regiment. Other groups of Druids also visited the stones, and in 1905 the Church of the Universal Bond in English was in open conflict with Sir Edmund Antrobus when they were caught burying the ashes of one of their members in the monument. Modern Druids continued to congregate at Stonehenge at the summer solstice, when the sun rises along the principal axis of the stones. From the 1960s, Midsummer Day became the focal point for what was called 'a festival of love and awareness'. The festival, which attracted large numbers of young people seeking an alternative lifestyle, became longer and larger each year, and at one point threatened to get out of hand completely.

Stonehenge was also affected by military activities. About 1900 the railway came to Amesbury, and with it even more visitors to the stones. The

railway came to Salisbury Plain largely to service the military, who were adding to the Stonehenge landscape with new camps at Larkhill and Normanton. During the First World War the military transformed the Stonehenge environment. Larkhill camp spread towards the stones, as far as the Cursus (a Neolithic elongated rectilinear earthwork), which was destroyed at its eastern end. A horse isolation hospital was built at Fargo Farm, to the north of the monument, and a grassfield aerodrome was created just to the west of Stonehenge. All the roads around Stonehenge carried heavy military traffic and the stones were also affected by the artillery firing on the Larkhill ranges. Damage to the numerous monuments in the vicinity of Stonehenge by military activity continued for much of the twentieth century.

Government involvement with the site was at first light-handed but, as in so many areas, government control and financial support became increasingly important as the century progressed. Stonehenge was not legally protected until the 1913 Ancient Monuments Act brought in compulsory scheduling, and the monument was protected against summary demolition or export. On the death of Sir Edmund in 1915, his estate, including Stonehenge, was put up for sale and bought by a local landowner, Cecil Chubb. In 1918 Chubb passed Stonehenge to the nation, in return for a knighthood, and the monument came under the care of the Office of Works. In 1927 a national appeal was launched to 'restore and preserve the open surroundings' of the Stonehenge monument. As a result of the appeal, some 1500 acres of land around the monument were bought and passed to the National Trust in 1929, following which the remains of the First World War aerodrome (latterly a pig farm) were removed, as well as two huts just outside the Stonehenge ditch and the recently erected custodians' cottages. When the lease expired, the Stonehenge café was also demolished. It was argued, in a manner which anticipated attitudes later in the century, that to retain a cheap, 'flashy little building like the worst type of bungaloid growth spoils the whole scene and vulgarizes unspeakably what should have been the sublime sweep of empty countryside'.

In the 1930s Stonehenge was once again to be flooded with visitors, this time arriving by car. Up to 15,000 a month would arrive during the summer and their cars would block the road; the custodian was overwhelmed at busy times when up to 'six charabancs crammed with Oldham mill-operatives' would draw up together at the turnstile, the only structure allowed on the site at that stage. Accordingly, a discreet car park was created, a little way from the stones; the car park failed to attract the motorist, but it did attract ice-cream vans, lemonade stalls and other refreshment vendors. After the Second World War there was a steady increase in the number of visitors, quite apart from the annual invasion of Druids at the summer solstice, and the Ministry of Works was obliged to build a range of subterranean lavatories in the car park. Eventually, in 1968, the car park was extended and other

visitor facilities were built in the form of a café, bookshop and tunnel under the road leading from the car park to the stones – all in standard Ministry concrete. These facilities were barely adequate for the number of visitors coming to Stonehenge in 1968, but they were to remain virtually unchanged for the rest of the century. In 1976 the number of visitors reached two-thirds of a million, and the Department of the Environment felt the monument could not accommodate any more. Direct public access to the stones was stopped and visitors were directed around the henge on temporary paths. At the same time, a working party was set up to consider long-term alternatives for the monument; in the event, the report of this group was not published because of a change of government in 1979, but its deliberations started a process of planning which was to last another quarter of a century.

Stonehenge posed a particularly difficult problem in terms of access, and plans for its most effective display were discussed for decades. The proposals included driving a road tunnel under the monument, thus diverting all traffic not going directly to the monument away from the area, and allowing its display in a more authentically open, carless environment. Stonehenge, a unique British archaeological monument, is a World Heritage Site at the centre of an extraordinary prehistoric landscape of ritual and funerary monuments, yet its visitor facilities are, to put it charitably, substandard. The custodians of Stonehenge are the two leading heritage organizations in Britain – the National Trust and English Heritage – and yet for almost a quarter of a century they have been discussing the best way to preserve and present the best known archaeological site in Europe.

In the autumn of 2004, Simon Thurley, Chief Executive of English Heritage, wrote:

> We are teetering on the brink of something quite extraordinary, something upon which I hope future generations will ... be grateful for our efforts. Certainly, they will also wonder why it took so long to sort things out ... a keystone of our efforts to transform the landscape around the stones into one of the biggest creative conservation projects the world has ever seen. The goal, simply, is to let people experience the magic and mystery of Stonehenge with as few twentieth- and twenty-first-century distractions as possible ... a 1.3 mile length of the A303 will have gone underground. There will be a new exhibition and education centre embedded in the landscape. And wildlife ... will be able to return to the area. From [the new visitor centre], visitors will be taken on a land train to the vicinity of the stones, via a series of drop-off points ... Woodhenge, King Barrows Ridge ... the Cursus, a two-mile-long early Neolithic ceremonial earthwork ... It will travel on non-intrusive, porous tracks, laid on the surface of the ground so that, should future generations decide they don't like it, it can be entirely removed.[3]

We shall see.

W. G. Hoskins

In 1955, just over halfway through the twentieth century, W. G. Hoskins wrote *The Making of the English Landscape*.[4] The central premise of his book was a very simple one. Hoskins argued that the English landscape we see around us is largely a product of man's activities in the past. He pointed out that by examining the landscape we are able to identify the result of historical processes at work; indeed, he claimed that the English landscape is a historical document and, 'To those who know how to read it aright the English landscape is the richest historical document we possess'. A sunken road with thick hedges in Devon is likely to be an ancient routeway, dating back perhaps to Anglo-Saxon times or earlier, while a straight stretch of road set within an area of regular square and rectangular fields will be a product of the work of Parliamentary Commissioners, implementing the Enclosure Acts of the eighteenth and nineteenth centuries. Hoskins showed that the row of miners' cottages here and the isolated church there all have a story to tell of man's past activities. The field full of irregular lumps and bumps represents a lost medieval village, while a richly endowed parish church in East Anglia or the Cotswolds will reflect the wealth of the wool industry in the late Middle Ages. Hoskins argued that the landscape is a 'palimpsest', on to which each generation writes its own story while at the same time erasing parts of the remnants of earlier stories. In his book, Hoskins looked at landscapes dating from prehistory to the Industrial Revolution, using existing features in the landscape as a starting point to interpret the economic and social forces that had created them. Hoskins wrote:

> Now I live in what many would call a suburban road in my native city [Exeter] and it might be thought it had little or no interest. The road itself began to be built up in 1839 on what were until then empty fields. Yet a few yards from my study runs a lane of Anglo-Saxon origin towards an Old English farm called *Madaworthi* (now called Matford). This lane itself comes off the Roman road that ran from Exeter to its port at Topsham. Matford Lane, still so called, has a right-angled bend in it, quite inexplicable as there are no physical obstacles to make it bend like this; so I assume that it was contrived to run around some Saxon estate that already existed. Even an early Victorian suburb can produce its own landscape and its own problems.[5]

Hoskins's ostensibly simple hypothesis had an important impact on historical scholarship. In the following half-century, geographers, historians and archaeologists all incorporated 'landscape' as an important element into their disciplines, and, on a more popular level, dozens of books were written on various aspects of the English landscape.[6] In the field of archaeology, Hoskins's work was responsible, in part, for changing the archaeologist's focus from the examination of individual discrete sites to the analysis of entire

W. G. Hoskins, the father of English landscape history, for whom the twentieth-century landscape was anathema.

landscapes. The application of non-intrusive survey techniques, such as geophysics, which were not available when Hoskins wrote, has helped transform British archaeology.

Hoskins's main concern was to interpret what survives, often in subtle forms, from previous eras, but the emphasis of historians and archaeologists gradually shifted to the reconstruction of past landscapes using a wide variety of material evidence. Hoskins and the majority of his successors concentrated on the pre-industrial landscape, although there were also a number of successful studies of the landscapes of the Industrial Revolution.[7] Relatively little attention has been paid by landscape historians to the twentieth century, although in recent years there has been an increasing interest in the relics of the two world wars. Sadly, even the demise of heavy industry in parts of the country was not always associated with detailed landscape recording. Yet while much of the work of landscape analysis of earlier periods was being undertaken, the English landscape was undergoing its most fundamental change ever. As early as the 1960s, British archaeologists woke up to the fact that these changes were resulting in their source material being rapidly eroded. The Rescue movement recognized the damage to archaeological deposits brought about by urban redevelopment, suburban sprawl, the spread of the motorway network and the work of aggregate quarrying which has fed these hungry changes. Rescue itself used the image of Stonehenge in the bucket of a digger as its logo. Nevertheless, landscape scholars, following on from Hoskins's lead, have for the most part ignored the impact of the twentieth century, tending to concentrate on what was being destroyed and the admittedly visually more attractive landscapes of earlier eras.

In the final analysis Hoskins himself was a Romantic, in the Betjeman mode, to whom the landscape should be evocative and beautiful. Hoskins studied landscapes that were 'dead', in the sense that the historical forces that had shaped them had moved on. Sleepy Cotswold market towns today are attractive because the wool industry that was responsible for the wealth which created them left long ago – they are delightful fossils which have been polished by twentieth-century tourism and consumerism. If the wool industry had remained on the same sites, the attractive medieval and Tudor buildings we so admire would have been swept away by subsequent phases of industrialization. Similarly, the eerie charm of the earthworks of a deserted medieval village lies in imagining the village as it would have been through an old sepia lens.

The twentieth century was anathema to Hoskins; he disliked virtually

everything visual about it. The short chapter on 'The Landscape Today', which concludes *The Making of the English Landscape*, is a cry of despair: 'England of the Nissen hut, the "pre-fab" and the electric fence, of the high barbed wire around some unmentionable devilment; England of the arterial by-pass, treeless and stinking of diesel oil, murderous with lorries', followed by his plea to 'turn away and contemplate the past before it is all lost to vandals'. When Hoskins was writing *The Making of the English Landscape* he was living in the Old Vicarage at Steeple Barton in the Oxfordshire Cotswolds. There he believed he would find the peace and calm to write. He had, however, neglected to take into account the recently founded United States airbase at Upper Heyford, only a few miles to the east of Steeple Barton. He was on the flight path of the F111 nuclear strike planes. It prompted the following: 'those misty uplands of the sheep-grey oolite (the Cotswolds), how they have lent themselves to the villainous requirements of the new age! Over them drones, day after day, the obscene shape of the atom-bomber, laying a trail like a filthy slug ...'

How much more Hoskins would have detested the late twentieth-century landscape. What he saw and wrote about in 1955 was a mere prelude to the avalanche of bricks and mortar, concrete, asphalt and plastic that has engulfed many parts of England since the Second World War. The impact of applied technology, of brand-based affluence, of the mobile globally orientated society has affected almost every part of England. Those buildings and environments and areas that are deliberately preserved now form part of the leisure industry – a self-conscious contribution to Theme-Park England.

Many modern landscapes are characterized by 'placelessness' or sameness, in which different locations in different parts of the country or even different countries look and feel alike. Suburbia, shopping malls, international airports, high-rise flats, office blocks, factory farms and public institutions such as hospitals and schools often exhibit standardized designs which result in one place looking virtually the same as any other. Perhaps this is what Hoskins intuitively anticipated and rejected so decisively. Yet Hoskins also appreciated that landscapes could not stay still; they were forever changing. In 1988 Christopher Taylor observed:

> Today we are passing through a period which can perhaps be regarded as a disaster. Yet it is not the faceless planners, mindless civil servants, wild military men or politicians who are always to blame. Ultimately they merely carry out what we as a democractic society demand. It is we who want broad motorways, cheap coal, instant electricity, subsidised food, and protection from alleged enemies without care for the past or indeed thought for the future. Perhaps we have achieved in our landscape what we deserve.[8]

It is my intention in this book to look at the contribution of the twentieth century to the English landscape, to try to use some of Hoskins's methods

of landscape analysis to look at many of the things which he found so distasteful, to try to understand what we have created and why. And suggest here and there that perhaps it isn't all quite as bad as we sometimes think.

Appleton, Oxfordshire

CHAPTER I | *The English Landscape*

And that will be England gone.
The shadows, the meadows, the lanes,
The guildhalls, the carved choirs,
There'll be books; it will linger on
In galleries; but all that remains
For us will be concrete and tyres.

Philip Larkin, 'Going, Going' (1974)

THE ENGLISH LANDSCAPE at the beginning of the twenty-first century owes more to the previous hundred years than any previous age. Much that changed was added to an older framework, but even more of what we see today is new and, what is more, owes little or nothing to what went before. In many respects, the landscape is no longer directly linked to the land on which it lies. Most of what has been built and engineered is functional and uniform. Local building materials or local craft traditions play little part in reshaping our environment today. The loss of distinctive local environments is the price to be paid for affluence, safety and cheap commodities. Perhaps landscape, in the historical sense of the evolving rural and urban scene, is dead.

In his autobiographical novel, *Cider with Rosie*, Laurie Lee observes the fundamental economic and social changes which altered the countryside and the way landscape was used during the first decades of the twentieth century. Writing of the Slad Valley in the Gloucestershire Cotswolds just after the First World War, Lee describes the disintegration of rural England: 'Soon the village would break, dissolve, and scatter, become no more than a place for pensioners.'[1] The social, economic and religious certainties that had bound Laurie Lee's childhood were also in the process of fragmenting. The First World War and its immediate aftermath accelerated the change from a world of horses, wagons, dusty lanes, oil lamps, thatched roofs, cob walls, and labour-intensive farming. Locally made tools and home-made entertainments gave way to the world of cars, lorries, motor buses, tractors, tarmacadam roads, council houses, electricity, telephones, wireless, piped water, mains drainage, standardized household articles and mass entertainment.

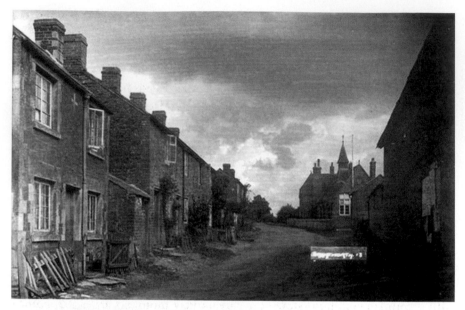

The deserted and somewhat desolate High Street in the village of Greatworth, Northamptonshire, at the beginning of the twentieth century.

The close links between man and the land, which had been a central feature of human existence since the origins of mankind, were broken and splintered in the twentieth century. In almost every respect the average lifestyle at the end of the century was fundamentally different from that in 1900, and these differences were reflected in the man-made landscape. Work, recreation, holidays and religion changed out of recognition during the course of the century. Lee's childhood world is the world that many travel writers reach for and still eulogize. At a superficial level, parts of it look the same as they did a century ago, but it is tidier, cleaner, sanitized. Few of its inhabitants have any real links to the countryside they inhabit, apart from their appreciation of its tranquillity and fresh air. In 1900 agriculture was still important; rural England was closely tied to the agricultural year and farming activities permeated village life at all levels. Within a hundred years this had all changed. Although agricultural productivity was higher than it had ever been, agriculture had become an industry, divorced from the people who inhabited the countryside. Large areas of rural England had become an inhospitable prairie – seen by millions and trodden on by hardly anyone at all. There are huge tracts of empty countryside, emptier now than they have been for thousands of years. Great swathes of giant fields are visited only two or three times a year by a mobile industrial unit that used to be the farmer and his plough. Farming became a technological business run along industrial lines, and paradoxically and criminally in a world where there was endemic famine in many third world countries, English farming was in trouble for reasons of overproduction.

The beginning of the twentieth century coincided with the start of the era of the motor car, and it is the internal-combustion engine more than

anything else that has created the contemporary landscape and fashioned our perception of that landscape. The growth of private car ownership and the personal mobility that this enabled has created a largely car-orientated society. Motorways and trunk roads built throughout England allowed rapid movement between the major population centres. Roads have been built from home to workplace, to shopping place, to leisure place, and everywhere there are acres of accompanying barren concrete and tarmac car parks. For large sectors of society in England, the car today is as important as running water or electricity. The motor car enables people to travel to work, shop and enjoy leisure from ever-widening radii of urban and rural settlements, with average daily journeys getting steadily longer. The average journey travelled by Britons multiplied six times in fifty years, from about five miles a day in 1950 to thirty miles a day by the end of the century.

Society has gradually become increasingly aware of the dangers of uncontrolled growth in the number of cars; while only a generation ago inner ring roads were blithely being bulldozed into the hearts of many ancient cities, with accompanying multi-storey car parks, today motorists are urged, bullied and coerced into leaving their cars, if not at home, on the outskirts of conurbations. Similarly, a society which neglected public transport, particularly railways, has become anxious to implement new schemes and incentives, and to encourage the use of public transport wherever feasible. Not only are there the immediately logistical problems of trying to cope with too many motor vehicles, there are now serious longer-term worries about the effect of engine emissions on global warming. There are many indications that it is already too late and that only the most drastic measures will be capable of controlling the monster that has been created.

The impact of the car has gone well beyond its immediate impact on the landscape. Paradoxically, freedom and speed of access have tended to restrict rather than enhance access to much of the English landscape. Roads, particularly motorways, are as rigid in their restrictions as railways, keeping traffic moving along narrow corridors, away from towns and villages. Many of our perceptions of a vanishing English countryside and an ever-expanding urban landscape in the more populated parts of the country have been engendered by the varied views during our travels along the motorways of the axial belt, locations that have had a magnetic attraction for industry and services as well as for housing. The vocabulary of travel is now in terms of junctions, access roads and service stations – the new coaching inns. The car has opened access to honeypot centres, such as the Lake District, Hadrian's Wall, Stratford-upon-Avon and Stonehenge, causing great problems in terms of visitor numbers, with the resultant erosion in the quality of experience at the locations visited.

Whatever definition we use, approximately nine-tenths of the total population of England lives in urban and suburban areas, the proportion

changing little in recent decades. Perhaps surprisingly to the great majority who live within urban areas and have an urban-orientated view of the landscape and countryside, urban areas still occupy only a relatively small proportion of the total land area. Even in England, which has a larger urban area than Wales and Scotland, it is still only 8.3 per cent of the whole.

At the time of the 1991 census, over half of the population of Britain lived in sixty large urban areas that had 100,000 inhabitants or more, fifty-three of which were in England, and only four in Scotland and three in Wales. Concentration was even greater in 'millionaire cities'; in 1999 London and the six metropolitan counties all with more than a million inhabitants each (West Midlands, Greater Manchester, West Yorkshire, Merseyside, South Yorkshire, and Tyne and Wear) contained 37 per cent of the population of England. Six of these large urban agglomerations form the core centres of a widening axial belt of towns and cities that runs from the coastal towns of south-eastern and southern England north north westwards through London, the East and West Midlands and South Yorkshire to Merseyside, Greater Manchester, Lancashire and West Yorkshire. This belt is sometimes referred to as 'hourglass' or 'coffin shaped', and has also been termed 'Megalopolis Britain'; and with increasing links to Europe, it has also been termed 'Megalopolis Europe'. It is not continuously urban but comprises a close network of towns, cities and conurbations that incorporates well over half the population of Britain. As communications improve, it is widening to incorporate economically successful and growing towns like Swindon, Cambridge and Peterborough, which are all within easy reach of London, and is also infilling through the rapid growth of towns like Milton Keynes and Reading.

Another major change since the 1960s is the way in which the process of migration from countryside to town has been largely replaced by a much more complex pattern of movement between town and country. Large cities and conurbations actually experienced a decrease in population to the suburbs, to smaller towns and villages and to surrounding rural areas, a process sometimes called counter-urbanization. It meant a dispersal of population, and this influenced the countryside, especially in the more populated parts of southern Britain. The rural population grew on average by more than 81,000 (0.7 per cent) a year between 1981 and 2002, while the urban population grew by about 48,000 (0.1 per cent) a year. In 2004, plans to double the level of house building in rural areas were described by the President of the Campaign to Protect Rural England (formerly the Council for the Protection of Rural England – CPRE) as 'the most reckless invasion of the rural environment staged by any government in history'.

During the second half of the twentieth century, the number of houses rose by about 78 per cent, from 13.8 million dwellings in 1951 to 24.6 million in 2000. Almost two-fifths (38 per cent) of all domestic houses were built

after 1965, when, for the first time, the number of separate dwellings in Britain began to exceed the number of households. Two-thirds of purpose-built flats or maisonettes have also been built since then, and there has been a shift in favour of detached housing. Although the growth in the total number of dwellings slowed during the 1990s, it was still increasing by about 180,000 a year at the end of the century. In addition, the percentage of dwellings that are owner-occupied more than doubled in the second half of the twentieth century, from 29.6 per cent in 1951 to 67.8 per cent in 2000.

Urban defusion was not just a matter of a move to the urban fringe, but the decentralization of many urban functions. Numerous out-of-town super-markets, shopping centres, industrial estates, science parks, garden centres and sporting stadiums were built around towns and cities, large and small, all over Britain, serving the populations of very large areas. Many were built on greenfield sites, replacing more centrally located corner shops, co-operatives, department stores and traditional football grounds hemmed in by terraced rows. The most conspicuous are the dozen 'megamalls', such as the Metro-centre in Gateshead, Meadowhall in Sheffield and the Trafford Centre in Manchester, which advertise as regional shopping centres and have vast car parks which attract visitors from long distances.

Three aspects of landscape-change in particular distinguish the twentieth from earlier centuries – speed, scale and power. The heavy industrial base of Britain more or less disappeared during the twentieth century. The coal industry, whose waste tips and winches once dominated County Durham, Yorkshire, Nottinghamshire, and even parts of Kent and Shropshire, was closed down. For most of the century, as industries declined, their plant and debris was left where it was. The waste tips from coal mining were the most obvious manifestation of this process, but everywhere in areas of old industry there were derelict buildings, sheds, rails, cooling tanks and chimneys. In the 1960s, the railway journey from Birmingham to Wolverhampton crossed the Black Country through a landscape of industrial dereliction worthy of Hieronymus Bosch – it looked like a giant scrapyard. In many parts of the country, industries lay where they fell; apart from salvaging those materials which had a second-hand value, little attempt was made to clear or tidy up industrial corpses.

In the later decades of the century, attitudes to industrial wasteland changed. As land which had been virtually worthless took on a new value, so waste tips were cleared or grassed over, and the detritus of industry was cleared up. The pit apparatus and old industrial plant has gone, except in those instances where it has been preserved within the context of a museum or theme park, and the vast expanses of waste have been grassed over and often given over to other uses such as sport and leisure. The railway journey across the Black Country still traverses an apparently dysfunctional, fragmented landscape, but one which has been transformed, with anonymous

industrial parks, ubiquitous multi-store shopping complexes and leisure facilities housed in great hangars built of steel, plastic and glass. It is a landscape which owes nothing to the ground on which it sits, but is there because it is within comfortable driving distance of large population centres. In the 1970s, W. G. Hoskins half-lamented the loss of the Black Country's 'tortured and tormented landscape'. He had heard that it had been 'cleaned up'.

> Sadly, this proved to be true: the tortured landscape I remembered from early explorations, the amazing monuments of the early Industrial Revolution like nowhere else, nearly all had gone. It proved to be hard to find a piece of the original landscape amid the high-rise flats, the nondescript buildings in the renovated streets. I tried to remember that it was vastly cleaner than it had been, far better to live in in many ways and too easy to lament the vanished ugliness if one does not have to live in it. Yet it is still a remarkable landscape and I found little pockets which I felt should be preserved as reminders of an almost vanished history.[2]

In the case of the Shropshire coalfield, the remnants of nineteenth- and early twentieth-century industry have been concealed beneath a New Town, Telford. In the area of post-Second World War housing, an alternative to New Towns – blocks of high-rise flats – have, for the most part, come and gone.

The scale of other aspects of landscape-change has also grown in the twentieth century. To take one example, quarrying: commercial stone quarrying goes back to Roman times and traces of old quarries are to be found throughout the country. Early quarries tended, however, to be relatively small and, when abandoned, tended to sink back into the landscape. Not so today; quarrying can remove whole hillsides or, in the case of sand and gravel, whole valley bottoms. Two examples illustrate this. Wenlock Edge is a Silurian limestone escarpment whose stone is to be found throughout the villages and small towns of south Shropshire, yet over the past few decades a whole segment of the magnificent escarpment has been quarried away, such is the capacity and voracity of modern extractive techniques. Similarly, in the Upper Thames Valley, huge stretches of sand and gravel have been excavated to supply the needs of the construction industry. The resulting string of marinas at one point promised to create a linear lake, extending the length of Oxfordshire, until a change of policy resulted in land restoration, which eventually returned much of the exhausted quarried areas to agricultural or other use.

Scale has also been an important factor in new institutional buildings. For example, in most cities relatively small Victorian hospitals have been replaced by massive multi-storey out-of-town hospital complexes which cover many acres. Similarly many schools, which were once located amongst the communities they served, have tended to be rebuilt on a substantial scale and serve much larger communities, pupils often being bussed in from several miles

away. A wide range of other municipal services which were contained within the Victorian city, including prisons and cemeteries, have also grown and moved to the urban fringe and beyond.

One only has to fly in to Heathrow Airport at night to appreciate not only the full extent of Greater London, but also the degree to which society is now dependent upon electricity. At the turn of the nineteenth century, oil and gas lighting were still dominant both in homes and in city centres. The first electric light system in a town was at Godalming in 1881. Electricity gradually took over these tasks and greatly extended their application. The percentage of homes wired for electricity rose from 32 per cent in 1932 to 65 per cent by 1938. By 2000 it was not just the centres of towns and cities that were illuminated by night, but all residential districts, many bypasses and stretches of motorway were also lit. The universal use of electricity in industry finally removed any link between the land and the power to run industrial processes. Industry no longer had to be located near a supply of power such as coal or running water. It was a fundamental change that, taken with the other technological developments of the twentieth century, contributed greatly to the 'footloose' nature of industry and other activities dependent on power in the twentieth-century landscape.

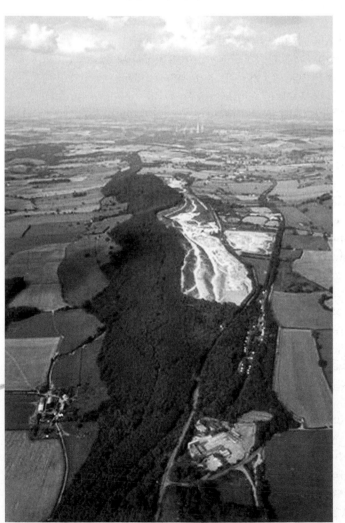

Limestone quarrying in the twentieth century has removed a large swathe of Wenlock Edge in Shropshire.

Planning policy and the controls and regulations necessary for its implementation have been another dominating aspect of the English landscape, particularly since the Second World War. As the pressures on landscape have increased, so too has the need to control and moderate those pressures. In the interwar years, largely unplanned suburban sprawl and ribbon development along roads were identified as problems which, if left unchecked, would give rise to immense damage to the countryside. Accordingly, town and country planning legislation was introduced in postwar Britain in order to contain development in what was perceived as a generally acceptable way. Thus

development control became one of the primary tools by which local government could contain the perceived excesses of the 'developer' and could help to create or mould balanced communities. For the first time in English history, government at national and at local level was involved in every aspect of life. The majority of the decisions concerning the making of the landscape in the twentieth century were made or acquiesced in by government or its agencies. In this respect, as in many others, the twentieth-century landscape is unique.

Much has been written about the role and control of planners, who are now in a position to determine not only what should and should not be allowed to be built and where, but often have a say in the minutiae of the colour and fabric of new buildings. Successive governments have come to power with a pledge to 'cut red tape' and to decrease the power of the planner. Often 'the planners' themselves are portrayed as the polluters responsible for the despoliation of England's green and pleasant land. It is, however, precisely because of planning control that England still has large unspoilt rural areas and roads free of the unsightly billboards which are to be found blighting the roads in parts of North America. A compulsory journey on the highway between Tampa and Fort Myers on the west coast of Florida should be undertaken by anyone who complains that planning is the root of all our countryside evils. The role of national and local government planning is in fact central to the understanding of the twentieth-century landscape.

One of the great attractions of the English landscape is its variety, a reflection of the geological kaleidoscope. The rapidly changing geography was once matched by changes in building and roofing materials, village size and field shapes. Although the twentieth century has done much to neutralize this variety, striking regional differences remain. Northumbria is different from Suffolk, Dorset is different from Lincolnshire, partly as a factor of topography and geology, but also as a reflection of historic, social and economic forces at play. It is the modern built urban environment which displays the most uniformity. Today, town and city centres throughout England share common building styles and materials, as do their suburbs. What is more, new developments pay little respect to what they are based on. The new landscape does not borrow from the old, it swamps it. There are no regional differences to distinguish new industrial and housing estates in Newcastle from those in Exeter. The new landscape owes almost nothing to its location, except in the case of some self-conscious gestures – a statue here or a street name there.

Today hundreds of English towns share the same mock-antique lighting, mass-produced pavement slabs, anonymous housing estates and ubiquitous chain stores. The high streets have the same banks, building societies and charity shops. A report published for the CPRE in 2004 observed: 'Year by year England is becoming less varied and more and more the same. High

Cattle market in a typical small town square before the First World War.

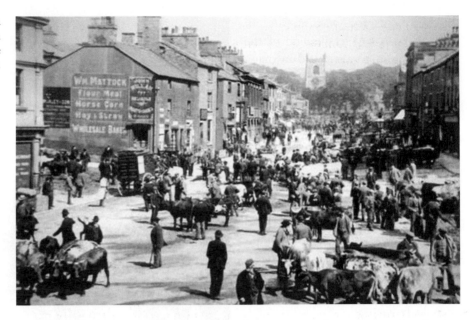

streets are becoming indistinguishable from one another. We are developing nowhere places ...' The report went on to say that loss of identity is now a serious cultural, environmental and economic problem. 'The value of diversity cannot be overstated. It is our shared record of the past. The variations help us root our lives, giving people a strong sense of place and inspiration for the future.'[3] Landscape, along with industry and the economy, no longer has links to the land on which it sits. Much of our contemporary landscape is rootless – as a society we have not understood this, let alone begun to come to terms with it.

When J. B. Priestley undertook his *English Journey* in 1934, he identified three distinct Englands. First, what he called 'Old England', 'the country of the cathedrals and minsters and manor houses and inns, of Parson and Squire; guide-book and quaint highways and byways England. We all know this England, which at its best cannot be improved upon in this world.'[4] Secondly, Priestley identified 'Industrial England', the England of

> coal, iron, steel, cotton, wool, railways; of thousand of rows of little houses all alike, sham Gothic churches, square-faced chapels, Town Halls, Mechanics' Institutes, mills, foundries, warehouses, refined watering-places, Pier Pavilions, Family and Commercial Hotels, Literary and Philosophical Societies, back-to-back houses, detached villas with monkey-trees, Grill Rooms, railway stations, slag-heaps and 'tips', dock roads, Refreshment Rooms, doss-houses, Unionist or Liberal Clubs, cindery waste ground, mill chimneys, slums, fried-fish shops, public-houses with red blinds, bethels in corrugated iron, good-class drapers' and confectioners' shops, a cynically devastated countryside, sooty dismal little towns, and still sootier grim fortress-like cities.

This landscape was already in decline then, and by the end of the century it was obsolete and in many areas had already disappeared. Finally, Priestley identified his third England, which he astutely observed 'belonged far more to the age itself than to this particular island'. 'This is the England of arterial and bypass roads, of filling stations and factories that look like exhibition buildings, of giant cinemas and dance-halls and cafés', and, as he entered London from the north, 'where the smooth wide road passes between miles of semi-detached bungalows, all with their little garages'.

What Priestley was seeing was the beginning of the authentic twentieth-century landscape. It was halted by the second war in the 1940s but its creation accelerated and mushroomed during the last decades of the century. 'Old England' has become cocooned and polished, while 'Industrial England' has all but disappeared, except where it has become absorbed into Old England as part of 'Theme-Park England'. It is the third England, the England that belongs to the age, which dominates.

Landscape is the product of thousands of different decisions and actions made in the past. The English landscape at the end of the twentieth century owed a great deal of its complexion to that century. The reasons for this have much to do with the rapid technological improvements which came to affect everyone's lives, largely for the better; the economics which brought a measure of prosperity to most people; and the way in which society ran itself. Ultimately, it is futile to condemn the twentieth-century landscape out of hand. Much will be swept away before the end of the twenty-first century, more rapidly and comprehensively than in the past, but some aspects will come to be treasured and preserved. The continuum of landscape evolution will prevail; it will just be different from the generally more leisurely developments of the previous five thousand years.

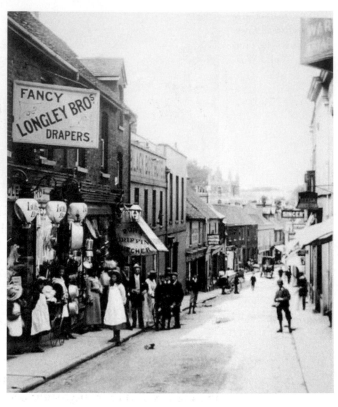

Church Street, Basingstoke, in 1904. Each town had its own range of small individual stores.

CHAPTER 2 | # The Age of the Car

When every high road is alive with cars, when there is a ceaseless
roaring of exhausts and blowing of horns, when the railways are
almost forgotten and the reign of the car is undisputed, then I
venture to question if pleasure will have any say in the matter at all.

Max Pemberton, *Amateur Motorist* (1907)

UNDERLYING almost all the major landscape changes in the twentieth
century was the internal-combustion engine. The motor vehicle
transformed ways of travel, work and recreation. In turn, the ability to move
faster, further and more flexibly has transformed the way we live. Our
perception of our environment is now mainly in terms of what we see from
the road. Whether in city, suburbia or countryside, our viewpoint is largely
dictated by our position from the metalled road.

The rural England of 1900 was traversed by a maze of frequently used
unpaved roads, rough tracks and paths between towns, villages, hamlets and
fields. As the century progressed, the choice of which roads to make suitable
for motor traffic determined and restricted the routes people took. Ironically, the
greater speed and freedom of movement brought about by motorized transport
was accompanied by a *de facto* shrinkage in access to the landscape. Although
an intricate network of tracks, footpaths and bridle paths still allowed access to
the depths of the countryside, in reality increasingly these were used by a
minority. We now know our environment only in terms of roads, and many
of us have lost that intimacy with our natural surroundings that was common
until a generation or two ago. In 'Last Days', the final chapter of his autobio-
graphical novel *Cider with Rosie*, Laurie Lee describes the change in transport
methods which affected every part of the country during the twentieth century.
He describes his rural Gloucestershire just after the First World War:

The last days of my childhood were also the last days of the village. I belonged
to that generation which saw, by chance, the end of a thousand years' life.
We were born in a world of silence ... of villages like ships in the empty
landscapes and the long walking distances between them; of white narrow
roads, rutted by hooves and cartwheels, innocent of oil or petrol.[1]

The twentieth century saw the demise of the horse as a means of mass conveyance. In 1900, central London was as congested as it is today, but horse-drawn vehicles were the principal means of transport. At the turn of the century, the Tilling Carriage Company alone stabled over 1500 horses at its depot in Peckham. Horses were used to pull carriages of all shapes and sizes as well as buses and trams, yet within fifteen years horse-drawn public transport was a thing of the past in London. The speed and scale in the decline of horse-drawn transport, at least at the upper end of the market, was reflected in the decline in investment in new horse-drawn carriages. In 1901, £1,200,000 was spent on new carriages; in 1907 this had dropped to £400,000; and by 1911 the figure had declined to £200,000. After the First World War, when there was a dramatic increase in the sale of new cars, virtually no one was buying horse-drawn conveyances for private use and, as a result, coach-building firms in Mayfair were replaced by motor garages. The London mews, narrow, pavementless alleys, provided the stables and coach houses for the affluent, but were already being converted for residential use before the arrival of the car. The coming of the car accelerated a trend which eventually saw the mews house transformed into a desirable and expensive London residence. Other topographical features of the horse age disappeared: for example, a large block of land next to Hyde Park Gate, which at the end of the nineteenth century had been occupied by a riding school, had by 1914 been replaced by streets and housing.

Outside London, horses were still used almost exclusively for local transport. But with the development of motor-powered transport even here the horse was progressively phased out of every aspect of passenger and commercial carriage. In Laurie Lee's Cotswold village before the First World War 'the horse was the fastest thing moving ... the horse was king, and almost everything grew around him: fodder, smithies, stables, paddocks, distances, and the rhythm of our days. His eight miles an hour was the limit of our movements, as it had been since the days of the Romans.' Lee's world was slowly invaded and eventually taken over by the motor car, the charabanc and the motorbike. Everywhere the use of horses died out and they were replaced by machines. By the second half of the twentieth century, horses were used almost exclusively for recreational purposes.

The Railways

During the nineteenth century, railways had been responsible for transforming long-distance travel in Britain. Railways united many parts of the country in an unprecedented way, bringing distant and often remote places close together in terms of journey time. The need to adhere to national railroad timetables had also brought about uniform national timekeeping and, for the first time ever, clocks in Newcastle upon Tyne recorded the same time

as those in Exeter or, indeed, anywhere else in Britain. The English landscape was deeply affected by the railway age, in the first place by the disturbance caused by the building of the railroads, often against the background of public opposition, and secondly in the changing patterns of settlement that grew up in response to the presence of the railway network. These included new towns such as Swindon, Derby and Crewe, whose very *raison d'être* was to service the new railway industry; they remained primarily railway towns for much of the twentieth century. Additionally, railways encouraged the growth of suburbs, by enabling workers to live further away from their place of work. Railways also fostered the growth of seaside resorts around the English coast and spa resorts inland.

The coming of the railways had adversely affected both canals and turnpike roads, whose ailing companies were frequently bought up by the new, successful railway enterprises. Long-distance turnpike travel was effectively destroyed by the railways, making thousands of toll houses and booths redundant along the routes of the old turnpike roads; the last toll gates on the Anglesey section of the Holyhead road were removed in 1894. In the late nineteenth century, care of the road network had passed to local authorities, but at the turn of the century most main roads were normally only wide enough for two wagons to pass; minor country roads were often much worse, deeply rutted and pitted with potholes. Many roads were too steep or otherwise difficult for early motorized traffic; as a result, the endless task of road improvement was started. The push for improved roads came partly as a result of the lobbying from groups such as the Roads Improvement Association, which had started with the early cyclists; by the end of the nineteenth century, the bicycle, although not a motorized vehicle as such, was an important means of transport, particularly in towns. The bicycle had developed in something like its present form, complete with pneumatic tyres, in the 1880s, but, unlike most earlier traffic on the roads, was used mainly for pleasure. By the turn of the century bicycles were to be found in great numbers and there was considerable opposition to the number of cyclists, who alarmed horses and pedestrians, raised dust, and could travel at the dangerously fast speed of twelve miles an hour. Consequently, lights (for all vehicles) and bells (for bicycles only) had been made compulsory in 1888.

By the time Queen Victoria died in 1901, England had become the most urbanized nation in the world, with the most comprehensive system of railway transport that any country has ever had, with over 18,000 miles of track. The railway penetrated into remote rural areas, enabling access to the countryside for town dwellers on a large scale for the first time. For example, the coming of the railway opened up northern Somerset and brought it into much closer contact with Bristol, Exeter and the West Country. The following account of the summer excursion of the Somersetshire Archaeological and

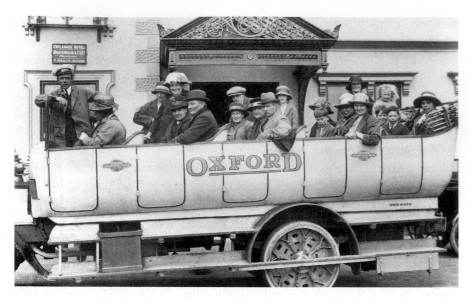

The open-topped charabanc was a favourite form of transport for group outings between the two world wars.

Natural History Society for 1898 demonstrates the convenience and flexibility of railway transport in the late nineteenth century:

> The Great Western Railway Company, with their usual readiness on such occasions, issued excursion tickets for the visit, and the intention was to provide special carriages by the 10.18 a.m. express train. The party, however, turned out to be a larger one than was anticipated, numbering altogether 100. Mr Linley, the stationmaster, thereupon promptly made arrangement for a special train to convey the visitors, which left Taunton at 10.20, running in advance of the regular express. Exeter was reached without stopping after a smart run of forty minutes.[2]

The Shropshire Archaeological Society also regularly used the railway, penetrating into remote corners of the county for its excursions. From 1911 onwards, however, private cars were used to carry members on their outings, and, after the First World War, charabancs were hired. The railways were also responsible for the creation and development of many English seaside resorts. Between 1850 and 1950 the railway carried most people to their destinations for their annual holiday by the sea. The dramatic expansion of Bournemouth as a resort only occurred after the opening of the railway link with London in 1870, and with the Somerset and Dorset line from Bath and the Midlands in 1874. By 1881 the population of Bournemouth had already reached 16,859; by 1911 it had grown to 78,674. Bournemouth had been transformed from a quiet coastal backwater into one of the major towns of the country.

The coming of the electric motor and the internal-combustion engine was at first seen as a means of replacing the horse for short journeys, rather than to compete with the railway for longer ones. Yet the failure of the railways

to share a significant overall growth in passenger traffic in the years up to 1914 was a sign that motor vehicles were already beginning to compete successfully with the railways over longer distances. This competition caused railway companies to electrify certain lines in the London area, in the North East and in Lancashire in and after 1904. When motor buses appeared in greater numbers a few years later, they attracted much of the traffic which would otherwise have gone by train. Road transport, now mechanized for short passenger journeys, had become more efficient and cheaper in much the same way as medium- and longer-distance transport had been made more efficient and cheaper by the steam railway fifty years before.

In general, however, road and rail were still complementary and the introduction of the car did not interfere with the continued expansion of the rail network in and around large cities. The growth in commuting, as urban areas expanded, encouraged a rising demand for suburban rail services. In Newcastle, annual passenger numbers on the Tyneside loop rose from six million in 1903 to nearly nine and a half million by the outbreak of the First World War. The London underground railway system expanded to become an overground network to the west, north and east of London, and, to a more limited extent, to the south of the Thames. The 'sub-surface' lines (as opposed to the 'tube', comprising the bored tunnels) had already penetrated well into Home Counties countryside by 1914. The first major 'tube' extension into greenfield areas was the Northern Line extension from Hampstead to Edgware in 1923–24. It was followed by the Metropolitan (later Bakerloo) to Stanmore in 1932, the Piccadilly to Cockfosters in 1933, and then the Northern to Barnet. South of the Thames, the Northern Line reached

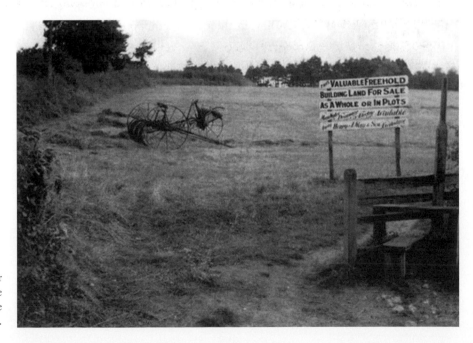

Agricultural land for sale, Home Counties, after the First World War.

Morden in 1926; the seventeen-mile tunnel between East Finchley and Morden was, at the time of its construction, the longest continuous tunnel in the world. The London Passenger Transport Board, which was created in 1933, brought together the management of underground lines, tramways and buses. A major development came with the government-backed 'New Works Programme' of 1935–40, which resulted in substantial lengths of ex-Great Western Railway (GWR) and ex-London and North Eastern (LNER) track being handed over to London Transport, following which the Central Line was extended as far as Ongar in Essex.

Outside London, by 1920, railways were already suffering financially, and the 'Big Four' railway companies were compulsorily created in 1923 with the amalgamation of more than 120 smaller companies. The Southern Railway, the one company that had electrified on a large scale, was the only financially successful enterprise. Cheaper motoring costs had hit the railways, which were also affected by the general adverse interwar economic climate. This resulted in a decline in their traditional freight markets of coal, metallurgy and heavy engineering. Added to which, the General Strike of 1926 had indicated that the nation could live without railways, and much high-value traffic never returned afterwards. Indeed, the work of dismantling the railway system started in the interwar period, when 240 miles of track and 350 stations, many of them located in remote rural areas, were closed, while another thousand miles of track and 380 stations were closed to passenger traffic. The era of the abandoned railway line and the decaying railway station had already begun.

At the same time there were improvements to the rail system. The standardization of locomotives and rolling stock helped increase the speed of delivery, and there was a revolution in the way freight was handled, with the introduction of containers and mechanized marshalling yards such as that at Whitemoor, March (Cambridgeshire). Much new building on the rail network in the 1930s used contemporary architectural techniques. Examples of this are to be seen at Surbiton station and Southern Railway 'glasshouse'-style signal boxes, as well as a more general trend towards streamlining.

Although the system had been absolutely essential for the war effort, the railways were particularly badly affected by the Second World War. At the end of the war there was no money to upgrade an exhausted system. Following nationalization in 1948, the railways were placed under the British Transport Commission, which also took over responsibility for London Transport as well as a large segment of road transport. The Commission was created in order to integrate the transport system and rebuild it after wartime damage and a lack of prewar investment. However, such integration was not pursued in the long term. Under the Railway Modernization Plan (1955), it was proposed that steam locomotives should be replaced by diesel and electric-powered trains. The West Coast Main Line from London, via

Birmingham and Crewe, to Liverpool, Manchester and Glasgow was electrified between 1959 and 1974. Nevertheless, financial investment on the railways never matched that being spent on roads, and there was a relentless rise in the volume of road traffic, both passenger and freight, much of it at the expense of the railways. For example, the single most important change in the character of a holiday by the sea in the postwar years was brought about by the growth of car ownership. In 1951, 47 per cent of holidaymakers went by train to their destination, 27 per cent went by bus or coach, and 27 per cent went by private car. By 1960, nearly half of the total number of holidaymakers went by car, and by the end of the 1960s that figure had reached nearly 70 per cent. After that, the pattern of British holidays changed, with an increasing number of people travelling by plane to take their principal holiday abroad, and normally travelling to their departure airport by road.

The implementation of the Beeching Report on the future of railway transport in 1963 dealt a further serious blow to the railways, and led to dramatic cuts in the network. Although Beeching argued for a concentration on fast intercity services and bulk freight carriage, for example to power stations, his remit was simply to make the railways pay their way, and his report did not consider the social and wider economic consequences of rail closures. Freight and passenger services were greatly curtailed, the workforce was cut, lines were taken up, and many stations became unmanned halts or were converted to other uses. The rest of the railway system survived, either because, though loss-making, it merited public support to keep it open on social grounds; or because modern city centre to city centre trains, which provided faster journeys than road (and air over most British distances), could still be full and profitable; or because railways provided their own

Abandoned rural railway station at Fawley, Herefordshire. A victim of the Beeching cuts in the 1960s.

valuable roads into conurbations where the existing thoroughfares were already becoming overloaded.

Many of the old lines were sold off in portions to adjacent landowning farmers, or for housing, making the restoration of services extremely difficult. Cross-country lines, such as the Somerset and Dorset (Bath to Bournemouth) and Oxford to Cambridge, were shut, as well as numerous branch lines. Railway buildings became homes, offices, workshops and storage units. In Berkshire, the Abingdon and Faringdon branches both closed to passengers in 1963, while in 1964 the Didcot to Newbury line was shut. With the rise of leisure activities, several former railway trackbeds, such as that between Consett and Sunderland, two former powerhouses of industry in north-east England, were turned into footpaths or cycleways. In another example, Stratford-upon-Avon Greenway began life as a five-mile section of the old Honeybourne railway line, which was closed in 1976. The Greenway is now a surfaced pathway for cyclists, walkers and wheelchair users. The disused railtracks of the twentieth century today form extensive linear earthworks in many areas, wooded, overgrown and sinking back into the landscape. Often they look like Iron Age or medieval linear earthworks, or Roman roads, their true origins only revealed by an occasional solid brick or stone bridge, or an abandoned station. Apart from providing safe and attractive walks and rides, the disused lines are often sanctuaries for a wide range of wild flora and fauna. Stations and crossing keepers' cottages have been converted into homes; sidings have become gardens; and station yards were taken over by builders or coal merchants, or, as often as not, were used as car parks. Some of the old lines were reopened as tourist attractions, as nostalgia for the steam age became part of a broader appreciation of and interest in heritage.

The rail system did remain an important means of travel between the major cities and for commuting into them. From the 1960s, the London Underground grew to cover more of the expanded city. The Victoria Line opened in 1968–69 as the first automatic underground railway in the world. It was followed by the Jubilee Line, which was completed in 1979. The Piccadilly extension to Heathrow opened in 1977, and the Jubilee extension to Greenwich began operation in 1999. The Docklands Light Railway was opened in 1987, and sections of the Newcastle Metro were opened from 1980 onwards.

The national train system avoided the dramatic cuts suggested in the Serpell Report of 1983, which had proposed the reduction of the system to 1600 miles, consisting of just a few major routes. Instead, the system stabilized at about 11,000 miles, a little over half the interwar mileage. Furthermore, there were important improvements to the system. The InterCity 125, a high-speed diesel train capable of travelling at 125 mph, was introduced in 1976 on the Paddington to Bristol and South Wales routes, and then spread to other non-electrified main lines. Journey times from London to cities such

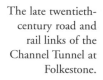

The late twentieth-
century road and
rail links of the
Channel Tunnel at
Folkestone.

as Newcastle were considerably shorter than they had been in the days of
steam. Another major new innovation, the Channel Tunnel, was opened to
rail travel in 1992, and new access roads and rail links were built at Ashford
and Folkestone, creating new concrete landscapes in Kent.

Although passenger and freight traffic on major rail routes rose in the
1990s, car traffic rose even faster. By the end of the twentieth century, railways
were attracting more passengers, despite very high fares, but only 1.5 per cent
of journeys in England were by train. By 2000 it had also become clear that
there was not a simple choice between rail and road. The rail system could
only carry a small percentage of a much more mobile population and a much
increased freight load. Moreover, railways did not serve many of the new
places of employment, and the cost of creating a comprehensive rail system
to meet the fluid transport needs of the twenty-first century was prohibitive.

Trams

Horse-drawn tram use had expanded greatly in the 1890s and 1900s. Like the
hackney carriages, horse-trams – 'crawlers' and 'growlers' – were heartily
disliked by many who found them 'dirty, smelly, slow and accident prone'.
The *Observer* of 13 April 1873 remarked that they were 'only fit for firewood'.
Together with other forms of traffic at the turn of the nineteenth century,
the horse-buses and tramcars brought traffic jams to many city centres. The
first electric trams in Newcastle ran in 1901, replacing the earlier horse-tram
network. Between 1897 and 1906, 2200 miles of tramway were laid in England
and Wales, largely on roads within towns and cities. By 1904 electric trams
were running on most of the main roads in Newcastle, and new lines

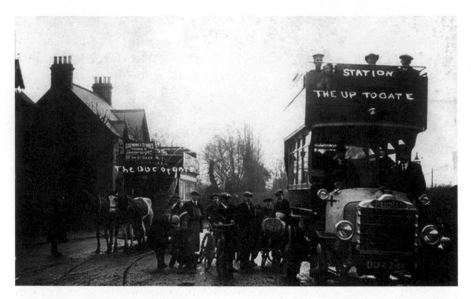

A horse-drawn tram next to a diesel-powered omnibus in Oxford before the First World War.

continued to be laid along the principal routes until 1928. In outer Liverpool, a pioneering attempt to design new roads incorporating tramway reservations, called the 'Brodie System', was applied. Under this system, dual carriageways with separate tramways sited on a central reservation were built. Manchester Corporation also experimented with reserved-track tramways such as the Kingsway, which was finished in 1930 and was responsible for extensive suburban growth.

Nearly all the trams were eventually replaced by diesel-engined buses. Many cities, such as Glasgow, Leeds and Liverpool, were still investing in tram systems in the late 1940s, but during the 1950s they were swiftly discarded. Newcastle's last tram ran in 1950, Gateshead's in 1951, and London's in 1952. By 1960 the sole surviving electric tramway in England was essentially a tourist attraction running between Blackpool and Fleetwood. London's last trolleybus ran in 1962, and in 1963 Newcastle Corporation decided to replace trolleybuses with motor buses. In the 1990s, however, there was a renewed interest in trams as an alternative to bus and car transport in congested cities. There was a revival of trams in Manchester, where they covered nineteen and a half miles, from Bury in the north to Altrincham in the south, passing through the city centre. A twelve-mile tram service ran from Birmingham to Wolverhampton, and there were also tram services in Sheffield and Croydon.

The Motor Car

During the twentieth century, despite many problems, motor transport proved to be more flexible, less expensive and more popular than rail transport, and by the end of the century was absolutely dominant. The building of dual carriageways and the motorway network, together with the

conversion of old roads for motor vehicles, was an immense engineering achievement, in many ways more impressive even than the construction of the railways in the nineteenth century. Motor transport changed both town and countryside, enabling the spread of suburbia, industrial activity and retailing. Indeed, the rise of the car made a significant contribution to the breakdown of the divide between urban and rural.

The motor car registered as No. 1 arrived in London on 3 July 1895. In the same month, Evelyn Ellis and S. F. Edge undertook a drive of fifty-six miles from Micheldever in Hampshire to Ellis's house at Datchet, near Windsor, which took five hours thirty-two minutes 'exclusive of stoppages'. It was, Edge claimed, 'the first ever made by a petroleum motor carriage in this country'. On 15 October 1895, half a dozen vehicles gathered at Broomhill, the country house of Sir David Salomons, at Tunbridge Wells, for the first motor show ever held in England. A few months later Salomons organized another motoring exhibition at the Crystal Palace in London. In 1896 Parliament repealed legislation that required steam wagons and cars to follow a man carrying a red flag by day and a red lantern at night. This enabled them to drive at a speed of up to 14 mph. By 1903 the maximum legal speed limit was set at 20 mph, where it remained until 1930, when all speed limits were abolished.

The Locomotives on Highways Act took effect on 14 November 1896. To mark the removal of the last legal barriers to motoring, a road rally trip from London to Brighton was organized. The scene at the Central Hall at the start of the Emancipation Run, as the rally became known, was described by Charles Jarrott, later a racing driver and co-founder of the Automobile Association:

> I shall never forget the scene which met my eyes when I entered. French mechanics and German inventors, with enthusiasts of all nationalities, were mixed up in indescribable confusion. Huge flares were being carried about from one machine to another to assist in lighting up the burners for the cars, which at that time were innocent of electric ignition. An occasional petrol blaze was seen through the fog which filled the hall, making the scene resemble a veritable inferno.[3]

At the breakfast held before the start of the run, at the Metropole Hotel, Northumberland Avenue, the Earl of Winchelsea produced a symbolic red flag and tore it up to the cheers of the assembled motorists. The Secretary of the Motor Car Club, C. Harrington Moore, issued the following instructions:

> Owners and drivers of motor vehicles taking part in the tour should remember that motor cars are on their trial in England, and that any rashness or carelessness might imperil the industry in this country.

Of the fifty-eight cars at the starting point outside the Metropole Hotel, only thirty-two actually started. It is not clear who passed the finishing line

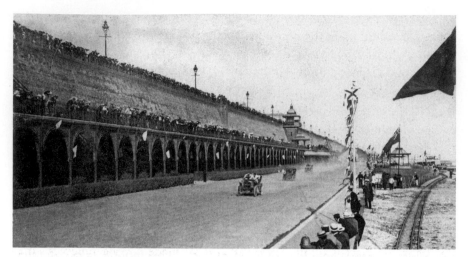

The Brighton motor trials in the summer of 1905.

first at the Brighton Metropole, nor is it certain how many cars actually finished legitimately, as a number of vehicles were driven to Victoria Station and loaded on a train which took them to Preston Park, a station just outside Brighton.

The Prince of Wales's purchase of a Daimler in 1900 further encouraged the fashion of private motoring, and by 1905 there were 15,800 cars on Britain's roads. By 1914 the number of cars in Britain had risen to 132,000, and at the outbreak of the Second World War there were two million vehicles. The first motor-car race in Britain was held at Bexhill-on-Sea in 1902, but the many enthusiastic motorists who wished to race their cars had before this been compelled to travel to Europe in order to take advantage of the higher speed limits, that is until Hugh F. Locke King decided to transform part of his large estate at Brooklands into the first purpose-built racing track in the world. The Locke King estate included over 300 acres of land where woodlands sloped down to an area of flat, marshy farmland by the River Wey. It was judged to be the ideal site for a showplace for British motoring, but, because Brooklands was the world's first purpose-built motor-racing circuit, there were no previous examples to follow. The design of the track was entrusted to Colonel H. C. L. Holden of the Royal Artillery, and the original plans quickly grew beyond Locke King's wildest expectations. Far from the idea of a simple road circuit, Locke King was persuaded that, in order for cars to achieve the highest possible speeds with the greatest possible safety, the two and three-quarter mile circuit would need to be provided with two huge banked sections, nearly thirty feet high. The track would be 100 feet wide, hard-surfaced and would include two long straights, one running for half a mile beside the London to Southampton railway, and have an additional 'Finishing Straight' passing the paddock and enclosures, bringing the total length of the track to three and a quarter miles. To begin with, many of the rules and procedures were based on horse racing, in order to try

and attract a ready-made audience to this new and somewhat curious sporting venue. In addition to the banked curves, features of the new motor course included the distinctive green-domed clubhouse, complete with a weighbridge for cars and changing rooms for competitors. The track was formally opened on 17 June 1907 with races and a motorcade. For thirty-two years Brooklands was the centre of motor-car racing in England, and after 1910 it also became a major centre of aviation. Much of the circuit at Brooklands was destroyed during the Second World War, but the members' banking and northern section of the finishing straight survive, as part of the Brooklands Museum.

The first full-size British petrol motor car, the Wolseley, was produced in Birmingham in 1895, while the first commercial motor-car manufacturing company was the German Daimler Motor Company, which established a factory in a disused cotton mill in Coventry. The site proved ideal for the company, as Black Country factories already made a wide range of small metal goods, including bicycles and gas engines, which could easily be adapted for the manufacture of cars. Coventry soon became the chief British centre for motor-car production, while Birmingham was second, as a prime source of components. The industry employed only 151 persons in 1900, but grew rapidly, and by 1905 there were twenty different motor manufacturers in the Hillfields district of Coventry alone, most of them continuing to make bicycles as well. The English pioneers of motoring were Henry Royce, Herbert Austin and William Hillman. Royce, also a pioneer of aeroplanes, produced a car in 1904 and two years later, after merging with C. S. Rolls of London, designed the famous Rolls-Royce Silver Ghost, with a 40 to 50 horsepower side-valve engine. Herbert Austin had begun designing his first car on returning in 1893 from Australia, where he had anticipated the future of mechanical road transport while managing a sheep farm there. By 1906 he had moved to a more spacious factory site at Longbridge, on the outskirts of Birmingham. William Hillman, originally a cycle manufacturer, also began to construct his own cars in 1909; his first cars were made in the grounds of his own home. The Singer Company became the largest manufacturer in Coventry; at its peak in the 1930s it operated five sites in Hillfields. The company continued to make cars at its Canterbury Street works until it was taken over by Rootes, who, in turn, were taken over by Chrysler in 1964. Other cycle firms who took up motor-car building in the Coventry area and who later became household names were Swift, Lea and Francis, Allard, Singer, Rover, Riley and Humber.

By 1914 the industry had spread to other towns, and 53,000 workers were employed in producing no fewer than seventy different models of light car. Among the other new manufacturers was William Richard Morris, a cycle mechanic who had grown up in east Oxford, where numerous small workshops tucked away in back gardens were run by craftsmen skilled in the repair and production of various wood and metal objects, largely for Oxford

William Morris's motor works on Longwall Street in Oxford before the First World War. The medieval city walls which form part of New College are in the background.

colleges. In 1893 Morris, at the age of sixteen, started to make bicycles from Midland components, and gradually moved on to motor cycles in 1900. By 1903 he was selling and hiring out automobiles from a garage in Longwall Street, between Magdalen College and New College. Nine years later he began producing, from components bought from Coventry and Birmingham engineers, a 'bull-nosed' Morris automobile, with a body made by Oxford coach builders.

After the First World War, William Morris formed Morris Motors Ltd and set up a factory in the vacant Military Training College in the village of Cowley, two miles to the south of Oxford. This factory was soon turning out over fifty cars a week. Morris gained a reputation among bankers as being financially astute; consequently, when many older car firms in the Midlands closed down during the 1920s slump, Morris was among the relatively few survivors able to obtain credit to modernize their production methods. By adopting flow production and standardizing parts, he lowered production costs by about one quarter, and broke the hold of American cars on the British market. By 1927 the Cowley factory at Oxford was producing nearly a thousand cars a week, and a radiator branch had been opened in the unlikely location of the Woodstock Road in north Oxford, an otherwise residential area adjacent to the Oxford Canal. In the meanwhile, the Pressed Steel Company had established a factory for steel motor-car bodies on the plateau adjacent to the Morris works at Cowley. Morris was also responsible for this development as he had persuaded a noted Philadelphian company, which was applying new techniques to the manufacture of steel car bodies, to join with him in the venture.

Morris Motors also manufactured prefabricated garages. These became an integral part of the suburban landscape between the two world wars.

The Morris firm struck a boom period for car sales abroad as well as at home, and by 1934 it was exporting no fewer than 450 vehicles weekly. At Cowley, the labour force commuted from within a radius of about twenty miles, and immigrants from many parts of the British Isles settled in the Oxford district. In particular, large numbers of unemployed miners from the South Welsh coalfield settled in Oxford. Between the two world wars, 10,000 new houses were built in Oxford and its outer suburbs, and the number of people living within the extended city boundary rose by 30,000. By 1936, Oxford, along with two other automobile manufacturing centres, Coventry

The cover of the Morris Motors' brochure for 1937. Note the strong triumphalist complexion.

and Luton, was one of the three most prosperous towns in England outside London. Oxford became what John Betjeman called 'motopolis'. Just as the real price of houses fell during the interwar years, so too did the cost of a motor car. In the mid 1930s the average cost of a London house was £500, while a Rolls-Royce cost £2500. At the bottom end of the market, however, the Austin Seven sold for just £165; the Morris Eight and Ford also sold at about the same price. These cheap cars encouraged motoring and resulted in a dramatic increase in road traffic.

Roads

One of the main problems with early motoring was the state of the roads. The drawback with existing roads was dust. Even the best roads designed by John McAdam were only built of stone held together with mortar, rubble and clay, and the suction action of car tyres drew out the binding medium in the roads, which then disintegrated. Contemporary motorists were unanimous in their complaints about the resulting problems of dust. An unexpected source illustrates the problem admirably. In Kenneth Grahame's children's classic *The Wind in the Willows*, Toad's traumatic introduction to the motor car describes a hazard experienced by many early motorists:

> [Rat, Mole and Toad] were strolling along the high road easily ... Glancing back, they saw a small cloud of dust, with a dark centre of energy, advancing on them at incredible speed, while from out of the dust a faint 'poop-poop' wailed like an uneasy animal in pain ... they had a moment's glimpse of an interior of glittering plate glass and rich morocco, and the magnificent motor-car, immense, breath-snatching, passionate, with its pilot tense and hugging his wheel, possessed all earth and air for the fraction of a second, flung an enveloping cloud of dust that blinded and enwrapped them utterly ...[4]

The growth of motor transport was accompanied by the metalling of roads and tracks throughout the country. Metalling had first been introduced in London in the middle of the nineteenth century, and several other city centres had metalled roads by 1900. In 1902 the County Surveyor of Nottinghamshire patented a method of mixing bitumen and ironstone slag or stone to produce a material that sealed the road surface. He called it Tarmac and with others, established a company to exploit it. In 1913 an International Road Conference was held at Reading and stretches of the Bath Road at Twyford, Berkshire, were surfaced with a variety of materials as a demonstration of their different qualities. The results were so impressive that by the end of that year the entire length of the Bath Road in Berkshire had been tarmacadamed. Subsequently, tarmac was used to cover and transform many thousands of miles of road in order to provide a consolidated surface for the transport revolution. Ease of motor transport

Dust was one of the main disadvantages of early motoring, as demonstrated in this early excursion along unmade roads.

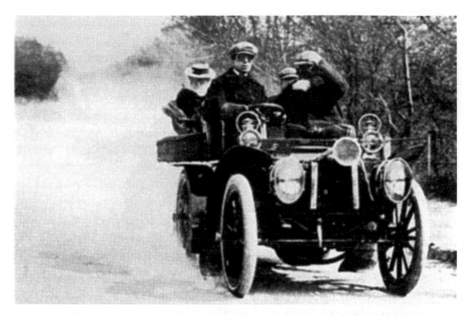

was assisted by the introduction of pneumatic tyres, which spread the weight of vehicles more evenly, an innovation that was originally designed for the bicycle.

During the first decades of the twentieth century, the ancient highways and byways of England were converted into black ribbons that criss-crossed the country. This in itself represented a major change to the landscape, and it also brought about a much greater degree of standardization in the width and quality of roads. The new metalled roads tended to be much narrower than the old Parliamentary Enclosure roads. The wide, straight tracks of Enclosure roads conformed to the regulation width that had been laid down by the Enclosure Commissioners in the eighteenth and early nineteenth centuries. The Enclosure roads were statutorily 40, 50 or 60 feet wide, in order to enable horses and carts to avoid obstructions or potholes. In contrast, many of the new tarmac roads were only the minimum twelve feet wide, which just allowed two motor vehicles to pass. The narrowness of the actual road was accentuated by the wide, grassy verges that were left on either side after the roads were metalled in the early decades of the twentieth century.

The application of 'tarmac' was well under way by 1914, and by 1930 the majority of roads which were going to be improved had been tarred. Tarring made roads waterproof and more durable; by binding the surface stones it also reduced the damage done by the traffic and reduced the large amount of dust that was raised on roads without tarmac. Villages, farmsteads, hamlets and towns were all changed by the advent of good roads. In rural areas, the decisions made in the 1920s and 1930s as to which roads should be properly surfaced and which left as tracks had an enormous impact in terms of contact among communities, and in some cases determined the very survival of those

communities. Many small upland farmsteads and crofting communities in the North might well have survived if good roads to them had been constructed at that time. Even in a prosperous county such as Northamptonshire, the main reason why the village of Faxton was finally abandoned at the end of the Second World War was the decision not to improve the roads leading to it. If the roads had been tarmacked, Faxton certainly would have survived and probably grown again with the postwar demands for rural housing. For the most part, the new roads simply followed the routes of their predecessors, radiating out from towns and intersecting with a labyrinth of minor roads. In some rural areas, such as south Shropshire, a complex maze of metalled minor roads survives, either offering alternative routes between two locations for no obvious reason or, in some cases, having no clear destination at all.

No county council, however, could afford to tar all its minor roads. Many ancient trackways, such as the Ridgeway in Oxfordshire, Wiltshire and Dorset, were not improved and today provide a playground for motorcycles and four-wheel drive vehicles, there are thousands of miles of such chalk roads in Wiltshire. Many of those roads not chosen to be tarred often rapidly became disused: for example, the road from Cavendish to Fenstead End, Suffolk, is shown on the 1905 Bartholomew half-inch map and recommended as 'a good secondary road' by the Cyclists' Touring Club, but is now ploughed out. The road at East Hatley, in Cambridgeshire, was important enough in 1862 to have a full-sized railway level crossing with a keeper's cottage. It was reduced by the encroaching Hayley Wood to a narrow bridle path, and now deteriorates into an unmarked right of way across fields.[5]

Where there were several roads entering a village, the choice of which ones should be improved for motor vehicles affected many village shapes in the twentieth century. New development automatically gravitated along the tarred roads. Often communities which had been clustered around church and green had linear elements added to them following twentieth-century road improvement. In those villages close to urban centres, ribbon development was a common feature of the interwar years, sometimes in the form of rural council housing but more frequently as speculative housing development. Some villages, such as Headington and Iffley at Oxford, were absorbed by neighbouring towns by this process. These alterations to rural settlement patterns and communication were widespread and represent one of the most important changes in the twentieth-century rural landscape.

Another example of road improvement having significant landscape implications can be seen in the Fenlands of eastern England. Before the Second World War most roads in the area were unsurfaced droveways, impassable for weeks at a time, and requiring regular ploughing to remove the ruts. The result was the existence of communities that tended to be isolated from both the outside world and their near neighbours. During the war, however, when there was the need to improve the agricultural productivity of the Fens, the

A photograph of a Parliamentary Enclosure road in Leicestershire taken by W. G. Hoskins in the 1960s. The metalled road takes up less than a third of the statutory 40 foot width of the eighteenth-century Enclosure road.

War Agricultural Committees laid down hundreds of miles of concrete tracks along the droveways to improve access to the land. These tracks not only succeeded in their immediate purpose, but later on fundamentally changed the way of life of the Fenland people by bringing their communities into contact with new markets and allowing their economies to grow in a way that had previously been impossible.

At the start of the twentieth century, the administration of English highways was in the hands of almost two thousand separate local authorities. Motivated by public anger at the state of the roads in the new age of the car, government was forced to become increasingly involved in their improvement. Through the automobile clubs, whose members were well represented on county councils and other road authorities, motorists used their influence to direct more local taxes towards resurfacing until, in the budget of 1909, a graduated horsepower tax and a small petrol duty were introduced to fund a national Road Fund. This was administered by a Road Board, which concentrated upon surfacing rather than road improvement. The Board encouraged councils to improve road surfaces by ensuring that they had a solid crust of crushed stone, which was rolled smooth and tarmacked. Councils were also asked to widen, straighten or level roads where required. At the start, the Road Board's jurisdiction only covered the 23,500 miles of roads in England and Wales maintained by the county councils, rather than the 95,000 miles under the control of the rural districts. For instance, the Great North Road fell under the jurisdiction of seventy-two local authorities, of which only forty-six were actually engaged in its maintenance. The plan to construct Western Avenue, a major road leading out of London, was complicated by the existence of twenty-three different local authorities along the projected route. The result was an erratic and sometimes

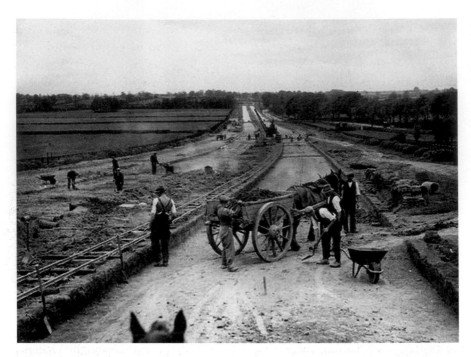

A section of the York to Malton road under construction at Whitwell in the 1930s.

chaotic response to the need for road improvement. The work of the Board stopped in 1914 with the outbreak of war, at the end of which the roads were in a worse state than ever. During the First World War, motoring was curtailed, but with the peace the use of motor vehicles expanded rapidly. A census at Barton Moss on the Manchester–Warrington road in 1919 showed that, compared to 1912, there was a sevenfold increase in mechanically propelled vehicles, compared to a drop of 25 per cent in the number of horse-drawn vehicles. The sale of large numbers of cheap ex-Army vehicles to private owners provided a stimulus to road haulage, and the volume of freight carried by road increased significantly in the postwar years.

The Ministry of Transport was set up in 1919. One of its first achievements was to undertake the classification of roads, which in the first instance were simply graded as One or Two. From 1920, central government began contributing towards the cost of road maintenance, and the interwar years saw the building of the first bypasses, to avoid congestion in towns throughout the country. The Trunk Roads Programme (1929) was devised both as a means of providing employment during the Depression and to ensure that road improvement schemes were implemented. In the 1920s and 1930s the first arterial roads, such as the East Lancashire Road from Liverpool to Manchester, went around towns rather than passed through them, and they undoubtedly eased the flow of traffic. These roads were the first additions to the network since the turnpikes had been built over a century before. Like the turnpike roads, they normally ran through agricultural land, for which compensation was paid.

The East Lancashire Road had a long gestation period. Notwithstanding the construction of the Manchester Ship Canal, two barge canals and three competing railway routes from Liverpool to Manchester, industrialists in the Manchester area remained dissatisfied with the transport network available. The only main road, the A57, between the cities ran through Eccles, Warrington and Prescot, and in the early 1920s, except for the laying of sett paving, the system was much as it had been in the time of the turnpike trusts. Discussion on improvements started as early as 1912, but the war intervened, and it was not until 1923 that a meeting of representatives of the ministry, the county council, and the corporations of Liverpool, Manchester, Salford, Bootle, St Helens and Warrington began serious planning.

It was decided that improvement of any one existing road would not provide an adequate solution and, instead, a completely new inter-urban trunk route was required. This, with some of the radial arterial roads in the London area, was to be the first British example of this type of scheme, the predecessor of the motorway. The Ministry of Transport offered a grant of 50 per cent (later raised to 75 per cent) for the £3 million cost of a twenty-seven-mile single-carriageway road, and suggested that other local authorities in the area should contribute. After further delay, in November 1926 the ministry authorized an immediate start, to assist with unemployment relief. Most of the work was to be carried out by Lancashire County Council, but Liverpool built its own length, and the first twelve miles from the city were built by the unemployed from the Liverpool, Bootle and St Helens labour exchanges.

A design office was set up at Newton-le-Willows in 1927, and powers for bridging various railways were included in a Railways (Road Transport) Act 1928. At a formal ceremony on 29 April 1929, Sir John Aspell, the chairman of the county Highways and Bridges Committee, 'cut the first sod'. By November 1930, 809 men were employed on the Lancashire county length, with 220 hired two-ton lorries for earthmoving. In all, more than three thousand men were involved in the work. For most of its length the road, which did not follow existing routes, involved extensive earthmoving, notably at the Windle cutting. The road involved the destruction of 135 houses, and sixty-nine new houses were built to provide alternative accommodation. For most of its length it was constructed to a standard width of 120 feet with a single carriageway. Space was left to provide additional capacity and a second carriageway was built after the Second World War. Most of the road was constructed of concrete and it was opened in sections as it was completed; a final tarmac surfacing was deferred because of the 1931–32 financial restrictions. The road was formally opened by King George V on 19 July 1934.

Surprisingly, between 1899 and 1936 the total road network grew by only 4 per cent, and, in contrast to other European countries such as Germany

and Italy, virtually no attempt was made to construct dedicated roads capable of carrying high-speed traffic. The first attempt at a nationally administered road network came with the Trunk Roads Act of 1936, the intention of which was to provide a 'national system of routes for through traffic', but the outbreak of war prevented its implementation. Major road bridges, however, such as the Tyne Bridge, which was built in 1928, did match their rail counterparts.

Motoring was encouraged as it became cheaper between the wars. 'The sound of horns and motors', referred to in T. S. Eliot's poem *The Waste Land* (1922), became more insistent, and created a new national mass culture. Between 1924 and 1936 the price of a motor car fell by 50 per cent, and production increased by 500 per cent. By 1938 there were half a million road-goods vehicles, nearly two million cars, and 53,000 buses and coaches. Within towns, motor buses (unlike trams, which ran on steel tracks and required a power supply, and trolleybuses, which also relied on an overhead power supply) required no route infrastructure and could respond rapidly to changes in demand. They gradually won the battle for passengers. And although the London County Council introduced 'Felthams', comfortable and quick trams, in 1930, the greater flexibility of buses and their routes ensured that by 1941 London was planning to phase out its trams.

Trunk roads with dual carriageways such as the Southend Arterial Road were built on greenfield sites on the edge of a number of cities and conurbations in the 1930s. Sometimes only one half of a projected dual carriageway was built in order to keep costs down; often, as with the East Lancashire Road, the second lane was not built until the 1960s, or, in some cases, never. Improvements to infrastructure included in 1934 what was then the longest underwater tunnel in the world, the road link under the Mersey between Liverpool and Birkenhead. Traffic forecasts for the Mersey Tunnel proved to be seriously underestimated. It was expected that two million vehicles would use the tunnel in its first full year, but this figure was reached in nine months, and the second year saw 3,164,627 vehicles. Nevertheless, the rapid growth of motor traffic, particularly in the South, brought fundamental problems. Sir Charles Bressey, a Ministry of Transport engineer, pointed out that there was a bottleneck on average every mile all the way from Birmingham to London, and added:

> [the] transport machinery is already overstrained ... Congestion in innermost London has already reached such a pitch that, on main routes through the city, vehicles are often reduced to a slow walk ... there is great reluctance to break with the past and embark upon a vigorous modernization of a decrepit highway system designed for horse transport.[6]

He proposed a programme of extensive new roadbuilding, including large roundabouts and flyovers to ease the traffic flow.

The uncontrolled spread of new housing along arterial roads led to the Restriction of Ribbon Development Act of 1935. This stated that no new access could be made on to any road classified before 17 May 1935, nor any building erected within 220 feet of the middle of the road, without the consent of the highway authority. The 1935 Act was of considerable importance for highway design and town planning. The differences between the road schemes built in the years after 1935, which generally function effectively as uninterrupted through routes, and those – such as the ring roads in Bolton and Burnley or the Ormskirk bypass – where adjacent development was uncontrolled are very obvious today.

The rural roads themselves were also subject to improvement. After 1926, the Ministry of Transport began to make grants of 20 per cent for strengthening and widening of the more important unclassified roads, to meet the needs of motor vehicles. In some cases, these were former 'secondary roads' that were still receiving 25 per cent grants from the county council. Urban spread in many areas obliterated much of the old network of lanes. In some places, for example in the Fylde and Lonsdale, Lancashire, where hedgerows have not been completely eradicated, the hedge on one side of a lane may be irregular, with abrupt changes of direction, and contain mature trees and a variety of shrub species. The opposite hedge may have a smooth alignment, following the road edge, be devoid of truly mature trees, and contain only one or two species of shrub. This is the consequence of early road widening, whereby one side of the original road was realigned but the other remained untouched.

The new roads led to new smells and sounds, and created their own micro-landscape of road signs, lamp posts, manhole covers and traffic lights, both

Britain's first roadside petrol filling station at Aldermaston, Berkshire, in 1920.

in towns and in the countryside. Traffic lights, or 'traffic control robots', as they were called, were first installed in Wolverhampton and Leeds in 1927; they arrived in Manchester in 1928 and in London, on a permanent basis, in 1931. Roads led to new boundaries and commands, to zebra crossings and Belisha beacons, the latter named after a Minister of Transport, Leslie Hore-Belisha. His period in office (1934–37) also saw the introduction of driving tests, urban speed limits and one-way systems.

The bypasses created a new genre of roadhouses and filling stations specifically designed to meet the needs of the new motoring classes. The Automobile Association established the first roadside filling station at Aldermaston, in Berkshire, in 1919. Up until then there had been some petrol pumps sited at garages away from the main roads, but motorists generally relied on petrol cans carried in the car. The oil companies then built strings of their own filling stations along the highways. By the 1930s, distinctive roadhouses were often splendid, large, brick public houses or hotels, sometimes built in flat-roofed art-deco style. They emphasized the glamour of motoring and often provided a wide range of exotic activities. Sporting facilities were particularly important: swimming pools and ballrooms were essential, as was some form of golf course. Some roadhouses, like the Clock at Welwyn, on the Great North Road, were organized along the lines of later motels. The Berkeley Arms Hotel, at Cranford, Middlesex, was built in French chateau style and boasted 'the delicate sophistication of a Mayfair restaurant complete with jazz band'. The Spider's Web was set in its own parkland on the Watford bypass and provided parking for 2000 cars. The most famous of all was the Ace of Spades on the Kingston bypass, which had a twenty-four-hour restaurant, a polo ground and a riding school. Such was the contemporary fame of the Kingston bypass that it prompted Noël Coward to write a song about it – 'Give Me the Kingston By Pass'. Nevertheless, many roadhouses have been left isolated or even destroyed as a result of later,

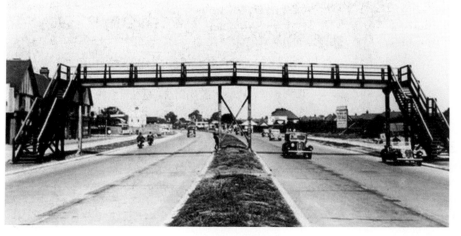

The Kingston bypass soon after it was opened in the 1930s. The hoarding advertising freehold land for sale shows the close relationship between new roads and suburban ribbon development.

larger roads and motorways, victims of the harsh commercial reality of twentieth-century motoring. The face of the English landscape as seen through a car windscreen, a view that was to dominate the latter part of the twentieth century, was changing dramatically, and advertising hoardings were a brash addition to the roadside clutter; the latter were common in the countryside between the wars but disappeared with more rigorous planning regulations after 1945.

Coming to Terms with the Car

As early as 1925 Sir Alan Burgoyne, speaking on the future of the motor car, reminded his audience at the Royal Society of Arts that 'twenty-five years ago the motor-car was an eccentricity; just before the war it had become an established fact, but was still a luxury; today it is a necessity, and in the near future no artisan's cottage will be built without its garage as part of the design'. There were many commentators in the interwar years who had already appreciated the dangers of the uncontrolled spread of car use, both to individuals and to the landscape. Amongst the most vociferous was Professor C. E. M. Joad, who wrote of a day spent walking peacefully in the countryside. On encountering a main road he noted how the cars, bonnet to tail, stretched continuously in an unending line:

> The procession moves, now faster now slower, and every now and then two cars in it change places ... The faces of the motorists are strained and angry; upon them there is an air of tense expectancy, and in the intervals between their spasmodic bursts of activity they glower at one another. From the country they are completely cut off; they cannot see its sights, hear its sounds or enjoy its silence.[7]

Joad saw the motorist as the modern Midas: 'whatever he touches turns to tin and brass'. A contemporary of Joad's bemoaned:

> Rarely is a horse to be seen, but lorries and motor omnibuses, motors of all kinds and whizzing bicycles usurp the road. To me there is something inexpressibly revolting in their violent rush, their vulgar gesture of contempt for the old stabilities of field and homestead, their brainless scorn for the past, their entire lack of dignity, tradition and culture ... This riot of blatant reckless hustling is alien to the historic English temperament.[8]

A more thoughtful and indeed prescient warning came from Patrick Abercrombie in 1926:

> It is only since the war that the normal method of approach to the country has been changed from the railway, by which it is accessible at fixed spots and at fixed times, to the motor car and bus, by which it is accessible by

main, secondary and local roads in all directions and almost continuously. The sudden outburst of the motor bus has caused a revolution in locomotion quite as remarkable as and indefinitely more swift than the railways. The immediate physical assault upon the landscape by motoring can indeed in no wise be compared with the scars inflicted by the railways: but the complete permeation of the country is more thorough.[9]

Other commentators warned of the dangers presented by the growth of motoring:

A motorist is apt to complain of the 'overcrowded' condition of the road if he finds he has not continually got a whole mile-long stretch of it to himself, but is one of a widely spaced and rapidly moving queue of half a dozen or so. He will declare there is no pleasure in motoring under such conditions. He will search his map for some alternative route by quiet lanes where he can speed along with the road to himself. And when others find that alternative route and all further alternatives are exhausted, he proceeds to demand a new road system so that his motoring may again become a pleasure.[10]

The impact of cars was not solely a matter of aggregate figures and national images. The local dimension was crucial, because the car changed the landscape and was to do so far more than canal or rail had done. The impact can be readily grasped in modern Britain: ribbon developments followed the new roads. Furthermore, car transport encouraged and made possible housing of a lower density. The tightly-packed terraces characteristic of the Victorian city, and the new garden suburbs, for middle as well as working class, were supplemented by miles of 'semis': semi-detached houses with mock-Tudor elevations, red-tiled roofs, and walls of red brick or pebble-dash, with a small front and larger back garden, each with a small drive and a garage. They were built in large numbers, not only around London but also on routes leaving all major towns, especially in such areas of prosperity as much of southern England. Suburbia had spread in the late nineteenth century with the railways, but development then had generally not moved far from the stations. In contrast, car transport permitted less intensive development. Abercrombie first used the term 'ribbon' in 1932, when he described 'the ribbon unrolling along the roadside' – the new houses distributed along the motor-bus routes. Miles of road frontage were built up, one house deep. C. E. M. Joad described the new arterial road from London to Southend: 'For the greater part of the way [the road] was flanked by houses, so that one had the sensation of motoring through a continuous loosely strung out town.'

There was a dramatic fall in car ownership during the Second World War, but afterwards it rose rapidly, especially after the end of petrol rationing in 1950. Car ownership doubled between 1949 and 1957, and trebled between 1949 and 1961, an increase that was made at the expense of bus, coach and rail transport. The percentage of goods traffic moved by road rose from

37 per cent in 1952 to 58.3 per cent in 1964, and it was lorries which benefited from the major programme of roadbuilding. The escalating growth in car use, particularly in towns in the 1950s, led to serious governmental concerns about the future impact of the car. As a result, Professor Colin Buchanan was commissioned 'to study the long-term development of roads and traffic in urban areas and their influence on the urban environment'. Buchanan's report, *Traffic in Towns* (1963), warned that the potential increase in vehicles was so great that, unless something was done, conditions would deteriorate quickly, and that 'the utility of vehicles in towns will decline rapidly, or the pleasantness and safety of surroundings will deteriorate catastrophically; in all probability both will happen together'.[11]

This conflict, it was believed, would not be alleviated by endorsing the 'very powerful force towards a spread of development'. To do so would merely create new problems at the expense of losing 'the degree of compactness and proximity which seems to contribute so much to the variety and richness of urban life'. On the other hand, the conflict could, it was thought, be greatly reduced, although not eliminated ('there is no straightforward or "best" solution'), by attention to the *design* of compact towns and cities, by careful arrangement and disposition of buildings and activities to enable the motor vehicle to be used to its best advantage. Indeed, the Buchanan team saw their basic task as essentially one of exploring a problem of design, and this was a matter of rationalizing the arrangement of buildings and accessways.

The basic design principle adopted was one of 'circulation', and here the analogy of designing the internal arrangements of a large hospital was adopted, invoking ideas of corridors of circulation and areas of environment (representing wards, operating theatres, laboratories and so on). The concept of 'urban rooms' was introduced: these would not be free of traffic, but would be designed in such a manner that their traffic was controlled in order to create acceptable environmental conditions. Large-scale application of the concept 'results in the whole of the town taking on a cellular structure consisting of environmental areas set within an interlacing network of distributory highways'.

The capacity of towns and cities to accept vehicles, moving and stationary, depended also upon what Buchanan referred to as 'traffic architecture', a process whereby buildings and their access facilities were designed in a single process. By the skilful application of traffic architecture, more vehicles could be accommodated in towns without violating environmental standards. Although many of the ideas in Buchanan's report were sensible, their implementation was largely to be undertaken by local authorities. Sectional interests and simplified interpretation of Buchanan's ideas actually led to further problems in many cases. Wolverhampton's ring road was opened in stages between 1961 and 1986, clearing away established landmarks and residential districts. Carlisle's, opened in 1974, cut the castle off from the city and was

followed by the replacement of a long-established residential area by a
shopping centre. In Oxford, a short segment of an inner ring road (the only
part constructed) led into a shopping mall and multi-storey car park, built
at the expense of an ancient but run-down neighbourhood in the city centre
– St Ebbes. There were similar stories from many other historic towns, such
as Bath and Worcester.

Postwar suburban England was shaped with motor transport in mind. But
traffic growth always outran road provision. Intersections, roundabouts,
signposts, footpaths, underpasses and bridges were all constructed throughout
England, normally to standard designs, to meet safety requirements and not
aesthetic sensibilities. As a result, side streets became 'rat runs', quick short
cuts linking busier roads, and the sides of all roads filled up with parked cars.
Parking space came to take an ever greater percentage of city space, and the
problems of parking became a major topic of conversation. Parking meters
became part of the street furniture of most towns and, where parking
problems persisted, clamping and other draconian measures were introduced.
Many cities, such as Oxford, almost gave up on trying to accommodate the
car altogether and adopted various measures to restrict motor access.

Park-and-ride schemes were introduced in the latter part of the century
in an effort to reduce traffic flows. Such schemes have persisted into the

Work in progress on
the Chiswick
Flyover in west
London, built to
ease the flow of
traffic off the M4
into the capital.

present and enable shoppers to park on the edge of town and take public transport to the centre. In places such as Oxford, where the scheme has been energetically promoted, there have been some positive results in keeping cars out of the congested city centre. The downside was the dedication of acres of land to access roads and parking spaces. Such land was adjacent to the bypass, but within the green belt, and contributed to the deterioration of the open space designated around the town. Such schemes were also accompanied by the introduction of dedicated bus and cycle lanes. Pedestrianization of city and town centres became important, and although the results of this are generally beneficial, they brought problems such as falling trade and vandalism in many places.

After the 1960s there were numerous schemes to improve roads, whether by widening, straightening, creating dual carriageways, improving junctions, or building bypasses or ring roads. Priority was given to intercity routes and to the main roads within urban areas, but virtually all roads have been 'improved' to some extent. Yet the number of vehicles, especially cars, has kept increasing, and at a faster rate than road space. Today it is clear from the experience of the M25 and other examples that traffic expands to fill the available roads, and the consequences in terms of congestion and falling traffic speeds are obvious. At the start of the 1990s the total mileage of Trunk and Principal roads was almost 30,000 miles. But the quantity of minor roads was considerably greater: there were almost 70,000 miles of B and C roads, plus over 120,000 miles of countryside roads that were unclassified. Most of the minor road network remained much as it had been in 1920, but thousands of miles of new roads were also created, most of which were unclassified suburban roads serving new housing estates, in the form of closes and culs-de-sac.

There were 12.2 million cars in Britain in 1970, but over 25 million by 2001, a rise proportionately far greater than that in population. Car ownership rose from 224 per thousand people in 1971 to 494 per thousand in 2001. By the close of the century, 93 per cent of miles travelled in Britain were by road. Of these road miles, cars accounted for 85 per cent and buses only 6 per cent. Commuting increased as well – only 42 per cent of those who worked in Newcastle in 1971 lived in the city, and most of the rest commuted by car. The same was also true of other cities. Between 1981 and 1991 commuting rose by 7 per cent into London, 18 per cent into Birmingham, and 29 per cent into Manchester. Public transport was generally unable to cope with this increase, and this, in turn, placed even greater pressure on roads. By the beginning of the twenty-first century, traffic in central London was flowing at the same rate as it had a century earlier at the end of the congested horse-transport age, and 'gridlock' was becoming a reality. The first 'congestion' charges in Britain were introduced in London in 2003, requiring drivers to pay a fee to enter central parts of the

capital in their cars. Other cities were actively examining the feasibility of introducing similar schemes.

The car age brought with it many other problems. Car exhaust emissions led to environmental pollution. The Royal Commission on Environmental Pollution, which reported in 1994, pressed for a switch from roads to railways. In addition, many people were killed or injured by cars. In 1962, 4287 children under ten were killed on the roads. In 1979, 6352 people were killed, but by 1994 the number had dropped to 3650 people. By the early 1990s, 45,000 children were being hurt on the roads every year and, among those aged five to fifteen, two-thirds of deaths were the result of road accidents. Alarmist and frequently lurid reports about the far lower murder figures (499 in 1992) fed popular concern about crime. In contrast, deaths and injuries due to cars aroused less public interest and concern and were treated as a fact of life, unlike rail and air accidents and terrorist incidents.

The need to cater for car parking has created a significant new twentieth-century land use. In city centres in the 1960s and 1970s public multi-storey and subterranean parks were built: featureless, utilitarian structures often replaced perfectly respectable and useful town buildings. The need for car parks at railway stations, airports and shopping malls has led to tens of thousands of acres of land being given over to the stationary motor vehicle. As the century wore on, private cars became increasingly well equipped and comfortable, while public parking space was often squalid and in some cases positively dangerous.

The greatest change brought about has been in shopping: out-of-town supermarkets and shopping malls now cater for 25 per cent of grocery require-ments in Britain. As a result, traditional town-centre grocers, greengrocers and butchers have been hit very badly. Their premises have been taken over by the offices of estate agents, building societies and mobile phone outlets. Everywhere the tendency is for larger stores, and everywhere there is a tendency for uniformity. Many, if not most, city centres boast the same range of national or international chain stores, and many high streets are indistin-guishable from one another, at least at street level. It is only if you raise your eyes to the first and second storeys that you can still see the diversity of historical architecture that gave each town and city its own distinct character. Cars also greatly influenced the layout of new residential areas. The cul-de-sac was used as a way of restricting traffic flows through areas where people lived, while at the same time providing road access to residential areas. At the neighbourhood level, major routes became obstacles, as high streets were turned into through routes. This encouraged the building of new through routes unrelated to existing neighbourhoods, such as the East Central Motorway in Newcastle in the early 1970s, and the Western Bypass in Newcastle in 1990.

At the end of the twentieth century, each person in Great Britain made

about a thousand journeys a year; these were for five main types of activity – work, education, shopping, socializing and leisure pursuits. Although the total number of trips remained constant after 1985–86, the total distance travelled increased by nearly 28 per cent – people were travelling much farther to carry out the same number of activities than they travelled in 1960. The average daily journey increased from five miles a day to thirty miles a day, and the car accounted for 61 per cent of all journeys and 79 per cent of all distance travelled. In 1971, 14 per cent of junior school children were driven to school; by 1990 this figure had risen to 64 per cent. Although walking and cycling accounted for 29 per cent of journeys (down from 37 per cent only twelve years earlier), these were mainly for short local trips and so made up only a small proportion of total distance travelled (about 3.5 per cent). Public transport also fell from accounting for 10 per cent of journeys to 7.6 per cent. The growth in road traffic was not, however, evenly spread across all roads. Over the period 1989–99 motorway traffic grew by 42 per cent in Britain, whilst traffic on built-up major roads with a speed limit of 40 mph or less remained stable. On other major roads in the suburbs and rural areas, growth was 21 per cent over the decade, as people moved to lower-density housing locations and chose to travel by car to neighbouring towns and the countryside.

Cars affected the development of leisure: 'days out' and the Sunday afternoon drive changed the nature of leisure (and especially of 'the day of rest'). Cars and motorcycles also became the primary reasons for taking holidays, as well as encouraging caravan holidays. Cars were a democratizing mechanism, making both work and leisure more accessible than ever before. Greater mobility for most of the population, however, exacerbated social segregation: car ownership brought a sense, maybe an illusion, of freedom and an access to opportunities and options for many, but not all. English roads, especially in towns, became ever more congested, and traffic speeds fell, largely because of an ever increasing number of cars.

The strategy at the end of the century was to build new roads and motor-ways, and to widen existing ones. But this can provide only a short-term choice of better routes between traffic jams. And there are limits to the number of new roads and improvements that can be made: Britain already has more tarmac per square mile than any other country in the world apart from Belgium. Roads in towns and in southern England in general present the most problems, but the main inter-urban routes are also becoming increasingly congested, as are some routes in other, less obvious, areas. Twenty million people live within a three-hour drive of the Lake District, thanks to the completion of the M6 in 1971. On popular weekends and especially on Bank Holidays the problem has become acute, and roads in the southern Lakes have become totally congested with cars on a number of occasions – in the 1990s the police were regularly obliged to close the area to incoming traffic. In this region there are

understandably strong objections to building more or wider roads, and thus the only solution appears to be to control demand.

The solutions adopted to date have wholly been piecemeal, belated, inadequate and often strongly influenced by current public opinion; they frequently do little more than shift the congestion farther down the road. Such a reactive strategy tends to ignore most of the fundamental issues, but, eventually, the country, through its government, will have to face up to the transport problem as a whole. It may well be that global issues such as the greenhouse effect and the need to control exhaust emissions may yet help to bring about a coherent transport policy by restricting the use of cars. Mildly punitive taxes to restrict motoring, imposed by governments in the late 1990s, brought about a major backlash in 2000, when there was a blockade of petrol distribution centres. The results were rapid and frightening in their implications. It was clear that much of the country would grind to a halt within a few days if petrol supplies dried up. The blockade revealed a dangerous national dependence on oil. At present, serious attempts to limit motoring through taxation are not an option for governments reliant on a car-based electorate for their mandate. Whatever happens to future transport planning, roads and cars are likely to remain at the heart of the transport system of Britain for generations to come, and the car will continue to play a major role in the fashioning of and our perception of the English landscape.

Motorways

As for the motorways, the less said about them the better.

W. G. Hoskins, *English Landscapes* (1973)

The single greatest change to the road system in the second half of the twentieth century was the creation of motorways. Motorways, like Roman roads and the railways before them, were designed to run in direct lines, and they ignored property and other boundaries in the landscape through which they passed. Their impact on the modern landscape was significant; motorways consume about twenty-five acres of land to the mile and are twice as land-hungry as railways. As early as 1906, there was a proposal for a high-speed motor highway between London and Brighton, but it was never built. In 1923 a company, with Lord Montagu as its chairman, was formed to build a motorway linking London, Birmingham, Manchester and Liverpool. The following year a Private Member's Bill, with a clause for compulsory acquisition of land for a motorway, was defeated by an alliance of the government, local authorities and the railway companies. A few years later there were hopes for a Channel tunnel and a 'marine motor road' running along the south coast of England, but these too did not materialize.

New motorways were actually being built in Italy, Germany and the USA in the interwar period, yet nothing comparable appeared in Britain. The Institution of Highway Engineers and the County Surveyors' Society put forward detailed proposals in 1936 and 1938 respectively. There were, however, still no motorways in Britain by 1939. Indeed, there was not a single stretch of dual carriageway along the 276 miles of the Great North Road from London to Newcastle by the outbreak of the Second World War. The official view was that existing highways could be widened and verges incorporated in the roadway. It was expressed by Colin Buchanan:

> We always seem to have been a lap behind the motor car: by the time we had thought of thirty-foot carriageways, it was dual that was really needed, by the time we had thought of duals it was motor roads that were wanted, by the time we had thought of round-abouts it was flyovers that were needed.[12]

The postwar government finally announced definite motorway proposals in 1946; it was not, however, until 1956 that the first motorway construction actually started. The first short stretch of the M6, opened in 1958, was little more than a restricted access bypass for the A6 around Preston, although it led to Blackpool and was part of the busiest holiday route in England. The engineer who designed the Preston bypass motorway was John Cox, who had been responsible for the rapid construction of several of the new airfields built in the Second World War. The new road was 8.25 miles long, with nineteen bridges. On 5 December 1958, hundreds of people assembled at Samlesbury, in Lancashire, to witness the official opening of the M6 by the Prime Minister, Harold Macmillan. In the following year, the first major length of motorway was punched through the Midlands: the section of the M1 from just outside Watford ran to a field near Crick in Northamptonshire, where it linked up with the A5 (the Roman Watling Street), the straight motorway making scant effort to follow the shape of the landscape or established land-use patterns. The motorway system spread. Motorways crossed the Pennines from Leeds to Manchester (M62), provided a second route from London to Exeter (M4 and M5), opened a means of travelling from London to East Anglia (M11), and encircled London (M25). There were major improvements to other major through routes, as roundabouts and junctions along trunk roads such as the A1 were replaced by slip roads.

Farming adapting to the motorway age at Tring in Hertfordshire.

The completion of London's 'Motorway Box', the M25, was the most expensive and controversial scheme. The M25 quickly became the busiest route in the country, and because of frequent traffic jams there were soon plans to add more lanes. Known colloquially as London's 'orbital car park', it was rapidly used to capacity, was often congested, and was soon in dire need of improvements. The M25 did, however, improve access to

London's two principal airports, Heathrow and Gatwick. One of the latest major additions to the national network, the forty-eight miles of the M40 from Oxford to Birmingham, designed in part to relieve pressure on the thirty-year-old M1, was opened in 1991. The total length of motorways by the end of the century was just over 2000 miles. A new motorway toll road, the first of its kind, was opened to the east of Birmingham in 2003. It was designed to relieve the M5 and M6 around the city, which are notoriously amongst the most congested stretches of motorway in Europe.

Major bridges and flyovers were also built as part of the motorway system. The first of these was the Chiswick flyover in London, opened in 1959. This was the first serious attempt to provide a smooth flow of traffic at a major bottleneck – by the end of the twentieth century it carried 140,000 vehicles a day. The Westway, at the eastern end of the M40, represented a similar attempt to raise through traffic above an area of inner-city congestion. Such attempts, however, only moved the problem further into central London. There were also significant engineering achievements that changed the geography of the country. The Humber Bridge, built in 1972–80 and opened in 1981, was the longest single-span bridge in the world, with an overall length of nearly one and a half miles, and 4626 feet between the towers. Due to its length, the two supporting towers had to be set out of alignment by one and a half inches to allow for the curvature of the earth. (The record length of the bridge was only beaten in 1998 by the Akashi-Kaikyo Bridge in Japan.) The Humber Bridge helped make Humberside more economically successful by improving links within the new county. In 1997 a second road bridge crossed the Severn estuary, helping bring Bristol and Cardiff closer. Partly because of cost, such ambitious projects were limited, and, indeed, the whole

The second road bridge across the Severn estuary under construction in the 1990s.

A typical late twentieth-century streamlined motorway service station on the M40 near Oxford.

of the motorway system is still small compared to that of other European countries.

Motorways brought with them new place-names, such as Spaghetti Junction, and, later on, even motorway art in the form of the Angel of the North. A sixty-six-foot high steel sculpture, with a wingspan of over 150 feet, located on the A1 and visible from the M1, it is estimated that it is seen by 90,000 people every day. On the M5, a giant wicker figure was erected near Bridgwater. Since the first motorway service station was opened at the Watford Gap in 1958, dozens of similar establishments have been built. For the most part they are purely functional, and for the most part they are unlovely and unloved, characterized by high-priced mediocre food and services.

> Overlooking the motorway between London and Manchester, in a flat, featureless expanse of country, stands a single-storey glass and red-brick service station. In its forecourt hangs a giant laminated flag that advertises to motorists and to sheep in an adjacent field a photograph of a fried egg, two sausages and a peninsula of baked beans.[13]

Attempts to improve the visual quality of service stations, as on the M40 at Oxford, have been only partly successful, tending to produce replicas of the ubiquitous shopping mall.

The national heritage was also affected, as shown by the impact on National Trust properties. The M1 speeds past Hardwick Hall, the M54 past Moseley Old Hall. The six-lane Plympton bypass was cut through the park at Saltram in 1970, largely obliterating the eighteenth-century carriage drive. In 1965, the M4 was driven through the Osterley estate, the M5 through the

Killerton estate. A study by Friends of the Earth demonstrated, not surprisingly, that the cheapest place to build a motorway was through a public park. Other victims of roadbuilding were Tring Park in Hertfordshire and Chillington Park, Kent. In 1964 the M4 carved through the northern parts of the parish of Datchet; in the process the hamlet of Ditton was destroyed. The Eccles bypass (M602) was built in a densely occupied area and resulted in the demolition of 353 houses, forty-seven shops, two public houses and two churches. Furthermore, it required thirteen side road diversions, and many public utilities were affected. For example, the replacement of a length of the Eccles main sewer required the driving of a thousand feet of 54-inch-diameter tunnel up to forty feet deep, much of it through the underlying sandstone.

By the end of the twentieth century, the process of building a motorway had become a long and complicated one. First, the need for a particular length of motorway had to be justified (usually on grounds of existing congested roads), and money made available. Then a route had to be chosen and a public enquiry held. The road was then designed, the land was bought (often by compulsory purchase), and compensation terms agreed, before construction could begin. In addition, many existing features, including other roads and footpaths, had to be modified to link in with the new road, and efforts had to be made to preserve flora and fauna; and where sites of historical and archaeological importance were involved, fieldwork and excavation had to be undertaken. Archaeological fieldwork along the length of motorways had demonstrated that it is reasonable to expect an archaeological site about every half mile. Many of these were of passing interest, but others were of considerable importance. On a stretch of the M40 excavated

The Chiltern cutting on the M40 in Oxfordshire, excavated in the early 1970s.

in the 1970s, finds included an Iron Age village, part of an Anglo-Saxon cemetery, and a deserted medieval village. Work on the M6 toll motorway in Warwickshire uncovered rare Mesolithic (Middle Stone Age) structures and artefacts.

Although motorways were able to ignore micro-landscape features, many of them roughly follow the routes of earlier lines of communication, both rail and road. Motorways were also 'landscaped', with graded cuttings and extensive programmes of tree plantation. As a result, the setting of most motorways tends to be uniformly bland; only occasionally are rock cuttings able to reveal the true nature of the underlying geology. The limited number of access junctions to motorways meant that many hundreds of minor roads had to be accommodated by bridges and tunnels, and in some instances, where a farm unit was divided by a motorway, a crossing was provided solely for the use of livestock. In some cases, roads were truncated and culs-de-sac created. In the case of Lewknor, at the foot of the Oxfordshire Chilterns, an access road to the M40 also acted as a village bypass. As a result, the old village through road was stopped before the motorway, and the village no longer has any through traffic, although the noisy motorway is only a few hundred yards away.

Heavy goods traffic was one of the main users of the motorway network. Freight, often in containers, was constantly on the move as road transport virtually replaced rail as the predominant means of commercial transport. Only heavy ores and coal being transported to power-generating plants were still sent by rail, and even here there was not a monopoly. Goods were imported and exported from massive container ports, such as Felixstowe, Bristol and Hull, and were carried to and from them by fleets of juggernaut lorries.

The motorways created new types of economies; rapid transport between new industrial estates, air and rail links, and London in particular encouraged the growth of industries along the axial lines of motorways, such as at Farnborough and Basingstoke on the M3. The M4 between London and Swindon was the most important of these and became known as England's 'Silicon Valley'. The M4 corridor lies to the west of London and follows the route of the M4 motorway towards Heathrow Airport, Reading, Newbury, Swindon and Bristol into South Wales. Many high-technology industries have been located within easy access of the motorway. These include a range of the so-called 'sunrise' industries, namely information-technology and computer-based industries, telecommunications and micro-electronics. Research and Development institutions are also widespread, some related to private industries and others to government bodies. This linear region possesses a number of economic advantages. The proximity of the M4 (from west to east) and the A34 (from north to south) aided communication by road, and the high-speed railway out of Paddington to Reading, Didcot,

The Skirsgill motorway interchange (M6) in Cumbria under construction. The motorways, like the Roman roads, were able largely to ignore local land ownership and geography.

Swindon, Bristol and South Wales also helped attract key workers. The presence of Heathrow Airport to the west of London allowed easy international access to the region. Swindon, one of the chief beneficiaries of the development of the M4 corridor, is centrally located between London, Bristol and South Wales. It began as a railway town and was the engineering centre of the Great Western Railway. Today, it has attracted a wide range of high-technology industries. An indication of the increasing wealth of Swindon is the fact that several major service industries have moved their administrative headquarters into the town. Motorways have rapidly become fixed features in the landscape, acting as boundaries for new developments, mainly housing and industrial estates. They also bring blight with them, particularly in urban and suburban fringe areas, where they often create conditions where development is the only feasible course to take. Even within green belts, blighted land can be given up to car parking or low-level industrial activity.

It is possible to argue that roads add aesthetically attractive elements to landscapes, in the same way that canals and railways have done. Motorways are carefully landscaped with embankments and a prodigious number of trees. Where necessary, hill shelter walls are built to cut out noise to nearby

neighbourhoods. Motorway bridges, viaducts and aqueducts are often clean-lined impressive features, and few would suggest that the Pontcysyllte Aqueduct or the Ribblehead Viaduct should now be pulled down because they are eyesores. It is worthwhile remembering that many railway schemes were objected to in the nineteenth century by aesthetes such as Ruskin, yet many of their structures are now jealously guarded. The Tinsley Viaduct,

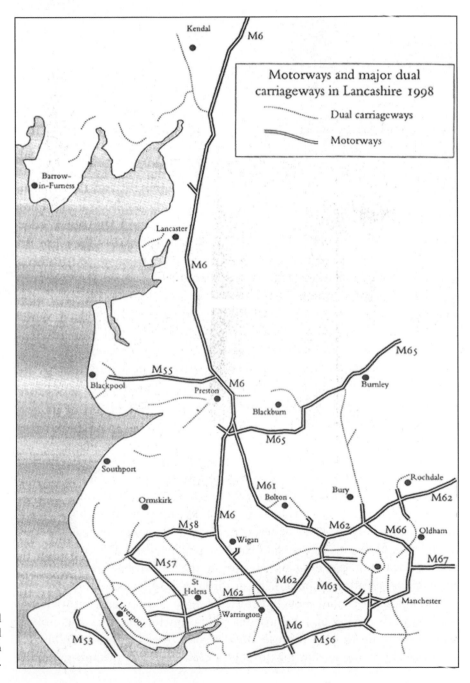

Motorways and
major dual
carriageways in
Lancashire, 1998.

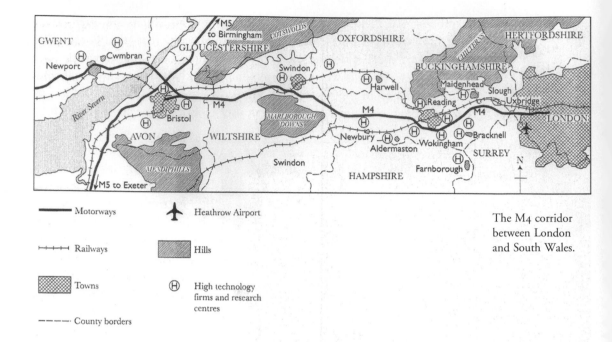

——— Motorways

✈ Heathrow Airport

Railways

Hills

Towns

Ⓗ High technology firms and research centres

――― County borders

The M4 corridor between London and South Wales.

carrying the M1 past Sheffield, and the Barton high-level bridge, taking the M63 over the Manchester Ship Canal, will no doubt stand as monuments to the road architecture of the late twentieth century. The two curving levels of the M6 as it passes through the Lune Gorge, the dramatic crossing of the Pennines by the M62, and the manner in which the M5 climbs the ridge south of Bristol have been identified as examples of good practice. It is, however, difficult to be objective about motorways in the landscape because of the immense amount of traffic they carry, which frequently makes them noisy, smelly and congested. Also, the building of the motorway network, which primarily caters for private traffic, appears to have created the illusion that little attention needed to be given to improving and developing public transport, notably railways.

Increasing environmental concern meant that there was a growing body of opposition not only to the details of the new roads, but also in principle to any expansion of the motorway network. The M66, one of the last major motorways to be built in England, threads a difficult path through the eastern side of the Greater Manchester conurbation, weaving its way between Middleton, Oldham, Ashton and Manchester. It involved sizeable engineering works (including the draining of part of the Audenshaw reservoirs) and angered conservationists because it cut through the Medlock Valley at Daisy Nook, a popular beauty spot, and crossed Ashton Moss, the last area of open land between Ashton and Manchester. The plans for the final stages of the M65, from Lostock Hall through Brindle and Lower Darwen to Whitebirk near Blackburn, were from 1993 to 1995 a *cause célèbre* of the anti-motorway

Building the Newbury bypass in the 1990s, which cut through several Sites of Special Scientific Interest.

lobby, with opposition centred on the sections crossing the northern end of Cuerden Valley Park near Bamber Bridge and through the steep-sided, wooded valley at Stanworth, near Blackburn.

Opposition to new trunk roads and motorways escalated at the end of the century in response to the M23 extension at Winchester and the twelve miles of the Newbury bypass, which cut through attractive woodland and Sites of Special Scientific Interest. Public awareness of and reaction to the damage caused by motorways became much higher than it was in the 1960s, but the level of concern expressed may be somewhat misplaced given the much larger area of greenfield land destroyed each year for housing.

Sir James Drake, a noted County Surveyor responsible for many of the early motorways in the north west of England, was well aware of the problems as well as the visionary nature of his work. He demonstrated his enthusiasm thus:

The building of a motorway is sculpture on an exciting grand scale, carving, moulding and adapting … earth, rock and minerals into a finished product, which must be both functional and pleasing to the eye, as well as economical and durable.

He added:

But in trying to accomplish this, one must be humanitarian and remember that all this affects people. The civil engineer on motorway projects, as on other public works, is the servant of the people, using his specialist knowledge on their behalf for the good of the whole community and, at the same time, mindful of their views and the rights of the minority who are affected.[14]

Motorways, dual carriageways, bypasses, byways, roundabouts, traffic

signals, parking meters, pedestrian crossings and underground car parks all affect or impinge on our everyday lives. The impact of the motor vehicle is woven into every aspect of England's twentieth-century landscape. A quote from the 1930s could equally have been made in 2000:

> The majority of the public today relies for transport of every kind mainly on the roads, and everything goes to show that they are doing so to an unprecedented degree ... People travel now more than they have ever travelled, and in the future they will travel still more. If they want more roads to travel by, you may be sure that they will get them, for in the last analysis nothing can stop the development of the road.[15]

Taking Off

It can hardly be a coincidence that no language on Earth has ever
produced the expression 'as pretty as an airport'.

Douglas Adams (1993) [1]

THE AEROPLANE made a distinctive and important contribution to the
landscape during the twentieth century. Air transport, however, did not
develop as rapidly as motor transport, and its impact on the landscape up to
the First World War was relatively small. Even those many airfields created
during the war were largely of grass, and after the war these were abandoned,
leaving little trace. As civil airports grew in the 1930s, characteristic airport
buildings began to appear, but the runways themselves normally remained
grassed. On the other hand, the Second World War brought a new gener-
ation of military airfields, rapidly constructed, but with concrete runways.
These tended to be much more difficult to erase from the landscape, with
the result that many of them survived through to the end of the century,
long after they had ceased to be associated with flying. Postwar civil aviation
developed rapidly. The new large airports required massive concrete runways,
and aviation exerted an additional pressure on the landscape. Modern airports
like Heathrow occupy as much space as a medium-sized town. They also
affect the surrounding areas, sometimes by the direct blight caused by aircraft
noise, but just as often by the development of a wide range of associated
activities. The widespread impact of busy airports is summed up below:

> If there was an international prize for the ugliest landscape, some of the leading
> contenders would be around a number of the world's leading airports. This
> is partly because airports have to be situated on flat land which does nothing
> to hide the acres of concrete, and partly, because for safety reasons, tall trees
> which might soften the skyline are not tolerated. As the more affluent owners
> flee from the aircraft nuisance – a nuisance which affects eyes, ears and nose
> – neighbourhoods decline and take on an unloved appearance. What we finish
> up with, all too frequently, is an unappealing wasteland of warehouses, car
> parks and poor housing.[2]

To which could be added tower-block hotels, fuel storage tanks and mass

catering facilities. Nevertheless, the impact of the aeroplane on the English landscape in the twentieth century was not as all-pervasive as that of the motor vehicle. Airports were large, but discrete, concrete islands, whose consequences lessened the further one moved away from them.

The Early Years of Flight

Although manned flight originated roughly at the same time as the motor car, initially there was considerably less interest in flying in Britain than in America or France. There were, however, a number of British flying enthusiasts, including Lord Northcliffe, proprietor of the *Daily Mail*, who, in 1905, proclaimed that, as a result of pioneer flights in France, 'Britain is no longer an island'. This assertion was to be made by him and others at regular intervals right up to the beginning of the First World War. By the end of 1908 the Aeronautical Society had acquired an area of reclaimed land, near Dagenham Dock, Essex, as an Experimental Flying Ground. (Many of these early airfields were located along the mudflats bordering the Thames estuary.) The Dagenham site eventually proved to be a white elephant, however, and in 1925 the Ford Motor Company started to build their motor assembly factory there. In July 1909, when Louis Blériot successfully flew across the English Channel, the age of the aeroplane had truly started. In the same year, the Aero Club acquired a flying ground at Shellbeach, near Leysdown on the Isle of Sheppey. The Short brothers established a factory here and manufactured the first aeroplanes in Britain, which were of a French design built under licence. Unfortunately, the Shellbeach site also proved to be unsuitable, as it had a surface made uneven by drainage ditches; so, in 1910, a more favourable location was found at Eastchurch, a few miles away. Eastchurch rapidly became the centre of aviation experiment and

Postcard celebrating an early aviation meeting at Blackpool in 1909. The plane seems to have been superimposed on a photograph of the front and Tower.

manufacture, and there is a memorial in the village commemorating it as the home of pioneer aviation in Britain.

In 1910 Claude Grahame-White acquired a site of two hundred acres of meadow at Hendon, north of London, for a flying school. The site was bordered by the Midland Railway and was considered to have considerable potential as an 'aviation centre'. Another location that became closely associated with the pioneering aviators was Brooklands, twenty miles south of London in the Surrey countryside, where a runway was established in the centre of the motor racing circuit. The British and Colonial Aircraft Company, later renamed the Bristol Aeroplane Company, took premises at Brooklands in 1910 and offered flying lessons. Before the First World War a group of wooden sheds housing a community of sportsmen and aircraft designers became known as the Flying Village at Brooklands. Most of the pioneers of British aviation, including A. V. Roe and Tommy Sopwith, were based here, and Brooklands witnessed an impressive range of aviation firsts. In 1911, for instance, the world's first flight ticket office was built at Brooklands, close to the Blue Bird restaurant. This consisted of a simple brick hut and was operated by Keith Prowse Ltd up to the First World War. Here, passenger flights in biplanes around Brooklands cost about £1. Brooklands continued to play a part in British aircraft design through the two world wars and right up to the Concorde.

At the beginning of the First World War, in August 1914, aviation in Britain was still in its infancy, yet, only four years later, the aeroplane had developed into a potent fighting machine, and it was clear that no future war could be waged without a strong air force. On Salisbury Plain the British and Colonial Company (later the Bristol Aero Company) leased two hundred acres at Larkhill to establish a school of flying conveniently close to the large army camp at Bulford. The Larkhill site eventually became home to England's first military flying school. By 1918 the RAF was the largest air force in the world, with 23,000 machines and over a quarter of a million officers and men. There were some four hundred airfields in the country, the majority of which disappeared in the following decade. A number of the wartime airfields, however, became civilian airports. For example, in 1919, Hounslow Heath, a field to the south west of what became Heathrow Airport, was designated the first 'Customs approved' aerodrome for foreign flights, and Customs control of passengers and freight was introduced. Later, several other airfields were approved for regular international flights, including Hadleigh (Suffolk), Cricklewood, Lympne and Dover.

Flight between the Wars

Hounslow Heath was one of a group of early airfields which were located close to Heathrow, but its role as London's international aerodrome was

short-lived; in March 1920 it was superseded by Croydon, and closed. Croydon Aerodrome comprised two adjacent First World War airfields, at Beddington and Waddon, that were thought to be more suitable for commercial development: it was considered preferable to have an international airport south of London, and the site was less prone to fog – a perennial hazard in the early days. Waddon had been the site of the large National Aircraft factory and became the flying area; whereas Beddington, to the west, housed the military hangars; thus the aircraft were forced to taxi across a main road (Plough Lane) before take-off, whilst a man with a red flag held up the road traffic. The local council did not want its name – Wallington – to be associated with the new venture, so nearby Croydon was chosen as the name of London's new 'air terminus', under the control of the Ministry of Civil Aviation. Trust House Ltd established a hotel there, the first to provide meals and accommodation for air travellers. In the early days, Croydon Aerodrome was far from a grandiose place, and was described as 'resembling … a wild-west township of the early mining days'. It was developed significantly, however, in the late 1920s and became the busiest international airport in Europe.

Lady Mary Hoare formally opened the new and imposing terminal buildings and the reconstructed airfield at Croydon on 2 May 1920. The spacious domed booking hall, with its arrival and departure indicators, weather information board, and clocks displaying the times around the world, became a famous meeting place. But it was dwarfed by the impressive control tower, which was to feature in many photographs taken in later years. Croydon's was the first specially constructed modern air terminal, replicated by several European cities. The new Aerodrome Hotel, close by, had a flat roof to enable spectators to watch the arrival and departure of the airliners. By the end of the 1920s, about twenty aeroplanes a day were leaving Croydon.

The only aerodrome to compete with Croydon in the 1920s was formally opened in 1929 – Heston in Middlesex, owned by Airwork Ltd. Up to 1939 Heston was increasingly used as the start point for foreign flights. In 1928, Airwork Ltd bought 170 acres of land between the villages of Heston and Cranford. After much prevarication, plans were drawn up to develop Heston as an alternative to Croydon – then the main civil airport in Britain. A number of buildings were erected, including a reinforced-concrete hangar, the first building of its type to use this method of construction. It also had a modern terminal and control tower. In 1936, the Air Ministry bought the airfield and much of the surrounding land. In 1938, Heston Airfield achieved national attention as the airport from which Neville Chamberlain flew to Munich to meet Hitler, returning with the notorious treaty promising 'peace in our time'. But for the war that ensued, it is probable that Heston would have become Britain's main airport. Plans were drawn up for the expansion of Heston, which would have extended from the Grand Union Canal in the

north to the Bath Road in the south and destroyed the villages of Cranford and Heston, making it one of the largest grassfield sites of the period in the world. Indeed, work had already started on the plan in 1939, with the demolition of some buildings in Cranford and the laying out of the route of the Parkway. Heston's expansion had not progressed far when war broke out in September, and plans for the construction of a new civil airport for London were ostensibly abandoned for the duration of the war. British Airways, by then the largest civil fleet in the country, moved their operations to Bristol, and Heston became a satellite to Northolt. Heston was intensively used during the war, particularly by Polish squadrons, but it was subject to a devastating air raid in September 1940. It was also hit by V1 flying bombs in 1944. Because of its close proximity to Heathrow, the new London airport, Heston was forced to close down after the war. In 1965 the M4 motorway was constructed directly across the airfield. The control tower and adjoining buildings were pulled down in 1978. Part of the field was returned to agriculture, but a few features of the airport survive. The concrete hangar is still intact; now a protected building, it has been put to industrial use, while five early aircraft sheds are used for storage purposes. Sections of the old perimeter track also survive.

Heston was one of three airfields sited in a relatively small area. Some miles due south was another airfield, at Hanworth Park. In 1911, Hanworth Park was described as containing 'many fine trees, which are the more remarkable as the rest of the parish is but sparsely wooded'.[3] The trees were cleared and the park was used as an airfield during the First World War, but at the end of the war all flying stopped and did not resume until 1928, when 229 acres of Hanworth Park were laid out as an airfield by National Flying Services Ltd, with Hanworth House serving as the clubhouse for the private airfield. In 1930, Hanworth hosted the premier flying contest – the King's Cup. Hanworth, also known as London Air Park, continued in use until 1946, when flying ceased there because it was too close to the developing Heathrow. In 1959, it became a municipal public park. The other new airfield in the vicinity was Fairey Aviation's 'Great West Aerodrome'. The company operated from Hayes and was growing in importance with its military aircraft. Hitherto, Northolt had been used for test flying, but the Air Ministry wanted to develop Northolt into a permanent station and the company were given notice to leave. Fairey's were forced to find suitable land not too far from their factory and, in early 1929, some 180 acres of land near to the village of Heathrow was purchased; the new aerodrome was called Harmondsworth, later acquiring its more familiar name of Heathrow.

For the first time, new airfields joined other developments as serious consumers of agricultural land. The Land Utilization Survey Report of 1937 described the brick-earth soils in the Harmondsworth area as being 'some of the best in England and they are, and have been, extensively used for market

gardening, although they are well-suited to almost any type of farming. In the national interest it is, therefore, a matter of regret that so much development of an urban and suburban character has been permitted to take place on this highly productive land.'[4] Furthermore, the report went on to lament, 'at least four aerodromes have been recently established in the region, three of them involving the conversion of excellent market-gardening land into grassland of little value'. The four airfields in question were Hanworth, Heston, Fairey's at Heathrow, and Hawker's at Langley.

In the 1930s, several private and public airfields opened away from London, notably Barton (Manchester), Desford (Leicester), Ipswich, Tollerton (Nottingham), Whitchurch Down (Bristol) and Gatwick, which at this stage was seen as an airport for Brighton. A few miles to the north of Brighton, a small airfield had been acquired by Alfred Jackman in September 1933. Jackman formed the Horley Syndicate to develop it into a civil aerodrome to rival those at Heston and Croydon, and in March 1934 a public licence was granted and work commenced on the design of a terminal building that was to become the famous 'Beehive'. In the following year, Airports Ltd was formed and the land was cleared, levelled and drained, the River Mole was diverted, and hangars were erected. The Southern Railway were persuaded to build a new railway station on the nearby London to Brighton line. The station, initially named Tinsley Green, opened in September 1934 and was linked to the aerodrome by a subway. The Air Ministry granted a subsidy to Airports Ltd, with the provision that Gatwick be kept open day and night, with night-landing equipment. Customs accommodation was provided, along with sufficient passenger facilities as befitted a major airport. On 15 May 1935, British Airways moved in from Heston, and two days later its first service

The popularity of flying in the 1930s is shown on this advertisement for Shell by Barnett Freedman depicting an Atlanta Class airliner.

left Gatwick for Paris. Although the aerodrome was then slightly larger than Croydon, it was not an immediate success. British Airways was also forced to move temporarily to Croydon and Heston in February 1937 because the landing area at Gatwick was frequently flooded during the winter.

To begin with, light aeroplanes used small grass fields, and for a while it was believed that every town and city would have its own airfield, just as it had its own railway station. One commentator in the mid 1930s speculated that 'every centre with a population of over 3000' might soon have an 'authenticated aerodrome'.5 And, indeed, during the 1920s and 1930s there was a proliferation of rudimentary municipal aerodromes, and the sight and sound of planes flying over urban areas became relatively common. Passenger numbers were still small, however, and many 'airliners' were single-engined biplanes carrying only two or three passengers. It was not until around 1930 that air travel became safe and comfortable enough to begin attracting a larger clientele. Aircraft such as the de Havilland Dragon, Westland Wessex and Spartan Cruiser had operating economies that allowed for the first comprehensive network of domestic air services to be established; while stately, multi-engined biplanes such as the Handley Page HP42 took care of long-range flights to Europe and further afield. All of these aircraft could fly quite happily from grass airfields, as take-off and landing speeds were low; and, because there were not yet many flights, minimal infrastructure was needed.

The 1930s saw a boom in the opening of British airports, most of them owned by city corporations keen to see their towns established on the aeronautical map. Indeed, there seems to have been considerably more appreciation of the potential for passenger air traffic at that stage than there was later in the century. Most of the airfields set up in the 1930s only consisted of a relatively flat grass area, a small administration building

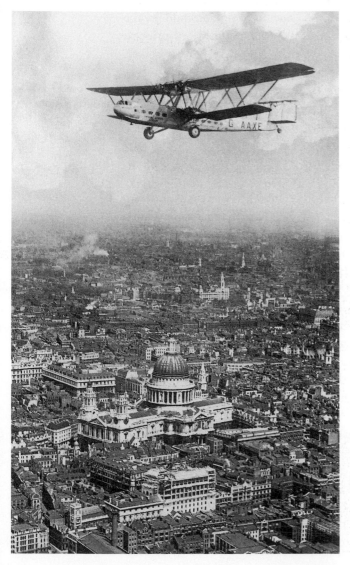

An Imperial Airways airliner over central London in the 1930s.

and a hangar or two. By 1939, however, many had grown significantly and some, such as Croydon, Heston, Liverpool and Manchester, had imposing buildings, often in Art-Deco style, as well as the latest navigation aids and flying control facilities. Aircraft had also increased in size, weight and complexity, and it was becoming apparent that simple grass airfields, no matter how large, would not support intensive use by these planes.

As the international situation deteriorated after 1935, the RAF acquired new airfields in anticipation of an aerial war. As many as thirty new airfields were built in eastern and central England, all conforming to a standard plan of two or three runways, three large hangars and, often, quarters for married personnel close by. The compulsory requisition of tens of thousands of acres, often of agricultural land, for military airfields during the Second World War represented a major landscape innovation.

The possibility of building paved runways, such as were common in the United States, on commercial airfields was already being considered prior to the outbreak of the Second World War. Manchester's Barton Airport laid claim to being the first civil airport in Britain with 'American-style' runways, although in fact these consisted only of a rolled cinder bed, an expedient forced on the airport's owners by the marshy nature of the ground. The only civil hard runway in the country in 1939 was at Bristol's Whitchurch Down Airfield, and for that reason it was selected as Imperial Airways' base on the outbreak of war. The first RAF station to have a paved runway was Cranwell, which was laid out in 1928 as part of a programme for experimental long-range flights, but by 1939 a handful of other airfields also had concrete runways. By 1942 the RAF had settled into a policy of laying six-thousand-foot long runways, with two subsidiary shorter runways, at almost all of its operational fields. When the American Air Force arrived, they joined in the airfield construction programme with vigour and created a number of large bomber bases in East Anglia. By 1945 the country had a network of several hundred modern airfields capable of accommodating the latest aircraft. As the bomber war developed, so did longer runways, some as long as eight thousand feet, to handle the heavier aeroplanes. Many of these were in the flat lands and plateaux of East Anglia, Lincolnshire and the south east of England, all in the front line as far as the air war was concerned. There were also many airfields further westwards, in the more remote counties of Midland England, Oxfordshire, Warwickshire and Gloucestershire; the flat gravel terraces of the River Thames proved particularly attractive and adaptable for wartime use.

After the War

After the Second World War, the government was slow to return the military airfields to their previous owners. Instead, their operation and development

came under the control of the Ministry of Civil Aviation. This postwar policy of state control of the air transport industry was similar to the nationalization of the railways in 1948. The state-owned BEA ran civil air services to the various state-owned airports around the country. In addition, the government funded the enormously expensive development of Heathrow as Britain's premier international airport, later to be followed by Gatwick in the mid 1950s. Although some airfields, such as Southend, were returned to private or municipal ownership from 1947 onwards, it was not until much later that the government relinquished their hold on other airports, such as Liverpool (1961), Southampton (1961) and Blackbushe (1960).

Two developments checked the early movement towards multiple small airfields and encouraged concentration into fewer and larger regional airports, which were usually located well outside the built-up area. One was the increasing size of aeroplanes, followed by the switch to jet engines, which were noisier and required longer take-off and landing strips. The other was that the facilities expected of airports in terms of radar and communications, complex passenger and baggage handling, landing lights and concrete strips made small airports uneconomical or unsafe. As a result of these developments, larger out-of-town airports such as London Heathrow, Manchester Ringway and Luton became common.

As the century progressed, the serious blight caused by large airports to their surroundings became increasingly apparent. Often, hundreds of acres of perfectly good agricultural land close to the airport lay uncultivated and unkempt. Owners of such land kept it like this in the hope that planning permission might eventually be forthcoming for an airport-related development that would realize millions of pounds, against the thousands which could be made from its sale as agricultural land. The area to the west of Heathrow is now given over to huge reservoirs and man-made lakes – the Queen Mother Reservoir was added to Wraysbury, King George VI and Staines reservoirs in 1975, when 500 acres of farmland in Horton and Datchet were swallowed up by the huge construction. Added to which, gravel extraction at Kingsmead Farm and at the Welley and Fleet Meadow has produced the Kingsmead and the Thames Valley water-sports lakes. In effect, the five-mile zone between the west of Heathrow and the River Thames at Windsor is a no-man's-land of water, motorways and industrial estates.

Ground transport to and from airports is essential, and provision for car parking and coach stations takes up more space than the airport itself. For example, Heathrow and Gatwick have motorway spurs to bring vehicles to the airport, although once there drivers can often be snarled up in traffic jams. At Heathrow, in particular, the tunnel under the runway, built in 1953, must handle most vehicles coming to the airport, and, although the original two lanes for traffic were widened by the incorporation of pedestrian footpaths, the tunnel is still inadequate for the task. Towards the end of the

century, airport authorities tried to restrict private car access to the terminals; the result was the spread of the parking over an ever-widening landscape – at Stansted, for example, there are public car parks up to five miles away from the terminal. In addition to parking facilities provided by the airport authorities, there are dozens of authorized and unauthorized off-airport car parks, often eating up adjacent village centres. The centre of Harmondsworth, near Heathrow, for instance, has the appearance of an enormous car park. Moreover, the design of airport buildings themselves no longer pays much attention to exterior appearances, as the approach is no longer mainly through a front façade, but by lifts and moving staircases from train and coach stations.

The 1960s and 1970s brought protest movements against the visual and auditory intrusion of numerous jet planes overflying urban areas. This led to objections to runway extensions or terminal expansion to accommodate an even greater number of aircraft. Planning enquiries into such proposals were standard, and airport development, along with road and motorway schemes, took several years, and, in some cases, decades, before they were completed. This was in contrast to the much quicker suburban growth around towns, which ate up considerably more 'greenfield' space year in and year out than either airports or road schemes.

In the last decade of the twentieth century, there was increasing activity at provincial airports. The high cost of long-distance rail transport, together with increasing traffic congestion, meant that domestic flights within the UK became more attractive. Additionally, the overseas annual holiday had become an annual feature of so many people's lives that they wanted to travel from near their homes, rather than from London. Consequently, Newcastle, East Midlands (Nottingham), Manchester, Birmingham, Bristol and Exeter airports all saw a dramatic increase in the number of passengers passing through each year. Also, London itself had acquired three major airports at Luton, Stansted and City, in addition to Heathrow and Gatwick.

Manchester Airport was the third largest civil airport in Britain by the end of the twentieth century. The Ringway site was not Manchester Corporation's first choice for an airport: it was developed there only after problems with a waterlogged site at Barton. In 1934 Fairey Aviation had set up a factory at Ringway, and in 1937/38 its airfield was developed as a commercial airport with the construction of a hangar, control tower and passenger terminal in a single building. Airline customers included KLM, Railway Air Services and Isle of Man Air Services. In addition, A. V. Roe also set up an aircraft plant on the airfield. During the Second World War, Ringway became an important aircraft production centre, with the Avro Manchester, Lancaster and York prototypes all making their first flights from here, while Fairey produced Fulmars and Barracudas, as well as Beaufighters and Halifaxes. In addition to its importance to aircraft production, Ringway was also a

centre for training the glider pilots and parachutists of the Army's airborne forces. Over 60,000 troops passed through the various training establishments between 1940 and 1945. Ringway continued to see some military flying until 1957.

In 1949 some of the buildings of the wartime Parachute Training School were converted to handle passengers, supplementing the original terminal, which was now too small to cope with the traffic. Later, in 1951, the runway was lengthened to around 1800 yards, and the following year the number of passengers flying from Ringway rose to 163,000.

Throughout the 1960s and 1970s, Manchester continued to experience economic growth, and further expansion of its airport became necessary. A new departure hall was opened in 1973 and was followed in 1974 by a third pier, further terminal extensions and a 20,000-space, multi-storey car park. In the 1980s a satellite pier and additional holding lounges were added to the third pier. One reason for the significant expansions and increase in passenger traffic was the government's designation of Manchester as an International Gateway airport. This allowed direct long-haul international flights to be operated to and from Manchester, and the airport was quick to take advantage of its new status. In 1992 a railway link and a new Terminal 2 were opened. The proposal for a second runway at Ringway met with considerable opposition, but it was approved. It opened in 2003. At the time of writing, some thirty million passengers a year pass through Ringway.

In 1952, after war service, Gatwick Airport was designated for development as an alternative to London's Heathrow. Over the subsequent years, terminal facilities were greatly improved and, with the increasing number of jet aircraft,

Shoreham airport terminal and control tower near Brighton. The Art Deco building has changed little since it was built in the 1930s.

the runway was progressively extended. Then, in 1988, a second, North, terminal was opened. In 1994 London Gatwick handled twenty-one million passengers, 190,000 aircraft movements and 227,000 tonnes of freight on its worldwide services, and employed over 25,000 people.

Heathrow

London's Heathrow is Britain's premier airport and one of the busiest in the world. At peak times over 12,000 passengers an *hour* pass through its four terminals, and there are well over a thousand aircraft movements a day, almost all of which are large passenger jets. The airport was established in a flat, prosperous horticultural area well to the west of London, and by the end of the century it was as large as a medium-sized town, with 60,000 people working there. In 1900 Heathrow, together with Longford, Sipson and Harmondsworth, made up the parish of Harmondsworth. Heathrow, the smallest township in the parish, was first documented in 1453, although it may well have been in existence long before then. It probably originated out of a squatter settlement on the edge of Hounslow Heath. Landless peasants would have illegally encroached on common land, and eventually would have amalgamated and been recognized as a legitimate hamlet within the parish of Harmondsworth. The hamlet of Heathrow lay to the south of the Bath Road in the south east of the parish, on the edge of Hounslow Heath, from which it derived its name.

Heathrow also has an earlier claim to fame in the national consciousness through the history of British cartography. Hidden away off the Bath Road between Heathrow police station and the airport perimeter road, there is a memorial plaque and a half-buried cannon to commemorate a significant landmark in the history of map-making. Five miles away, in the centre of a housing estate in Hampton, there is a similar memorial. These memorials, 27,406.19 feet apart, mark the end points of a baseline, measured out in 1784 under the direction of Major General William Roy, across what was then part of Hounslow Heath. He established an accurate baseline as a prelude to undertaking a trigonometrical survey of the whole of Great Britain, the method by which the country was surveyed for the first Ordnance Survey maps. Roy, who later became the first Director-General of the Ordnance Survey, chose this site 'because of its vicinity to the capital and the Royal Observatory at Greenwich, its great extent and the extraordinary levelness of the surface without any local obstructions whatever to render the measurement difficult'.[6] These are exactly the same attributes which made the area suitable for Britain's largest airport 160 years later. The work was carried out as part of a project to determine the relative positions of the Greenwich and Paris Observatories.

The western end of Roy's baseline was located at King's Arbour, which

takes its name from one of the prehistoric earthworks which were located on the heath, and the other end was at the workhouse in the village of Hampton. The spire of Banstead church in Surrey was in direct line with the two ends of the baseline and was used as a sighting point. Roy discovered that glass tubes were the most accurate means of making the measurement, as their dimensions did not alter in different temperatures. The work was executed in the second half of August 1784. Roy complained that carriages passing along the Great Road (Hounslow to Staines) continually interrupted his work. He was judged to have performed his task with 'a labour sufficient to derange a more than common degree of perseverance', and he was presented with the Copley Medal of the Royal Society in 1785 for 'the accurate and satisfactory manner in which he measured a base for operations of Trigonometry, upon Hounslow Heath'. In 1791, two cannon from Woolwich Arsenal were half-buried in the ground, muzzle upwards, one at each of end of the baseline. In 1926, to mark the bicentenary of Roy's birth, bronze plaques were fixed to each gun. The cannon at Hampton now stands in Cannon Close, surrounded by a small council housing estate. The cannon at King's Arbour was moved in 1944, when it was deemed to be a danger to aircraft, but was

Heathrow in 1932. The large hangar in the far centre of the photograph belonged to the Fairey aerodrome.

replaced in its original position in 1968. Roy's work in establishing a base from which the survey of Britain could be undertaken is further celebrated in a plaque on the wall of Heathrow police station.

In 1800 the Bath Road was the most important route from London to Bath and Bristol, which was then the leading provincial city in England and the major port of departure for the Americas. By the standards of the time, the Bath Road was one of the busiest in the country as, before the advent of the railway, it was the only overland means of travelling from London to Bristol. The traffic on the road reached its peak in 1830, when every day there were some fifty stagecoaches and four mail coaches travelling in each direction, in addition to a considerable amount of local traffic. The frequency of the stagecoaches on the Bath Road and the loneliness of the adjoining heathland attracted highwaymen to the area, and Hounslow Heath was notorious for their presence in the mid-eighteenth century. A large number of coaching inns were built in the vicinity of Heathrow to cater for the travellers on the road. Many of the inns claimed a spurious association with the outlaw Dick Turpin, whose main area of activity was the Great North Road. Many of the old coaching inns in the vicinity of Heathrow eventually disappeared to make way for the construction of airport hotels on the same sites.

The original hamlet of Heathrow extended along Heathrow Road, with most of its buildings on the west side of the road. Even on the eve of its destruction to create the airport in 1944, it retained a rural character; there were very few modern buildings, and the whole area was given over to agriculture and horticulture. Until 1930, Heathrow remained exclusively agricultural and, when change did come, initially it had little effect on the tranquil nature of the area. In the mid 1930s Heathrow was described in the following terms:

> If you turn down from the Bath Road by the Three Magpies you will come upon a road that is as rural as anywhere in England. It is not, perhaps, scenically wonderful but for detachment from London or any urban interests it would be hard to find its equal; there is a calmness and serenity about it that is soothing in a mad rushing world.[7]

Heathrow's location as a flat plateau on the western edge of the ever-expanding metropolis and along a major routeway meant, however, that it came under increasing pressure from the services required by the capital.

The first appearance of aircraft at Heathrow was the establishment, in 1929, of a small aerodrome belonging to the Fairey Aviation Company of Hayes. Heathrow, a small private grass airfield in the 1930s, enjoyed the inflated title of the 'Great West Aerodrome'. It was used by the Fairey Company mainly for test flying; most commercial flights at that time operated from nearby Heston or Hanworth Park. Another development in and around Heathrow was the opening of a sludge disposal works at Perry Oaks by Middlesex

County Council in 1935, as part of the West Middlesex Drainage Scheme. At about the same time the Ham River Sand and Gravel Company also began excavating gravel from land to the east of Heathrow Road.

Sir Richard Fairey (1887–1956), an individual whose life and works had a considerable impact on Heathrow's history as an airport, began his aeronautical career by selling model aircraft to Gamages of High Holborn. In 1915 he formed his own aircraft manufacturing company – the Fairey Aviation Company – which initially operated from factory premises in Clayton Road, Hayes. Fairey also bought a field in Harlington, which became the company headquarters and factory. A few flights were made from this field, but, from 1917, Northolt Aerodrome became Fairey's test-flying base. Northolt was owned and operated by the Air Ministry, which in 1928 served notice on Fairey's company to vacate its leased premises, so he was obliged to find another site for his experimental and production test-flying.

The new site had to be within a reasonable distance of the factory at Hayes, and it is believed that the Heathrow site eventually purchased was chosen because Norman Macmillan, Fairey's test pilot, had a few years earlier, in 1925, made a forced landing there and later managed to take off again without difficulty. Macmillan was impressed by the flatness and stability of the ground so, when he learned that Fairey's were obliged to leave Northolt, he suggested that somewhere in the vicinity of this Heathrow field would be a suitable choice for a new aerodrome. Macmillan made some aerial surveys of the area, which confirmed his original impressions, and Fairey's then contacted the owner of the field and owners of adjacent fields, and negotiated their purchase. Harmondsworth's open fields and common lands, which formed part of Hounslow Heath, had been enclosed following the 1819 Enclosure Act. A landscape of large rectangular and square fields was created and, for the most part, old tracks were abandoned and straight new roads and lanes were established. By the 1930s, however, some of the enclosure fields had been consolidated, and much of the land was given over to intensive market gardening and orchards. Divided into broad strips, the landscape had something of an open, medieval appearance. In order to create the Great West Aerodrome, Fairey's bought further individual fields between 1929 and 1943. The first was a plot of seventy-one acres in the hands of the Reverend R. Ross, vicar of Harmondsworth. This land had passed to the church living at the time of enclosure in lieu of titles. A further five plots, consisting of 108 acres, were bought by 1930. Another two plots of forty-eight acres were acquired during the early years of the Second World War. All of this land had been common heathland before enclosure, but had been cultivated and improved during the rest of the nineteenth and early twentieth centuries. During the 1930s, ploughing matches with horses had been organized at Heathrow by the Middlesex Agricultural and Growers' Association.

The land purchased by the company was consolidated and initially sown

with couch grass. In 1930 the airfield was levelled and regrassed by the specialist company C. P. Hunter and laid out as an area of high-quality turf. The airfield was known originally as the 'Harmondsworth Aerodrome', but later as the 'Great West Aerodrome'. It was known for its level and smooth turf, and the hangar located on the northern corner of the site was said at the time to be the largest in the world. Because of the location's obvious advantages, the company decided to expand the site so that it could transfer its factory from Hayes to Heathrow, thus bringing the works and flight-testing facilities together. With this end in view, Fairey's gradually acquired additional land, as opportunity occurred, and by 1943 they owned about 240 acres of land between Cain's Lane, High Tree Lane and the Duke of Northumberland's River, otherwise called the Isleworth Mill River.

The Fairey aerodrome, and the large numbers of people in the aviation world who visited it at the time of the Royal Aeronautical Society's garden parties, drew attention to the potential of Heathrow as a site for a civil airport for London. As early as 1937 there were suggestions that Heathrow might be the most appropriate location for a much expanded London airport. With the outbreak of war, the whole area was requisitioned for the RAF, and the process of the development of a military airport began. It was not, however, until 1944 that work began on building a bomber base at Heathrow; it was intended to house US Air Force Flying Fortresses there. It appears, however, that the real motive behind this work was to ensure that Heathrow would be available as a civil airport after the war ended. Temporary arrangements were made for the Fairey Aviation Company to use Heston Aerodrome. The effect of the prospective loss of their airfield on the company can be judged from the correspondence that passed between Sir Richard Fairey and his co-chairman, Sir Clive Baillieu. When he first learned, officially, of the news on 7 January 1944, Fairey cabled: 'Decision so utterly calamitous, suggest liqui-dation only practical prospect. However, detailed reply coming quickest route.'[8] In his detailed reply Fairey wrote:

> It is manifestly so much easier for the Civil Aviation authorities to look over the airports near London, that the foresight of private companies has made available, and then using government backing forcibly to acquire them, than to go to the infinite trouble that we had in making an aerial survey to find the site, buying the land from different owners, and then building up a fine airfield from what was market-gardening land. And why the haste to proceed? I cannot escape the thought that the hurry is not uninspired by that fact that a postwar government might not be armed with the power or even be willing to take action that is now being rushed through at the expense of the war effort ...

In his autobiography, Lord Balfour confirmed that, during the war, when he was Undersecretary of State for Air, he had deliberately deceived the

government committee that a requisition was necessary so that Heathrow could be used as a bomber base. In fact, Balfour wrote that he had always intended the site to be used for civil aviation, and used a wartime emergency requisition order to avoid a lengthy and costly public enquiry.[9] Certainly, neither the RAF nor the US Air Force ever made use of the airport, although work was started on the construction of runways for military use. The runway running from north west to south east constructed by the RAF was in fact completely redundant and was never used by civil aircraft – it cost £350,000 (at 1946 prices). Indeed, it has been argued that the RAF never intended to use the airfield for military purposes, and that the early stages of construction using the classic RAF aerodrome design was an expensive deception. Control of Heathrow was transferred to the Ministry of Civil Aviation on 1 January 1946. Fairey's hangar at Heathrow was not demolished until the question of compensation had been settled finally in 1964; it was the last of the original buildings at Heathrow to disappear. After the takeover, aircraft continued to be built at the Hayes factory site until it was closed by Westlands and became an industrial estate in 1972.

According to the Greater London Development Plan of 1944, 'although the airport (Heathrow) is on land of first-rate agricultural quality, it is felt, after careful consideration and thorough weighing up of all the factors, that the sacrifice for the proposed purpose of the airport is justified'. When the airport plan was developed, Heathrow was at the centre of the Thames Valley market-gardening plain. At a time of food shortages and rationing, this important market-gardening area close to London was a valuable national resource. The problem of destroying the land for the construction of an airport was described by Dudley Stamp, the leading authority on land use and classification at the time:

> The brick-earth is a magnificent soil – easily worked, adequately watered, of high natural fertility and capable of taking and holding manure. It is a soil fit to be ranked with the world's very best ... In addition to the destruction of this good land by gravel digging, a further using up has recently been made manifest where huge areas are taken for the construction of the airport. Was there ever such a profligate waste?[10]

The construction of the airport in 1944 involved the requisition of a far larger area than that taken for the Great West Aerodrome: initially this was some 1300 acres of agricultural land, which represented 15 per cent of the agricultural land in south-west Middlesex. Twenty growers were displaced, either wholly or partly, from their holdings at the time, and subsequent airport-related developments made further inroads into the agricultural land in the area – the once prosperous west Middlesex market-gardening industry was virtually destroyed in less than a generation. A relatively small number of buildings were destroyed to make way for the airport, but Heathrow hamlet and parts of Harlington and

Hatton were immediate casualties. According to the plan, Terminal 3 (the Oceanic) was to occupy the site of Heathrow hamlet, and a number of seventeenth-century farms and the eighteenth-century Heathrow Hall were destroyed. The new airport extended almost to the Bath Road in the north and the Duke of Northumberland's River in the south. This river had originally been dug as a leat for Isleworth Mill in the sixteenth century, and it appears to have been widened by Capability Brown to create a large lake, a quarter of a mile long and forty feet wide, at Syon Park in the mid eighteenth century. The river is man-made, the channel having been constructed in the mid sixteenth century to increase the water driving Isleworth Mill and to provide water to Syon House. It runs from the Colne at West Drayton by way of Longford, Heathrow and Bedfont to join the Crane for a short distance at Baber Bridge, before proceeding on its own course to Isleworth. It is probable that the river followed the line of a natural watercourse to some degree, because in the Heathrow area it formed the boundary between the parishes of Harmondsworth and Stanwell, which would have been established well before the sixteenth century. The route of its former channel continued to form the southern boundary of Harmondsworth parish, and hence of the Borough of Hillingdon, until the boundary changes in 1994. When construction of the airport began in 1944, the river was diverted to a more southerly route for about two miles of its length, and some twenty marker blocks with plaques were placed along its former course 'in order that a permanent record of the old bed could be maintained'. Most of these plaques have long since disappeared.

At the end of the Second World War, in 1945, it was clear that commercial aviation would play an increasingly important role in the development of postwar Britain. Wartime technical developments had brought about significant changes in the capacity and performance of airliners, and it was obvious that London required a large, modern airport equipped with long runways, modern navigation aids, engineering facilities and passenger terminals. The partly-built RAF site at Heathrow was handed over by the Air Ministry to the Ministry of Civil Aviation on 1 January 1946. By this time the first runway had been completed and rudimentary passenger facilities had been established, in the form of tents, adjacent to the Bath Road on the north side of the airfield. The three original runways were completed by 1947 and work continued on a further three, which were intended to provide a pair of parallel runways in each of three directions, with the overall plan resembling the six-pointed Star of David; this was a scaling down of one design which proposed no fewer than nine runways. In 1950, work began on terminal facilities in the central area. At the same time, BEA and BOAC started to establish their engineering facilities and hangars on the east side of the airfield.

When the airport was first built, the Bath Road (the A4) was the only means of gaining access to the airport from London and, although the M4 motorway and rail links were built subsequently, the A4 still remains an

The greatly expanded Heathrow Airport from the air in the 1970s.

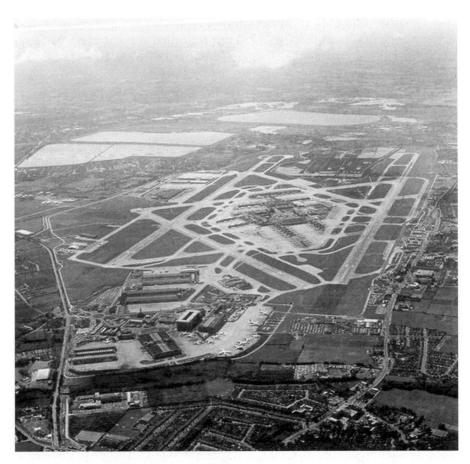

important route to the airport today. Many hotels have been built, mostly on the Bath Road frontage of the airport. The major exception to this was the construction of the Post House Hotel, later renamed the Forte Crest Hotel, in the heart of the Green Belt between Harlington and Harmondsworth, which was built in 1969. The inspector who conducted the public enquiry for this construction at the time recommended that the site was 'at present of negligible visual interest and offered great opportunities for substantial landscaping which could be a major contribution to the M4 Linear Park. An hotel reaching to about 120 feet, set well back from the M4 would do no violence to any part of the M4 or its immediate surroundings.'

Until 1970, the only expansion of the airport outside the boundaries set in 1952 was the extension (approved in 1967) of the northern runway to the west. During the 1960s and early 1970s, it became apparent that Heathrow and Gatwick, as they had been planned, would not be able to cope with the anticipated expansion of air traffic. The cancellation in 1974 of the proposal to construct a third London Airport at Foulness (Maplin) increased pressure on Heathrow. Proposals were therefore made in the mid 1970s to expand the capacity of Heathrow by constructing a fourth terminal on the southern side

of the airport, outside its existing perimeter. Following a public enquiry, the inspector's report, published in 1979, stated that 'in my view the present levels of noise around Heathrow are unacceptable in a civilised society'; but, despite this, he recommended that permission be given for the construction of a fourth terminal. The reason given for the decision was the 'overriding national necessity'. Whilst recommending that the expansion of the airport be approved, the inspector, however, went on to say:

> In the past the growth of Heathrow untrammelled by normal planning control has appeared to proceed without proper consideration for its effect on the environment especially in relation to noise. There is an inevitable danger that permission for T4 should be seen by some as yet another instance of prece-dence being given to the interests of travellers by air over the enjoyment of life by the local population. If this impression is to be dispelled it is, in my view, essential that if they decide to permit T4 the Secretaries of State should reiterate that it is the Government's policy that there will be neither a fifth terminal nor any other major expansion of Heathrow.[11]

Air control radar system on the Clee Hills in south Shropshire, giving the impression of a bleak space-age landscape.

The Government accepted these recommendations and the fourth terminal was planned for opening in 1986. It also became official policy that no further expansion would be permitted. This was made clear by a statement on 14 February 1980, when Lord Trefgarne, the then Government Aviation spokesman in the House of Lords, said: 'The Government conclude that the idea of a fifth terminal at Heathrow and a second runway at Gatwick should not be pursued. This effectively limits expansion at these airports.' By the end of the century, however, pressure on Heathrow Airport had increased to the point where, despite earlier protestations, a fifth terminal was inevitable, and, at the time of writing, work is in progress on its construction.

The fifth terminal is being built on the west side, within the present boundaries of the airport. When it is completed, Heathrow will be able to

handle up to ninety million passengers a year, up from its current limit of sixty-five million. The transport network around Heathrow will also be extended to cope with the additional passengers. A spur motorway will run from the M25 to the new terminal. The rapid-transfer railway line from Paddington, the Heathrow Express, will be extended, and the Piccadilly underground line will be similarly extended. Furthermore, a white paper, published in December 2003, on the future of aviation in the United Kingdom proposes the construction of a third runway. Such a runway would require the building of a sixth terminal, and the expansion of the airport outside its present limits to take in extensive areas that are currently occupied by suburban housing. One of the proposals is that the third runway would run to the north of the Bath Road. It would obliterate the middle of Harmondsworth, Sipson and Harlington, communities which, despite being blighted by Heathrow, have survived over half a century of airport expansion.

If, as seems probable, air traffic continues to expand, these or similar developments will surely take place. Heathrow will become a gigantic airport-city, similar in dimensions to the airports at Miami or Chicago, and it will cover several square miles on the western edge of London. The landscape of flight is not particularly attractive. Instead, it is merely functional, and any efforts that go into improving the aesthetic tend to be concentrated inside the passenger terminals. For the rest, one international airport is virtually indistinguishable from another.

| *London*

But what is to be the fate of the great wen of all? The monster, called ... 'the metropolis of the empire'.

William Cobbett, *Rural Rides* (1821)

L ONDON HAS BEEN THE PREMIER TOWN OF ENGLAND for two thousand years, since the era of Roman Britain. From the time of the first surviving records which enable estimates of population to be calculated, London has been far larger than any other city in England. Yet, as late as AD 1500, nearly its entire population of around 100,000 was contained largely within the circuit of the Roman and medieval city walls, which covered a mere 330 acres. To the west, Westminster formed the focus of a separate royal establishment – palace and abbey; while to the east, stretched out along the River Thames as far as Limehouse, was the port of London, together with the normal extramural activities of slaughter houses, livestock markets and the leather industry. To the south of London Bridge, Southwark formed another small extramural community.

By 1800 the city had expanded to house a population of about one million, but its physical growth was still relatively restricted, as most people still travelled by foot. Westminster had been joined to the city by a development along the Strand, and a number of 'planned' developments were created in the West End on lands previously owned by the Church. Unplanned expansion extended to the east as far as Poplar, and to the north incorporated Clerkenwell and Spitalfields. This growth was fuelled by the development of the port and the influx of large numbers of migrants, while new bridges across the Thames, constructed from 1750 onwards, enabled extensive growth to the south of the river.

London's greatest expansion was in the nineteenth century, during which time it became the world's leading financial, political, commercial, industrial and trading centre – the heart of the British Empire. Outer London expanded rapidly, but the historic core including the City – the commercial centre of London – shrank and there were far fewer people living there in 1900 (30,000) than in 1800 (128,000). With the introduction of improved methods of transport, the rest of London grew exponentially – to Hampstead Heath in

the north; to the Lea Valley and beyond in the east; to Fulham and Hammersmith in the west, along the Thames; and to Camberwell and Wandsworth to the south of the river.

During the twentieth century London continued to expand. Before the Second World War this expansion was largely unplanned, and it was during this period that London more or less achieved its present shape. The establishment of a Green Belt and overspill New Towns after the Second World War slowed the physical spread of the city, but the influence of London became all-powerful and developments of all types, far away from the ancient core, constituted the new 'Greater London'. By 2000 a city-region covering the Thames estuary, and much of south-east England besides, had been established.

Edwardian London

Between 1900 and 1939 the commercial and administrative centre of London was transformed and essentially became the city we know today. The process was a piecemeal one but Harold P. Clunn, in his *London Rebuilt* (1927), applauded the chief features of this transformation, notably the straightening and widening of the principal streets; the replacement of three- and four-storey buildings, of the type characteristic of the Victorian centre, by five- and six-storey ones; and the supplanting of blackened brick and stucco buildings by gleaming stone-faced replacements. He also welcomed the destruction of such statements of aristocratic exclusivity as the 'high garden walls of grimy black brick' which protected the town houses of the Marylebone Road from 'the nosy gaze of humanity'.[1]

Many of these changes actually took place before the outbreak of the First World War in 1914. In the north of the City, Finsbury Square, Finsbury Pavement and Finsbury Circus, as well as Moorgate and London Wall, were largely rebuilt in these years. East of Mansion House, the Baltic Exchange was opened in 1903, and Fenchurch and Leadenhall Streets were widened. The establishment of the Port of London Authority in 1909 destroyed a group of fine old houses in Seething Lane and Trinity Square to make way for its new headquarters close to the Tower of London. Gracechurch Street was remodelled around 1912 for a clutch of new banks, and King William Street for new insurance companies. West of Mansion House, the old Newgate Prison was demolished and replaced by the Old Bailey in 1903. Fleet Street was widened and Holborn redeveloped with a red-brick 'fairy-tale castle' for the Prudential Assurance Company (1899–1906).

Two other quarters of London were transformed by rebuilding during this period: Whitehall and the West End. In 1900 Whitehall, the Tudor and Stuart seat of royal power, still largely contained seventeenth- and eighteenth-century buildings. The old houses and mansions had become government offices as leases fell in during the second half of the nineteenth century. From

the 1860s, during the era of imperial government and bureaucratic expansion, a number of old buildings had been demolished to make way for a succession of immense administrative palaces. This process accelerated with the so-called 'Wrenaissance' of the 1890s and the Edwardian years. The Admiralty (1895) was first to be built, followed by a huge Parliament Street office block for the Board of Trade, Ministry of Health and Education Department, built between 1900 and 1915; Sir Aston Webb's Admiralty Arch (1906–11); and the Office of Woods and Forests (1908). The thousand-roomed War Office (designed by William Young and built between 1899 and 1906), ironically, was located close to Sir Edwin Lutyens's Cenotaph of 1920.

The Lyons Corner House in Coventry Street, which was opened in 1909.

Changes which had far more impact on Londoners at this time were made in the West End. *Building News* in 1898 reported the rebuilding of the north side of Leicester Square, the widening of Cranbourn Street, demolition and rebuilding at the Elephant and Castle, the widening of the Oxford Street end of Tottenham Court Road, the widening of the Strand between St Mary-le-Strand and St Clement Danes, and the widening of Southampton Row between High Holborn and Theobald's Road. In the same year Sir J. Wolfe Barry, chairman of the London County Council, created in 1888, told the Society of Arts of ambitious plans for the new century: 'To meet the traffic of London it was not so much additional railways, underground or overground ... that were wanted as wide arterial improvements of the streets themselves.'[2]

This was the era of the great London hotels, restaurants, gentlemen's clubs and large department stores. Numerous smaller two- and three-storey buildings were destroyed to make way for these new giant buildings. Of the hotels and restaurants, the most prestigious was Norman Shaw's Piccadilly Hotel (1904–8), his final London work and considered among the most accomplished buildings of its time. The Ritz Restaurant

The half-built
Selfridges palatial
department store in
Oxford Street (1929).

and Hotel, Piccadilly (1903–6), were built by Mewès and Davis, the archi-
tects who had been responsible for the Paris Ritz a few years earlier. The
Regent Palace Hotel (1912–15), which occupied an island site at the bottom
of Regent Street and became famous during the First World War, was the
largest hotel in Europe, with over a thousand bedrooms, when it opened in
May 1915. The first of the hugely popular Lyons Corner Houses opened in
Piccadilly (1904), followed by one in Coventry Street (Leicester Square, 1909),
one in Throgmorton Street (1907), and another in Oxford Street (1915). The
Coventry Street Corner House was built on land bought from the Arundel
Estate, and involved the demolition of a hotel, a goldsmith's, a costumier's,
a bookseller's and an area of slum dwellings. Of the new clubs, the most
important Edwardian example was the Royal Automobile Club (1908–11),
built in 'French Renaissance' style with a spectacular swimming pool carved
out of the marble floor.

The department stores were even more important to the economic future
of London's West End. Up until the 1870s they had remained collections of
existing small shops knocked together and had expanded on a piecemeal basis.
The first purpose-built department store was the Bon Marché in Brixton,
named after the Parisian store and opened in 1877. As West End land values
increased, so store owners preferred to build upwards: multi-storey premises
extended from bargain basements to roof gardens. By the 1890s lifts were
common, and in 1898 Harrods installed the first moving staircase. An earlier
technological innovation had been plate glass, allowing much more impressive
window displays, while from the 1880s electric lighting was introduced,
increasing the attractions of night-time shopping. To raise capital for these
changes, many stores ceased to be private family businesses and, after
becoming limited companies, tended to grow in size.

The most impressive brand new department store was built in 1909 by Harry G. Selfridge, who had previously worked in the Chicago store of Marshall Field. Selfridges, in Oxford Street, was almost a town in its own right; by 1914, 950 men and 2550 women were employed in its 160 departments. With restaurants, hairdressers, writing, reading and rest rooms, Selfridges was the equivalent of a gentleman's club for women. Indeed, Selfridges proclaimed itself as being 'dedicated to the service of women'. It joined an already thriving retailing environment boosted by new stores such as Waring and Gillow (1901–5) and Mappin and Webb (1906), and new extensions and modernizations of nineteenth-century enterprises like John Lewis, Peter Robinson, Marshall and Snelgrove, and Bourne and Hollingsworth. Oxford Street itself faced new competition from superstores elsewhere in London: Harrod's undertook an immense Knightsbridge development of 1901–5, and there were other massive department stores, such as Gamage's at High Holborn from 1904, and Whiteley's at Queensway and Swan and Edgar's at Piccadilly Circus, both 1908–12. The creation of these great hotels, restaurants and stores in central London transformed the cityscape. The number of individual enterprises on Regent Street, Oxford Street and Piccadilly, for example, was dramatically reduced. They were replaced by huge buildings of five or six storeys, normally built in neoclassical style – London had once again become visibly quite distinct from any other British city.

In the second half of the nineteenth century, space was required for the rapidly expanding rail network, and up to 100,000 Londoners were displaced, often forcibly, by the construction of railways and their stations. There was very little attempt to rehouse, and the displaced people were forced into the overcrowded and insanitary living conditions in many parts of the capital. Most of the inner London poor were cramped in housing with high rents in order to remain within walking distance of their traditional employment. In the Edwardian period, only eight of the twenty-eight boroughs recorded an improvement in their statistics of overcrowding. 'Place a disused sentry-box upon any piece of waste ground in South or East London,' wrote C. F. G. Masterman in 1902, 'and in a few hours it will be occupied by a man and his wife and family, inundated by applications from would-be lodgers.'[3]

Small shops in Camden Town at the turn of the century.

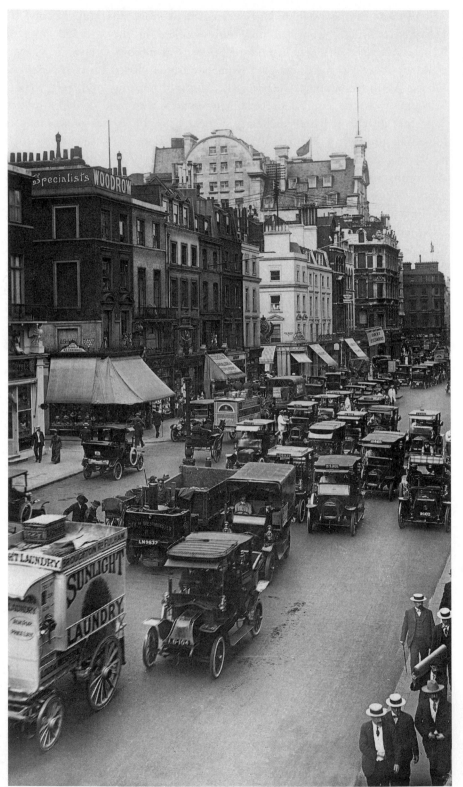

Piccadilly before the First World War. Motor traffic was already becoming congested.

In central London in 1901, about 30 per cent of the population was classified as living in overcrowded conditions, compared to the national average of just 8 per cent. In east London the situation was deteriorating with an influx of Jewish emigrants. In George Gissing's novels, the London streets, whether of proletarian Clerkenwell and Hoxton or of petty-bourgeois Camberwell, are uniformly drab and desolate. It was not just the slum-courts, those 'lurking-holes showing destitution at its ugliest', which upset Gissing, it was the housing for the better paid: 'To walk about a neighbourhood such as this [the Wilton Square district of Islington] is the dreariest exercise to which a man can betake himself; the heart is crushed by uniformity of decent squalor; one remembers that each of the dead-faced houses, often each separate blind window, represents a "home", and the associations of the word whisper blank despair.' Gissing's London was the London of defeat, a nightmare region 'beyond the outmost limits of dread', 'a city of the damned'. Tenements, like the Farringdon Road Buildings – 'millions of tons of brute brick and mortar' piled up in unornamented 'vast, sheer walls' – epitomized to Gissing the prison cage of the modern city within which the industrial army was barracked: 'an army fighting with itself, rank against rank, man against man, that the survivors might have whereon to feed. Pass by in the night, and strain imagination to picture the weltering mass of human weariness, of bestiality, of unmerited dolour, of hopeless hope, of crushed surrender, tumbled together within those forbidding walls.' Fogs and drizzle envelop the bodies of Gissing's men, whose souls were equally unlit. His urban world was barren, barbaric, beyond improvement.[4]

At the end of the nineteenth century Charles Booth mapped London's

In the early years of the twentieth century many parts of London were still Dickensian in character. This Thames-side scene at Hammersmith was typical of 'unmodernized' London.

poor, classifying the population into seven groups, ranging from 'Wealthy. Upper-Middle and upper-classes', through to 'Lowest class, vicious, semi-criminal'. In north Southwark he recorded that 'the rich have already left, the fairly comfortable are leaving and the poor and very poor will remain until they are evicted'. Lewisham too was recorded as 'a middle-class district into which wedges of the better class working people are gradually forcing their way. The tendency of the district is downwards ...'[5]

The worst housing conditions were in shanty towns like 'the Potteries' in North Kensington and in central London 'rookeries', where former middle-class housing was converted to tenements. Some slum areas were also known as 'piggeries', because of the proclivity of some of the inhabitants to keep pigs in overcrowded neighbourhoods. After the 1890 Housing Act the London County Council began to clear slum areas in the East End and Deptford. The most extensive slum clearance scheme was in Bethnal Green, where 'Old Nichol', a maze of narrow streets, was replaced by the Boundary Street Estate, which was completed in 1900. This estate was distinguished by wide streets and blocks of flats, focused on a central garden, Arnold Circus. The widening of thoroughfares at this time, such as Creek Road, Deptford (1896), Tower Bridge Road after the completion of Tower Bridge (1902), and Aldwych Crescent and Kingsway (1898 onwards), also resulted in the clearance of large areas of slum dwellings.

The casual labour of the old East End was trapped within an economy of declining trades. Conditions of employment deteriorated. Most London industries were subject to pressure because of scarce and expensive land, rising rents and fuel costs and, in the case of shipbuilding and heavy engineering, distance from raw materials as well. By the early 1870s, Thames shipbuilding and ancillary trades had slumped beyond the point of recovery, and thenceforward were occupied mostly by repair work. By the 1880s, most of London's heavy engineering, iron founding and metal work had gone the same way, reduced to a repair basis or to supplying sundries to the building trade. Civic improvements and the transition of the City into a largely non-residential district had shunted thousands into adjacent working-class parishes and engendered a spiral of rising rents and increasing overcrowding. The housing problem deepened between 1860 and 1890, since most of the cleared and dispossessed could not contemplate a suburban alternative. There was insufficient cheap, plentiful or convenient transport to, from or within the suburbs; and there were insufficient opportunities for employment.

More recent analysis of Booth's data suggests that conditions in the East End at least were already improving at the turn of the century. The creation of the LCC saw the first attempts at dealing with the problem of inner-city overcrowding. Two years later (1890), the Housing of the Working Classes Act gave municipal authorities the opportunity of clearing their slums. The

Act gave local authorities the power to acquire land compulsorily for additional housing, and after 1900 this right even extended beyond the boundaries of the local areas governed by those authorities. About twenty London authorities adopted the Act, but the most extensive use was that by the LCC at Tooting and Norbury. Between 1903 and 1911, the Totterdown cottage estate at Tooting was built, with 1299 houses and four shops. The estate was popular, with a good tram service, and a population of about 4500 after the First World War. The first LCC 'out-county' estate was built at Norbury, south of Streatham and outside the LCC boundaries, between 1906 and 1910. This cottage estate was built on a hilly thirty-acre site, with a grid of roads and twenty-nine houses to the acre. A small group of shops was provided, but, as was common in such developments, no pub was allowed. Work continued on the estate after the First World War; the later sections were more picturesque with more provision of open space, reflecting the influence of Parker and Unwin's Hampstead Garden Suburb.

During the last two decades of the nineteenth century, the area of outer London almost doubled. In 1905 Henrietta Barnett, the inspiration behind Hampstead Garden Suburb, wrote: 'Every year London grows, stretching out into the country long and generally unlovely arms'. Such growth was characterized as a 'beast' or an 'octopus' by later writers as development tended to follow the main transport arteries away from the city centres.

'The expansion of London during the Nineteenth Century is a fact unparalleled in the history of cities', wrote Sir Walter Besant in 1899:

> I have before me a map of the year 1834 ... showing South London as it was. I see a small town or collection of small towns, occupying the district called the Borough Proper, Lambeth, Newington, Walworth, and Bermondsey. In some parts this area is densely populated, filled with narrow courts and lanes; in other parts there are broad fields, open spaces, unoccupied pieces of ground. At the back of Vauxhall Gardens, for instance, there are open fields; in Walworth there is a certain place, then notorious for the people who lived there, called Snow's Fields; in Bermondsey there are also open spaces ... without any buildings. Battersea is a mere stretch of open country.[6]

The spread of housing in London, as elsewhere, was associated closely with developments in transport, which enabled large numbers of people to commute to work in the centre. To begin with, the regular railways, built to connect the capital to other parts of the kingdom, played little role in these developments. By 1870, however, new local stations and new suburban lines had been built around the city; lines were also completed southwards across the River Thames. The Underground railway network began operating in 1863, from Paddington to the City, and horse-drawn trams were developed, away from the City and in the West End, after 1871.

Towards the end of the century, the pace of suburbanization increased

dramatically. Cheap transport and rising wages allowed many more workers to move further away from their work. The Cheap Trains Act of 1883 obliged railway companies to charge lower fares on their suburban lines, allowing the suburbs to stretch out as far as Tottenham, Leyton and Walthamstow. In about 1906, the Liberal reformer Charles Masterman wrote:

> [When I first went to live in Camberwell in 1900] our sole communication with London ... was a few erratic horse omnibuses and lines of slow-moving, two-horse trams ... [Now] we have fast lines or electric trams, brilliantly lighted, in which reading is a pleasure, hurrying us down from over the bridges at half the time expended under the old conditions ... Family after family are evacuating the blocks and crowded tenements for little four-roomed cottages, with little gardens, at Hither Green or Tooting.[7]

An early example of this process was seen in the impact of the District Railway's western extension, which provided a direct service to Westminster and the City from 1877. The construction of this line prompted the development of Bedford Park, a new middle-class suburban housing estate adjacent to Turnham Green Station, and helped turn the village of Hammersmith into a 'suburb for City clerks'. John Betjeman described Bedford Park, with its Arts and Crafts buildings, as 'the most significant suburb built in the last century, probably in the western world'.

The suburban villa was becoming home for many ordinary Londoners. 'There is a great flood ... which has overtaken London and our great cities with houses and dwellings for the middle and working classes', *Building News* observed in 1900:

> Go where we will – north, south, east, or west of this huge overgrown Metropolis – the fungus-like growth of houses manifests itself, stretching from town to suburb and village – as from the southern suburbs to Herne Hill and Dulwich, and from Streatham to Croydon. In every direction we see the same outward growth of dwelling-houses of a small and unpretending class – generally a repetition of a type of house that has been found to meet the requirements of the middle class and artisan. The larger and more commodious residence of fifty years ago is being pulled down, or swamped by this tide of small houses: where one large house existed, ten or a hundred or more have been built, absorbing the acres of gardens and private park lands. This is one of the social revolutions of the age ...

As the grounds of private estates were covered with new developments, the semi-rural quality of many suburbs disappeared. 'Only a few years ago it was possible to distinguish the invasions of the speculator-builder by the number of private estates which were dotted over the landscape', *Building News* recalled in 1896:

> Between them were acres of woodland or meadow or old residences of a past

generation with their acres of land. But this partial invasion of the landscape may no longer be seen; the building estates have coalesced or joined, and what before was a varied mixture of old and new have now become a mass of dwellings. Even the hilly slopes of the 'Northern Heights' and the hills stretching from Brixton to the Sydenham ridge are more or less covered . . .

'Where, when, how will the continual growth, frightening in its speed, of London . . . come to an end?' asked a French visitor in the 1880s:

One cannot take five hundred steps in one of the innumerable suburbs . . . which daily attach themselves more firmly to the centre until they lose themselves intimately and entirely in it, without coming upon a field that one had seen three months before, quiet, grassy, populated with sheep or cows, but whose appearance has in so little time altered completely. Turned over from top to bottom, cut into deep trenches, covered with heaps of mud, piles of bricks, stacks of timbers, in the midst of which are working bustling navvies and people loading or unloading the tip carts, you see quickly rise there – the works stop only on Sundays – not a single isolated house, but the beginning of a new street. This changed scene, which seems magical by the brief time that it requires – the English dwelling . . . is built in a few days. If you return in a few months, you will find the street finished, with pavements on each side, lit by gas . . . And don't be thinking that the houses . . . remain long empty; most of them are rented, *occupied*, before they have been completed, while the carpenters, plasterers, roofers, and painters are still working on them, well before the plaster inside the rooms is dry and the walls papered.

The physical operations involved in the creation of each new suburban development were everywhere much the same. 'A stranger walking a few miles around London would see sights that would surprise him', 'a Kensaltonian' informed the *Builder* in 1880:

Here . . . are carts and wagons laden with building materials, endeavouring to gain access to a field; the wheels are sunk axle deep in the mire, wagoners smacking their whips and beating their horses unmercifully, but all to no purpose; the destined place for unloading is, by mud and mire, rendered inaccessible. Building operations have commenced in this field. As the stranger approaches, he sees a mass of brickwork on either side of an impassable road, that is destined to be called a street at some future day; the walls of the houses, though newly built, look very shaky . . .

There was a uniformity in the design of the new estates which, even after a century, is still obvious. House design was largely in the hands of the builders, who built houses – even detached ones – more or less uniformly in

rows. 'People tenant these houses because they cannot pick and choose, and the speculative builder is content to reproduce them', complained *Building News* in 1893. External style was no better than internal design:

> It is either a sort of builder's nondescript style, in which a carver and a tesse-lated tile manufacturer are permanently engaged on the job; or a travesty of 'Queen Anne', or 'modern' Renaissance, or Gothic ... Monotonous repetition of features ... is one of the saddest things in this fearful spreading of tenements and middle-class dwellings. Ugly corners, where there is a turn in the road, and hideous roofs and chimneys and gables fill us with dismay as we tread such neighbourhoods as Putney, or Richmond, or Wimbledon, or Brixton ...

The choice that such a situation ostensibly gave the prospective buyer was, many argued, illusory, as in fact all houses produced by the speculative builder were essentially the same. Suburban houses 'are planned generally, without the slightest regard to the different requirements of tenants; they are cast in the same mould and stereotyped in feature', asserted *Building News* in 1883. 'Every suburb of the metropolis is overrun with these ready-made houses. The needy tenant has no choice – he is obliged to take the stereotyped dwelling ...'

'It is amazing, certainly, amid the diversity that exists, how few houses are to be found in the suburbs that really satisfy the householder', the same journal had observed six years earlier:

> The builder of a row of houses or a colony of detached villas selects what he considers a tenantable model, and builds them wholesale ... His doorways are placed in set positions that experience has approved, and his offices are planned after all the conventional ideas of tenants have been consulted. He often gets

Trams dominated the roads of Leyton up to the First World War.

his elevations drawn for him to suit his own whims, or they are allowed to follow his notions, and to conform to his idea of cheap construction and ornamentation.

The standardized design seemed to please prospective buyers, however, possibly because 'all the conventional ideas of tenants' really were incorporated into the plans:

> Though pretentious and vulgar they let well in spite of their architectural defects. At Finsbury Park, Holloway, Dalston, Chalk Farm, Hampstead, Kilburn, on the north; Norwood, Streatham, and Brixton, on the south; and Kensington, Hammersmith, and Battersea, on the west, we meet with houses and villas of this class by the hundred ...

The cheapest form of public transport was the horse-drawn LCC tram, and this, like the railway, enabled many working-class families to move to the suburbs. By about 1900 horse-drawn trams operated along most radial routes, as well as providing lateral connections. Working within a six-mile radius of Central London, they were cheaper and more convenient than the buses. By 1906 the London United Tramways Company was also operating an electric tram service to Kingston upon Thames and Surbiton, and the line was extended to Merton in 1907. Elsewhere, as at Erith, Dartford, Bromley and Croydon, local councils also operated trams, and an efficient LCC system had spread out from the initial line between Westminster Bridge and Tooting by 1915. The electric tramcar became known as the 'gondola of the people', used for weekend trips to parks, countryside and football matches, as well as for journeys to work. Neither horse-drawn nor electric trams were allowed in the City or West End; and the only connection between north and south London systems was through the Kingsway Tunnel, opened in 1908.

South London continued to spread between 1880 and 1914. There was intense building activity on the eastern side of Wimbledon; at Raynes Park; between Balham and Tooting along the tramway and thence to Streatham; and along the railway at Wallington, Carshalton, Sutton and Cheam, Coulsdon and Purley. The highest increase within the whole of London between 1901 and 1911 (156 per cent) was at Merton and Morden, where the old mills on the River Wandle (where William Morris and Liberty's established workshops in the 1880s) were now swamped by housing, while the population of New Malden and Mitcham almost doubled.

By 1902 industrial centralization was slackening, and many employers wanted to move their operations out beyond the jurisdiction of the LCC and London rates. The lower Thames-side area began to attract engineering, oil mills and armaments factories (at Erith); gasworks and power stations grew up at Greenwich; and the Arsenal and associated military manufacturing were

located at Woolwich. New housing to cater for these workers was built at Croydon and at Bexleyheath, on the enclosed common to the north of Bexley village. In 1903 a local authority tramway opened between Bexleyheath and Woolwich, allowing workers to reach Erith and Woolwich Arsenal early in the morning. Bexleyheath thus became a dormitory area for Thames-side workers, contrasting with the London-orientated middle-class suburb around Bexley village.

By 1914 the motor bus had effectively taken over from the tram as far afield as South Croydon. The railways responded by concentrating on middle-class commuter traffic in a zone between twelve and thirty miles around London, and by electrifying suburban lines where feasible. The LBSCR South London line was electrified in 1909, as were a number of others by 1912, the impact of these improvements being enormous. In the period before 1914 a complex pattern of independent villages, semi-dormitory enclaves and suburbia had developed well to the south of the Thames. By the 1930s it was generally appreciated that the improvement in transport facilities had brought about far-reaching changes in the life of the whole community in London. Transport influenced almost every Londoner, both in his work and in his play. It extended the urbanized area, increased the mobility of labour, offered a partial solution of the problems of housing and overcrowding, assisted in standardizing wages and prices, and increased opportunities for culture, recreation, amusement, and even crime. Journeys on public transport in Greater London numbered 935 million, or 142 per person, in 1901. They nearly doubled to 1813 million, or 250 per person, in 1911. By 1921, when the public transport system was largely in place, they had risen to 2689 million, which coincidentally represented 364 per person a year.

Ease of moving around inner London helped some move out altogether. Inner London reached its greatest-ever population in 1901 – 4.54 million. It fell away slightly, probably the first decline since the 1660s, to 4.52 million by 1911. But this small drop disguised enormous migration out of inner London. Once the natural increase of births over deaths is taken out of the figures, it is clear that inner London experienced a net loss of over 550,000 people (12 per cent) through migration between 1901 and 1911. For the next seventy years and more, the population of inner London fell steadily and reached a low (in the mid 1980s) of just over half the 1901 figure.

The volume of emigration from Edwardian inner London had no precedent. Of course, London's outer suburbs had attracted people from the centre for some generations. A trend among the rich to leave the West End for villages like Barnet or Blackheath was already well established by 1870. This was a fashion which had spread to the middle classes, and even to workers, by the end of the nineteenth century. Within inner London, the out-migration of middle-class households freed up some single-family houses for multiple occupation by working-class families renting a single floor or

even a single room. 'We find today [1905] thousands of empty houses in almost every borough; there is a steady exodus of the middle classes, the mainstay of a neighbourhood ... In fact, London is in a state of progressive dissolution', observed one contemporary chronicler. Similarly the demolition of houses in the oldest districts of London to make way for commerce squeezed manual workers out of their old domain close to the City.

In the Edwardian period, the first of the tube railways to reach the fringes of London had a similar effect. At the end of the nineteenth century, Golders Green was a small hamlet in a rural location. Even in 1906 there were only a few middle-class houses in the hamlet. It was, however, an important cross-roads between Hampstead, Hendon and Cricklewood. Moreover, gas lighting had been erected along the Finchley Road, and the Underground Electric Railways Company had obtained a site for a station at Golders Green. Earlier attempts to build a station there in the late nineteenth century had failed for financial reasons. Between 1900 and 1906, however, an American syndicate financed and built a tram link between Charing Cross and Golders Green, serving the Hendon and Finchley populations. The Hampstead tube opened in 1907 between Charing Cross and Golders Green, then on into open country. Within five years a completely new suburb had grown up around the station. Golders Green demonstrated that rapid development followed the introduction of the railway into a suburban area.

Between 1904 and 1906 the area was drained, roads were lit, and the ground prepared for housing development. As a result, land prices escalated. The first houses were built in 1905, and the pace of building increased rapidly after 1908. By the end of 1910, ten miles of new sewers and five miles of new roads had been laid. There was no overall plan at Golders Green, and there was no local authority control, apart from the imposition of standards relating to road widths and the provision of utilities. The street layout reflected the pattern of previous landownership. Houses were packed into small groups as the plots of land were sold off and there was little regard by the developers for the provision of open space. The Golders Green houses were described as 'half-timbered, tiled and gabled, and cottagey in appearance', and they set the trend in suburban houses for the next thirty years. Although the gardens were quite small, due to the cost of land, the houses were relatively expensive and attracted a mostly middle-class clientele. Transport facilities in and around London continued to improve. In 1907, an Underground train stopped at Golders Green every twelve minutes, by 1908 every ten minutes, and by 1910 every three minutes at peak times. Golders Green helped the development of Hampstead Garden Suburb and, by the 1920s, it was the fifth-busiest Underground station in London, with over a million passengers every month. In addition, electric trams operated here from 1909, and a motor-bus station was opened in 1913.

Though London was the target of the first Zeppelin raids during the First

World War, damage to the city's fabric was minimal by comparison with that caused by the Blitz in the Second World War. The war's main effects on London derived from its galvanizing impact upon the capital's economy. London's industry quickly turned to supplying needs created by the war: many traditional industries – tailoring, bootmaking, leather working – needed little adaptation to military needs, while the small scale and habitual flexibility of London industry enabled others to adapt quickly. For example, an umbrella factory was rapidly adapted to produce gun components. London also benefited enormously from direct government investment in new war-related industries. The areas around Woolwich Arsenal in the south east and the Hayes–Willesden–Wembley belt in the west both grew rapidly, the latter forming the basis of the west London industrial belt, which was to become the greatest concentration of manufacturing industry in southern England between the wars.

Between the Wars

The redevelopment of the City quickly regained its prewar impetus after 1919, and in the 1920s it was led by the banks. The Midland and the National Provincial headquarters competed with each other for pride of place in Poultry; the rebuilt Bank of England (from 1921) was an attempt to surpass the new Lloyds Bank and London City and Westminster. Ironically, all these major new buildings were ready just in time to support the financiers as the Great Depression began to bite. The banks were joined by a host of company headquarters. Insurance companies were prominent and were joined by industrial giants like Unilever, Spiller and the great newspaper proprietors. By the late 1920s some parts of London, especially around Finsbury Circus, had been so entirely remodelled that they were called 'the "New City"'. It was in Fleet Street that 'metropolitan modernism' was first seen in London, with Sir Owen Williams's black glass *Daily Express* building (1930–33). But there were to be few imitators until well after the end of the Second World War.

The most ambitious redevelopment scheme between the wars took place in the very heart of London – the West End. The new Regent Street was to George V's reign what Kingsway had been to his father's. Sir Reginald Blomfield's designs for the street's new frontages were approved only after the Cabinet itself, in the second year of a world war, had found time to consider and reject an earlier scheme as too costly and unsympathetic to trade: the shopkeepers of Regent Street had been vociferous and influential in their opposition. Building eventually began in 1921. From then until 1927, when the King and Queen marked the new street's 'opening' with a drive through, Regent Street 'resembled the devastated regions of France and Belgium' or 'the aftermath of some disastrous fire or earthquake.' Little thought was given to protect John Nash's Regency façades, even though they were the

greatest town planning scheme attempted in London between the Great Fire and the 1860s. The rebuilding at the south end of the Quadrant turned Piccadilly Circus into a square: there was even a plan to rename it King Edward VII Square and replace the statue of Eros with an equestrian statue of the old King.

Redevelopment spread outwards from Regent Street through every part of the West End. There was clearance and rebuilding for offices and restaurants in Piccadilly Circus, for hotels in Bloomsbury, for cinemas around Leicester Square and Haymarket, and for 'probably the largest restaurant in the world', seating 4500 diners, at the extended Lyons Corner House in Coventry Street (1923). Much of Piccadilly was rebuilt from 1921, significantly for the age, with glamorous motor car showrooms a prominent new feature. Oxford Street's shopping area was extended west of Selfridges to Marble Arch. As Park Lane acquired what Clunn celebrated as 'a typical American appearance' in the 1920s, the aristocratic Regency town 'houses' around it succumbed to the developer. Just as the squeeze was on the great landowners in their country estates, so too it was in their town houses, and if it was a choice between keeping town or country houses, then it was the London houses that had to go. In fact, by the end of the First World War, during which many of their houses had been used as hospitals or convalescent homes, most of the grandees had come to accept that the time had arrived to sell up or settle for less extensive accommodation. Around 1906 the Duke of Cambridge's mansion on the corner of Park Lane and Piccadilly made way for luxury flats and a car showroom. Devonshire House was demolished in 1925, Grosvenor House in 1927, the Holbein family's Dorchester House in 1929 (to make way for the Dorchester Hotel), Lord Tweedmouth's Brook House in 1933, Chesterfield House in 1935, and Lansdowne House, in recognizable form, in 1937.

Flats invaded Mayfair, taking down hundreds of eighteenth-century houses in the process, and new offices transformed Berkeley Square, Bruton Street and other locations into commercial areas. Further north, the Marylebone and Euston Roads were largely lined with new office buildings between 1921 and 1939. Offices spread, too, along the north bank of the river. Most striking were the gigantic Adelaide House (1921–25) at London Bridge and Shell-Mex House (1931) on the Victoria Embankment. The latter required the demolition of the Hotel Cecil, which had been one of the grandest hotels in Europe in 1900; it was just thirty-four years old when it was pulled down.

The four decades after 1900 saw the greatest amount of rebuilding all over the metropolis that had taken place within so short a period of time since the Great Fire of London. In these years, the inner London cityscape was remade in a new commercial image, and little attempt was made to preserve existing historic buildings. 'London cares nothing about its past', remarked H. J. Massingham in 1933.[8] Even so, the first stirrings of conscience were detectable. Nineteen City churches, by Wren, Hawksmoor, Inigo Jones and

others, were destined for clearance in 1920 to make way for offices, but a campaign saved almost all of them. From 1900 the LCC had begun to buy up the gardens of squares in the East End to stop them being built on for factories, and in 1904 the picturesque Edwardes Square garden, just south of Kensington High Street, was put up for sale for residential development. The local outcry grew to London-wide proportions, and the LCC sought parliamentary powers to safeguard all metropolitan squares as open spaces. This failed, but Edwardes Square was eventually saved through legal action by the leaseholders. Following this confrontation, in 1906 the gardens of sixty-four London squares were protected by an Act of Parliament, in which freeholders agreed to waive their development rights in perpetuity. After the First World War developers renewed their assault on the London squares, but this time with more success. In the late 1920s the open space in Endsleigh Gardens on the Euston Road was built over for Friends' House, and Mornington Crescent made way for the giant Carreras cigarette factory. In 1928 agitation by the London Society and the LCC led to a Royal Commission on London Squares, which recommended almost universal protection of London's 461 surviving squares and other enclosures. This was eventually confirmed by law in 1931.

In these same years London grew upwards, normally by two storeys. Four-storey Georgian or Regency buildings were replaced by structures at least six storeys high in modern office blocks, hotels or department stores. Yet even the tallest buildings in London at the end of the 1930s still had to keep their street fronts at no more than eighty feet, although a further two floors were allowed in the roof as long as this was raked back from the façade. No floors could be occupied more than a hundred feet from the ground. Some – notably Senate House in Malet Street, headquarters of London University (1932–37) – exploited the provision in the London Building Acts that allowed unoccupied towers to exceed the hundred-foot limit. Charles Holden's 210-foot tower became the tallest secular building in London erected during the first half of the century. Still 150 feet short of the dome of St Paul's, it was called 'the dummy skyscraper' when first built.

These grand schemes were merely the tip of the development iceberg. Building to support commerce continued to consume run-down residential areas near the City. There were riots in the Brick Lane area when 135 people were evicted to make way for a cinema in 1919, and other protests that same year when a hundred Marylebone families were displaced for a new factory. The expansion of Spitalfields Market in the 1920s destroyed the Dorset Street area; the enlargement of Waterloo Station to become the biggest railway terminus in Europe destroyed eight north Lambeth streets in the process; warehousing had 'almost' cleared the Italian settlement from the whole of Holborn by 1934; south Hackney was increasingly depopulated by the expansion of industry north from Shoreditch and Bethnal Green; and Finsbury was taken over by warehousing from the City. These developments

were merely the leading edges of an accelerating process that was changing living space into work space all across inner London.

Such developments in central London did alleviate the slum problem to some extent. With data gathered mainly about 1930, *The New Survey of London Life and Labour* was published in 1934. It was a sequel to Charles Booth's great survey carried out at the turn of the century.[9] It cites a marked improvement in the situation of the poor. As a result of emigration from the County of London and slum clearance, and with the national shift in income distribution from rich to poor, thirty years had brought about a large drop in the proportion of Londoners living in poverty. The reduction was especially large in Hampstead, Kensington and Westminster. On the wealthy, *The New Survey* is much less informative that its predecessor, but it is clear that Fulham and Hammersmith had continued in decline, while Chelsea was on a rather tentative upward path.

In 1938 Cicely Hamilton described the northern suburbs flung out in layer after layer, ring after ring:

> Journeying from the centre to the outer rim of London, one perceives the various strata of suburban growth. Brick of a dirty-grey colour, which begins in the inner regions, near King's Cross, denotes mid Victorian expansion; then farther on, comes the ugly red of the late Victorian builder; while here and there, as you draw towards the rim, there will be a little house of older date which, sandwiched into a terrace of yesterday, survives from that vanished countryside of Middlesex in which its foundations were laid. The last and newest layer of London is the layer of suburban flats.[10]

The demolition of older housing was accompanied by council-housing building programmes. The LCC pulled down the homes of over 127,000 people in inner London in the 1920s and 1930s, and the Metropolitan Borough Councils demolished the homes of a further 55,000. In twenty years, a population as big as Bolton's was displaced, and not many returned to occupy the new flats that had replaced their old neighbourhoods. All this rebuilding pushed people out of central London. This push combined with a pull from the suburbs to produce a flood tide away from Victorian London, especially during the 1930s. From 1921 to 1939, inner London's population declined by 471,000, a net loss of 11 per cent. Such displacement, coupled with voluntary migration for other reasons, resulted in a total population loss of 650,000. Over 80 per cent of this reduction took place in the years between 1931 and 1939. Once again, it was the central areas which were losing the largest share of their people during the 1930s. But apart from Woolwich and Lewisham, where there were still green fields for suburban building, and Hampstead, where middle-class flats were being developed on the sites of old mansions or fashioned from large houses, all boroughs lost population.

The building of the Edgware Underground station in a rural setting in the 1920s.

The characteristic features of late nineteenth-century growth continued in London up to the Second World War. Between 1914 and 1939, the population of London increased by 33 per cent to over six million people, while in London's built-up area it increased threefold. This growth changed the shape of the city from being predominantly radial, reflecting growth along railway routes, to circular. In 1921 Edgware was still a small village in rural Middlesex, but as soon as the Hampstead tube was extended northwards from Golders Green in 1923–24 speculators began buying up land for houses and shops. By the late 1930s the population had increased tenfold. Hendon's population rose by over 90,000 between 1921 and 1939. Similar new streets of semi-detached houses followed the extension of the same tube line south to Morden in 1926 and the projection of the Piccadilly Line north of Finsbury Park to Cockfosters in 1932–33.

By the Second World War, London's built-up area could be encompassed only by a circle thirty-four miles across, from Cheshunt in the north to Banstead in the south, and from Uxbridge in the west to Dartford in the east. Outside this circle, substantial urban islands were linked by 'causeways' to the central mass in all directions. That mass had, by means of 'an unbridled rush of building ... in the form of a scamper over the home counties', filled in the spaces between Edwardian London and the swelling dormitory villages and towns around it. From the end of the First World War to the outbreak of the Second, around 860,000 houses were built in Greater London. In the peak year of 1934 some 1500 suburban houses were being run up every week

Edgware by the
1980s.

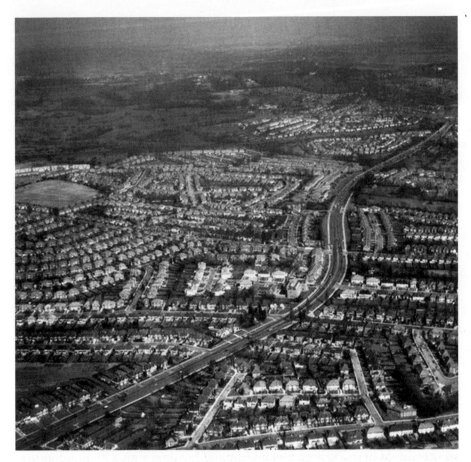

in the capital. In *Coming up for Air* (1939), George Orwell places his hero, George Bowling, in Ellesmere Road, in a west London suburb. There are fifty others like it, says Bowling, always with the same long rows of semi-detached houses, with stucco front, creosoted gate, privet hedge and green front door.

This was a land rush on a scale not seen in Britain before or since. The last remaining farms were sold and cut up for building; country house estates surrendered to the forces of brick and concrete; fields between the ribbon developments along the roads leading into London were covered over. Villages were absorbed, leaving original buildings and street patterns swamped by the suburban flood; and old towns became new London districts, with their main shopping streets redesigned to look much like one another. The roads and crescents and avenues were filled with the semi-detached houses that make the interwar suburban style so immediately recognizable: every house marked out from the one next door by tiny distinctions in its gate or gable or glazing. Mock-Tudor, black-and-white half-timbering, clay-tiled roofs, stained glass in doors and fanlights, and bay windows provided a considerable change from the stolid domestic architecture that had gone before it.

Eight new cottage estates were built by the LCC between 1919 and 1938, while three pre-1914 developments were completed (including Norbury) and seven more were started. The St Helier's Estate, astride the 1926 Sutton bypass, contained about 40,000 people by the end of the 1930s; and at Downham, Whitefoot Lane and Mottingham there was a combined population exceeding 30,000. The latter development was to the south of Catford, where the Bellingham Estate had been started in 1920, with over 2000 houses and flats built within three years. To the west was the Castelnau Estate, with over 600 houses in the late 1920s; and the larger Dover House (Roehampton) development had over 5000 people by 1938. Largest of all was the Becontree Estate, just twelve miles to the east of Charing Cross. It was planned to house more than 100,000 people. The magnitude of this local authority rehousing is even more pronounced when one remembers that many other London authorities were also active. Between 1919 and 1939, possibly as many as 250,000 people came to live in council property south of the Thames.

The growth of private speculative building was enormously significant in Kent and Surrey. Middle-class families escaping the worst of the Depression thrived in an economy partly dependent on London and partly growing as a result of its own consumer-durables, distributive, service and administrative jobs. From 1932 the building societies became more active in permitting the growth of owner-occupation, and demand soared. By 1933 private firms had finished over 618,000 houses in the Greater London area, compared with 1918's local authority total of 153,000. Up to two-and-a-half million people were involved in this private building around London, with a high proportion south of the Thames.

The major interwar growth areas south of the Thames were Merton and Morden Urban District, where the 1921 population of 17,532 grew to 68,980 by mid 1938, and Carshalton, which grew from 13,873 to 59,510. On the claylands between Sutton and Kingston there was a great concentration of cheaper housing (under £1000); there were more expensive properties further out, around Epsom, Croydon, Effingham and on the heaths south of Esher and Weybridge. Bexley was transformed from a Thames-side dormitory into a 'metropolitan suburb' by the mid 1930s: its 1921 population of 21,104 grew to 77,020 by 1938. Chislehurst, Orpington and Sidcup saw similar levels of growth.

The resultant landscape of outer London became formless, and extensive suburbias grew piecemeal as whole areas were submerged beneath red-tiled roofs, mock-Tudor elevations, and red-brick or pebble-dash walls. The focal points were new shopping parades with flats above. Bypasses attracted their own speculative housing, petrol stations, mock-Tudor pubs and factories; while middle-class dormitories infilled between the pre-1914 nuclei. Such 'ribbon development' came eventually to be seen as a great eyesore, but by

the time that the 1935 Ribbon Development Act was passed, much of the damage was done.

Surprisingly, perhaps, London's unprecedented spatial expansion was not matched by a comparable overall growth in its population. Building densities in the suburbs were low, and population growth in the years between 1921 and 1939, at 16.6 per cent, was not much above the Edwardian low point (13.7 per cent between 1901 and 1921). Even so, London's growth rate in the 1920s and 1930s was double that of the rest of the country. And London was now so huge that the numbers involved were enormous. Greater London's net population growth in eighteen years was 1,228,000, one-third the growth of the population of Great Britain as a whole. The outer ring housed 810,000 more people in 1931 than it had done in 1921; that was comparable to adding the population of Manchester in a decade. Almost 900,000 more people were added in the next eight years, nearly as many as if the whole population of Birmingham, Britain's second city, had migrated to the capital. In 1939 more than one in five people in England and Wales was a Londoner. Also in that year London reached its historic maximum population of 8,615,000, a figure that is unlikely ever to be reached again.

By far the most dramatic growth in terms of numbers of people took place, however, north of the Thames in Middlesex, west of the Great North Road. In west and north-west London the population grew by 800,000 between 1921 and 1939. These years represented a decisive shift westwards in London's economic centre of gravity. Many areas shared in this expansion, but the largest effects were seen in the 1920s in Wembley (200 per cent increase, to 48,000), Kingsbury immediately adjacent (800 per cent, to around 17,000), and Hayes, Harlington and Harrow, which all showed rises of over 150 per cent. Nor did the flood abate in the 1930s, when Harrow again doubled in size to reach 190,000 (as big as Salford), when Ruislip trebled to reach nearly 50,000, and when Wembley and Kingsbury absorbed another 56,000 between them. These were the suburbs of Metroland, each with its station on the Metropolitan Railway line out of Baker Street, each with its estate agent's selling point – of 'residences' rather than houses, of golf clubs, 'breezy heights', 'amiable undulations' and beech woods of 'tremulous loveliness'.

The siting of chain stores, such as Woolworths, became the best indicator of the status of local shopping centres. But it was the cinema which was to have the greatest impact on the lives of ordinary Londoners. Picture palaces, lavishly decorated and hugely popular, were sited away from the traditional theatrical heartland of the West End, their locations mirroring the new prominence of suburbia. By 1929 there were 266 cinemas in the LCC area alone.

It was between the wars that London came to subjugate the whole of the south east of England: 'Travelling by road to-day [1934] you must travel at

least thirty miles before you have shaken off the fact and rumour of London.'
The outskirts of London began to epitomize both the twentieth century and
the 'New England' described by J. B. Priestley:

> This is the England of arterial and bypass roads, of filling stations and factories
> that look like exhibition buildings, of giant cinemas and dance-halls and cafés,
> bungalows with tiny garages, cocktail bars, Woolworths, motor coaches,
> wireless, hiking, factory girls looking like actresses, greyhound racing and dirt
> tracks, swimming pools, and everything given away for cigarette coupons. If
> the fog had lifted I knew that I should have seen this England all round me
> at that northern entrance to London, where the smooth wide road passes
> between miles of semi-detached bungalows, all with their little garages, their
> wireless sets, their periodicals about film stars, their swimming costumes and
> tennis rackets and dancing shoes.[11]

The government became increasingly alarmed by the dangers of an ever-
expanding London. In 1936 there was an Act of Parliament to tighten up the
rules on ribbon development, and the Green Belt Act of 1938 began the
creation of a Green Belt around London – a girdle to constrain suburban
outflow and to create a barrier between town and country. Not everyone was
enthusiastic: the Council for the Protection of Rural England, for instance,
was opposed, afraid that developers would leapfrog the belt and put more
countryside at risk than would be rescued. This was indeed to happen, but
the Green Belt did break up the sea of urban sprawl.

After the First World War, many of the small industrial enterprises that had
been based in central London moved out under the pressure of redevelopment.
London, unlike much of the rest of Britain, did not suffer badly during the
Depression; indeed, industrial growth continued throughout the 1920s and
1930s. In comparative terms, even these developments were based upon small
units of production, but the new industries had much greater space than
producers in the centre. The west London industrial area and the Lea Valley
in the north, initially developed by the furniture industry seeking to escape the
pressures of the East End, soon attracted large employers in the new industries
of the interwar years. With the completion of the national electricity grid in
the 1920s, industrial location became less restricted by energy supply and
more concerned with proximity to the consumer. The motor industry, with
the exception of Ford's Dagenham plant, was attracted to the west London
industrial estates, not only because they had once housed factories for tanks
and aeroplanes, but also because they offered easy access to the car showrooms
located in the heart of the West End. In the 1930s, American manufacturers
came to west London to work within Britain's imperial tariff protection: the
Hoover Building on the A40 survives as the most elegant memorial to this
phase of London's industrial evolution. Such developments promised to turn
London, for the first time, into a factory town.

Greater London, an area of something like thirty miles across, was in a category of its own. Its share of new factories emphasizes how exceptional it was: between 1932 and 1937, of the net increase of 644 factories in Britain, no fewer than 532 were in the Greater London area. In the interwar period Greater London accounted for one-third of the total expansion of built-up land in England and Wales, with most of its industry located to the west and north west. Most industrial workers, on the other hand, lived to the east and south east. As a result, huge crowds daily moved from home to workplace, with this movement usually concentrated within short periods in the morning and evening. Ironically, decentralization of industry and of homes for industrial workers actually led to more congestion, not less, and the pressure was the more severe since office workers as well now had further to travel. Unlike industries, however, banks, insurance companies, stock brokerages and other financial services were concentrated in the centre, in the City of London. While the largest share of the south-east region's population growth was absorbed by London, population in the region as a whole grew by a fifth between the wars. The main urban beneficiaries were London's 'satellite' towns. These were industrial centres in their own right in the cases of Slough, Luton and Watford; and commuter towns for 'City men' in the cases of Guildford and Woking.

There had already been considerable progress in the improvement of rail and road services since the First World War as the organizational strands of transport in the capital were brought together to create London Transport. There were particularly strong pressures to provide or improve local railway services to the newly developing suburban areas. Southern Railway's huge electrification programme, covering almost all the overground suburban lines south of the Thames, was complete by 1930. Only one tube line ran south of the river, the City & South London, until 1926 when it was extended to Morden, where the terminus was located half a mile to the north of the old Surrey village and a bus interchange allowed the Underground to penetrate further into Southern Electric territory.

North of the river, the LMS electrified some of its overground suburban services, and the LNER met traffic demand by operating more suburban steam trains. The Metropolitan and the Underground led the way with new developments. The Met extended its electric services out to Rickmansworth and opened new branches to Watford (1926) and Stanmore (1932). As suburban Metroland grew, there was an enormous rise in demand for season tickets. To take just one example, monthly season ticket sales at Wembley Park rose from 3000 to just over 13,500 between 1923 and 1928.

The Hampstead tube was extended overground from Golders Green to Edgware in 1923–24, stimulating yet more suburban growth around the new stations. At the same time, the old City & South London Line was enlarged and linked to the Hampstead Line at Camden Town, creating what is now the Northern Line. By 1933 the Piccadilly Line had also been extended at

both ends, to reach Uxbridge and Hounslow in the west and Cockfosters in the north. In central London, some of the busier interchange tube stations were rebuilt, the most impressive being the one at Piccadilly Circus, which reopened in 1928 with banks of escalators instead of lifts and an elegant circular booking hall below the famous road junction. This modern underground transport hub at the very heart of the city was much admired by visitors to London from overseas and inspired metro development elsewhere, most notably in Moscow.

After 1911 the number of motor buses increased dramatically, but when war broke out many London buses were requisitioned for moving troops in France. There was therefore a shortage of vehicles at the end of the war, but in 1919 a new model (K Type) was introduced; this seated more passengers than earlier models and marked the end of the horse-bus design. Significant numbers of motor buses, however, did not return to the London streets until 1922. In the following year the new NS Type bus was introduced. This was a

low-loading vehicle which, over the next seven years, acquired a covered roof, pneumatic tyres and an enclosed driver's cab, and could be described as the first modern bus. 1923 was also the year when buses for the first time carried more passengers than trams.

An advertisement for the Underground, offering rural delights early in the twentieth century.

Despite a national decline in tram services from the mid 1920s, at first London's trams managed to survive. From 1931 some routes were equipped with modern 'Feltham' trams, streamlined machines with sliding doors which proved very popular and attracted back many passengers. The tramlines and many of the trams dated from before 1910, however, and the cost of replacing vehicles and track was seen as too great. In addition, the growing motorists' lobby objected to the tramlines, and the fact that trams ran down the centre of the road was seen as an encouragement to jaywalking. From 1931 trams in

south-west London began to be replaced by electric trolleybuses, using the tram network's generating stations and keeping down imports of diesel oil for the new buses.

In north London trolleybuses were introduced from 1936, when the trams were replaced in Edgware. The Enfield, Barnet and Waltham Cross routes were converted in 1938. The 'trolleybus for tram' programme was stopped by the Second World War, and afterwards the LPTB policy was to use buses only. London's last remaining trams were phased out by 1952, and the trolleybuses themselves disappeared ten years later.

Traffic congestion in London began to be taken seriously in the interwar period, as was made evident in a warning that formed part of the authoritative *New Survey of London Life and Labour* of 1930. In the words of this report: 'unless some definite policy with regard to the main traffic arteries in the central areas is adopted soon, the growth of street traffic in London, and with it probably the growth of London itself, must be checked and restricted'. In 1936 the *Economist* observed that 'possibly a general ban on the poor patient horse [in central London] may be followed by the prohibition of private cars in the centre of our cities, if the interests of reasonably speedy public transport are to be adequately served'.

London at War

The Blitz began on 7 September 1940 – 'Black Saturday' – with day and night-time raids that left the East End and docks burning so fiercely that fire crews had to be brought in from Birmingham, Nottingham and other provincial cities. Casualties were heavy, with 1800 killed or seriously injured. London was then bombed virtually every night for the next three months, until an unofficial truce brought an uneasy peace for three nights over Christmas. The attacks resumed and on 29–30 December 1940 – 'The Second Great Fire of London' – Herbert Morrison, the Home Secretary, recorded this horrific event with his photograph of St Paul's emerging triumphantly from the tumult of fire and smoke around it. The first period of the Blitz was the most sustained of the various attacks on the capital. By the end of 1940 London had suffered 40 per cent of its total war casualties, with over 13,000 killed. Another 6500 were to die before this main phase of the Blitz ended (for London) on the night of 12–13 May 1941. Included in this phase were 'The Wednesday' of 19–20 March 1941, when the East End and docks endured a merciless battering, and 19–20 April, which saw the heaviest raid of the war as measured by bomb tonnage. The onslaught was as ferocious at the end as it had been at the beginning. Indeed, the most destructive night of the war for Londoners was 10–11 May 1941 – the 'Full Moon' bombing – when 100,000 incendiaries fell; an indication of the scale of the attack is that some sixty-one local government areas in London suffered bombing.

Bomb damage in central London during the Second World War.

The city was free from attack for more than two and a half years, until the 'Baby Blitz' of January to April 1944. This comprised fourteen night raids, some of them comparable in devastation to the first phase. Finally, Londoners were again subjected to bombardment late in the war through the V1 flying bomb (the 'doodlebug' or 'buzz bomb') and the V2 rocket. Some 2340 V1s fell on London between 13 June and 1 September 1944, with a further seventy-nine from then until the end of the war. They killed over 5000 people, about twice as many as the 517 V2s which hit London between 8 September 1944 and 27 March 1945.

The most devastated quarter of the capital was at its very heart – the City, which lost nearly a third of its prewar floorspace. Virtually every building between Moorgate and Aldersgate Street was destroyed. The Blitz made short work of almost all the buildings in the vicinity, including the nave of St Augustine's Watling Street, close to St Paul's. Older buildings fared worst, while post-1900 steel-framed construction stood up reasonably well to high explosive and fire. Postwar clearance and development opened up much of the area, though the decision was made to leave what remained of St Augustine's church as a feature of St Paul's churchyard. It was subsequently adapted to form part of a new structure for the cathedral choir school. Not far away is Christopher Wren's St Alban's Wood Street, which the Blitz left as a gutted ruin: St Alban's was demolished, apart from the tower, which now stands desolate, purposeless and incongruous in the middle of a road, dwarfed by modern buildings.

A number of London's ruined churches were demolished and cleared away altogether. St Swithin Cannon Street, which had an octagonal dome, was bombed and its ruins survived until 1962, when the site was cleared

completely. St Mary Aldermanbury, one of Wren's less-accomplished structures, stood close to St Alban's Wood Street at the junction of Aldermanbury and Love Lane and ended up as a gutted and roofless shell, but with an intact tower, after the firestorm of 29–30 December 1940. The lower sections of the walls remain *in situ*, together with the stumps of columns, in a carefully laid out garden. But the rest of what survived in 1945 was systematically dismantled, sorted and numbered, and transported to Fulton, Missouri, in the USA. Here the church was entirely rebuilt, restored and reopened as a place of worship and a memorial to Winston Churchill.

Very few of the City churches or those in other parts of London were left as they were at the end of the war. St Anne, Soho, a church of uncertain pedigree, was yet another gutted ruin and tower. It now survives with a garden in what was once the nave, while the 1803 tower built by Samuel Pepys Cockerell still stands on the site. Christ Church Greyfriars Newgate is probably the most conspicuous ruin of all, standing as it does very close to St Paul's, in a busy part of the City's one-way system. That it was not rebuilt was the occasion of some controversy, because it was one of Wren's most extravagant creations. The extant ruins are a powerful reminder of the destruction wrought in 1940–41 and the most conspicuous monument to the Blitz. But the church was rather less substantially destroyed by the Blitz than it looks; much of the eastern section was summarily cleared away to make room for road widening. Christ Church could well have been rebuilt as many others were, such as St Bride's, Fleet Street (destroyed 29 December 1940) and St Clement Dane (destroyed 10 May 1941), amongst others. The latter still bears visible scarring from bomb damage on its outside walls. Nearby, St Mary-le-Strand and, in the City, St Magnus the Martyr escaped more or less unscathed. Between St Paul's and Christ Church lay Paternoster Square, which was destroyed along with approximately six million books and the bookshops and publishers for which the square was renowned. The replacement pedestrian precinct was ugly and unpopular, and at the end of the century it too was demolished.

The classic effect of a bomb falling in a road was to destroy the façades of dozens of houses and to smash the glass of others. Typically, bombed houses were cleared where possible and the sites abandoned until peacetime. Where damage was confined to the façades, houses were sometimes repaired after the war in an approximate emulation of the style of architecture that prevailed in the street concerned. In the case of the block of flats called Coronation Avenue at the north end of Stoke Newington Road, hit in October of 1940, the subsequent rebuilding is only detectable from the brick colour, creating an exact facsimile of the destroyed section.

Truncation, or adaptation, another approach to dealing with damaged buildings, involved making something usable out of what remained without rebuilding or replacing anything. For example, Holland House, a Jacobean

mansion in Kensington dating to 1606, was burnt out in the early hours of 28 September 1940. The building stood derelict for seventeen years, much of it being demolished in 1957, by which time what was left of it, together with the park and gardens, had passed into the hands of London County Council. All the upper floors, apart from those in the east wing, were destroyed. This section remains in use, and the rest of the house has been consolidated. Together with its gardens it remains open to the public, despite an appearance which makes it look like an elaborate garden folly.

Outside the City, the full extent of the damage caused by the bombing in London is difficult to estimate. Probably 50,000 houses in inner London were destroyed or damaged beyond repair, with a further 66,000 destroyed in outer London. Some 288,000 more houses London-wide were seriously damaged, and another two million slightly damaged. Despite the enormous pounding absorbed by the East End, which, except for the City, was London's most ruined district, it is clear from these figures that the bombs respected no division between the two Londons, old and new. Stepney, in the heart of the East End, had lost a third of its housing stock, with 10,800 houses destroyed or incapable of occupation without major repair. In Croydon, V1 rockets alone damaged 54,000 houses, and 18,000 out of 22,000 in Sutton and Cheam. Twice as many V2s fell on outer London as on central London, and the frontline status of London's Essex suburbs later in the war earned them the nickname 'Doodlebug Alley'.

Many other aspects of London life were affected by the Second World War. Open spaces, including sports stadiums, were taken over for a wide variety of defensive and paramilitary activities. Much of this impact was short-lived and left little trace in the landscape. It was bomb damage which made the most long-term impact, with evidence of derelict, bombed-out premises lasting late into the twentieth century in some areas, such as the East End of London. The piecemeal redevelopment which followed the war often provided uncomfortable elements to the cityscape. During the 1950s and 1960s, planners, architects and developers often colluded to build new structures which were out of scale with their surroundings, in styles and building materials which were frequently inferior to what had gone before. Despite a general political environment which was sympathetic to large planning schemes, the rebuilding of bomb-damaged sites resulted in an unfortunate acceptance of small-scale redevelopment, which was a feature of London's streets for much of the second half of the twentieth century.

Replanning the Capital

The harm done to the capital's fabric between 1940 and 1945 provided the opportunity, while the wartime necessity for planning provided the motivation, to produce the semi-planned city that became postwar London.

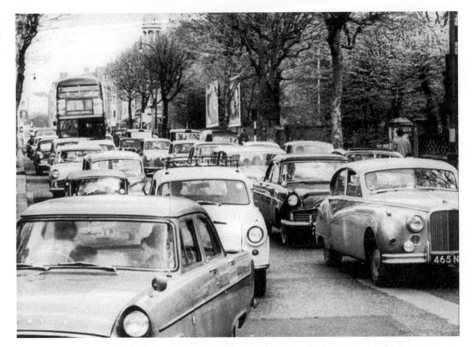

Congestion in London in the 1960s.

It had become clear even before the war that London needed a plan, particularly to deal with the problems of coping with motor traffic. In 1936, Minister of Transport Leslie Hore-Belisha had already commissioned Edwin Lutyens to prepare a plan for London in conjunction with his ministry's Roads Department. The plan envisaged a new capital, encompassed by ring roads and crossed by arterial roads, with tunnels under the parks. A model was exhibited at the Royal Academy and a report was published in 1938, but the project became a casualty of the war. It has been described, however, as 'the most comprehensive and imaginative survey ... since Sir Christopher Wren's abortive design after the Great Fire'.[12]

The blueprints for the scheme that was, however, adopted were the two major proposals by Patrick Abercrombie, the doyen of postwar urban planning – the *County of London Plan*, produced for the LCC in 1943, and the *Greater London Plan* of 1944. Abercrombie, Professor of Town Planning in the University of London, was a member of the Barlow Commission, but had refused to sign its majority report, which he considered insufficiently comprehensive in its ambition. The Barlow Report was a package of legislation carried through in 1945 by the new postwar Labour government, of which the New Towns Act and the Town and Country Act were two principal elements. Abercrombie's own two plans envisaged a comprehensive redesign of London. The *County Plan* envisaged residential and industrial zoning, the channelling of London's traffic, and even the regeneration of the Thames, 'London's most beautiful and neglected open space'. The *Greater London Plan* was the most famous and influential of all wartime plans. Unlike other plans,

it focused upon the metropolitan region, comprising London and its surrounding hinterland, not just the city itself. It also considered a wide range of problems and solutions. In the *Greater London Plan*, London was represented by four rings: an inner, tightly developed ring; the low-density suburban ring; the Green Belt; and an outer, country ring. Abercrombie also proposed the establishment of ten New Towns beyond the Green Belt to relieve the concentration of people and industry in the centre.

There was much that was visionary, even utopian, about the Abercrombie proposals. The *County Plan*'s emphasis on establishing designated 'precincts' – the doctors' quarter, the university quarter, the theatre quarter, and so on. – later seemed, however, rather quaint. The suggestion that the radial roads considered central to traffic management could become 'pleasant parkway[s] along which the Londoner can reach the country' also seems bizarre to today's users of Westway or the Old Kent Road, while the objective of providing for 'a greater mingling of the different groups of London's society' is now recognized as outside the planner's capability. Above all, the view that the 'staggering' cost of redesigning the entire metropolis could be tolerated because extensive rebuilding was necessary anyway took little account of the financial realities of postwar Britain. What was actually implemented of Abercrombie's vision was only what could be achieved relatively cheaply: the consolidation of the Green Belt and the establishment of the New Towns.

Although the policy of building up a Green Belt by means of public land acquisitions and restrictions on development had been introduced before the war, the fully established postwar Green Belt owed much to the virtual end of new building after 1939. In fact, the limits of the built-up area today lie roughly where they were on the outbreak of the Second World War. Once it was established, the Green Belt acquired tenacious defenders in the dormitory towns that grew up beyond it, in a process of leapfrog development. The Green Belt protected these towns from metropolitan encroachment and served as a *cordon sanitaire*. The New Towns, beginning with Stevenage in 1947, were intended to disperse industry and population, but their success in both respects was limited. The New Towns proper, along with the economically similar overspill communities of Swindon, Northampton and Peterborough, accounted for less than 20 per cent of population growth in the non-metropolitan South East in 1951–66. Those people who did move tended to be the skilled workers required by New Town industries. This meant that the initiative did little to shorten council-housing waiting lists in London, as had been intended. Moreover, these limited efforts at decentralization were more than offset by the opposite effects of the erection of office buildings in the centre. Between 1948 and 1961 the capital's office space almost tripled – an expansion largely unanticipated by Abercrombie. Hemmed in by the iron girdle of the Green Belt, housing,

industry and commercial real estate all competed for space in a constricted metropolis.

As a result, Abercrombie's integrated concept of the planned city was mostly never implemented. Large-scale remodelling of the type he had envisaged – impeded anyway by the weakness of the LCC as a planning authority and by the lack of any single strategic authority for the whole Greater London region – now became prohibitively expensive as the cost of central land escalated. Postwar strategic planning in central London was limited to attempts to resolve specific problems, and even these attempts frequently encountered resistance from local authorities or interests. With the defeat of the proposals to 'rationalize' Piccadilly Circus in 1960, it became evident that the tide had turned against Abercrombieism. When the Buchanan Report on *Traffic in Towns*, issued in 1963, discussed the complete rebuilding of the area bounded by Euston Road, Tottenham Court Road and Oxford Street, it was made clear that this was only an exercise, which was likely to remain abstract. And by the 1960s the planners, had turned their attention to the growing housing crisis.

The idealism of the time was perhaps best symbolized by the South Bank

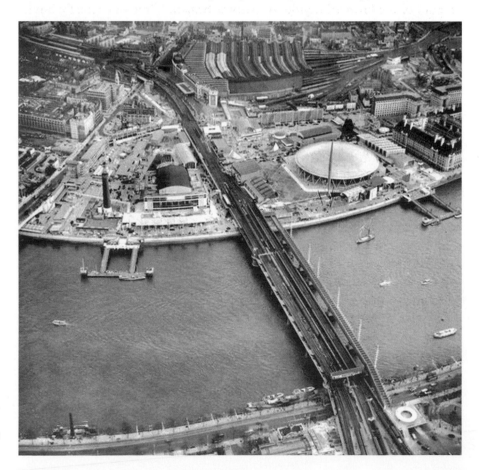

The Festival of Britain site from the air in 1951.

Exhibition, the centrepiece of the 1951 nationwide Festival of Britain. One hundred years after the Great Exhibition in Hyde Park, this was intended to 'demonstrate the contributions to civilization made by British advances in "Science, Technology and Industrial Design" against a background representing the living and working world'. Built on derelict land on the south bank of the river, the most striking features were the 'Dome of Discovery', containing exhibits on modern exploration, and the cigar-shaped 'Skylon', balanced on wires high above the spectators. After wartime and postwar deprivations, exhibits on 'The Land' of Britain and 'The People' presented the morale-boosting prospect of a planned, technologically based welfare state. The Festival's legacy to London was a section of river wall bounding the site, and the Festival Hall, which was later joined by other major South Bank cultural buildings – the Hayward Gallery, the Queen Elizabeth Hall, the National Film Theatre (1956–58) and the National Theatre (1961–76). The Shell Centre (1953–63) completed this group of optimistic postwar buildings that line the south bank of the Thames in central London, in an area which previously had been regarded as 'depressing', 'derelict' and 'lacking in dignity' before the war.

The Postwar Boom

The 1950s and early 1960s were generally acknowledged as the worst period of the century for London architecture.[13] Criticized at the time for its routine functionalism or pugnacious 'Brutalism', over half a century's familiarity with this building style has hardly softened contempt. Many of the boom buildings weathered shabbily and soon looked tawdry. Even when not especially high, they dominated by their bulk and breadth on the streetscape; and many, like those in Paternoster Square around St Paul's Precinct, or the South Bank's Hayward Gallery, seemed deliberately ugly. By the end of the century only the Barbican, built between 1959 and 1979, still impressed by the self-confidence of its vision; but its segregation from neighbouring areas and its alienating and confusing deck access made even this an equivocal success.

The office boom of 1954–64 changed the London skyline for ever. By 1969 there were over 100 office blocks in the City and West End that were taller than the 100-foot barrier, and there were sixteen above 300 feet. Even if few yet rivalled St Paul's Cathedral, these tall buildings dwarfed the City's and Westminster's spires and turrets. Centre Point (1963–67), designed by Richard Seifert, was one of the new generation of skyscrapers. Located at the southern end of Tottenham Court Road, it has been described as 'a fine building squeezed too tightly into the wrong place'. Notoriously, it remained empty for over a decade, and it came to symbolize the absurdity of much of the office boom. The Post Office Tower (built in 1966, and some 230 feet taller than St Paul's) was next to add its distinctive shape to London's skyline, at

the other end of Tottenham Court Road. And Seifert's Tower 42 (1970–81), Britain's tallest building of the time at fifty-two storeys and 600 feet, was to dominate London's skyline in the 1980s. Yet observers looking Citywards from Parliament Hill or from Greenwich Observatory around 1970 would have been struck less by the cluster of tall buildings at the centre than by the forest of towers stretching east and west across London's panorama as far as the eye could see: the years of the office boom saw another boom in tower blocks comprising massive council-housing estates.

During the war, some 116,000 houses in the Greater London area had been destroyed or so badly damaged as to require virtual rebuilding. Around half the houses that did survive dated from before 1918. And of some 30,000 wartime prefabs handed over to local authorities in 1948, many were still occupied in the 1970s. To meet the twin problems posed by slum clearance and multiple occupation, two sorts of council estate had developed. In the inner areas cleared as slums, the old houses were replaced with blocks of flats. Building high, traditionally up to five storeys, without lifts, was the only way to put enough modern dwellings back on the site to accommodate the number of families displaced by clearance.

High-rise flats had been a European-inspired dream for British architects since before the Second World War. Some luxury private developments – like Lubetkin's famous Highpoint 1 and 2 (1936–38) at Highgate, praised by Le Corbusier as 'a vertical garden city' – had taken off in the late 1930s. Although the public sector had not yet followed suit, LCC architects had travelled to study the latest municipal architecture in 1930s Vienna, Rotterdam, Stockholm and elsewhere. One of the first postwar LCC estates, Woodberry Down, with its elegant white nine-storey blocks overlooking the New River reservoirs at Manor House, was a close facsimile of buildings in prewar Stockholm. So were the high-rise flats at Lansbury and the famous eleven-storey 'point blocks' at Alton East Estate at Roehampton (Wandsworth), opened in 1954. Contrasting with the high-rise construction, the Lansbury Estate in Poplar was built as the Festival of Britain's Exhibition of Living Architecture. This pioneering neighbourhood scheme was intended as a blueprint for the redevelopment of the deprived areas of the East End. It incorporated the Chrisp Street Market, the first purpose-built pedestrian shopping area in Britain. Unfortunately, its intimate scale, low-rise design and generous provision of open space was not widely adopted because of the subsequent growing pressure for mass-production building techniques. These estates were rivalled by borough council commissions like the Spa Estate, Finsbury (opened 1950), the bright new Churchill Gardens Estate, Pimlico (1950), Denys Lasdun's eccentric point blocks in Bethnal Green (Usk Street, 1952, and Keeling House, Claredale Street, 1960), and the Hallfield Estate at Paddington (1951–59). Yet another example, Golden Lane Estate, built just north of the City, was particularly colourful and included a sixteen-storey

tower (1957–59). Such estates became icons of the new Britain emerging from the shadow of war and were models for municipal architects from every corner of Britain and, indeed, the world over.

A notable feature of these early postwar council estates was their scale – they were generally much larger than any inner London estate of the first half-century, apart from White City. Their size reflected the aspirations of the time for 'comprehensive development': for example, the Stepney–Poplar Comprehensive Development Area, adopted by the LCC in 1946, proposed the clearance, over thirty years, of much of 1300 acres housing 75,000 people. And the years 1949–55 were the busiest of all for the LCC, which built nearly 65,500 dwellings during that time. Where LCC efforts were most concentrated, the effects were dramatic. As early as 1961, Ashley Smith noted that:

> The writing of a book on the East End just now has an immediate urgency ... for such as the East End is today it has never been before and will never be again ... A pattern that has existed for generations is breaking and what the new pattern will be is unclear even to those who are making their way across the shifting sands.[14]

The fashion for tall buildings was assisted by government subsidy changes in 1956, which gave councils more money per flat the higher it was from the ground! The LCC led the way, and eighteen-storey blocks were erected at the Brandon Estate, Southwark, with a twenty-one storey building at the Warwick Estate, Paddington, and a twenty-four-storey one at the Pepys Estate, Deptford. The Greater London Council, which from 1965 inherited the LCC's housing stock and its building programme, accelerated the high-rise and slab-block combination. Industrialized building methods, with factory-made components assembled on site, boomed from 1962 and became an essential part of GLC housing policy from 1965. In ten years, the GLC alone built 384 tower blocks. The new London boroughs followed suit, and some 68,500 flats in blocks of ten or more storeys were built in London. In 1968, however, a section of Ronan Point, a new tower block in Newham, collapsed and killed four people. No formal change of policy was announced, but the short-lived era of the residential tower-block fashion was over. Since then, one by one, they have been coming down, giving more pleasure in their spectacular destruction than they did in their erection.

Some of these giant estates were more successful than others. More than a few, like Broadwater Farm (Tottenham) or Holly Street (Hackney), became some of the most notoriously dangerous urban neighbourhoods in postwar Britain. Despite returning to the traditional verities of brick and timber and slate, low-rise estates like Marquess Road (Islington) still managed to create a labyrinth of claustrophobic walkways, ill-lit living space, and walls and roofs that sprang mysterious and obstinate leaks. In all, some 201,000 council

homes were built in inner London between 1945 and 1970, and a further 247,000 appeared in outer London during the most productive quarter-century to date for public housing. Many thousands of good houses were demolished to make way for the new styles, and London's architectural balance sheet for the period shows more losses than gains.

The biggest planned expansion within Greater London during the postwar period was Thamesmead. In 1963 a report highlighted the age and condition of much of the housing in inner London and declared that 500,000 new homes were needed in the following ten years. The Erith marshland had been mostly unused, apart from some allotments that were cultivated by the residents of Abbey Wood. The area was inhospitable and unsuitable for housing, but the expansion of London meant that land was desperately needed. Over the years various efforts had been made to drain the land and protect it from flooding. The site originally chosen for development by the then London County Council straddled the London boroughs of Bexley and Greenwich, which were created in the mid 1960s. Thamesmead was actually developed by the London County Council's successor, the Greater London Council (GLC), in conjunction with these two boroughs. The Ministry of Defence's decision in the early 1960s to give the LCC a thousand acres of marshland previously occupied by the Royal Arsenal gave impetus to the project. The master plan was prepared as one of the first acts of the new GLC in 1965. In 1966 the Woolwich–Erith project, as it was then known, was formally launched by Sir William Fiske, who wrote in the foreword to the launch document:

> It would be hard to exaggerate either the challenge or the opportunity which this three-mile stretch of London's riverside offers to all those concerned with the planning and execution of its development. From land which has for centuries formed the marshes of Plumstead and Erith, and in part has been given over to the munitions of war, a community of 60,000 will rise over the next ten to fifteen years. Between the broad reaches of the Thames and the hills of Abbey and Bostall Woods, a desolate scene will be transformed for the well-being of Londoners.[15]

This huge project involved draining and laying out 13,000 acres of the Erith marshes, a tract that crossed the border of the boroughs of Greenwich and Bexley. Thamesmead was to be a new town for 60,000 people. The project was not without its critics, who decried the choice of location as 'ridiculous' because of the problems involved in land reclamation and building on peat, and also because of pollution from the nearby sewage works and heavy industry and incineration on both sides of the river. The architect Richard MacCormac appraised the project in the *Architects' Journal* in 1972 and made reference to this, stating how absurd was 'the decision to build a new community at Thamesmead, on 20 feet of peat, next to a major sewage

works and under an umbrella of pollution from Barking (on the north bank) and Belvedere power stations, which is obnoxious enough to prohibit building above 200 feet'.

Before work on residential buildings could begin, engineers had to ensure that the site would be suitable for the builders. To this end they provided a new central pumping station that was linked to canals and channels for the efficient drainage of what was still marshland. Three miles of Thamesmead's riverbanks were raised and strengthened to prevent any future flooding. But water draining on to the marshes could be discharged into the Thames only before or after low tide and so had to be stored somewhere temporarily. The architects came up with the innovative solution of building five lakes into the design of the site, which, as well as being functional in storing water, could also be used as aesthetically pleasing amenities. The first of these lakes, none of which would be more than two feet deep, was Southmere Lake, opened officially in 1971.

Earlier building foundations were excavated (and recycled for use in road construction) and transport networks were set up before any building could start. Attempts to reclaim this land were complicated by a long history (beginning around 1700) of using convict labour to infill the marshland with various materials – including, in later years, rubble from the bombing of London during the Second World War. As a result of survey, some areas had to be further refilled or stabilized. Another necessary preparation was to move munitions and incendiary devices from the site. This proved to be a huge task, which was never completed – many unexploded bombs and bullets were found during the laying of the foundations.

Building of the first 'neighbourhood', near Abbey Wood, began in January 1967. This was later known as Newacres and comprised just over 4000 homes. The first stages were built using concrete slabs that were then fitted together, with the main accommodation on the first and second floors to reduce the danger of flooding. Space for car parking and garages was located under the accommodation, and walkways connected the different buildings. The piled foundations, in addition to lifting the areas to be inhabited above the danger of flooding, also served to transmit the weight of the structures through the clay, peat and alluvium to the load-bearing gravel stratum below. This method of building was changed to more conventional, lower-level brick building after the river walls were raised and the danger of flooding was subsequently reduced. The first residential construction was the five-storey tower block at Coralline Walk.

The Green Belt

In the late nineteenth century, Ebenezer Howard proposed 'the limitation of the spread of towns, and their permanent separation, by zones of country

land generally immune from building'. The first significant steps towards creating the Green Belt were not taken, however, until the interwar period, when, in 1927, Raymond Unwin suggested the idea of a 'Green Girdle' around London to stop uncontrolled urban growth. By 1935 the London County Council started buying up land, and giving grants to surrounding counties to buy up land to stop it being developed. The land so purchased was identified as land upon which development would not be permitted. In 1938 the Green Belt and Home Counties Act was passed, and by 1939 20,000 acres had been bought; immediately after the war another 30,000 acres were secured. Local authorities still own most of this land and have been able to maintain a substantial part of the Green Belt through the use of powers of development control.

In the *Greater London Plan* (1944), Patrick Abercrombie proposed a Green Belt, five miles wide, to stop the outward growth of London. The width of the Green Belt had an important bearing on the overspill problem. Since the outer edge of the Green Belt represented the outer limit of commuting in the mid 1940s, new, self-contained communities outside the Green Belt would be created to rehouse the people being moved from central London and would provide them with jobs. It was a solution very close to the original ideas of Ebenezer Howard, namely, self-sufficient communities for living and working. The plan proposed a ban on new industrial development within the inner area, especially Central London, although factory relocation would be allowed. The Green Belt around London was to be enlarged, and it would be enforced by planning controls rather than public ownership.

The Green Belt was finally in place in 1958, but by then the LCC's post-war overspill estates had already eaten away some of the land intended for preservation. Elsewhere, inside the Greater London boundary, the suburbs still expanded where they could – in the backlands of suburban mansions now demolished to make way for Closes and Groves, along estate roads laid out before 1939 but not yet built on, and in the few spaces left between developed land and Green Belt. These 1950s suburbs were necessarily small-scale and fragmented except in three or four areas. In west London, the closure of Heston Airport freed up a large site for building, and the development of what would become Heathrow Airport stimulated new building from 1946 in Feltham and Stanwell, the latter just outside the Greater London boundary. In east London the 1940s and 1950s saw suburban development north of Hornchurch in Harold Wood and Harold Hill (including a big LCC overspill estate), and similar expansion at Orpington, kept alive the suburban impetus of twenty years before. There are many pressures on London's Green Belt from 'appropriate developments' such as agriculture, sport, mineral extraction and transport. And some land uses that conform to development restrictions have created severe problems. These include the intensification of agriculture, diversification of agriculture,

mineral workings, and sports stadiums. Consequently, parts of the Green Belt are run down and unattractive. The M25, which encircles the metropolis, was built almost entirely on London's Green Belt, and that motorway has attracted the attention of developers for commercial and industrial purposes.

There has also been a noticeable increase in the demand for new housing in the South East. Housing (justified on the grounds of 'exceptional need') steadily devours more land. In south-east England as a whole, in each of the last few years of the twentieth century an area of Green Belt land three times the size of Hyde Park was annexed. Estimates for Green Belt housing between 1981 and 1991 were as high as 820,000 homes, many of which are in the Thames Gateway – the area stretching from the East End of London to the Medway Towns and Southend. There is now a real possibility that the Green Belt will develop into a zone of highly attractive real estate between central London and the 'Greater' London that occupies south-east England.

The Docklands

The London Docklands is an area of urban regeneration stretching downstream from London Bridge through Wapping, Limehouse, the Isle of Dogs, Surrey Docks and the Royal Docks. This area was, until the 1960s, the leading port of the UK, and the Port of London employed 30,000 workers. It began to suffer a major decline, however, as shipping switched to the use of both larger vessels and the container-based system. New and expanded ports were established around the country, at places such as Gravesend, Tilbury, Felixstowe and Dover, causing the decline of London as a port and huge dereliction of the docks. The government set up the first Urban Development Corporation, the London Docklands Development Corporation (LDDC), in 1981. With government grants, private investment and the sale of reclaimed land to developers, together with improvements to the infrastructure such as new roads and a new light railway, the economy of the area was largely transformed. A new short take-off and landing airport (London City Airport) was built on the site of the Royal Docks, with links to other European cities such as Paris and Frankfurt. The area has also developed private housing, offices, shopping, hotels and leisure facilities, with over seven hundred new firms having located there.

It was the creation of most of the Isle of Dogs as an Enterprise Zone in 1982 that marked the beginning of the Docklands regeneration. Tax and other investment incentives, described by some as 'not so much seductive as wanton', attracted capital into Docklands from all over the world. 'The result has been [by 1994] a whirlwind of development producing a physical transformation that has been rapid and spectacular', where the landscape could alter out of recognition in weeks, and where the roads shifted on the ground

The Royal Docks in 1950. The docks closed in 1981, and in 1987 the City Airport was opened here.

from one month's end to the next, so that even a frequent sightseer would inevitably be lost within a few minutes of entering 'The Island'.

Some 70 per cent of investment in the Isle of Dogs initially came from abroad. Foreigners were said to be less prejudiced against the East End than the British, who were still put off apparently by the poor image of 'Whitechapel' and 'Cable Street'. And it was the decision, in 1985, of a consortium of North American investors to build a speculative office development of eight million square feet at Canary Wharf that was really to change the fortunes of Docklands – and of east London – into the twenty-first century and beyond.

Prior to the Canary Wharf proposal, development in Docklands had, by London standards, been on a fairly small scale – generally, schemes involved fewer than 100,000 square feet. After Canary Wharf, however, developers worked on a much larger scale. They were helped to do so in October 1985 by a relaxation of the Bank of England rule that banking headquarters had to be located in the Square Mile; by the virtual abolition of tax breaks on development outside Enterprise Zones in April 1986; and by the deregulation of the City in October of that year. In anticipation of the 'Big Bang', as it was called, the buoyant demand for office space in the City spread to the Docklands. By the summer of 1986 the President of the Board of Trade, Norman Tebbit, called the Docklands 'Manhattan-on-Thames' and 'Wall-Street-on-Water'.

The Argentinian-born architect Cesar Pelli was responsible for 1 Canada Water (the Canary Wharf Tower, 1988–91), which immediately made a unique and defining contribution to London's skyline: 'I wanted it to look un-American, to step outside the three main styles of classical, Gothic and

The high-rise cityscape of the renovated London Docklands.

art deco.' In the end his design was compromised by the need to remove five storeys for air-safety reasons, while adding the missing floorspace to the remaining fifty floors. This bulked out the tower to a disproportionate stoutness. Even so, Pelli's 824-foot tower was more than twice the height of St Paul's, making it the tallest building in Britain at the end of the century, and Europe's second highest. With its stainless-steel cladding, it was an extraordinary achievement and established the Docklands as 'central London's third office district'.

At its demise in 1998 the LDDC was able to claim the following successes during its seventeen-year existence: in addition to attracting large amounts of private finance, 2200 acres of derelict land had been reclaimed, eighty-six miles of new and improved roads had been built, and the Docklands Light Railway was an economic success. Something like 24,000 homes had been constructed and seven million square feet of commercial and industrial floor space had been created. The area now employs 85,000 people and is a major tourist area, attracting two million visitors a year.

The City

The pace of development on the Isle of Dogs was so fast that by 1990 the office market east of the City was saturated; the demand for offices far outstripped the supply. A contributory factor had been yet another wave of redevelopment in the Square Mile. This was a final fling in a century-long process of continual renewal that had hardly paused, apart from the war years, and which needed no tax incentives to stimulate it. Competition from the Docklands caused the

City to look to its own laurels, encouraging architectural innovation within the Square Mile to compensate for the poverty of much of the building there in the 1950s and 1960s. The Docklands had freed up space in the City by seducing tenants away with lower rents and high-tech accommodation. A particular case was Fleet Street, where Rupert Murdoch and News International changed the face and location of newspaper printing in London. By 1988 'The Street of Ink' had largely run dry, its passing marked by a *Farewell to Fleet Street* exhibition at the Museum of London, and its old tenants relocated at 'Fortress Wapping', just west of the Isle of Dogs. Here took place the last great London industrial struggle of the century, in 1986–87, over the power of the printworkers in an age of computerized text production. It was a struggle decided, after much violence, in favour of the employers. Fleet Street became as hectic a site of demolition and rebuilding as it had been between the wars. But now, through buildings like Peterborough Court (1988–91), it was consolidated into the financial services world of the City.

The architecture of the 'Atrium Office Block' was the 'characteristic product of this boom' of the 1980s. The City's first dated from 1972–8, but it was somewhat later that those astonishing glass fronts exposing lifts, escalators, reception areas and what appeared to be the looted relics of tropical rain forests became a familiar feature of the City street scene. The Lloyd's of London building (1978–86), the Standard Chartered Bank (Bishopsgate, 1980–85), and 1 Finsbury Avenue (1982–84) stood out impressively within a successful genre. This was part of the Broadgate development on the site of the former Broad Street Station, incorporating the renovated Liverpool Street Station. Broadgate was thought to be 'by far the most attractive and impressive piece of postwar planning in the City' and, indeed, the whole of London. It rose dramatically in just six years after 1985, when, after a decade of abortive plans and public inquiries, developers were appointed. The result was an architectural feast – 'some eclectic art deco-ish and retro-chic', some (like Exchange Building) uncompromisingly modern – and a huge commercial success that pushed the boundaries of the City north east into Shoreditch and east to the edge of Spitalfields.[16] By the end of 1993, it was claimed that half the City's stock of office accommodation had been built since 1986; this was probably an exaggeration, but nevertheless the speed and scale of development in this area almost matched that in Docklands. Certainly, well over a quarter of the original postwar City buildings had been demolished by 1997.

The frantic redevelopment of the City was not without its critics, most notably the Prince of Wales, who complained that planners, developers and architects had conspired to wreck 'the London skyline and desecrate the dome of St Paul's with a jostling scrum of office buildings'. The particular proposal which promoted this outburst was for the second postwar rebuilding of Paternoster Square. The first, undertaken in cheap concrete soon after the war ended, was a sorry affair, which by the 1980s was looking distinctly shabby.

The plan was to replace it with a postmodern design of the type which then dominated the City, and this is what upset the Prince. In the event, amidst much controversy, a conservative, neoclassical design prevailed. For the most part, late twentieth-century landscapes across the country were divorced from the land they occupied. Most buildings did not reflect the activity within. There was a uniformity of style and construction material which masked function. The same cannot be said of the buildings of the City at the end of the century; flamboyance and ostentation accurately reflected the manufacturing industry taking place there – the making of money.

The City boom spilled over into the parts of central London that the first postwar office building wave had not reached. So, for instance, an office block was built on Tolmers Square for the Prudential Assurance Company, although the 'square', on a meaner scale than the original, was rebuilt as a Camden council estate. And a beautiful new British Library was eventually opened on the Somers Town side of St Pancras Station in 1997, some fifty years after an urgent need for a new library to replace that in the British Museum had first been identified. Also, Portcullis House was a welcome, well-designed addition to the Palace of Westminster.

Most positive of all, the new world emerging in Docklands helped refocus developers' attention on London's river. A river view from office or penthouse was at a premium. A riverbank location granted designers an almost unlimited breadth of vision, and it was exploited with a flamboyant self-belief that London architects had rarely equalled at any other time in the twentieth century. The riverside buildings of the Terry Farrell Partnership – 'Farrell is the key figure ... in the development of Post-Modern London', it was said in 1991 – were temples to an infallible god of commerce worshipped by a corporate state.[17] They were as secure in their faith as the work of any medieval master mason: like the green and beige ziggurat of Vauxhall Cross on the unfashionable Albert Embankment (1989–92), home to MI6 at the century's end, or the cathedral bulk of Embankment Place at Charing Cross Station (1987–90), or the Conran Roche development at Butler's Wharf nearby (1987–91). The riverside remained a focus of imaginative, if controversial, exploitation through the 1990s, not least with Lord Rogers's Montevetro glass ski slope in Battersea (1998).

The Millennium Wheel, popularly known as the London Eye (1999), near Westminster Bridge, was an inspired addition to the city's skyline and immediately became a favourite landmark, unlike the unloved and infinitely more expensive Millennium Dome (1999) downstream in Docklands. The Dome revitalised the Bugsby Marshes, the old site of the South Metropolitan gasworks at the Greenwich peninsula, but, despite its interesting design, it proved to be a white elephant and may eventually make way for yet more riverside apartments.

Church building in London, as elsewhere in England, slowed down as

The London Eye
and the Thames
embankment at the
turn of the century.

the century progressed and there was relatively little new in the final decades. In contrast, other religions, particularly Islam, began to make themselves much more conspicuous. A number of mosques were constructed; perhaps the best known is Frederick Gibberd's London Central Mosque in Regent's

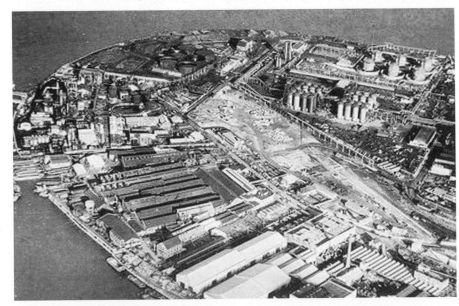

The Greenwich
peninsula in 1965.
The South
Metropolitan
Gasworks was one of
the largest in Europe
and occupied most
of the Bugsby
Marshes.

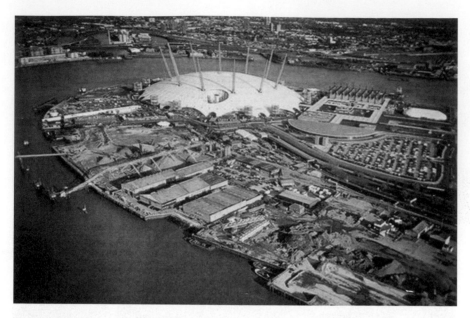

The Greenwich Peninsula in 2000. The Millennium Dome is largest in the world.

Park (1978–85). It was built in the grounds of one of the park's Victorian villas. The golden copper dome and minaret rising behind the trees by Hanover Gate provide an unusual and exotic contribution to the Regent's Park skyline.

This most recent wave of London renewal, in contrast to all those preceding it, managed to reach a considerable degree of accommodation with conservation. No longer were old streets or buildings singled out for demolition. By the end of the 1970s any struggles over conservation (like Liverpool Street Station) were largely settled in the preservationists' favour. Rather, it was the product of the first postwar office boom that proved most vulnerable to redevelopment: 'well over a quarter', it was estimated, of postwar City buildings had been demolished by 1997, a trend destined to continue when still more renewal was undertaken at the very end of the century. Of those office buildings built in the 1950s and 1960s that escaped demolition in the 1980s and 1990s, a few were 'refitted' with postmodernist facelifts, 'spicing up brutalist façades for a more fanciful age'.[18]

Towns and Industry

'... the real tragedy of England, as I see it, is the tragedy of ugliness. The country is so lovely: the man-made England is so vile.'

D. H. Lawrence[1]

L OOK AT ALMOST ANY ENGLISH TOWN on the modern map, or from the air, and the characteristic patterns of the twentieth century dominate. Much of what meets the eye is of twentieth-century origin: even solid commercial high streets, well-established Edwardian suburbs and ancient-seeming trees in public parks. And this is quite apart from the mass of inter- and post-war housing estates, the redeveloped city centre, the retail park, the urban motorway, the industrial estate, the crematorium and the sewage works. During the twentieth century, English towns were subject to immense pressure from the motor car, from wartime bombing, and, during the 1960s and 1970s, from the retail revolution and from the desire to create modern, car-friendly shopping environments. What we see is the attempt at many levels to transform ancient patterns of settlement to contemporary require-ments. It is not surprising that the mechanisms to plan, control and monitor these changes often follow the forces of change themselves. The resulting townscape often upset sections of society. Despair at barren late twentieth-century townscapes was almost as deep as that expressed by D. H. Lawrence about their Victorian predecessors. Yet society has no grand blueprint or overall consensus for the future landscape except in the most general terms. Therefore, despite a number of conspicuous failures, we should perhaps be grateful that many English towns looked as good as they did at the end of the twentieth century.

During the twentieth century urban systems became increasingly complex and geographers adopted terms such as 'city region', 'metropolitan area' and 'local labour market area' in order to describe new, more complex urban communities. Globalization added a further dimension to urban dynamics and, although the idea of overseas influence on towns and cities was nothing new to an imperial nation like the British, the rising volume of moving goods, capital and information during the last three decades of the twentieth century gave this process a completely new meaning. In the last half of the twentieth

century, towns and cities had a difficult task to adapt to complex and often conflicting pressures. The urban landscapes we see today reflect both the conflict and the pressure. Given the pace of economic, social and technological change in towns, this process of transformation may never be complete again in a way that our predecessors would have understood.

The historic towns of England are composed of a wide range of urban elements they acquired over the centuries in order for them to carry out their roles as defensive, commercial and administrative centres. For the most part, the plans and buildings of town and city centres evolved over a long period, giving them an intricate framework of texture, colour and scale. Early changes in the urban landscape tended to be incremental, and even during the Victorian era most of the changes which occurred took place within an existing historic framework. Townscape changes in the twentieth century tended to be on a much larger scale. Particularly after the Second World War, which saw the centres ripped out of a number of cities, there were strong pressures to redesign city centres to meet the perceived needs of a postwar society and in particular to accommodate the motor car – the results of which were often socially and visually disastrous. The balance between ancient and modern which had characterized many English urban centres before 1950 swung decisively towards the modern.

The geography of urban Britain had been influenced by a pre-existing settlement pattern that had been in place since Norman times. Each county had its own county town, which was the administrative and commercial headquarters of the shire and normally the largest town in the county: places such as York, Leicester, Worcester, Lincoln and Norwich. Below this there was a network of smaller provincial market towns spread fairly evenly across

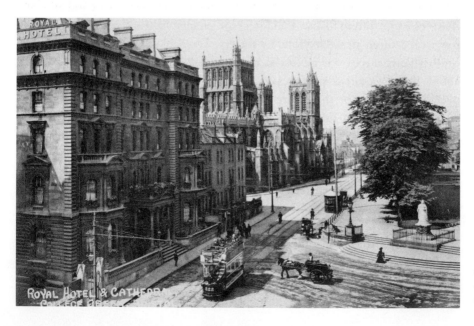

Central Bristol in the early years of the twentieth century.

the country. The exceptions to this county town hierarchy were the great ports, of London, by far the largest; Bristol; Newcastle; Plymouth; and Southampton. In the north of England and the Midlands, a new generation of industrial towns had mushroomed in the nineteenth century, and these were based initially on the coalfields and other industrial raw materials: Birmingham, Manchester, Sheffield; and a host of smaller sprawling urban settlements exploded in places such as Stoke-on-Trent, Bolton, and Leeds. Because of their rapid and often unplanned growth, many of the new industrial towns lacked a heart. Many large towns overspread their core and coalesced with smaller towns in their region. Few observers, then and since, have had a good word to say for this development. J. B. Priestley saw the results at their worst, during the 1930s Depression. He described south Lancashire as 'an Amazonian jungle of blackened bricks'. In the Midlands, places had names, 'but these names were merely so much alliteration: Wolverhampton, Wednesbury, Wednesfield, Willenhall and Walsall. You could call them all wilderness, and have done with it. I never knew where one ended and another began.'[2]

The transport revolution of the nineteenth century brought about profound changes in the scale and complexion of urbanization. Traditionally, most buildings had been constructed from material that was found close to hand, be it stone, timber, or clay for bricks. There were, of course, exceptions – cathedrals, churches, secular public buildings and high-status town houses were often built with imported materials sometimes carried over long distances – but it was normal to build with what was available locally. Thus there was a very close relationship between the buildings of a region and the local geology, and it is generally possible to characterize any particular location from the dominant vernacular building material used prior to 1800. Hence stone buildings predominate in the limestone-rich Cotswolds; but only a few miles away in the Vale of Evesham, where there was no readily available local building stone, half-timbered and brick buildings are the norm. All this began to change in the eighteenth century with the construction of canals, which enabled stone, brick, tile and, in particular, Welsh roofing slate to be moved throughout the country. The process of distribution of building materials accelerated with the coming of the railways in the nineteenth century: the new rail system allowed the easier movement of heavy building materials, including new commodities such as cast iron and steel, at a fraction of the cost of road transport. By 1900 the cost of material, rather than its immediate availability, was the guiding principle in selection, and thus the ancient link between landscape and its buildings was broken. In the twentieth century, with ever-increasing ease of access and availability of a wide range of building materials – plastics, steel, glass, aluminium and, above all, concrete – the link was completely broken, except where fashion and taste demanded the use of particular traditional local materials. This break with

local building materials was part of a more general process of disassociation between place and location that was to accelerate during the twentieth century. Increasingly, new developments in towns resembled one another and took little account of the localiti es in which they were built. Not only were old street patterns and property boundaries ignored, but, in many places, the texture, colour, size and shape of new developments were all quite distinct from the urban context in which they were placed.

The Second World War marked a fundamental change in attitudes to townscapes. As in all other areas, government involvement increased, both at national and at local level. Under the new legislation, planning was seen as the mechanism by which towns, in particular, could be redesigned. The Garden City was seen as the template which would improve both the living standards of the inhabitants and the aesthetics of the townscape. There was also a radical change in attitudes to who was responsible for new development. In the Edwardian era it was axiomatic that building development was best left to private enterprise, apart from housing for the working classes, which had been recognized as appropriate for government intervention. The new postwar towns and new urban development would be the work of government.

A number of towns and cities were seriously damaged by bombing during the Second World War. After the war it was felt that the centres of places like Plymouth, Exeter and Coventry, which had been particularly badly affected, should be redeveloped with little attention to what had gone before, to make a fresh start and to design towns suitable for the second half of the century. It was also believed that many other large and medium-sized towns, which had not been damaged in the war, would benefit from a new design, and plans were drawn up for city centres that reflected the new age of the car. Most of these involved improving road access to the middle of the town, by way of inner ring roads and gyratory systems, urban flyovers and extensive parking facilities. Despite grand aspirations, many of the new cities were rebuilt in the cheapest available material – concrete. There was a generally accepted belief that the new cities should be more egalitarian; thus, redevelopment was often accompanied by slum clearance and the construction of new estates, often of high-rise apartment blocks.

It turned out that for the most part the new postwar city centres presented only an illusion of improvement. In reality, they were often uncomfortable, inefficient and apt to become very shabby very quickly. Giving the car precedence catered for one aspect of modern living, but failed to provide an acceptable urban environment for shopping, walking and leisure. The car swallowed everything and wanted more; a fear grew that town centres would be reduced to one great car park. Many first-class historic buildings were destroyed, and in some places the environments of ancient towns were irreparably damaged through ill-conceived redesign. For much of the

Brackley, Northamptonshire, in the 1920s. A modern bypass has ensured the preservation of the heart of the historic town.

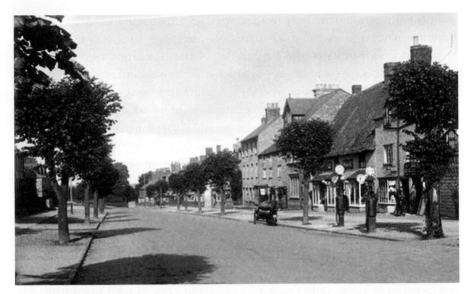

twentieth century there was an assumption that new building was better than old, and that historic buildings could and should be sacrificed to make way for new developments. It was only towards the end of the century that there was a reaction to the policy of development for development's sake. As a result, far greater emphasis began to be placed upon preservation and restoration, both of individual historic buildings and older urban environments. Buildings of all ages and functions, which previously would have been demolished, were salvaged and adapted for new uses. Generally speaking, the larger the town, the greater was its vulnerability to radical change; as we move down the urban hierarchy, the centres of the hundreds of small market and provincial towns remained remarkably intact. In part this was due to their having been bypassed by the fashion for city-centre urban redesign of the 1960s and 1970s, and having survived into the late twentieth century, when a far higher premium was placed on the preservation of historic buildings and environments.

Edwardian Towns

In 1900 there was considerable variety in English town landscapes. In general terms, the towns of southern and central England were enjoying an unprecedented level of growth and prosperity. In the last decade of the nineteenth century the eight fastest-growing towns in England were all suburbs or satellites of London, while in the North the long decline of heavy and manufacturing industry had already begun, and this was reflected in the decay and deterioration of many of the region's towns and cities. There were, however, several northern towns which did not follow this general trend: York, for instance, was growing rapidly, not on the basis of traditional heavy

industry but through railway workshops and marshalling yards, as well as Rowntree's mass-produced food manufacturing.

By 1900, four-fifths of the English population lived in towns and about half of these people were in conurbations. 'Conurbation' was a word first coined in this period to describe the areas around the great industrial and commercial cities. These dense concentrations of population consisted of a network of satellite towns – many of them old villages, market towns or small industrial towns – absorbed into the conurbation and grouped around a central core. The Potteries, for example, were once a collection of separate communities. Stoke, at the centre, had a municipal population of 30,458 in 1901. Another 184,500 people lived in the townships of Hanley, Longton and Burslem, and in the urban districts of Fenton and Tunstall. These were formally united in 1910; later, in 1925, Stoke was advanced to the status of city. But an unreal quantity hung about these creations. T. W. Freeman observes that, 'On the ground Tunstall, Burslem, Hanley, Fenton, Longton and Stoke are still recognizable as towns for each has its own shopping centre and even its own town hall'.[3] In common opinion, Stoke remains a non-city.

Many of the old industrial towns were in a state of advanced decay. In the early 1930s, J. B. Priestley reserved special scorn for Tyneside, and Gateshead in particular: 'Insects can do better than this ...'

> They used to build locomotives in Gateshead, very fine complicated powerful locomotives, but they never seem to have had time to build a town. A place like this belongs to the pioneer age of industrialism, and unfortunately the industry appears to be vanishing before the pioneers themselves have time to make themselves comfortable. It is a frontier camp of bricks and mortar, but no Golden West has been opened up by its activities. If anybody ever made

Central Gateshead at the end of the twentieth century. Gyratory road systems and high-rise apartments have replaced the bleak industrial landscape of the early twentieth century.

money in Gateshead, they must have taken great care not to spend any of it in the town ... How is it that a town can contain one hundred and twenty-five thousand persons and yet look like a sprawling swollen industrial village? The answer is that this is a dormitory for the working class.

Post-Second World War Gateshead continued to suffer and was particularly badly hit by the heavy industrial meltdown of the 1980s. In 1986, however, the Metro Centre at Gateshead was the first example of an integrated regional shopping and leisure complex and attracted vast numbers of visitors from a wide hinterland.

The advent of electricity was one of the most important factors driving change in towns in the early twentieth century. The new source of energy was rapidly applied to public enterprises in the form of underground trains, trams and street lighting. Shop lighting allowed the development of larger stores, and the illumination of window displays at night. Town centres were transformed into spaces for pleasure by night, taking on a new existence as offices and factories closed. Just as important as electric lighting was the use of electricity to power hydraulic lifts. Lifts enabled a substantial increase in the size of office blocks, as they made upper floors attractive to commercial tenants for the first time, starting a 'vertical transport revolution'. The lift also opened up the desirability of much taller buildings, made technically possible by the development of steel-framed construction techniques in America in the late nineteenth century. England's first steel-framed building was the London Ritz Hotel, built in 1904. Reinforced concrete also began to be used by the building industry from the turn of the century. Although there were very few really tall buildings by North American standards for several decades, these innovations did allow the development of much larger four- and five-storey department stores in city centres. Store size grew, culminating with the construction of Gordon Selfridge's massive Oxford Street store from 1909. Prior to 1890, most department stores had extended by way of successive extensions, either amalgamating or rebuilding adjoining properties, rather than through new construction.

Although city centres, with the exception of those in the half-dozen largest cities, were made up largely of small shopkeepers and craftsmen, large retail chains became increasingly important and began to dominate city high streets. Bainbridge's first department store in Newcastle upon Tyne had opened as early as 1869. Thomas Lipton started his first grocery in Glasgow in 1871, while in 1883 Julius Drewe opened the Home and Colonial stores in London, and by 1890 there were 107 of his shops in the country. Regional multiples, such as Hinton's in and around Middlesbrough, also developed. During the early twentieth century the number of chain stores increased dramatically, with each town boasting its own Woolworths, whose first British store opened in Liverpool in 1909. This American chain store led the way in offering a

very wide range of products at low prices, presented in an unashamedly popular way. The Co-op and Boots were to follow the Woolworths' methods. Jesse Boot opened his first chemist shop in Nottingham in 1877. By 1896 the Boots Pure Drug Company (later called Boots the Chemists) owned twenty-six shops in twenty-six towns. By 1914 Britain had a substantial large-scale retailing sector which had transformed the appearance of many city centres. Sixteen multiples had over 200 branches each, and seven of them had over 500 branches.

The rise of the department store was linked with the growth of consumerism in Britain. In turn, this was due to rapidly rising living standards and the appearance of mass-produced consumer goods such as factory-made furniture. Sales of furniture and other higher-cost items were encouraged by the growth of credit facilities. Expenditure on building and maintaining department stores rose: prestige fascias were used to give each multiple chain its own elegant, characteristic corporate style, while plate-glass windows, extensive lighting and marble or hardwood counters gave stores an attractive appearance. Boots the Chemists, for instance, had a policy of acquiring premises which would make attractive shop sites and rebuilding them, with the aim of creating 'a spectacular new shop whose size and layout eclipsed all other chemists' shops and, where possible, all other retail businesses in the locality'.[4]

In the early twentieth century local authorities were granted new powers, notably in the areas of education and housing. This movement had its start in the late nineteenth century, when slum clearance in English cities was undertaken with mixed motives. City-centre sites were valued at £1 million an acre by 1900, putting enormous commercial pressure on areas of the poorest housing. Consider the transformation of central Birmingham, using the Artisans and Labourers Dwellings Improvement Act of 1875. A ninety-acre area of 4000 back-to-back houses was cleared, but the corporation selected for purchase only half this district. Rehousing the 18,000 dispossessed persons was left mainly to private enterprise. The resultant showpiece was not the new council housing but a thoroughfare, Corporation Street, fronted and bordered by commercial premises. Everywhere more slums were demolished by private enterprise to extend business facilities than were cleared by municipal authorities from a humanitarian commitment.

Following the Town Planning Act of 1909, local authorities were empowered to prepare Town Planning Schemes 'with the general object of securing proper sanitary conditions, amenity and convenience in laying out and use of the land'. In Birmingham, the City Council led the way in 1913 with the Quinton, Harborne and Edgbaston scheme. This scheme proposed to link the suburb of Edgbaston with the outlying villages of Quinton and Harborne with broad highways, prescribed a maximum density of twenty houses to the acre, allocated land for parks and open spaces, made the erection

The Cowley Road between Oxford and the Cowleys in the early years of the twentieth century before it was built up.

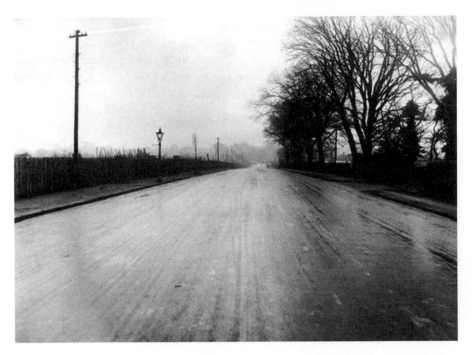

of factories and shops subject to special consent, forbade trades using noxious substances, and prohibited all but approved advertisements. Birmingham was, however, well ahead of the rest of country, apart from some London boroughs.

At Oxford in 1900, despite some development along the roads leading to them, Iffley, Temple Cowley and Church Cowley were still quite separate villages from the ancient university city. The medieval common fields of Cowley had extended southwards from the Cowleys almost to Magdalen Bridge, and it was the boundaries of the individual strips of these fields which were to form the basis of the streets between Iffley Road and Cowley Road. Indeed, the whole urban topography of this area was dictated by the original open-field divisions. By 1938, however, the two Cowleys had grown together to create the heart of the industrial centre of Cowley, which had virtually joined together with Oxford; only the low-lying areas of Cowley Marsh and Lakefield impeded the total fusion of the two settlements. By the end of the century, although Cowley Marsh was still partially open, with college playing fields and other recreational areas, Cowley and Oxford were inseparable. Only the creation of the post-Second World War Green Belt stopped Oxford from joining with other surrounding settlements such as Wheatley or even Woodstock. And nearby Kidlington, which was located within the belt and which had over 10,000 inhabitants, grew to be known as 'the largest village in Europe'.

As at Oxford, the expansion of the motor industry was an important factor in the growth of a number of other cities. Factories and workshops devoted

to the manufacture of motor vehicles were overwhelmingly situated in the South and Midlands, often in new suburban areas or even, as at Luton or Oxford, in towns which had at least in part a rural character and hinterland. R. C. Whiting, writing of Morris Motors Cowley before 1914, argues that the surrounding rural population had little to do with Oxford. However,

after 1920 the interpenetration of rural and urban was far more marked ... There were certain ways in which Oxford as a town within a largely rural area was bound to have some attraction as a centre for social activities once rural transport improved. In this way there were general changes, which brought the rural and urban worlds closer together; the impact of the Cowley works, located within what was still an outlying village, was more specifically economic.[5]

The main economic effect of the Morris works and its associated supply companies was to increase opportunities for employment. Arthur Exell, who worked at Osberton Radiators, one of Morris's suppliers, remembered the workforce in the late 1920s:

They were mostly locals at Radiators, though there were a few Cockneys. We had ever such a lot who had been farm labourers, and some had worked in the [Oxford] colleges. They were thankful for the work because it paid better wages.

Increased employment opportunities in the motor industry were reflected in the decline in the number of farm workers in Oxfordshire. Between 1921 and 1931, the number of farm workers, male and female, in England and Wales fell by about 10 per cent. In Oxfordshire the number fell by 32 per cent. Whiting estimates that by 1936, about 3000 ex-farm workers were part of the 5000-member workforce at Cowley.

J. B. Priestley remarked in his *English Journey* (1934) that the flavour of modern Britain was best savoured not in the centres of the great industrial towns but in the outer suburbs, traversed by new roads and dotted with new electric-powered factories.[6] Industry developed in random fashion on scattered sites, while heavy industry such as shipbuilding, and long-established manufactures such as cutlery and footwear and cotton goods, continued to operate in traditional areas. The rapid increase in motor and lorry transport, coinciding with extension of the electricity grid, enabled 'footloose' industry to take sites on less expensive land on the outskirts of towns, especially along new arterial or bypass roads.

The 1932 Town and Country Planning Act offered little assistance in controlling the location of industry: local authorities were not obliged to prepare planning schemes; and no funds were put at their disposal for purchasing land that was being used for industrial purposes to the detriment of other land in the vicinity. So development proceeded indiscriminately and

virtually unhindered; and in some parts of the country 'conurbations', so called by Patrick Geddes,[7] spread and sprawled over far greater areas than during the worst phases of the nineteenth-century Industrial Revolution. Suburban sprawl, whether of housing or industry, occurred far more in the relatively prosperous South East and Midlands than elsewhere. The economic slump of the late 1920s and early 1930s, and the ensuing high unemployment, were most acute in regions that specialized in one economic activity. Failure of the basic industry to find markets or to produce at costs lower than those of foreign competitors brought poverty and distress to north-east and north-west England, and started a drift of population to the Midlands and South East. Government was thus obliged to introduce a measure of control over the location of new industry; they designated four 'Special Areas', accorded them priority for government-sponsored factories (especially for munitions), and set up 'trading estates' at Team Valley near Gateshead, Hillington near Glasgow and Treforest near Cardiff. This form of control over industrial location went only a small way towards curing the ills, but formed a precedent for similar action after the Second World War.

Inner-city blight was to be a feature, particularly of older industrial cities, throughout the rest of the century. As suburbanization gathered pace, the central areas stagnated, and blackened public buildings were largely ignored by a generation attracted by ideas of a cleaner, more hygienic future. Those who could afford it moved from the cities into the suburbs or even the countryside, attracted by Arcadian visions. The vital link between the urban merchants, industrialists and professionals who had preached the 'civic gospel' in the nineteenth century and the cities from which their wealth derived was broken.

Municipal England

Although there had been a significant amount of new building in Victorian times, many provincial towns were still contained within their medieval boundaries. Those suburbs which had begun to grow tended to be close to the ancient urban cores, and, outside London, the location of suburbs was largely restricted by the walking or cycling distance from the town centre. Indeed, many provincial towns outside the industrial zone had changed little in size or in population since the sixteenth century. The years between the 1870s and the outbreak of the Second World War marked the zenith of urban 'local self-government' and saw the creation of a spate of municipal buildings. Until this time, many towns contained few public buildings apart from churches, and other public buildings that did exist, such as grammar schools and market halls, were often ancient. From the late nineteenth century onwards, however, a new range of large and often brash buildings appeared on the squares and high streets of many English towns and cities. By the

early twentieth century, each town centre was equipped with a full range of public buildings, including the town hall, public library, art gallery and museum, and post office. While most of these buildings were paid for by corporations, some were supported by local businessmen. The new art gallery at Bristol, for instance, was paid for by the cigarette manufacturer Sir W. H. Wills.

A new town hall often stood out as the most prominent building in an otherwise architecturally undistinguished neighbourhood. An example is at Croydon, a market town and commuter satellite ten miles south of London, whose population in 1900 was larger than that of any provincial town in England a century before. In Croydon, a neo-Jacobean town hall and police station were built in 1892–96 after a smaller predecessor had been demolished as part of a street improvement scheme. The town hall still proclaims the town's distinct identity, despite the virtual reconstruction of the town centre in

Cornmarket, Oxford, in 1922. The 'town' was adapting to the twentieth century.

the 1960s and Croydon's absorption as a London borough in 1965. Soon after Oxford attained County Borough status, an imposing neo-Jacobean town hall was built in 1893–97 in the heart of the city. The building celebrated the new municipal self-confidence which was emerging from the shadow of the University. Baroque architecture inspired by Christopher Wren's churches in central London was also used in the palatial town hall at Stockport (1904–8), part of the Manchester conurbation. Local government was also represented by other municipal service buildings such as new police and fire stations. At Halifax, for example, the police traditionally had been housed in the town hall; but in 1900 they acquired their own headquarters, which they shared with the magistrates' court in an imposing new building complete with a campanile. New fire stations could sometimes be equally impressive – in Manchester, for example, with its terracotta-clad station in Whitworth Street (1906). Distinctive smaller police stations and fire stations were also scattered through the suburbs of the larger towns. Evidence of public utilities also

appeared, both in town centres and in urban fringe areas: gasometers were followed by electricity generating stations and water towers as public services became widespread.

Between the wars, new premises were required to house the officials who administered the growing municipal empires and, while commercial building often declined during the Depression, grand blocks of local government offices, many in a neo-Georgian style, began to rise up in larger cities like Birmingham and Manchester alongside the existing Victorian town halls. Some towns in the South, the Midlands and the East, which escaped the worst excesses of the Depression, were able to build completely new civic buildings in the interwar years. For example, Norwich (1932–38) and Nottingham (1927–29) acquired new, larger town halls overlooking their ancient market places. At Southampton, a city which benefited from the transatlantic steamer trade, the town hall (1929–39) was part of a new and spacious civic centre on an open space called the West Marlands to the north of the walled medieval city, with a guildhall, law courts, a library, a school of art and art gallery, as well as local government offices. The construction of this complex and its associated approach roads encouraged a process under which the city's centre of gravity shifted northwards outside its ancient core.

The impact of government on the lives of the urban population in the late nineteenth and early twentieth centuries was particularly great in education. The direct involvement of the state in the building of schools began with the Education Act of 1870. In Nottingham, for example, by 1902 there were ninety-four Board schools and seventy-eight denominational schools, of which sixty-four were run by the Anglicans and the rest by the Roman Catholics. In many inner-city areas the Board Schools were, together with Victorian and Edwardian churches, the largest and most architecturally accomplished buildings. E. R. Robson, architect to the London School Board and author of *School Architecture* (1877), wrote: 'School-houses are henceforth to take rank as public buildings, and should be planned and built in a manner befitting their new dignity.'[8] In Birmingham, J. H. Chamberlain, a devotee of the doctrines of John Ruskin, designed a number of attractive red-brick schools, many of which still survive (though some are derelict) in parts of the city today.

School Boards also began to establish institutions to provide secondary education for some children, particularly after the Education Act of 1902. In Kent, secondary girls' schools were opened in nine towns – Bromley, Dartford, Dover, Erith, Folkestone, Ramsgate, Sittingbourne, Tonbridge, and Tunbridge Wells – between 1902 and 1906, and boys' schools were opened in similar numbers. These institutions, many of them offering an academic curriculum along grammar school lines, were normally located, like Bedford High School, among playing fields in the suburbs, and their architecture was usually neo-Georgian. Such schools, and their interwar successors, provided the setting of secondary education for many English adolescents down to the present day.

In the last part of the nineteenth century, higher education began to make a significant impact on urban landscapes other than those of Oxford and Cambridge, when the first civic or 'red-brick' universities came into being, some of them growing out of earlier institutions, such as Armstrong College in Newcastle upon Tyne and Mason College in Birmingham. The University of Birmingham received its charter in 1900, with Joseph Chamberlain as its Chancellor. The University moved out of the city centre to the southern edge of Edgbaston, Birmingham's premier middle-class suburb. Between 1900 and 1909, Webb and Bell built what was intended to be the first of a series of massive neo-Byzantine buildings radiating from a central campanile: a conception which remains impressive even in its incomplete state. Suburban parkland was also chosen for the 'palace of education' erected by University College, Nottingham, out of funds provided by Jesse Boot. Work started in 1922, and the college became a university in its own right in 1948 and has since expanded greatly on the same site. At Bristol, by contrast, the University remained on a site close to the city centre, from which it expanded piecemeal, culminating, between 1919 and 1925, with the erection of the Wills Tower, one of the last examples of secular Gothic architecture in an English town centre.

The uncompleted Edwardian campus of Birmingham University, dominated by the central campanile. Universities represented some of the most ambitious public buildings in the twentieth century.

At Leicester in 1919 another college and school development plan began when a local manufacturer named Thomas Fielding Johnson bought the county lunatic asylum (disused as such since 1907) together with thirty-seven acres which he gave to the town adjacent to Victoria Park. The asylum building and nine acres was for the college, and the remainder of the property was for a boys' and a girls' school. William Keay was appointed college architect, and in 1921 the adapted asylum (renamed the Fielding Johnson Building) opened as Leicester, Leicestershire and Rutland College, with nine students. It became a University College in 1926 and grew rapidly after the Second World War, from 109 students in 1944 to 741 in 1951, achieving more than local status. In 1946 the target number of students was set at two thousand, for which more accommodation was required. Between 1946 and 1958 the entire site was filled. In 1950 the city council sold the college the nine more acres of land that were opposite the original site. When, in 1957, the college became a fully-fledged university with a thousand students (a total which by 1984 had risen to over five thousand), Sir Leslie Martin drew up plans for science buildings on this new site.

At Newcastle upon Tyne the university occupies a site extending half a mile west from the Haymarket and Barras Bridge, where a miscellany of buildings has appeared since 1888. The original college had been founded in 1871 and was incorporated into the University of Durham in 1874. The building of 1888 was the first phase of a roughly four-sided group built by the college. In 1904 the institution was renamed Armstrong College in memory of Lord Armstrong, the local industrialist who had laid the foundation stone for the new building in 1887. The College of Medicine came to the Haymarket site only in 1937, when it joined with Armstrong College to become King's College in the University of Durham. By 1937 there were many more departments and buildings, and after the Second World War a master plan for the development of the site was drawn up. In 1963 King's College became the University of Newcastle.

Exeter University developed from the Schools of Art and Science, founded in 1855 and 1863, respectively, and from 1868 associated with the Albert Memorial Museum. The Royal Albert Memorial College, established in 1900 after the schools had merged with university extension classes, was based in the museum and in nearby buildings in Gandy Street. The Streatham estate, the nucleus of the present spectacular site to the north of the city, was acquired for the college in 1922. Exeter expanded slowly, for the college remained small and short of funds; indeed it was not granted a charter as an independent university until 1955, before which time degrees had been granted by London University. The ample, undulating grounds of the university now stretch east from New North Road to Pennsylvania Road, and include a splendid wooded valley on the northern fringe and much admirably preserved exotic late Victorian and Edwardian planting around

the former Streatham Hall. The setting is indeed far more memorable than the individual twentieth-century buildings awkwardly scattered over the hilly terrain. The topography does not lend itself to the gentle symmetry proposed by Vincent Harris's master plan of 1931, which envisaged a formal axis running up the steep slope to Reed Hall (the former Streatham Hall), with the main buildings fanning out from it to take advantage of the view over the city. The idea was given up after the war, when Sir William Holford, appointed planning consultant in 1953, devised a more relaxed layout of winding roads, with the principal centres established as self-contained groups strung along The Queen's Drive. The more incoherent and crowded assortment of large buildings further north and east dates from the rapid university expansion of the 1960s and 1970s.

City libraries were also an important reflection of the spirit of self-improvement that characterized late Victorian and Edwardian England, and cities and towns were as affected by this as they were by the building of educational institutions. A massive new central library had been built in Birmingham in the 1860s, and Chamberlain and Martin went on to design a series of suburban branch libraries, such as those at Spring Hill (1891–93) and Small Heath (1893). The latter was built on a triangular site which also include a public baths. Following the examples of schools and other public institutions, hospitals were increasingly located in the suburbs, where space was plentiful and fresh air more likely to be found than in city centres. Thus the Queen Elizabeth Hospital, Birmingham, was built close to the university in Edgbaston (1933–38), being designed on a symmetrical plan that grouped its buildings around courtyards to admit air and light. Buildings like this brought a modernistic character into the public architecture of the 1930s, and their presence helped to impose the values and demands of mass society on to what had once been quiet and prosperous middle-class Victorian suburbs: a movement which was to accelerate greatly after the Second World War.

As public authorities took on more responsibility for providing the cultural and moral infrastructure of urban life, the role of the churches correspondingly declined. Yet, paradoxically, some of the finest of all Anglican town churches date from the late Victorian and Edwardian years: these include the magnificent Church of England cathedrals at Truro (1880–1910) and Liverpool (1904), and countless churches in the suburbs. There was also great building activity among the Nonconformists. Starting in the 1860s, the Baptists, the Methodists and the Congregationalists began building large town-centre churches, often called Tabernacles or Central Halls, designed for revivalist preaching, with space for social clubs below the main auditorium. Many of these buildings are enthusiastically detailed, and several have prominent towers and spires, like the Victoria Hall in Norfolk Street in the centre of Sheffield (1908) and the Methodist Central

Hall at the northern end of the recently created Corporation Street in Birmingham (1903–4).

Nonconformist church building flourished until the First World War, but in the interwar years it was the Anglicans and, to a lesser extent, the Roman Catholics who made the greatest impact. Their parish churches are the only monumental buildings to be found in the outer suburbs of many towns. Ninian Comper's beautiful church of St Mary (1908–30) is a fine example of neo-Gothic, located in an otherwise undistinguished environment, in suburban Wellingborough. Buildings of this size and stature acted as a counterweight to those quintessential interwar secular buildings, the cinema, the public house and the semi-detached residence.

During the first half of the century, there was a new form of mass entertainment – the cinema. By 1914 there were already 3000 cinemas in Britain, many of them converted or part-time music halls. By 1939, the number had risen to almost 5000, including the new, purpose-built 'super cinemas' of the 1930s, often with greatly enlarged seating capacity of up to 4000. By 1937, Bolton had fourteen cinemas to serve a population of 180,000, while at York, in 1936, Seebohm Rowntree noted that the seven cinemas there attracted an audience of about 45,000 per week, almost half the population. Large cinema chains adopted the principle of spending their way out of the recession, with a programme of cinema building, and by 1939 something in the order of twenty million cinema tickets were being sold each week in Britain. At its height, in 1942, there were one and a half billion cinema visits in Britain as a whole.

The cinemas brought a totally new form of architecture to the high streets and suburbs of England. Odeons, Regals and Gaumonts mushroomed on prime sites in towns and were characterized by flamboyant and architecturally eclectic buildings. Almost every style imaginable was represented, from neo-Georgian to neoclassical, Italianate, Egyptian and modernistic. The interiors were as 'unreal' as the façades. Typical of one of the early picture palaces was the Picture House, Commercial Street, Halifax, which opened in 1913 and was subsequently renamed the Gaumont. It was a large neoclassical building, sited in a prominent position, with an octagonal tower and cupola. Some of the largest and most impressive cinemas were to be found in the suburbs of outer London. For example, the Astoria cinema, Finsbury Park, was one of the largest cinemas in the world when it was built in 1930. Its plain exterior contrasts 'with a fabulous escapist interior: a "fountain court" as a foyer, and a vast auditorium with starry ceiling and an "Andalusian Village"'.[9]

In Manchester, the Piccadilly, built in 1922, was the first of an even larger and grander genre of picture palaces. Overlooking the new Piccadilly Gardens, it contained a restaurant, café and dance hall as well as a cinema. The coming of talking pictures in the late 1920s created an alternative world of glamour and opulence in contrast to the harshness of the Depression years.

In Manchester, the Paramount, in Oxford Road, became the premier establishment of the 1930s. The Paramount's souvenir brochure enthused over the cinema's decoration:

> The general scheme of the theatre is a harmonious assembly of lighter tints such as gold, silver, grey and tones that please the sub-conscious eye ... the whole spirit is one of repose-content-one might almost say a caress to the senses to soothe the nerves and prepare it for a show ... The decoration of the auditorium is ... a free treatment of the Baroque period.[10]

During the twentieth century, as traditional heavy industries slowly ground to a halt, a new industrial phenomenon appeared – the light-industrial estate. These were normally located on the edge of towns and cities, providing accommodation for a vast range of light industrial activities. They were housed in basic building units that had no pretence of any architectural merit but which were cheap and functional. The estates relied on electricity for power, and the industries they catered for were termed 'footloose' because they did not have to be located in any one particular place. As they tended to use roads, neither were they dependent upon specific locations for their transport requirements as much earlier industry had been. By the end of the century, industrial estates appeared in a variety of guises – business parks, science parks, and enterprise estates; every town had at least one, and many larger towns had half a dozen or more. The industrial heart of England had been fragmented into thousands of separate units.

Trafford Park

The prototype of the industrial estate in Britain was Trafford Park, near Manchester. The park and the reclaimed area of Trafford Moss lay between the Ship Canal and the old Bridgewater Canal. The 1200-acre estate of Sir Humphrey de Trafford was offered to Manchester Corporation as parkland in the early 1890s. It was an extensive flat area to the immediate west of Manchester with excellent communications – the Salford docks lay on the north-western edge of the park. The corporation procrastinated in accepting the offer, and in 1896 the land was bought by Ernest Hooley for £360,000. Hooley then created the Trafford Park Estates Company and set about developing the former medieval deer park as an industrial estate – then a radically new concept. The Trafford Park Estates Company laid down a tramway to be operated by the British Gas Traction Company from 1897. The Trafford Park Estates Company took over operation from 3 November 1899, and gas traction was used to power trams until 1908. An electric tramway that ran on the public roads within the park started on 14 July 1903.

Trafford Park was the industrial home of the Co-operative Wholesale Society, a Rochdale-born organization which had a major food packing

The mammoth
Trafford shopping
centre from the air.

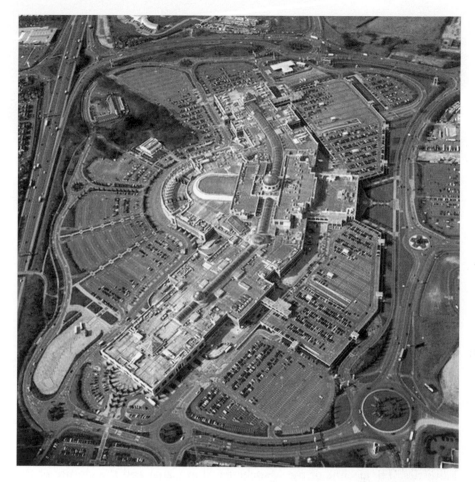

factory and a flour mill there – the Co-op had purchased land at Trafford
Wharf in 1903. Within the next few years, over forty companies had relocated
to Trafford Park, and it was, from the outset, a major economic success story
for Manchester. The British Westinghouse Electric Company purchased large
tracts of land in the park in 1899, and began manufacturing turbines and
generators there in 1903. A large housing estate was also built by Westing-
house to accommodate its workers. At that time, Westinghouse employed
half of the 12,000 people working within Trafford Park. In 1919 Westing-
house renamed the company Metropolitan Vickers – it was here that Alcock
and Brown met each other and talked the company into building and
supplying the Vickers Vimy aeroplane which they flew across the Atlantic in
1919.

Some of Trafford Park's earliest constructions were wooden grain silos built
by the Hovis Flour Mill (now Rank-Hovis McDougal) to receive the corn
from America and Canada that fed the population of Manchester. These silos
were destroyed in the 1940 Blitz and were subsequently replaced by concrete
silos on the adjacent Ship Canal. The Hovis company opened its mill here

in 1914. Rank-Hovis still have major production facilities in the park. Many of the buildings on the estate were factories and warehouses of no special architectural distinction, constructed from locally made bricks, with the lightweight forms of steel construction conventional in the early years of the twentieth century.

With widespread laying-off of textile workers in the two decades after the Great War of 1914–18, Manchester came to depend more than ever on its distribution infrastructure. In 1938 the Kellogg Company opened a major industrial complex at Barton Dock, and increased the importation of maize and grain products into the region on a large scale – their factory uses Trafford Park as its European headquarters and still makes corn flakes there. By the outbreak of the Second World War, Trafford Park had grown so much that it acquired the status of a borough in its own right. At its peak (around 1945), the park employed over 75,000 workers. Many foreign businesses were also attracted to Trafford. By 1933 over 300 American firms had bases in Trafford Park. The Ford Motor Company had moved to the park in 1910, and by 1913 the Model T Ford car was in production there. In 1931 Ford relocated to Dagenham, but Ford returned to Trafford during the Second World War to build Rolls-Royce aircraft engines. The Guinness Company began brewing in the park, and even went so far as to sink artesian wells to obtain clean water for their products. Later ICI built its first specialized factory for the mass production of penicillin here as well.

Trafford Park has continued to grow and has offset many of the worst effects of depression on employment in Manchester. Many new service industries have moved in, as well as light engineering and cleaner hi-tech industries. The decline of the Manchester Ship Canal and the closure of the Port of Manchester in the 1960s and 1970s was reflected in a depression in the park's fortunes. In the late twentieth century, however, the park's fortunes revived, as the M62 and M60 motorways began to fulfil the functions of the old Ship Canal; the park has once again found itself connected to the rest of the world. The Lowry Centre was built on the site of the old, derelict docks; the Imperial War Museum North now faces the Lowry Centre; and the Trafford Centre retail and leisure park has been built at Dumplington. Opened in September 1998, the Trafford Centre has attracted over 23 million visitors from all around Britain and further afield. At the time of writing, the Trafford Centre site covers 150 acres, and contains 100,067 square metres of retail and 29,954 square metres of catering space. There are 7000 people employed there. It has three miles of shopfronts, with 280 stores. Trafford Park is now the largest business park in north-west England and one of the biggest in Europe. The park now covers a total area of 1650 acres, and is the base for over 1400 companies employing in excess of 40,000 people.

Slough

Come, friendly bombs, and fall on Slough. It isn't fit for humans now.

John Betjeman, *Slough* (1937)

During the 1920s, the western and north-western suburbs of London became one of the principal industrial regions of Britain. This development was based on the munitions factories and depots which had been established around London during the First World War to supply the armies fighting on the Western Front. The Hyde, at Colindale, and Park Royal accounted for the greatest concentration of manufacturing activity in southern England at the time. The development that epitomized industry in the interwar period in the south of England was, however, the Slough Trading Estate.

Until the mid nineteenth century, Slough was little more than a scatter of buildings within the parish of Upton-cum-Chalvey; its parish church was St Laurence, Upton. A map of 1675 shows a few buildings round Crown Corner where the Bath Road met the Windsor to London road, and some more round the coaching inn at Salt Hill, further west on the Bath Road. In 1837, when its own church of St Mary was built, Slough still amounted to little more than these small clusters of buildings. Then the GWR arrived (1838), and a station opened in 1840. The railway brought industry, residents and visitors, as the station was the nearest to Eton and Windsor. The brickfields in this area began to be exploited, and a variety of other industries were started. A hotel was constructed and large houses began to appear north of the Bath Road, near the station, and south of it, close to the parish church. Upton was absorbed by Slough in 1837, and by 1900 the town had also spread west to engulf Chalvey. The population rose steadily throughout the nineteenth century until the First World War, from 2405 (1841) to 11,543 (1911). The growth of the town is reflected by the gradual enlargement of St Mary's church between 1876 and 1913. The town grew even more prodigiously after the founding of the trading estate in 1920, on War Office land to the west. In 1921 Slough's population was 16,000. By 1931 it had grown to 28,000 and later, after part of Wexham and Langley Marish were incorporated in the 1930s, to 60,000.

In 1917 a vast repair depot to service the entire mechanized transport of the British Army in France was established on the 668-acre Cippenham Court Farm, to the west of Slough. At the end of the war there were over a thousand vehicles awaiting repair; these and other military vehicles were bought by a syndicate of businessmen and sold off by auction. This formed the basis of the Slough Trading Company Ltd, later Slough Estates Ltd, which began to lease factories to manufacturers; and from 1927 it began to build them in advance of requirements. The company installed railway, roads, water, gas, steam and electric power supplies. Plots for factories were laid out along formal avenues,

some lined with grass verges. Many of the best-known consumer products of the interwar period were made at Slough: O-Cedar mops, St Martins jam, Aspro, Mars bars, Chappie dog food and Black & Decker tools. The effect on the town and its neighbourhood was immediate and permanent. By 1931 the population of the Urban District was over 33,000, and in the late 1930s there were a hundred firms on the trading estate, employing over 23,000 people. There was a simultaneous rapid and virtually uncontrolled residential development. Street after street was built of three-bedroomed semi-detached houses, often plastered white, with metal window frames set in rounded bays running across both houses in a pair, characteristic of the 1930s. More than 4000 private and council houses were built in the 1920s and 1930s, most of them in neighbouring parishes. By 1938 Slough had a population of 50,000 and was designated a borough. Although a pleasant town hall was completed in 1936, little attempt was made to provide an appropriate town centre.

The Second World War brought a temporary halt to Slough's expansion, but it started growing once again by the early 1950s. By 1971 there were over 87,000 people living in Slough and 800 factories on the trading estate, making pharmaceuticals, confectionery, television sets, and a wide range of machinery and electrical goods. Industrial development was by no means confined to the estate; for instance, ICI Paints Division was built in Wexham Road. Factories in Slough were rarely more than three storeys high and their entrance forecourts were often planted with trees and flowers. The industrial landscape of Slough is an altogether more humanized one than that to be found over much of northern and Midland England. Nevertheless, there was at the same time much rebuilding in the town's High Street; several tall, slab-sided office blocks of glass and concrete dominated the skyline, quite out of proportion with the nineteenth-century villas and terraced houses immediately behind them. Residential development had of necessity to keep pace with industrial growth, but stricter control has meant the infilling of existing estates, in addition to the building of new ones such as the London County Council estate at Langley, where little attention was paid to visual variety.

Most of the houses associated with the various phases of Slough's industrial development are unexceptional, and in the town centre there is precious little of note. All the Victorian villas in and around Wellington Street have gone, along with many others in the rest of the town. High Street (a stretch of the Bath Road) was partially redeveloped in the 1960s and 1970s, and Wellington Street was made into a dual carriageway to take the Bath Road traffic. In the 1960s, office blocks began to invade the streets round High Street, though the suburban air of some of the streets south of High Street has still not completely vanished. Many of the office blocks have been rebuilt for a second or even a third time since the 1960s, as successive waves of prosperity (for instance, the one that followed the opening of the M4 through Slough in 1963) touched the town. In 2001 Slough had a population of 120,000.

The growth of Slough was restricted by a number of factors – the town extended mainly along the east–west axis of Bath Road. Expansion to the north has been prevented by the existence of several large parks and commons, and further encroachment into Burnham Beeches, Farnham and Stoke Commons, and Black Park would not now be tolerated. Expansion to the south is effectively barred by the M4 motorway between the town and the Thames. Tuns Lane, the A355, provides the link between the town and the motorway, and at the same time it bypasses Eton and Windsor by means of a new bridge over the Thames. Another link road now joins this bypass to the old Windsor road. The view to the north from this road, encompassing factory and office blocks, electricity pylons and power station cooling towers, with huge aircraft flying overhead every few minutes as they make their approach to Heathrow Airport, presents a stark contrast to the view to the south, where Eton College Chapel and the keep of Windsor Castle rise above the tree-lined horizon.

Postwar Towns

By 1980 many English town centres had changed dramatically, and in some cases out of all recognition. The initial catalyst was the Blitz of 1940–42, which, by reducing large areas of cities such as Southampton, Coventry and Plymouth to rubble, set in train a process of rebuilding city centres along what were believed to be more rational lines, in keeping with the motor age. It was estimated that a third of the half-timbered houses in Coventry were destroyed in the Blitz. The city fathers subsequently destroyed almost all the rest. A unique row of historic houses of Great Yarmouth were half destroyed by bombs, but almost none survives today. Bombing was used all over England as an excuse for the eradication of houses as 'slums' that already, in West London, were being converted into smart residences for the new rich. Bulldozers wiped out areas of cities that today would form the historic districts rightly regarded as magnets of urban renewal for tourists and local citizens alike. Warsaw, Budapest, Hamburg and Tours restored, even rebuilt, their historic cores; at Plymouth, Southampton, Portsmouth, Bristol and Coventry the ancient centres were obliterated.

The lack of available funds during the immediate postwar era meant that rebuilding was delayed until the 1950s or even the 1960s. Moreover, the character of the rebuilding varied according to the extent of the damage and the preoccupations of the local authorities, whose powers were greatly enhanced by the Town and Country Planning Act of 1947. But there were certain common themes among the plans drawn up by the architects and city engineers: these involved the need for better roads and, above all, for an inner ring road around the town centre; the introduction of pedestrian shopping precincts; and the need to maintain population densities within the existing urban area so as to prevent the uncontrolled ribbon development of the 1930s.

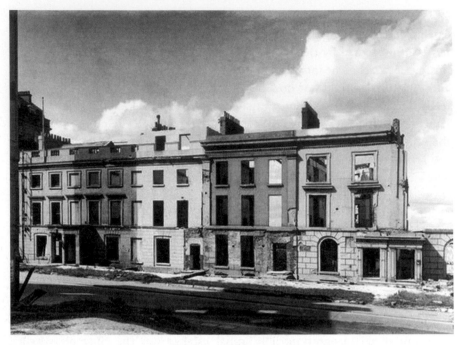

Bomb-damaged housing in Plymouth.

These concerns were carefully considered in the rebuilding of the city centres of Coventry and Plymouth, two of the very few instances in which the Luftwaffe presented the postwar planners with a virtual *tabula rasa*. In Plymouth, a city of a quarter of a million people in 1939, the plan, framed in 1943, envisaged a new layout of streets inside an inner ring road, with a main east–west street bisected by a broad pedestrian avenue leading from the railway station to the famous Hoe. At Coventry, too, the layout of the new shopping centre was unrelated to the older street pattern: here the shops were arranged in a single traffic-free pedestrian precinct – one of the first of its kind in the country – aligned on the surviving medieval spire of the blitzed cathedral. Both schemes were carried out after the lifting of stringent postwar development controls in 1954, and in both cases the bland, and now distinctly shabby-looking, low-rise architecture reflects the egalitarian and anti-monumental impulses expressed by the City Architect of Bristol in 1941, when he called for 'a good, simple and dignified architecture, cutting out all unnecessary "frills", and spending our money on good, sound hygienic ideas'. This generally shared desire to sever links with a discredited architectural and social past explains the creation of such mediocre monuments of postwar public taste as the Broadmead shopping centre at Bristol (completed 1960). It was only rarely, as in Basil Spence's new Anglican Cathedral in Coventry (1956–62) – one of the few genuinely popular public buildings of this era – that a more individualist and creative note was sounded.

During the war and for a decade or so after 1945 there was a shared belief

that planning could eradicate most of the prewar urban problems. It was a period of radical reports and Parliamentary Acts such as the Barlow Commission (1940) on industry; the Scott Report (1942) on land use in rural areas; and the Uthwatt Committee (1942), which provided a framework for planning administration and compensation. The Distribution of Industry Act (1945) enabled government to guide industrial development into what were believed to be appropriate areas. The New Towns Act (1946) provided the machinery for designating, acquiring and developing sites for New Towns, while the Town and Country Planning Act (1947) provided a comprehensive set of powers for land use and development.

There were many other reports and Acts during the second half of the century which were to have an impact on the landscape. One of the most important in terms of the visual townscape was the Clean Air Act (1956). This Act was passed in response to a specific crisis, the London smog of 1952, which killed 4000 people. It was, however, part of a movement for smokeless zones in towns – Manchester (1946), Coventry (1951), London (1955) and Newcastle (1958) – which resulted in putting a stop to harmful smoke emissions in built-up areas. Not only did the clean air legislation lead to healthier towns and cities, it stopped the continuing blackening of buildings, largely from domestic coal fires, which had been a feature of the urban scene throughout the century up to then. Corporations slowly began the process of cleaning up buildings, and town centres which had been black or grey changed colour to either red brick or white limestone.

Much of Exeter city centre had been lost in the air raids of 1942. Although Thomas Sharp's plan, *Exeter Phoenix*, of 1946 showed an appreciation of the best of the surviving older buildings, this did not prevent the north part of the High Street, where war destruction was worst, from being rebuilt in the undistinguished manner favoured by developers of the 1950s. The south-west section, where slum clearance had begun in the 1930s, was savagely fragmented for an inner road (a departure from Sharp's original plan for a northern ring road), so that the river and its quays are no longer an integral part of the city centre. Additionally, the Guildhall shopping centre, developed from 1969, involved the destruction of the best surviving medieval frontage

Postwar 'brutal' concrete redevelopment in Plymouth at the Tricorn Centre.

(No. 38 North Street), the gutting of older buildings, the replanning of back streets and the imposition of car parks. As a result, the surviving historic buildings in the city centre can only occasionally, as in the Close or in parts of Southernhay, be enjoyed as part of a visually satisfying townscape.

Elsewhere work continued on the redevelopment of countless town centres, including many that had not been affected by bombing. Local authorities were encouraged by central government to work in partnership with private

developers, who had been accumulating town centre sites, often at very low prices, ever since the end of the war. With the lifting of building controls after 1954, these developers and local authorities were in a position to embark on the largest commercial assault on town centres ever. The role of the local authorities was to provide the roads and car parks needed to enable the growing number of car-owners in the suburbs to exercise what was almost universally believed to be their right to free movement to shops and offices in city centres. With the number of motor vehicles doubling in the 1950s, and both population and traffic projections moving upwards, it was hard to counter the argument of the influential planner Colin Buchanan that: 'If we are to have any chance of living at peace with the motor car, we shall need a different kind of city.'[11] For example, after the Second World War, Newcastle became established as the major shopping and entertainment centre of the North East, and the massive replanning of the city centre that was undertaken in the 1960s was followed by a transport scheme of similar scale. By the time the huge Eldon Square shopping centre was opened in 1978, and the Tyneside Rapid Transport System ('the Metro') began operating in 1980, some aspects of the plans of the 1960s had been dropped; but not before many of the buildings of the historic centre had been destroyed to make way for new roads and developments that were not always of the highest quality.

Some of the impetus for the rebuilding of English city centres came from the architectural profession. The vision of a totally redeveloped city centre, with high, glass-clad concrete buildings set amid abundant open space, had attracted radical British architects ever since the publication of Le Corbusier's *The City of Tomorrow* in 1929. By the early 1960s the architectural avant-garde had become the new establishment, and 'modernist' architects were

Two generations of multi-storey car park in central Bedford.

Carfax in central
Oxford at the
beginning and end
of the twentieth
century. Coping
with motor traffic
remains Oxford's
main problem.

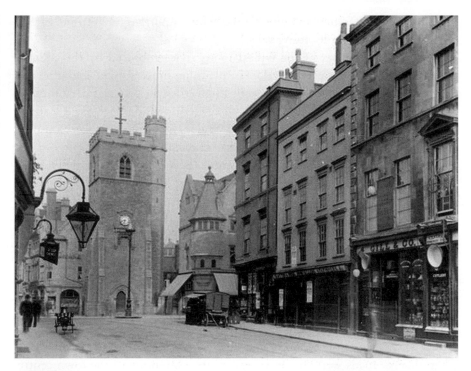

employed both by public authorities and commercial developers. Not only
was modern architecture new and (at the time) glamorous, it also had the
advantage of being cheap – especially when the lack of ornamental detail
was taken into account. The new style also lent itself to speed and ease

of construction, factors that were especially important at a time of full employment and rapidly rising wages.

The negative impact of the typical 1960s style embraced by this alliance of local politicians, property developers, planning officers, road engineers and architects can be seen in almost every English town. Some, like Worcester and Derby, suffered especially badly, but few escaped 'damage' on a scale far outweighing that of the Second World War. The 1960s imperative was to create a ring road that would allow easy vehicular access to all parts of the town. In a place like Wolverhampton, where there were few historic building constraints, this was achieved relatively easily. In Hereford a *cordon sanitaire* in the shape of a ring road hugged the medieval town walls; similar inner ring roads were built at Canterbury and Chichester, alongside the Roman and medieval walls. But in Worcester the relationship of the cathedral complex to the main bridge across the River Severn meant that the southern section of the ring road could only be built at the expense of the historic core, and this is exactly what was done. An incredibly insensitive roundabout, whose function is now largely redundant because of pedestrianization, actually cut across the northern part of the ancient cathedral close. In another negative development of the 1960s and 1970s, at the chemical- and glass-making town of St Helens, roads were ruthlessly pushed into the heart of the town centre, and were accompanied by unlovely multi-storey car parks. This resulted in the centre of the town losing its own character. Later pedestrianization of the remaining core failed to provide a recognizable identity for this fragmented town, which has something of the feeling of the Blitz about it even today.

Even in central Oxford, where much of the land was owned by the fiercely independent colleges of the university, the ancient district of St Ebbes, which contained the only area of working-class housing within the medieval city walls, just to the south west of the city centre, was destroyed. It was replaced with the usual mixture of inner ring road, concrete shopping mall (the Westgate Centre), and a hideous multi-storey car park. By the end of the century, plans were already being drawn up to rebuild the unloved, dysfunctional Westgate shopping centre. To create the Westgate Centre, the inhabitants of St Ebbes were rehoused in out of town council estates such as Barton and Blackbird Leys. One segment of Oxford's inner ring road that was not completed was across Christ Church Meadow, an area of open park and meadowland between the River Thames and Christ Church. The proposal, which originated in Thomas Sharp's *Oxford Re-Planned*, was designed to protect the High Street, described by Sharp as 'the greatest and most typical work of art England possesses'. The proposal for the Christ Church Meadow road stirred enormous controversy and for over twenty years this issue deadlocked planning in central Oxford. Even at the height of the Suez Crisis in 1956 the Cabinet found time to debate the matter and, not unexpectedly (five of its members were Christ Church men), stalled the

proposal. This delay was crucial as the climate of opinion was shifting against unlimited provision for the car. By the time the Labour Party gained control of the council in 1972, it felt able to throw out the inner city relief road option altogether.

At Shrewsbury, the county town of Shropshire, determined attempts were also made to bring the town into line with the new orthodoxy, but the geography of the urban centre defeated all attempts to build an inner ring road within the tight loop of the River Severn. The town did not, however, escape unscathed – a large area of half-timbered houses and shops was destroyed to create a bus park; a perfectly respectable, centrally located Victorian market hall was replaced by a dysfunctional concrete shell in the 1960s; and a steady stream of unique, historic half-timbered buildings were casualties to the urge for change for change's sake. The undistinguished county hall buildings in the centre of town were demolished to allow in the usual range of undistinguished chain stores, but the replacement Shire Hall in the Abbey Foregate suburbs adjacent to Lord Hill's Column is generally regarded as a successful example of modern architecture.

At Gloucester in the 1960s and 1970s, city centre redevelopment was heavy-handed, with little attempt to preserve any surviving worthwhile buildings later than those originating from the seventeenth century. Much of the shopping area was completely rebuilt, and there are few compensations: the Corbusian Eastgate Market Hall (1968) and King's Square (1969–72) are exceptions to the generally negative aspects of Gloucester's rebuilding. Conservation, never the city's strong point, at last blossomed in the 1980s, heralded by the City Council's bold relocation to nineteenth-century warehouses at the Docks.

In many towns and cities the building of new roads was often accompanied by the construction of offices for the local authorities who planned them. Thus the skyline of Aylesbury, a market town of only 51,000 inhabitants in 1991, became dominated by a brutal twelve-storey concrete office tower which reared up in 1963–66 to house the employees of Buckinghamshire County Council. In other towns, the local government reforms of 1974 were followed by the building of yet more offices for the growing number of local authority employees. At Reading, when a new block of civic offices was erected next to an inner ring road in 1976, the nineteenth-century Town Hall in the Market Place was lucky to escape demolition. Then a massive new Shire Hall for Berkshire was built next to the M4 motorway on the southern fringe of the town, only to become redundant in 1998 when the County Council was abolished under legislation splitting the county into 'unitary authorities'. 'Impersonal buildings like these witness both to the growing power of officialdom in the modern world and to the collapse of the tradition of enlightened architectural patronage by local authorities in the postwar era.'[12]

In the latter part of the century, much urban infrastructure which dated

from Victorian times needed to be replaced; notably, centrally located hospitals were replaced by giant new hospitals, normally located on the urban fringe. Powell and Moya's Princess Margaret Hospital near the M4 at Swindon (1957–9), the John Radcliffe Hospital in Headington, Oxford (1980–90) and, in a more central location, the massive, monolithic Royal Hallamshire Hospital at Sheffield (1948–79) became great regional medical palaces. The impact of such buildings on their surroundings was considerable: not only were there service roads and the usual car parks, but housing for the large contingents of nursing and ancillary staff was also created, both as blocks and as conversions of existing housing. School building also expanded, especially after the decision in the 1960s to pursue comprehensive education. Dour, flat-roofed, Bauhaus-like comprehensive schools stranded amidst acres of grass and tarmac can be seen in every English town above a certain size. These new schools and colleges were much larger than their predecessors and took over large swathes of land either on the edge of, but more often within, the new suburban estates of the 1970s and 1980s. Elementary (primary) schools were also rebuilt in large numbers, but, although they tended to be smaller and more humane in character, even these were considerably larger than their predecessors.

The landscape of the third quarter of the twentieth century was dominated by governmental activities and initiatives, both at national and at local level. There was a considerable expansion of higher education in the aftermath of the Robbins Report of 1963, which argued persuasively for the provision of higher education for a much larger percentage of the population of school leavers. New universities were established, usually on the fringes of ancient cathedral cities or in open countryside. Funded by central government, they were inspired by Prime Minister Harold Wilson's vision of a future shaped by the 'white heat of technology'. One such new institution of higher education, the University of East Anglia at Norwich (1962–68), attracted much attention for its architectural originality. The city had donated what had been the Earlham municipal golf course for the site of the campus, and traces of the fairways can still be seen around the grounds today. In 1962 Denys Lasdun (who also designed the National Theatre) was appointed as UEA's founding architect and was asked to produce an integrated physical design that would reflect and complement the academic structure. It was Lasdun who designed the University's core buildings, including the monumental Teaching Wall, the raised walkways, the central Square and, most famously, the striking 'ziggurats' of Norfolk and Suffolk Terrace. His plan was that no building on campus should be more than five minutes' walk away from any other. In another example, the buildings of the University of York, begun in 1962, were integrated into an existing parkland landscape in what was generally considered a successful manner.

At York a collegiate-style university was planned in 1962 on an open site

adjoining Heslington Hall. The first colleges were opened in 1965. Here, where speed of construction and low cost were essential, the CLASP system (with its modular, prefabricated parts) was accepted as the main building technique. The architects avoided monotony by setting the buildings in a varied landscape, with a large serpentine lake as the unifying feature. The most original building is the Central Hall, 1968, a half-octagon cantilevered over the lake. It was not until the late 1980s that the first major break was made from the original concept, with the design of brick accommodation blocks in a traditional style around open courtyards. Much building was also carried out by the older 'red-brick' universities and the numerous colleges of technology and further education; they were often situated near the central core of the towns they served, however, and expansion here meant building upwards, as in James Stirling's engineering building at the University of Leicester (1959–63), which became an icon for the younger generation of British architects.

In the last quarter of the twentieth century, decentralization was a dominant feature of British towns and cities, and its main impact was on manufacturing and industrial activity. It took over a hundred years, from 1851 to 1951, for technology and foreign competition to halve the numbers employed in British agriculture; it took only thirteen years, from 1971 to 1984, to cut manufacturing jobs by one-third.

> There are striking parallels between the 1880s and the 1980s. Then rural England was in the process of losing much of its traditional economic base. Now it was urban England's turn. The root cause in both was structural transformations arising from the new technologies and the changing balance of geographical disadvantage.[13]

Over four million people live in the inner cities of the UK. These areas are often characterized by economic decline, personal poverty, social problems and environmental decay. Since the 1950s there has been a widespread movement of employment away from the large cities to smaller urban towns, suburbs and rural areas. The decline in manufacturing was accompanied by a growth in employment in service industries. This growth, however, did not completely compensate for the massive job losses in manufacturing. The de-industrialization in the inner cities was accompanied by the expansion of both the manufacturing and service sector forms of employment in rural areas and small towns.

This dramatic change can be partly explained by the changing levels of technology and space requirements of manufacturing industry, which resulted in a shortage of suitable land and premises in the inner cities. The consequent employment losses were biased towards the inner cities because they contained many of the types of workplaces most likely to be closed down. These were the older plants with the oldest production techniques, lowest productivity and most highly unionized workforces. Unemployment thus

became a major problem for the inner-city areas of the former industrial centres of Liverpool, Manchester, Sheffield, Newcastle upon Tyne and Birmingham. Between 1951 and 1981 the UK's largest conurbations lost 35 per cent of their populations. For example, the migration of population from inner areas of Liverpool and Manchester led to a population decline of over 25 per cent in the 1970s. Many of these people moved away from inner-city areas in search of better employment and housing opportunities. In the 1960s and 1970s such migration led to the expansion of the small towns around the large conurbations. And from the 1980s a significant proportion of the out-migration from cities involved people moving to rural areas, a process known as counter-urbanization.

The physical environment of the inner cities was usually poor, with low-quality housing, empty and derelict properties, vacant factories and overgrown wasteland. The physical deterioration of inner-city environments was characterized by high levels of vandalism and dereliction. These areas also tended to have very few public environmental amenities, such as parks, open spaces and play areas. The more recent construction of urban motorways, with their flyovers, underpasses and networks of pedestrian walkways, contributed further to the bleak, concrete-based landscape. Some of this dereliction is also due to the continued existence of remnants of poor-quality nineteenth-century terraced housing. Slum clearance schemes of the 1960s and 1970s, however, created equally unsightly estates of poorly constructed houses and high-rise flats. Many of these have since been demolished, but some still remain as unpopular and difficult living environments. There were many attempts to deal with the problems of run-down inner city centres. There were signs by the end of the century that some of these, at least, were beginning to succeed. A more sensitive approach to redevelopment, backed by direct government grants and Lottery money, began to pay dividends. In places like Liverpool and Sheffield derelict industrial and port facilities were turned over to tourist and amenity uses, improving the urban environment immeasurably. Although many problem areas remain, the quality of many town and city centres in northern England enjoyed a renaissance at the turn of the century.

At the other end of the spectrum is the process of gentrification. This occurs when housing is improved in association with a change in the neighbourhood composition when lower-income groups are displaced by more affluent people who are usually in professional or managerial occupations. It is a process by which the regeneration of some inner-city areas takes place, carried out by individuals or groups of individuals, and not by supported bodies. Gentrification involves the rehabilitation of old houses and streets on an individual basis, but it is also openly encouraged by groups such as estate agents, building societies and the local council. One of the clear positive outcomes is that the social mix of the area is changed in the direction of

greater affluence. The purchasing power of the residents becomes greater, which leads to a rise in the general level of prosperity in the area. The area becomes dominated by 'yuppies' (young upwardly mobile professionals), with a subsequent increase in the number of bars, coffee shops, restaurants and other higher-status services. There are negative outcomes of gentrification; for instance, local people on low incomes find it increasingly difficult to purchase houses, as the price of refurbished property rises markedly. Indeed, the size of the privately rented sector diminishes as more properties are sold off, and, in some cases, friction and conflict occurs between the newcomers and the original residents. Examples of gentrification include Notting Hill and Islington in London, Brindley Place in Birmingham and the Castlefields area of Manchester. 'Gentrified' upmarket converted dwellings can now be found in the central parts of most towns. Other areas where there has been total

Decaying warehouses in the port of Liverpool have the feel of ancient Ostia or Herculaneum about them.

redevelopment of a similar nature include the Albert Dock in Liverpool, the Salford Quays in Greater Manchester, the Quayside in Newcastle and the Marina in Hull. These are all waterfront locations which are particularly attractive and often provide a focus for such new developments.

The development of out-of-town supermarkets and shopping centres has had an important impact on retailing within many well-established town centres. Much essential shopping is now done in supermarkets located on the edge of town, or at least away from the centre, with shoppers arriving by car. Between 1975 and 1985, large-scale retail organizations began to develop large out-of-town sites, such as Brent Cross in suburban north London. This was followed by the Metro Centre, Gateshead; Merry Hill, Dudley (470,000 square feet); and Meadowhall, Sheffield (400,000 square feet), built on the site of an abandoned steelworks and crowned by a metal and glass dome – a reference to the former industrial glory of the city. The Lakeside Centre at Thurrock (400,000 square feet) was a similar development. In the 1990s retailing developed into a form of shopping tourism, with the emergence of outlet malls or shopping villages, such as the Clarks (Shoe) Village at Street in Somerset, and the outlet fashion shopping 'villages' at Bicester (close to the M40 in Oxfordshire) and at the former Great Western works at Swindon (Wiltshire), which became tourist attractions in their own right; shoppers travelled long distances in large numbers, often brought in by coach, in order to visit them. Shopping in the old centres, often in areas which have been pedestrianized, has become restricted to low-bulk, high-turnover products, such as greetings cards, mobile phones and fast foods. Other businesses found on almost every high street are estate agents, cafés, insurance brokers and travel agents. Bakers, butchers and greengrocers are a dying phenomenon in their traditional locations.

Allied with new shopping developments have been positive moves towards traffic control and management. This development has also included in-town shopping-centre projects, such as Nottingham's Victoria Square and Broadmarsh, and Newcastle upon Tyne's Eldon Square, which have been designed to add to or upgrade more traditional retail provision. Between 1984 and 1994, 95 per cent of new retail space was developed in existing city centres. Large department stores continue to invest in city centres and local authorities improved central city environments by landscaping and traffic management schemes, and many office functions that have a high level of direct contact with consumers continue to locate centrally.

Between the early 1970s and the early 1990s manufacturing jobs in Britain declined from 7.5 to 4.3 million. The main industries affected were those that had been established in the nineteenth and early twentieth centuries. Their growth had been based on the use of coal and imported raw materials, such as iron ore and cotton, and a key aspect of their development was the ability to export finished products to other countries around the world,

A rare survival of heavy industrial landscape on the River Calder in Lancashire.

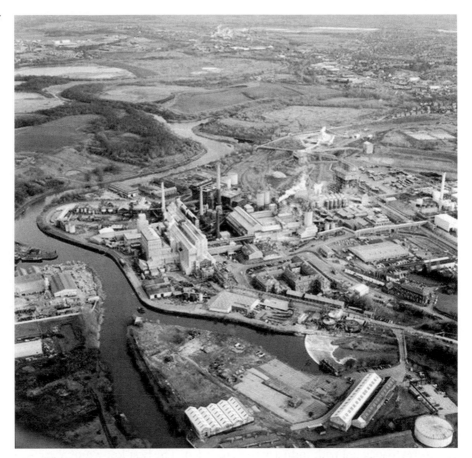

particularly former colonial countries. Consequently, the major industrial areas were either on the major coalfields or at coastal ports located on deep water estuaries. Industries involved were notably textiles in West Yorkshire (Leeds, Bradford, Huddersfield) and in Lancashire (Bolton, Bury, Burnley); steel in Sheffield and Middlesbrough; and shipbuilding in Newcastle and Sunderland. Additionally, there was chemical-based industry in the North East (Middlesbrough) and the North West (Widnes and Runcorn), while the car industry and component suppliers were located in Birmingham, other parts of the West Midlands, Luton and east London. Clothing, food-processing and other port industries were found in the East End of London, and pottery and other household-goods manufacture were in the area around Stoke-on-Trent. All of these areas were hit by plant and factory closures in the decline in the manufacturing base of British industry. Initially, high unemployment of a specialist workforce was common, but all of the regions affected were restructured in one form or another.

For much of the twentieth century, the coalmining and other extractive industrial areas were characterized by a landscape of spoil tips and waste. At its height, just before the First World War, the immense northern coalfield

employed almost a quarter of a million men; by the end of the century the coal industry in the region was nearly dead. The virtual end to coalmining in Yorkshire, Nottinghamshire and Derbyshire was followed by a cleaning-up campaign. In particular, the Millennium Commission undertook the reclamation of some of the worst wastelands. Derelict collieries, former chemical dumps, old quarries and industrial areas have been transformed into parks, wildlife areas, gardens and sports facilities. Even one of the bleak landscapes portrayed by L. S. Lowry in the Irk Valley of Manchester has been transformed. His painting 'Britain at Play' showed a run-down area, known as Angel Meadow, at Collyhurst. Under the Millennium scheme the area is now given over to parkland and would be unrecognizable to Lowry. Areas of industrial waste were viewed as symbols of lost enterprise, but more than that they were also dangerous, and it was increasingly understood that the land could be more profitably used. Thus in the 1980s and 1990s many coal tips were levelled or grassed to use for parkland, housing or light-industrial activities. Some of the land was polluted and had to be treated in the same way that landfill sites were handled. As this involved careful monitoring of noxious gases and subsidence, such sites tended to be left as open ground for several years before they could be reused.

The buildings associated with old industry also posed a problem. Many of them were simply destroyed, others were of sufficient historic or architectural interest for them to be salvaged and used for other purposes. A rash of new industrial museums was experienced across England, particularly in the North, in the last part of the century; mills, warehouses, kilns and a wide range of other structures associated with industry were recycled. The best known of these was at Ironbridge in Shropshire, the reputed 'cradle of the industrial revolution'; others were found at Burslem. Almost as soon as the collieries closed, some of them were transformed into museums of coal mining. Although not all the enterprises that grew out of the relics of heavy industry were successful, and there was a high casualty rate amongst the new museums and theme parks, the changeover was remarkably smooth. Both the plant and landscape of the old industrial world was 'rehabilitated' in a relatively short time. It was sanitized and municipalized – made user-friendly. The 'dark satanic mills' had become bright new museums of the lost manufacturing industry.

Consett lies about twelve miles to the south west of Newcastle upon Tyne, on the eastern edge of the Cheviots. It began as a steelmaking town in 1840, based around local deposits of coking coal and blackband iron ore. By the late 1880s the furnaces at Consett were producing 10 per cent of the nation's steel. The town, which grew up around the steelworks, was largely owned by the British Steel Company. The town was particularly badly affected by the decline in demand for coal and steel in the latter part of the twentieth century. In the mid 1960s, the British Steel Corporation had a workforce of 250,000 producing nearly twenty-five million tons of steel at twenty-three centres; by

the mid 1990s, British Steel had reduced its workforce to 55,000, with a production of fourteen million tons at just four centres. This decline was prompted by huge overproduction of steel around the world, with new steel-making facilities in places such as India, South Korea and Taiwan. As a consequence in Britain steelmaking was cut right back. Many high-cost inland locations, such as those at Bilston in the West Midlands and Consett in north-east England, were closed.

In 1980, with the closure of the Consett works, production was transferred to the more 'cost-efficient' works on the coast at Redcar–Lackenby. The local raw materials at Consett had long since been exhausted, and financial losses were high due to the small capacity of the works. The main market for the Consett plant, shipbuilding on the rivers Tyne and Wear and at Barrow-in-Furness, had also largely closed down. Closure of the Consett works resulted in the immediate loss of 4000 jobs, and the town faced economic disaster. Male unemployment in the town was anticipated to rise to 30 per cent, adding to the unemployment already brought about by the decline of the surrounding coal industry.

Contrary to expectation, however, Consett did not die as a town. Shortly after the closure of the steelworks, a number of organizations (private businesses, local government agencies and the local authority) set up the Derwentside Industrial Development Agency. This encouraged a number of light manufacturing and IT companies to move into the area. Over 200 companies were established in new purpose-built units, creating over 3500 jobs in total. These companies were encouraged by grants and loans, and also by the substantial improvements made to the local environment, such as the planting and landscaping of the industrial spoil tips. In terms of retail trade, Consett town centre continued to prosper. By the early years of the twenty-first century there was a lower level of vacant retail floor space than the national average, despite the close proximity of major shopping centres in Durham and the massive Metro Centre in Gateshead.

In those cities where industry had been centrally located, such as Birmingham with its jewellery and gun quarters, these activities declined or, more often, ceased altogether, leaving a range of industrial workshops and stores either to be demolished, preserved as museums, or adapted for such other uses as housing or offices. Like retailing, light industry moved to the city edge, into the trading estates or science parks that became the new industrial base of England by the end of the century. Such estates, with their anonymous single-storey aluminium or plastic structures, were to be found in every city and town in the country and in many rural areas as well. They represent a quiet and largely uncharted landscape revolution, reflecting industrial fragmentation and a speed of change in the nature of the national economy unknown to previous generations.

The majority of new manufacturing industries in the late twentieth century

were high technology industries, such as computer and computer-related equipment manufacture, telecommunications and microelectronics. In addition, many of the traditional industries, such as car manufacture, advanced by adopting new technologies and working practices. A key feature of these types of industries was the importance of Research and Development. This is needed to develop new products and modify existing products, as well as to keep 'ahead of the game' in terms of product design. For these 'new' industries a highly skilled and qualified workforce is essential, while access to raw materials is less important. Consequently, the new industries have become concentrated in areas where the workforce can either be attracted or is already available. Such industries are sometimes called *footloose*, in so far as their geographical location within the country is relatively unimportant. They are also known as sunrise industries and are most commonly found on new industrial estates on the edges of towns, or alongside motorways, close to an efficient transport system for distribution purposes. The main areas of new industrial growth are around the Cambridge area and along the M11; the 'Sunrise Strip' of the M4 corridor; the new car assembly plants in the North East (Washington) and the East Midlands (Burnaston); and many small light industrial estates in rural areas such as East Anglia and Sussex.

This industrial and economic development reflects changes both within the UK and around the world. There was massive investment in UK-based industries by overseas transnational companies, particularly from Japan, South Korea and Germany. In the case of the motor vehicle industry, a number of Japanese car manufacturers moved to the UK and built huge new plants; the three largest were Nissan, Toyota and Honda. Nissan began production in 1986 with an initial output of 100,000 cars per year, rising to over 270,000 in 1993. Their factory at Washington New Town, in the north east of England, represented the largest single investment by a Japanese company in Europe. Other similar investments followed at Burnaston, in north Derbyshire, where a large Toyota plant was built next to the A38 trunk road, and at Swindon, with the Honda assembly plant on the M4. Further industrial investment followed in other parts of the UK. In these industries, speed of access to people, raw materials and products was important, and the building of the motorway network and the development of provincial airports for ease of communication have been major factors in their success.

Proximity to universities, with their expertise and research facilities, and to highly skilled and intelligent labour has also been a factor in their success. The first and biggest science park in the UK was at Cambridge, located on the northern edge of the city. There are well over 700 hi-tech companies within the Cambridge region (known as 'Silicon Fen'), and they employ over 20,000 people. The building of the M11 also acted as a growth factor, and in 1999 Microsoft chose Cambridge as the centre of its European

operations and began work on its first European computer research centre. Its creation encouraged yet more companies to move into the area, keen to take advantage of the 'synergy' that will develop. To many of these new industries, an attractive environment is a very important factor, and their locations have the outward appearance of a suburban estate. Many business and science parks have been built on greenfield sites, where the relative low cost of land has been an advantage, with access to high-quality, low-density rural housing.

Other developments have been less structured. Until the mid 1980s, 'Westwood', in the Isle of Thanet, east Kent, was the name for the cross-roads between the main roads serving the area's three long-established coastal resorts – Margate, Broadstairs and Ramsgate. Today Westwood is a vast developed sprawl in the centre of Thanet, featuring massive retail and business parks, a motorcycle training centre, a riding establishment and a branch of the University of Kent, all adjacent to market gardens, isolated old farmhouses and farmworkers' cottages, and a former mental hospital; the road names bespeak the juxtaposition of old and new – 'Poorhole Lane' beside 'Enterprise Road'. Similarly, north of Bristol, an employment and shopping centre has grown up over what was agricultural land. This development has become so large that it now rivals in size the central business district of Bristol itself. The close proximity of three motorway junctions has also attracted a science park, the procurement headquarters of the Ministry of Defence (one of the biggest office developments in Europe, with a workforce of 6500), British Aerospace, Rolls-Royce, the European headquarters of Orange, and the European headquarters of Hewlett Packard, together with a shopping mall offering as much retail space as the main shopping centre in the heart of Bristol. The University of the West of England is also located here. Yet the whole area, which provides employment for 34,000 people and has an employment capacity of 66,500, is known only as the 'North Fringe'.

Newcastle-upon-Tyne

Much of Tyneside beyond the centre of Newcastle changed rapidly after the First World War. Many of the Victorian and Edwardian houses, described by Henry A. Mess in his social survey *Industrial Tyneside* (1928) as small, densely packed and overcrowded, were demolished and, between the wars, the inhabitants moved to large new local-authority housing estates on the edges of the towns. Mess recognized the sound construction and good accommodation of the Tyneside flat, but he criticized the layout of the streets. In general they cut across the contours of the land, which may have been efficient for drainage but made walking and transport difficult. Mess pointed to the better layout at Lemington, where Newburn Urban District Council had begun a different sort of housing after the 1919 Housing Act.

This was established under the direction of W. A. Harvey, whose best-known housing was at Bournville, for Cadbury. These interwar council estates were influenced by the Garden City and Arts and Crafts movements, and in Newcastle as early as 1908 at Walkerville, Rosewood Crescent and its neighbours' semi-detached 'model cottages' had been designed by a group of architects for the Walker Model Housing Exhibition. Along all the main roads out of the Tyneside towns spread ribbons of modest 'semi-detached' private houses. 'Once the flight started,' wrote Thomas Sharp, 'there has been no stopping it.' He added that Hartlepool, Stockton and Darlington were all acquiring the 'biological structure of the octopus'.[14]

After 1945 new ideas for building techniques appeared in the public sector, where the need for more houses was met by prefabricating as much of the buildings as possible. Of the many prefabricated designs adopted on Tyneside, two were notable for their success: the most numerous was the single-storey 'Tarran' design, the most surprising the two-storey 'Howard'. Examples of both are to be found in Gosforth. Greatly increased demand, however, eventually led public authorities away from factory-built individual homes towards larger and taller buildings containing many units – the high-rise flats of the 1960s. Among the better designed dwellings are the multi-storey blocks in Jesmond Vale and Shieldfield, Newcastle. The poor seven-storey blocks at Elswick have been demolished and replaced with low-rise housing, and at Killingworth, though the two-storey houses of the post-1945 development are still in use, the linked tower blocks have gone. Private housing seldom took the multi-storey form, but where it did it was built to high standards; an example is the Beacon House flats (1962) near St Mary's Island at Whitley Bay. Two large comprehensive development areas were created by local authorities in the form of townships: Killingworth to take overspill from Tyneside; and Cramlington to give new life to a decayed industrial area. In neither place, despite the provision of leisure and shopping facilities, were cohesive communities successfully established. The same is true of the contemporary Kenton Bar Estate in Gosforth (1964–68), with its stark, bare design.

In reaction to this type of mass rehousing, the community architecture movement began and found its supreme expression in the world-famous redevelopment of Byker by Ralph Erskine for the City of Newcastle from 1968. Here, where Tyneside flats once filled the hillside between the ship-yards below and the engineering works above, small houses cluster and the high flats of the 'Byker Wall', as it is affectionately known, undulate behind them. The highly successful redevelopment of much of Byker in the second half of the twentieth century was one of the milestones in the development of community architecture. Alongside concern for the 3000 inhabitants who needed rehousing went care for the landscape. Varied shapes and textures, materials and colours flow along the contours of the hillside and rise steeply

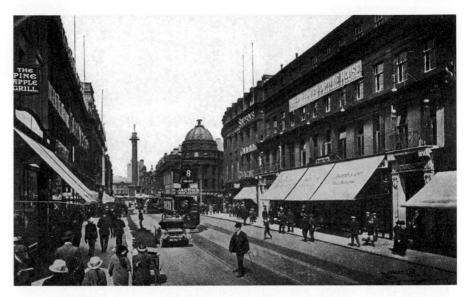

Grainger Street, Newcastle, in the early years of the twentieth century.

to the peak of a single wedge-shaped block at the west and the escarpment of a wall of flats along the north. This undulating Byker Wall is blank to the north, save for tiny lights to minor rooms, in order to make a barrier against traffic noise from the Byker bypass, opened in 1990. From the homes in the wall that face the sun there are panoramic views of the river valley. On this south side are cheerful timber balconies and window boxes. In contrast, the hill below is filled with small houses laid out in short terraces, and threaded with gently rising steps and well-planted pathways to create an atmosphere far removed from that of the severe rows of cobbled streets, flagged pavements and brick terraces of Tyneside flats which filled this site before. Those older streets had their own special character but, as a solution to the problems of a steep site and the need to shape a new setting for an old community, the Byker redevelopment (1969–71) is highly satisfactory and set new standards for local authority housing. The steeply sloped old people's home rides high over all at the west end of the wall, with views of the whole river.

Grainger Town covers eighty acres of land in the southern part of Newcastle's city centre. It extends from Stowell Street in the west to Pilgrim Street in the east; from Blackett Street in the north to Neville Street in the south. Within this area there is a fine collection of late Georgian and early Victorian classic buildings dating back to the 1820s. Over 60 per cent of the buildings are listed, and 20 per cent have a Grade 1 status.

By the mid 1990s, Grainger Town had become an area of office, retail, residential, leisure and cultural uses. Parts of the area, Bigg Market, Stowell Street and the Theatre Village, had developed distinctive characters. Despite this, however, the area had lost retail and commercial activities to new out-of-town locations. The area's economic base was being eroded, and the fabric

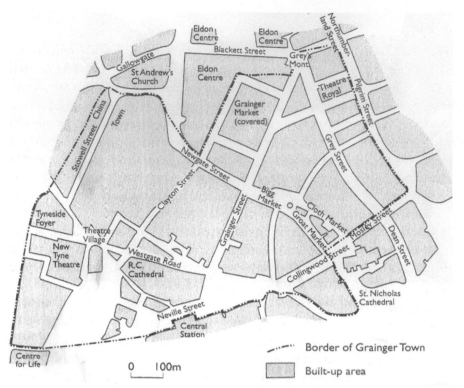

Grainger Town, Newcastle upon Tyne.

of the buildings was beginning to fall into disrepair. A large area of commercial floor space was unoccupied, and several of the listed buildings were classified as being at risk by English Heritage. Grainger Town's public spaces were of poor quality, and there were parking and traffic problems.

At the time of writing, a huge regeneration programme is being undertaken, involving the private sector, and central and local government. The scheme is intended to develop existing businesses and to promote the creation of new businesses; to improve the quality of traffic management and the quality of the public areas; to increase the residential population by creating a range of affordable housing for both rent and sale; and to reuse historic buildings for offices, retail, and arts and leisure. Part of this strategy is to promote the area as a centre for the arts, culture and tourism. To achieve this mixed-use potential, certain parts of Grainger Town have been targeted for specific uses. For example, the area immediately south of the Eldon Centre is to be an extension of the shopping area; housing is to be reintroduced in the west of the area, along Clayton Street and Grainger Street; the office area is to be strengthened along Grey Street and Collingwood Street; and leisure and cultural areas are to run from St Nicholas's Cathedral along Newgate Street, and in the south west of the area from the new museum, the International Centre for Life, to the Tyne Theatre and Opera House.

St Ives

The small town of St Ives in Cambridgeshire is about sixty-five miles north of London. It lies on the A1123 road, three miles east of Huntingdon and seven miles north west of Cambridge, just off the A14 main trunk road. Historically, although the town was an important market centre, it was relatively small, consisting of two principal roads running west–east, parallel with the Derwent, between All Saints Church and St Ivo's priory. There was also a north–south street leading to a bridge across the river. The town is very close to both the A1 trunk road and the main East Coast railway line. During the 1990s commuting to London increased as the main line to London was electrified and journey times were much reduced. The station at Huntingdon is about fifty minutes from King's Cross in central London.

The surrounding rural area is mainly farmland. In recent years, however, there have been large new housing developments on the periphery of this small town. There has also been a considerable amount of new, exclusive apartment building within the heart of the town, and particularly along the south bank of the Great Ouse. The population structure of the town is changing as a consequence. Whilst the indigenous population is ageing, the newcomers tend to be much younger. A large proportion of the working population is now employed outside the town. In particular, there has been a substantial influx of people who commute to London on a daily basis. It is estimated that 25 per cent of St Ives's working population commute to London each day. Consequently, many people in St Ives have higher incomes and higher standards of living than in other parts of the UK. With these higher incomes, they are able to afford the higher travel costs to London on the railway. Recently, retired people are also moving into the area, and their impact is also noticeable in the increased demand for bungalows and small riverside apartment blocks along the River Derwent.

In 1957 the town's population was just over 3000. By 1991, however, it had risen to over 15,000, and the shape of the town had been completely changed by the building of housing and industrial estates to the north of the historic core. Whereas the historic centre had been established in the early Middle Ages, and the range of buildings found there have been added and blended over many centuries, the majority of the townscape dates from the late twentieth century. Its priorities can be seen in its plan, which emphasizes car accessibility and private home ownership. Its plan owes nothing to the former agricultural land on which it is built, and, apart from the historic core, it is indistinguishable from hundreds of other small English towns where the twentieth century has laid a heavy hand.

The small town of ... on the ... road, three miles out of Huntingdon and seven miles north-west of Cambridge ...

CHAPTER 6 | *New Towns and Garden Cities*

Democracies have always been reluctant to spend much time or money trying to plan their cities ... Only compulsion of circumstances will make democracies plan.

H. Myles Wright [1]

DURING THE FIRST HALF OF THE TWENTIETH CENTURY, New Towns came to be seen by philanthropists, planners and politicians as the primary means of dealing both with urban congestion and the surviving extensive slum areas, characteristic of run-down Victorian industrial inner-city housing. Before the Second World War, there were various private urban experiments which involved the creation of new towns and suburbs; after the war, New Towns were adopted as government policy and some thirty-eight planned towns were created in Britain, the majority of which were in England. By the end of the twentieth century, over two million people in Britain were living in New Towns, and several hundred thousand more were housed in towns that had been expanded on New Town principles.

Although there is a natural tendency to think of new towns as a recent phenomenon, planned towns had been part of the English landscape since Roman times, when urban centres such as Winchester, Lincoln and Colchester were established as regional capitals. These early towns normally had street plans which had been developed in the Mediterranean region by the Greeks and Romans. Such towns were designed to administer *Britannia* – that far-flung territory of the Roman Empire. Romano-British towns were characterized by their regular grid plan, which incorporated standard features such as forum, market place and public buildings. For the most part, Roman street plans were eventually superseded, although here and there elements do survive in modern city centres. Many Romano-British towns were surrounded by substantial walls and ditches, and it is normally the lines of these defensive circuits that are the most obvious surviving topographical features in cities such as London, Canterbury and York. Later, defended planned towns such

as Hereford and Oxford were created in Anglo-Saxon England. The defences of such *burhs*, as they are known, can still be clearly identified at places such as Wallingford (Oxfordshire) and Wareham (Dorset). The Saxon town planners also created regular street plans within the defences. Some of these also survive, providing the footprint for modern town centres at places such as Oxford and Winchester.

The Norman Conquest heralded a renewed emphasis on towns as strategic administrative and commercial centres. The Normans concentrated secular and ecclesiastical power in urban centres, which were used as the basis for castles, cathedrals and, above all, trade. Urbanization was seen as a means of consolidating power in places like Durham and of monopolizing trade at places such as Bury St Edmunds. In such towns, particular care was taken to provide a layout in which there was adequate space for markets and commerce – a provision which had not been made in earlier Saxon towns. It was this latter function which prompted the creation or redesign of hundreds of small market towns in the early Middle Ages. The scale of planning between 1100 and 1300 was extensive and is still not fully appreciated. Most of the plans of these towns remained virtually unaltered in 1900, and they still provide the basic structure of the centre of many provincial towns today.

In medieval planned towns, such as Marlborough (Wiltshire), the market place normally dominates the town plan. In Oxfordshire, the historic centres of the market towns of Bicester, Burford, Chipping Norton, Faringdon, Witney and Thame all demonstrate a strong element of deliberate planning, with regular, extended, rectangular properties known as burgage tenements (properties of town merchants) laid out at right angles to a large, central, open market area. These plans still provide an attractive urban environment and partly explain the difficulties that arose when attempts were made to adapt such historic towns to the motor age. The aim of creating these market places was to try to monopolize trading rights with the attendant market tolls and taxes over the new town's hinterland. This meant attracting all traffic into the town centre. The imperative to attract trade was such that it was often necessary to divert roads into the new town centres, as at Thame and Chipping Norton. Where such elements of early town planning did survive into the twentieth century, they were initially ignored, derided or resented for the problems they posed; as the century wore on, however, these elements began to be valued and, eventually, conserved. Ironically, in the later twentieth century, bypasses were essential at many of these places to divert traffic from the small town centres and undo what had been deliberately fashioned in the Middle Ages. At Berwick in Northumberland, for instance, a bypass was essential to prevent the town from being strangled through congestion, but before the Second World War bypasses were rare, except in larger urban centres, and motorists were obliged to drive through the heart of the majority of English towns.

The pace of new town creation slowed down considerably in the later Middle Ages, reflecting a national decline both in numbers of towns and in the overall population. From the eighteenth century onwards, however, new towns appeared once again: Cheltenham and Bath are two of the better known examples of towns created or greatly expanded as they became fashionable spa resorts. The eighteenth and early nineteenth centuries comprised a period of elegant, neoclassical town design, marked by the introduction of boulevards, squares and terraces, and mirroring the new, elegant urbanization on the Continent. Everywhere there were regular planned elements being added to existing towns or replacing older housing. The Bellevues, Bellevoirs and Beaumonts were all part of this movement to establish graceful, open urban centres, creating some of the most imposing townscapes to be found in Britain; such townscapes were to be much imitated, often badly, in the twentieth century.

William Hesketh Lever, *c.* 1901, co-founder of Port Sunlight, one of the most attractive garden towns in England.

The neoclassical movement continued into the nineteenth century, but it was far surpassed in scale by the growth of the new industrial towns. There was an explosion of bleak artisan housing that created new industrial cities and gobbled up villages in the process in Yorkshire, Lancashire, Staffordshire and County Durham. Much nineteenth-century urbanization was unplanned or badly planned, but as the century wore on there were attempts at integrated planning at places such as Bournville and Saltaire in order to create more attractive, balanced communities. In the middle of the nineteenth century there was relatively low-density housing at Bournville, on the outskirts of Birmingham. This cottage-style housing in semi-detached and short terraces was provided for the workers at the Cadbury's chocolate factory, while open space and recreational amenities were provided in the interests of communal health and welfare. In addition, Bournville's moral and cultural development was encouraged by a range of churches, chapels,

libraries, art galleries and theatres. Among nineteenth-century reformers and philanthropists, both at Bournville and elsewhere, much emphasis was placed on the importance of nature and scenery in these new industrial towns; the concept of village life was highly romanticized. In the early part of the nine-teenth century, several village associations had been set up to build around London. One such was around Ilford, planned for five to six thousand people in 1848. The ideals behind these foundations were very similar to those found in the later Garden City prospectuses:

> Air and space, wood and water, schools and churches, shrubberies and gardens, around pretty self-contained cottages in a group neither too large to deprive it of country character, nor too small to diminish the probabilities of social intercourse.

The interest in picturesque qualities led to Victorian villa estates for the middle and upper classes on the fringes of rich industrial towns becoming common from the 1850s onwards. Detached and semi-detached houses with large gardens, with trees, shrubs and winding roads added to produce a village environment, were designed for the new middle classes. Such dwellings created the blueprint for suburban housing throughout the twentieth century.

Port Sunlight

Port Sunlight, the equivalent of Bournville in Cheshire, was built by the soap manufacturers the Lever brothers. At Port Sunlight the brothers established one of the most successful companies of the age, together with a town that was an inspiration throughout the world. The brothers had originally rented a factory in Warrington in 1884. Within three years demand for their soap had risen so much that, unable to expand on the Warrington site, they looked for an alter-native location for their new factory, eventually choosing a bleak location on the Wirral peninsula adjacent to the Mersey estuary in Cheshire. This was an area of marshy farmland criss-crossed by tidal creeks lying between the New Chester Road (built as a turnpike between Tranmere and Bromborough) and the main railway line from Birkenhead to Chester. The main settlement here was the village of Lower Bebington, which lay just to the west of the railway. Another manufacturing firm was already present near Bebington: Price's Candle Works, which had exploited the potential of the Bromborough Pool, a tidal navigable inlet which lay just outside the jurisdiction of the Mersey Docks and Harbour Board, had been founded here in 1853.

It was here, on 3 March 1888, that an invited party of guests came ashore at the 'Stone Quarry' to watch the ceremonial cutting of the first sod, under-taken by Mrs W. H. Lever. The first fifty-six acres of the site, which was to become Port Sunlight, cost Lever £200 an acre, and he subsequently purchased another 165 acres; 130 acres of the entire holding were to provide

the site for Port Sunlight village. Lever's dream of providing a healthy and pleasant environment for his workers began to materialize. At the end of 1889 not only was the factory complete and producing soap, but twenty-eight cottage dwellings in Bolton Road designed by the factory architect, William Owen of Warrington, were ready for occupation. During 1891–92 there followed more cottages, larger houses, a shop and the first of the public buildings, Gladstone Hall, which was opened by Gladstone himself on 28 November 1891. The Levers, perhaps remembering the confined and claustrophobic rows of terraced houses from the Bolton of their childhood, ensured that the layout of the village incorporated as many open spaces as possible. The houses, in a variety of architectural styles, were built in small groups, all with front and back gardens. Each house had a kitchen, scullery, parlour and either three or four bedrooms. Port Sunlight village also had public buildings: two large schools, a museum, library and cottage hospital. The village pub was originally unlicensed, in accordance with the brothers' views on temperance. When the villagers were consulted on the matter, however, they voted overwhelmingly in favour of lifting the ban on alcohol, and the brothers gave way to popular feeling.

The style was described by one contemporary as 'Old English', and was intended to demonstrate that it was possible to erect a large number of industrial dwellings without their being 'hideous in design and grieving in aspect'. In the next eight years the number of cottages had risen to 278. Architectural styles became more varied and included Flemish and Dutch, as well as two houses which were actual reproductions of Anne Hathaway's cottage at Stratford-upon-Avon. The streets were laid out in continental boulevard style, wide and lined with elm and chestnut trees. The school that was provided for the workers' children had 500 pupils in 1899. William Lever was involved in the development of the village at every level. The first plans were his own,

Gladstone Hall, Port Sunlight, opened by William Gladstone in 1891.

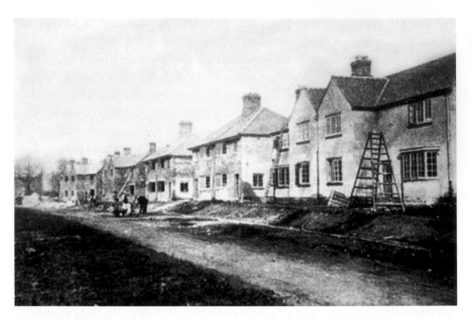

Early housing in the process of construction at Port Sunlight *c.* 1900.

and he travelled extensively in Britain and on the Continent looking for new ideas. He considered that 'the life of the people, in all town planning, must be the first consideration' and that this should be achieved without the sacrifice of what he called 'beauty and inspiring vistas'.

Port Sunlight was to have its own fire brigade, an ambulance carriage, a cottage hospital, a municipal swimming pool and a gymnasium. By 1909, there were 700 houses and a population of 3600. In 1910 there was a competition for a revised layout plan for the centre of Port Sunlight; this resulted in the construction of the formal, intersecting straight avenues known as The Diamond, which still forms the central feature of the community. Work continued on the development of Port Sunlight between the wars: the factory widely extended the range of its Unilever products, and the model village was eventually joined to the north by Birkenhead and from the south by Bromborough. Port Sunlight, however, has maintained its unique character and charm, which have both matured with age; and although the direct link between the village and the factories has long been broken, it remains one of the most attractive examples of a planned town or factory in Britain.

William Lever also had lavish schemes for the redevelopment of Bolton, his home town. He employed the architect Thomas H. Mawson to draft out these ideas, and the results appeared in 1911.[2] Lever's vision was of wide boulevards linking the main features of the town with a series of connecting parks on its perimeter. He took a step towards this by buying 98 acres of land on the east side of the town, now Leverhulme Park, and donating it to Bolton in 1918 during his term as mayor. The town council never adopted his scheme, however, even though he offered to pay something towards the cost. Drawings of the proposed new city show monumental public buildings and roads, with

factory chimneys hidden in the background. Significantly, perhaps, no houses are portrayed!

Garden Cities

According to Ebenezer Howard, 'A Garden City is a Town designed for healthy living and industry; of a size that makes possible a full measure of social life, but not larger; surrounded by a rural belt; the whole of the land being in public ownership or held in trust for the community'. Bournville and Port Sunlight were not strictly towns in their own right, but appendages to factories or cities. At the end of the nineteenth century a new concept of urban town planning developed, and, although it owed much to these two examples, it was a new type of self-sufficient community called the 'Garden City'. The Garden City concept provided a model for living in the new Industrial Age without the horrors of the then-familiar industrial city.[3] Howard had been born in the City of London, in a street that was subsequently engulfed by the Barbican complex, but as a young man he had migrated to the United States and worked for a time in Chicago, when it was developing into the 'metropolis of the prairies'. Howard saw large cities as undesirable in principle, quite apart from the special shortcomings of those which had been built in the Industrial Age, and he particularly deplored smoke pollution and the inadequate provision of public or private spaces in many city areas. He also regretted the increasing separation of cities from the countryside, and the decay, in his time, of rural areas due to the slump in British agriculture.

Howard's solution was to propose the creation of a 'Garden City' comprising a network of small, well-defined towns, each with its own industries, shops, cultural facilities and public open space. Each town was to be self-sufficient as far as possible, apart from dependence for certain specialized facilities on the occasional larger cities. Because their size would be limited through strict planning control, all parts of these towns would always be within easy reach of the countryside – which, Howard believed, would be revitalized in the vicinity of such towns by supplying some of their food needs. He produced a famous diagram, 'The Three Magnets', in which he contrasted the two magnets of urban and rural life and their advantages with the third magnet, the garden city, portrayed as giving the best of both worlds. These towns were to have many of the characteristics of traditional English country towns, yet Howard conceived them as being completely new and his model appeared to take little note of the tight, long-established network of small towns and villages already in existence in England. This single-minded attitude was illustrated by the siting of Letchworth (1903), which represented the first attempt at putting his theories into practice. Letchworth was located on a 'greenfield' site between and close to two very well-established market towns, Hitchin and Baldock, of which little account was taken in his new design.

In Howard's Garden Cities, public buildings and entertainment facilities were concentrated in the town centre together with the shops, while factories and railways were on the perimeter. Between the centre and the industrial zone were residential houses, built largely in traditional styles, each of which was set in its own garden plot. In addition, there was a park containing a range of public buildings, including schools and churches. Since Howard's model town was planned before the private car or bus became a significant factor in urban life, it was limited in size, so that all the houses were within walking distance of working, shopping and recreational facilities.

The first Garden City Association conference was held in 1901. Appropriately, it was held at Bournville, the Cadbury factory village. Cadbury was the host and George Bernard Shaw one of the distinguished speakers. Shaw initially had been very sceptical about Garden Cities, but he later became an enthusiastic supporter. Among the high-minded architects in attendance was Raymond Unwin, who had joined Morris's Socialist League in the 1880s. In 1903 the association founded Letchworth Garden City, the very first of its kind; Unwin and Barry Parker (Unwin's brother-in-law) were appointed its planners and architects the following year, to create a new town with a population of 30,000.

Letchworth was unique in that it was the first 'new town' not built by a philanthropic industrialist. In 1903 the population of the original village of Letchworth was 508 people when the Garden City Association bought 25,000 acres to build its Garden City. The plan for Letchworth Garden City included low-density housing, the segregation of industry from housing, and large areas of open space. The first house in Letchworth Garden City was built in 1904, and a new independent school was added in 1905. Other amenities included a public house (1907) called The Skittles, which, like Port Sunlight's pub, was initially alcohol free; the Cloisters centre for arts, crafts, summer schools and general entertainment (1905); a library (1906); and numerous churches. Each of the villages in the estate had its own parish church and, by 1930, there was a total of nineteen churches in Letchworth, when the population had grown to 14,500. After the Second World War the population continued to grow, reaching over 30,000 by 1971.

Certain architectural styles were associated with Letchworth as a result of Unwin and Barry Parker's involvement as planners and architects. For example, the Arts and Crafts-inspired Spirella Building (1912–22) by Cecil Hignett was, until the 1980s, a factory making patented, spring-structured ladies' corsets. It has subsequently been turned into a local museum. Parker, Unwin and a host of minor Arts and Crafts and neo-Georgian architects provided comfortable, handsome homes, supported by sober, upright public buildings and civic amenities. It adopted a village green-type plan with low-density housing and with the houses angled to catch the sun and maintain their own privacy. The Homesgarth block, built in 1909, had thirty-two

kitchenless units around a quadrangle, with a communal kitchen and dining room in the corner. Communal living had been one of the ingredients of Howard's ideal Garden City, and Howard himself actually moved into one of these units in 1913. The communal playrooms and laundries and other socially ambitious ideas associated with the early Garden City movement rarely, however, became popular. The urban legend about Letchworth was that it attracted a 'zealous, teetotal, smock-wearing Arts and Crafts' type and the town quickly became famous for the crankiness of its citizenry. It is said that Cockney workers on their Sundays off booked excursions by train from King's Cross to come and look at Letchworth's 'implausible gathering of quacks, weavers, potters, feminists, yoga fetishists and birth control fanatics',

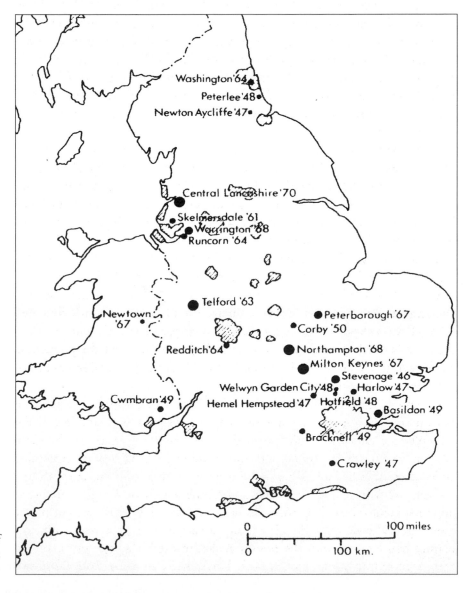

The distribution of New Towns in England and Wales.

but Letchworth was also judged a success by many. John Betjeman penned a gently mocking poem called 'Group Life: Letchworth':

> Sympathy is stencilling,
> Her decorative leatherwork,
> Wilfred's learning a folk-tune for
> The Morris Dancers' band.[4]

Letchworth was described as having 'salubrious surroundings, plentiful greenswards, trees and open spaces which truly unite Town and Country within predetermined limits of acreage and population. Letchworth Garden City was unique in that it came into being almost entirely in the form conceived by its creator.' It was designed on a greenfield site initially located on a rectangle of land between the A505 and the railway. Some of the old field boundaries and lanes were respected in the new layout, although the centre was made up of wide roads or boulevards with trees and grass verges. Today it is a pleasant, mature, wooded, self-contained town, and more people travel in to work there than travel out to work elsewhere. The civic centre was designed on an ambitious scale, in deliberate formal contrast to the informality of the outer residential areas, but it was never properly completed. The adjoining shopping area, however, developed along curving roads and quickly established the atmosphere of an old country town.

Letchworth is no longer a pioneering or idealistic development, but neither is it some thoughtless stretch of suburbia. The way it was planned and the ideas behind it have ensured that it has a character all its own, a century on from its foundation. Letchworth has, however, also expanded well beyond its original design. It has all but blended with Baldock to the north east and is joined to Hitchin to the south. The town proved attractive to industry

Burnage Garden Estate, Manchester, built in the Arts and Crafts style between 1906 and 1911. There were 138 houses centred on a bowling green and tennis courts.

because of its good rail links in the first instance; then, after the Second World War, the M1 provided a rapid road link to London. Added to which the A1(M) motorway now links this group with Stevenage, Welwyn Garden City and Hatfield to create a string of New Towns running due north from London in a form of grotesque ribbon development.

Letchworth's example was soon followed at Welwyn Garden City, the first Garden City to benefit from the 1919 Housing Act. In 1919, Ebenezer Howard bought 1688 acres of the Cowper estate in Digswell, Hatfield and Welwyn parishes. In 1920, Welwyn Garden City Limited was formed, and in December of that same year the first house was occupied, in Handside Lane. The original population was 400, but by 1951 it had reached over 18,000. The area was handed over to a Development Corporation in 1948, when Welwyn Garden City and Hatfield were designated New Towns.

Louis de Soissons designed Welwyn Garden City along classical lines. The 'campus' area, the Parkway with its Coronation Fountain, Welwyn Stores, the White Bridge and the public buildings near it all provided a striking town centre, with a resemblance to Parisian boulevards and gardens, but on a much smaller scale. The visual success of Welwyn, as compared to that of some of the later New Towns, is due partly to its grand centre, but there are also many streets of attractive housing. The predominant style is 'a quiet comfortable Neo-Georgian', with round windows applied to houses of different types and sizes. The town plan followed the natural contours of the landscape and, as a result, curving streets dominate Welwyn, as they do Letchworth. This reflects one of the important contributions that Garden Cities made to the twentieth-century town landscape, in that they provided a break with the more normal grid pattern of earlier urban design. The architectural treatment of these curving streets is varied. In some of the older areas of middle-class housing, the general effect is of good-quality, detached suburban housing with large gardens, roomy streets and much greenery. In some of the newer areas, to the east along Howlands for example, the effect is more like that of an eighteenth-century crescent. There was considerable variety in Welwyn Garden City's housing, and there was a variable building line. A particularly striking feature was provided by the line of houses along Knightsfield, which is parallel with the crest of a hill and gives the serrated skyline the appearance of an enormous battlement.

At the time Welwyn Garden City was designed it had been assumed that kerbside parking in Parkway and Howardsgate, two particularly wide streets, would suffice for those few residents who might use their cars to go shopping. It was the last New Town that did not incorporate the car as an integral part of the planning process. The Welwyn Department Stores were the largest commercial premises in the new town. They were designed by de Soissons in a neo-Georgian style, and above the store on the upper floors there were sixty-two flats, as well as a Masonic Suite with badminton and squash courts on the roof.

Raymond Unwin, the author of *Town Planning in Practice: An Introduction to the Art of Designing Cities and Suburbs* (1909), brought wider social and political ideals to his planning than Howard had done. By coincidence, Unwin, who is attributed with inventing the term 'town planning', had his book published in the same year as the first town planning act was passed by Parliament. Unwin wrote: 'The truth is that we have neglected the amenities of life. We have forgotten that endless rows of brick boxes, looking out upon dreary streets and squalid backyards, are not really homes for people.'[5]

Early twentieth-century planning sought to correct this. Unwin and Parker built New Earswick outside York. The garden village of New Earswick was the idea of Joseph Rowntree, the York businessman who built up the cocoa and confectionery business that bore his name. In 1901 his son, Seebohm Rowntree, published a study of the living conditions of the working classes in York entitled *Poverty: A Study of Town Life*. It revealed appalling statistics of dark, overcrowded and insanitary housing. This was in direct contrast to his father's belief that it should be possible to provide better housing for people on low incomes. Rowntree acquired 150 acres of land near the village of Earswick, two and a half miles to the north of the centre of York, for his garden village project. The building of New Earswick was an attempt to create a balanced village community, where houses were to be open to any working people, not just Rowntree employees. The village was to be a demonstration of good practice. If New Earswick was successful, Joseph hoped that similar communities would be built elsewhere in the country.

New Earswick was based on the idea of having only eight houses per acre. In each group, the houses were located in order to catch the sun, and the cul-de-sac was used as a device to maintain privacy. At Rowntree's insistence, all houses had gardens with fruit trees and enough ground to grow vegetables. The trust deed of the Joseph Rowntree Village Trust (which was set up in 1904 to build and manage New Earswick) safeguarded generous open green space. All the grass verges were planted with trees – and almost all the roads are named after trees. The village was built from bricks made with local clay; the brickworks were located on the outskirts of New Earswick. The brickyard, which closed down in the 1930s, was later developed into a nature reserve. Mature trees were left and a small stream was incorporated in the scheme. In the 1903 plan there was generous provision for sporting and other leisure facilities – New Earswick was planned to become a sizeable self-contained centre in spite of its proximity to York. The Rowntree Foundation is now planning another community in York: known as Derwenthorpe, this is intended as a twenty-first-century model 'edge of town development'.

Another Quaker industrialist, Sir James Reckitt, was responsible for a similar Garden City development close to his starch works at Hull. In February 1907 Reckitt wrote to T. R. Ferens: 'It seems to me the time has come ... to establish a Garden Village, within a reasonable distance of our

Works, so that those who are wishful might have the opportunity of living in a better house, with a garden, for the same rent that they now pay for a house in Hull – with the advantages of fresher air, and such Clubs, and outdoor amusements, as are usually found in rural surroundings.' Reckitt soon afterwards purchased the Holderness House estate, and Runton & Barry were immediately commissioned to design the layout and buildings for a 'garden village'. The Garden Village was officially opened on 2 July 1908 and by the middle of 1913 over 500 houses had been completed. There are twelve avenues laid out in an irregular mixture of curves and straight lines, with two focal points – the Shopping Centre and the Oval, a large, open green around which were sited the main public buildings, notably the Village Hall (demolished after bomb damage) and the Club House. The houses were built twelve to an acre, and the 'garden' nature of the development was emphasized by the street names, most of which were of trees or shrubs: Lilac, May, Laburnum, Maple, Lime, Chestnut, Beech and Cherry. Except around the Oval, however, it is lacking in the spaciousness of other garden villages, and some of the tree-lined streets are surprisingly narrow. The housing also lacks the picturesqueness of Port Sunlight or the originality of New Earswick; or, as Reckitt's biographer put it, the houses are 'not self conscious and aggressively and irritatingly artistic and arty and crafty'.[6]

Garden suburbs, or garden villages, were developed as smaller-scale versions of garden cities and were applied to existing cities in the form of planned suburbs. The best known of these was Hampstead Garden Suburb, one of the most famous private developments in London. Work started in 1906 and developed along with the extension of the Underground network to nearby Golders Green. The scheme was once again the work of Unwin and Parker, and its aim, in Unwin's words, was to 'give working people the opportunity of taking a cottage with a garden within a 2d. fare of Central London'. In 1911, George V paid a visit to the rapidly expanding settlement and commented on the provision of gardens, for he 'could not imagine anything better calculated to give relief from the monotony of the ordinary City worker's life'. Hampstead was initially criticized on the grounds that it was a dormitory suburb, not a self-sufficient community. Many of the residents did use the Underground to commute into London, but in the early decades the Suburb was socially mixed. Hampstead Garden Suburb did attract some working-class people to the area to work on the Underground and in local shops, and it is still considered one of the triumphs of twentieth-century British urban design. In fact, in a very short time the garden suburb became a central part of British urban planning philosophy; most suburban development in the UK follows the principles of the Garden Cities, with low-density, low-rise housing and open space. Garden suburbs extended the upper-class ideal of a family home to less wealthy households by offering smaller, owner-occupied homes.

The first section of Hampstead Garden Suburb was created just to the north

of Golders Green. The idea for the foundation of Hampstead Garden Suburb had first come about in 1896. The inspiration was that of Dame Henrietta Barnett, a cosmetics heiress and wife of Canon Barnett, the founder of Toynbee Hall. Barnett was a social worker who had spent thirty years working to improve the housing conditions of the poor in Whitechapel. Transport to the London suburbs was improving all the time, and Golders Green tube station was proposed to Parliament in 1902. When the tube came to Golders Green, Barnett had formed the Garden Suburb Trust for the purpose of buying land on Hampstead Heath to prevent building developers from defacing the area with 'jerry-built villas and cheap terraces'. The first plans for the Hampstead Suburb were produced in 1905. The site, which had belonged to the Trustees of Eton College, was an awkward wedge shape, with one end touching Hampstead Heath. This projection was made a feature, with a heavy wall to introduce the idea of a German medieval town behind its bastions. Unwin gave Hampstead wide, winding tree-lined roads, and existing landscape features, such as woods and fields, were carefully preserved within the plan. Edwin Lutyens designed the central hilltop square, which included two churches (Anglican St Jude's and a Free Church), an institute and housing. Lutyens's design was a grand one, and he frequently found himself at odds with Dame Henrietta, who tried to keep to the 'garden' ideal. The village did indeed have a remarkable central area, but one that was hardly in keeping with the early ideas of creating what was essentially to be a village.

There were a number of other developments that were directly inspired by the Garden City movement located mainly in the London overspill area, such as the Norbury Estate, Croydon. For example, the Brentham Garden Estate, at north Ealing, was begun in 1901 by Ealing Tenants Ltd, but from 1907 Unwin and Parker were involved in its design. The estate covered sixty acres of former agricultural land and by 1916 consisted of 650 houses. As at Hampstead, variety was achieved by the use of winding roads and culs-de-sac, and also by careful location of the houses in relationship to the roads. Although the estate was less comprehensive in its social provision than Hampstead, an institute provided the social centre, and a school and church were also built. A small, but flamboyant, shopping arcade, decorated with yellow terracotta, was added in 1909.

A much smaller development also took place near Croydon. A superior garden suburb of half-timbered houses was built at Woodcote Village, between Croydon and Purley. It has been described as 'very leafy, expensive and handsome', based around a trim, triangular green. It was laid out and partly designed by William Webb, a horticulturalist who called it the 'Garden First' system, between 1901 and 1920:

> The name Garden First means that the garden shall not only have prominence but that partial garden construction shall be carried out before any buildings

are erected ... the house is but the complement of the garden in a general survey of the estate.[7]

Only one shop, at the corner of the green, was built, in the form of the Lord Roberts teetotal pub and village stores. A church was added in 1910.

The LCC adopted some of the ideas of the Garden City movement in some of its early twentieth-century working-class housing when it began to build cottage estates on the edge of built-up London. Many of these were to the south and east of the extended city, but work on the Old Oak Estate, based around East Acton station, on the northern fringe of Hammersmith, was started in 1911. Parker and Unwin's principles were used in picturesque groups of houses interspersed with small greens and large front gardens; and by 1914 there were over 300 houses and flats here. After the First World War, building continued to the north of the railway and to the south of Westway, on the Wormholt Estate, which followed similar Garden City principles. By 1926 there were 600 houses on the fifty acres between Old Oak Common Lane, Steventon Road and Bloemfontein Road. This area still gives a good idea of the high quality of design and materials employed in the 'homes fit for heroes' campaign. The houses are mostly of brick with pantiled roofs and are set back attractively around little greens.

During the First World War the government had been obliged to provide housing for the much increased workforce at the Woolwich Arsenal. This accommodation was required urgently, and the Well Hall Estate, between Shooters Hill Road and Rochester Way, was conceived, planned and built in under twelve months in 1915. The estate, built along garden suburb lines, was intended as a showpiece solution to the housing problems created by the war. Frank Baines, the principal architect for the Office of Works, was faced with an acute shortage of building material. His solution was to make use of whatever materials were available:

> architecturally the result was a tour-de-force of picturesque design. Variety in materials and finishes (timber-framing, tile-hanging, slate-hanging, stone, brick, and rendering) was matched by complexity of shape and silhouette, and combined with period details such as the raised pavement to produce a virtuoso re-creation of the 'old English village'.[8]

Elsewhere in greater London, there were other schemes influenced both by the Garden City and the Arts and Crafts movements, such as Mitcham Garden Village. Some, such as the Hanger Hill Garden Estate (1928–36), went to help create the interwar Metroland, but few were as integrated as the Brentham Garden, Old Oak or Well Hall Estates.

A number of garden suburbs, such as those at White Hart Lane in Tottenham and Totterdown Fields in Tooting, South London, were developed by local councils and built with higher density housing than contemporary

private developments. This housing tended to be cheaper, and therefore affordable to working-class people. The Becontree Estate in Essex was the largest of all the interwar developments. It was built by the London County Council, partly to house soldiers from the First World War and their families. Between 1921 and 1932 over 25,000 houses, for 100,000 people, were built on agricultural land, much of it compulsorily purchased, in the parishes of Barking, Dagenham and Ilford. The estate lay between the small village of Dagenham and the River Thames about two and a half miles to the south. The Becontree Estate provided affordable housing for the better-off working-class Londoner. The new houses were equipped with gas and electricity, inside toilets, fitted baths, and gardens back and front. The LCC imposed strict rules on house and garden maintenance as well as the behaviour of children and the keeping of pets. Becontree, however, was essentially conceived of as a housing settlement, and although the inhabitants enjoyed good facilities, it was never intended to be a community in the full sense of the Garden City. Ford established its motor-manufacturing plant at Dagenham, partly because of the large pool of ready labour, and employed 25,000 workers, many of them from the Becontree Estate, in the 1930s.

Unlike such Garden Cities as Welwyn, the new suburb of Wythenshawe (near Manchester) was entirely dependent on road transport. The city's corporation had bought the main block of land from a local landowner ostensibly in order to rehouse slum dwellers. It was designed around the focal point of Wythenshawe Hall and Park, which were given to the city by Ernest (later Lord Simon) and Sheena Simon, who played a major role in the early development of the settlement. Wythenshawe was a 'garden city', meticulously planned, and complete with a permanent 'green belt' and generous playing fields and open spaces. By 1931, when the main construction work got under way, it was already larger than the original Garden Cities of Letchworth and Welwyn, with such well-known planners and architects as Unwin and Patrick Abercrombie involved in its design. It included two parkways, the first in Britain, for free-flowing traffic, segregated from housing and minor roads, and had a target population of 100,000. Houses were built rapidly, and by 1939 nearly 40,000 people inhabited over 8000 homes here.

Wythenshawe soon became the most popular destination among applicants for corporation housing. But most Wythenshawe tenants came from the better-off working class, not from the slums. There is evidence that the authorities exploited Wythenshawe's popularity to maintain high standards. A resident recalled the early years:

> Not everyone could get a house in Wythenshawe. Before we got one an official from the Town Hall wanted to know all about us: our parents had a nursery in Northenden and my husband had steady employment and a fair wage. We

had to prove we would be good tenants ... We ... heard that some people were from the slums but we never met any of them.[9]

It was not until the 1960s that Wythenshawe reached full capacity. Although factories for the production of electrical goods, embroidery, hosiery, biscuits and other products were established early on, it was not till the 1950s that Wythenshawe's three industrial zones (at Sharston, Roundthorn and Moss Nook) took proper shape. Equally, the much awaited civic centre was not completed till the 1960s. In the event, Wythenshawe became a garden suburb rather than a satellite town. It was too close to Manchester to be independent (it was incorporated in 1931), and there was too little employment in Wythenshawe during the early decades, which restricted the chances of a self-contained community to develop.

Unwin and Parker had determined a minimum standard for housing densities of nine houses per acre. Subsequently, this ratio was cited in the Housing Act of 1919 and adopted for all private and municipal estates throughout England. Thus, in the early years of the twentieth century, the 'ideal' suburban format was embodied in legislation and remained the model for the rest of the century. This model was responsible for the creation of oceans of semi-detached dwellings, complete with front and back garden and later a garage, as the accepted norm throughout the country. Great swathes of England were (and continue to be) covered by estates of detached and semi-detached houses. These, together with a generally low-rise approach to new developments, have created the suburban norm, and here is the inspiration and blight of the twentieth-century English landscape: experiments with alternative methods of dwelling, such as terracing, flats and apartments, were either limited in their scale or judged to be social disasters.

The architectural styles of the Garden Cities were a mixture of vernacular revivals. Many of the public buildings had a Georgian quality to them; the houses were mostly brick with red-tile roofs and a rustic look, harking back to the 1850s. In Letchworth, Unwin and Parker created designs that adapted the traditional brick farmhouses and town houses of south-east England and then scaled them down to something affordable for most of the residents. Vernacular revivals and modifications have dominated the commercial suburban developments of England ever since – they can be seen in fragments of fake half-timbering, in semi-Georgian doorways, leaded windows, steeply pitched gables above doorways, and decorative brickwork and stonework.

New Towns

After the Second World War, New Towns were seen as the solution to the 'urban problem', in that they would provide for the clearance of the surviving slums in London and cope with the continual growth of urban populations.

The central square at Stevenage New Town from the air.

The perception that traditional town-centre streets, shared by pedestrians and motor vehicles, were outdated was heightened by the appearance of their buildings, which were dirty and ill-maintained after six years of war. Blitzed centres and new towns seemed blessed with a unique opportunity to develop alternative models, for which inspiration was found in the modern pedestrianized precincts of such Dutch towns as the postwar Lijnbaan in Rotterdam. The first-generation New Towns designed by Abercrombie and others used the Garden Cities of Letchworth and Welwyn Garden City as models and were mainly located around London. These towns were run and controlled by development corporations appointed by the government. The second-generation

Late twentieth-century detached housing in front of the Weetabix factory in Corby New Town.

Peterlee New Town,
County Durham, at
an early stage of
development.

New Towns, on the other hand, were built in the 1960s and were located in
the East Midlands, Wales, the North East and Scotland. They were generally
much larger than those of the first phase, and a major aim of these New Towns
was to aid regional development in areas where old industries were ailing.

Abercrombie's wider plan for London, including the Green Belt and the
building of New Towns, was accepted in principle – though some towns were
to be on different sites from those he had selected. In 1945 Louis Silkin was
appointed Minister of Town and Country Planning to head a newly created
government department that was to have a fundamentally important role in
the English landscape during the second half of the twentieth century. Silkin
established the postwar New Towns programme, and the New Towns Act
was passed in 1946; the first New Town was designated at Stevenage the
following year. Between 1946 and 1950, eight more New Towns were desig-
nated in southern England, with a further six in the North. Most of the
towns were planned to have populations between about 50,000 and 80,000,
and each was to be contained within a 'Green Belt' – a hinterland of perma-
nently protected countryside. Harlow, for example, designed by Sir Frederick
Gibberd, took advantage of a gently undulating landscape, preserving most
of its trees, with many more added to provide 'green wedges' that penetrated
from the urban perimeter towards the town centre.

The majority of the early postwar New Towns were located in a ring
around London, on the outer edge of the Green Belt (Basildon, Bracknell,
Crawley, Harlow, Hatfield, Hemel Hempstead, Stevenage and Welwyn).

Their main purpose was seen as relieving the congestion of inner London and providing a healthy, balanced community in new, low-density developments. These towns, like the Garden Cities, were intended to be self-sufficient, providing all the regular needs of the residents for work, leisure, shopping, education and culture. Other New Towns designated during this period were intended to accommodate workers for a variety of industrial activities. Corby (Northamptonshire) housed workers from the large steelworks, as well as a range of new factories; Newton Aycliffe (Durham) was based on an industrial trading estate developed during the Second World War; while Peterlee (Durham) was a new centre for a scattered mining population with additional new industries.

Most early New Towns stand out not so much as utopias but as creatures of their time. Almost all have passed through a phase of being judged 'visionary' and then 'soulless' places. The tone was set at Stevenage (1957–58), whose pedestrianized central square lies at the heart of the shopping area, enlivened by a clock tower, fountain and abstract sculptural group: features deemed to be more in tune with the mood of the times than the statues of frock-coated worthies on pedestals who preside over the public spaces of many Victorian towns. The surrounding buildings – an arts and sports centre, police station, magistrates' courts, college of further education, and railway station – are of the clean-cut variety characteristic of the early years of English modernism, featuring large expanses of glass curtain walling. The Co-op building in Stevenage is adorned with a ceramic mural depicting 'the spirit and activities of the Co-operative Movement as a whole and in relation to Stevenage'. The ensemble proclaims the welfare ideals shared by most local authority planners and architects in the immediate postwar era.

In 1947, when Hemel Hempstead was first designated a New Town, it had a population of less than 25,000 people. Its location, just thirty miles north west of London, made it an ideal site. It already had excellent transport links, which were later supplemented by the M1 and M25 motorways, and thus had ready access to many parts of the country. It also lay on the main Euston railway line with good connections to the north of the UK and, in addition, there were three airports within reach: Heathrow, Luton and, later, London City Airport. Hemel Hempstead was planned with a classic New Town neighbourhood structure, where each neighbourhood consisted of 4000 to 10,000 people and had its own local shops, pubs, churches and community. The town was also designed to include large areas of open space – 15 acres per thousand people, with a target population of 80,000 people. Hemel Hempstead was to consist of fourteen neighbourhoods, an industrial area in the north east of the town, and a town centre. In 1947 four families from four different London boroughs became Hemel Hempstead's first new residents. About 10,000 new dwellings were built in Hemel Hempstead during the 1950s. There was a wide diversity of housing types and styles, such

as starter homes, homes for larger families, accommodation for the elderly, and two- or three-bedroomed homes for low income families. By the 1990s it had reached its population target, with approximately 80,000 people living in the new town.

Hemel Hempstead became a major employment centre, providing almost 50,000 jobs; it had a low unemployment rate and attracted many large businesses, including BP and Kodak. In addition, the town had many firms in the high-technology sector, such as Lucas Aerospace, who were major employers in the town. The dominant industrial sector in the town was, however, the service sector, which employed three quarters of the workers. Since the mid 1980s, the banking, finance and insurance sector alone has grown by over 150 per cent. Likewise, sports and recreational facilities are an increasingly important sector of Hemel Hempstead's economy. Like several of the New Towns, in the 1990s Hemel Hempstead town centre was completely redeveloped and now has a restructured town market.

In the early 1960s, there was renewed government interest in the concept of New Towns, and, between 1961 and 1970, fifteen New Towns and three New Cities were designated. Unlike the early New Towns, which were mostly concentrated in the South East, these New Towns were to be mainly in peripheral development areas. In particular, the government recognized the value of merging New Town and regional growth policies to attract new manufacturing and service industries to disadvantaged regions. The design principles behind these second-generation New Towns reflected a change of philosophy, away from the Garden City movement. The new emphasis was on providing a unique architectural environment for each New Town through a variety of means such as mixed population densities and distinctive town-centre architecture. The second-generation towns also accommodated increased traffic in their urban designs. The first of these towns in England was Skelmersdale, an overspill town for Liverpool.

There were also a number of developments that were not fully fledged New Towns, but which were planned along similar lines. Killingworth Township in Northumberland had a population of around 10,000 in 2001; but in the 1960s, when it was established as a completely new settlement, it was intended for double that number of people. Killingworth was known in the eighteenth century for its large tract of moor on which Newcastle Races were held, and in the nineteenth century for the pioneering engineering work of George Stephenson at West Moor Colliery. Collieries continued to dominate the area during the early twentieth century, but they eventually suffered the same decline after the Second World War as the rest of the North-East coalfield. In 1960 the Ministry of Housing and Local Government gave the county council approval to develop 'an unsightly area of land', and a Comprehensive Development Area was defined under the Town and Country Planning Acts, with Longbenton Urban District Council as the

housing authority. The linchpin of the layout was an artificial lake crossed by the main access road. To the north of the lake lay a rigid box of public and commercial facilities within a long loop of distributor road, from which the network of houses opens. There was more housing to the north west, and an industrial estate west and south of the lake, near the railway. Before the linked blocks of concrete deck-housing were demolished in 1989, the distant impression from the north over the coastal plain 'resembled nothing so much as a set for Fritz Lang's *Metropolis*'.[10] Houses of a more traditional style have been built since 1970, and even the supermarket is the usual 1980s rural barn for Killingworth Township.

During the late 1960s there were two further developments in New Town philosophy; the first of these was a reaction against building completely new communities on greenfield sites. One reason for this change was the growing recognition of the social problems that had arisen during the building of the earlier New Towns in close proximity to existing, established towns and villages. It was believed that some of these problems could be overcome by expanding the existing communities, each with its own historic and well-established centre. The designations resulting from these ideas were based upon the expansion of regional centres such as Peterborough and Northampton. The second development emphasized accessibility both for industry and for the individual. Three sites were designated: Telford in Shropshire, Milton Keynes in Buckinghamshire and the Central Lancashire New Town. Master plans were prepared which included a grid of roads linked with the national motorway network. Such plans provided for maximum accessibility and for flexibility in the growth of these New Towns, whose populations were each projected at a quarter of a million.

These later New Towns were also larger, and had higher population densities and greater architectural variety than their predecessors. There was greater emphasis upon private development, home ownership and also greater reliance on private transport. They also tended to favour large supermarkets instead of shopping parades. There was a move back in favour of two-storey housing, though at tighter densities than Unwin had advocated. The early postwar New Towns had continued to provide houses rather than high-rise flats, and the New Towns designated in the 1960s, such as Runcorn and Milton Keynes, were also designed mainly for houses. The quality and form of the late 1960s and 1970s housing in such places varies greatly; at its best it is pleasant and imaginative, but it can also be rigidly geometrical and repetitive.

Milton Keynes

Milton Keynes was designated as a New City in 1967 projected to cover a site of about 35,000 acres in north Buckinghamshire. It was planned to accommodate a quarter of a million people. It was not designed as a city in

the conventional sense, but as more of a 'regional complex' incorporating several existing towns and villages. The result is similar to the city of the future forecast by the theorist Kevin Lynch, who describes future cities as composed of small settlements set in a landscape with trees, farms and streams, and linked by a grid of major roads adapted to the topography, which he terms 'urban countryside', an appropriate description for parts of Milton Keynes.[11] In 1967 the total population of the designated area, which included the towns of Bletchley, Wolverton and Stony Stratford, as well as ten villages, was about 40,000. By 1992 (when the Development Corporation was wound up), its population had reached 148,000.

Bletchley, one of the old settlements within the designated new city, had already grown since the Second World War: it was the first country town to be chosen for expansion under the Town Development Act of 1952. Wolverton, too, had been the subject of postwar development proposals. Then, in 1964, F. B. Pooley, the County Architect, proposed a new city of 250,000 between Bletchley and Wolverton, consisting of townships of 5000 to 7000 linked by monorail. The idea of a new city based on Bletchley also appeared that year in the government's *South-East Study*. The new city plan's

Milton Keynes prior to the building of the new town in the 1960s.

curving net of main roads followed the contours of the low, undulating landscape, and divided it into roughly equal one-kilometre squares – a loose arrangement intended to allow maximum flexibility as the town was built. Two grid-squares were devoted to the city centre and another to a city park. Other squares were allocated for housing; half for rent, half for owner-occupation. Each of these squares was intended for about 5000 people on 250–300 acres. Other squares were intended for employment and for recreation. Linear parks followed the natural features of the canal, the rivers Ouse and Ouzel, and the Loughton Brook, occupying one-fifth of the city's area.

It was envisaged that there would be a very low density, of about twelve houses per acre, in a widely spread, car-dependent city, with a high degree of individual privacy and opportunities for leisure activities. It was to be a rural English version of such American freeway-linked conurbations as Los Angeles. Many of the architects and planners on the Milton Keynes Development Corporation in the early years had worked in the United States and been influenced by Webber, who became their 'urban consultant'. But just as important was the idea, promoted by Derek Walker, Milton Keynes Development Corporation's first Chief Architect and Planning Officer (1970–74), that Milton

Milton Keynes in the 1980s.

Keynes should share, particularly in the centre, some of the large-scale urban grandeur of nineteenth-century Paris and Chicago. As a result, the centre was to be clearly distinctive from the surrounding countryside. Some of Walker's ideas can be seen in the boulevards of Central Milton Keynes and in some of the early housing schemes. The master planners of Milton Keynes envisaged a city of 'variety and choice'. The existing towns and villages were preserved – the historic main street of Stony Stratford was carefully conserved, and the industrial character of Wolverton respected. New development in villages like Great Linford was integrated with existing historic buildings.

The fields of north Buckinghamshire, which dated largely from Parliamentary Enclosure in the eighteenth century, were transformed into a wooded landscape in which the city was almost hidden. Some roads were set in deep hollows with wooded sides, and the straight boulevards became formal avenues of trees. Campbell Park, the city park, linked Central Milton Keynes to a swathe of parkland down the Ouse Valley, forming the largest and most imaginative public park to have been laid out in Britain in the twentieth century. Other open spaces varied in character from natural woodland, such as Linford Wood, to such sculpted parkland as the terraced amphitheatre (called the Bowl) designed by the sculptor John Csaky, to narrow linear parks along streams and canals, and village greens. The Development Corporation commissioned works of art for public places and employed artists-in-residence – Liz Leyh's concrete cows, which graze in Loughton Valley Park, have become, perhaps embarrassingly, the city's most famous landmark.

The regular grid of east–west boulevards and north–south service roads is impressively spacious and logical, designed to accommodate the motor car. All buildings are accessible by car, and parking regimented in rows in front of the buildings beneath avenues of trees makes a positive contribution to the streetscape, in contrast to the makeshift arrangements in most towns. Larger car parks are sited off the north–south roads, and motor transport is essential in Milton Keynes, not only to reach the centre from the suburbs, but to cover the distance (two grid-squares) from one end of the centre to the other. Routes across the centre pass through a few public gardens and semi-private courtyards.

After the grandeur of the grid and exceptional quality of the landscaping, most of the buildings are a disappointment. None are more than six storeys high and they, like the housing beyond the centre, will eventually be engulfed in greenery. Public buildings are absorbed almost imperceptibly into the grid amongst commercial buildings; only the disappointing city church, with its bulbous dome, is a conventional and incongruously traditional landmark. The earliest commercial buildings designed by Milton Keynes Development Corporation – Lloyds Court, Ashton and Norfolk House, and the Shopping Building – were impressively built in a sleek, Miesian steel-framed and glass-clad style that suited the rectangular grid. Slightly later buildings adapt this

theme somewhat with brick or stone cladding. In the late 1970s, however, an invigorated push for office development caused planning controls to be relaxed to accommodate the house styles and materials of private developers and commercial concerns. In theory the grid was strong enough visually to hold any variation of style and material, but this has not worked in practice; too many of the commercial products are mediocre or worse. Of the buildings put up between 1985 and 1992, only the Magistrates' Court can claim any real merit.

> The architectural mood, especially outside the city centre, is cool and understated, resulting in an urban landscape that is inward-looking, fragmented, and unassertive. This is perhaps a reflection of the prevailing values of urban England at the close of the twentieth century.[12]

Telford

Telford lies in eastern Shropshire, in an area of early industry that became redundant in the first half of the twentieth century. The New Town covers some 25,000 acres, which incorporate the worked-out east Shropshire coalfield. In the early nineteenth century, the area contained Britain's second largest ironworks, and the landscape was characterized by the spread of mining spoil, canals, new roads, railways and sprawling industrial settlements. From the mid nineteenth century, the area declined, as mineral deposits were exhausted and other better resourced industrial areas developed. By the mid twentieth century, the Shropshire coalfield was derelict and impoverished. About 40 per cent of the designated area was badly affected by shallow mining, spoil heaps and geological instability. An essential part of the New Town scheme was the reclamation of these extensive areas of landscape dereliction. Telford's scattered settlements incorporated several small towns – Wellington, Oakengates, Dawley, Madeley and Ironbridge. Dawley was identified as the centre and original name of the planned New Town. Madeley had originally been created as a new town by Wenlock Priory in the thirteenth century, but never really prospered, and the small industrial town of Ironbridge, which clings to the side of the Severn Gorge near to Coalbrookdale, the home of Abraham Darby's ironworks, was the site of the world's first iron bridge.

Dawley New Town was intended to rehouse overspill population from Birmingham, and in the late 1950s and early 1960s the first houses were built there for Birmingham families. Originally, in 1963, the town was intended for an overspill population of 50,000 people, but plans faltered in the mid 1960s, only to be revived in 1968 in the form of a larger town, to be called Telford, after the Victorian civil engineer Thomas Telford. Between 1968 and 1983, nearly two million square feet of factory space were provided in the

new town, despite Telford's being placed 'on the sick list' at one stage because of unemployment and a national recession. Telford was, however, able to attract new firms for relocation, not only from Britain, but also from the USA, Europe and Japan. In the 1970s Telford grew rapidly; its population increased by 25,800 and the number of new jobs by 8500. Four of the planned nine district centres were built, as was much of Telford town centre, on reclaimed land at Malinslee.

By 2001 Telford's population had reached 160,000, still well short of the 220,000 originally planned for, but there was every indication that the town would reach this target early in the twenty-first century. Between 1965 and 1981, the main objective of the New Town changed from absorbing Birmingham's overspill to becoming a regional economic 'growth point'. The process of reclamation and rehabilitation of a derelict and depressed area was seen as having been essential to promoting this new development.

The existing industrial dereliction within Telford, however, threatened to spoil the splendour of a natural setting dominated by the Wrekin and opening out into awesome prospects along the Severn Gorge. So great were the problems of reclamation that, uniquely among New Towns, Dawley, later Telford, had a landscape structure plan that was just as important as its basic development plan. Much work was done in the 1970s and early 1980s, and by 1983, 4000 acres of derelict land had been reclaimed and 1295 mine shafts had been treated, almost entirely by the development corporation. Much remained to be done: another 3000 acres of derelict land remained

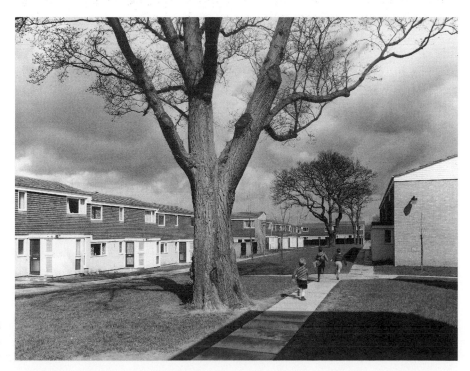

Early housing at
Sutton Hill in
Telford New Town.

for reclamation, and over 1600 mine shafts for treatment. Much of the reclaimed land was destined for housing, industry and roads, but a second objective was to penetrate the town with areas of semi-wild, wooded landscape crossed by footpaths, which was both attractive and cheap to maintain.

The centrepiece of the landscape plan was Telford Town Park (laid out in the mid 1970s, and extending over 600 acres between Dawley, Stirchley and the town centre). The park recalled, albeit on the larger scale typical of second- and third-generation New Towns, the central feature of Ebenezer Howard's original concept of the 'social city'. With a fair measure of success, Telford Town Park combined the traditional municipal playground and landscaped garden with large areas of informal country park. The most formal sections of the park lie at its north end, where the Chelsea Garden was created with gazebo, water, summer house and rose gardens; its design is based on entries made in 1977–79 by the Development Corporation to the London flower show. Nearby are the Maxell Cherry Garden, given to Telford by its first Japanese company, established in 1983, and a garden designed for partially sighted and disabled people, with scented plants, boulders and a bubble fountain. South of the park, the Silkin Way footpath, opened in 1977, led to extensive areas of open space for recreation. In those recreational areas, the natural beauty and historic remains of Coalbrookdale and the Severn Gorge were protected and conserved, and, emphasizing the areas's historic significance, the internationally celebrated Ironbridge Gorge Museum of industrial archaeology was built up from 1967, and in 1990 was declared a World Heritage Site.

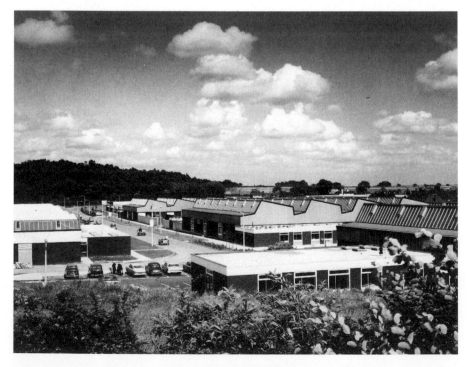

Industrial estate, Telford New Town. Such anonymous low-rise buildings came to dominate industrial estates throughout the century.

Telford's road system and motorway link had always been central to the town's design and to the plans for its growth. The new roads linked old and new settlements and, by separating through and local traffic, greatly reduced the time taken to travel about the town. Late in 1983, Telford was finally provided with its most important missing feature and the essential means of promoting its economic growth, a link to the M6 and the national motorway network. Apart from the Ironbridge Gorge Museum and the cores of the ancient settlements, the new town landscape incorporates relatively little of what went before. However, the emphasis on open space and a vigorous tree planting campaign to create a 'Forest City' at least incorporate the ethos of the Shropshire landscape in which the city lies.

Even after several decades it is difficult to judge the long-term aesthetic success of the New Towns. By their very nature, they are likely to upset the landscape observer who has a Romantic or nostalgic point of view. Bill Bryson described Milton Keynes in 1992 as follows:

> The town itself was a strange amalgam of styles. The grassless, shady strips along the centres of the main boulevards gave them a vaguely French air. The landscaped light industrial parks around the fringes looked German. The grid plan and numbered street names recalled America. The buildings were of the featureless sort you find around any international airport. In short it looked anything but English.[13]

By their very nature, New Towns replace open fields with houses, roads and shopping malls, all built within the limitations of their age. In the first instance, New Towns represented a visionary answer to social and economic problems; later they became much more functional and realistic in their design. Some New Towns have become bywords for social and structural decay. In Harlow, for example, there are estates where many of the houses and flats are falling down or semi-derelict. Indeed, Harlow used to be known as the 'concrete jungle' and it is still suffering from infrastructure problems; everything was built at one time using experimental techniques and, as a result, everything tends to go wrong at the same time as well. The town hall is condemned, the water gardens have been demolished, and the Henry Moore statue, whose head was knocked off, has now disappeared altogether.

Nevertheless, the twentieth-century New Towns' aggregate achievement has been impressive. Altogether they house over two million people and do business with 50,000 companies, providing over one million jobs. New Towns have been innovators in styles of urban living, styles that are now so diffused they are almost taken for granted; pedestrianized streets, shopping malls, multiplex cinemas and artificial ski slopes first appeared in one or another New Town, as did the first science park, solar-heated home and system of domestic-refuse recycling. New Towns have been exemplars of low-density housing, built on reclaimed land as well as on greenfield sites. The standard

has been a maximum of twelve houses per acre, each overlooking open ground. Several of the New Towns can boast outstanding environmental amenities: Telford has the Ironbridge Gorge, a World Heritage Site; Bracknell has over eighty wildlife sites; and in the North East, at Washington, the Wildfowl and Wetland Centre is a major tourist attraction.

By the end of the twentieth century the public experiment of creating New Towns had virtually come to an end. It is unlikely that there will be any more publicly sponsored new towns in the foreseeable future, such is the current hold of privatization and the market economy on political philosophy. There are, however, a number of ventures that can be called private new towns. Most of the pressure for new housing was directed towards existing towns and villages in southern England, and attempts at creating completely new communities tend to have been thwarted by planning controls. The pressure for new housing in the South East during the first decades of the twenty-first century are likely to be intense. Proposals are well advanced for the expansion of Milton Keynes and other New Towns, while plans for building in the Thames Gateway promise to create a massive New City in all but name.

CHAPTER 7 | *Suburbia and Metroland*

Out into the outskirts' edges,
Where a few surviving hedges
Keep alive our lost Elysium – rural
Middlesex again . . .

John Betjeman, 'Middlesex',
A Few Late Chrysanthemums (1954)

D URING THE FIRST HALF OF THE TWENTIETH CENTURY, many towns and villages grew outwards along the main roads which connected them to other centres. Although their historic cores continued to be adapted to contemporary uses improvements in the transport system encouraged cities to expand, and, in the early decades of the twentieth century, railways, electric tramways and buses became crucial to the growth of residential suburbs. As transport was cheap and the price of farmland had dropped dramatically, there was unprecedented scope for urban expansion. Despite the agricultural depression, it was a period of optimism for many, characterized by rising wages, living standards and expectations. Housing was now available, affordable, and of a quality unimaginable only a few decades earlier. The lives of many working-class people were transformed: instead of overcrowded slum conditions, there was now the possibility of new, low-density, well-equipped housing in pleasant suburban locations offering security and respectability. As late as the 1930s there were few planning controls and urban growth was allowed to take place alongside main roads without hindrance. One-third of all houses in England and Wales were built between 1918 and 1939. New planning regulations were brought into being and the Restriction of Ribbon Development Act, 1935, for example, tried to impose controls on the spread of developments along major routes out of cities, representing the first serious attempts to constrain suburban sprawl.

Postwar Green Belts were created – areas of open space and low-density land use around existing urban areas, where further development was strictly

controlled. After 1950 suburban expansion continued, but ostensibly there was greater planning control. The 1950s and 1960s were the period of large-scale construction of council housing, for which the only places with sufficient land available were located on the suburban fringe. In the 1970s, many small and middle-sized towns lost political control of their own destinies as local government reorganization into District and County authorities saw planning and development decisions on issues such as housing and roads being trans-ferred from municipal to regional level. Local government reorganization in 1974 was followed by County Structure Plans which, in many parts of England, identified those towns and villages which were to expand.

This suburbanization of village England started during the nineteenth century in London's rural fringes and in such popular scenic areas and middle-class retirement retreats as the Sussex coast, the Lake District, and the Berkshire and Buckinghamshire stretches of the Thames Valley. By the early years of the twentieth century in the Home Counties, and within reach of the largest provincial cities, such village suburbanization was beginning to spread out over wider areas, transforming village landscapes in the process. George Sturt, the son of a village wheelwright, described what was happening in the countryside to the south of Farnham, on the edge of the Surrey Weald. Here, some thirty miles away from the centre of London, but within walking distance of a main line railway station, suburbanization was already well entrenched by the time he began writing his book a few years before the outbreak of the First World War. Rustic cottages and old farmhouses were being 'snapped up' and occupied by affluent city incomers, whilst speculative new residential development for weekday railway commuters was becoming a familiar sight. In the Home Counties, the new suburban housing was spreading over former common land and heathland that in living memory had succumbed to the final 'mopping up' phase of Parliamentary Enclosure. Sturt describes the scene:

> And now, during the last ten years, a yet greater change has been going on. The valley has been 'discovered' as a 'residential centre' ... No sooner was a good water-supply available than speculating architects and builders began to buy up vacant plots of land, or even cottages – it mattered little which – and what never was strictly speaking a village is at last ceasing even to think itself one. The population of some five hundred twenty years ago has increased to over two thousand; the final shabby patches of the old heath are disappearing; on all hands glimpses of new building and raw new roads defy you to persuade yourself that you are in a country place.[1]

The architect Clough Williams-Ellis, author of *England and the Octopus* and editor of *Britain and the Beast*, described it all as 'a planless scramble'; and C. E. M. Joad looked out in horror over 'a ravished landscape'. Hugh Massingham saw the connection between the long-term 'internal decay' of

Octopus by Clough Williams-Ellis

ENGLAND AND THE OCTOPUS

by CLOUGH WILLIAMS-ELLIS.

5s. net

BLES

The dust cover for Clough Williams-Ellis's polemical book, *England and the Octopus* (1928). This was an outspoken protest about the 'Octopus' of urban sprawl choking the English countryside.

rural England and the whole modernization process: 'it expels the native population, pulls down its cottages or puts them in fancy-dress, builds houses of its own as characterless and innocent of design as are all its acts, debases the neighbouring countryside and suppresses its crafts and husbandry'.[2] Similar thoughts are expressed by J. B. Priestley's 'Britain in Danger', his conclusion to an anthology entitled *Our Nation's Heritage*, written just before the outbreak of the Second World War: 'It took centuries of honest workmanship and loving craftsmanship to create the England that was renowned for its charm and delicate beauty. In twenty years we have completely ruined at least half of that England.'[3]

Not only did suburbanization reach further and further into the countryside and devastate more and more of the rural landscape, it also damaged village culture, breaking down all that was left of traditional rural virtues. Priestley and other preservationist writers, however, were virtually silent about the positive benefits that rural suburbanization might bring for villagers by way of services and employment. The farmer and novelist A. G. Street spoke for most ruralists when he rebuked the unthinking townsman: 'In his desire to get away from his hideous town and live in more pleasant surroundings he has let loose a swarm of red brick and drab concrete locusts, which has spread over thousands of acres of God's own England and destroyed all the beauty and charm which once graced them.' In a similar tone, Thomas Sharp pointed his finger at the 'little' man and his seemingly unrestricted freedom to live more or less wherever he pleased: 'Every little owner of every little bungalow in every roadside ribbon thinks he is living in Merrie England because he has those "roses round the door" and because he has sweet williams and Michaelmas daisies in his front garden.' According to the planning historian John Punter, what was really at stake in reproaches like these was the threat that widening suburbia and mass enjoyment of the countryside presented to the 'culturally selfish' – those privileged and well-off people who, in terms of where they lived and where they spent their leisure, were already

'in possession' of rural Britain. Viewed in this light, the 'defence' of the English countryside may be seen as what became known in the 1980s as 'Nimbyism' (Not In My Back Yard).

The interwar period saw the construction of 865,000 new dwellings in rural England and Wales, of which over 80 per cent were owner-occupied. To provide the space for all this development, conversion of agricultural land accelerated sharply, with yearly acreages of new building averaging around 30,000 between 1918 and 1936. Such encroachment further increased to as much as 60,000 in the housing boom of 1936–39 – an intensity of rural suburbanization that has not been surpassed since.

Council Housing

Public housing had been a feature of the urban landscape in London particularly since the late decades of the nineteenth century. Following the 1909 Town Planning Act, council housing appeared in other cities. The Budget of the same year supported the planning act by taxing underdeveloped rural sites in order to release land for housebuilding. Many local authorities expanded their boundaries to incorporate new suburban areas, thus increasing their rateable revenue. This resulted in one of the most important landscape changes of all in twentieth-century England – the spread of suburbia in the interwar years. Before the First World War, most suburbanization had been for the wealthy, who could afford the costs of travel to work and so were able to move out to larger, more expensive houses. But between the wars hundreds of thousands of acres of largely agricultural land were taken over for new housing estates. A frenzy of public and private housebuilding transformed large tracts of landscape, particularly in southern England, but also in the Midlands and around the great metropolitan industrial cities of Manchester, Liverpool and Newcastle.

During the First World War there was relatively little bomb damage in English cities, but recruiting activity during that war caused the government to recognize that the quality of life for many working-class people was low in terms of health, education and employability, and that important steps were required to provide better housing conditions. It was discovered that the standard of physical and mental health was very poor among army recruits: 40 per cent nationally, and 60 per cent in some areas, were rejected on account of poor health. In the 1918 election the Prime Minister, Lloyd George, claimed that he wanted to create 'a land fit for heroes to live in', and, under the 1919 Housing and Town Planning Act, the government provided subsidies to enable local authorities to embark on a large-scale programme of council-house building. Two main subsidies were available: the Wheatley subsidy for local authorities and the Chamberlain subsidy for private builders. These subsidies, which continued into the 1930s, were the

main source of funding for low-income housing, and were largely responsible for fuelling the suburban explosion of the interwar years.

Birmingham, the second largest city in England, and a centre of the motor and engineering industries, had seen a steady migration to the suburbs since the start of the century. In 1913 authority was given to develop 2300 acres at Edgbaston, Harborne and Quinton in the south west, and 1500 acres in East Birmingham. Further schemes, for Yardley, Stechford and South Birmingham, taking in parts of Warwickshire county, followed in 1914. The members of the Town Planning Committee also passed a resolution 'far beyond their present legal powers' in authorizing the city surveyor to plan for the entire Greater Birmingham area, defining new ring and radial roads, and allocating open spaces and residential and industrial zones.[4] By the 1920s the stream had turned into a torrent, with large municipal estates surrounding the city, to the north, east and south, and with the ever-swelling suburbs dependent on ring roads. By 1938 one in seven of the population lived in the innermost ring of the city, two in seven in the middle, and four in seven in the outer ring. The Weoley Castle Estate was one of the largest public-housing schemes ever undertaken, and by 1933 over 40,000 new houses had been built there.

The availability of subsidies led to the nationwide development of many other council-house estates, and after the First World War all local councils built dwellings for rent, mainly to ex-servicemen. The council houses usually took the form of well-spaced blocks of semi-detached dwellings with sizeable gardens aligned beside a road on the fringe of the main built-up area of villages and towns. The houses were normally well built, where possible of good local materials, often with a pebble-dash finish. At Cheltenham, for example, council-house building began in earnest after the First World War – the most popular area was the St Mark's Estate, which was started in 1920 and was given a layout somewhat resembling a garden suburb, with brick and roughcast houses set amongst trees and hedges. By the mid 1930s, layouts had become more spacious, but more formal, and individual houses less appealing (as at the Whaddon Estate of 1935–38). A similar pattern can be discerned in nearby Gloucester, but here the City Council built attractive brick houses along the main roads, but drearily rendered ones in the less visible streets behind.

In Dagenham, Essex, some of the best market-gardening areas in the county were converted into housing estates. The village of Dagenham was hemmed in on the north by the Becontree Estate after 1921, and rapidly lost its rural character. In 1876 Dagenham had been described as 'a long straggling village, chiefly of cottages, some pretty good, some decent, but too many poor, low, and dirty thatched mud huts ... Becontree Heath, which gives its name to the hundred, is two miles north of Dagenham. The heath is enclosed, and is a collection of mean houses, with a beer-shop and Wesleyan chapel. Dagenham Common, the last of the open heathland, fell

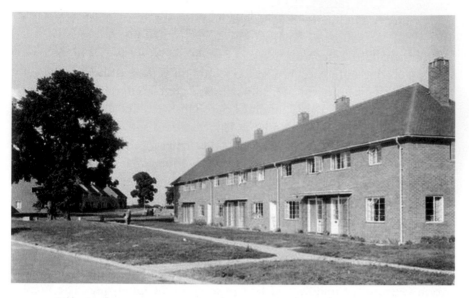

Early postwar rural council housing in Oxfordshire.

under the Enclosure Act of 1862. The occupations are chiefly agricultural, a considerable portion of the land being marsh.'[5] Between 1921 and 1934, dozens of farms were compulsorily purchased and 25,000 houses were built by the LCC. Over 100,000 people moved here, making the Becontree Estate the largest council housing estate in the world at that time.

By 1939 some 159,000 council homes had been constructed in the Rural Districts of England and Wales, most of them after the 1936 Housing Act. The earliest rural council housing took the form of small-scale development within the core of the village, often on or adjoining the sites of the first cottage clearances. After 1936, new council housing was usually built on the periphery of the village, either in standard terrace blocks of four to six dwellings, or as semi-detached housing grouped around a short cul-de-sac access street. In 1944 *Country Planning* described such developments as 'council colonies' – a reference both to their peripheral position and their intrusive appearance. It went on to declare:

> The common practice ... is to select sites on the edges of villages – a field, or the village allotments – upon which to execute their housing schemes. The new houses, raw as most new houses must be, stand out stark and staring on the bare site, with no setting, no background, their gardens mere pieces of land fenced off from the field, without a tree or a bush or even a hedgerow to suggest a natural boundary. Inevitably, the new houses are the most remote from the shops, inns, schools, and places of worship.

Ribbon Development

Ribbon development in the interwar years was widely condemned by preservationists and planners such as Thomas Sharp, who saw it not only as a

growing threat upon the rural landscape but also as entirely out of keeping with the cohesive and 'enclosed nature' of the traditional English village. Ribbon development, however, was certainly the cheapest and the most convenient means of providing new suburban houses with direct access to a transport route for car and bus travel. Moreover, in rural areas the verges of main roads entering and leaving villages were now being used for the first lines of modern infrastructure, which made it easy and inexpensive to connect ribbon housing to existing electricity and water mains and to equip it with up-to-date sewage disposal.

The reasons for the popularity of ribbon development, both from the speculators' and the residents' points of view, were summarized by the architectural historian Arthur Edwards:

> Ribbon development was, however, the natural consequence of motor transport, of a depressed agriculture, and of weak planning control. To the farmer, bungalows were often a more profitable crop than corn. For the developer, it was often easier to build along an existing highway than to lay out roads of a new estate. To the householder, ribbon development seemed to provide the ideal combination, easy access at the front and a view over open countryside at the back.[6]

The longer ribbons – those that stretched from the edges of cities and large towns to the nearest villages – consisted of more than just housing development. As Thomas Sharp described in his *Town and Countryside*, published in 1932, these ribbons contained a 'semi-suburbia of personal houses, poultry farms, refreshment shacks, petrol stations, wide roads, and linking wires that stretch from pole to pole'. Moreover, by the 1930s, suburbanization of the countryside and village England was not limited to the Home Counties,

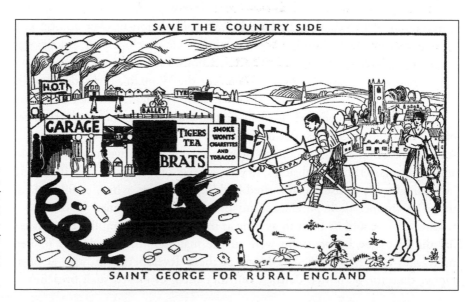

St George postcard, 1928. This was one of a series of postcards and posters produced by the CPRE as part of the 'Save the Countryside' campaign.

the environs of the big cities, and the more sought-after of rural retirement havens. It was now encroaching along certain coastlines and around smaller urban centres. John Moore observed the effects of rural suburbanization even in the Cotswolds and the Vale of Evesham, some considerable distance away from any large city: 'I could see the towns and even some of the villages nibbling their way outwards, not wisely and orderly, but as haphazard and casually as caterpillars nibbling at a leaf; I could see the mess creeping along the sides of all the roads that radiated from the market towns.' In his novel *Coming Up for Air* (1939), George Orwell describes how his principal character revisits Lower Binfield, in Oxfordshire, where he had grown up before the First World War. He drives over the hill on the remembered road, then macadam, now tarmac. 'The village has gone, not demolished, merely swallowed.' He sees in its place a 'good-sized manufacturing town [with] an enormous river of brand-new houses which flowed along the valley in both directions and half-way up the hill on either side'.[7]

During the 1930s private housebuilding had intensified. Over 100,000 houses were built in 1930 alone – more than had ever been built in a single year until then. In 1935 and 1936 275,000 houses were built in each year, and even at the start of the Second World War, in 1939, over 200,000 houses were built. During the 1930s over 2.7 million houses were built in England and Wales, and overall during the interwar period some 4.3 million houses were built. Of these 31 per cent were built by local authorities, 11 per cent by private developers with state assistance, and 58 per cent by private contractors helped by low-interest mortgages.

Sidcup, in Kent, grew from a small village in 1851, when it had a population of 390, to the size of a small town in 1901, when, swollen by London railway commuters, the population had reached just under 6000. The population continued to expand and during the interwar years Sidcup became synonymous with suburbia: by 1939 it had a population of over 40,000 and was already joined to London. One of the major developers in Sidcup was New Ideal Homesteads Ltd, which offered houses for sale in Montrose Park Estate said to be 'Designed by a Woman for the Woman'. New Ideal homes came with electricity and a range of labour-saving devices, and they promised 'that the charming countryside shall permanently retain the rural character of its vistas and shall not suffer disfigurement in any way'. Given the feverish scale of building at the time, this was a somewhat disingenuous claim. In addition to government subsidies, developers had other advantages: they were increasingly able to use prefabricated building processes, which enabled them to make cheaper bulk purchases and use cheaper, less skilled labour. As a result, houses could be built in as little as three weeks. To simplify the process for the first-time buyers, who were in the majority, the developers offered mortgages and legal assistance. Many of these developers also built at or at higher than the permitted density, but they often disguised such breaches in

the regulations by making four semi-detached properties look like a spacious pair of detached houses.

Typical of the new developments was the Danson Estate between Bexley-heath and Welling. The development of the 350 acres of the Danson Estate occurred in a piecemeal fashion between 1922 and about 1936. Many different developers were involved, resulting in a wide variety of styles and designs – mock-Tudor mansions, pebble-dashed semis, whitewashed bungalows and even the occasional modernist construction. In this Danson differed radically from the two other major developments in the area, the Welling Council Housing Scheme, which had 426 homes built by the local authority in 1922, and the Falconwood Park Estate, where more than 2000 houses were built by New Ideal Homesteads in 1932. Large sums of money were required to provide essential services to the residents of the new estates. Bexley Council provided electricity and street lighting, the South Suburban Gas Company provided a gas supply, and the Metropolitan Water Board supplied domestic water. The council was responsible for sewerage.

Suburbia

Between the two world wars, a debased mock-Tudor style became a favourite with commuters. There was a rash of what Osbert Lancaster snobbishly termed 'By-Pass Variegated' and 'Stockbroker's Tudor' in the suburbs, and houses, pubs, shopping parades and even cinemas and churches were built in 'Tudorbethan' style. In *The House Desirable* (1929), by P. A. Barron, there are chapters on 'New "Old" Houses'; 'The Art of Building with Antique Oak, Bricks and Mossy Tiles'; and 'Modern Houses Which Look Centuries Old'.[8] The expression 'rurban' was coined in 1931 for the kind of settlement that was neither town nor country, but a hybrid of the two. This seemed to fulfil a prediction of H. G. Wells that 'the city will diffuse itself until it has taken up considerable areas ... The country will take to itself many of the qualities of the city. The old antithesis will indeed cease, the boundary lines will altogether disappear; it will become indeed merely a question of more or less population.'[9]

In his perceptive book, *Oxford Observed* (1991), Peter Snow pokes gentle fun at the house names of the period in the leafy upper middle-class area of Boars Hill, just outside Oxford:

> What essence of English rural idyll breathes there – Inglewood, Deepdene, Orchardlea, Greenaways! Some chase butterflies on Boars Hill, but you can collect house names with equal pleasure, and minutely classify them. There is the Sylvan-Substantial genus – Gorselands, Pinecroft and Brackenhurst – which have a robustness and heathery toughness and would make excellent names for furniture ranges or household deodorizers. Then you encounter the

Rustic-Romantic family which dwindles to the twee and dimity world of faery, the sub-Tolkien underworld of the country garden gnome – the Rustlings, Windswept and Tinkerbell. Enough nonsense! barks a third class. As clipped as colonels, these bristle with briskness – Grainings, Downings, Haltings and Sprivers. Finally, after the 'animal house' category (a whole warren of badgers' holts and foxes' combes) come the Exotics, named for idiosyncratic or senti-mental reasons. These often sound like racehorses ('And at the line it's Lamorna neck and neck with Craigellachie, with The Sheiling in third place and By the Way trailing badly in fourth!') ... the neighbourhood was developed piecemeal as plots were sold off by farmers and family trusts, there is a remarkable lack of uniformity and a low density – only 350 houses in the whole neighbourhood. You search in vain for a central focus, a parade of shops, a church or village hall. Instead there is a long winding involvement of lane and close, flanked by broad verges and boxy beech hedges permitting discreet glimpses of lawn and drive and garden outhouse. And there are trees, everywhere trees ...[10]

Suburban areas were criticized because of the lack of community spirit. They were seen as cold, soulless, impersonal and class conscious. In some areas walls were built separating private housing estates from council housing – the 'Cutteslowe Walls' in north Oxford are a particularly well-known example of this phenomenon. The Cutteslowe Walls were built in 1934 to keep the inhabitants of Cutteslowe council estate separate from another estate of middle-class houses built by the Urban Housing Comany.

Demolition of the notorious Cutteslowe Wall in north Oxford in 1959.

Two seven-foot-high walls with iron spikes were erected across two streets by the private developer. Ostensibly, the walls were intended to reduce traffic in the private estate. However, they also effectively cut off council tenants' direct access to the centre of Oxford. As a result of these walls, the Cutteslowe tenants were obliged to make a detour of nearly a mile, which, according to Arthur Wynn, writing in the *Communist Review* in August 1935, cost the workers, and the children on their way to school, several extra hours a week.

Four years later, the City Council took direct action, demolishing the walls with a steamroller, only to be ordered to rebuild them by the High Court. The saga did not finally end until 1959, when the City Council paid £1000 for the nine-inch stretches of land on which the walls stood and summarily demolished the 'insult to the working class'. Today, the only indication of the walls' former presence is an abrupt change of road name in the middle of a street. With the gentrification of privately-owned former council houses, the contrast between the old private homes and council houses is now not so obvious. Cutteslowe was not the only place where such actual class barriers were erected. At Bromley, in Kent, a similar high wall was built in 1926 by residents of a private housing estate to cut themselves off from a newly built London County Council estate, which they called 'Little Moscow'.

Around Birmingham and Wolverhampton suburban development of a kind familiar in the south and east spread into the rural districts. By the mid 1930s the decline of the rural population in both rural Staffordshire and rural Warwickshire had been reversed, while, for example, the population of Stoke-on-Trent declined as the surrounding areas 'began to attract young couples who worked in Stafford or the Black Country and travelled daily to work by bus, train or car'. In the former industrial village of Neston, in the Wirral, the 1930s were remembered as a time of similar change, with 'the building trade ... one of the few steady occupations'. The whole area in the 1930s was slowly but surely changing into an irreversible dormitory town for the city administrators. The city was where the new work was, and new staff were needed, from manager to office boy, from manageress to typist, and they commuted daily by trains and crowded buses. Even in the North East, one of the areas worst hit by the Depression, the Council for the Protection of Rural England could still bemoan the development of the Jesmond area of Newcastle. 'There is a pathos in the rush to build dwellings in green surroundings, which, through lack of early planning, blots out those green surroundings.'

Metroland

Metroland was the region developed by the Metropolitan Railway to the north west of London, out towards Amersham and Aylesbury. The railway

provided the transport and sold land for building along the route. Rural charms were much emphasized in its publicity of the time:

> The song of the nightingale for which the neighbourhood is renowned; its mingled pastures, woods and streams; its gentle hills clothed with verdure; the network of translucent rivers traversing the peaceful valley render it a Mecca to the City man pining for country and pure air.

The Metropolitan was the only railway company to become directly involved in the commercial exploitation of land adjacent to its line. By 1900 a number of new housing estates had already appeared on railway property close to stations such as Wembley Park and Pinner. In 1915 the name 'Metro-land' was coined to publicize the districts served by the Metropolitan Railway. It appeared as the title of their annual guide produced under their commercial and publicity manager John Wardle. The guide claimed to be a 'comprehensive description of the country districts served by the Metropolitan railway'. The new *Metroland* booklet, thanks to improved printing techniques, was enhanced by colour photographs, many of the more idyllic sun-dappled corners of the Chilterns and beyond. It marketed the villages and landscapes served by the line leading through Harrow-on-the-Hill to the Chalfonts, Chesham, Amersham, and on to Missenden and Wendover. The descriptions of this 'rural arcadia', in varying hues of purple, painted their own scenes of the countryside – 'Each lover of Metroland may well have his favourite beech wood and coppice – all tremulous green loveliness in Spring and russet and gold in late October'. It also described the small towns and villages – 'neat, prim little towns which keep their old-world aspect, like Amersham and Missenden and Wendover'. Nostalgia was interrupted by tempting historical titbits and interspersed with allusions to the improved levels of personal well-being that were to be

Cover of the Metropolitan Railway timetable, 1913.

found in this milk-and-honey landscape: 'The good air of the Chilterns invites to health by day and to sleep by night.'

In 1919 Metropolitan Railway Country Estates Ltd was established to develop the area more extensively, in anticipation of a postwar housing boom. Work started on the first two estates in the early 1920s – Chalk Hill in Wembley and Cedars Estate at Rickmansworth. Further estates followed at Rayners Lane and deep in the Chilterns at Amersham. Eventually, nine estates were opened, mostly with new homes to buy, or with plots of land where purchasers could build individual architect-designed properties. The estates were built all down the line, and allowed the Metropolitan to create a captive market of season ticket-holding passengers who lived in Metroland and commuted daily to the City by train. There was the familiar twentieth-century contradiction between the Metroland dream of a new home on the edge of unspoilt countryside and the reality of the suburban sprawl that soon engulfed many of these areas.

The influence of the railway on these early Metroland estates in the Chilterns is unmistakable, because the railway line in many cases bypassed the old town, leaving the station on the outskirts. This created the opportunity for an entirely new dormitory town to spring up, near to the station and without interfering with the old town centre. Such was the case in Amersham, with the new town situated on the hill, while the old, broad High Street remained in the valley half a mile away. Prior to the opening of the station, Amersham's population was falling, but it then grew rapidly as the suburban villa community of Amersham-on-the-Hill expanded. By 1931, when the Metropolitan acquired and developed the Weller Estate there, the population had reached 29,000. The development at Gerrards Cross went a stage further, transforming a tiny, loose-knit hamlet scattered around the common into an entirely new dormitory that grew from a population of 552 to 2942 in thirty years. The railway from Marylebone through High Wycombe opened in 1906, and along with it the rush for new houses. Farms and parkland were dug up to become the streets and gardens of over 400 houses, although the common remained intact.

The improved lifestyle was not restricted to those who could purchase. There was an enormous increase in council rented accommodation and this was not confined to areas near to railway lines. The *Metro-land* issue for 1932 specifically mentions local councils who had built a number of estates in Chorleywood and Chenies; in Chesham the 'Local Council have erected 150 houses and cottages, fifty more in course of construction, 200 more contemplated. Extensive private building is taking place on Lowndes Avenue, Shepherd's Farm, Charteridge Lane and Chiltern Hills Estates.' The 'House Seekers' section of the Metropolitan Railway Company's guide took up nearly half the space in this last issue. A typical house on the Eastcote Hill Estate, four miles from Uxbridge, was advertised at £975, with a £25 deposit. Priced

1897 GERRARDS CROSS 1923

Gerrards Cross, showing the growth of Metroland commuter estates along the railway. Coppock, J. T., and Prince, H. C. (eds), *Greater London* (Faber & Faber, London, 1964).

at £1225 was a rather grander affair at Amersham, an 'exclusive Tudor Type', set well back in woodland, with three large bedrooms, one bathroom and built-in garage. While Stanmore Ideal Estates were asking no less than £3500 for some of their houses, there were plenty, if you did not require a golf course or tennis courts next door, which were listed at under £1000. Nevertheless, for many middle-class families who moved out of inner London, Metroland represented a way of life in which they enjoyed new, and formerly inaccessible, pleasures and comforts.

Sometimes a suburb remained an affluent and thinly-populated enclave, like Virginia Water with its golf course and expensive houses occupied by celebrities or rich City folk. This was the world much loved by John Betjeman, the unworldly poet of Metroland, which he frequently sentimentalized in verse:

> Return, return to Ealing
> Worn poet of the farm!
> Regain your boyhood feeling
> Of uninvaded calm!
>
> When smoothly glides the bicycle
> And softly flows the Brent
> And a gentle gale from Perivale
> Sends up the hayfield scent.

Plotlands

As the interwar period unfolded, countryside preservationists were confronted with a lengthening list of 'outrages' and 'national disgraces'. Suburbanization, with its ugly ribbons and intrusive bungalows, continued to be the prime concern, but other 'horrors' were making their presence felt and were perceived as contributing to the ruination of the rural landscape. Roadside petrol stations and garages, many of which had evolved from a blacksmith's or a wheelwright's workshop, were strongly condemned. Clough Williams-Ellis also betrayed a distaste for the economic opportunism of their owners, describing their motley enamel advertisements and unsightly concrete or corrugated iron sheds as 'bludgeoning importunity' and 'destroyers of highway amenity'.[11] Market gardens and poultry farms, two of the much needed new directions in British farming during the long period of agricultural depression, were likewise widely disparaged. John Moore, having observed the disorderly scattering of market gardens along the northern edge of the Cotswolds, claimed that these 'can devastate a beautiful landscape as thoroughly as a mushroom suburb', and complained about their owners having a tendency to 'erect horrible little sheds and shelters at the sides of the roads and stick up scrawled notice boards about the price of asparagus or plums'.

To some preservationists, the most offensive spectacle of all was the eruption of 'plotland' settlements, most commonly found on the cliff tops and shingle shores of coastal England, but also on inland river banks, in secluded chalk vales, and along the margins of woodlands and heaths. In the south east of England, the plotland landscape was to be found in pockets across the North and South Downs, along the Hampshire plain, and in the Thames Valley at riverside sites like Penton Hook, Marlow Bottom and Purley Park. It was interspersed among the established holiday resorts on the coasts of East and West Sussex at places like Shoreham Beach, Pett Level, Dungeness and Camber Sands, and, most notoriously of all, at Peacehaven. It crept up the east coast, from Sheppey in Kent to Lincolnshire, by way of Canvey Island and Jaywick Sands, and clustered inland all across south Essex. Plotlands were invariably on marginal land. The Essex plotlands were on the heavy clay known to farmers as three-horse land, which was the first to go out of cultivation in the agricultural depression. Others grew up on such vulnerable coastal sites as Jaywick Sands and Canvey Island, or on estuary marshland or riverside meadowland in the Thames Valley, also subject to flooding, or they were to be found on acid healthland or chalky uplands.

Sites for such settlements were easily acquired by speculators, able to take advantage of depressed prices of agricultural land and the absence of planning controls. The land was then divided into small rectangular or square plots that were sold off randomly to individuals free to develop them according to

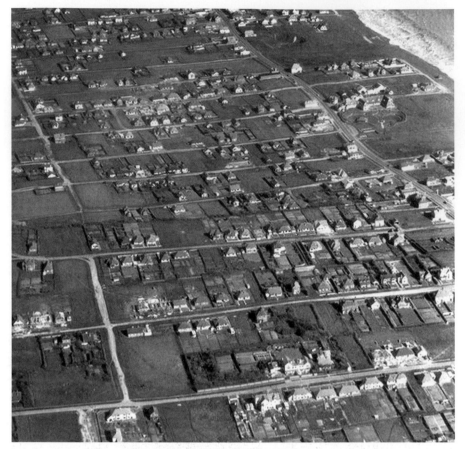

The plotland settlement at Peacehaven on the south coast in the 1930s. Despite almost universal hostility, this was a relatively well-planned, low-rise community.

their own particular aspirations and resources. Plotland development became instantly recognizable as a ramshackle landscape, 'put together on the cheap ... a colourful kaleidoscope of shacks and shanties'. Each settlement contained a curious collection of personalized 'architecture' – a clear reflection of the plotlanders' freedom and spirit of independence. Very typically the plotland landscape consisted of cheap, improvised dwellings, including 'army surplus' huts, old railway carriages, converted buses and 'kit-built' wooden chalets. More often than not, these makeshift homes were painted in the brightest of colours, with pink, primrose yellow and sea blue predominating; and the cheapest of building materials were used, especially asbestos, corrugated iron, plywood and old railway sleepers. As far as public utilities were concerned, plotland settlements were usually ignored by local authorities. For a long period in many cases, plotland houses were without mains electricity and street lighting; many, too, lacked a sewer line and were considered to be a threat to public health. Access lanes and streets were rarely surfaced, and most quickly degenerated into rutted, mud-filled tracks.

Mais, alarmed at their intrusion into some of the choicest spots in southeast England, described plotland dwellings as 'hideous shacks, thrown

haphazard like splodges of mud'; and C. E. M. Joad, who encountered them on his countryside rambles in the Home Counties and elsewhere, saw them as the very worst excesses in a general process of rural desecration. At Marlow Bottom, where one of the Chiltern chalk denes opens out into the Thames Valley, Joad reported: 'To my horror I found not an empty valley but a muddy road running through an avenue of shacks, caravans, villas, bungalows, mock castles, pigsties, disused railway carriages and derelict buses, scattered higgledy-piggledy over the largest possible area of the Chiltern hillsides.'[12] In all respects, plotland developments stood out as the very antithesis of normal, old-fashioned village England and the values that it represented. Plotland complexes were often ephemeral, unsightly, anarchistic and an affront to good taste; in complete contrast, the long-established English village was still seen by middle-class observers as the acceptable unit of countryside living. Plotland settlements were very popular during the

An advertisement for the 'Cottabunga', a prefabricated bungalow of the type which were found in large numbers in the Chilterns.

The "COTTABUNGA" (Regd.)

THIS CHARMING BUNGALOW COTTAGE delivered, carriage paid, to any goods station in England or Wales, ready to erect, for - - - £245 : 10 nett.

"COTTABUNGA" buildings may be seen dotted all over the Countryside, North—South—East—West, and are giving universal satisfaction. No better value at the price is possible, and if you would enjoy the comforts and luxury of this artistic residence this coming summer place your order NOW.

Our illustrated Catalogue, No. 103, containing full particulars and a full range of other Bungalows, Pavilions, Motor Houses, Chalets, etc., post free to any address.

BROWNE & LILLY, LTD.
THAMES SIDE, READING

Telegrams: Portable, Reading. *'Phone: Reading 587*

Second World War, when their resident populations were heavily swollen by friends and relatives seeking refuge from the bombing of cities such as London, Southampton, Bristol, Plymouth, Hull and Liverpool. Since then many plotland landscapes have disappeared or been transformed.

By the mid 1930s, 60,000 acres a year were being lost to agriculture. Most of this land was being taken up by new housing estates as part of the march of suburbia. The uncontrolled spread of the suburbs was noted with alarm by a variety of commentators. As far as small towns were concerned, H. G. Wells spoke for many when he described his home town of Bromley, in Kent, as being swamped under 'the deluge of suburbanism' and the ancient core of the old market town as being distended into 'a morbid sprawl'. He described how, as meadows were built over, hedges became iron railings, and the little River Ravensbourne was engulfed by a new drainage scheme and general rubbish. 'It was a sort of progress that had bolted; it was change out of hand, and going at an unprecedented pace nowhere in particular ... it was a hasty, trial experiment, a gigantic experiment of the most slovenly and wasteful kind.' [13]

Protest and Protection

In the 1920s and 1930s there was growing realization that the pace of landscape change in Britain was accelerating, with increasing concern that many of the changes were undesirable. This led to the foundation of organizations such as the Council for the Protection of Rural England in 1926 and, at a more local scale, groups like the Friends of the Lake District (1934). The CPRE, established largely through the effort of the planner Patrick Abercrombie, was less concerned with the conservative protection of traditional landscapes than with creative attempts to plan for change. The CPRE argued that *laissez-faire* attitudes in the nineteenth century had destroyed British towns, and that the same approach in the twentieth century was threatening the countryside. Beneath its umbrella, organizations and individuals concerned with rural preservation formed a crusade to reduce the scale of the 'personal and corporate thoughtlessness and selfishness of which the despoliation of the countryside was a symptom'. They attacked on a broad front and not necessarily with consensus; houses, roads, petrol stations, electricity pylons and wirescapes, billboards and factories all came under fire.

One of the most outspoken critics of the time was Clough Williams-Ellis, who, as a self-proclaimed angry young man, published an impassioned plea against 'urban beastliness' in 1928 in his book *England and the Octopus*. This was followed in 1937 by a series of twenty-six essays which he edited in *Britain and the Beast*. The CPRE represented a very middle- and upper-class viewpoint, lamenting so many of the changes that were overrunning the countryside now that the big country landlords were no longer its guardians.

They sent a travelling exhibition called 'Save the Countryside' with Saint George for Rural England battling against a dragon whose scaled wings represented cigarettes, petrol, tyres and other billboard advertising slogans which so incensed the preservationists.

The need to avoid chaos and inefficiency in landscape management prompted some admiration, for a time at least, of planning in fascist Germany and Italy. Suburban sprawl, occurring at an unprecedented scale, was the aspect of landscape change that prompted most concern, although the construction of bungalows, chalets and shacks around seaside resorts and elsewhere was also seen as a major eyesore. To the rural working class and even to many farmers, 'trippers' were at worst a source of mild irritation or envy, at best a chance to make an honest shilling. Cafés and tea rooms sprang up wherever there was a demand and came in for particularly vitriolic attacks. Some of them were converted railway carriages, and the fear was, 'a café on the top of every hill ...'. In September 1930 the CPRE wrote to the Design and Industry Association that: 'We feel that the number of these [tea] shops is increasing rapidly and their untidiness almost rivals that of the average garage, and is often worse. The owners are small men and anxious to attract attention, and have neither means or education to build anything very decent.'

In many areas of southern England, Joad's view of the 'uneducated' townsman found echoes in organizations like the Surrey Anti-Litter League, which reported those who dropped litter to the police, and on occasion instituted private prosecutions, as well as campaigning (successfully) to get Surrey County Council to revise its by-laws on litter. They also campaigned against unsightly advertising. John Betjeman displayed a similarly patronizing attitude when describing Swindon's new semi-detached houses as the 'brick-built breeding boxes of new souls'.

Conflict could and did become more serious. Parish and district council minutes from many country areas are full of minor disputes, especially over rights of way and access, throughout the interwar period. For example, about 50 per cent of the business conducted by Heathfield Parish Council in Sussex, in those years, concerned questions of footpath closures, rights of way and responsibility for maintenance of footpaths and tracks. On the border of Kent and Sussex at Withyham in 1938–39, a year-long battle, which involved a large part of the village, was fought to persuade the parish council to take action to reopen an illegally closed footpath

The desire was to keep the urban and rural areas separate, but the reality was that the towns, their buildings and their occupants were creeping outwards at an alarming rate. Improved public transport was one of the main reasons for the spread of suburbia, but just as significant, and even more dramatic in its impact, was the 'sudden triumph, in the interwar period, of the internal-combustion engine over all its rivals'. Harold Perkin, in *The Age*

of the Automobile, described it thus: 'In the automobile age, the flexibility of the bus, the car and the goods vehicle enabled the city and the suburbs to burst like a poppy head, scattering its seeds into every available space ...'[14]

By 1929 the Thames Valley branch of the CPRE had produced a detailed report on the Thames Valley from Cricklade to Staines, which included suggestions for preservation of the 'more attractive parts of the area' as well as attacks on ribbon development and plotland settlements at Bablock Hythe. From the late 1930s, the Isle of Wight branch campaigned vigorously against holiday camps on the island as, although the branch was in 'general sympathy' with camping, they 'do not consider that permanent holiday camps should be placed in or near a good class residential area, or in an area of outstanding natural beauty'. Nor was it only a southern phenomenon: the Northumberland and Newcastle branches were also opposed to ribbon development and the 'destruction' of market towns and villages.

The Scott Report, presented in August 1942, was concerned with the protection of agriculture and rural communities. Scott declared that there was a new Industrial Revolution, brought about by the automobile and by electricity. He went on to report: 'A factory can now be established in a field at the edge of the town, or right out in the country some miles beyond. Its choice of site is indeed only limited to being near a reasonably good road and a 'bus route along which its workers can travel out from the town and its suburbs where they live.'[15]

The rising importance of the private car and other forms of road transport after the Second World War gave suburbanization a further boost. The edge of town became the favoured location for new offices, factories and shopping outlets, where there was more land available for car parking and expansion. In a number of cases, the 'strict control' of the Green Belts was ignored or at best modified in the light of changing circumstances. In the Green Belt of the south east of England, where there is the most pressure for more housing developments, the controls have been generally effective.

Green Belts preserved agricultural land that would normally have been swallowed up by urban growth. Such urban fringe land, however, often suffered blight; ring roads and feeder roads have been imposed around many cities, even those with Green Belts. These intrusions created truncated and odd-shaped fields, ripe for the development of supermarkets, garden centres, park-and-ride, and a range of sports and leisure activities. Such developments were often able to sidestep planning regulations as in many cases they appeared to be meeting genuine needs. Thus around many towns and cities there was creeping suburbanization, where essentially non-agricultural and non-rural activities spread out into the surrounding countryside. The journey northwards from Oxford to Woodstock, which lies within Oxford's Green Belt, now takes you past a range of these urban fringe activities: ribbon development, a park-and-ride car park, several major road intersections, a service

station with hotels, shops and restaurants, a garden centre, a civil airfield, an industrial estate, and an asylum seekers' centre. In 1900 it was all entirely open fields. Since the late 1970s, the range and scale of demands for which the countryside can be exploited have changed. Leisure and sports interests and tourism are the biggest growth sectors. In the Home Counties and around most other conurbations, thousands of paddocks were preserved and created for the suburban horse and pony owners. 'Horsiculture' reflected the demand by urban dwellers for recreational horse riding within easy driving distance of their homes.

The future growth of housing in the South East is still a major issue. A recent report suggested that over one million new homes in the region will be needed by 2016. This will involve the expansion of houses by 130,000 in Essex, 72,000 in Hertfordshire, 55,000 in Bedfordshire and so on. This will require a dramatic expansion of Harlow in Essex, and the building of the equivalent of two new towns as large as St Albans in Hertfordshire. One county councillor complained that the government was turning south-east England into a kind of Hong Kong, an industrial and commercial power-house for the UK. 'This may be good for economic growth, but it is not in the best interests of the country as a whole.'[16]

In a polemical essay on 'Urban Landscapes', Simon Jenkins speaks for many who deplore what happened in and around England's towns in the second half of the twentieth century:

> Circumnavigate any large settlement in England short of a metropolis and you will see round it a spreading stain of uncoordinated, unplanned suburban development. Round Exeter or Cirencester, Cheltenham or Ely, Nottingham

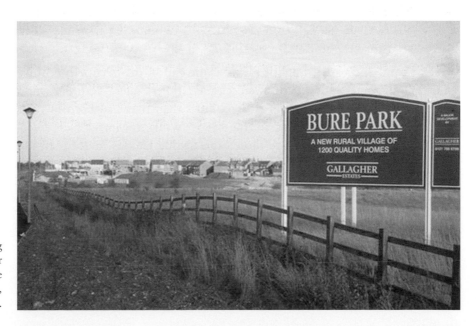

A new housing estate under construction in the 1990s at Bicester, Oxfordshire.

or York, a fringe 'green' activity such as playing field, pony club or farm depot wins planning permission to move farther out and, on the grounds that it is already semi-developed, is allowed to sell on to a speculator with planning permission. Wherever there is 'soft' land near a garage, hypermarket or motorway junction, there is pressure to infill round it. A hard-pressed farmer with friends on the council wins a caravan park or industrial estate. The process is now utterly remorseless. Nor does it have anything to do with relieving urban housing stress. I have yet to see a new estate in Bedfordshire or Buckinghamshire, Cambridge or Somerset that is anything other than for car-borne commuters. England may have the lowest amount of green space per head of any big country in Europe, but it continues to lavish what is left on the lowest housing densities ... Modern English townscape is the embodiment of the celebrated contrast between private affluence and public squalor ...[17]

He goes on to describe the task of 'rescuing England' from this process as the greatest challenge facing politics today.

This was a view shared by many writers who saw the relentless march of suburbia and its associated hypermarkets and ring roads into the countryside as an assault upon that which they held most precious – the English rural landscape. Viewed from an aesthetic standpoint, towns were undoubtedly uglier, blander and had less individual character in 2000 than a hundred years before.

Nothing on earth would induce me to lay down my sleeping bag on the pavements of Bradley Stoke, the sprawling satellite town that since 1980 has grown to fill the gap between my home city of Bristol and the M4. No enlightened planning there, just an unholy alliance of highway engineer, house builder and estate agent. It is our car-dependent society, devoid of any inspiration, that is the legacy of the last quarter of the twentieth century.[18]

Yet, for the most part, English towns at the end of the twentieth century, whichever barometer one used, were cleaner, tidier, safer, healthier, more affluent and more democratic in their facilities than they had been in 1900. It is interesting to note that in the 1880s William Morris had voiced remarkably similar sentiments to those expressed by Jenkins in 2002. In 1881 William Morris was devoid of hope: 'we have begun too late and our foes are too many; *videlicet,* almost all people, educated and uneducated. No, as to the buildings themselves, 'tis a lost cause, in fact the destruction is not far from being complete already.'[19]

CHAPTER 8 | *The Village*

> The last days of my childhood were also the last days of the village.
> I belonged to that generation which saw, by chance, the end of a
> thousand years' life.
>
> Laurie Lee, *Cider with Rosie* (1959)

T HE ENGLISH VILLAGE POSSESSES GREAT TENACITY. Over the
centuries it has proved to be an extremely flexible unit of settlement, and
its survival into the twenty-first century is a mark of that tenacity. The 1894
Local Government Act preserved the village and parish as elements of local
government; and the newly founded civil parishes closely followed the bound-
aries of the ancient ecclesiastical parishes. The 1974 Local Government Act
continued to recognize the parish as the first rung of democratic decision-
making in Britain. Despite this administrative identification of the village as
a place where people still dwell, the village as an independent form of
community is all but dead – the village is now essentially an adjunct to the
town and city.

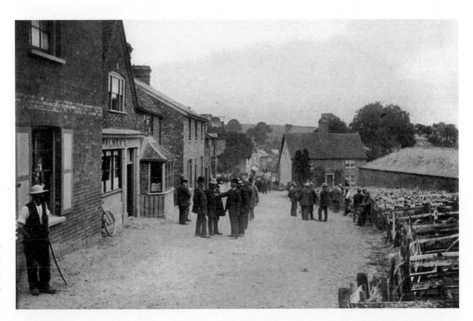

A sheep fair in the
High Street at East
Isley, Berkshire, at
the beginning of the
twentieth century.

We all have a picture of the perfect village with its church, manor house, inn, smithy, a scatter of picturesque thatched cottages, and the village stores. This caricature was well expressed by Miss Mitford in *Our Village* as long ago as 1824:

> Of all situations for constant residence, that which appeals to me as most delightful is a little village far in the country; a small neighbourhood, not of fine mansions finely peopled but of cottages and cottage-like houses, 'messuages or tenements', as a friend of mine calls such ignoble and non-descript dwellings, with inhabitants whose faces are familiar to us as the flowers in our garden; a little world of our own ... where we know everyone, are known to everyone ...[1]

This conventional 'chocolate-box' portrait does contain elements of truth, in that it depicts a self-contained and self-sufficient rural community. The reality of life in the English village even as late as 1900 for many of its inhabitants was, however, much harsher: many agricultural workers were ill-paid, badly fed and poorly housed; often, cottages were overcrowded, with poor sanitation and in a state of decay. Conditions were improving slowly, but poverty and even destitution were still common. There was a steady movement away from the village to the town, which had started in the last quarter of the nineteenth century and was to continue for much of the twentieth.

Because of an almost continuous agricultural recession up to the Second World War, many of those villages which lay further than ten miles or so from a major town or city were in decline until the 1960s, and rural depopulation was a major problem, as people left villages and services closed. Since then, however, village property in many parts of England, almost irrespective of its distance away from an urban centre, has become increasingly valuable. The rural environment with an urban standard of living has become the ideal for millions of people, and this has brought about a sharp reversal in the movement away from the countryside. Commuters, the retired and second home owners have turned to the village in large numbers. The new inhabitants have brought a new prosperity to the village that has resulted in the rebuilding and restoration of much of the housing stock. This refashioning has sometimes been undertaken in traditional styles with traditional material, partly as a result of the preferences of the relatively affluent newcomers for the 'rural idyll', and also increasingly with the support and dictates of planning policies; more often, however, the rebuilding has used standardized material that owes nothing to the locality in which it is used. Nevertheless, many ancient villages are as well kept as they have ever been, apart from the presence of the all-intrusive motor car. The reborn villages, however, are very different in their economies and their social mix from their predecessors. Villages abound in references to a rural past: elements resonating of the past

Cardington, Shropshire, in 1970, looking much as it had in 1900.

– Miller, Wheelwright, Blacksmith, Baker and Windmill road names – are ubiquitous. Yet the traditional rural infrastructure has all but disappeared and has normally been replaced by something that owes little to the particular village in which it is located. 'Anywhereness' or 'nowhereness' has penetrated deep into the countryside.

Nevertheless, in 2000 the central core of many English villages was much the same as it had been in Queen Victoria's time. The parish church, the manor house, the rectory and the manor farm (home farm) were still there. The buildings and the place names survive, but the social structures they represented have gone. The church is now as much a historic building as a house of prayer; the rector, if there is one, will not live in the rectory and will have responsibility for half a dozen parishes. Although church restoration is widespread, and even the occasional new parish church was built in the twentieth century, church redundancy is far more common. The church no longer underpins the faith and 'moral fibre' of the parish, and the days have long since gone when the squire was at the top of the village's social and economic order. To observe such changes is not to condemn them. Life in the village for most residents is far more prosperous and comfortable than it has ever been. The stultifying sub-feudal hierarchy of many rural communities has gone, although the English ability to replicate it in a variety of forms is quite astonishing. And this sentiment was not universally shared, witness James Lees-Milne's reflection on the loss of a benevolent aristocracy. 'This evening the whole tragedy of England impressed itself upon me', he wrote in 1947, while negotiating the National Trust's acquisition of Brockhampton, Worcestershire. 'This small, not very important seat in the heart of our secluded country is now deprived of its last squire [John Talbot

Lutley]. A whole social system has broken down. What will replace it beyond government by the masses, uncultivated, rancorous, savage, philistine, the enemies of all things beautiful?'[2] Lees-Milne saw the social fragmentation of the village and deeply regretted it, but there is still an implicit reluctance by many to recognize the structural changes that have taken place and to admit that the English village is not the place it used to be.

> The romantic model of the village assumes that villages were once self-sufficient, intimate communities. Idealising the cosy community immigrants may seek an 'authentic village'. The expectation is that here the natives will be friendly and, by implication, the immigrant outside will be accepted, if not into the bosom of the family/village, then at least as an integral part of the system.[3]

Until the early nineteenth century, the majority of the population of England lived in the countryside. Agriculture and its associated skills and crafts in one form or another provided the main occupations for most people, and the village, hamlet and farmstead were the basic units of English settlement. The pattern of discrete nucleated rural communities – the villages that we still see scattered over much of the English countryside today – came into being in the late Anglo-Saxon and Norman period, and with it came the parochial organization which, in a modified form, still covers the kingdom. The parish place names, churches and boundaries that provide the framework for the rural landscape all have an ancient pedigree. The rural landscape was fashioned to service these agrarian communities, with networks of local tracks and paths to connect the fields, meadows, pastures, commons and woodland etched out to serve the lord of the manor and the villagers. During the eighteenth and nineteenth centuries the agricultural revolution, with the enclosure of the old communal open fields, dealt a severe blow to many villages, effectively weakening the village fabric. Following the Parliamentary Enclosure of about half of England, many farmsteads moved out of the village into a countryside of newly-created fenced and hedged fields. In large parts of England, Parliamentary Enclosure resulted in an end to subsistence arable farming. Such farming was replaced by more profitable livestock and mixed farming. Far fewer workers were required to manage the reformed farming system in the countryside after Enclosure, and many of the displaced found work in the newly founded industrial towns. Thus the balance between the number of people living in the country and the number living in towns began to swing inexorably towards the towns.

In the middle of the nineteenth century the village as an institution still appeared to have a future as an economic and social unit. Country occupations were still thriving in 1851. Tuxford (Nottinghamshire), for long a posting-station on the Great North Road, in 1851 had saddlers, a tinker, an umbrella repairer, a ropemaker, coal merchants, a baker and home-made sweet shops – in addition to a chemist, a vet and a lawyer. Even in the

remote Lindsey Wolds, the village of Binbrook (Lincolnshire) could boast of 109 craftsmen, thirty-one tradesmen and eleven professional men out of a total population of just under 1300. The turnpike roads, canals and the railway in particular all conspired, however, to break down country isolation and self-sufficiency. In the second half of the nineteenth century, accelerated by the agricultural depression, village communities began to disintegrate. At Cerne Abbas, a large Dorset village not served by the railway, the fifty-seven tradesmen of 1851 had shrunk to a mere eleven by 1901. The decline of rural manufacturing both contributed to and resulted from the more general contraction of population in the countryside. As the number of agricultural workers decreased, so proportionately the demand fell for the services of a wide range of associated craftsmen. In 1851 there were as many as 112,000 blacksmiths in Britain, most of whom were still employed in villages. Many blacksmiths were enterprising and rapidly adapted to the motor age; indeed, during the Emancipation Run of 1896, drivers were surprised to come across a blacksmith in the village of Albourne Green on the Brighton Road who advertised 'Motor Cars Repaired while you wait'. By the outbreak of the Second World War, the number of blacksmiths had dropped dramatically, and many of the survivors were involved in garage work as well as maintaining their traditional tasks with the diminishing number of horses.

Added to this was the continued polarization of manufacturing industry in the towns. Industries which had once been widespread in the countryside occupied new locations at ports and major concentrations of urban population. The grinding of corn, for example, one of the oldest forms of rural industry, ceased to be a truly rural activity during the last quarter of the nineteenth century, as large mechanized mills were established in towns to deal with home-grown supplies brought in by rail. Such mills were also established in the ports to handle grain imported by ship from overseas. In the 1880s some 160,000 chairmakers had been scattered throughout the Chiltern villages; within two decades, however, the industry was concentrated in new factories in High Wycombe. Everywhere village industry and crafts were on the wane – the final phase in the life of the village as a coherent community had begun.

In 1850 the urban population equalled that of the countryside, but by 1901 the majority of the population were classified as town dwellers. Perhaps even more important than this statistic is the percentage of the population who actually worked the land – in 1911 there were under one and a half million men employed in agriculture, compared with six and a half million men in industry. Cheap imports of grain and other foodstuffs that came into Britain in the second half of the nineteenth century resulted in falling prices and land values, and this undermined British farming, with a resulting rural crisis that led to large numbers of village dwellers leaving for the towns. This drift from

the countryside continued for much of the twentieth century. Increasingly sophisticated farm mechanization and higher yields as a result of the use of fertilizers and technological farming meant that agriculture progressively became a high-yield, low-density employer.

Added to this in the latter part of the twentieth century were the considerable strains brought about by England's membership of the European Union; although British farmers continued to be subsidized, as they had been since the Second World War, their continental competitors received higher subsidies and most were operating with lower costs in better climatic conditions. By 2001 the percentage of the population directly involved in farm work was the lowest in Europe. Furthermore, overproduction was a problem, and farmers found themselves in the extraordinary position of being paid for not producing specific crops of which there was a European surplus in a scheme known as 'Set-Aside'.

The result of this was that farming was not the only occupation in the countryside; indeed, it was no longer even the primary occupation in the countryside. Nevertheless, it remained the primary occupier of space: agriculture still dominated the rural landscape, but rural settlements were to a large extent divorced from this primary activity. Highly mechanized farms operated largely independently of village England, although village farms did still exist in parts of the country, mainly in the upland zone. Elsewhere, villages essentially became outlying extensions of suburbia.

There were other forms of village in England, notably those that had grown up, largely in the nineteenth century, as a result of industrial activity. For example, a large number of villages linked to coalmining were to be found in County Durham and Northumberland, Yorkshire, Derbyshire and Lincolnshire, with smaller numbers in counties normally thought of as being wholly agricultural, such as Kent and Shropshire. Such villages were often small, consisting of strings of workers' terraced housing, with few public buildings and facilities, although a number of more philanthropic industrialists did build closed industrial villages. Such communities were very similar to the rural estate or model villages in structure and appearance.

Given the pressure upon the countryside, there are questions about the very survival of rural Britain. Is there an 'urban' and a 'rural' in the traditional senses of those terms? Clearly, in terms of lifestyles and values, the distinctions have become blurred, but some differences do persist. Many people, particularly long-term rural residents, believe that the village still has a separate and distinctive entity. There was a rural community to which they felt they belonged, and attitudes towards in-migrants who either tried to take over or did not participate in the local community were generally antagonistic. The Countryside March in London in November 2002 attracted over 400,000 people in a protest against threats to the country way of life. Although many of the assembled had dubious countryside credentials,

Bibury in the Gloucestershire Cotswolds in the 1930s. In the second half of the century the village became a very popular tourist attraction.

however, if viewed from a traditional standpoint, they did reflect an adversarial stance – an attitude of them versus us – between town and country that was still very strong.

There remain marked regional variations. The further one moves northwards or westwards, and in pockets of East Anglia and Kent, the easier it is to obtain a feeling of village life as it was a generation ago, or in some remote places even a century ago. Generally, however, there has been an inexorable process of breakdown in the social and physical fabric of the village. Regional horticultural and agricultural specialisms have also broken down. Redundant oast houses in Kent and Herefordshire are a reminder of a time, not so long ago, when beer was brewed locally in many areas. Similarly, as the century progressed, many traditional market garden areas were hit as imported fruit, vegetables and flowers were brought in by aeroplane throughout the year. The very basis on which the village flourished for thousands of years – agriculture and crafts – no longer plays a serious part in the life of most rural communities. The basic agricultural activities that welded the village population together and dictated the village calendar, such as harvest time, have now all but disappeared, or have been made remote from the average villager by mechanization and technology.

Other traditional forms of village employment, such as craftwork, have now also virtually disappeared from the countryside. There have been sustained efforts of regeneration of local crafts in recent decades, encouraged by a demand from the new, affluent village dweller, but the scale of employment available still tends to be limited. The result of this has been

that farm and village have become increasingly divorced from each other. It is true that this is a process that in some places started in the nineteenth century, but it is now universal and has been heavily emphasized by the development of efficient, mechanized farm complexes of giant silos and intensive rearing sheds, normally sited well away from the old rural communities. Thus the links between the farm and its land and the village community have been all but severed in many places. The farm now employs few if any local inhabitants, and the farmer himself can often be a professional manager with no links with the locality. 'The majority are not so much farmers as full-time administrators and managers, who might as easily be working in an office or factory in any large city.'[4] The village and the parish have long since ceased to be the market for local farm produce, except perhaps for specialist products sold at farmers' markets; and the farmer is part of a national and, increasingly, an international syndicate.

Village England between the Wars

The First World War exacted a heavy toll on village England. Yet, even before the war, many young men from the country had joined the Army, preferring military life to a life of agricultural drudgery. Fourteen young men left Akenfield in Suffolk to join up between 1909 and 1911. 'There wasn't a recruiting drive, they just escaped.'[5] Of the half a million or so rural men and youths who served, nearly one-quarter were killed or wounded. The social impacts of this vast scale of death and maiming were far-reaching, and were felt in virtually every English village. One very tangible monument to the human sacrifice of 1914–18 was the erection of public war memorials listing and honouring those who had given their lives and placed in prominent positions – on the village green, in the middle of the main street, or in front of the church – in virtually every village. There are many versions of these solemn monuments, the size and quality of which were not always commensurate with the size of the village population or the numbers of bereaved relatives and friends. The less expensive ones, a stone cross standing upon an inscribed block was the most widely adopted structure, were financed through the normal channels of public subscription, house-to-house collections and local money-raising events. The more elaborate types of village war memorial, however, such as the ones that were embellished with decorative carving or carried a life-size 'soldier-with-rifle' statue, were usually beyond the scope of ordinary communal funding and relied on wealthy families remembering their dead.

The decline of the country house was also an important factor in the weakening of the fabric of many villages between the wars. And one more nail in the coffin of the traditional rural social order was the decline of church-going, a trend that became more pronounced after the First World War.

Flora Thompson, writing shortly before her death in 1947, was one of those who had noticed its impact on village life:

> On Sundays village churches were no longer as well filled as they had been ... very few of the clergy preached to full churches or had much influence over their parish as a whole, for a common faith no longer knit old and young, rich and poor, into one family and the church was no longer the centre of village life. The new centre for surrounding villages was the nearest town.[6]

The period between the two world wars was a transitional time in the evolution of village England. It saw the shoots of economic and social recovery emerging in some villages, representing islands of rural regeneration; but it also witnessed the persistence of population decline and economic decay in many others. More than half of the parishes and villages in the East Riding of Yorkshire experienced continual population decline between 1911 and 1951. Some parishes in the High Wolds suffered a loss of more than half their population. A few villages were completely depopulated; for example, the last family abandoned their home in the now abandoned village of Snap, in Wiltshire, in the 1930s.

The coming of the motor car was responsible for the revitalization of some villages, and in the Edwardian era advertisements from estate agents such as Hamptons promoted country residences especially suitable for motorists, 'being within a speedy run of town, on good roads'. J. J. Hissey discussed the impact of the car on remote villages in Sussex with an estate agent in 1910:

> There is quite a boom in such property ... property of this class, that it was very difficult to deal with a few years back, is now readily saleable, provided it is situated in at all pretty country. Not long ago, nearness to a railway was almost an imperative condition of my clients; now, very often, the stipulation is, 'well away from the railway'.[7]

With few exceptions, the successful villages were those that were suitably positioned for the development of a dormitory function and new economic activities. Access to a main road, and proximity to a railway station or halt and a focus of employment, such as an urban centre, a large rural factory or a military airfield, were all desirable. At the same time, coastal villages, 'beauty spots', literary and artistic shrines, and any other villages with a special tourist attraction were 'discovered' and frequented in an age when motor transport – the car, the bus and the charabanc – was beginning to make its mark. This process of opening up rural and village England was, however, imposed upon a predominantly depressed and decaying countryside, rather than on one that was prosperous and energetic. In the 1920 and 1930s, therefore, there was a clear contrast between the poverty and sleepy backwardness of the old village life, and the town with its bustle of motor cars, trams and buses.

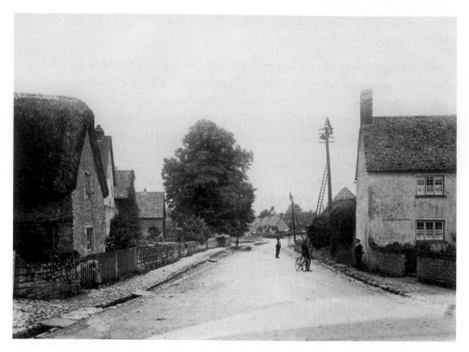

The telephone being introduced at Cumnor, Oxfordshire, in the 1920s.

With the numbers of private cars on British roads rising from just 109,000 in 1919 to the million mark in 1931 and over two million in 1939, the motor car was arguably the most important single influence on village life, creating opportunities for such new enterprises as petrol stations, repair garages, fruit and flower selling, and countryside tea rooms. For the last, the spread of bus services and the increasing popularity of charabanc outings provided additional custom, as did the growth of such pastimes as cycling and organized 'rambling'. This upsurge in mass outdoor leisure and exploration of rural Britain – what the philosopher and polemicist C. E. M. Joad disparaged as 'the untutored townsman's invasion of the country' – also rescued many struggling village public houses whose trade had been falling away as a consequence of rural depopulation.

The provision of public infrastructure – gas, electricity, water and mains sewerage – was a principal function of the Rural District Councils, especially after the 1933 Local Government Act enhanced their powers and granted them larger financial resources. Following this Act, there began a wave of infra-structure investment in rural England that continued until the outbreak of the Second World War. Much the greater part of this improvement was focused, however, only on the largest and the most accessible villages, leaving countless numbers of more remote and smaller settlements, including many picturesque closed villages, still unsupplied. The 'Scott Report' in 1942 indicated that one out of every three villages in England was still without any piped water, and only one-quarter of farms were connected to mains electricity. Two years later, the Agricultural Economics Research Institute, in

a comprehensive survey of a rural area in the Oxfordshire Cotswolds, reported that:

> Houses themselves are too often damp, dark, ill ventilated and ill found. Piped water is almost unknown in most cottages, and in hundreds of villages there are no supplies even to stand-pipes in the streets. It follows, of course, that internal sanitation and arrangements for sewage disposal are equally rare. Slops are emptied in the garden, baths are non-existent, and the outside privy-vault is universal.[8]

Nevertheless, the interwar period saw a nationwide enthusiasm for constructing village or parish halls, institutions that played an important role in resuscitating thousands of rural communities and broadening their way of life. Another stimulus came in 1919 with the introduction of a Saturday half-day off for agricultural workers, giving them more time to play football in the winter months and cricket in the summer. Encouragement for village sports came from the Rural Community Councils, which provided funds for playing fields and the construction of pavilions. Village football and cricket helped to widen horizons: with the formation of 'district' and 'county' leagues in the 1920s and 1930s, closer links were forged with neighbouring rural communities, and contacts were made with some of the more distant villages and market towns.

A very noticeable and widely criticized addition to the landscape of most English villages in the interwar years was the advent of rural council housing. The Tudor Walters Report in 1918 and the Addison Housing Act in 1919 had set the stage for the nation's first large-scale programme of council house

A group of council houses (top centre) lies apart from the core of the picturesque village of Pembridge in Herefordshire.

construction. For several years, however, this was almost wholly urban in application. In rural Britain, where farm workers and their families still predominated, authorities were reluctant to undertake the building of dwellings for households whose low incomes meant that there was little chance of them being able to pay an 'economic' rent. Accordingly, until the late 1930s, most villages only had a cluster of council houses. Eventually, the National Government's Housing Act of 1936 offered rural local authorities subsidies of up to 80 per cent of the costs of constructing new homes for agricultural workers. In Akenfield, sixteen council houses were built in the late 1930s. They stood 'in an attractive position in the main street but reveal their authorities' brutal indifference to taste, feeling and imagination ... bathrooms and water closets are only now being installed [in 1968].' The Housing Act was followed by rural slum clearances, nearly all of which were in open villages. It also led, however, to the removal of many run-down, but historically important, old cottages, and this provoked a strong reaction from preservationists, who saw this process as 'state vandalism' and bureaucratic insensitivity:

> Old houses and cottages in the villages are diminishing rapidly. A heritage of unique value is in danger of being destroyed. Modern acts and by-laws, and the interpretation of them, weigh heavily against the preservation of work which, of its kind, is not likely to be equalled again.[9]

By the early years of the twentieth century, it was thought that farming had fallen into a disastrous state, and any lasting recovery from depression and any reversal of rural decay would require not only fundamental changes in agricultural methods, but also the settlement of more people on the land. Support for smallholder farming included politicians, agricultural advisers, and influential writers such as Rider Haggard and Thomas Hardy. The 'smallholder movement', therefore, became part of a wider 'back to the land' ideology. Smallholdings offered a means of entry into farming – the first rung on the agricultural ladder – for the enterprising 'small man'; and creating them was seen as a practical means of reversing rural population decline and reinvigorating rural England and its village communities. Hugh Massingham, writing in 1945 and looking back to the vanished age of peasant England before its 'ruination' by the Parliamentary Enclosures and the agricultural revolution, saw the smallholder movement as 'the road back to craftsmanship and a true husbandry'. Idealistically, it was believed that the movement would be accompanied by the reconstruction of rural and village England through the restoration of the lost culture of self-sufficient peasant cultivation. This solution would enhance the rural landscape and not bring the sort of 'unsightliness' that had been allowed to become commonplace in such market-gardening and poultry-farming areas as the Vale of Evesham and west Lancashire.

The smallholder movement had its first political victory in 1892, when the first Small Holdings Act was passed. This legislation gave the newly constituted county councils the powers to acquire land for the purpose of providing smallholdings for agricultural labourers and other landless villagers to purchase by instalments. At first, only a handful of counties – Worcestershire, Lincolnshire, Norfolk, Cambridgeshire and Hampshire – actively responded, but eventually most other counties followed their example. Further Small Holding Acts were passed in 1908, 1919 and 1926. These served to speed up the whole process and provided government subsidies to the authorities concerned.

By 1908, some 14,000 council smallholdings had been established and occupied. These ranged in size from just one or two acres to a maximum of about fifty acres. The large majority were to be found in open parishes, where they were taken up mainly by agricultural workers and the sons of poorly off tenant farmers. The provision of smallholdings was increased again soon after the First World War. Rural local authorities sought to establish new enterprises and homes in the countryside for those 'returning heroes' who had a rural background. By 1926, the number of council-promoted smallholdings in England and Wales had risen to 30,000, many of which were occupied by ex-servicemen. A decision was made that year, however, to shift the financial burden from central government to the county councils, resulting in far fewer new schemes being introduced after this date. Until then, the construction of smallholders' dwellings, some laid out in small detached colonies and others built on their own alongside the roads leading into and out of a village, had been virtually the sole means of public supply of rural housing. After 1926 this role was taken over, and substantially augmented, by the construction of village council housing.

Some county councils were more enthusiastic than others in promoting smallholdings: the horticultural counties of Worcestershire, Bedfordshire, Cambridgeshire and Lincolnshire were amongst the most active. Many council smallholdings were established in the districts of Evesham and Pershore, in the heart of the main fruit-cultivating and vegetable-growing area. Significantly, between 1911 and 1921, Evesham Rural District was one of a small number of rural localities in England to have witnessed a reversal of population decline. Within the Vale of Evesham, a distinction emerged between the smallholding and horticultural parishes that experienced population growth and the parishes, dominated by cereals and livestock farming, that continued to decline. Just after the Second World War there were some 395 horticulturists in the Vale, occupying holdings which averaged seven acres.

Smallholders were romantically described by Massingham as 'the new peasantry', and they played a leading role in the expansion of horticulture here and elsewhere in rural England during the Depression. 'And how is the

new peasantry to be created?' asked Massingham: 'Only by fostering the small holder and small owner, and by opening up new opportunities for them' was his answer. Yet the smallholder movement never really attained the momentum and the degree of success that its advocates had hoped for. Indeed, many of the new enterprises were unable to survive the difficult farming conditions of the 1920s and early 1930s; and the number of holdings under five acres in England declined during this time. By 1935 there were 25 per cent fewer smallholdings than there had been in 1914. Building on the initial success of the smallholding movement, however, the Land Settlement Association was established by the Quakers, with similar ambitions, in the 1930s. The LSA, which received government financial help, was instrumental in developing twenty-one estates, transferring some 800 families from Northumberland, Cumberland and County Durham. The estates on better soils were divided into holdings of three to six acres with a bias towards horti-culture, whereas Fulney estate (Lincolnshire), on rich silt land, was completely devoted to horticulture, with some two-acre holdings eventually concen-trating on the forcing of spring-flowering bulbs. On poorer land, as at Abington (Cambridgeshire), larger holdings of eight to ten acres were biased towards pig and poultry keeping, whilst Stannington's (Northumberland) twelve-acre holdings were totally devoted to livestock. Many of the new houses that were needed were designed to be compatible with their locality. The estate's Local Advisory Committee at Fox Ash (Essex) considered non-flushing lavatories in sheds appropriate for 'that class of house', whilst timber-framed, asbestos-lined prefabricated houses were erected at Andover (Kent) as the result of an offer, made by the Hurlingham Bungalow Company, of one free bungalow in every four purchased. The introduction of the LSA scheme at Fen Drayton, in Cambridgeshire, increased the population from about 200 to about 550. Generally placed on individual holdings, houses on some estates were grouped in hamlets in order to help foster community spirit.

The End of Village England

Since the Second World War, many villages have experienced both a new upsurge of vitality and a dramatic fall in the number of available services. Increased mobility through the motor car and, to a lesser extent, public transport has meant that many services that were previously provided in each village are now available only in the nearest town. The local store, post office and even the public house have followed the secondary school to the town, and parish churches are still being made redundant at the rate of about one hundred a year as congregations continue to decline. The ingredients that make up the village community have changed dramatically. The village has thus both suffered and benefited as a result of this increased personal mobility,

with the resultant profound change in work patterns – many people are now prepared, and able, to travel considerable distances to their places of work.

Until the 1970s, the work opportunities available in most villages remained restricted. This changed, however, with the introduction of light-industrial estates in rural locations across the country and, latterly, with the growth in the use of the internet. Thousands of small businesses have now taken root in villages as telecommunications have become cheaper and easier to manage. The development of villages for recreation has resulted in tourism becoming a major rural employer. The countryside is increasingly regarded by the town dweller more for its amenity value and less for its capacity to produce food.

Initially, villages which lay within twenty miles of a town or an employment centre were taken up as pleasant places to live, and this is reflected everywhere in the rebuilding and renovation of houses, house extensions, single and double garages, infilling and village expansion. Later, when distance was no longer a consideration, villages throughout the country experienced a wealth of newcomers. We have only to look at those villages which lie close to large urban centres in southern England to see this process of change at work. Since the Second World War, many of these settlements have been chosen or, more often because of close proximity to a town, have evolved as nuclei for commuter development. Large private and council estates have been grafted onto ancient centres, in many cases changing the physical form and character of the original village out of all recognition. In some cases a new road has bypassed the old village centre and acted as a focus

The historic core of the village of Hurworth-on-Tees, County Durham, has been swamped by post-Second World War housing.

for development, while in others the development has joined old villages to an outward-spreading conurbation – a process that occurred in the eighteenth and nineteenth centuries in places like London and Birmingham, and one that continued at an accelerated rate around many towns and cities in the twentieth century. If we look at Nottingham, for instance, we see that the former separate villages of Burton Joyce, Ruddington, Radcliffe on Trent and Nuthall have been absorbed, while the former textile village of Calverton has been greatly expanded as a dormitory settlement.

Such development has transformed many rural areas, making them virtually indistinguishable from the suburbs of countless towns and cities. In some cases there has been a complete transformation from village to town within a decade. For instance, the population of Ringmer (East Sussex) nearly trebled after 1960, and it has changed from a small rural settlement to a medium-sized industrial town. The postwar period has seen a transformation not only in the social composition of most English villages but also in their physical appearance. Today, only a small proportion of villages bear a close resemblance to their appearance even half a century ago. The most widespread and most conspicuous feature of this physical transformation is the large quantity of new private residential development, much of it built in the form of trim-looking housing estates located on the periphery of the village. The houses in these developments used standardized, mass-produced construction materials and have bequeathed to village England a universal ordinariness of housing design. During the 1950s and 1960s a plain, functional design prevailed that made no reference to past architectural forms. Instead it was typified everywhere by its box-like shapes, plain walls, gently sloping roofs and absence of decorative features. Semi-detached and detached housing was the norm, from roomy 'executive' homes at the higher end of the market to bungalows and chalets at the lower. The bulk of the residential housing was constructed in the form of orderly arranged estates, with rigid building lines set back from a circulatory public road and branching streets – a design which was indistinguishable from that used in urban contexts at the same time. Throughout the country, extensive use was made of artificial roofing tiles, plate-glass windows, concrete breeze blocks, and reinforced-plastic drainpipes and guttering. Garages with steel doors were often placed in a conspicuous position at the head of the drive or protruding out from the front of the house. All of this was very different from the much derided prewar fashion for pseudo-historical architectural styles.

Since the Second World War, increased pressure on the village has been met by increasingly broad planning measures to control and monitor development. After 1970, in particular, there was a growing tendency to try and maintain the 'status quo'. Local government reorganization in 1974, which created both counties and districts with planning responsibilities, was accompanied by the introduction of planning policies in the form of County

Village school in the early twentieth century, housed in a thatched building of the type of which many were destroyed later in the century.

Structure Plans and, later, Local District Plans. Added to these were national government housing policies which local authorities must implement. The European Union, too, has a wide range of environmental policies which have had an increasing impact on the rural landscape.

Village histories almost invariably focus on the ancient church, the lord's manor house and the picturesque, rose-covered cottages; but they ignore those numerous other features – the craftsmen's workshops, the Nonconformist chapels, the rows of labourers' dwellings, the parish hall, the interwar ribbon development, and the council-housing colony – that, taken together, constitute much the greater part of most English villages. Each of these, however, has important things to say about village history and is a significant piece of the historic building fabric, even if it does not have any pretensions to beauty and charm. They inform us of a very different rural world.

Recent decades have seen widespread changes to long-established community institutions. Hundreds of village schools and their grounds have been closed down and sold off in the property market. Nonconformist chapels, which once provided for the spiritual life of the rural working class, are likewise diminishing in numbers, either being left derelict or being put to some new use. And parish halls, proud symbols of the interwar spirit of rural self-help and community revitalization, are now being upgraded or completely transformed. Prior to these changes, the village building-fabric stood as a visual record of the way of life, past and present, of the whole community. Today, however, anyone in search of a balanced and realistic social history has to look carefully amongst all the gentrification and refurbishment.

Rural planning policies have had to balance the competing pressures imposed by the need for more housing, on the one hand, and the desire to maintain the rural quality of villages, on the other. Most authorities have opted for a policy of infilling gaps in existing rural settlements and identifying a small number of villages as suitable for growth. Other villages are deemed to be sacrosanct and may not be subjected to any new development at all. Inevitably, such a wide range of policies and legislation has meant that the control of the shape and form of our villages is now largely in the hands of government, national and local, and developers. Central control of what goes on, in planning terms, in the countryside has never been stronger, and although many would argue that it has never needed to be stronger, others complain about the dead hand of bureaucracy and the need to 'cut red tape'. The latter is normally a thinly veiled plea by individuals or groups to be allowed to do exactly as they like – build new houses in restricted areas. Today, the size, shape, colour, and texture of all new developments is monitored by a development control mechanism which, although sometimes flawed, has protected many parts of England from the shambles of ad hoc suburbanization which characterizes parts of the USA.

Since the 1970s, developers have been faced with a shortage of good quality building land on the edge of villages; therefore, residential infilling has become the prevailing form of village growth. Generally speaking, infilling has tended to be encouraged rather than opposed by planning authorities as the lesser of two evils. Some infilling has taken place on former vacant spaces lying between the village cores and existing postwar housing estates, but more noticeable, and often more harmful to a village landscape, is the cramming of new housing within the ancient property boundaries which extend back from either side of the main streets. The infilling process is not only removing local shapes and spaces, it is also destroying some of the best and most familiar sights looking into and out from the village. Trevor Wild writes: 'There had once been a time when people could gaze across such spots and admire a good view of the medieval church, an interesting old farmhouse or a favourite group of cottages. One by one, however, such visual pleasures are now being taken away by the intrusion of infill housing and its incongruous post-modern architecture.' [10]

Replacement windows in uPVC can introduce styles and finishes completely in conflict with the local character. The fast-developing 'nostalgia industry', with its 'olde worlde' carriage lamps and other adornments, can infuse a street scene with a character that is inappropriate to the area and can introduce a dull uniformity that obscures regional differences. The arrangement of the new village housing is often decided upon first, then access roads are fitted in around the houses. The flexibility of the new approach, often accompanied by dispensing with building lines, is much better suited both for incorporating higher-density housing and for making optimum use

of smaller and more confined sites. Entrance into a modern infill estate is normally provided by a cul-de-sac access lane, since a circulatory road takes up too much space and is often impossible to place inside the narrow and elongated configuration of a typical village croft or close. Typically, a group of a dozen or so dwellings are focused upon a short driveway or 'mews-court' branching off from the access lane. Often in such developments there is no distinction between communal and private space. Their design often incorporates a variety of traffic-calming devices, including rumble strips, ramps, chicane-like 'gateways', and deliberate twists and turns. The use of brightly coloured paving is also quite out of keeping with the traditional rural environment.

It is instructive to compare the central parts, or cores, of villages today with photographs of them taken several decades ago, when they were still populated by agricultural communities, and when motor vehicles were too few in number to disturb the tranquillity of the scene. In most of these, including some village centres that came to be designated as village conservation areas under the terms of the Civic Amenities Act of 1967, the difference is striking. Along the main streets, which are now full of noisy traffic and are often cluttered with modern road signs, advertisements and traffic-calming devices, the old photographs show just the occasional parked or passing car, an unobtrusive county council direction post, and perhaps one of the familiar red post-office telephone boxes. But, whilst there are many more cars and other vehicles in the landscape today, there are fewer people.

In village after village a row of farm labourers' cottages, a disused farmstead and an old wall or grassy bank have been pulled down to make way for a wider road junction, housing redevelopment, or just an extended car park for a renovated, franchised country pub. In some villages there is a reasonable balance between preservation of old buildings and essential renovation, and external restorations have been carefully done and structural extensions have been hidden from view. In other villages, however, the effects of so-called cottage 'improvements' are all too evident. The new owners can afford one or other of the various and often quite out-of-character alterations to cottage doorways, porches and window frames which, for properties that are not 'listed' buildings and lie outside specially protected areas, come within the sphere of permissible development. Inappropriate repointing and reroofing have also become commonplace. In response to the growing 'fortress' mentality and fixation on electronic technology, so has the installation of burglar alarms, security lights and satellite receiver dishes. Moreover, no sooner have some incomers settled into their dream cottages than they find these too small; hence the popularity of extensions and conservatories, some of which may blend well with the original building and its surrounds, but many of which can destroy an old cottage garden, are constructed from inappropriate materials, or do not have the right lines and texture.

Their isolation is a drawback to most people but, for some, these village developments offer social exclusiveness and detachment from other settlements, as well as something of an agricultural image. Many developments are designed to have a protective, fortress-like aspect, with high surrounding walls or railings, bright security lighting, video cameras and electronically operated iron gates all being standard features. More so than any other new feature in the English rural landscape, they signify today's eclipse of the agricultural spirit and the supremacy of the dormitory function of village housing.

> Into our delicate old villages have come swaggering new executive housing estates. Identically dressed dwellings line up around a cul-de-sac like grey-suited managers around a conference table. Double-glazed, double-garaged, double income houses have elbowed their way past church and cottages and eased their bulk on to little infill sites that might once have been a garden or a paddock.[11]

Such developments can be seen simply as a transfer of suburbia into the countryside, and the resulting community is often better served and probably more balanced than that in some of the more ancient sites which have been chosen as conservation areas. These developed villages often maintain their ostensible charm but have lost their intrinsic value as integrated communities. Quite apart from a large percentage of older inhabitants, many villages now have a number of 'second homes' normally occupied only at weekends or during the summer months. The pretty commuter-and-retirement settlements, together with the tourist villages, both on the coast and inland, have become the new 'closed villages'.

> It is time and not design that has given our surviving villages diversity, character and strength, and time that has mellowed church, dwellings, lanes and field, welding them into thousands of individual personalities.[12]

Not all villages have changed out of recognition, however. For instance, St Neot, in Cornwall, is virtually unchanged since the interwar period, apart from a little infilling. Unusually too, the surrounding fields and hedges are unaltered. Such unchanged villages tend to be in the hillier, more remote districts of England, but examples are to be found in the 'quieter' counties, such as Lincolnshire, Shropshire and Dorset. The village cannot survive as a fossilized museum piece. In some rural areas house prices have risen so high that it is virtually impossible for agricultural workers to afford to buy a house or cottage close to their work A reverse form of commuting has developed, where farmworkers live in urban suburbs where accommodation is less expensive and drive out into the countryside each day to work. One pessimistic observer recently wrote, 'Villages are rapidly becoming ghettos of the elderly, housebound and the wealthy'.

New Villages

After the Second World War there was a spate of literature by planners and sociologists who saw the village as a model for a better life, and writers like Thomas Sharp who, in his *Anatomy of the Village* (1946), promoted the village as being highly relevant for the creation of new communities. Sharp was given the job of planning a number of villages for the Forestry Commission, on the remote borders of Scotland and England. These illustrate graphically the shortfall between the ideals of the most enlightened planners and the numerous intervening factors which can so easily invalidate the best of schemes. At the beginning of the twentieth century, the last of the great country houses grew increasingly extravagant, so too did their corollaries, the villages. In 1910 work began on a holiday village centred around a lake at Thorpeness, on the Suffolk estate of the Stuart Ogilvy family. On a desolate, flood-prone area of coast between the festival town of Aldeburgh and what later became Sizewell nuclear power station rose an exotic group of buildings, based on a country club. Work on Thorpeness village began in 1911 and continued after the First World War into the 1930s. The village is a curious amalgam of weatherboarded and half-timbered housing laced with oddities. Two water towers, which provided water for the houses, were masked, one by a mock Norman keep, the other by a wooden cottage. The latter was known as the House in the Clouds and, like the houses at Portmeirion, was partly a façade. The idea for this form of disguise at Thorpeness came from a children's writer, Mrs Mason, an early resident of the village. The four corner towers of the golf clubhouse are topped by vast golf tees, and the Swiss chalet is decorated with a frieze of painted red and yellow tulips. The architects of Thorpeness reconstructed a windmill, built a new half-timbered country club, and a new 'Norman' church in stone. It remains an upmarket holiday village today, and in many respects it may have been ahead of its time; other dedicated mass-market leisure centres such as Center Parcs were only created in the latter decades of the century.

In 1911 W. H. Lever directed his architects to build him a country estate village, Thornton Hough, on the Wirral peninsula, the rural counterpart to Port Sunlight. Joseph Hirst, a textile manufacturer, had already started work on an estate village here in the 1860s, consisting of a church with a spire and five clock faces as well as a quantity of housing, including a row of cottages with a turreted shop on the corner. After Lever bought Thornton Manor, he employed several of the architects from Port Sunlight and rebuilt the housing, a club, primary school and a medieval church, the latter to complement the existing Gothic structure built by Hirst. The cottages compete with Port Sunlight in the range of their eclecticism; in the space of a single terrace, Dutch, Tudor, brick, plaster and half-timbered façades are all to be found.

The Chequered Skipper Inn at Ashton, near Oundle in Northamptonshire. The village was rebuilt by Charles Rothschild in 1900.

The village as a whole is set off by a large village green with a pavilion, beyond which stretches open country.

The village of Ashton, near Oundle in Northamptonshire, was created as a result of one of those whims that few but a Rothschild could afford to indulge. The area was the natural habitat of a particularly rare butterfly, the Chequered Skipper, and Charles Rothschild, who was an enthusiastic entomologist, bought the entire locality and presented the village to his bride as a wedding present. The Rothschilds' architect, Huckvale, constructed a Picturesque village of stone cottages with thatched roofs, clustered around the village green. A chapel and an inn were built to cement the new community together. Huckvale extended the vernacular building style of the

The village of Stewartby in Bedfordshire. The chimneys of the London Brick Works are in the background.

village to the boathouse, dovecotes and model farm attached to his new mansion, Ashton Wold. The mill at Ashton appropriately now houses a museum of dragonflies, the only one of its kind in the country.

Bailiffscourt, Climping, near Bognor Regis, was an exercise in medieval whimsy. It was built for Lord Moyne, of the Guinness family, in the 1920s. Bailiffscourt consists of a scattered group of mock medieval buildings set around a genuine medieval chapel in parkland adjacent to the coast. Since 1948 it has been a hotel. Edwin Lutyens and his son Robert were involved in a somewhat similar scheme at Cockington, near Torquay, in Devon. The Cockington Trust was formed in the 1930s, aiming to preserve 'entire and unchanged the ancient amenities and character of the place and in developing its surrounding to do nothing which may not rather enhance than diminish its attractiveness'. The one-storey thatched forge and cottages of the village were assiduously preserved. The Trust planned to complement these with a model village centre, designed by Lutyens, illustrated in a brochure of 1935. The inspiration was the eighteenth-century planned village rather than local vernacular tradition: a village green with estate office was to be flanked by thatched rows of cottages with shops. The only part of the scheme actually built was the thatched Drum Inn.

Immediately after the First World War, Sir Ernest Debenham (owner of the department store) built a model village at Briantspuddle in Dorset. The scheme centred on a farm which had been built to encourage rural repopulation when the smallholdings project was gathering impetus, together with an attempt to provide economical village housing. The cottages at Briantspuddle were built in a Picturesque style – thatched and whitewashed, and grouped around a vast war memorial. A similar and contemporary village was built in Hertfordshire, at Ardeley, by the architect F. C. Eden, with cottages clustered around a village green and a large oak tree. Here every detail was included which reflected links with the traditional villages of the area, at a time when Hertfordshire was falling victim to the demands of London housing and needed to state its regional identity.

The village of Jordans, in Buckinghamshire, was built around the most famous of all Quaker meeting houses, dating from 1688. Jordans was designed by Fred Rowntree and building started in 1919. It follows the lines of Hampstead Garden Suburb, but is unusual in having been established (by Jordans Village Ltd) as an ideal community exclusive to Quakers, which would protect the surroundings of the meeting house from speculative encroachment. Jordans Village Industries were founded to secure an economic base but lasted only until 1923; workers were supposed to be craftsmen and work in a guild system. The Guild Hall was opened in 1919, but was subsequently demolished. The original plan was for about a hundred houses and cottages but many fewer than this number were built. Rowntree was uncompromising: cottage appearance took precedence over convenience. At the

centre of the village there was a large, oblong green with birch trees and Lombardy poplars. Red-brick houses in a dignified Tudor style were all equipped with sweeping roofs, tall chimneys and gables. The six informal groups of terraced cottages for workers in Jordans Village Industries were built first (1919–20), round the green and its south-eastern approach. The village was complete by 1939.

An area in which the village image was cultivated for its particular associations was the Cottage Homes movement, which gathered strength in the Edwardian period. The Cottage Homes were an extension of the idea of the almshouses, with accommodation provided by the employer or philanthropist rather than the parish or local landowner. In 1907 the movement received an impetus from the foundation of an entire village planned along these lines at Whiteley, Surrey. The Mill Hill enclave of the Linen and Woollen Drapers' Homes founded by James Marshall, another philanthropic store magnate, was a series of one- and two-storeyed cottages, some in red brick, some half-timbered, ranged around a garden and a central institution – the clubhouse, offices and so on all under one roof. Taking this pattern as his model, and enlarging it enormously, Frank Atkinson drew up the winning design for the competition for Whiteley Village.

Whiteley's trustees bought over three hundred acres of Surrey heathland, where the sandy soil and pine trees were believed to create a healthy environment. Atkinson, who also built Selfridges, laid out a central circular area which was to be left in its natural state with rhododendrons and wild flowers. This was enclosed by a road flanked by curving blocks of cottages, mostly single storey, around which there was an octagon, with radiating access roads. The housing was carried out by seven architects who each took a portion of the octagon and, working independently, produced different designs. They were only restricted by the fact that all had to use the same red brick building material. Housing was thus provided for 350 pensioners, who were given the traditional almshouse accommodation. Additionally, there was a village store, library, chapel, public hall, and communal kitchens and restaurant. Wooded grounds insulated the area from the surrounding exclusive closes and avenues and made Whiteley visually entirely self-contained.

The Cottage Homes movement continued with the Haig Memorial Homes and the building of the British Legion Village, near Maidstone, where the accommodation consisted of simple bungalows with verandas and sizeable gardens, very like the Chartist cottages of the late 1840s. The post-First World War 'Homes for Heroes' movement had attempted to tackle the vast backlog of housing through an enthusiastic propaganda campaign. In some cases people continued to help themselves through housing trusts, but mass housing for the next twenty years was essentially the province of the speculators and private developers, who were rarely directed by any other motive

than the financial potential of land. Munitions estates showed that work could be carried out to remarkably high standards. At Gretna, Raymond Unwin was in charge of creating houses for workers, and another notable effort was that at Eltham, the Well Hall Estate, a scheme carried out in ten and a half months.

Following in the tradition of Bournville and Saltaire, twentieth-century companies continued to find it expedient to be able to offer decent housing, close to the factory, and the firms could thus ensure themselves a reliable workforce and, if properly administered, establishment of a village could promote goodwill between workers and their employers. At Stewartby, in Bedfordshire, the London Brick Company set up a new (brick) village for their workers, and at Kemsley, in Kent, Bowaters, the paper manufacturers, used the marshy area around their mills to construct a village for their employees, situated close to their place of employment. Kemsley is built in a rather timid brick neo-Georgian style despite the fact that Maxwell Fry, soon to be a leading figure in bringing the International Modern style to Great Britain, was one of the partnership responsible. F. H. Crittall decided to build Silver End in Essex for the workers in his company. This firm produced the metal door and window frames for most new houses of the period. Crittall had already been sufficiently conscientious to provide a surgery and dental clinic for his workmen, and he had established himself as a twentieth-century representative of a long line of Nonconformist enlightened employers. In the 1920s, when the firm was undergoing considerable expansion, Crittall saw the creation of a new community as the perfect way in which to express his ideals in practical form. A firm believer in land nationalization, he also claimed to nurse a secret ambition to be a builder. 'I saw a pleasant village of a new order ... enjoying the amenities of a town life in a lovely rural setting – rather than content ourselves with a few streets tacked upon a country town, perpetuating its errors and extending its shortcomings, should we not instead pioneer in pastures new and fashion for ourselves a completely new "Jerusalem".'[13] Crittall commissioned various architects to work on the scheme for a brand new company village, and building began in the late 1920s.

A company was set up to allow the employees to administer the village themselves, and the houses were planned to a high standard, including gardens and allotments. At the early stages of the operation, houses were being built at the rate of a hundred a year, in various sizes and styles. Simplicity, light and space were Crittall's requirements and, before long, the village, consisting mostly of flat-roofed International Modern housing, rose incongruously from the fields of Essex. Other housing was of a plain neo-Georgian type, built of pale pinkish-grey brick, whilst the church, designed by the editor of *Studio* magazine, was given an idiosyncratic thatched roof. There was also a village hall, hotel, bank, telephone exchange, school, playing

The model village of Freefolk in Hampshire, built by Lord Portal in the 1930s.

fields and a central public garden. The wide streets were planted with silver birch and poplars. Silver End did not take long to achieve its aims, and the picture of self-sufficiency was emphasized by farms whose produce was sold directly to the villagers.

Almost contemporary with this enterprise, Bata, the giant Czech shoe manufacturing concern, built a company village at East Tilbury, on the Thames estuary in Essex. The design was based on a prototype worked out at other locations, including towns built in Czechoslovakia, Canada and India. East Tilbury, though small-scale, followed the pattern of the other settlements with its central hotel, the division of factory and housing by a green belt, and the use of advanced building techniques for its cottages in the International Modern style. The factory was built using revolutionary all-welded lightweight construction methods and attracted considerable notice as a result. On a wider front, for a brief period in the 1930s, the flat-roofed International Modern cottage was taken up by speculative builders as a cheap alternative to Tudorbethan standard patterns, and it featured in the 'Village of Tomorrow' section of the Ideal Home Exhibition in 1934. The sales line made great play of the possibilities of the flat roof, where the suburban family was encouraged to take up an open air existence, with summer evenings spent eating and sleeping among the chimney stacks.

Freefolk, in Hampshire, the estate village built for a former Minister of Housing, Lord Portal, provides ample evidence of the continuing appeal of the 'chocolate-box' village over all alternatives. The Freefolk cottages are set in a long, curving terrace of eighteen separate homes. They are heavily thatched with some half-timbering, the windows are mullioned and there are heavy chimneys. Behind them rise the spires of the village church and a hillside thickly covered by woods, while in front of the cottages are a number

of thatched wells and, finally, a thatched bus shelter. Freefolk provoked a letter to a country magazine: 'I should like to see a pretty photo of the village church at Freefolk. It is my dream village.' Lord Portal himself commented on his work in the village: 'There is something very satisfying about seeing where you would like people to live and how you would like people to live.'

After the Second World War, priority was given to the building of new towns, but there were also a number of attempts to create smaller communities. At Ash, on the North Downs in Kent, it was proposed to build a new village on land that had been designated for the Green Belt. Consequently, there was considerable opposition to the scheme, and planning permission was only granted after a public enquiry in 1964. Richard Crossman, Minister of Housing, stated, 'This may well be a model of how to get a civilized modern community living in an area of beautiful landscape'. New Ash Green took its name from two farms, North Ash and New House, and was to consist of just 2000 new houses built on 190 acres by a partnership of private and public resources. The intent was to build a range of houses, a quarter of which would be occupied by Greater London Council tenants. All houses were to back on to common land; and pedestrian pathways and roads, in keeping with new town practice, were to be kept apart. Offices, studios, shops and light industry were to be established to generate employment, and a community centre, library, church and school were to be created to encourage community spirit. In order to provide a sense of continuity, local field names and old Kentish terms were used for roads and districts. In the event the GLC withdrew and the scheme was not completed in its original form. Nonetheless, New Ash Green became an affluent and successful community, largely because of its location close to London and as part of the Medway light industrial belt.

Towards the end of the century, the concept of the model village once again became popular with planners and sociologists. At Poundbury, on Duchy of Cornwall land on the outskirts of Dorchester, Dorset, an attempt is being made to create a community in which residence and work are brought together, and car use is restricted. At Poundbury, private and social housing are mixed and built to a high quality and design. Commercial buildings, factories and offices lie among the residential areas, with shopping, community and leisure facilities.

In 1988 the Prince of Wales appointed the architect and urban planner Leon Krier to prepare the overall development concept for Poundbury. Krier, known as a champion of traditional urban design, was commissioned to create an autonomous new extension to the town within the context of traditional Dorset architecture. Much of the housing was situated in mews, lanes, squares and courtyards. Roads tended to be irregular both in width and angle, controlling the speed of vehicles without recourse to humps or traffic signs. The architecture at Poundbury was unashamedly traditional, and paid

homage to the rich variety of Dorset materials such as stone, slate and render. Larger commercial buildings are generally sited on the periphery to permit access, but they are designed similarly to frame their sites and create a sense of enclosure, disguising parking areas and equipment.

Overall, some 20 per cent of the housing is being built by housing associations for rental by people on the local housing list. Uniquely, at Poundbury the social housing is interspersed with, and indistinguishable from, the private housing, and some of the housing has also been designed for special needs or retirement. Provision of workshops and playrooms recognizes the demands for flexible living arrangements and allows people to work from home. Poundbury set out to demonstrate that it is possible to build high-quality traditional housing at affordable prices, and provide new factories and offices on competitive terms within the context of radically different urban design. The scheme is not without its critics, who claim that it is creating yet another middle-class ghetto, and there is considerable disagreement about the feasibility of applying the same principles in areas of high social deprivation. There are plans, however, for a similar development on the site of a former railway goods yard at St Austell, in Cornwall.

In 1998 work started on a private new settlement, to be called Cambourne, nine miles to the west of Cambridge on an isolated greenfield site, sponsored by three major housebuilding companies – Bovis Homes, Bryant Homes and George Wimpey – and planned eventually to have three thousand houses occupying a thousand acres of land. The community is to be divided into three 'villages', each set around a 'traditional' village green. It is to be provided with two primary schools, a sports centre, playing fields, hotel and nursery school, and will have the usual range of pubs, shops and public services. As in Milton Keynes, Cambourne's emphasis will be on the provision of green open spaces, with a golf course running through the middle of the community, and woodland paths, cycleways, bridleways and allotments. Additionally, there is a business park providing jobs for over five thousand people. Unlike earlier new towns and villages, however, there will be no attempt at a social mix. The price of the houses will ensure that the population is exclusively middle class. It will be interesting to see how this attempt at a twenty-first-century utopia works out. Will it, for instance, eventually require walls and permanent guards, as do some of its counterparts in the United States?

CHAPTER 9 | *The Countryside*

> England is London says one, England is Parliament says another,
> England is the Empire says still another; but if I be not much
> mistaken, this stretch of green fields, these hills and valleys, these
> hedges and fruit trees, this soft landscape is the England men love.
>
> <div align="right">Price Collier, England and the English
from an American Point of View (1912)</div>

T HE COUNTRYSIDE remains one of England's richest assets. Its wealth of charm and variety has for long been the inspiration for artists, novelists and poets, and it is still regarded by many as one of England's greatest cultural belongings. One only has to compare the rural landscape of almost any English county with, say, southern Texas to appreciate what a blessing and joy it still is. Describing the view over the Vale of Evesham from the Cotswolds in 1992, the American Bill Bryson exemplifies the thoughts and feelings generated by the English rural landscape at its best:

> The view from the top over the Broad Vale of Evesham was, as always from such points, sensational – gently undulating trapezoids of farmland rolling off to a haze of distant wooded hills. Britain still has more landscape that looks like an illustration from a children's story book than any other country I know – a remarkable achievement in such a densely crowded and industrially minded little island.[1]

The English rural landscape, with its mixture of fields, lanes, farms and distinctive place names, has been a long time in the making, and its beauty and fascination owe much to a gestation of two to three millennia. In 1924 Prime Minister Stanley Baldwin told the Royal Society of St George that 'England is the country and the country is England'. In what today sounds like a pastiche he extolled its qualities:

> The sounds of England, the tinkle of the hammer on the anvil in the country smithy, the corncrake on a dewy morning, the sound of the scythe against the whetstone, and the sight of a plough team coming over the brow of a hill, the sight that has been seen in England since England was a land, and may

This depiction of an idyllic rural scene in Devon on a Shell advertisement of the 1930s was by Eric George. It would not have been seen as incongruous until much later in the century, when the motor car was recognized as a serious threat to the rural landscape.

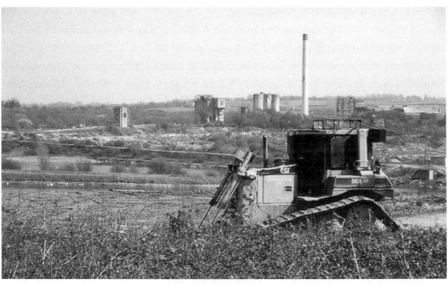

A massive limestone quarry near Woodstock in Oxfordshire. The chimneys of former limeworking are in the background. The empty quarry, which contained dinosaur footprints, is now given over to landfill.

be seen in England long after the Empire has perished and every works in England has ceased to function, for centuries the one eternal sight of England. The wild anemones in the woods in April, the last load at night of hay being drawn down a lane as the twilight comes on ... and above all, the most subtle, most penetrating and most moving, the smell of wood smoke coming up in an Autumn evening ...

This interpretation of the countryside, which has survived into the twenty-first century, is seen by some as being pernicious and dishonest.

It is easy to see why the concept that 'God made the Countryside, Man

made the Town' was a popular one, although Arnold Bennett was so irritated by William Cowper's oft-quoted sentiment that he responded with a poem of his own, written in 1907, which ends:

> For me a rural pond is not more pure
> Nor spontaneous than my city sewer.[2]

Indeed, there was little that remained completely natural in the countryside of 1900, let alone that of 2000. There was little virgin woodland left by 1900 and few undisturbed areas of fen or upland moor. All had been subject to man's activities to a greater or lesser degree. The difference was that, although man had fashioned the countryside, his touch had been somehow lighter in the hillier and wilder areas, and the resulting landscape more palatable to most people. Yet, during the twentieth century, the rural landscape was subjected to change and pressure on an unprecedented scale.

The principal agents for change and destruction to the countryside in the twentieth century were housing, quarrying, industrialization and farming itself. The changes to the rural environment brought by these essential elements of modern living have had an immense impact on animals, plants and terrains. Housebuilding and collateral activity steadily diminished the size of the land base – by the end of the century it was estimated that a rural area the size of Bristol was being transformed each year. Changes in agricultural practice also radically altered the way the remaining land was farmed. This impact varied between different parts of the country – housebuilding, for example, was much more of a problem in south-east England than in Northumberland. Nevertheless, the overall trend was one of a cumulative assault on the English countryside after 1900.

Most of the changes outlined in this book have taken place within what

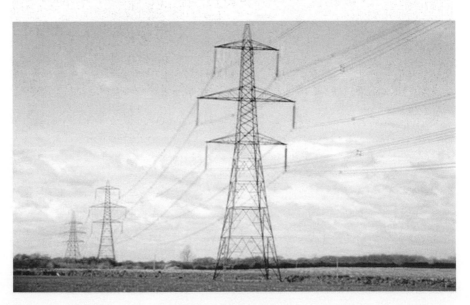

The 'steel giants' – electricity pylons, which were seen as a great eyesore, particularly in the interwar years.

could be regarded as typical English countryside. Huge chunks of agricultural land were eaten up by the spread of the suburbs and the building of new towns; and, on a smaller scale, fields, hedges, moorland and marsh have been taken over by a myriad of twentieth-century developments. It is perhaps easy to overestimate the scale of the rural loss, particularly when viewed from a south-eastern English perspective, where the 'damage' has been greatest. There are still large chunks of rural Wessex that would be familiar to Thomas Hardy, and even parts of Shropshire that would be recognizable to A. E. Housman, or at least Worcestershire, as he rarely visited the Arcadian shire he immortalized in *A Shropshire Lad*.

Even the countryside that survives has, however, been buffeted by the pressures of the restless century. The Electricity Supply Act of 1919 established a national transmission grid which resulted in a rash of electricity power lines carried by 'arms-stretched, steel giants' across rural England. In the early twentieth century, it was fashionable to decry electricity pylons as eyesores; a notorious line of them on the western edge of Oxford, disturbing the vista of the 'dreaming spires', was subject to particularly vitriolic attacks. S. P. B. Mais, a prolific writer and observer of the English landscape, described them as sprawling 'wantonly across our noblest landscape like a lunatic's slashings across the face of an old master'.[3] Such services now tend to run underground or have been compressed into much less conspicuous forms of transmission. Even electricity pylons themselves have become more acceptable, partly because of familiarity, partly because they have actually

The electricity generation station cooling towers at Ironbridge in Shropshire. The station is sited close to Coalbrookdale and the world's first cast-iron bridge.

blended with their surroundings in some areas, and partly because they are now viewed with affection by some. In areas of eastern England, in the wilderness created by prairie farming, they are actually viewed as a beneficial contribution to an otherwise visually barren landscape. Later intrusions such as oil and gas pipelines also tended to be hidden underground. And although the process of laying them is disruptive and destructive of archaeology and wildlife, after completion they tended to blend in with their surroundings. The satellite and digital age brought a new rash of dishes and pylons in the countryside. Such intrusions were often sited in marginal or blighted land alongside motorways or in old quarry workings, but, although they tended to be smaller than their predecessors, their appearance nevertheless frequently elicited local opposition.

One of the most intrusive elements in the rural landscape of the twentieth century were the massive cooling towers of electricity generating plants. These powerful symbols of twentieth-century power production dominate whole swathes of rural England. For example, the cooling towers at Didcot, in the Thames Valley in Oxfordshire, can be seen up to fifty miles away and from half a dozen surrounding counties. They are not, however, universally disliked, and some admire them for their grace and cleanness of line. Less popular are the smaller, but more numerous, wind turbines, which have, curiously, hit a nerve amongst some conservationists, who complain that they are both unsightly and ineffective.

As the century progressed, the waste from heavy industry was levelled, grassed over and generally tidied up. New industries such as opencast mining and quarrying tended to be more discreet, hidden behind shelter belts of trees and backfilled when operations were completed. Many of the exhausted stone quarries were used to bury domestic waste in what was known as landfill. Gigantic midden pits for a wasteful age of overconsumption were generally hidden away and covered over as soon as possible. The corporate disposal of waste represented yet another break between individuals and the land on which they lived; no longer were they responsible for or sensible of the consequences of the detritus they produced.

As the population became increasingly urbanized, in terms of the sense of place and identity, the past seemed more fixed and the countryside came to represent, superficially, eternal values and traditions. Attractive images of a countryside of apparently timeless appeal and values had been used in recruiting posters as early as the First World War, and in railway and petroleum posters between the wars. Indeed, as rural England gave way to suburban England, nostalgia was built into the new landscape in the names of pubs, roads and estates, which were consciously given names with 'olde worlde' associations. The further away living styles moved from peasant farming tied to the countryside, the more valued were the images of an imagined former rural idyll.

Farming before the Second World War

Since 1900, the speed and intensity of change in farming has been greater than in any previous age. The need to produce more food during two world wars led to the development of a far more efficient agricultural industry, added to which technological change and application proceeded at an unprecedented rate. Government intervention through the Agriculture Act 1947 and other price support systems, and the European Community's Common Agricultural Policy (CAP), encouraged the often highly subsidized expansion of productivity. These subsidies were accompanied by a revolution in farm practice. British farming became highly mechanized, with a very low workforce. 75 per cent of England's land area was still given over to agriculture, but less than one per cent of the population was employed in agricultural work by 2000. Moreover, the importance of agriculture in the British economy shrank throughout the century, until by 2000 it accounted for only one per cent of GNP. Farmers sought ways other than farming to make a profit from their land. By the end of the 1990s, farmers had taken out over two million acres of land from agricultural use, and much of this went into leisure activities. The notion that the main purpose of rural land was to produce food was no longer true in some areas, especially those close to large centres of population.

England was still a largely agricultural country in 1900, although farming was economically much less important than it had been a century earlier. It is true that there was heathland and wetland which might appear today to be 'waste', but even this was cropped for bracken, gorse, sedge and rushes. Before the onset of the agricultural depression around 1870, the fields were hedged, walled or ditched, and all these boundaries were well maintained. The crops were weeded and the soils boulder-free. There was little fallow in this intensively farmed countryside. Woodland was thinned and trees were pollarded to provide the poles needed for fences and hurdles. The buildings were in good order and many had been replaced during the previous fifty years. All these were signs of both prosperity and a relatively cheap and abundant labour supply; both were set to change over the next two generations. During the Edwardian era, English farming began to reflect the accumulated impact of the agricultural depression. On the surface, at least, things remained much as they had done during Victoria's reign. The Enclosure movement was virtually over – England was an enclosed country of fields and hedges. The countryside had absorbed the railway and had yet to meet the problems of the motor age, although the process of suburbanization was gathering pace, particularly around London.

In *Cider with Rosie*, Laurie Lee paints an almost painfully evocative picture of the English rural landscape as seen through a child's eyes in the years leading up to the First World War:

The untarred road wound away up the valley, innocent as yet of motor-cars, wound empty away to other villages, which lay empty too, the hot day long, waiting for the sight of a stranger ... There was nothing to do. Nothing moved or happened, nothing happened at all except summer. Small heated winds blew over our faces, dandelion seeds floated by, burnt sap and roast nettles tingled our nostrils together with the dull rust smell of dry ground. The grass was June high and had come up with a rush, a massed entanglement of species, crested with flowers and spears of wild wheat, and coiled with clambering vetches, the whole of it humming with blundering bees and flickering with scarlet butterflies. Chewing grass on our backs, the grass scaffolding the sky, the summer was all we heard; cuckoos crossed distances on chains of cries, flies buzzed and choked in the ears, and the saw-toothed chatter of mowing-machines drifted on waves of air from the fields.[4]

In a few places, the medieval open fields had survived into the twentieth century, but were finally enclosed into the usual pattern of regular rectangular and square fields before the First World War. The common fields of Ailsworth and Castor in the Soke of Peterborough were not enclosed until 1898, those at Totternhoe in Bedfordshire in 1892, while those at Grimstone in Dorset survived as late as 1907, but these were the exceptions. In other places, curious new field shapes appeared. Around Newmarket in Suffolk, for example, the enlargement of the long-established racehorse breeding and training industry based there led to the growth of an unusual form of fields

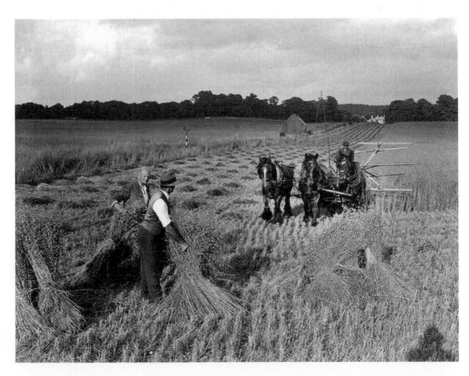

Horse-drawn harvesting between the wars.

in the late nineteenth century. The area was already one of large, long rectangular fields as a result of Parliamentary Enclosure; now these became lined with thick shelter belts of trees and subdivided into small paddocks, also edged by wide tree belts or plantations, to provide runs for the horses. Fields designed for a similar purpose were established at Lambourn on the Berkshire Downs and in other areas of racehorse training.

In some areas, especially close to the larger towns or where good railway communications existed, there was the development of smallholdings based on market gardening. The result was a break up of existing fields into a patchwork of small plots of less than an acre. Many towns in southern England had nursery and market garden areas, often with extensive glasshouses, sited just outside the built-up area. Around many towns the market gardens were interspersed with clay pits, the contents of which were used to make bricks for new suburban housing. Frequently, there was a regular transition from pasture to market garden to suburbia in quick succession in the early decades of the century.

From the 1870s, with the opening of the prairies and the steppes, British farming had begun to suffer from overseas competition. Intense competition from North American grain, Argentinian beef, Australasian wool, mutton and lamb, and Danish bacon brought about a protracted agricultural depression, which lasted with a few brief intermissions until 1939. The technological advances of steamships, refrigerated holds, railways and barbed wire that helped the development of export agriculture in distant areas, much of which was, ironically, financed by British capital, badly affected British farming. This crisis also affected the economy of provincial towns dependent on agricultural processing and serving rural hinterlands. Arable farmers bore the brunt of a decline in production. In the last decades of the nineteenth century, the price of wheat dropped by 50 per cent. On the other hand, dairying and livestock husbandry expanded, as did specialist agriculture, for example, fruit and potato production in East Anglia. Between 1873 and 1939, the total area of arable land use in Britain decreased by almost 40 per cent, from 14.7 million to 8.9 million acres. Gradually, the countryside took on an uncared for complexion. In counties such as Essex, 30 per cent of the arable area was officially classified as 'derelict', routine tasks such as hedge laying were neglected, walls were left to collapse, and many fields became overgrown with weeds and shrubs.

A parliamentary commissioner, reporting on Dorset farming in 1895, described the falling rents, the unlet farms, and the chalk downland abandoned to scrub and rabbits. He concluded that 'the ownership of land is rapidly becoming a luxury which only men possessing other sources of income can enjoy'. In the Chilterns, 'the polish went out of cultivation', in the words of Hugh Prince. In the parish of Great Missenden, for example, arable land fell from 80 per cent of the farming area in 1870 to 50 per cent

in 1914. In this area, not only was arable land converted to dairy pasture, but some former ploughland on hillsides was turned to woodland. Such plantations are often marked by their straight boundaries, and their names, such as Jubilee Plantation, are indicative of when they were established. Derelict farms were found in once prosperous areas, and there was considerable social tension in some rural areas, but migration to the cities or abroad helped to relieve some of the strains.

The desolate state of much of rural England in the latter years of the Victorian age and in the early twentieth century is portrayed in some of the contemporary literature. The Reverend P. H. Ditchfield, for example, in *Vanishing England* (1910),[5] complained about the increasing frequency of old cottages being left to crumble away and disappear from the landscape through a combination of rural depopulation and neglect by their owners. Throughout rural England, but particularly in the hardest-hit areas, villages were becoming smaller as more and more farmsteads and cottages became derelict, some of them sinking into ruins and others being quickly pulled down. Indeed, it was not unusual even for the church, the spiritual focus of the traditional English village and a prominent symbol of its antiquity and stability, to fall into a ruinous condition. Ditchfield described such a state of affairs in East Anglia where, a few years before the First World War, he counted some sixty dilapidated churches: 'many of which have been lost, many that are left roofless and ivy-clad, and some ruined indeed, though some fragment has been left secure enough for the holding of divine service'. Later, in the 1930s, just before government intervention and the imminence of the Second World

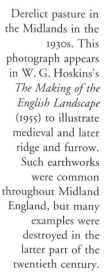

Derelict pasture in the Midlands in the 1930s. This photograph appears in W. G. Hoskins's *The Making of the English Landscape* (1955) to illustrate medieval and later ridge and furrow. Such earthworks were common throughout Midland England, but many examples were destroyed in the latter part of the twentieth century.

War at long last brought agricultural depression to an end, Thomas Sharp wrote:

> Village Greens, roadside streams, ponds and a score of pleasant features that seemed once to be the very essence of the rural scene, all now seem ownerless and unvalued. Even the fields in many parts display the same characteristics. The land itself has deteriorated. Vast areas of once valuable and productive land have gone back to bracken and gorse, and rank marsh ... The English countryside to-day, to those who can read its meaning, is indeed a disturbing and a melancholy place.[6]

H. J. Massingham described the dismal scene in the Cotswolds: 'We saw more gates open than shut, more gates that could not be shut than could, more gates broken than whole, tousled heaps of straw, dishevelled combined fields, tumbled or gaping drystone walls, ivy-covered trees, indifferently ploughed fields, weedy pastures, dilapidated farm buildings, even barbed wire sagging or twisted'. Unkempt and tumbledown land was indeed the most striking feature of the depression landscape. Often entire farmholdings and, as for example in the Essex claylands and parts of the Chiltern chalklands, even whole parishes had been reduced to such a state. The contrast between this and the tidy, highly prosperous landscape of the Victorian High Farming age could not have been starker.

The profitable sheep and corn farming system of the chalklands was also severely affected by the agricultural depression. A run of cold, wet summers coincided with a sharp fall in the price of corn and meat as imports flooded into England. As a result, more and more land was laid down to grass, many farmers were unable to pay their rent, and the income of estate owners fell dramatically. The retreat from arable farming, together with the availability of artificial fertilizers, brought to an end the long supremacy of the downland sheep flocks, which were no longer required for folding on the cornlands. In Dorset, for example, the number of sheep fell from about 500,000 in 1895 to 200,000 in 1914 and to 46,000 in 1946; many hundreds of acres of water meadow fell into disuse and became overgrown; farmers' incomes slumped, and there were many bankruptcies. Between 1872 and 1914 the average rent of farm land fell by 29 per cent, with a devastating effect upon the income of estate owners.

Only the production of milk remained profitable, since this was transported by railway to the towns, and many downland farms became dependent upon their dairy herds. Milk was one product that was free from foreign competition, and demand for fresh milk grew dramatically. Railway companies, in particular the Great Western Railway, which provided special trains travelling through the night from south-west England to London, Bristol and Birmingham, invested heavily in the running of milk trains from pastoral England to the major cities. One such train features in a symbolic

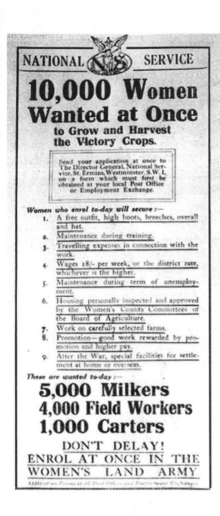

A First World War poster calling for women to work on the land.

passage in Hardy's *Tess of the d'Urbervilles*, where Tess and Angel Clare, one autumn evening whilst conveying some pails of milk from Talbothays farm to the nearest railway station, came to a spot within the Vale of the Great Dairies where: 'by day a fitful white streak of steam at intervals upon the dark green background denoted intermittent moments of contact between their secluded world and modern life'. From here, the couple moved on and eventually:

They reached the feeble light, which came from the smoky lamp of a little railway station: a poor enough terrestrial star, yet in one sense of more importance to Talbothays Dairy and mankind than the celestial ones to which it stood in humiliating contrast. The cans of new milk were unladen ... Then there was the hissing of a train, which drew up almost silently upon the wet rails, and the milk was rapidly swung can by can into the truck ... 'Londoners will drink it at their breakfasts to-morrow, won't they?' she asked. 'Strange people that we have never seen.'[7]

The overnight milk train – the 'Milky Way' – from the countryside to the heart of the city became a vital factor in the economics of agriculture. The great dairy herds increasingly dominated the farming landscape. Improvements in well-digging and water ditches helped to increase the water supply to farms and helped them expand their dairy herds. The conversion to dairying can often be seen through the late Victorian and Edwardian cow stalls and feeding troughs which were installed into much older farm buildings and barns. On many farms, open yards were roofed over to cater for livestock, and landlords were often obliged to roof yards or provide new buildings for livestock before they could let their farms. Milk and the new market gardens established to serve the ever-growing urban population provided an increasing part of the farmer's income.

Agriculture recovered in the First World War as German submarines attacked shipping bringing food imports. Food supplies became a matter for government action and, with the Food Production Act of 1917, the government actively encouraged the expansion of arable land. The price of grain was guaranteed by the government, and land that had not been worked for a generation was ploughed up again; there followed a 30 per cent rise in national cereal production. The war had brought a change of fortune to farmers, and for a brief period it shielded them from the effects of foreign competition. This prosperity proved, however, to be short-lived and at the

end of the war many landowners were anxious to sell before prices fell again.

The burden of taxation was not the only blow to the world of rural grandees. Many heirs to estates died in the First World War, and the conflict was followed by massive land sales, which broke the traditional landlord-tenant relationship. Land sales increased considerably between 1910 and 1914; and from 1918 to 1922, in the wake of the war, the land market reached a level of activity unequalled since the Dissolution of the Monasteries in the sixteenth century. In these four years many great estates were broken up, and as much as a quarter of the land of England changed hands. For example, the Lincolnshire estate of the Earls of Yarborough, 60,000 acres in 1885, fell to about half after land sales in the first part of the twentieth century. Another aristocratic Lincolnshire family, the Brownlows, sold most of their Ashridge estate in the Home Counties in the 1920s. Most of the land that came onto the market was bought by the tenant farmers by whom it had formerly been worked. As a result, while only 11 per cent of the farmland in England and Wales was in owner-occupation before 1914, by 1927 this proportion had risen to over 37 per cent. Even so, the majority of farmland remained in the hands of tenants.

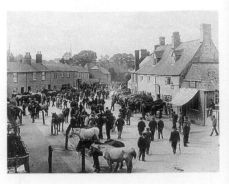

A village horse fair at Bampton, Oxfordshire, before the First World War.

Agriculture was hit again in the 1920s and early 1930s, as it was once more exposed to the full force of international competition. This was particularly a problem for cereal farmers, as grain subsidies ceased in 1921. In Berkshire, for example, acreage devoted to wheat fell from 40,000 in 1918 to under 28,000 by 1930. Even dairy farmers and livestock producers encountered problems, particularly when prices fell dramatically in 1932, but, on the whole, still managed to do better than arable farmers. Between 1921 and 1939 the number of agricultural workers in Britain fell by a quarter.

By 1927, when S. L. Bensusan toured England in the footsteps of Sir Henry Rider Haggard's 1902 agricultural tour, he found parts of Norfolk virtually waste:

> The area of desolation, that embraces Methwold and passes eastwards to Watton and descends by Tottington, Wretham and Croxton in the direction of Thetford, did not seem to belong rightly to England; it recalled to me in part the backlands of Ontario and the bare plains of Manitoba before the settlers came ... The only crop to be seen was weeds, and a multitude of these were seeding generously; houses there were none for miles ... nor was there any traffic.[8]

A dramatic fall in wheat prices after the collapse of the New York stock market in 1929 was followed by a new period of government intervention in farming. Various marketing boards were introduced between 1931 and 1933,

and the Wheat Act of 1932 at last gave farmers a guaranteed price. Prices and confidence in farming, however, remained low until 1939. An article in *British Everyman* in 1936 voiced the belief of many at the time when it stated: 'Farming is dead in England. Everyone will tell you that!' A farm bought by Henry Williamson on the north Norfolk coast in 1936 was typical of many:

> Black thistles and the frost-wreckage of nettles lay everywhere on the grass, rotten sticks and branches lay under the trees, the lane or road leading to the buildings was under water, and the yard we looked into seemed nearly three feet in mud. Flint walls were broken down, every gate was decayed or fallen to pieces. Tiles were off, showing rotten woodwork patched with dryrot. The place seemed entirely forsaken.[9]

On the whole, fenland farmers survived the interwar depression better than those elsewhere. This was partly because their farms were small and tended to be more manageable in the circumstances, and partly because increasingly they specialized in growing profitable vegetables and flowers. Even so, drainage taxes went unpaid and drainage work was restricted or abandoned, and, as a result, a spiral of limited finance, poor drainage, floods and the abandonment of land developed. More and more land was given up to the water, and even such measures as the 1930 Land Drainage Act, which tried to simplify and improve the administration of fenland drainage, failed. Navigation on the fenland rivers came to an end as the railways and, later, road transport took over the movement of goods.

By the end of the 1930s probably more land was liable to flooding in the fens than at any time since the seventeenth century. The fens were saved by the onset of the Second World War and the demands for home-produced food. From 1940 to 1946, the Ministry of Agriculture, through its local War Agricultural Committees, poured money into the fenland farms. Drains were recut, banks rebuilt, new pumping machinery installed, roads paved and thousands of acres of land brought back into cultivation. Perhaps the greatest change the war brought, certainly for the people living and working on the fens, was the construction of a new road system.

Mechanization did most to depopulate the countryside, although, in the first instance, it did not displace the horse; in 1911 there were still almost a million horses at work on British farms. They were, however, already under threat – in 1902 Dan Albone of Biggleswade had produced a petrol-driven tractor and the following year he began to build tractors commercially. Nevertheless, there were only about 40,000 tractors in England by 1938, and those mostly on holdings of over 300 acres. As Charles Rawding wrote about the Lincolnshire parish of Binbrook:

> On the Wolds, tractors first appeared in significant numbers in the early 1930s, principally on the larger farms, although some contractors had tractors, which

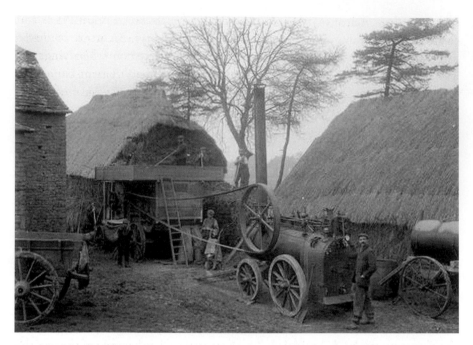

A steam-driven threshing machine at work in the early years of the twentieth century.

were taken around the smaller farms to work the land where the farmers themselves were still using horses only. Smaller farms generally had to wait until the Second World War.[10]

Even as late as 1939 there were still ten times as many horses on British farms as there were tractors, but significantly it was the tractors that were already responsible for most of the work.

Between the wars other signs of mechanization appeared: combine harvesters and milking machines were relatively unusual, but they were to become universally used and dominant two decades after the Second World War. The most significant change in the interwar era was probably the widespread use of the reaper-binder. Where the corn was flat on the ground even large farms still resorted to the scythe before the First World War. Reaper-binders represented a real gain over mechanical reapers by reducing the workforce required at harvest and, by the 1930s, they were generally used for the cereal harvest. In contrast, the combine harvester made very little progress. It was an expensive machine, temperamental in bad weather, and only able to pay its way on very large farms. Even in Norfolk, where in many ways conditions were ideal, there were only about thirty combines working by 1939.

There were, of course, exceptions: the most famous of these was the Alley brothers' Bluestone Farm near Fakenham, in Norfolk. By 1935 it was worked entirely by machine, including caterpillar tractors, combines and grain dryers. The farm created huge interest, appeared on cinema news and farming documentaries, and was frequently written up in the farming press. The Alleys

also produced their own wheat flakes, sold under the name 'Farmer's Glory' direct to Woolworths – in every way a very 1930s arrangement. Similarly, signs of changes in farm buildings heralded what was to come. Dairying, pigs and poultry were the growth areas, and there were developments in animal housing which were a signpost to what was to happen in the second half of the century. The first battery housing for poultry appeared in 1933, and intensive pig housing was also introduced. Electricity had been applied to agriculture before the First World War, but it was only slowly taken up between the wars. Many farms, particularly in outlying areas, had to wait until the 1950s before they were connected to the national grid. Between 1919 and 1929, one farmer, Richard Mathews, an electrical engineer with a farm at Great Felcourt, Surrey, was using electricity to power a range of machinery from ploughs to hay-dryers; as a result he only needed to keep two horses on his 600-acre farm.

Silage had been introduced by more enterprising farmers at the end of the nineteenth century; then came the import of the American silage tower constructed in wood, concrete, steel or brick. The silo was the first building of the modern age to challenge the barn as the most prominent structure in the farmyard. Since the Middle Ages, these majestic cathedrals of the agricultural world had been at the centre of the farm's activities. Increasingly, they had become irrelevant to the daily routine, often operating as little more than storehouses. Their vast size and huge, timbered roofs made them expensive to maintain; the only thing that saved them from mass destruction in the years before and after the Second World War was the fact that many farmers lacked the money to demolish and replace them. Where the funds did exist, Dutch barns, unsightly constructions of steel and corrugated iron, rose in their place; where they did not, the barn was often decayed to the point of collapse. Corrugated iron, so prominent in the Dutch barn and many other twentieth-century farm buildings, vied with cement as being the single most important element in the first wave of the farmyard's material transformation. It was cheaper than thatch, tiles or timber, quicker to install, and easier to maintain. The fact that it was also liable to rust, however, made it both unsightly and, more importantly in the eyes of most farmers, in need of regular replacement. In the early 1930s, asbestos-cement sheeting began to take its place.

In the Second World War, unlike the First, the policy of encouraging arable farming was imposed as soon as hostilities started. Farmers were also provided with labour, especially young women from the Land Army, and machinery, as agricultural workers joined up. Arable rose greatly: by 1945 it was 55 per cent more than the 1935–39 average. At the end of the Second World War, British farmers were seen as the guardians of the countryside, and they were largely exempt from the legislation embodied in the Town and Country Planning Act of 1947. The post-Second World War mechanization

and commercialization of agriculture, which transformed farming into 'agribusiness', have produced some of the most marked changes in the rural landscape.

During the Second World War, the Scott Committee produced a blueprint for postwar land policies. It laid down that 'self-sufficiency in food should be a primary objective of postwar agricultural policy', but did not anticipate the great changes about to overtake farming, which was effectively another agricultural revolution, altering the landscape as fundamentally as any that had gone before. The Agriculture Act of 1947 ensured that, in the future, agricultural change would be supported by government. The return of profitability to agriculture after decades of depression, and the opportunities presented by new technology and modern chemical fertilizers, made possible the modernizing of agriculture and the alteration of the countryside on a huge scale.

After the war, the government was committed to ensuring stability for agriculture, but mechanization led to a continued fall in the workforce. There were other important changes. The process of replacing horses by tractors accelerated: although there were still 300,000 horses in 1950, a decade later they had become a rarity. With them went their grazing and the fields of oats. Local mills, both windmills and watermills, fell into disuse as they were superseded by electricity; while hand milking was replaced by machines. In Berkshire, for instance, between 1942 and 1950, the number of tractors doubled, while milking machines increased fivefold and combine harvesters fourfold. The decline in manual work was followed by a further fall in the number of farm workers, and, by the early 1970s, only 2.5 per cent of the UK's workforce was employed in agriculture. The impact on the landscape

A hedgerow along the parish boundary between Ramsden and Henley in Oxfordshire in the process of being grubbed up. St John's Lane, which marked the parish's boundary, may have been a Roman road.

of a falling workforce again included deserted farms and abandoned and derelict barns and stables, many of which were bought up and converted to residential use in the 1980s and 1990s. In particular, converted barns became desirable residences and a significant and controversial feature of the rural landscape, particularly in southern and midland England.

The Rural Dilemma

The scale of change after 1945, and from the 1960s in particular, was dramatic, and it was associated with the collapse of the rural infrastructure. Rural schools, shops, pubs and post offices closed, as well as more traditional services, such as blacksmiths, wheelwrights and bakers; rural bus and train services were severely cut or ended. Once crucial to a sense of community, order, hierarchy and place, rural churches were increasingly declared redundant or demolished from 1950. In the Withern group of parishes in Lincolnshire, for example, there were thirteen parish churches in the Middle Ages, eleven in 1900, but only five by 1993. Many unused churches have simply been left to decay. In East Anglia, dozens of ruined medieval churches lie abandoned and overgrown, sitting on islands amidst immense arable prairies. Some redundant churches have been conserved and remain open as historic buildings, while others have been converted into private residences, as indeed have thousands of Nonconformist churches and chapels, both in towns and the countryside.

Alongside the relentless move away from working on the land there was a significant tide of rural repopulation coming in the other direction. Much of this was brought about by commuters seeking an urban way of life in a more tranquil rural setting. The countryside and coast were also particularly attractive to the retired, and that sector of the rural population increased greatly. Thus, due largely to commuting and retirement, the countryside became for many of its inhabitants a place of residence and leisure rather than of work. Commuters and the retired came to dominate many villages and hamlets. This reflected both the appeal of an image of the countryside and a shift in the nature of rural life. The consequence was an effective erosion of any significant social boundary between rural and suburban society over large parts of the country. There became in effect two rural environments: that of life outside the towns, and that of agriculture. Three-quarters of the UK space continued to be used for farming and forestry, but these no longer provided the majority of jobs in the countryside.

Capital investment, the substitution of powerful machinery for manual labour, highly effective pesticides, and abundant, cheap synthetic fertilizers all helped to transform agriculture after the Second World War. By 1969 about nine million acres were being sprayed with hormone weedkillers that prevented weeds from seeding. Pesticides gave farmers greater flexibility in

selecting crops and rotations, but the loss of arable weeds hit wildlife. New crops also made a visual impact: this was particularly true of maize; of the striking yellow colour of the somewhat noxious oilseed rape, especially from the 1970s; and in the 1990s of the pale blue of European Union-subsidized flax, and such specialist crops as lavender in Norfolk. The loss, fragmentation and small size of surviving habitats was a significant factor in species decline, and agrochemicals continue to have indirect adverse effects on species populations.

Birds of prey, such as peregrine falcons, and other species at the top of the food chains within which the chemicals were concentrated, such as otters, were the hardest hit. But the process of human pressure on wildlife was not all one-way. The Welsh red kite was brought back from the brink of extinction, and the numbers of many species, such as sparrowhawks in the 1990s, were stable. Pheasants were also affected, but the decline in the indigenous population was partly offset by increasing the number of birds reared artificially and released for shooting. The grouse population had also declined in upland Britain.

Percentage of Population Decline in Farmland Birds, 1970–95

Tree sparrow	89
Grey partridge	82
Corn bunting	80
Turtle dove	77
Bullfinch	76
Song thrush	73
Spotted flycatcher	73
Lapwing	62
Skylark	58
Linnet	52 [11]

Fertilizer nitrogen was perhaps the greatest threat of all to biodiversity. Much leaking of nitrogen takes place from farmland into surface- and ground-waters and, through dust and denitrification, into the atmosphere. The consequent nutrient enrichment of both water and land favours the more vigorous species, which outcompete others, and so reduces diversity. Blanket weeds often choke waterways, while nettles, thistles, cleavers and cow parsley dominate hedgerows, and bracken invades hill pastures once full of wild flowers. In some parts of Britain up to 36 lbs of nitrogen per acre per year now fall in rain, perhaps ten times previous levels. Not all this is attributable to farming – industry, car exhausts and many other kinds of pollution supply nitrogen oxides and sulphur oxides – but farming is a major contributor. Fertilizer chemicals are seen as essential for modern farm production. Though free of pesticides, even organic farming depends on natural fertilizers, and

these can be just as polluting as synthetic nitrogen. The limiting factors of poor fertility, waterlogging, pests and difficult terrain, which previously confined different kinds of low-intensity production to particular kinds of land, were easily overcome with modern machinery and agrochemicals. As a result, simpler, specialist, more productive large-scale enterprises replaced much of the old crop, livestock, and biological and landscape diversity with homogeneous monocultures.

Features of value are still being lost from the landscape as a result of intensive agriculture, although the speed of such changes may be declining. There is recognition that the landscape needs to be managed by farmers with the aid of environmentally-orientated grants, but existing schemes appear to be marginal; they do not tackle the problems of landscape change fundamentally. The Wildlife and Countryside Act of 1981 established Sites of Special Scientific Interest, which were partly protected from 'damaging agricultural operations'.

By the late 1980s, government and European Union policies, which had encouraged increased output, particularly of cereals, so that Europe could be self-sufficient, had resulted in massive surpluses. In the early 1990s there were efforts to persuade farmers to reduce output. This, coupled with an increase in private transport and leisure time, and the public awareness of the pleasure of 'country pursuits', has resulted in government and EU efforts to encourage farmers to produce less and diversify. Some farmers now find golf courses more profitable than agriculture.

While the mixed farming and predominantly arable areas of England became increasingly monocultural, large acreages of formerly pastoral land were converted to arable agriculture. This process intensified considerably in the 1960s and 1970s, when the pastoral shires of the Midlands, and in particular Northamptonshire and Leicestershire, were increasingly used for the production of cereals. Similarly, large tracts of chalk downland were ploughed, in many cases for the first time since the Roman era. The heathlands of southern England were being eaten away, and attempts were even made to plough up the North York Moors.

Large machines, and in particular combine harvesters, can only be effective in very large fields, so the use of increasingly large machinery has necessitated the removal of thousands of miles of hedgerow – formerly a quintessential element in the English countryside. Between 1947 and 1990, approximately 230,000 miles of hedges were destroyed, which amounted to almost half the UK total; over 2000 miles a year of hedgerow are still being lost, despite conservation measures which actually pay for the maintenance and restoration of hedgerows. Furthermore, as agriculture has become highly mechanized, there has been a decline in mixed farming. Farmers cannot afford to invest in the plant that is appropriate for carrying on both arable and pastoral enterprises, while the availability of a wide range of artificial

A large, late twentieth-century field near Aynho in Northamptonshire. The solitary tree is a remnant of a former field boundary.

fertilizers means that arable farmers are no longer dependent on dung. Farmers no longer need to keep animals and so they have no need for hedges – no barrier is necessary to prevent the barley from getting into the wheat. Hedges have become not only redundant but a nuisance in many areas and, until fairly recently, financial inducements were offered to farmers to destroy them. Hedge laying, an almost dead craft, was, however, revived towards the end of the century.

The removal of hedgerows represented the most dramatic landscape change. From the 1950s, the amalgamation of fields and bulldozing of hedges led to the replacement of the earlier patchwork of small fields surrounded by dense hedges by large expanses of arable land. The amalgamation of fields by removal of hedgerows and walls to allow more efficient use of machinery eroded the historic fabric of the landscape. In areas such as the Wessex downlands, old hedges were removed in order to cut costs, and huge prairie-like fields were created. The removal of hedges was a process that went on throughout England as the twentieth century advanced. Over broad stretches of England, the general appearance of the countryside is reverting to a pre-Enclosure one. The trim and well-wooded hedged landscape, for hundreds of years a feature of much of lowland England, has been changed, apparently for ever. Where new boundaries were needed, they were often of wire. The creation of larger fields was often accompanied by the redirection of footpaths and bridle paths or, more seriously, the obliteration of ancient rights of way. It was common practice when removing field boundaries simply to ignore rights of way so that the walker was faced with the daunting prospect of a vast ploughed field, with no indication of where the footpath

used to run. Such activity effectively sterilized the landscape as culturally as it was botanically.

The Great North Road had become a highway through sad prairies almost as far as Scotland. There was a sadness about that landscape, relentlessly simplified, big and empty when once it had been small and complicated. It had seemed more concentrated in those days somehow, more dense, so that mile for mile, journeys were much richer.[12]

Overall, the quality of the rural landscape was still deteriorating at the end of the century, with field sizes increasing and modern farm buildings of standard industrial design proliferating. Between 1983 and 1994, 16,280 miles of hedges were removed in England, but only about two per cent, 3225 miles, were restored, although, with a new agricultural recession, the rate of removal is falling. Although there were few hedges to remove in the Cambridgeshire fens, dykes were filled in as larger pumps meant fewer main drains were necessary and more drainage could be underground. The average size of a field in 1974 – thirty-one acres – was more than double that of 1945 – fourteen acres. In Huntingdonshire, on the heavy midland clays, an area that had traditionally concentrated on livestock became intensive cereal land. This meant that economies of scale were more necessary and resulted in a massive loss of hedges. Average field size in a sample area rose from nineteen to forty-five acres between 1920 and 1970, while the number of holdings had halved, with the average size rising from 122 to 317 acres over the same period.

Since 1947, the race to produce more food has resulted in between a third and a half of ancient woodlands being lost, and 60 per cent of fens drained,

Ploughed-out prehistoric field systems in Wiltshire show up as dark soil marks against the lighter chalky soil. At the top of the photograph the ancient field boundaries survive as low linear earthworks.

whilst heathlands have been reduced to mere fragments. Small farms, particularly in the hills, have been declining in number at a rate of two per cent a year. The size of farm that is needed to support a full-time farmer has nearly doubled every decade since 1945. The result, therefore, is fewer, larger farms, containing regular and often huge fields in an almost hedgeless landscape.

The attempts to conquer nature became increasingly intense, but there was a price to pay. For example, large-scale land drainage and major changes in the use of low-lying areas left more land vulnerable to flooding throughout Britain. Variations in flood frequency and magnitude in areas like the Yorkshire Ouse catchment and the Upper Thames Valley were in part due to atmospheric changes, but land-use alterations have also been important. The ploughing of downland also affected drainage. Improved drainage systems enabled the water to get away more quickly, but low-lying land because more liable to flood when rivers overflowed.

In 1977, the Nature Conservancy Council produced a report emphasizing the damaging effects that new-style agriculture was having on the biodiversity of the environment, and in 1980 Marion Shoard published an angry book, which spoke for many, lamenting *The Theft of the Countryside*.[13] Intensive and technologically advanced farming was responsible for greatly increasing production, but, at the same time, such developments eliminated much of the biodiversity, archaeology and even topography so widely cherished in the British countryside. The idea that farming not only produced food but automatically delivered the kinds of attractive landscape that people liked was deeply ingrained.

From being the guardians of the countryside, farmers have received an increasingly bad press since the 1970s, as the scale of landscape change associated with agribusiness became clear. Realization that all was not well with farming not only took a growing catalogue of habitat, species and landscape losses, but the revelations that first, far from being short of food, British and European agriculture was producing huge unwanted surpluses, and, secondly, far from enjoying a cheap food policy, the consumer was paying above the world market price for many basic foodstuffs. The Set-Aside scheme, which was designed to take at least some land out of production, had only limited success in reversing landscape change. More recently, initiatives such as the Countryside Stewardship Scheme have encouraged a more environmentally friendly approach by farmers. From 1991 the scheme offered payments to conserve or restore landscape or features, as well as to improve public access to them, with targeted grants. There has been a focus on particular endangered landscapes, such as lowland heaths, calcareous grassland, lowland meadows and wet grassland with high landscape and conservation value, along with the preservation of historical and archaeological sites.

At the end of the twentieth century agriculture again faced a crisis. EU subsidies were diminishing in size, and there were problems of competition

both from within an enlarged EU and from outside. Many foodstuffs were available more cheaply from outside Britain. One answer to this was Set-Aside; under the original scheme, farmers had to leave at least 20 per cent of the farm's arable land uncultivated for five years. Set-Aside land can be left fallow, planted with trees or used for non-agricultural purposes, but it is a controversial policy. It has been criticized because, in spite of costs, it brings too few environmental benefits to the countryside. Against that, alternative rural activities continue to multiply, and it is estimated that there are a million enterprises in the countryside – a higher rate of businesses per head of population than found in urban areas. In many parts of England, wherever planning legislation allowed it, farmland was being sold off for 'redevelopment', which normally meant housing or light industry. Elsewhere, diversification was normal, and agricultural land was being given over to a wide range of alternative uses. Llamas, ostriches and buffaloes were among the exotic species found on some farms trying for more profitable activities. In terms of land use, agriculture remained the dominant activity in England, with 75 per cent classified as farmland. Such was the degree of agricultural industrialization, however, that farm workers made up only 1 per cent of the population in 2001.

With the increasing industrialization of farming, the shape and nature of farm buildings changed. Chicken farms took the form of controversial battery hangars, which, apart from the smell, in terms of design could have happily been housed on an industrial estate. The scale of many farm buildings changed the face of the countryside – great silos the size of parish churches are found on many arable farms in central and eastern England. And by the end of the century the general appearance of many farms resembled that of a light industrial complex, with groupings of low-rise anonymous sheds and warehouses. As the use of asbestos became suspect and plastic more adaptable, plastic sheeting of various weights, shapes and colours became a common sight on farms. The wood, stone and brick which had been ubiquitous in the nineteenth century were now rarities, used mainly by the rich with an eye for the picturesque. The gap between farm and factory was diminishing. Facilities for storing and drying grain became more substantial, and grain stores took over from silos in challenging the barn for pride of place. The quantities of liquid fuel that were used every year by the larger farms called for massive tanks, usually sited on piers beside a cement roadway. Cornstacks and haystacks, for so long a visible manifestation of what the farm was all about, became as obsolete as windmills; if crops remained outside at all it was in giant circular bales covered in black plastic sheeting. There was also a tidying-up both in the fields and the farmyard. Economic efficiency called for the removal of unwanted rubbish. Neatness was a part of the suburbanization of the farm, along with the village. The characteristic smells of the farm also began to disappear. Despite the intensification of effort, ironically,

the agricultural countryside is emptier now than it has been for many centuries. Huge areas of fields are mechanically tended by a handful of agricultural workers and much of the stock is kept permanently indoors.

In answer to criticisms of the impact of modern agriculture, the farming lobby argued that the English countryside is always changing. The present changes are therefore seen as merely the latest of a never-ending series of alterations. The farming of the past created the fabric of the rural landscape, by adding new features while others were taken away – Hoskins's 'palimpsest'. In contrast, the farming of the late twentieth century was almost exclusively destructive. It did little or nothing to enrich the environment; it added few new habitats to replace those which were lost; and both ecologically and aesthetically its consequences were almost entirely negative. In particular, twentieth-century agricultural developments did much to suppress the diversity of the countryside. The innumerable local variations in landscape, as well as more regional contrasts such as that between woodland and champion areas, were gradually blurred by the emergence of a number of very broad agricultural regions. A basic distinction between an arable east and a pastoral west gradually replaced the complex pattern of specialized farming regions that was characteristic even of the first part of the twentieth century.

Descriptions of farming at the beginning of the late Victorian era not only belong to another age, but to another culture, one which had more in common with the pre-Roman Iron Age than with agribusiness at the start of the twenty-first century. The following is an account of harvest in Akenfield, Suffolk, by John Grout, a farmer who was eighty-eight in 1966–67. He recalls the harvest and its rituals when he had been a young man:

> The holy time was the harvest. Just before it began, the farmer would call his men together and say, 'Tell me your harvest bargain'. So the men chose a harvest lord who told the farmer how much they wanted to get the harvest in, and then master and lord shook hands on the bargain. We reaped by hand. You could count thirty mowers in the same field, each followed by his partner, who did the sheaving. The mowers used their own scythes and were very particular about them ... Each mower took eleven rows of corn on his blade, no more and no less. We were allowed seventeen pints of beer a day each ... The lord sat atop of the last load to leave the field and then the women and children came to glean the stubble. Master would then kill a couple of sheep for the Horkey supper and afterwards we all went shouting home. Shouting in the empty old fields – I don't know why. But that's what we did. We'd shout so loud that boys in the next village would shout back.[14]

CHAPTER 10 | # *The Country House*

During their heyday, and also in their century of decline (after 1880), the most important reference group for most notables was that they belonged – or had once belonged – to the British landed establishment. For most of the time, they had much more in common with each other (whatever their occasional and sometimes abiding differences) than with any other social group (whatever their occasional and sometimes abiding similarities).

David Cannadine [1]

I N THE NINETEENTH CENTURY, England was a country where wealth, power and privilege could be easily recognized in the countryside. Country houses and their parks were the conspicuous representation of the aristocratic establishment. It was estimated that the power and wealth of Britain was in the hands of a few hundred aristocratic families, each of whom would have owned at least one country estate. For example, when the tenth Duke of Devonshire died in 1950 he owned 120,000 acres (an area just larger than the

The manor house at The Lee in Buckinghamshire. This was rebuilt by Arthur Lasenby Liberty, founder of Liberty's, London, in the first decade of the twentieth century. The adjacent model village, complete with green, was created at the same time.

Isle of Wight). There were additionally many families who had prospered in the nineteenth century, through the Industrial Revolution and through imperial trade, who were able to establish country houses and parks for themselves. Towards the end of the century, a new breed of country house owner came into being with the growth of retailing chain stores. Fortunes made on the high street were translated into country estates, some of them bought from English landowners and some of them new creations. There was also a trickle of North American entrepreneurs, able and prepared to buy their way into an aristocratic way of life. Thus throughout England there was a patchwork of private parks, large and small, with their associated houses. There were concentrations close to London in the Chilterns and the Cotswolds, but country houses from the Middle Ages to the Victorian era were to be found in many parts of the country. Most of them were attached to parks of several hundred acres, some of which had been elaborately landscaped in the eighteenth or nineteenth centuries, others where landscaping was restricted to the immediate surrounds of the house. Park boundaries, ostentatious gateways and tree-lined avenues proclaimed the presence of the rich, powerful and privileged. In his memoirs, *The Passing Years* (1924), Willoughby de Broke portrayed the nature of county society at the start of the twentieth century:

> From a modern perspective Willoughby de Broke's record is appalling: an indulgent, unproductive, thick-headed bigot, resisting all change, whether technological or for social and political justice. On the other hand it is a fond tribute to a privileged caste who were forthright about their title to live as their forebears lived – and as their tenants and servants expected them to live. The maintenance of this style was expensive, time-consuming, and physically exacting. Hunting four times a week for seven months of the year demanded intimate knowledge of country people and country ways. When Willoughby de Broke wrote about his estate employees – that 'there was a mutual bond of affection that had existed for many generations between their families and the family of their employer, a bond that cannot be valued in terms of money' – he was underlining the strength of the patriarchal system.[2]

The agricultural depression of the late nineteenth century made life difficult for many country landowners. In the first half of the twentieth century, taxation and the disappearance of the large labour force of cheap servants also took its toll on country house life, and, as a result, many country houses were demolished or institutionalized. Over 1200 were destroyed or abandoned between 1918 and 1975. In particular, in the decade after the Second World War, some 400 stately homes were demolished. Many others were transferred to the National Trust and became reliant on paying visitors, or were converted into schools or other institutions.

Country houses tended to be at the head of a rural estate consisting of

Wilton House Park, near Salisbury in Wiltshire, is home to the Earl of Pembroke. The park acts as a buffer against residential housing (centre right), but today is run very much as a commercial business.

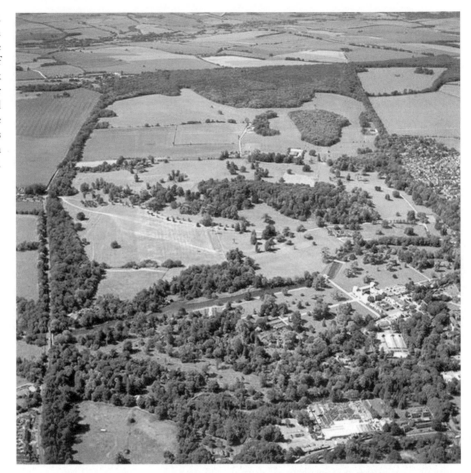

many tenanted farms. In 1900 the majority of farmland in England was held by tenants in units of less than 300 acres. In 1900 landownership still represented power and the landed gentry still represented a powerful political force, but a force whose power was to diminish rapidly as the twentieth century evolved. During the century, the country house grandees were to lose some of their wealth, much of their control of the agricultural land of England and virtually all their political power.

Country houses were the seats of the aristocratic and wealthy families of England – here they lived and entertained; visitors for the most part came by invitation. There was also, however, a tradition of opening houses and parks to the 'right type' of visitor. Some landed gentry saw it as *noblesse oblige*, while others were proud to show off their belongings in their ancestral homes. Few saw it as a means of making money, and where regular entrance fees were charged, they were regarded more as a means of restricting the number of visitors than a serious form of income generation. In the nineteenth century about a hundred properties in England were advertised in guidebooks as open to the public on specific days of the week, or at any time in the absence of

the family. When he inherited Battle Abbey in 1857, Lord Henry Vane was amazed to discover that up to 800 visitors came and peered through the window of the study 'till they fairly stared him out of countenance, and drove him from the room ... Others glued their faces with equal persistence to the panes of the Duchess's sitting-room windows; but there they met their match, for being roused to great indignation ... she started steadfastly at the invaders, and rising very slowly from her chair, without averting her eyes, moved gradually, step by step, across the room ... long before she had reached the window the whole party had fled.'[3] Similar, probably apocryphal, stories were recorded at other houses: at Lowther Castle in the Lake District, and at Holkham in Norfolk, where one house guest was once surprised in his dressing room by a large party of visitors.

The fashion for country house visiting grew in the second half of the nineteenth century. In 1900 Chatsworth was receiving 8000 visitors a year; but by this time the tide had already turned, and owners were reacting against country house opening. In 1883 an American banker, M. P. Grace, who had bought Battle Abbey and installed bathrooms and electric lighting, severely restricted the tourist trade. Many country houses became much more homely than they had been before. In addition to electric lighting, oil-fired central heating, lifts and modern kitchens all made an appearance. Some of these improvements were paid for from the proceeds of the sale of country house collections, which also helped meet the growing problem of estate duties. Of the hundred or so houses publicized as open to the public in the 1860s and 1870s, about half were closed by 1914, and of those, two-thirds before 1900. Whereas in earlier days foreigners often remarked on the openness of country houses, in 1904 a German diplomat, Muthesius, warned, 'The curious traveller who imagines that by journeying across England he will be able to see the much celebrated English country-houses in their dozens will usually be in for a rude disappointment ... Special arrangements are necessary if one is to make its acquaintance, as well as good connections to break the spell of its privacy.'

At Castle Howard in 1919 Lady Rosalind Carlisle decided personally to vet all applications from parties to view the house, thus modifying the open-door policy formerly operated by her husband: 'a request to see the house must be granted as a favour, and each case considered on its merits ... In this way excursionists will learn that the house is not open as a matter of right, but a privilege.'[4] Nearly all of the great showhouses that had attracted thousands of visitors in the nineteenth century were now closed. These included Woburn, Eaton, Haddon, Lumley, Berkeley, Cobham, Belvoir, Alnwick, the Dukeries' parks, and Newstead Abbey (until its donation to the local authority). Many owners of lesser houses, who had prided themselves on their accessibility, also quietly withdrew, and those houses that remained open welcomed a declining number of visitors.

The 1894 Liberal Budget introduced a consolidated death duty, Estate Duty, which fell on property as well as personal wealth. Although the government believed it to be fair and even generous to the landowners, the latter took a very different stance, as reflected in the Duke of Devonshire's response in a melodramatic public oration at Buxton:

> I do not contend that it is a necessity that I or my family or my successors should be in a position to keep up great places like Chatsworth, or Hardwick, or Bolton Abbey, or Lismore, in Ireland. I do not contend that it is a necessity that we should be placed in a position where we can enjoy the luxury of striving to be surrounded by a contented and prosperous tenantry and people ... These things have been a pride and a pleasure to my predecessors and to myself; but they are not necessities.[5]

The popular, less than sympathetic response to this was expressed in *Reynolds's Newspaper*:

> The Duke of Devonshire, one of the wealthiest landgrabbers in the world, is suffering from a fit of melancholia because Sir William Harcourt's Budget provides that landlords shall in future pay taxes like other people ... Was ever such a thing heard of? How on earth is the fabulously-rich Duke of Devonshire to find money for his race-course orgies, and his country house parties, and the other resources of idling luxury if he pays his taxes?[6]

The introduction of death duties and the aristocratic reaction had opened a wider debate on the country house, its contents and grounds. Were they part of the 'national heritage'? If so, and their owners were unable to maintain them, should the nation take responsibility for them? The Duke of Devonshire had hoped that, faced with these choices, his opponents would prefer to return to the old system of private ownership and voluntary benevolence, supported where necessary by tax concessions. He was surprised by the degree to which anti-aristocratic feeling now made this impossible. Despite some tempering by subsequent Tory administrations, death duty was there to stay.

During the course of the twentieth century the dominance of many areas of rural England by the aristocratic estate became a thing of the past. Many country houses were expensive to run and many were in need of wholesale renovation. Rather than stagger on from one crisis to the next, some owners decided to sell their collections, or part or even all of their estate, including the houses. In general the smaller estates of less than 10,000 acres were more vulnerable than the larger. The long-established land aristocracy with the largest estates tended to fare better, and fewer of their great estates were broken up.

The aristocracy suffered particularly badly during the First World War, with high casualties among family heirs. For example, in Chester Cathedral there is a monument to thirteen members of the Grey-Egerton family of

Oulton Park who fell on active service. Although this scale of family tragedy was rare, the rural elite suffered terrible casualties, along with the rest of the community. As David Cannadine writes:

> The British aristocracy was irrevocably weakened by the impact of the First World War. Not since the Wars of the Roses had so many patricians died so suddenly and so violently. And their losses were, proportionately, far greater than those of any other social group ... Of the British and Irish peers and their sons who served during the war one in five was killed. But the comparable figure for all members of the fighting services was one in eight.[7]

Death duties were doubled to 50 per cent in 1919 and were raised again in 1925. The sale of landed estates, which had already been increasing in the prewar years, reached its height between 1918 and 1922, when seven million acres – approximately 25 per cent of rural England – is said to have changed hands, a level of activity in the land market which had not been seen since the Dissolution of the Monasteries in the reign of Henry VIII. Much of the land was sold to sitting tenants and, as a result of these sales, the proportion of English and Welsh agricultural land held by owner-occupiers rose from 11 per cent in 1914 to 37 per cent by 1927. The crisis afflicting the estate owners was reflected in the increasing incidence of overgrown parklands, notices of sale, and the neglect of many country mansions. There were also a suspiciously large number of country house fires at this time. Many estates were in a poor condition when sold, and the purchasers often demolished the mansion and converted the park to other uses. Rents were cut, and legislation passed in 1923 gave tenant farmers greater freedom. The upkeep of large-scale, elaborate houses and landscapes was increasingly difficult in the postwar years, and agricultural fortunes returned once more to the doldrums.

Lord Lansdowne confided, after selling Lansdowne House to London property developers, that 'for the first time in his life he realised what real comfort was', 'installed in the small comfortable house in Brook Street'. The Duke of Portland's heir, announcing that he 'prefers not to be burdened with residence in a palatial mansion' like Welbeck Abbey, built himself a new, smaller house in the old house's grounds. It was almost impossible to sell a big house, no matter how historically important it was. Landlords considered themselves lucky if they were able to divest themselves of historic houses for the price of the land they sat upon.

This was to be the fate of some of Nash's larger mansions, traditionally the most prized houses in the land. Edward Wood sold Temple Newsam and its 600-acre park to Leeds Corporation on easy terms in 1922. Nottingham Corporation acquired both Wollaton Hall and Newstead Abbey: the former in 1924 from Lord Middleton for the price of its 800-acre park (upon most of which houses were built), the latter in 1931 free as a gift from Julien Cahn (after the National Trust had declined it). Cheshire County Council refused

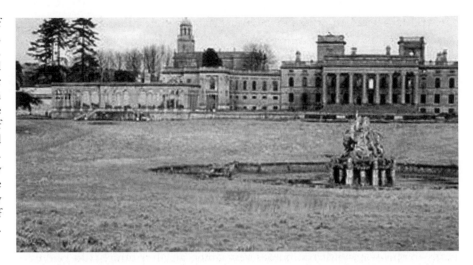

The ruins of Witley Court, Worcestershire. The Tudor and Jacobean manor was rebuilt as an Italianate palace for the Earl of Dudley in the mid nineteenth century. It was accidentally destroyed by fire in 1937. It is now in the hands of English Heritage.

the gift of Crewe Hall, but Lord Crewe arranged to transfer it along with most of his estates to the Duchy of Lancaster. Bramshill, in Hampshire, described by Hussey as one of 'the five supreme houses in England intact with all its wonderful things', was one of the few to find a private buyer. Another of Nash's mansions, Bramall Hall, in Cheshire, was about to be demolished when a local businessman stepped in and bought it cheaply. Others were advertised to let – Knole in 1921, Levens Hall, in Lancashire, in 1928. Montacute, which had been leased off and on for years, failed to sell at auction in 1929 and was only saved from dereliction by the intervention of Ernest Cook – an heir of Thomas Cook. Cook eventually conveyed the house and park to the National Trust. Around England, many country houses were used for local authority museum collections. A survey in 1928 found that 20 per cent of local authority museums were housed in former country mansions.

It is estimated that 7 per cent of the total stock of country houses was demolished between the wars. Many of these were houses in the classical style, long criticized as ugly and foreign, now doubly damned as too big and uncomfortable. The *Field* advised owners to demolish houses that, twenty years ago 'emblems of justifiable family pride', were today 'incubuses sitting heavily upon impoverished acres which can no longer support them ... It may be taken practically for granted that the vast mansions of Vanbrugh, Inigo Jones, Wyatt and others can never again be supported by their land.' Nuthall Temple, a Palladian villa outside Nottingham, was bought by a property developer when it was put up for sale in 1929. The buyer and a local journalist set fire to the house, which was destroyed – 'Impressive Scene' boasted the next day's headlines in the *Nottingham Evening News*.

Short of demolition, some of the white elephants were converted to a remunerative use, and some of the largest were taken over by institutions. In 1919 it was proposed, unsuccessfully, to turn Warwick Castle into a hostel

for wealthy American girls. On the other hand, Stowe's four hundred rooms were successfully converted in 1922 for use as a boys' public school. Horace Walpole's Strawberry Hill became a Roman Catholic teacher-training college. Maxstoke Castle made a better hotel than a private home, according to *Country Life*. A number of country houses in the Peak District and the Welsh Marches were converted into youth hostels for hikers. Some developers had hopes that conversion of country houses into flats might be economical. In 1936 the Earl of Dudley converted the ruins of Dudley Castle into a zoo.

In the vicinity of major towns and cities, parks often provided suitable areas for suburban development, public parks or golf courses. Eastbury Manor House was a fine Elizabethan house in Barking, eventually taken on by Barking District Council, but was chiefly of interest for its bowling greens and tennis courts. Most of the growing suburban London councils acquired parks in this way, with the houses very much an afterthought. In one case, Broomfield House in Palmers Green, a classical house, was given a half-timbered façade to make it more acceptable to the ratepayers. Kenwood was added to Hampstead Heath for its 'woodland joys, sylvan beauties, shady dells, leafy delights, umbrageous spaces', not for its Adam house that was described in the guidebook as 'massive rather than elegant'. The house would have been omitted entirely from the bargain had not Lord Iveagh bought it and donated it free of charge to the London County Council, to house his collection of pictures. Another Palladian villa, Chiswick House, was spared Nuthall Temple's fate for the value of its walks and gardens, so long 'screened off ... from the public eye'.

There were particular problems in industrial areas, what John Walton has called 'the drift to fairer climes' away from Lancashire. Some country estate owners described Nottinghamshire as 'uninhabitable' by the 1930s, while Phillips and Smith, in their *History of Lancashire and Cheshire*, wrote that 'industrial pollution threatened old family homes (for example, Norton Priory and Madbury Hall in Cheshire were reportedly pulled down because of it)'. In Staffordshire, the Duke of Sutherland had sold Trentham before the war as it was too urbanized; the house was demolished in 1911. In 1917 the Duke sold his other Midlands house, Lilleshall, in Shropshire, and moved to Surrey, 'where I could enjoy the beauty and peace of the countryside'.[8]

Agecroft Hall, on the edge of Manchester, became engulfed in industry, and the Dauntsey family sold up and moved to Dorset in 1926. *Country Life* articles of 1902 and 1903 reported that: 'Agecroft is both fortunate and unfortunate – fortunate in the loving care which adds new beauty to its antiquity, unfortunate in the fact that the country thereabouts is much given over to the whirl of modern things ... There are dead oaks, which have been killed, it is said, by the smoke and fumes from the chimney shafts of coal mines in the vicinity ...' The fine half-timbered hall was sold to an American, demolished, and re-erected in Richmond, Virginia.

Its site is now occupied by a large power station. Similarly, the Earl of Ellesmere abandoned nearby Tudorbethan Worsley Hall for the charms of Berwickshire; the hall was eventually demolished in 1945. Even Hardwick Hall, the remarkable Elizabethan house belonging to the Dukes of Devonshire, was abandoned by the family in 1924 because it was surrounded by coal mines and subject to 'soot pollution'. Hardwick Hall was transferred to the Treasury in 1954 in order to meet death duties and eventually passed to the National Trust.

Great Barton House, near Bury St Edmunds in Suffolk, was the home of the Bunbury family, one of whose eighteenth-century members, Sir Thomas Bunbury (1746–1821), had been instrumental in developing Newmarket as a horse-racing centre. Thomas was also responsible for landscaping the 150-acre park. In 1913 the house was destroyed by fire and the north-western part of the park returned to agriculture. The remainder of the park was developed as a select housing estate, complete with 'village green', in the 1960s. The north-west boundary of the green followed the line of the original drive to the hall. The copses on the green and many of the mature individual trees were part of the original park.

Cassiobury Park, near Watford, in Hertfordshire, was sold off in a number of stages in the 1920s, and different parts of the park were converted to various uses. In 1910 *Country Life* had described the ancient seat of the seventh Earl of Essex as 'set in great and delightful grounds and surrounded by a grandly timbered park'. The development potential of one of the largest plots offered in the sale of 1922 was described in glowing terms:

> Its contiguity to the important town of Watford with its growing population ... coupled with the fact that there are no less than 7700 feet of available frontages to existing roads, constitutes the Estate one of the Finest Buildings Propositions within this distance of London ... while the Mansion itself, apart from its Residential attractions, might readily be converted into an Hotel, Public Institution, or Convalescent Home.[9]

The house was demolished in 1927; the former stables became Cassiobury Court. Part of the park was turned into a golf course, in which some of the park landscaping survives, and the remainder developed for housing. After moving to various homes, the eighth Earl of Essex was listed in *Burke's Peerage* as living in Little Cassiobury, Southampton, Jamaica.

Another notable casualty was Clumber Park, in Nottinghamshire, the seat of the Duke of Newcastle. The house had been rebuilt on a grand scale by Charles Barry Junior after a fire in 1879. It had lavish gardens and a private chapel larger than most parish churches. The seventh Duke preferred, however, to live in much smaller and less pretentious accommodation at Forest Farm, near Windsor. After his death in 1928 the house contents were sold and the house eventually demolished; some 300,000 bricks were acquired

Cassiobury, near Watford in Hertfordshire. The house was deliberately destroyed in 1927.

for the church of St Bernard at Parson Cross, in Sheffield. Eventually, the National Trust bought the surviving 4000 acres of parkland. Presumably, a delay of ten years or so might have saved the house, if not its contents.

Sales in the south east of England tended to be on a smaller scale and were usually to make way for housing. For example, part of the Lovelace estates at Leatherhead had been sold just after the war to 'Tommy' Sopwith, the aircraft manufacturer, but in 1925 the estate farms were being advertised as 'excellent sites for the erection of first-class houses'. Similarly, in the area around Shere the Bray family had been selling and letting land for villas since the 1880s, including the arts and crafts settlement of Holmbury St Mary. By 1922, realizing that land for large-scale housing was used up, they turned their attention to more modest developments on the outskirts of Holmbury. Also in the Home Counties, in 1923 a small estate and pheasant shoot of 300 acres, known as Selsdon Vale, was bought by the Surrey Garden Village Trust and developed as a smallholder settlement.

The Forestry Commission was also a major purchaser of country estates, especially of those on marginal land, and the report prepared when Croxton (Norfolk) was acquired in 1923 describes a not untypical scene of dereliction:

The various land and timber speculators through which these lands have passed during the past seven years are responsible for the deplorable condition of the estate ... In consequence of the timber operations the park, as such, has ceased

to exist. An avenue of limes and a few quasi-ornamental trees of little commercial value are all that are left, except in a few wild belts where a few ragged conifers remain, the best timber having been cut out.[10]

What remained of the park was subsequently obliterated by regimented conifer plantations, a fate experienced by a number of other parks, especially in eastern England, during this period. But other landscapes lost at this time have left more tangible traces. Where parks were turned over to agriculture, for example, the perimeter belts or stone walls, grand entrances, sections of avenues of trees and ha-has often survive as elements in the landscape.

The National Trust had been founded in 1895 to care for land or buildings of beauty or historic interest. Initially, the Trust was only concerned with land, but it soon began to take responsibility for properties. By 1998 the Trust owned 603,000 acres, making it the largest private landowner in England as well as one of the largest owners of farmland. Moreover, it also had more members than any political party, in 1998 over 2.5 million, and visiting Trust properties became a part of the lives of millions.

In the 1930s, the National Trust and others began to press for government action and help in saving historic country houses for the nation. At the Trust's annual meeting in July 1935, William Ormsby-Gore, the head of the Office of Works, the government department responsible for historic building, stated:

> wonderful houses in their beautiful parks, houses which still contained the accumulation by many generations of successive occupiers of the utmost historic and artistic interest in almost every county, was a unique heritage of

A derelict small country house in Shropshire.

Britain. No other country could match possessions like Penshurst, Knole, Bramshill, Hatfield, and Blickling.[11]

There were, however, entrenched attitudes by government, estate owners and the public which made the acceptance of the idea that the state should intervene to help preserve country houses very difficult.

In 1933 the Liberal peer Lord Methuen, who had recently inherited Corsham Court, in Wiltshire, tried to interest the Land Agents' Society in organized country house tourism. At this time, country house visiting was at its lowest ebb, but Methuen was a Francophile who had developed an enthusiasm for 'La Demeure Historique', the French system of public visiting. Corsham Court had long been open to the public for two days a week for viewing of its art collection, and though Methuen acknowledged that this custom was little known even in the immediate vicinity, he believed in its potential. In 1935 he wrote:

> The *Demeure Historique* advertises the chateaux and houses and organizes char-a-banc tours and uses its revenues to make grants for the restoration or repair of selected houses which are falling into ruins. The core of the whole system, however, is the tourist industry. I see no reason why once prejudice against intrusion into privacy is broken down in this country a very considerable income should not be made available to the owners of ancient houses in the same way. I should imagine that a good many thousand people every year, both foreign and British, would spend part of their summer holidays in visiting houses as they now do in visiting cathedrals and natural beauty spots.[12]

As a result of Methuen's arguments, the National Trust established a Country House Committee with Lord Esher as Chairman and James Lees-Milne as its full-time Secretary. This committee was to oversee a scheme under which the Trust could accept houses without payment of death duties and even lease them back to their owners, but in return the owners would have to submit to visiting, a degree of public control, and even some sharing of profits by the most successful houses. The initial response was predictably disappointing: 'Nearly every owner who has replied to this Memorandum', Lees-Milne reported in October 1936, 'has shown undisguised and bitter disappointment over this Scheme.'[13] Their hopes had been raised by talk of sweeping tax exemptions, but they now saw themselves asked to sacrifice their own privacy and limited funds to an unproved tourist trade. Only the very poorest and most desperate were interested in this option, hoping for subsidy from their richer fellows and the Trust. Others showed a marked lack of sympathy for their peers. 'I fully understand the merits of the arrangement for owners of these houses who are at the last gasp', wrote Lord Salisbury, but as to others, 'Why in the world should they come into the Scheme?'

Those who already opened their houses saw no particular reason to

contribute a portion of their earnings to anyone else either, and were not keen to attract any more visitors than they already had. Mrs Roper of Forde Abbey complained of the 'considerable trouble' involved in opening: 'The public require continual supervision in the gardens as well as in the house.' Lord Harewood 'is put to enormous expense by char-a-bancs in the upkeep of his drives ... he is often under the necessity of turning a surplus number of visitors away'. Of these owners, only Mrs Whitmore Joncs of Chastleton and Lord Bath of Longleat – both on the American route through the Cotswolds to Bath – thought that tourism was really profitable. Those who did not open entertained a variety of fears about doing so. Lord Burnham thought that 'once the Public had been allowed into a House, they would look upon it as a legal obligation and become tiresome'. Lord Ilchester felt Holland House would become impossible to live in and worried about burglary. Others, such as Mr Bishop of Shipton Hall, wanted to exclude 'undesirable looking people'.

At the virtually unstaffed Castle Howard estate, in the late 1930s, the furious agent regularly confronted parties of cyclists, motorists and motor-coach tourists picnicking and playing games in the private park. One party brought in hundreds of schoolchildren from Hull, another erected a tent as a refreshments pavilion, and, on one Sunday, sixty motors were counted parked on the private road. Even the well-heeled Duke of Marlborough found it difficult to grapple with such incursions. Blenheim Park, which was open to the public, was subject to various acts of vandalism. He reported that: 'Fair Rosamund's Well was stopped up with clay (cutting off the water supply to the palace), notice boards had been hacked down and saplings felled, iron fencing was thrown into the lake, the private gardens broken into and flowers stolen'. One prominent land agent argued that it was impossible to combine tourist and residential functions: 'Gardens lend themselves to be seen by the Public, but not private houses.'

Lees-Milne toured the country lobbying estate owners, but early interest invariably disappeared when the limited financial advantages of the scheme were revealed. The scheme's first firm offers nearly all stemmed from acts of philanthropy by high-minded owners. The Liberal MP Sir Geoffrey Mander gave Wightwick Manor, which was not really a historic house at all but a fifty-year-old example of Arts and Crafts historicism which the Trust would only take on because of Mander's generous endowment. Lord Methuen offered Corsham Court, Lord Lothian offered Blickling, Sir Charles Trevelyan, a prominent aristocratic Socialist, offered Wallington. All these early offers came from Liberals or Socialists, and Lord Bath advised the Trust not to publicize Trevelyan's offer 'if we do not wish to make [the] majority of owners suspicious'. Apart from Wightwick, the only offer that could be accepted before the war came from 'that desired rarity, a rich landlord without immediate heirs', Sir Henry Hoare of Stourhead in Wiltshire. Stourhead's

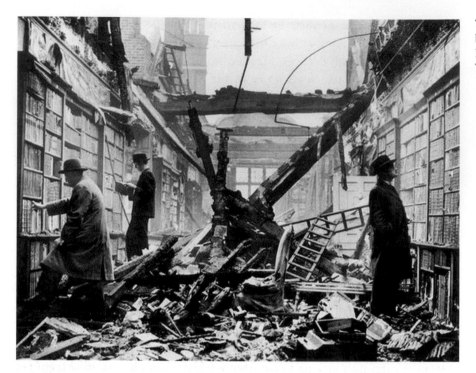

The ruins of the bombed library at Holland House in Twickenham.

historic value had been reduced by a catastrophic fire in 1902, but it also had a rich collection of paintings and antiques, and a remarkable Georgian landscape garden.

In the early years, the National Trust's Country Houses Scheme was ostensibly a failure. No amount of *Country Life* propaganda could disguise the fact that most owners were unwilling to participate and saw themselves as trustees for their heirs, not for the public. It took a social and political cataclysm, in the form of the Second World War, to effect a widespread conversion. In 1929, when the second Lord Montagu of Beaulieu died, leaving the Palace House and Beaulieu Abbey to his three-year-old son, he chose as his epitaph: 'He loved Beaulieu, deeming his possession of it a sacred trust to be handed on to his successors in a like manner.' In the hands of the third Lord, after the Second World War, that private trust became something quite different, a playground for the millions; and hundreds of other country houses and estates followed suit.

During the Second World War many country houses and parks were taken over for military or ancillary use. The collateral damage inflicted by wartime requisitioning was far greater and more extensive than from any direct hits by enemy action. Only a few of the major houses incurred serious bomb damage: Holland House in the centre of London, Radnor House in Twickenham, Mount Edgcumbe on Plymouth harbour, Sandling Park in Kent and Appuldurcombe on the Isle of Wight. But a number of those houses which were requisitioned for use by the military experienced serious damage, both

to the house and to its associated landscape. Many still bear some traces of this phase of their development in the form of concrete roads, trenches and bunkers.

James Lees-Milne paints a grim picture of many country houses in the middle of the war, when he was inspecting them on behalf of the National Trust. For example, he described Elsing, in Norfolk, as 'incredibly shabby, dirty and primitive. The porch room ceiling fell when Norwich was bombed and the debris has been left on the tables and chairs . . . The walled garden is an absolute wilderness.' He recorded that a bomb fell near to Bradley, a small medieval manor house in Devon, breaking windows 'and bringing down the Blue Room ceiling, and dislodging many stone mullions and transoms'. The important formal seventeenth-century gardens at Ham House, Richmond, were 'pitted with bomb craters' and not restored until the 1970s. Many other houses held by the National Trust were requisitioned during the war. For example, the park at Attingham Park in Shropshire was used as an RAF airfield, Attingham Hall having first been used as a school for evacuees from Birmingham and later by the WAAF. Blickling Hall was used as an RAF mess; Farnborough Hall, Warwickshire, as a military hospital; and Castle Drogo as a refuge for children made homeless by the Blitz. Wartime occupation led sometimes to extensive damage, including a serious fire at Melford Hall, Suffolk, and Blickling Hall was vandalized by the RAF during its wartime occupation. Lees-Milne censured Canadian troops for cutting their names and addresses inches deep in the James Paine bridge at Brocket Park, Hertfordshire, yet he reflected, 'what an interesting memorial this will be thought in years to come'.[14]

During the war, country house gardens were frequently maintained by only the one or two older members of the estate staff who were not drafted into the services. The 'Dig for Victory' campaign changed the face of many parks, such as Windsor Great Park, which was ploughed, and even gardens near the house might be forced into production, as at Chatsworth. A few were deliberately destroyed; for instance, the intricate parterre at Somerleyton (Suffolk) was grassed over because it was felt that its white gravel would provide a landmark for enemy bombers.

Country house landscapes continued to deteriorate in the postwar years. Compensation for damage or for lack of maintenance caused by wartime use was almost universally considered inadequate. Taxation took an increasingly heavy toll on country houses and their surroundings: Gibside in Tyne and Wear was a postwar casualty of ploughing. Even when agricultural fortunes began to recover during, and after, the war, the fortunes of the country house did not necessarily improve. The 1950s and early 1960s were peak years for demolitions: at least 10 per cent of the national stock disappeared completely, including such illustrious houses as Eaton Hall and Panshanger. Some great houses were much reduced in size, like Bowood and Woburn; many others were taken over by the National Trust under its country houses scheme. Many

Lulworth Castle in Dorset was heavily restored towards the end of the century and is now in the hands of English Heritage.

more were sold off for institutional use as schools, colleges, hospitals and nursing homes. Attingham Hall in Shropshire became an adult education college run by Birmingham University and was taken over by the National Trust. Lord Methuen leased part of Corsham Court to Bath Academy of Art, with whom he cohabited happily for the rest of his life. The City of Bath was encouraged to convert two other neighbouring country houses for educational purposes. After a long struggle, the highly important Gosfield Hall in Essex was bought by a charity for use as a residential nursing home. Government agencies purchased dozens of country houses for a variety of purposes. The Duke of Portland shared Welbeck Abbey with an Army preparatory boarding school, and Bramshill, one of Nash's mansions, was purchased by the Home Office for use as a police training college.

A large number of country house parks were wholly or partly turned into golf courses. Other casualties were Wollaton, Knole, Sudbrook, Hampton Court, Veralum, Stoke Poges, Goodwood, Repton and Ashridge. Even the small home park at Stowe succumbed to golf when a nine-hole course was laid out in the 1950s. The new golf courses were accompanied by subsidiary buildings such as holiday chalets, hotels and conference centres which further encroached upon the parkland.

Ditchley Park was the home of the Lee family since the sixteenth century. During the Second World War it became Churchill's weekend residence in the early 1940s. The owner of Ditchley Park, redesigned by Geoffrey Jellicoe in the 1930s, finally abandoned it in frustration when he was refused a permit

for the erection of entrance gates because of the postwar shortages. Following the war, it became the home of the Ditchley Park Foundations, essentially a diplomatic conference centre.

Some finance was initially made available from the National Land Fund to pass a dozen or so properties to the National Trust, but by the early 1960s the Fund was essentially moribund. In such a climate of apparent devastation, John Harris and Marcus Binney mounted an exhibition at the Victoria and Albert Museum in 1974 on 'The Destruction of the Country House'. The exhibition's catalogue listed over 450 houses demolished, their parks sold in many cases for golf courses or for building development.

By the mid 1950s, however, demolition of country houses was no longer seen as a private matter. The postwar historic-building legislation had strengthened the role of the state at the expense of the private owner. In 1953 the Duke of Bedford was fined for pulling down part of Woburn Abbey. In 1961 Mawley Hall, Shropshire, was in the hands of a demolition contractor when a building preservation order was enforced. The tide was turning. When the 1968 Town and Country Planning Act required owners of listed buildings to 'seek permission to alter or demolish', rather than simply inform, it became much more difficult to destroy historic buildings. In fact, by the time of the 1974 'Destruction of the Country House' exhibition, the battle had essentially been won. The last quarter of the twentieth century saw a much smaller loss in the number of destroyed houses than in the previous three-quarters. Not only was historic building legislation much stronger, but agricultural land had become valuable again, producing a surplus for its owners. Added to which, in the 1990s Lottery money became available to supplement the scarce government grants for restoration.

Although there were many serious losses of country houses in the twentieth century, in retrospect it was not as bad as it seemed at the time. A recent analysis by Giles Worsley suggests that perhaps only one in six houses was destroyed. Worsley commented, 'that five out of six country houses should have survived after a century of enormous social, economic and political change is perhaps more remarkable than that one in six has gone'.[15] F. M. L. Thompson observed, 'What has happened since the First World War is something far short of the collapse or catastrophe which has been over-dramatised by many commentators'.[16] Worsley went on to argue that the concentration on the fate of the country house has masked the virtual disappearance of the substantial London private house, large numbers of which have been demolished. Very few retain their contents, appearance or use. Similarly, there has been a comparable disappearance of the substantial, well-appointed, upper-middle-class suburban villa set in its own grounds, which was a common feature on the edge of every town and city in the late Victorian and Edwardian eras. Such buildings have been destroyed to make way for denser housing complexes, or converted to flats or institutional use.

A revival came for many in the more affluent times of the 1980s. Houses began to diversify and offer different attractions: Beaulieu had a motor car museum, while Longleat opened a safari park and established a fashion for keeping exotic animals in English country parks. Country houses opened to the public on a scale never seen before. Increasing mobility among all classes provided the market, and visiting National Trust houses at places such as Sissinghurst or Stourhead became part of the enormous and ever-growing leisure industry.

Blenheim

Blenheim Palace, the seat of the Duke of Marlborough, and Blenheim Park, one of the largest man-made parks in the country, was one of the most popular houses visited. Based on a Saxon and medieval royal hunting chase, the present park was developed after Queen Anne made John Churchill the first Duke of Marlborough in 1705. Early designs for the park included the palace, a bridge, canals and cascades, and plantations. There was, however, no overall cohesion to the design. This was to be provided by Capability Brown later in the century, and it is his design that still forms the Blenheim landscape. His design includes the palace, the bridge, slopes, plantations of deciduous trees, copses and the Column of Victory. It also contains the Great Lake, which was formed by damming the River Glyme.

It is still maintained as a country seat, occupied by the Duke and his family, but, in order to survive, Vanbrugh's great house is open to the public for much of the year, and the visiting public are provided with the usual range of facilities, such as restaurants and souvenir shops; while the park, which is still used for shooting, is opened up for a range of activities including rallying, horse trials and craft fairs. The park's current land use includes woodland, arable land, permanent pasture and the pleasure gardens. Agriculture dominates in the north and south east of the park, while nature conservation dominates the south west and the lakes. Part of the park contains remnants of oak woods from the medieval park, and this area has been designated as a Site of Special Scientific Interest. Forestry is also important to Blenheim's economy, and it has its own sawmill, which is self-financing. Most of the commercial forestry away from the main park involves coniferous trees, whereas closer to the tourist and sporting areas (pheasant shooting) deciduous trees are planted.

Tourism remains the most important function of the park. Blenheim Park attracts over 800,000 visitors each year. A large area adjacent to the house is used as a car park, and a miniature steam train takes visitors to the various attractions such as the miniature golf course and maze which now inhabit the walled garden. There is nothing exceptional in any of these activities; the estate is run as a business, geared to maximizing revenue without sacrificing the historic integrity of the house and park. In 1900, however, most of these

The maze at Blenheim forms part of a series of visitor attractions located within the old walled garden.

activities would have been quite unthinkable, when the priority would have been the comfort and privacy of the Marlboroughs and their guests.

At the end of the twentieth century Blenheim was administered by a charitable trust, a device which a number of large country house owners adopted in order to maximize the income from the house and estate and avoid passing the property to the National Trust. Chatsworth House is similarly administered. The logistics of an estate such as Chatsworth in the twenty-first century are formidable. In 2003 there were almost half a million visitors to the house and garden. The house has more than 300 rooms; the garden is 100 acres and the park 1100 acres. The house has 1.3 acres of leaded roof, 3426 feet of passages, seventeen staircases, three lifts and 359 doors, and is lit by 2084 light bulbs. The estate has a workforce of 286 full-time and 226 part-time employees. There are 170 houses on the estate, which incorporates a cricket club, a bowling green and a golf course. The range of income-generating activities includes a farm shop, a restaurant, a bar and conference rooms, and there is an Angling Fair, Country Fair and international horse trials.

New Country Houses

Despite the general decay in country estates, a number of new houses were built and gardens laid out in the first part of the twentieth century. The fashion for great, rambling historic houses was replaced by smaller, more homely buildings, often designed in the Arts and Crafts style. Edwin Lutyens was the creator of a considerable number of medium-sized country houses in the early decades of the century, the most famous of which was Castle Drogo, in Devon. Lutyens had already gained experience working on an English castle, as in 1902 Edward Hudson, the owner of *Country Life*, bought Lindisfarne Castle on Holy Island, off the Northumbrian coast. It was the ruin of a Tudor castle, with massive defensive walls, and Hudson commissioned Lutyens to convert it into a home. The garden, which was equally remote, in the form of a walled enclosure some way from the house, was laid out by Gertrude Jekyll. Opinions differ on the success or otherwise of Lutyens's work at Lindisfarne. Lytton Strachey, who stayed there in 1918, complained that it was 'all timid Lutyens – very dark, with nowhere to sit, and nothing but stone under, over and round you, which produces a distressing effect'.[17] It was clearly one of Lutyens's more uncomfortable houses; there was only one bathroom, and a cramped kitchen. When the Prince and Princess of Wales visited the castle in 1908, they complained about the steep ramp and the cobbles. Lutyens wryly observed, 'The only thing they specially admired were some fleur-de-lis on a fireback'.

Lindisfarne Castle, on Holy Island off the Northumbrian coast, was designed by Edwin Lutyens for Edmund Hudson, the owner of *Country Life*.

Castle Drogo was the brainchild of Julius Drewe, the founder of the Home and Colonial stores empire. As a young man, Drewe had been to China as a tea buyer and had realized that, by buying goods directly from the country of production, retailers could make a fortune, which he then proceeded to do. He had opened his first grocery in 1878, and by 1889 had made sufficient money to retire from direct involvement in the business. In 1899 he bought Wadhurst Hall in Sussex, with all its contents, much of which were later moved to Castle Drogo, which was by far the largest country house built in England in the twentieth century.

Drewe became convinced that he was descended from Drogo, a companion of William the Conqueror, who had settled at Drewsteignton in Devon after the Norman Conquest. Drewe began to buy land there and eventually accumulated a 1500-acre estate, which included a remarkable granite outcrop overlooking the Teign Valley, on the edge of Dartmoor. The foundation stone was laid in April 1911, with Drewe specifying a budget of £50,000 for the house and £10,000 for the garden. Lutyens was lukewarm about the idea of a castle, in 1910 writing, 'I do wish he did not want a castle but a delicious lovely house with plenty of good rooms in it'. The work proceeded slowly, and when Drewe's eldest son, Adrian, was killed in the Great War, the design was scaled down. It was still not ready for the family to move in until 1927, and work went on until 1930, a year before Drewe died. Lutyens created a spectacularly sited baronial stronghold, which was one of his most Romantic buildings, medieval in spirit with strong Tudor influence, but contemporary in detail. It was in total contrast to his

contemporary formal classical work at New Delhi. Nikolaus Pevsner, writing in 1951, saw Drogo (which was originally intended to be three times the size) as an elephantine folly, confirming his view of Lutyens as the greatest folly builder the folly-building English had ever produced. 'Castle Drogo beats Fonthill, the Drum Inn at Cockington beats Blaise Castle and Viceroy's House at Delhi beats any other folly in the world.' Lutyens's admirer Christopher Hussey, however, argued that, 'The ultimate justification of Drogo is that it does not pretend to be a castle. It *is* a castle, as a castle is built, of granite, on a mountain, in the twentieth century.' The Drewe family gave the castle with 600 acres to the National Trust in 1974 but are still resident there.[18]

The Jersey estate at Middleton Stoney was created by buying up farmland in the eighteenth and nineteenth centuries. Although the house was located within a medieval deer park, a much extended park was established out of the old village fields, and the old village itself was uprooted and rebuilt as a model village on the edge of the new park in the 1830s. The first country house on the site had been built in 1753, but this was largely burnt down and rebuilt in 1806–7. In 1938 Middleton House was dismantled and the present house was built on the same site to a design by Sir Edwin and Robert Lutyens – the last of Lutyens's buildings and one of the last great country houses to be built in prewar England. It was designed in a combination of early Georgian, French classical and Queen Anne styles, and was a grand country seat for an aristocratic landowner with an expensive American wife. Virginia Cherrill, the second Lady Jersey, was a film star who had been briefly married to Cary Grant. It was more luxurious than the houses Lutyens built before 1914, and was

Lutyens's last country house at Middleton Stoney in Oxfordshire, built for the Earl of Jersey, dates from 1938.

designed to hold forty people at weekends. The fittings included elegant bathrooms in pink onyx and white marble, and a Hollywood-style cocktail bar. It was essentially a folly. The Earl spent only two nights here before war was declared, and he did not move back afterwards.

The new house was taken over as a military hospital during the Second World War, as the tombstones of Canadian soldiers in the churchyard testify. For a decade or so after the war ended it was occupied as a private residence by a member of the Jersey family. In 1969, however, it was sold to the National Westminster Bank and became their training headquarters. In the 1970s it enjoyed a short spell as a health spa, before being divided up into luxury apartments operating on long leases. The parkland at Middleton Stoney is leased out for mixed farming.

At Anglesey Abbey, near Cambridge, American money went into creating on a modest scale a house and garden of eighteenth-century splendour. The Augustinian priory of Anglesey was founded in 1135, and a relatively modest L-shaped house was built on the site after the Reformation, incorporating mid thirteenth-century fragments of the monastic buildings. After an uneventful history, the house was bought in 1926 by the wealthy art collector Huttleston Broughton – Lord Fairhaven – who inherited a mining and railway fortune made in the USA. He proceeded to transform the unpromising fenland site by creating a garden on the grandest scale, filling the house meanwhile with a rich and varied collection of pictures, furniture, tapestries, clocks, Chinese and European porcelain, and much else. Both house and grounds were left to the National Trust on his death in 1966, and today they survive intact as a valuable example of twentieth-century country house taste. Ironically, the garden was furnished with mostly eighteenth-century statuary from a number of houses all over England. Some of it came from Stowe, the great Grenville house, whose sale to a school in 1922 was seen by many contemporaries as the end of the old order.

Towards the end of the twentieth century, a new generation of country house owners, whose wealth derived from oil, high-tech industry, sport and popular music, began to commission new houses on the grand scale. There was a new interest in the restoration and remodelling of old country houses and even in building new houses. In 1997 new country houses 'of exceptional quality' were to be exempt from the normal planning restrictions which hampered much 'greenfield' development. Among the houses to be build under this dispensation were St John's House in Oxfordshire and the neo-Palladian Wootton Hall in Staffordshire.

Hardwick

The Hardwick estate was acquired by John Burdon, a wealthy Tyneside merchant, in 1748. Shortly afterwards, he embarked on an ambitious

programme of landscape improvement, establishing a large ornamental lake to the south of the house, into which flowed an artificial serpentine 'river', channelled over a cascade. A circuit walk was laid out around the lake, incorporating a set of decorative buildings, each located in a carefully landscaped and planted setting. At each of these focal points, new views were revealed, and the visitor could pause to admire ornamental façades and interiors. The route eventually led across a bridge and finished at the grandest of the garden buildings. The whole layout appears to have been implemented during the 1750s, giving it an unusual integrity of style.

The designer of the garden layout is not known, but Burdon employed some of the finest designers and craftworkers available in Europe in his grounds. His architect was James Paine, a man with a considerable national reputation. Paine had produced designs for a series of ornamental buildings in the Palladian and Gothic styles, and carried out interior schemes of exceptional richness, using a team of craftsmen including the painters Francis Hayman, Samuel Wale and Giuseppe Mattia Borgnis, and the stuccoist Giuseppe Cortese.

The resulting design, characteristic of its time, owes much to the work of William Kent, the acknowledged originator of the English landscape garden. Hardwick, however, was more than a pattern book layout; it was a bold, rich, subtle and carefully worked scheme, with all its elements carefully integrated and sequenced so that the visitor would experience a series of visual and atmospheric contrasts. The banker Henry Hoare was engaged on a layout with many similarities to Hardwick at his Stourhead estate in Wiltshire, now recognized as one of the great achievements of the early landscape garden. Other parallels were Studley Royal in Yorkshire and Painshill in Surrey.

During the mid nineteenth century, the house and garden were tenanted, and a long, gradual period of decline set in. The lake was drained, for reasons that have yet to be explained, before 1873, whereupon the circuit walk lost its focus and the design its coherence. During the twentieth century the property was used for a variety of purposes, none of them particularly sympathetic. The ornamental buildings were still largely intact as late as 1938, but by 1950 they were in advanced stages of decay. The decline has continued until the present day, only partially arrested by the acquisition of the south-eastern portion of the garden in 1972 by Durham County Council as a country park.

The process of decay has been accentuated by the fragmentation of the original layout into several ownerships and uses. The country park is managed for informal recreation and wildlife conservation by the County Council; the house and the northern part of the garden is operated as a hotel with various ancillary land uses; the western part of the garden is under arable farming and forestry. The former park, separated from the garden by a modern bypass, is in mixed agricultural use.

The effect of the fragmentation has been to obscure the 1750s layout, making it difficult to identify John Burdon's original design. The long period of decline has, however, had one unintentional benefit in that no significant alteration was made to the original layout. Hidden beneath scrub, marsh and insensitive planting, the remains of the ornamental buildings, paths and features survived. Gardens of this vintage had previously emerged from the undergrowth to international acclaim before now, as at Painshill and Claremont. The essential integrity of this early Georgian layout has been recognized by English Heritage, through the inclusion of Hardwick in the 'Register of Parks and Gardens of Special Historic Interest'.

CHAPTER 11 | *Uplands and Forests*

It will be said of this generation that it found England a land of beauty and left it a land of 'beauty spots'.

C. E. M. Joad, *The Horrors of the Countryside* (1931)

Aᴛ ꜰɪʀꜱᴛ ꜱɪɢʜᴛ, the pressures of the twentieth century appear to have had least impact upon the English uplands. Large areas of open land given over to rough grazing or no agricultural activity at all are still to be found on Dartmoor, in the Welsh Marches, in the Pennines, the Peak District, the Lake District and the Cheviots. Amongst these areas of apparent wilderness are some of the most attractive 'unspoilt' landscapes in the world. Wordsworth's Lake District and Kilvert's upland Welsh Marches survive, albeit in increasingly smaller portions.

The traditional English divide between upland and lowland zones, roughly along a line from the River Tyne in the north east to the River Exe in the south west, still marks fundamental differences in topography, demography and economic activity. The uplands are still relatively empty and during the twentieth century saw fewer dramatic changes than other parts of England. The population remained low and motorways, intensive agriculture and suburbia rarely intruded. Yet, during the twentieth century, the English uplands were subject to a wide range of pressures in the form of afforestation, large-scale extractive industry, military training ranges, reservoir construction and recreation. Accordingly, between 1800 and 1946 Bodmin Moor shrank by nearly 50 per cent, and continued to diminish after that. On the North Yorkshire Moors, the Forestry Commission began planting conifers in 1921 and by the end of the century 14 per cent of the area was covered with trees. In Northumberland, the Forestry Commission began work in 1926, and six years later acquired most of the Duke of Northumberland's upland estate; they now own over 152,000 acres of plantations, stretching in an almost continuous belt of woodland from Hadrian's Wall to the Scottish border.

In the 1950s and 1960s, supported by government subsidies, hill farming was comparatively prosperous, but conditions deteriorated in the 1970s and

1980s. This led to the overstocking of pastures, and, as labour costs rose and non-family labour almost vanished, the maintenance of stone walls, outbuildings and other landscape features declined. Derelict farmsteads, abandoned and decaying stone walls, and outward migration were a feature of the uplands for much of the twentieth century. The Environmentally Sensitive Areas scheme, under which upland farmers can enter into contracts

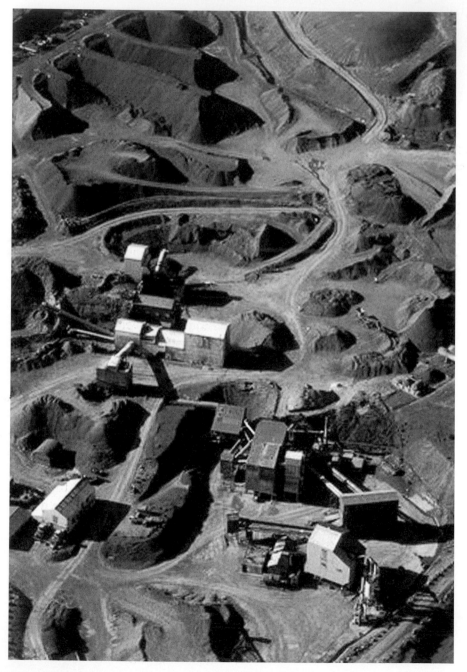

Quarrying for dhustone, a basalt used in road making, on the summit of Titterstone Clee in south Shropshire.

to undertake such tasks as maintaining stone walls, repairing field barns, managing farm woodlands and wetland sites, restoring flower-rich meadows and reducing stocking levels, has started to make hill farmers part-time countryside stewards. Given the current lack of profitability of hill farming, this trend is likely to increase in the future, particularly with the probable reduction of grazing densities following the foot-and-mouth outbreak of 2001.

Reservoirs

From the mid nineteenth century onwards, growing industrial towns required additional supplies of water for their inhabitants and industries on an unprecedented scale. Neighbourhood wells and municipal conduits gave way to water piped into almost every individual home by the 1960s. The deep valleys of the upland moors in England and Wales, where the most rain falls, were chosen for the construction of large dams whose reservoirs could provide a regular supply of piped water to midland and northern conurbations. Manchester, for example, obtained most of its water from reservoirs such as Thirlmere in the Lake District. In 1879 there was a Parliamentary Act passed to allow Thirlmere to become the principal reservoir for Manchester. The reservoir was created by flooding a valley which contained a number of smaller lakes and the village of Wyborn. When a hundred-foot-high dam was built at the beginning of the twentieth century, the valley was flooded and an artificial lake three and a half miles long was created. New roads were constructed around the reservoir and over 2000 acres of spruce and larch were planted on the surrounding slopes. Derby, Nottingham and Leicester were supplied by reservoirs such as Ladybower in the Upper Derwent Valley, in the remote moorland district now known as the Dark Peak. The upper valley of the Derwent is a deep valley dominated by three large reservoirs, known collectively as the 'Peakland Lake District', which was entirely a product of the twentieth century. The Derwent Valley Water Board was set up in 1899 to supply water to Derby, Nottingham, Sheffield and Leicester. A series of Parliamentary Acts authorized the flooding of valleys and the destruction of several small villages, hamlets and isolated farmsteads to make way for the new reservoirs. Great dams were built to contain the waters of Howden Reservoir (1912) and Derwent Reservoir (1916). Birchinlee village, known as 'Tin Town', was built to house the workers and their families. The town was set out along the River Derwent in three streets in 1901–3, with a school, recreation hall, two hospitals, a bathhouse, public house and shops, and accommodated nearly a thousand people in August 1909. Tin Town was demolished in 1914–15, upon the completion of the reservoirs, and the site is now marked only by a memorial cross. The disused quarries that provided the stone and the railways that were constructed to take stones to the dams now survive as industrial

The Derwent Reservoir from the air.

archaeology, but the temporary villages that were quickly erected to house the workers in 'huts' with corrugated-iron outside walls have disappeared entirely and are recorded only in contemporary photographs.

In 1935 it was decided to build a new large reservoir downstream from the earlier reservoirs – Ladybower – to provide more water for Sheffield, Derby, Nottingham and Leicester. This flooded the part of the valley where the villages of Derwent and Ashopton lay, which at the end of the nineteenth century had been two typical Peak District communities. The land around was not particularly fertile, but there were fourteen farms scattered in and around the valley. Although the population was small, the villages had churches, a school, inns and shops. A viaduct was built to carry the Snake Road over the reservoir at Ashopton and another for the road to Yorkshire Bridge, and new houses were built for the villagers at Yorkshire Bridge. The 'protected' packhorse bridge at Derwent was moved stone by stone and rebuilt at Slippery Stones, at the head of Howden Reservoir. The graves in the churchyard were excavated and the bodies reburied in an extension to Bamford churchyard. The water gradually rose and the remains of the demolished villages disappeared. Ladybower Reservoir was finally completed in 1945.

The ruins of
Mardale during a
drought. This
Cumbrian village
was drowned in 1929
when the
Haweswater
Reservoir was built.

The drowned Derwent church tower was left standing at first, but that too
was demolished in 1947.

In Cumbria, at Haweswater Lake, the construction of the dam to provide
water for Manchester in 1929 resulted in raising the level of the lake by 95
feet. The new reservoir was four miles long and half a mile wide, which
resulted in the drowning of the village of Mardale, with its school, inn, church
and four farms. When the water level in the reservoir is very low, the outline
of the drowned village re-emerges in the form of field and property bound-
aries. Cow Green Reservoir in upper Teesdale, built in 1967, drowned a
significant proportion of the area's rare arctic and alpine flora. With the
decline of heavy industry, the need to expand water-supply facilities in the
uplands has been reduced. There has been a greater emphasis on recreation
at new reservoirs such as Kielder, in Northumberland, created to supply water
to a steelworks that was never built. Other recently constructed reservoirs,
such as Rutland Water, have been more low key and understated in the design
of their dams and infrastructure.

The Army took over large stretches of moorland during the Second World
War and has remained in some of them to practise tank manoeuvres and
erect rifle ranges. These moors are normally inaccessible to the general public.
The battle for access to other moors was fiercely fought from the beginning
of the twentieth century, nowhere more so than in the Peak District, where
ramblers and climbers from the surrounding industrial towns sought weekend
recreation in an environment different in character but close to their homes
and places of work. The Council for the Protection of Rural England
campaigned successfully for the prohibition of housing developments that
threatened the traditional heather moorland landscape, but they were less
successful in limiting the impact of large-scale extractive industries.

Forest and Woodland

Virtually none of the original virgin forest in England was left by the end of the Middle Ages. The pace of change in the twentieth century was, however, greater than hitherto. Since 1945, 45 per cent of the UK's ancient semi-natural forest has been damaged or destroyed. This abrupt disappearance contrasted with the generally stable and conservative management of woodland in previous centuries, with its emphasis on regular cutting or coppicing, although the quality of woodland management declined in the nineteenth century. There are now fewer trees in heavily farmed lowland areas. Not all the decline can be attributed to agricultural change. Dutch elm disease, for example, hit elms hard in the 1960s. Elsewhere, large plantations of coniferous trees planted on upland moors and slopes as in south-west Shropshire, and on infertile lowland areas such as the Norfolk and Suffolk Breckland, disrupted earlier habitats. Monoculture – large blocks of the same species – has caused the problem. Upland afforestation with non-native conifers had its origins in the late eighteenth and early nineteenth centuries, when landowners such as the Duke of Atholl planted them extensively on their estates. Manchester Corporation established conifer plantations around Thirlmere to control run-off in the catchment and reduce silting.

At the beginning of the twentieth century, the total woodland area in Great Britain covered 2.5 million acres, some 5 per cent of the land surface. As early as 1909 a Royal Commission on coastal erosion drew attention to the perilous condition of Britain's woodlands. It proposed to convert comparatively unprofitable land into forests and hoped as a consequence to stem the tide of rural depopulation in some upland areas. But in the next decade 500,000 acres of timber were felled to help meet the country's needs during the First World War. The inevitable reduction of Britain's forest resources showed both the importance of timber in the contemporary industrial economy and also the need for large domestic supplies of wood for use in emergencies, in one of the least forested countries in Europe. Lloyd George considered the supply of home-grown timber to be more important to the war effort than agricultural self-sufficiency. In 1916 a forestry sub-committee was appointed to decide on the best means of conserving and developing the nation's forest resources; it recommended that 1.8 million acres should be afforested so that 'large areas of the United Kingdom, now almost waste ... might be put to their best economic use'.

The Forestry Commission was founded in 1919 and was required to establish new forests, encourage private forestry, and help maintain an efficient timber trade. In the interwar period the Commission planted 320,000 acres of trees in Great Britain, largely in upland Britain and East Anglia. An initial shortage of funds restricted its volume of planting and did not manage to compensate for wartime losses. This target was achieved,

however, as 200,000 acres were planted by private landowners. The Forestry Commission's policy of planting quick-growing conifers rather than native deciduous trees attracted criticism, especially in the Brecklands of Norfolk and Suffolk, the North Yorkshire Moors and at Kielder in Northumberland. In the 1920s, S. L. Bensusan commented:

> I recalled Julius Caesar's description of these islands – 'one horrible wood'. Now, after 2000 years in the course of which the English land has been brought under cultivation so successfully that for centuries it supplied the needs of the entire population, we are permitting a vast acreage that could produce food at need to revert to the condition old Julius Caesar found it in.[1]

When the Ennerdale Forest, Cumbria, was established between 1927 and 1929, some 2000 Herdwick sheep were displaced from their traditional pasture. The ruler-straight lines and single-species planting evoked considerable hostile criticism, including the nationalistic objection expressed by G. M. Trevelyan that they were creating 'German Pine Forests'. Forestry Commission policies, especially their preference for the establishment of plantations on previously unforested land, the choice of quick-maturing conifers, and their planting in regularly spaced rows for efficient management and felling, emphasized the differences between new forests and traditional woodland. The visual impact of serried ranks of dark-green trees in huge geometric blocks, as well as concern over the interruption of access to the fells for walkers, led in 1936 to an agreement between the Forestry Commission and the Council for the Protection of Rural England under which no further large-scale planting was undertaken in the central mountain core of the Lake District. This understanding, which still holds good, was an important early example of integrated upland planning.

More felling of mature and semi-mature timber took place during the Second World War and this reinforced arguments for more rapid afforestation in order to maintain a large reserve of timber in Britain. In 1943, even before hostilities had ended, the Forestry Commission reported on the problems of postwar afforestation and suggested that by AD 2000 there should be five million acres of properly managed woodland in Great Britain. Such an area was considered to be

> required for national safety and will also provide a reasonable insurance against future stringencies in world supplies. There are also valuable contingent advantages associated with forests, such as the development of rural Britain ... The five million acres should not merely be planted with trees but also systematically managed and developed. This conception entails, among other things, the continuous application of good silviculture, the development of markets and internal transport, and the settlement of forest workers in a good environment.[2]

Two million acres were to be established by replanting old woodland areas; the remaining three million acres were to be on open ground. The greater part involved planting of new land and, if this target was reached, Britain would have 8.8 per cent of its total land area under timber. Even so, Britain would still be one of the least wooded countries in Europe, despite having a climate and soil conditions that are generally well suited to tree production. For instance, the average annual growth of properly managed trees in Great Britain is nearly twice that recorded in eastern and central Europe.

The combined area planted annually by the Forestry Commission and by private landowners increased from 5500 to 55,000 acres a year between the wars. The annual planting rate fell to 14,000 acres during the Second World War, but had risen again to reach a record 140,000 acres in 1961. After that the annual rate remained at about 125,000 acres. Three-quarters of this involved extending the wooded area, while restocking cleared woodland accounts for the remainder. The Forestry Commission acquired areas of Royal Forestland, and purchased or leased tracts of felled woodland, moor and mountain from private owners. Much property was acquired from large landowners keen to sell land in order to obtain capital or to settle death duties. The Commission also took over marginal land in upland areas previously used for sheep farming. Most Forestry Commission land in England and Wales was to be found in upland areas, with the exception of the New Forest, in Hampshire, and Thetford Chase, in East Anglia.

At the end of the century, 90 per cent of the industrial and commercial demand for timber in Great Britain was for softwoods, most planting by the Commission being designed to help meet such demands in the future. Much of the available land for planting or replanting is of poor quality and would not satisfactorily produce hardwoods. In the latter part of the century the Commission made strenuous attempts to present a more welcoming face by the provision of designated picnic areas and other facilities; visitor centres such as Grizedale in the Lake District are now major attractions. By the end of the century visitors to British forests did not object to conifers as much as had been previously supposed. In fact, the Commission also planted over 100 million broadleaved trees in the last two decades of the twentieth century. Care was taken to avoid ruler-straight edges to newly planted woodland blocks, as part of the Commission's growing concern with sympathetic landscaping of its vast estates.

Timber planting by private landowners also increased dramatically, from 7000 acres each year between 1920 and 1946 to an average of 52,000 acres in the 1960s. This trend had been encouraged by the availability of special tax concessions for afforestation. Mr G. M. T. Pretteyman, farming near Orwell in Suffolk, abandoned to rough grazing nearly 1000 acres of heathland that had been under wheat during the war. Eventually much of this land ended up in the hands of the Forestry Commission, as did much of

the Brecklands on the border of Norfolk and Suffolk. By 1966 a total area of 4.8 million acres was afforested, covering 7.5 per cent of the land surface of Great Britain. The ownership of British woodland has changed fundamentally since the creation of the Forestry Commission. In 1914, 97 per cent of all woodland had been privately owned, but now the proportion has fallen to two-thirds of a much larger total area.

Afforestation has emerged as the fashionable mechanism for transforming as much as possible of marginal areas into something more acceptable to society, and hiding as much as possible of the rest of it from view. Vast areas bordering towns from Bristol, Swindon and London Colney to Bolton, Warrington and Hartlepool, together with much of the urban fringe of Romford, Rainham, Nottingham, Manchester, Liverpool and Sunderland, are to be transformed by courtesy of substantial grants into so-called 'community forests'. The community forest programme covers an area of more than 1700 square miles in England. 'We're transforming the living and working environment of the North East' proclaims a policy statement that sets out how 101,000 acres are to be planted with twenty million trees to make the area more attractive for business and housing, and to 'improve the landscape and the image of the North East'. The same document presents pictures of an old industrial landscape that has been bulldozed clear of any upstanding features or natural vegetation alongside the replacement landscape aspired to: a line of trim, brick houses surrounded by a sprinkling of trees and new, high-tech factories.

The National Parks

'Is there no nook of English ground secure from rash assault?' asked Wordsworth in a sonnet of 1844 about the projected Kendal and Windermere Railway in the Lake District. Wordsworth claimed that only a cultured minority could appreciate the beauty of the Lake District and that the railways would attract 'the imperfectly educated classes', who, he argued, were 'not likely to draw much good from their rare visits to the lakes'. Instead, he proposed that artisans, labourers and the humbler class of shopkeepers would do better to 'make little excursions with their wives and children among neighbouring fields ...'[3] Behind Wordsworth's uncharitable elitism lies the question at the nub of late twentieth-century tourism – how do you stop the hordes of visitors destroying the very attractions they have come to see?

During the twentieth century the terms preservation, conservation and protection of the landscape became increasingly important. As the power to destroy and disfigure became ever greater, public awareness of the need to protect various aspects of the physical landscape grew proportionately. The most ambitious attempts at landscape protection were in the form of the National Parks created in the second half of the century, alongside the

designation of Areas of Outstanding Natural Beauty (AONBs). The creation of National Parks, beginning with the Peak Park in 1951, became one of the most important factors in the conservation of the English uplands in the twentieth century.

In 1949 the government created the National Parks Commission, with power to designate national parks in England and Wales. The first were established in 1951 in the Lake District, the Peak District, Snowdonia and Dartmoor; these were followed by the North York Moors (1952), the Pembrokeshire Coast (1952), Exmoor (1954), the Yorkshire Dales (1954), Northumberland (1956) and the Brecon Beacons (1957). The Commission did not own the parks but operated through the county councils. After 1974, eight of the ten National Parks were run through committees of county councils. Only the Lake District and Peak District operated as autonomous planning boards. As a result of the 1995 Act, all ten National Parks became independent local authorities with sole responsibility for local planning matters, including minerals planning. Something like 7 per cent of England lies within a National Park.

A well-worn footpath in the Peak District.

The principal pressures that apply within National Parks can be grouped broadly under three headings: industry, development and recreation. The National Parks are functioning landscapes where people live and earn their keep. The most obvious industry for many is still agriculture. It is farming that gives the landscape much of its character and it is daily agricultural management that maintains the familiar appearance of the scenery. Evidence of such management, such as great lengths of walling, is apparent in even the remotest fells and moors. A less extensive but often more emotive activity in the National Parks was mineral extraction. The very fact that the Parks are almost all in upland areas means that they contain exploitable deposits of hard rock of various types, and many contain or are fringed by stone or mineral quarries of considerable size. Most quarry developments within National Parks have been resisted successfully, and many applications are only resolved on appeal. The application of the so-called 'Silkin Test', which seeks to discover whether a particular mineral is only available in a National Park, has been a useful tool in the conservation management of Park landscapes. Because of their remoteness and the type of landscape they encompass, all National Parks are affected to a greater or lesser extent by MOD training requirements. These include low-flying zones, gunnery ranges, infantry training areas, and the host of installations, buildings and other infrastructure required to support the modern military machine.

National Parks need such activities as forestry and farming in order to maintain the land. Without farming, the character of individual National Parks tends to disappear beneath a tide of scrub. The mineral, forestry and military industries bring investment and income to the areas, maintaining the social and economic fabric and feeding ultimately into management of elements of other parts of the landscape.

The main recreational uses in the minds of those drafting the 1949 Act were climbing and, more particularly, walking. As we have seen in earlier chapters, social changes in the second half of the century have increased many people's leisure time; and increased mobility, particularly through private car ownership, has made many previously remote areas of countryside accessible. The resulting traffic jams and roadside parking are becoming so serious a problem that several Parks are beginning to consider such radical remedies as the restriction of vehicular access. Many National Parks were obliged to introduce traffic management solutions of various types, whether to manage existing levels of traffic or to tempt people away from their cars. These include car park provision with measures to prevent roadside parking, subsidized bus and train fares, weekend road closures and park-and-ride schemes. Such measures have met with varying degrees of success: the introduction of charges in previously free National Park car parks in the Peak District, as a means both of deterring car drivers and generating additional income for the management of the landscape within the National Park, has met with a mixed response. However, such is the popularity of the Lake District National Park – twenty million people live within a three-hour drive of it – that on a number of Bank Holidays towards the end of the century it reached saturation point, and it was found necessary to close the Park to incoming vehicles. This popularity was a feature of the Lakes for much of the century. As early as 1927, H. V. Morton records his visit in familiar terms: 'I joined the Windermere queue at Lancaster, and hoped for the best. Everyone in the north of England seemed at this moment to have decided to visit what the guide-books call so inanely, "the land of the Lake Poets".'[4] The motorways of the 1960s and 1970s made the Lake District that much more accessible for vast numbers of mobile visitors. The problem is neatly summed up in two of the aims of the National Park, each of which is in conflict with the other: namely, to provide access and to preserve the landscape. It is extremely difficult to promote such an area and encourage people to visit it without destroying something of what the visitors have come to enjoy. 'At worst the Lake District may have to be redesignated as a National Car Park.'[5]

The popularity of countryside recreation pursuits has had an increasingly detrimental impact on National Park landscapes. The apparently harmless pursuit of walking

Walkers in the Lake District.

results in damage to footpaths as the number of ramblers increases. Improvements in outdoor clothing and footwear mean that people are more inclined to go out in poor weather, when footpath erosion accelerates. The result is that the start of the Pennine Way in the Peak District has been the subject of a programme of major repairs, resurfacing and re-routeing to stem the erosion of the peat areas that it crosses. Stone flags have been helicoptered in to create causeways across the landscape, reminiscent of those built in the medieval period for packhorses, and for exactly the same reason: to provide a sound surface to use across soft ground, thereby minimizing erosion. A number of National Parks have been able to provide ambitious walking routes by converting redundant railway lines to such ends. In the Peak District, the closure of the Matlock to Buxton and the Ashbourne to Buxton lines provided an ideal opportunity for such initiatives. These are now heavily used trails with walkers, horse riders and cyclists using them throughout the year.

A wind farm at Delabole in north Cornwall.

Nevertheless, the recent popularity of mountain bikes and trail bikes brings with it its own problems. While there are claims to the contrary, empirical evidence does suggest that the use of mountain bikes on bridleways results in increased erosion. Their common and illegal use on footpaths creates further erosion and damage as well as posing a danger to walkers. Trail bikes create further damage and pose a noise pollution problem that is impossible to deal with. The increased use of 4 x 4s has vastly accelerated the damage to soft rural routes, with green lanes becoming quagmires. In these increasingly litigious times, highway authorities are being threatened with prosecution for not maintaining green lanes or roads used as public paths when they have been damaged by inappropriate, but not illegal, use. At the same time, some highway authorities have attempted to limit use of or declassify particular routes, recognizing that they were never intended for or subjected to such uses in the past. Such attempts often meet with legal challenges by individuals and organizations that are well financed, vocal, informed and determined to pursue their right to a particular minority activity, apparently regardless of the wider impact of their actions.

The Peak District

Early travellers to the Peak District did not appreciate the natural landscape of mountain and moorland. The Seven Wonders of the Peak were described

first in 1636, but Daniel Defoe, travelling in 1725, described the moors above Chatsworth as 'a waste and a howling wilderness'. Gradually the taste for wild scenery grew, and Ruskin enjoyed the 'clefts, glens and dingles of the Peakland dales' just as modern visitors do. In 1951 the Peak National Park became the first National Park in Britain. It covers 555 square miles of beautiful and often wild countryside, from high, 2000-feet moorlands in the north to green farmland in the south. The majority of the National Park is still in private ownership and most of it is farmed. The Peak District National Park is now one of the most visited areas in the world; during the summer up to half a million people visit the Park each week. There are thirty million visits to the Peak Park each year – only Mount Fuji National Park in Japan has more visitors.

Almost 40,000 people are resident within the Peak District National Park, yet only a small percentage are employed within the Park – the majority are either retired or work outside the Park. This leads to higher property prices within the Park than in the areas surrounding it. At one level it means that, given the relatively low level of incomes in industries within the Park, property prices move outside the reach of local families and houses are then purchased by people from outside. In the Peak District National Park there is a general policy against new housing in the countryside. Development is effectively confined to existing settlements and in this way the open character of the rural landscape is maintained. Since, however, many of the villages in the Peak District were larger or more densely settled in the medieval period, spaces within them earmarked for development are often locations where structures existed in the past.

There are well over two thousand farms in the Peak District National Park. Most of these farms are small – less than a hundred acres. Some of them are farmed by tenants of large landowners such as the Duke of Devonshire or the Duke of Rutland. Others are privately owned. Over 60 per cent of the farms are considered by the Ministry of Agriculture to be too small to provide a full-time living and many are therefore run on a part-time basis (the farmer has another job as well as running the farm). The census of 1991 showed that 2000 Park residents were farmers or agricultural workers.

Around 54 per cent of the National Park is enclosed farmland; much of the rest of the Park provides rough grazing – mostly the 35 per cent of the Park which is moorland. Areas of the moorland are managed for grouse but a good deal is also used as grazing for sheep. Dairy farming is most common in the limestone areas and in the lower river valleys where the land is not so exposed and the grass is richer. All of the Peak District National Park is a 'less favoured area' under EU classifications and so qualifies for special grants and subsidies. Productivity is poor because much of the land is three hundred metres or more above sea level and temperatures are low, so the growing season is very short.

There are fifty-five reservoirs of over six acres within the Park. The largest area of reservoirs is in the Upper Derwent Valley with Ladybower, Derwent and Howden reservoirs covering over 100 acres. Other major reservoirs are in the Goyt Valley (Fernilee, Errwood) and in Upper Longdendale. Around the reservoirs there are a number of walking and riding routes. The large water catchment area owned by the water companies (15 per cent of the National Park) was originally needed to control water quality. Improved water treatment methods mean such a high degree of control is no longer needed. This fact and the establishment of the private water companies may result in changes in the land use of these areas. An example is the sale of Crookhill Farm (420 acres) in the Upper Derwent Valley from Severn Trent Water to the National Trust. There have also been a number of proposals to convert water company properties to other uses. Most of the Peak National Park is privately owned. Only 4.2 per cent of the Park is owned by the National Park Authority.

There are ten large quarries and several mines within the Peak District National Park, most of which have been operating since before the National Park was formed. There is also a fluorspar processing plant at Cavendish Mill and the Blue Circle cement works at Hope. The National Park Authority had to accept use of parts of Warslow Moors Estate and Eastern Moors Estate (Totley rifle range) for military training when they were acquired. An agreement with the Ministry of Defence limits damage. Wilder areas are used by the army for adventure training. Ramshaw Rocks, the Roaches, Stanage and Birchen Edge (all owned by the Peak Park) are used for climbing instruction under licence arrangements. Low-flying training takes place over the Park.

English Nature has designated 30 per cent of the Park as Sites of Special Scientific Interest (SSSI). In these areas, managers must consult English Nature before making any changes which would adversely affect the conservation interest. The Derbyshire Dales National Nature Reserve includes parts of five important limestone dales and is managed by English Nature. The human contribution to the making of a distinctive British landscape that at first sight seems to be 'untouched' and 'natural' has been enormous. In the late twentieth century a consensus has been reached that the highland, upland and moors must be carefully managed to ensure their preservation. For those who know them well, they are, in Emily Brontë's words, 'In winter nothing more dreary, in summer nothing more divine'.[6]

CHAPTER 12 | *The Impact of War*

> We digged our trenches on the down
> Beside old barrows, and the wet
> White chalk we shovelled from below;
> It lay like drifts of thawing snow
> On parados and parapet.
>
> Francis Brett Young, 1919 [1]

T HE ENGLISH LANDSCAPE IS LITTERED with the remnants of conflict and warfare, extending back to the hill-forts of the pre-Roman Iron Age. Romano-British forts, linear defences, such as Hadrian's Wall and Offa's Dyke, and medieval town walls and castles all reflect former episodes of discord and conflict. The twentieth century was no exception, and the landscape incorporates many elements relating to the great conflicts of that most barbarous of centuries. Time is gradually gracing the surviving remnants of

The incongruous sight of an American tank in the River Windrush at Burford in Oxfordshire during the Second World War. The medieval bridge was badly damaged in the accident.

twentieth-century warfare with both the historical respectability and the false romanticism that is associated with earlier conflicts. Now that many of those who survived the two world wars have passed away, it seems safe to indulge in cathartic nostalgia. Groups have started to re-enact events of the two world wars in the same way that battles and skirmishes of the Civil War and Roman Britain had been enthusiastically reconstructed. There was a similar change of attitude towards the physical debris of recent warfare – for many years the Nissen huts and gun emplacements of 1939–45 were regarded as so much rubbish to be cleared up with the same vigour as bomb damage. By the end of the century, however, relics of that war began to be preserved with a comparable level of care previously reserved for the monuments of earlier conflicts.

In hedgerows, barbed-wire pickets and airfield matting can still be found, and the concrete roadblocks intended to stop enemy movement across railway crossings or bridges may still sit in their original positions, awaiting the invasion which never came. Various forgotten devices, like the curious stone pre-radar coastal sound mirrors for detecting approaching bombers, re-entered public awareness, along with the hides and communications systems intended to be employed by the British Resistance Organization in the event of a German invasion. The sites of anti-aircraft batteries, radar transmitter stations and decoy airfields are among the many examples of twentieth-century defences to be found in the English landscape. In recognition of the importance of what had been a neglected area of historic evidence, the *Defence of Britain* project was launched by the Council for British Archaeology in 1995. This aimed at identifying, recording and recommending for preservation the archaeology of the Second World War.

Though they are large in number, twentieth-century military remains tend to lack the 'monumentality' of the relics of earlier wars. They display an amazing variety and diversity, but they have less substance than many former fortifications. Apart from the battery and the pillbox, airfields, prisoner of war camps, radar sites, anti-aircraft positions and command-and-control centres are just some of the more obvious manifestations. Yet their remains are mostly fragmentary and often appear incoherent, and they lack the visual appeal to match their profound historical interest. Many Second World War sites survive in the form of ephemeral earthworks and poor-quality concrete, along with rusting steel and corrugated iron. The fact that these structures have survived in such a bad condition is partly due to the poor materials used in their construction; many of them after all were hastily built at a time of national danger, often using materials, such as beach aggregates, which would not have been acceptable in peacetime. Just as often, however, their destruction was a result of deliberate demolition policies and the removal of 'eyesores' by local and national government in the postwar era. The emergency defences built in 1940 in anticipation of a German invasion, in particular, were erected so rapidly that no proper record of their construction survives.

Standard layout of
interwar RAF
airfield, with service
accommodation in
the foreground.

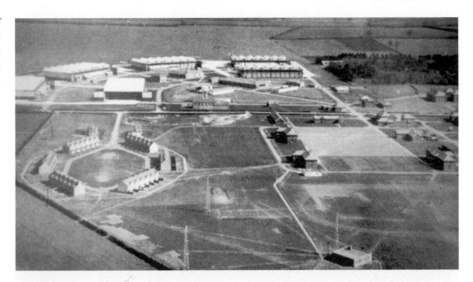

There are a number of areas where the remains of warfare stretching over many centuries are concentrated. Here there has been continuity in fortification, and examples exist in the ports of Dover, Portsmouth, Portland Bay, Southsea and Falmouth. Indeed, the ravaged fortifications of Sheerness and Sheppey still provide traces of First World War defences. Hurst Castle and Landguard Fort retain the batteries and operations towers of the second war, and Newhaven and Pendennis Castle were refortified as part of their display as ancient monuments. A remarkable example of continuity is at Pevensey, where, in 1940, pillboxes were built into the ruins of a Roman 'Saxon Shore' fort and the subsequent medieval castle, camouflaged to merge into the earlier remains.

Probably the most extensive evidence of military activity in the twentieth century, however, is in the form of service housing. Living accommodation was found in a wide range of military contexts. During the First World War, for example, extensive estates were built for the thousand of munitions workers at the Woolwich Arsenal. The Progress Estate at Eltham and the Vickers Estate at Crayford were both government funded. New towns and villages were developed during the century to accommodate military personnel. Aldershot and Bovey Tracey are military towns that have matured, and the regular rows of uniform buildings have been softened by trees and shrubs; while the service quarters at Biggin Hill in Kent, built between the wars, have the mellowed feel of a garden city. After conscription ended in the late 1950s, many new estates were built by the MOD to house an army of professional soldiers and their families, and some villages were dominated by uniform semi-detached institutional houses and have the feel of a barracks. Military housing estates can still be found, although in recent years many houses have been sold off by the MOD and, free of regulated decor, have begun to blend more comfortably with their surroundings.

Harperley prisoner of war camp in Northumbria, now a scheduled ancient monument.

In addition to the regular permanent housing for the military, thousands of camps were built to support military needs during both world wars. Camp buildings were normally built of wood, corrugated iron and, later, of concrete. At the beginning of the Second World War some thirty-three new camps were required for the militia. The return of the Expeditionary Force from Dunkirk and then the build-up to D-Day required hundreds of new hutted and tented camps. Wartime camps were also required for such purposes as housing, refugees and prisoners of war. Although such huts were normally intended to provide temporary or short-term accommodation, many of them were refurbished and lived on as government offices for several decades after the war ended. Most camps were eventually built over for housing or industrial estates. Harperley prisoner of war camp in Northumbria survived more or less intact, however, and is now a scheduled monument.

Military landscapes have always possessed an element of secrecy, but the escalating size of defence establishments in the twentieth century meant that increasingly large areas of land were out of bounds to the public. Furthermore, many military facilities simply did not appear on Ordnance Survey maps. Secret landscapes were not only associated with military bases of all types, but also training grounds and research facilities such as Porton Down and Aldermaston were closely guarded. Despite the end of the Cold War, large expanses of England remain under military control and under strict security. There are extensive training grounds, where public access remains restricted, on Salisbury Plain, in Norfolk and in the Pennines. There are fewer military airfields now than at any time since the 1920s, but some of those that do survive, such as Lakenheath in Suffolk, cover thousands of acres.

In the period just before the First World War, the Army required training

grounds and residential accommodation in addition to the conventional barracks, and permanent evidence of military activity appeared in the peacetime landscape. By 1890 the Army had already begun to use parts of Salisbury Plain as a training ground; and the camp at Bulford, for example, grew from 341 persons in 1891 to over 4000 in 1931. A small utilitarian town was created to house the soldiers stationed there.

The First World War

At the start of the First World War, land defences built around Portsmouth, Plymouth and Dover during the nineteenth century were still in good condition, as were the Chatham forts and Mobilization Centres built to defend London in the 1890s. The Mobilization Centres were defensible storage depots designed to receive artillery and ammunition in the event of a threat of invasion. If invasion became a real prospect, the artillery pieces would be emplaced in fieldwork systems. Whilst reliance was still placed upon the Royal Navy to protect Britain from invasion, the German naval bombardment of Hartlepool and Scarborough in 1914 and the rapid German advance to the Belgian coast in the same year raised fears that invasion still might occur.

Before and leading up to the First World War, most inland defensive arrangements in England were designed to restrict the movement of a potential horse-borne invasion. Simple defence lines were created in East Anglia, and across Kent and the south east of England. They were built using a combination of ditches and banks, barbed wire, and scattered strongpoints formed by pillboxes and batteries. The London Defence Positions were a series of strongpoints begun in 1889 as a result of alarmist media articles about the undefended state of the capital. Two lines were created: one protecting the approaches to London from an invasion via the Essex coastline, and the other along the North Downs from the Thames Estuary across to Guildford. These sites had been abandoned or were incomplete but, where they did exist in 1914, they were incorporated into the stop-line system. Other stop-lines, such as the Medway–Swale Line, were part of the Thames and Medway Defence Plan which had been devised before the war. At Shoeburyness an extensive network of trenches and barbed wire was constructed, with block-houses providing strongpoints. Similar schemes were executed around the naval bases at Portland and Falmouth. On the Isles of Sheppey and Grain hexagonal pillboxes were built (in contrast to the circular form favoured in East Anglia). As well as the long-established batteries and harbour defences of the twenty-six defended ports and naval bases, there were miles of barbed wire, scaffolding, trench systems and pillboxes along the south and east coasts. Most of these defences have long since disappeared, leaving no permanent imprint on the landscape.

Large ordnance factories were established throughout southern England. For example, the Royal Naval Cordite Factory at Holton Heath was Dorset's largest industrial site, spread over several hundred acres and employing thousands of workers. It was established on the orders of Winston Churchill, then First Lord of the Admiralty, who required a supply of high-quality cordite propellant for shells. Holton Heath was a level, barren site with access to a railway and the sea, and, although remote, was near a large pool of labour. The factory opened in January 1916, with some workers being transferred here from the Royal Gunpowder Factory at Waltham Abbey. Water was brought from a steam pumping station at Corfe Mullen to a reservoir on Black Hill, within the site. The factory included a nitroglycerine plant, guncotton factory, boiler house, electricity generating station, gasworks, laboratories, workshops, messes and canteen. There were five miles of sidings from the LSWR, and an extension to a jetty at Rocklea, from which sailing barges took cordite to Gosport and Chatham. In addition, there were fourteen miles of narrow-gauge line within the factory. The railways were worked by fireless locomotives, using high-pressure steam, as well as battery locomotives.

Acetone was vital in the incorporation of nitroglycerine and guncotton. The biochemist Dr Chaim Weizmann, later the first President of Israel, developed a large acetone factory at Holton Heath. Creation of acetone was a fermentation process involving such items as maize, artichokes, horse chestnuts and acorns. Eight large concrete fermentation vessels were built, and 20,000 tons of acetone produced during the First World War. In 1927 a new solventless cordite was developed, and the acetone factory became redundant. The fermentation vessels were never demolished. They became air-raid shelters in the Second World War and are still there today.

The Defence of the Realm Act of 1914 greatly extended the powers of the wartime government, which took over control of the railways (1914), the coal mines (1917) and even the flour mills (1918). A powerful Ministry of Munitions, which transformed the production of battlefield materials and resources, developed from 1915. New ministries were created for labour and shipping, and a food production department was established in 1917. Food rationing was introduced, and county agricultural committees engineered a 30 per cent rise in national cereal production. By the end of the war, the Royal Arsenal at Woolwich employed over 80,000 people. Other communities also registered the impact of the war: for example, in London's northern suburbs, Edmonton gained a major military hospital, while Enfield became an important centre for munitions production.

During the First World War, one of the largest, short-lived and most secret of railway ports was built in the marshlands of the Stour estuary, separating the Isle of Thanet from 'mainland' Kent. Richborough Port, close to where the Romans landed before they conquered Britain in AD 43, was developed, with miles of sidings, as the major trans-shipment depot for war materials

Bomb damage in Hull during the First World War.

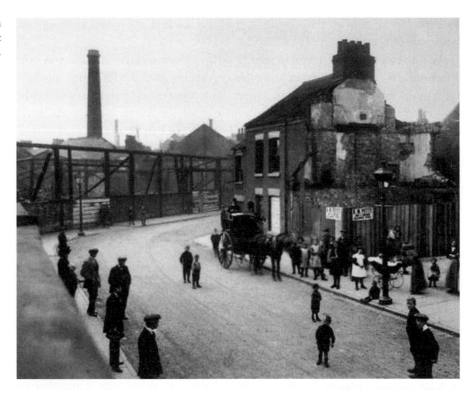

and troops sent to and from the Western Front in France. This was the terminus of the first cross-Channel rail ferry, used for military traffic. Private railways were also built for the military; for instance, the larger ordnance depots, such as those at Longmoor and Donnington, were also served by their own internal railway systems.

Although manned flight developed more slowly in Britain than in the USA or France, its wartime potential was quickly appreciated. In H. G. Wells's serialized novel *War in the Air*, the first part of which appeared in January 1908, there were stark and dire warnings of the perils that could lie ahead. It described 'death and destruction to civilians – men, women and children – in cities far from the front line'.[2] The following year, after the first successful flight over the English Channel, Wells warned, 'we are no longer from a military point of view an inaccessible island ...', and Lord Northcliffe exhorted the military authorities to take aeroplanes seriously as weapons of war. Stanley Baldwin was later to remark: 'Since the days of the air, the old frontiers are gone. When you think of the defence of England you no longer think of the chalk cliffs of Dover; you think of the Rhine. That is where our frontier lies.'[3] In 1911 Herbert Asquith, the Prime Minister, asked the Committee of Imperial Defence to consider 'the future development of aerial navigation for naval and military purposes' and 'to propose measures that would create an efficient and effective aerial force'. In 1912, the Royal Flying Corps was established. It included Military and Naval Wings along with a

Central Flying School. The flying school was created at Upavon Downs on Salisbury Plain.

The scale of aerial warfare escalated during the course of the First World War and, as a result, early in 1918 the two wings of the RFC were amalgamated to form the Royal Air Force. The few existing civilian airfields, including Hendon (London) and Brooklands, were taken over by the military, and many of the airfields whose names became familiar in the Second World War had their origins in the First. RFC bases were built at Figheldean, Rollestone, Upavon, Chiseldon and Tidworth; while a little later, in Hampshire, aerodromes were constructed at Abbotts Ann and Worthy Down. Ford and Tangmere opened as Royal Flying Corps establishments in 1918. These early airfields consisted of six or seven hangars for the aircraft, workshops, magazines, firing ranges, 'bomb dropping towers' and 'buzzing and picture target' huts, as well as barracks, and it is mainly the early hangars which survive today. One of the most accessible of the early airbases is Calshot, which was opened by the Royal Naval Air Service in March 1913, and here some of its seaplane and flying boat hangars survive. By the end of the war there were over four hundred airfields in Britain, the majority of which were to disappear within a few years.

Although damage from aerial bombardment during the First World War was on a far smaller scale than in the second war, there were a number of areas that experienced significant destruction. In 1915 and 1916, for instance, there were bombing attacks by Zeppelins on Humberside, Tyneside, East Anglia, Kent and London. Later in the war, heavy bombers attacked London and the South East. On 25 May 1917 Folkestone was subjected to the largest aerial bombardment of the war to date, when ninety-five people were killed and nearly two hundred injured. Less than a month later, a raid on London resulted in the death of 170 people, including eighteen children killed when the Upper North Street School at Poplar was destroyed. Following the loss of large numbers of German bombers, there was a shift to night-time raids. In the first of these, on 3 September 1917, Chatham Naval Base was heavily bombed and 132 recruits were killed. The air raids continued into 1918 and, in late January, Odhams printing works in the City of London was hit, resulting in the death of thirty-eight people who were sheltering in the basement. The First World War 'blitz' of London came to an end on 19 May, when six out of thirteen Gotha bombers which set out to bomb the capital were destroyed.

During and after the First World War a series of sound-detecting acoustic dishes (sound mirrors) were also built at strategic locations around the south and east coasts of England. In principle, the acoustic dish acted in exactly the same way as a concave mirror, but it reflected sound, instead of light, on to a microphone placed at its focal point. Under ideal conditions it worked well, picking up the sound of an approaching aircraft at ranges of eight to

A sound detecting acoustic dish used during the First World War and after to detect approaching aircraft.

fifteen miles, but performance was easily impaired by strong winds and extraneous noises. As aircraft performance improved, the intruder would arrive at an increasingly brief interval after detection, so diminishing the value of the mirror as an instrument of early warning.

Some of the earliest sound mirrors known to survive are sited on the north-east coast of England. No two are alike, but they share in common a near-fifteen-feet square vertical slab of concrete with a concave circular depression or 'dish' at its centre. Several varieties of sound mirror survive in Kent, including the only wall mirror to be built in Britain, at Greatstone. This consisted of a curved wall, some 200 feet long, which, when in use, had microphones placed at intervals in front of it. Radar was developed from 1935 onwards, originally at Orford Ness, where the experimental site, which later became an Atomic Weapons Research Establishment, is now owned by the National Trust.

Between the early 1920s and the outbreak of the Second World War, large technical advances in early warning were achieved. Visual observation posts, established during the First World War as part of the defence of London, were from 1925 manned by the Observer Corps (later the Royal Observer Corps), whose main function was to track aircraft movements. Though never redundant, visual detection was first supplemented by a system based upon sound detection, and later by Radio Direction Finding (RDF), or radar, tracking the movement of aircraft from coastal Chain Home stations. Remains of all three major phases in early warning systems can be recognized today.

The Second World War

The Second World War was a total war involving the whole country. Virtually every aspect of life was affected, and the short- and long-term impact on the landscape was considerable. During the war, and particularly in the build-up to D-Day, much of the English landscape was used for military purposes. By June 1944, three and a half million military personnel were sharing the land with the civilian population, and eleven and a half million acres (or 20 per cent of the total British land surface) were directly or indirectly under military control. The militarized landscape was acquired and defined through the Defence Regulations. These came into effect under the

Emergency Powers (Defence) Act 1939 and included the power to requisition land and evict the civilian inhabitants. Some one million acres were requisitioned in this way. Given this intensity of military occupation, it is not surprising that much evidence of wartime construction and land use still survives.

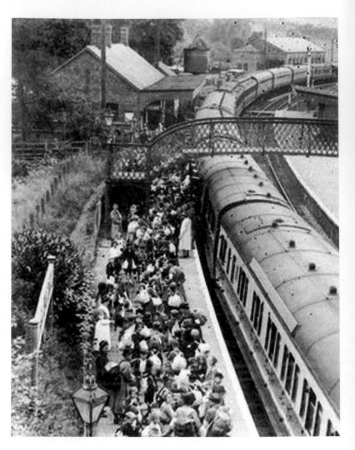

The second world conflict of the twentieth century had a much greater impact on the landscape than the first. An acute shortage of food during the Second World War encouraged a ploughing-up campaign of unprecedented speed and extent, because this time it was undertaken mainly by tractors. Between 1939 and 1945 the percentage of all farmland under tillage almost doubled, and approached that of the golden age of farming a century earlier. The 'Dig for Victory' campaign brought park-land, common land and upland heath under cultivation, often for the first time. The total area of agricultural land actually fell by 300,000 acres, however, due to the extraordinary growth in the area of military airfields, training areas and depots.

The evacuation of children to Chipping Norton in Oxfordshire in August 1939.

During the Second World War, the Commander-in-Chief Home Forces set up an Advanced Headquarters close to the Cabinet War Rooms in Whitehall. In the event of the Germans invading, the War Cabinet, Chiefs of Staff and the Naval, General and Air Staffs were to stay in London; if driven from Whitehall, they would move to duplicate War Rooms in the suburbs. The Whitehall War Rooms are now displayed to the public by the Imperial War Museum and provide an insight into the environment of command at the highest level. There were other deep-cellared 'fortresses' elsewhere in central London, and the Admiralty Citadel, complete with machine gun loops, still stands at the corner of Horse Guards Parade.

In August 1939, Vice-Admiral Ramsay became responsible for protecting the Dover Straits from enemy naval forces and for the safety of allied cross-Channel shipping. He saw the potential of the casemate tunnels, dug in 1797 into the cliff below Dover Castle, as a bombproof naval headquarters below the Port War Signal Station of the First World War. For nine days in late May and early June 1940, these tunnels were to be the nerve centre controlling

the naval part of the evacuation of 338,000 troops from Dunkirk. In 1941 the underground system was extended and other tunnels were excavated. One of these was for the General Post Office, which had charge of all land communications. After the Navy had abandoned the tunnels in 1958, they were adapted to form one of ten regional seats of government that were intended to function during and after a nuclear attack. New communications equipment, air filtration plant and improved generators were installed, while the remainder of the tunnel system was abandoned. The western group of tunnels were modernized to become dormitories, mess rooms and a telephone exchange.

At Corsham, Wiltshire, a project started in 1928 as a result of growing concern over the danger from aerial warfare grew substantially during the Second World War. Established in old stone quarries, a six-acre secure storage depot holding 12,000 tons of ammunition expanded until it had become a complete underground town covering 125 acres, housing 300,000 tons of explosives and costing over four and a half million pounds. 'Many thousands of lights burn continuously in this land of hidden cities', proclaimed the *Daily Express* in 1943. 'Here, carved from the living rock, is a great bomb-proof cloister hundreds of feet long, supported by square thirty-foot columns hewn out of stone.'[4]

The Defence Requirements Committee, established in 1933, had highlighted the potential risk of air attack from Germany and the new threat of a 'knockout blow' from the air. This led to an 'expansion period' of the RAF with emphasis on the bomber, and an air defence strategy involving early warning systems, fighter commands, and associated anti-aircraft guns and searchlights. Many new airfields were constructed at this stage, and old ones were refurbished; they were characterized by two or three runways and

Part of the massive Second World War defences at Dover Castle.

the usual assemblies of hangars and watch/control towers, operation blocks, armoury, station HQ, guardhouse, engine-testing house, blast shelters, parachute stores, machine gun butts and air-raid shelters. Recognizable military architectural styles emerged for domestic structures on the airfields such as barracks and the officers' mess. The first style dates from the end of the 1920s and the second from the late 1930s. Some of the 1920s operations buildings survive at Hawkinge, while the neo-Georgian officers' mess at Biggin Hill is typical of the later 'expansion period'.

Civil airfields were converted for service uses, existing service airfields were enlarged, and over ninety new airfields were created and equipped with hangars and personnel barracks. In the interwar period, the creation of new airfields had met with considerable opposition from the Council for the Protection of Rural England, amongst others. 'Aerodromes cannot be anything but ugly blots on the landscape and it would be a pity to add to their number unnecessarily', was a typically expressed view. Some airfields were constructed in the clay vales. Many more, however, were placed on flatter parts of the well-drained limestone uplands to suit the increasing weight of aircraft and to allow for long runways that could be laid out for take-off into prevailing westerly winds. The eastern and south-eastern seaboard counties of England provided ideal locations for interceptor and fighter training and bomber planes, which often needed several hundred acres and concrete runways. There were 38 new airfields in the Oxford–Swindon district alone.

The building of airfields during the war represented one of England's largest wartime engineering works. The Emergency Powers (Defence) Act of 1939 allowed the 'Aerodrome Board', as the requisitioning authority was known, to purchase land compulsorily. Construction companies such as McAlpine, Laing, Wimpey and Mowlem were then contracted to demolish and clear obstructions, such as buildings, woodland, and field boundaries, on this largely agricultural land. They then proceeded to lay the runways, normally three, with the principal runway orientated north west to south east to take advantage of the prevailing wind direction. At fighter aircraft fields the main runway was about 2000 feet long, but on airfields to be used by bombers, such as the one at Greenham Common, runways were as much as 6000 feet long.

In mid 1942, the United States Army's Aviation Engineer battalions came to England and built fourteen bomber airfields, of which eight were in Essex. Work on one of these, at Andrews Field, began in July 1942, with the widening of lanes leading to the village of Great Saling. (Widened roads with kerbing are often a clue to the existence of a former airfield site.) To clear the ground, twenty-three acres of mature oak trees were felled, and Muchmores Farm and associated buildings were levelled. Work on construction went on twenty-four hours a day in twelve-hour shifts. The finished airfield had three runways, one of 6300 feet in length and two of

The runway of a Second World War airfield at Stanton Harcourt in Oxfordshire. It cuts across a Neolithic henge monument and later the whole area was excavated for aggregates. Over 400 similar airfields were constructed during the Second World War.

4200 feet each. The airfield was opened on 24 April 1943. Andrews Field had a relatively short life as a military airbase and was abandoned in 1948. On the 1:50,000 Ordnance Survey map there is no reference to Andrews Field, but its site remains empty, apart from a series of roads that end in a cul-de-sac. These were either roads serving the base or roads which were cut off at the time the airbase was constructed.

In all, 122 airfields were constructed or converted for use by the US Air Force. At the height of the war, in 1942, it is estimated that construction on a new site (most of which were in East Anglia) began every three days. It was an enormous logistical endeavour on the part of the British civilian contractors, requiring the removal of millions of tons of earth, hundreds of miles of hedgerow and hundreds of acres of trees. Additionally, vast quantities of bricks were required for miles of sewers, water mains and drainage channels to serve the airfields, each of which cost in the region of £1 million. Some of the hardcore was supplied from locally demolished buildings, but, after the war had started, rubble from bomb-damaged sites in London was brought by train and lorry to airfields such as Little Horwood in Buckinghamshire. The vast quantities of concrete required were normally mixed close to the site, with aggregates from local sand and gravel quarries.

By 1939 the threat of a mobile invasion was also a distinct possibility, this time not with horses, but with mechanized vehicles; and a number of inland sites of strategic importance were liable to be attacked. The size of the airfields, their visibility, and the mobility of an airborne enemy made them particularly vulnerable. The Luftwaffe were also capable of attacking and destroying a whole range of other installations and centres of population, and they could drop parachute troops near these targets, all of which required new forms of defence. The response at the start of the Second World War was to create a new system of defensive lines comprising a mixture of natural barriers, particularly rivers, backed by fixed defences consisting of thousands of miles of anti-tank ditches supported by pillboxes and other obstacles. These anti-tank ditches were part of the greatest system of defensive earthworks ever built in Britain, and the shortest-lived.

Tests carried out by the British Army in May 1941 showed that the best and cheapest obstacle to stop tanks were not the lines of concrete blocks that had been designed and manufactured in a variety of sizes and shapes, but a V-shaped ditch, nine feet deep, eighteen feet wide at the surface, and supported either side by two two-feet high ramparts.[5]

Thus an elementary device which had been used from the Iron Age onwards was applied during the most technologically advanced war in history, and anti-tank ditches were excavated in a variety of widths, depths and profiles. Before 1941, most of the ditches had a vertical revetted face on the defender's side with a more gradual slope and a rampart on the attacker's side to expose the vulnerable underside of a tank to defensive fire. Some elements of the stop-lines were improvised from existing features, such as railway embankments, whilst others were newly built. Concrete walls were constructed along the bases of embankments, and bridges and gullies blocked. Traffic on overbridges could be impeded by walls and by concrete anti-tank blocks similar to those used on the coast. Waterways, too, were adapted to serve tactical purposes as pillbox lines were integrated with rivers and canals

that had been deepened or straightened to produce anti-tank barriers. In low-lying areas, tank mobility could be further restricted by the judicious flooding of fields. All of these systems were complemented by trenches, blocks, pillboxes, weapons pits, barbed wire and minefields.

Villages and other settlements within a stop-line were sometimes adapted as formidable tactical areas, being converted into anti-tank islands (also known as nodal points, keeps, defended locations and hedgehogs). The anti-tank island was designed to attack the flanks and rear of a force which had succeeded in breaking through the stop-line. The last of the ditches were dug in 1942, after which the threat of a land-based invasion diminished. Indeed, the ditches, which had split up farms and disrupted drainage and movement, were filled in and had largely disappeared by 1945. We can no longer see the courses of the ditches and, with very few exceptions, there is no known record of their exact positions.

In addition to the beach batteries around the coast, there were tank obstacles, trenches and pillboxes. Beaches were mined and obstructed, and roads leading inland blocked. Builders' scaffolding fitted with mines was erected below high-water mark for about seventy miles of coastline, and scaffolding and buried mines were used as obstructions on a further three hundred miles of beach. Anti-tank ditches were dug and obstacles erected, generally consisting of blocks, cylinders and 'dragon's teeth'. After the war these defensive devices were subject to coastal erosion, incorporation into sea defences, and deliberate destruction and removal. Only a few survive, with examples at Eastney and Milford, Hampshire, where there are the remains of anti-tank blocks, and a length of anti-tank wall at Norman's Bay, Sussex. There is also an unusual grouping of pillboxes and strongpoints at Porthcurno, Cornwall, which were built to defend the terminus of the international submarine telephone cable. And there is a notable group of defensive strongpoints of anti-tank ditches and pillboxes that survives at Blandford in Dorset.

The General Headquarters Line ran from Musselburgh near Edinburgh along the eastern side of the country through Yorkshire, Cambridgeshire and East Anglia to London, and then from the River Medway across Kent, Surrey, Berkshire and Hampshire to end at the Bristol Channel. There were secondary stop-lines protecting the manufacturing centres around Derby, the territory bordering the Solent, and the hinterlands of the ports of Plymouth and Dover. These lines were designed to be manned by volunteer troops and the Home Guard, supported by local efforts to block routes with dragon's teeth, barbed wire and other obstacles. A long line of square concrete blocks survives on the beach at Wilsthorpe Cliff, East Yorkshire, and there is another group of them blocking a crossing point on the River Avon at Malmesbury in Wiltshire. The Avon formed part of the 'Green Line' established in 1940 and designed to protect Bristol and Midland towns from attack from the south west.

The small reinforced structures called pillboxes were probably the most familiar type of twentieth-century defensive building. Sometimes referred to in official literature as defence posts, blockhouses or police posts, concrete pillboxes were first used by the Russians in the Russo-Japanese War. The German army adopted the use of pillboxes in the First World War and the British followed. It was the introduction of the machine gun to the battlefield that caused the development of the pillbox. Since machine guns needed a good field of fire to be effective, they were often sited in a house with a commanding position, which would then be strengthened by the use of concrete to thicken the inner walls and provide extra protection for the machine gun and crew. Such reinforced gun emplacements led to the development of the purpose-designed pillbox, especially in open country where there might be no convenient house at the best fire position.

The majority of Second World War pillboxes were associated with beach defences, stop-lines and nodal points, though some were sited to defend coastal batteries, airfields, radar stations and factories. A massive programme of pillbox building was commenced at the start of the war, and great ingenuity was displayed in the camouflage applied – disguises included a tea kiosk near Newlands Corner in Surrey, railway coal heaps, chicken sheds, and even a public convenience. At a remote coastal location at Druridge, in Northumberland, a pillbox survives, perfectly disguised as a small stone-built house. By September 1941, Eastern Command had spent nearly £4 million on 5819 pillboxes, while Southern Command had spent a similar amount on 3242 pillboxes. In total, about 18,000 pillboxes were built, using concrete and scrap iron reinforcement within wooden or brick shutters. A number of designs were produced, with various sizes to provide shelter for varying numbers of troops and sizes of weapon. Smaller pillboxes housed riflemen, while larger ones held Bren guns, sometimes designed to enable anti-aircraft fire; the latter were particularly concentrated around airfields, and the largest pillboxes were designed to house an anti-tank gun. Some special types included the Pickett-Hamilton retractable pillbox, which could be raised or lowered into the ground by means of a winding mechanism. The Tett Turret was a concrete turret set over a concrete shaft sunk into the ground, with a 360° field of fire.

Pillboxes were strategically placed. For example, parachute landings and bombing raids were perceived as the main dangers during the first part of the war. Consequently, airfields were heavily defended with trench systems, pillboxes, machine gun emplacements and subterranean command posts. As part of the attempt to prevent a glider-borne invasion, pillboxes were located close to potential landing areas along the Thames Valley. Two pillboxes are quaintly sited at either end of the banks of the Iron Age earthworks at Dyke Hills, near Dorchester on Thames. Obstacles were also built around the earthworks of the Anglo-Saxon barrow cemetery at Sutton Hoo. Much

A Second World War pillbox at Dorchester on Thames in Oxfordshire. There are two boxes at either end of the Iron Age earthworks of Dyke Hills. They were located throughout the Upper Thames Valley at the onset of war to prevent an enemy glider invasion.

ingenuity was applied to pillboxes and their placement; by mid 1941, however, the whole programme was abandoned as defensive priorities moved towards the building of coastal emplacements.

Attempts had been made during the First World War to deceive the enemy by using decoy airfields and flare paths to divert bombers and exaggerate the number of operational airfields in France. Decoying was also a feature of British defences in the Second World War. In October 1939, the decision was taken to commence the construction of daytime decoys – 'K' sites – for all satellite airfields, and night decoys, known as 'Q' sites, for both permanent airfields and satellites. Daytime decoy airfields consisted of tents and dummy aircraft, and were almost all abandoned in 1941. After this date, daytime decoys tended to be used only for strategic deception, particularly in connection with D-Day. Night decoys consisted of electrical lighting to represent airfield flarepaths.

Other night-time decoys, known as 'QF' sites, were established to provide mock fires, and thereby encourage enemy bombers to attack the decoys rather than the real targets they were protecting. The first of these fire decoys were used to protect airfields. Night-time urban decoys were also used. These 'QL' sites, as they were called, represented permitted lighting, such as hooded lighting, tram-wire flashes, furnaces and marshalling yards. Following the November 1940 attack on Coventry, many major towns were provided with decoys codenamed 'Special Fires', 'SF' or 'Starfish'. These sites had a variety of effects to represent both small fires and major conflagrations.

Due to the temporary nature of decoys, and the fact that they covered large areas of open land, very little tends to survive. The only substantial structures associated with decoys were the control shelter and generator building, and some of these can still be identified. They were sited about 400 yards from the decoy itself and were usually of brick construction with

The Red Sands group of Maunsell forts on the Isle of Sheppey on the coast of Kent.

a concrete roof and earthen banks. All of these defences tended to be ephemeral, rather like the camouflage that covered many wartime factories and other strategically important buildings, but the firebreaks for a strategic Starfish decoy system survive in the form of earthworks at Sneaton Moor, near Middlesbrough, and also at Little Humber, in the East Riding of Yorkshire. Large irregular circles sit on top of earlier ridge and furrow to create a curious 'cropmark' visible from the air. Similarly, where gun emplacements have been completely destroyed, their footings sometimes appear as cropmarkings alongside much older markings, providing a puzzle for archaeologists.

To counter minelaying aircraft and to supplement the London air defences, a number of sea forts were built in 1943 off the Thames and Medway estuaries and the east coast. Known as Maunsell forts, twenty-one were built in the River Medway and twenty-one in the Thames Estuary. They were positioned between June and December 1943 and were defended by 165 men. Each group of forts consisted of four 3.7 inch gun towers, one 40mm. Bofors gun tower, a searchlight tower and a radar/control tower. Of the twenty-one army towers built in the Thames, only thirteen survive. Seven of the Nore group towers were dismantled in 1959/60 and parts deposited on the foreshore at Cliffe, in Kent. The Red Sands group of seven towers, directly off Minster, on the Isle of Sheppey, visible from Herne Bay, was abandoned in 1956 and later occupied by a pirate radio station. The Shivering Sand group, which lies about seven miles off Herne Bay, consists of just six towers today. It, too, was occupied by a pirate radio station for a while.

During the German bombing raids on London in June 1917, the need to provide the civil population with shelter became apparent. Despite much discussion, however, little was achieved until the threat from Nazi Germany

Building a new
airfield in the early
phases of the Second
World War.

led to the Air Raid Precautions Act 1937. This Act placed a statutory
obligation on local government to provide shelter and introduce anti-gas
measures, whilst the Munich Crisis in August 1938 gave new impetus and led
to increased central government control. The air-raid protection policy intro-
duced personal gas masks and domestic air-raid shelters, most commonly the
ubiquitous Anderson shelter. By September 1939, over 1,500,000 Andersons
had been issued to households with an annual income of less than £250. Large
bomb-proof underground air-raid shelters were less popular during the
Second World War on the grounds of cost and the risk of high casualties
from a direct hit. The only public shelters provided were, therefore, of the
trench variety, or single-storey surface shelters intended only to protect groups
such as schoolchildren, those living in narrow terraced streets, and those
workers caught away from home. In certain badly bombed towns fear of air
raids led to an exodus of population towards nightfall. From 1941, colonies
of shelters were established on the fringes of some urban areas to accom-
modate these so-called 'trekkers'. Colonies usually consisted of ten to fifteen
shelters, each of fifty-person capacity, together with facilities for first aid and
the provision of food.

Between September 1940 and May 1941, 141 major air attacks were made
on twenty-one British cities. In both Coventry and Southampton 30 per cent
of the housing stock was destroyed. The Blitz in London is seared on the
memories of survivors and, through oral testimony and film, on those of
subsequent generations. There are many first-hand accounts which bring
home the dangers and inconvenience of the impact of the Blitz on the East
End of London:

> When war came in 1939, shelters appeared in the streets and gardens. We went
> to shelter in the railway arches near Cable Street and also in the Free Trade

Paddington Station during the Blitz.

Wharf, sleeping on orange boxes ... Coming from the shelters in the early morning, the streets were always different from the previous night: houses were just a pile of bricks, craters, dust and glass, and there was always a smoke haze.[6]

Strategic centres of industry and communications such as Birmingham, Liverpool and Plymouth suffered serious physical damage. The bombing of the south west of England had a considerable impact on local inhabitants. W. G. Hoskins, a native of Devon, wrote with feeling about the experience:

The first German bomb fell on Plymouth on 6 July 1940: the enemy had his airfields only a hundred miles across the water in Brittany. All through the winter fire and high explosive shook the city. Then, on 20 March, the barbarians began the systematic destruction of the town. In one week they killed over 1000 men, women and children, wrecked the homes of 10,000; and so they continued. From far away down the Cornish coast, and far inland in Devon, that red, pulsing glow over Plymouth could be seen night after night, through late March and April. Help flowed in from all over the civilized world ... It was Exeter's turn next: in late April and May of 1942 the city was burnt and shattered in a manner not know since the heathen Danes had destroyed the Anglo-Saxon town 900 years before. Then 'tip-and-run' raiders began to sneak along the south coast in 1943, bombing and machine-gunning the seaside towns. Teignmouth suffered severely; so, too, did Torquay and Dartmouth. But even the harmless little fishing hamlets did not escape.[7]

By contrast, in Bristol just 5 per cent of the housing stock was devastated, and in Leicester, a city of over a quarter of a million inhabitants, only six bombs fell during the entire Second World War. On the other hand, Coventry, one of Britain's leading centres for aircraft components, was the first British provincial city to be selected by the German air force for a highly concentrated aerial bombardment by explosives and incendiaries. On the night of 14–15 November 1940, an intense blitz killed 554 citizens and seriously wounded 865 others. In further concentrated air raids, in early April of the following year, the city suffered a similar number of casualties, and the core of the city, including the medieval cathedral, was destroyed.

In the concluding stage of the Second World War, the south east of England became an indispensable springboard for the seaborne Allied assault upon Europe in June 1944. Country houses and their estates were commandeered for Allied troops; remote rural areas were supplied for the first time with piped water and electricity; and new roads were constructed and many byways metalled. In the months leading up to D-Day, thousands of army vehicles were stored under camouflage on the northbound carriageway of the A24 near Dorking and elsewhere. Extensive areas of the Weald were used as military training grounds. At the ports, hundreds of landing craft, barges and torpedo boats were built, and petrol pipelines were laid from the Isle of Wight to Normandy and, later, from Dungeness to Calais. A major deception that the main assault would be across the Straits of Dover involved fleets of dummy ships in the Cinque Ports and simulated concentrations of troops in parts of Sussex and Kent.

The construction of the two artificial 'Mulberry' harbours, built in sections (different component parts generally at separate sites) and towed across the Channel for disembarkation of troops and landing of supplies, was in Churchill's words, 'a principal part of the great plan', and was decisive in the first days of the invasion. Although one harbour failed, the remaining structure – at Arromanches – was significant in providing the tactical advantage of surprise, and the logistical advantage of not having to land on a defended shore and at the mercy of the weather. Some components of the harbours were surplus to requirements and remained in England; some sank on route or were 'beached' for other reasons. Significant sections of the harbour survive on the Normandy coast today. Many sites were involved in this construction process, stretching at least from Southampton, via south coast ports and London, to the North East. These sites were located either in largely unmodified dry docks or slipways, or in excavated basins or beaches. Much use was made of existing facilities, with security, camouflage and deception being of vital importance. It is the beach construction sites, however, that retain most evidence for this construction task, comprising construction platforms, slipways and winch-house foundations. A fine set of D-Day embarkation slipways survives at Torquay harbour.

The actual Anglo-American invasion force was an immense armada of about 4000 ships and several thousand smaller craft which made a rendezvous off the Isle of Wight. The whole of the southern coastline was involved in the huge preparations for the liberation of Europe, which began in 1944. In the preparations for the Second Front, a large area of country behind Start Bay, in Devon, was taken over as a battle practice ground, six parishes being completely emptied of civilian life and goods. It was a countryside that closely resembled that of Normandy, where the final attack was to take place, and for months the American troops trained there. A memorial to them now stands in the middle of Slapton beach. Dozens of prefabricated airfields were erected in southern England, enabling some 10,000 aircraft to participate in the invasion of Normandy. Southwick House, on the site of a former Augustinian priory three miles inland from Portsmouth, became the headquarters of Generals Eisenhower and Montgomery, and it was there that the final decision to launch the attack (Operation Overlord) on the French coast on 6 June 1944 was taken. The original map that plotted the Allied and German military movements on and around D-Day still hangs in Southwick House. After the war, the house and park remained in the hands of the military; as it does to this day.

The impact of military activity was not restricted to the archaeological remnants of the two world wars. There are extensive military remains from other conflicts throughout Britain in the form of barracks, depots and docks. For example, there was a large military depot, originally in the hands of the Ordnance branch of the War Office, on a site conveniently near two main railways in Ambrosden, near Bicester in Oxfordshire. Eventually, this military installation absorbed 8000 acres of farmland, but the loss to agriculture was partly offset by improvements in drainage, which prevented flooding and so raised the productivity of the land left for farming. The employment provided by the depot affected all the surrounding area, and the consequent explosion of housing may be judged from the total population of Ambrosden, Arncott and Blackthorn, which numbered 937 during the good farming years of the 1850s, dropped to 474 by the slump of 1931, and then expanded to 5879 by 1951. Graven Hill, also near Bicester, has been in the hands of the Ministry of Defence since the 1920s and is honeycombed with storage tunnels; it is still the largest ordnance depot in Europe. The area around Graven Hill, incorporating the villages of Arncott and Ardley, remains a military landscape, with housing estates, training areas and a wide range of MOD buildings. In the 1990s a new prison for Oxford was located in this area, and at the time of writing, an attempt is being made to establish a new asylum seekers' centre there as well.

Factories manufacturing military hardware and munitions were an important feature of the industrial landscape of both world wars. Often factories producing civilian goods such as cars were rapidly converted to

The naval Admiralty depot at Ditton Priors in Shropshire. This ordnance facility covers four square miles and incorporates twelve miles of service roads.

produce military machines. At Elstow, in Bedfordshire, a massive explosives factory was opened in 1942. The complex covered some 350 acres, and incorporated 250 separate buildings, fourteen miles of roads, fifteen miles of railway lines and its own electricity generating station. Between the buildings, earth mounds were built up to limit the damage in case of an explosion. It is estimated that almost 15 per cent of bombs dropped on Germany were produced here. Before the war, the area of the factory was agricultural land; afterwards, the factory was taken over by the Central Electricity Generating Board and leased out for light industry. At the time of writing, plans have been approved to build three linked villages on the site. These are to be known as Elstow Garden Villages and will provide housing for 15,000 people. Before work can begin, however, it will be necessary to move more than 100,000 tons of polluted soil from the site, as the digging of footings is likely to disturb toxic waste.

The Legacy of War

Although there was a rush to rebuild some bomb-damaged sites in central London at the war's end, in the suburbs and in such other cities as Liverpool rebuilding was a much slower process. Bomb-damaged sites remained·part of the urban landscape in northern cities and even Southampton and Plymouth well into the latter part of the century. The impetus to replan city centres after the war was in part provided by the desire to take full advantage of the new start offered by wartime damage. The drive for new city centres more in tune with the 'car age' was, however, executed in shire capitals that had not seen a single German bomb. A frequently heard criticism at the time was that the 'planners' managed to do more damage than Hitler.

Yet the war's interruption to new house building and the disrepair into which the housing stock slumped because of rationed materials and wartime construction priorities ensured that most towns and cities emerged in 1945 with a serious backlog of housing demand. 'Temporary' housing in the form of 'prefabs' – system-built in factories and assembled on site – was a common and affectionate legacy in the landscape of postwar Britain. 'Temporary' prefab estates were found on the edge of many towns and cities, at first housing demobbed servicemen and often surviving well beyond their envisaged lifespan. Some experiments in the use of non-traditional materials such as steel-framed housing and Swedish-style timber building occurred, but these had a very limited impact on meeting overall housing needs.

By 1955 over sixty airfields in the English Midlands had been closed down and put to other uses; by the mid 1960s only twenty-five remained in active service. About half of them were military. The remainder were civilian with municipal and special flying uses, as at Kidlington, which became a training airport. Most of the military stations tended to mature and grow, reflecting the increasing size and complexity of modern aircraft. The buildings for their personnel took on a more permanent aspect and, for example, a well-built village sprang up on the plateau top above Little Rissington (an airfield now in mothballs). At Bicester, the RAF station remained active as a supply centre for British forces in Germany during the war; but the airfield was also spacious enough to provide for extensive agriculture, particularly pig breeding and root cultivation. In 1950 the War Office decided to base a garrison in the town and proceeded to erect a barracks, which, with 300 new council houses built by the local authority, caused the population to expand from 4171 to 5521 in the following decade. The town changed appreciably in nature from an old market and fox-hunting borough into a part-garrison centre with almost as many cafés as pubs and a population of over 15,000 in 1978. A few miles away, at Upper Heyford, the aerodrome was used for parachute training, before being leased to the US Air Force and provided with an extensive new American town with all the usual service and retail facilities. The population of Upper Heyford parish, which had dwindled to 319 in the early twentieth century, rose to 1504 in 1951 and 2976 in 1971. A still larger population growth occurred around the RAF aerodrome at Brize Norton, on the flat fields of the Upper Thames Valley. The installations kept pace with the size of modern transport aircraft and, since 1967, have included one hangar measuring 1000 feet by 200 feet and said to be the largest in Europe, and about seven times as long as the nearby medieval tithe barn at Great Coxwell. A large air transit centre was added, and over the last few decades of the twentieth century the whole district was transformed by the addition of housing, both on and near the airfield. For example, the nearby village of Carterton was founded by William Carter in 1901, when he bought land to divide up to enable a colony of smallholders to live off the produce from

their plots. In the 1920s the hamlet consisted mainly of four ribbons of widely spaced houses, some with glasshouses for market gardening. Today, under the influence of the aerodrome, Carterton is a vast collection of dwellings, mainly bungalows and semi-detached service housing. The population of the parishes of Brize Norton and Carterton, along with nearby Black Bourton, rose from about 3000 in 1951 to over 15,000 in 2001.

A casual glance at an Ordnance Survey map of almost any part of Britain reveals a surprising number of airfields, particularly in eastern and central England. For a small country, the United Kingdom is replete with landing strips, active and redundant; and an older one-inch edition of an Ordnance Survey map will reveal the sites of many more than are evident today. This is no more apparent than in East Anglia, where the proliferation of bases for the American Eighth and Ninth Air Forces during 1942 and 1943 has left an extraordinary amount of evidence for England's time as a landlocked aircraft carrier. Nowadays, that evidence is confined increasingly to a few derelict hangars and huts. The Snetterton (Norfolk) racetrack, once a US bomber base, still bears significant traces of its wartime history, as does North Weald (Essex), an RAF fighter base now sliced in two by the M11 motorway. Andrews Field (Essex) and Seething (Norfolk), both of which were American bomber bases with comprehensive facilities including concrete taxiways and runways, are now home to light aircraft using just small parts of the original space. Kenley (Surrey), an RAF fighter base and a major target of the Luftwaffe on 18 August 1940, now serves gliders. Fowlmere (Cambridgeshire), once a satellite station for Duxford during the Battle of Britain, later became home to the 339th Fighter Group of the American Eighth Air Force. Today, apart from small sections of roadway, it is all but undetectable in the modern landscape.

Other airfields, such as Manston, near Margate, have been converted into civilian airfields and, as at Biggin, this has necessarily involved removing much of their wartime facilities. Goodwood airfield is one of the very few which genuinely resembles its wartime appearance as a grassfield fighter base. Known as Westhampnett in the 1940s, this was once a satellite airfield for Tangmere, east of Chichester. During the Battle of Britain this was home first to the Hurricanes of No. 145 Squadron and, from mid August 1940, to the Spitfires of No. 602 'City of Glasgow' Squadron. After the war the airfield's perimeter roadway was used by the landowner, the Duke of Richmond and Gordon, for the basis of what became the Goodwood motor racing circuit. In 1958 the grass interior was revived as an airfield, and it still serves light aircraft.

By their very nature, Battle of Britain and other Second World War airfields are unlikely to exhibit much trace of the parts they played in the summer and autumn of 1940. Along the southern and south-eastern coasts and their hinterland were some 110 military airfields, mostly fighter bases or bases used by the Fleet Air Arm. The bomber bases tended to be further

inland, in the Midlands and East Anglia. Fighter airfields associated with the Battle of Britain, such as Biggin Hill, Hawkinge, Manston, Detling, Tangmere and North Weald, were built during the 'expansion period'. Most have some surviving physical remains from 1940, though bomb damage, as at Tangmere, accounted for the loss of most of their prewar buildings; and no airfield, apart from Goodwood, has survived to anything approaching its wartime integrity, although the camp at RAF Bicester, at present in mothballs, has many of the original Second World War buildings and struc-tures intact. Relatively few airfields were released immediately after the war, but gradually those surplus to requirements were sold off, either as civilian airfields in the case of the municipal airfields such as Newcastle and Southampton, or for industrial development as at Sunderland and Derby, which have been covered by car assembly works. Still others, as at Stanton Harcourt, in Oxfordshire, have been quarried away for the sand and gravel on which they were located. Duxford, to the south of Cambridge, was a prewar station which boasts some remarkable neo-Georgian barrack blocks dating from the mid 1930s. Duxford's airfield was of critical importance during the Battle of Britain, but after the war it was abandoned until adopted by the Imperial War Museum in 1977 as a site at which to display exhibits too large for its headquarters in London.

Most of the scores of airfields that did not continue as military or civilian flying bases were eventually reclaimed for agriculture, and their unwanted concrete structures were gradually dismantled. The reclamation was accel-erated after the late 1950s, when concrete runways could be sold profitably as hardcore for road making. For example, in 1963 the neglected and derelict airfield at Great Horwood, near Buckingham, was reclaimed for agriculture by a farming company; large areas of concrete were sold as hardcore at a price equal to the cost of the land beneath them, but enough was retained to provide ideal foundations for poultry and pig breeding units. A considerable number of the other disused airfields became industrial estates. At Witney, for example, the former De Havilland airfield was sold, in 1949, to a motor accessory company, which built a large new housing estate and business park.

Other airfields found non-agricultural uses, such as car racing at Silver-stone and go-karting and gliding at Shenington. Several others became research establishments: the impressive nuclear research institutions at Alder-maston and Harwell transformed the appearance of their sites and enhanced the prosperity of villages within a wide radius. The large airfield at Culham became a high-technology research centre.

Salisbury Plain

Land was first purchased for military training on Salisbury Plain in 1897. Within five years the total area in the hands of the War Department had

The church of Langford is all that survives of the village which lies in the Stanford Artillery Ground in Norfolk.

risen to 43,000 acres. Permanent barracks were started at Tidworth in 1905 and, after the First World War, the War Department resumed buying land on Salisbury Plain, moving westward across the Devizes to Tilshead road. The Larkhill Royal School of Artillery was built in 1920, while the Warminster Infantry Training Centre dates from 1937. The village of Imber and its surrounding terrain were acquired between 1928 and 1932, although the 110 villagers were not actually evacuated until 1943, when the US Army needed the land to train for the Normandy campaign. The village remains uninhabited, although one service a year continues to be held in the church.

During the twentieth century, the Salisbury Plain Training Area became the Army's largest field training centre in the United Kingdom and remains so today. At 140,000 acres, measuring twenty-five miles west to east and ten miles north to south, and representing about 10 per cent of Wiltshire, it was (during the Second World War) the only training centre in the country large enough to allow unrestricted exercises using the Army's full range of vehicles. Today, the main land use on the Plain remains military training, followed by agriculture and forestry. Farmland is divided into two categories: Schedule I, leased to tenants on a full agricultural basis and acting as a buffer between military training areas and civilian settlements, and Schedule III, the main training area, parcels of which are farmed to add an element of realism to the landscape for military training purposes. The forestry provides cover for soldiers and vehicles. Due to the inherent dangers of military training, the public have only limited access to certain areas of the Plain.

Salisbury Plain is an area of remarkable landscape and archaeological value, which the Army's stewardship over the last 100 years has surprisingly perhaps helped to conserve, despite damage caused to some monuments by training activities. Six large Sites of Special Scientific Interest (SSSIs) were designated, comprising some 58 per cent of the training area. The Plain is a valuable archaeological archive, with over 2300 monuments identified. Although the

first priority is military training and public safety, archaeology and conservation, agriculture and forestry follow closely. About one-third of the training area is closed permanently to the public for safety reasons, but public access is encouraged whenever possible. Elsewhere, the Plain is used for leisure pursuits ranging from riding, walking and flying model aircraft to field sports, and over 200 licences are issued annually for such purposes.

A number of railways were constructed on the military estate, connecting the major garrisons to the main civilian lines to move both troops and supplies. A branch line between Ludgershall and Tidworth was completed in 1901, and four years later another was built to link Amesbury and Bulford. The line from Larkhill to Amesbury, built in 1909, was the longest of those constructed. There is little surviving evidence of these railways on Salisbury Plain. However, the Larkhill branch line, which extended as far as the animal hospital at Fargo, does survive in the form of a curving earthen embankment north of the present road between Larkhill and Shrewton, where it skirts around a long barrow on Durrington Down.

Salisbury Plain played an important role in the development of air warfare, with eight airfields constructed between 1910 and 1986, two of which, at Upavon and Netheravon, were still in use at the end of the century. While there had been an earlier balloon school at Rollestone, the earliest of the Salisbury Plain airfields was constructed in 1910 at Larkhill. This incorporated eight hangars and a runway. A number of the former hangars remain standing and represent the oldest aeronautical buildings still in existence in the country. The airfield to the west of the present military camp, at New Zealand Farm, was used during the Second World War. A perimeter ditch extended southwards from the main track in the north and enclosed an area of approximately 500 acres. Within this boundary there were a number of splinter-proof shelters. No clearly defined runway has been identified, although aerial photographs depict a number of hangars and at least one hut in the vicinity.

Though the impact of the military on the entire area was substantial throughout Salisbury Plain, the most distinctive military remains survive on the chalk plateau. Used extensively for training since the turn of the century, the intensity of training in this area increased dramatically prior to and during the two world wars and at other periods of conflict. It is sobering to realize that British forces have been continuously engaged in some form of conflict since the Second World War, and this has resulted in uninterrupted activity on Salisbury Plain. To cater for this intense use, a whole new garrison infrastructure, with barracks, schools, churches and hospitals, together with new roads and a railway, was established. An impression of the transformation can be obtained from the words of an officer who, writing in 1916, observed that:

At times one could easily imagine oneself at the front, with the constant gun

practice going on, and the exploding of mines, trench mortars and grenades, to say nothing of the incessant rifle fire. Trenching and mining of all kinds are practised extensively here. If you have never seen a large hutted camp, you must imagine a huge town built entirely of wooden huts of various shapes and sizes according to their requirements, but as the streets in our case are not named, it is very difficult to find one's way about.[8]

The impact of this intense activity over such a short period of time has been profound. Not since the Romano-British period has the effect on the landscape been so dramatic and, even now, land use is continually changing as new tactics and weaponry demand fresh approaches and an upgraded infra-structure. Many of the military earthworks on Salisbury Plain were only temporary, while others were reused for a variety of purposes. Nonetheless, there are extensive remains of features such as rifle ranges, gun emplacements and large tracts of trench systems, all of which played a crucial part in military operations on the Plain during the twentieth century. Trenches were a major feature of land warfare during the nineteenth and the first half of the twentieth century, and, although infantry trench systems have been identified elsewhere in the country, at such places as Cannock Chase in Staffordshire and Otterburn in Northumberland, only on Salisbury Plain do they survive on such a large scale. Practice trenches were being dug by at least 1902, when 'three four-foot deep S-shaped Boer trenches, filled with standing dummies, were fired at both by guns and howitzers with fair effect'.[9] Since then, large numbers of trench systems have been constructed and, indeed, apart from the 'Celtic' fields and linear ditches, military trenches are the most extensive earthwork monuments on the training area. These have been mapped and range from small slit trenches close to the aircraft hangars at Netheravon to fully developed systems, such as the extensive complex near Shrewton Folly and Perham Down. The trenches are remarkable both in their magnitude and scale of survival, and in a number of places, such as on Compton Down and New Copse Down, obstacles such as wire entanglements are still in place. The most spectacular example of an early trench system lies near the Perham Down rifle ranges. It covers about 300 acres, consists of at least three separate trench systems, and illustrates the ebb and flow of warfare where successive firing lines were constructed as the typical battle progressed.

The largest area of trenches is on Knook Down, one and a half miles to the south of Imber village. This trench complex was used up to and during the Second World War. Its most conspicuous element, and one of the latest, is a deep and broad linear trench, probably part of an experimental anti-tank ditch, dug in 1943. To the east of it and overlying a long barrow and 'Celtic' field system are further trenches that, in plan, form a rectangle half a mile by a quarter of a mile, with a small honeycomb of subsidiary trenches in the south-east corner. More large trench complexes are present in the north and

to the west of the anti-tank ditch. This system, together with another on Chapperton Down, appears to have been deliberately shelled, and it illustrates how the military used pre-existing earthworks such as 'Celtic' fields and Bronze Age burial mounds. Three trenches, each measuring between a hundred and 150 yards in length, are situated on rising ground with the firing trench on the brow. An isolated, crenellated trench lies a hundred metres in front of the firing trench. The firing line is approached along a communication trench extending half a mile from the valley bottom in the south, and, significantly, the trench uses the five-foot height of a lynchet to provide additional cover from the west.

In total, some 2300 archaeological sites have been recorded in the Salisbury Plain training area, of which 551 are scheduled as Ancient Monuments. The extent and diversity of the remains is remarkable, as is their survival as earthworks, which are acknowledged as some of the best preserved in western Europe. This survival can be put down to the fossilization of the landscape since being taken into military ownership at the end of the nineteenth century: the military occupation of Salisbury Plain over the past century has limited the spread of intensive agriculture, with its joint threat of ploughing and fertilizing, and has encouraged the survival of huge areas of unimproved grassland. This type of grassland was once widespread across the chalklands of southern England but is now found only rarely, Salisbury Plain being the single largest area in north-western Europe. Chapperton Down is situated on a north–south ridge towards the east of Salisbury Plain. The earliest monument on Chapperton Down is a Neolithic long barrow, known as Kill Barrow, whilst two Bronze Age round barrows are also recorded. There is also evidence of an extensive series of linear boundaries, thought to be ancient territorial markers found over Salisbury Plain, running east–west from the vicinity of Kill Barrow. By the late prehistoric period, the landscape was also covered with distinctive field systems, which continued in use into the Romano-British period. Indeed, Chapperton Down is best known for an extensive Romano-British settlement, which covers some 110 acres and comprises a series of house platforms aligned along a central street over half a mile in length running along the spine of the ridge. At the end of the Roman period the site was abandoned and reverted to grassland; apart from occasional interludes of cereal farming, it has remained under grass ever since.

Like Salisbury Plain, the village of Tyneham and the Lulworth range were heavily used for military purposes. In September 1916, the first tanks went into action on the Somme. By the start of the following year, the Machine Gun Corps (Heavy Branch) – and later the Tank Corps – moved from Elveden, Thetford and Bisley to Bovington Camp, on Dorset heathland. Eventually, a full-calibre gunnery range came into being on the Dorset coast, east of Lulworth Cove, and, in time, this became the Gunnery School of the

Tyneham deserted village in Dorset, known as 'The Village that Died for England'. It was abandoned during the Second World War, when it was incorporated into a training area for the Tank Corps.

Tank Corps Depot. After the war ended, the area was compulsorily purchased by the War Office and extended eastwards to reach Arish Mell.

In September 1939 the area of land occupied by the Army for all purposes, including training, was 235,000 acres. By February 1944 this had risen to 9.8 million training acres alone. Land was required for infantry, tank and beach-assault training, and for weapons practice. Coastal sites involved use of both the land and the seabed, as designated by navigational exclusion zones. Where the land was selected, often requiring the expulsion of its civilian population, camps for the incoming troops had then to be built. The villages and farms occupied by the civilian population prior to their removal are also now part of the military landscape.

By 1943 it was becoming increasingly clear that the Lulworth range was inadequate for training purposes. The development of more powerful weapons, the long distances required for safe high-explosive firing, the need for more realistic battle training in fire and movement, and a general expansion in personnel (and associated training needs) meant that there was an urgent need to expand the area of the range. The story of the resulting evacuation of nearby Tyneham is recorded in the series of half-yearly reports

on the progress of the Royal Armoured Corps. The report for early 1943 commented that 'the range at Lulworth has been rendered quite inadequate by virtue of the necessity for longer ranges and high explosive shooting to cope with the modern guns'. The next report noted that this problem had been solved: 'Fortunately, it was possible to obtain a larger area in the vicinity, otherwise the removal of the [Gunnery] School with all its training repercussions, would have had to be forced.' This bland phrasing hid the story of the eviction of the inhabitants of the village of Tyneham and of two smaller settlements at Povington and Worbarrow, and of a number of isolated farms, all within the extended range. The inhabitants left just before Christmas in 1943, many with the understanding that they would be allowed to return at the end of the war, under a promise later known as 'Churchill's pledge'. A note was left pinned to the door of the church: 'Please treat the Church and houses with care. We have given up our homes where many of us have lived for generations, to help win the war to keep men free. We shall return one day and thank you for treating the village kindly.'

After the end of the war, it was anticipated that the Army would vacate the Heath range area. Instead, the ranges were still being developed, apparently for permanent occupation, and a programme for a tank gunnery demonstration held at the Gunnery School in April 1946 indicated that the wartime extension of the ranges was to be permanent:

> The development of tank guns during the war made the extension of the ranges essential. It was therefore decided to use the heathland between Wareham and East Lulworth for long-range firing. The maximum range for HE shooting is 5000 yards. The battle area is south of the Purbeck Hills in the Tyneham valley and, although small, offers scope for a useful battle practice with a somewhat restricted arc of fire. The ground in the valley is good for tanks and can be used all the year round.[10]

The local authorities, in association with local landowners and several MPs, approached the War Department about releasing some of the land it held in Dorset – and in particular the Tyneham area. A public enquiry followed, after which Louis Silkin, the Minister of Town and Country Planning, announced the outcome in July, telling a public meeting that when the pledge was given it was assumed that, if the war were won, the country would be 'in a position to prevent aggression, at any rate for a long time in the future'. After the defeat of the Axis forces, however, Britain needed to 're-arm and prepare for a fresh war', this time with the Soviet bloc. In *The Village that Died for England*, Patrick Wright observed that the village that had already died for D-Day was 'going to have to die all over again for the Cold War'.

From 1946 onwards, Tyneham ceased to exist as a real village but formed part of the myth of a lost English idyll, supported by occasional journalistic

visits and the publication of Lilian Bond's *Tyneham: A Lost Heritage* (1956).[11] The Army contributed to myth ensuring that it became common currency – the Elizabethan part of Tyneham House was taken down by the Ministry of Works in the late 1960s and parts were reconstructed at Athelhampton and Binghams Melcombe. One of the great ironies of the various campaigns to release MOD land in Purbeck and elsewhere has been the gradual realization that the Gunnery School's presence at Lulworth and Tyneham may not only have been of benefit to the local economy, but also to the environment. The campaigners in the late 1960s were concerned with the negative effects that the Army's use of land was having on wildlife. They reported craters in Worbarrow Tout, damage to Gad Cliff's crags, rifled badger sets and – especially – the potential risk to wildlife created by firing wire-guided missiles. Halfway through the Friends of Tyneham campaign, however, some protesters began to realize that the Army may have been more of a positive impact on the environment than commercial development. Once it was clear that application of rules to release MOD land meant that the ranges would first have to be offered back to their former landowners, Friends of Tyneham began to consider what impact this might have on the environment. Visions of caravans, extensive ball-clay quarries and factory farming were conjured up in an attempt to swing public opinion behind the National Trust 'option'.

The range area began to be regarded for its environmental 'purity'. An article in the *Observer* eulogized that the coast was 'virginal, inviolate, usually unapproachable and majestic'. 'The wildlife does not appear to fear the shells or the bullets. Explosives seem to demand less of local life than man. I would leave it all for our time as it is. Here, by chance, we have laid up treasure.' The Army has also preserved three medieval field systems in the deep valley around Tyneham, as well as the earthwork remains of three small associated hamlets. High on the hillside above Tyneham valley, littered with unexploded shells, the field systems associated with the adjacent Iron Age hill fort of Flowers Barrow survive, while further south similar fields have thirteenth-century plough-ridges on top of them, with traces of eighteenth-century ploughing near by. Without the Army to protect them, there can be little doubt that these remains would have been ploughed out long ago.

The work undertaken since 1975 to improve access to the Lulworth and Tyneham ranges had a significant impact – but not to everyone's liking. The 'upgrading of public access facilities and the insistent considerations of public liability have significantly altered the "unspoilt" qualities of the village'. Cottage walls have been lowered and capped with concrete, strips of wood keep the window frames in place, and there are picnic tables and a very large car park. Tyneham is, nevertheless, a favourite picnic spot for visitors, and as an example of a twentieth-century deserted village is as well preserved and presented as could be hoped for.

An abandoned village on the Stanford Artillery Training Ground in Norfolk.

The Stanford Artillery Training Ground in Norfolk is made up of an area of about 30,000 acres. It was taken over during the Second World War and has remained in the hands of the military since then. It is of particular interest to the landscape historian as it contains a group of four parishes, which, when they were requisitioned, included six villages and their associated landscape as well as a country park. The villages of Stanford, Buckenham Tofts, West Tofts, Langford, Tottington and Sturston were displaced when, in 1942, the Stanford range was expanded. Although little direct damage was done by the Army to the buildings, the villages have largely disappeared, leaving the parish churches as markers of the former rural landscape. Otherwise, only the shells of a row of council houses at Stanford, built in the 1930s, remain. These council houses were constructed with brick walls and tiled roofs, unlike houses in the rest of the village, which were of cob and thatch. Accordingly, as soon as the roofs of the latter disappeared, the rest of the house simply dissolved under the impact of wind, frost and rain.

Buckenham Hall, an elegant nineteenth-century country house in the area, was dismantled in the 1950s, and only the footings of the buildings and the immediate garden area can today be identified in the form of earthworks. On the other hand, the churches of All Saints Stanford, St Andrews Langford, St Andrews Tottington and St Mary's West Toft are well maintained by the MOD and remain consecrated to be used occasionally throughout the year. The parishioners who visit the churches on these occasions are amongst the few non-military personnel to have access to the abandoned area. As a consequence, the area is a rich oasis of natural fauna and flora on the edge of the Norfolk Brecklands. The training grounds incorporate six Sites of Special Scientific Interest as well as twenty-six scheduled ancient monuments.

Amongst the rarer inhabitants are otters and the stone curlew. The quiet walk through these lost villages feels like taking a step backwards in time to the original villages, albeit without the people and animals that would have inhabited them.

Hornchurch Airfield

The airfield at Hornchurch, in Essex, is now called Hornchurch Country Park. The only explicit reminders of its wartime role are the road names, which recall some of the more famous pilots who flew from here and other Essex airfields. Closer examination, however, reveals a considerable amount of evidence, from the scattered brick and concrete fragments of airfield buildings in the soil right through to pillboxes and a virtually unaltered skyline. Excavations have revealed gun emplacements and a range of other defensive structures.

Hornchurch was conveniently located close to London and the Thames, and just far enough from the Channel to render it less susceptible to the regular bombing raids which afflicted Manston, Kenley, Hawkinge and Croydon (amongst others). Sutton's Farm, Hornchurch, occupied by the Crawford family and owned by New College, Oxford, was one of the new air bases created in a ring around London during the First World War. Successes against enemy airships in late 1916 brought one of the Hornchurch pilots, Lieutenant Leefe-Robinson, a Victoria Cross. Although Hornchurch was returned to the Crawford family at the end of the First World War, it was eventually decided that the site had long-term strategic importance, and in 1928 the airfield was reopened and named RAF Hornchurch. During the succeeding ten years the airfield was used for displays and training. By 1938 Hornchurch had been prepared as a Sector Headquarters in No. 11 Group of Fighter Command, which oversaw the protection of south-eastern England and subsequently played a significant role in the Battle of Britain. Hornchurch was essentially an open grass field, with a cluster of buildings – hangars, messes and stores for fuel and ammunition – on the north-western edge and surrounded with a perimeter road, fortified by pillboxes and barbed wire.

A series of photographs taken in September 1940 show Hornchurch in full operational mode. Remarkably, much of the skyline is unaltered today. Although Hornchurch survived as an airfield after the war, it was closed in 1962 and became a quarry, while the area of former RAF buildings was built over with a modern housing estate, the boundaries of which approximately reflect the original zone. The backfilling of the quarry has restored a little of the appearance of the original aerodrome, but the subsequent growth of bushes and young trees has destroyed any sense of an open grass runway.

In spite of this, the site still exhibits some of its original infrastructure.

To the west and south, stretches of the perimeter road stand exposed from the scrub, and on the eastern side, close to the stream, the elevated land surface stops abruptly alongside the fighter pens that clustered around the perimeter. These pens consisted of three earth embankments arranged at 90° to create a three-sided enclosure, allowing aircraft to be dispersed around the field such that it would be difficult to destroy all the planes on the ground in a single sweep. The embankments also prevented blast produced by a bomb from affecting machinery and installations in the less immediate vicinity.

Hornchurch Country Park lies within the Green Belt, close to the M25 and the A13. However, despite its proximity to London and the large number of visitors, the park still provides a range of different habitats for a wide range of plants and animals, with a mixture of open grassland, tree plantations, marshes, ponds, a lake and the River Ingrebourne. The river extends down the eastern side of the park with extensive reed beds, flood meadows and willow thickets, providing a nature reserve that has been classified as a Site of Special Scientific Interest.

Clifton Airfield

Clifton Airfield, near York, is typical of the many hundreds of airfields that were created and developed during the Second World War, only to be abandoned soon afterwards. The contribution to the landscape in this instance was to isolate a large block of open land relatively close to York. This land became available for development as a light-industrial park at the end of the century.

At the beginning of Clifton Airfield's history, on 27 May 1933, a travelling air show visited a large meadow at Rawcliffe Manor in Clifton, and not long after this the City of York decided, along with scores of other towns, to have its own civil aerodrome, choosing as its site the area known as Clifton Moor. The airfield sat in the Ouse Valley immediately to the north of York, between the Northallerton road and the Helmsley road. Its southern boundary was the Bur Dike, and to the north the airfield was bounded by the higher ground of Rawcliffe Moor. The grass landing ground, complete with a small hangar and clubhouse, was constructed in 1935 and was ready for flying by its official opening on 4 July 1936. From then up to the outbreak of the Second World War a successful flying club operated here.

In September 1939 the aerodrome was taken over by the Air Ministry and allocated to RAF Station Linton-on-Ouse, which decided to send its bomber aircraft there in case of enemy attack. Consequently, for the first few weeks of the war, 'A Flight' of No. 51 Squadron with its Whitley Mk 2 bombers stayed at Clifton Aerodrome. In the spring of 1940 the Air Ministry made plans to develop the airfield more fully, and erected wooden buildings

around the clubhouse area in the south-west corner. A canvas hangar was also provided, to be replaced by a steel 'T1 type' erected later in 1941. Later still in 1941 a complete RAF station was built on the south-east side, and accommodation was built for 500 personnel.

Because of the large number of bombers based in Yorkshire, the Ministry of Aircraft Production established a Civilian Repair Unit at Clifton in 1941. This involved the enlargement of the landing area to cope with bombers, three concrete runways, and the provision of a perimeter track. It was also at this time that numerous fighter pens and revetments were constructed for the resident RAF Mustangs, together with some twelve Blister hangars and flight-huts dispersed around the perimeter. The bomber repair and overhaul depots were run by Handley Page Ltd, and two large hangar complexes were built, one at the Rawcliffe village side to the west, the other at the Water Lane end to the south.

During the remainder of the war, some 2000 Halifax bomber aircraft were repaired or overhauled at Clifton by a large civilian workforce. After the war ended, nearly 1000 surplus Halifaxes were flown in from all over the country, and for the next two years the main task at the airport was the stripping down of these old planes. This resulted in a huge pile of metal, some 80 feet high, that became a landmark near Rawcliffe village. By mid 1947 all work came to an end and the airfield and the repair complexes closed down. Like hundreds of other disused airfields, the government did not dispose of the site immediately but, instead, leased the buildings near the main entrance to the Army. They in turn used them as offices and for storing Army pay records and equipment.

In 1949 the York Flying Club was formed, using Clifton Airfield as its base; due to its small membership it could not afford the rent asked by the Air Ministry, and it closed at the beginning of 1953. With the exception of the Water Lane hangar complex, which was retained as a Ministry of Agriculture corn store, the government finally sold the airfield to York Corporation in 1955. Encroaching housing development and lack of funds undermined a scheme to turn it into York Airport, and the airfield was leased out for livestock grazing. In the mid 1980s work began on developing the airfield into a light industrial park, housing estate and shopping complex. The Clifton Moor industrial estate now has a wide range of successful businesses. At the time of writing, the only major relics are the two hangar complexes, one used for agricultural storage and the other for light industry.

A similar fate befell Portsmouth Airport, which occupied a large flat area adjacent to the sea. Portsmouth Corporation were unwilling to make the necessary investment to make the airport a serious commercial concern in the 1970s, and it closed. Since then it has been subject to continual development, and is now covered with a massive housing estate, an industrial estate and an out-of-town shopping centre.

The Cold War

Although training for conventional warfare still has a major impact upon the English landscape, after 1945 the nature of global warfare changed forever with the development of nuclear weapons. The nuclear age brought relatively few obvious landscape changes; instead, alterations were subtle and clandestine. Regional Seats of Government were established as secret chambers, capable of withstanding a nuclear attack. It was here that it was anticipated administration would be carried on in the aftermath of a nuclear war. These places were so secret that they often appeared as blanks on the Ordnance Survey maps, which in itself excited interest amongst archaeological fieldworkers. There were nine Regional Seats of Government in England in 1963, spread evenly throughout the country. Existing Second World War underground war rooms were used at Cambridge, Nottingham and Dover, while at Drakeslow, Kidderminster and Warren Row, near Maidenhead, the RSGs were placed in Second World War underground aircraft factories. At Bolt Head, Devon, an existing RAF bunker was used. Little is known of the other three RSGs, as they were on the same sites as local military headquarters and remain in Army control.

'Monuments' of the Cold War were structures built, or adapted, to carry out a possible nuclear war to be waged between the end of the Second World

Cold War airfield at Bentwaters in Suffolk.

RAF Chicksands in Bedfordshire. A device known as Flare 9 or the Elephant Cage. It was one of only five built worldwide and was able to detect signals coming from all directions and determine their precise location.

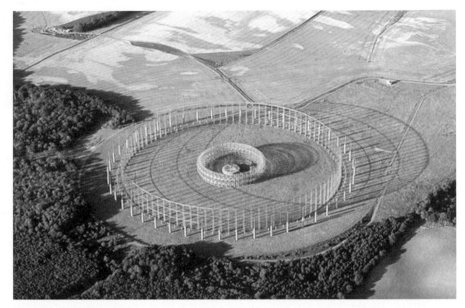

War and 1989. As such, these structures formed a significant, but relatively small, part of the post-1945 defence estate, many older sites having continued to meet the needs of the armed services. A distinctive feature of the Cold War was the permanent stationing by the United States of large numbers of their armed forces in England, at airfields such as Greenham Common, Upper Heyford and Lakenheath. The distinctive design and layout of the American bases reflected the different cultures (and disposable wealth) of the Cold War allies. The American bases were characterized by a wide range of stores and leisure facilities, alongside which their British counterparts looked somewhat spartan. Upper Heyford, Lakenheath and Greenham Common were turned into small American towns on British soil, but were different only in scale from earlier American bases. These airfields, which were used to house nuclear weapons such as the Cruise missile, had vast networks of underground facilities associated with them, virtually replicas of what was on the ground surface.

The architecture of the buildings of the Cold War was severely functional. Largely of concrete, steel and earth, it is an extreme example of the dictum that function dictates form. Nevertheless, some structures had strikingly innovative forms: the massive Rotor bunkers erected in the early 1950s, for example, represented a new type of architecture in the United Kingdom, based as they were on German wartime design. More often, however, centralized planning and the deployment of standardized weapons systems resulted in nearly identical site and structural types across the country, although minor variations were to be found, created by local landscape or building materials. Prefabricated structures, widely employed during the Second World War, continued to be used, and many minor buildings were

Old hangars at the US nuclear airfield at Upper Heyford in Oxfordshire. The site was abandoned at the end of the Cold War.

erected using prefabricated concrete or plywood panels, or were clad in asbestos sheets or aluminium sheeting – a postwar innovation. In contrast to the 1920s and 1930s neo-Georgian style, which was favoured for the more prestigious military buildings, the few prominent structures erected after 1945 generally followed contemporary functional and utilitarian designs.

Most Cold War structures were more significant for the technological innovations they housed than for their architectural style. The Cold War arms race was, with the space race that was part of it, the chief driving force behind technological advance in the late twentieth century, and new systems replaced old in a bewildering sequence. Information technology dominated all areas of military planning, and within the divided world of the Cold War the seeds of the modern global information age were sown: many now common components and systems (including the transistor, modem and Internet) resulted from military projects. The introduction of the germanium transistor also influenced the design of buildings, as computers could be made smaller and the ventilation equipment required to cool hundreds of valves was no longer needed.

A number of Second World War airfields were also adapted in order to cater for new Cold War needs. Many of these were in eastern England, in East Anglia, Lincolnshire and Yorkshire. Although the nature of the bases was transformed by missile storage and launching facilities, the overall lasting impact on the landscape was limited. 'Concrete ... is the defining construction of the Cold War age' according to Neil Cossons. 'From it were created miles of runways and dispersal bays, observer posts and bunkers, hardened shelters, missile launch pads and test stands.' [12] With the end of the Cold War in around 1990, Upper Heyford, amongst other bases, was at

first mothballed and then closed. The search for an alternative use continues at the time of writing. An area of 2000 acres of flat land already supplied with essential services in the middle of rural Oxfordshire is incredibly tempting for governments seeking to increase the number of new houses by over one million by 2033. At Greenham Common, the Cruise missile bunkers have been preserved, and while most of the base has been given over to a large industrial estate, the remainder has been returned to common land.

Another, less obvious, manifestation of the nuclear age was the development of nuclear power plants. In 1956 Calder Hall, on the Cumbrian coast, was the first industrial-scale nuclear plant to be opened in Britain. It had the appearance of a conventional station, but with four nuclear reactors and four of the mammoth cooling towers that characterize all post-Second World War power stations. When it opened, the claim was that the plant would produce electricity 'too cheap to meter'. In fact it proved to be the most expensive way possible of generating electricity, and it eventually emerged that the main reason for building Calder Hall was not to provide cheap electricity but to make plutonium for the nuclear weapons programme. Eleven nuclear power plants were opened in Britain, but they managed to produce only 10 per cent of the country's electricity. For a while nuclear energy was seen as the way forward, but with the discovery and exploitation of North Sea oil and gas from the 1970s onwards the imperative for Britain to find an alternative source of power diminished for the time being. Also, concerns about the long-term dangers of nuclear power became a major problem as the century wore on. In the event, several nuclear plants had closed by 2000, and Calder Hall closed in 2003, but it will be well into the twenty-second century before the land will be safe to be used for alternative purposes. As the pressure on fossil fuels grows, a strong lobby for future investment in nuclear power is once again flexing its muscles.

At the end of the century, the Cold War was over, but war was as much a feature of life as ever. The talk was of waging war in space, that is, until 11 September 2001.

The Seaside

Yes, Bournemouth has certainly changed and if August Bank Holiday 1938 was anything to go by a good many residents must have emphatically decided that change has not been for the better.

Bournemouth Times, August 1938

N o previous society flocked to the English seaside like the Victorians and Edwardians – a fashion that was to continue throughout the twentieth century and to transform coastal England. During the twentieth century, the English coastline came under increasing pressure as the holiday industry continued to expand and coastal resorts spread to accommodate large numbers of holidaymakers and full-time residents. Additionally, industry in the form of oil refineries and, later, nuclear power stations required coastal locations, and new ports were developed to cope with the container revolution. Tilbury, Bristol, Felixstowe and Immingham expanded greatly as the use of containers as a means of conveying goods for import and export became universal. Former maritime activities, however, declined.

Typical seaside scene *c.* 1910.

Shipbuilding and even commercial fishing almost disappeared during the course of the century. As early as 1946 the *Little Guide of Sussex* did not try to hide its disappointment at the nature of coastal development and commented, 'It cannot be denied, of course, that much of the coastal fringe has now lost whatever natural charm it possessed ...'

Seaside resorts developed into distinctive urban environments; typically, they were a combination of formal gardens and funfairs. There was a mixture of promenades, piers, lidos and public gardens and lawns, resulting in a new environment catering for a mass market. In the last decades of the twentieth century, the character of many resorts changed as the number of residential holidaymakers declined. Many people still wanted to live close to the English seaside, and bungalows, apartments and mobile homes continued to sprawl along the coast where permitted, but far fewer wanted to spend their annual vacation by the English coast. Such municipal investment that there was tended to go into amusement arcades or low-grade public amenities. Some resorts attempted to compete with Mediterranean resorts by offering family theme-park holidays, while others went spectacularly downmarket.

The concept of 'open' and 'closed' villages, used by geographers to distinguish those rural settlements that had a strong central authority (closed) and those where such authority was absent (open), was applicable to coastal resorts, particularly before the First World War. Closed resorts tended to be well ordered and sedate, and were developed to attract largely middle-class visitors; entertainments were strictly monitored and outside elements tended to be excluded. In contrast, open resorts allowed a range of different attractions to move in; there was far less emphasis on manicured lawns. In 1900, Blackpool, Margate and Southend were examples of open resorts, while Eastbourne, Torquay and Bournemouth were closed. As with villages, the concept was modified over time, and parts of a resort might demonstrate elements of both categories.

The Duke of Devonshire's development of Eastbourne was typical of the closed resorts. The Duke's agent, George Ambrose Wallis, managed to obtain a strategic position of power on the local authority and imposed the Duke's will, which included the banning of donkeys on the beach and the Sunday marches of the Salvation Army. The Duke demanded minimum building standards, made-up roads and drainage, and planned public ways in order to attract the Edwardian middle classes. He also restricted the number of public houses and other developments which might bring in the 'wrong sort' of visitor, such as fairgrounds on vacant lots and stalls in front gardens. He provided land and resources for parks, promenades and piers. By 1901 the population of Eastbourne had reached 43,000, making it the second largest town in Sussex. 'Cornfields and barns [had] given place to substantial shops and dwelling houses, almost from one end of the parish to the other' and the 'Belgravia of Eastbourne', with wide, tree-lined streets and spacious villas,

stretched from the seafront to Compton Place. Under patronage, hotels, baths, pavilion, park and pier, and full civic amenities, accompanied this development. Market forces made themselves felt, however, and Eastbourne did not make money, and eventually the Duke withdrew his patronage from the resort.

Along the coast, to the east, the population of Bexhill increased by over 3000 in 1881, reaching 15,330 by 1911. The enthusiastic promotion by the eighth Earl de la Warr, the 'Maker of Bexhill', ensured success. In the late nineteenth century the Earl built a sea wall and esplanade, and established other attractions such as a kursaal, a cycle track, a golf club and the Sackville Hotel, the latter used by the Earl for his *fin-de-siècle* parties. As with many of the southern resorts, social leadership set the tone; the Earl was also mayor. Bexhill, like a number of south coast resorts, attracted the children of imperial civil servants to its private schools, located in genteel surroundings. The aristocratic 'one-man towns' of Folkestone, Eastbourne and Bexhill established a recognized tone that was generally successfully maintained by later local government boards and councils. The importance of landowning connections was prized, and when resorts enjoyed royal visits, whether to eighteenth-century Brighton or twentieth-century Bognor, status was greatly enhanced.

The 'closed' resorts were also characterized by the wealth of their visitors and by a winter season. Agatha Christie, in her *Autobiography* (1977), described Torquay as being made up of 'villadom' of good quality; grand hotels and a regatta in late August which emphasized that the resort was an expensive playground. Torquay was 'a winter resort ... the Riviera of England, and people paid large rents for furnished villas there, during quite a gay winter season with concerts in the afternoon, lectures, occasional dances, and a great deal of other social activity'. Typical of the permanent residents were 'fat old ladies with obese landaus', occupying ample villas with 'clipped hedges and shaven lawns'.

In 1893, Bognor had been 'a quiet little place of eminent respectability and unimpeachable sanitary record'. Villas were the fashion here too until, in 1929, King George V convalesced at Bognor, giving the town its 'Regis' suffix and a renewed lease of life. In 1929 the West Bognor Estate Company was formed to develop Aldwick and Pagham, and the usual rash of mock-Tudor and neo-Georgian villas appeared to the west. To the east of the pier, meanwhile, smaller plots of land, by the sewage outflow, were being acquired by Billy Butlin, who became a local celebrity in the 1930s. A new type of entertainment, for different groups of people, was about to burst on Bognor in 1939.

Bournemouth was always a sedate resort; in the 1860s its councillors had fought a rearguard action against the railways for fear that an influx of plebeian visitors might put off the wealthy invalids who patronized the town.

In so doing, they almost killed off Bournemouth as a resort. In the 1930s they forbade whelk stalls on the seafront, and slot machines on the pier were banned well into the 1960s.

By 1881 the population of Bournemouth had already reached 16,859. It had grown to 78,674 by 1911, an expansion which transformed Bournemouth from a quiet backwater into one of the major towns in the country. Resorts built on traditional lines, with a row of hotels and shops directly opposite the seafront, were considered unfashionable by the 1920s. The authors of guides to resorts that were of later vintage and built differently were keen to mention this point. Bournemouth's *Guide* in 1926 tells us: 'Its seafront is not disfigured by rows of shops or terraces of houses ... Its numerous hotels and boarding houses and private residences lie half hidden amongst the pine trees and well-kept gardens.' The *AA Hotel Handbook of 1938* listed no fewer than 120 appointed hotels in Bournemouth, five of them receiving the organization's highest five-star classification. That was nearly 50 per cent more than any other seaside town.

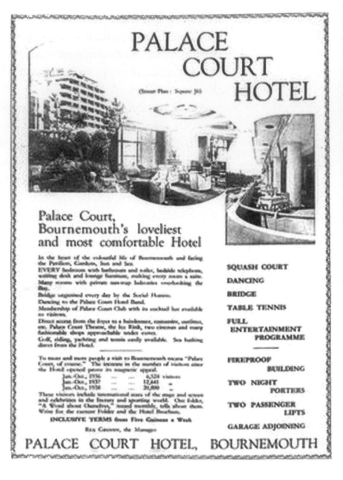

Advertisement for the Palace Court Hotel in the 1930s – a new type of hotel offering luxury and entertainment to the wealthy middle class

An unusual closed resort was Clovelly, in Devon. Clovelly was (and is) a picture-postcard village of cottages along a steep main road leading down to the sea, where a fishing port for herring had developed from the sixteenth century. There is universal agreement that Clovelly is romantic and picturesque. It began to emerge in the nineteenth century as a favourite tourist spot after Charles Kingsley, whose father was rector here, published *Westward Ho* (1855), in which Clovelly features prominently. Dickens also wrote about the village in *A Message from the Sea* (1860). Murray's *Handbook to Devon and Cornwall* of the 1850s recommended Clovelly for its beauty and solitude to the discerning traveller, but by 1895 the *Handbook to Devon* reveals that this solitude had ended and that there were by then three hotels and several lodgings. The handbook complained about the rash of notices advertising refreshments and the flood of tourists from the excursion steamers that docked by the old pier.

The high street was too steep for early cars, and the Hamlyn family, who owned the estate, made a virtue out of necessity and maintained Clovelly as a motor car-free village. They had also introduced a number of other measures typical of closed settlements to ensure that it maintained its charm and character. When H. V. Morton visited Clovelly in the 1920s, he clearly found it over-regulated.

> Clovelly is difficult to write about because it is the old-established beauty queen of England; and knows it. It cannot be left out of any tour because it is unique: an English Amalfi rising sheer from the bay. Beneath its apparent simplicity is a deal of artifice; it is a beauty spot that has been sternly told to keep beautiful. Its washing is displayed discreetly on a certain day. No signs disfigure its bowers: no motor car may approach within half a mile of its sacrosanct charms, and when an old cottage dies it rises phoenix-like from its ashes exactly as it was, looking at least five hundred old, but with 'C. H., 1923' inscribed on it. Those two initials are the secret of Clovelly. Behind its beauty is an autocrat, the lady of the manor, Mrs Christine Hamlyn, who owns the town.[1]

The Hamlyn family lived at Clovelly Court and had owned the village since the mid eighteenth century. Sir James Hamlyn (d. 1829) landscaped the coast to the east of the village, creating what is known as the Hobby Drive, and other parts of the adjacent coastline were redesigned in the Romantic style. In one respect, Morton was wrong in his description of Christine

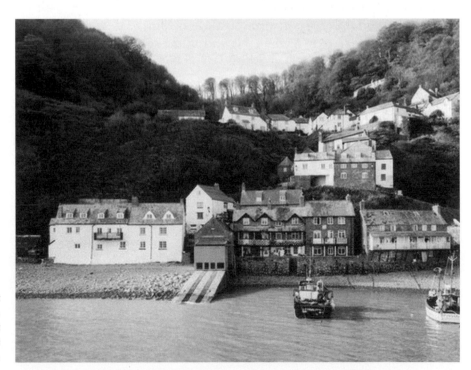

The harbour at Clovelly in Devon. A 'closed' resort throughout the twentieth century.

Hamlyn. She did spend considerable sums of money on restoring and rebuilding the village, mainly with the fortune of her banker husband Frederick Gosling, but her choice of architecture was eclectic and she built in a wide range of styles, which included mock-Tudor cottages and the Arts and Crafts New Inn. The village and estate remain in the hands of Christine Hamlyn's descendants, who, with income from tourism, are maintaining the village in its historic 'closed' form.

The open resorts, on the other hand, provided a wide range of entertainments. Many of the larger resorts adopted 'pleasure palaces' behind their promenades. There were Aquaria, Winter Gardens, Towers, Halls and Alhambras catering unashamedly for a working-class market, usually northern or metropolitan, with popular concerts and music hall, zoos, circuses, aquaria, roof gardens, exhibitions of exotica, and fairground rides, all for a single admission fee, usually of sixpence. The distinctively 'seaside' aspects of these ventures lay in their scale and elaboration, and the exotic exuberance of their architecture and decor, which, in the largest and most popular resorts, went beyond most that was on offer in the big industrial towns or even London.

The Seaside Pier

Piers were some of the great public civil engineering works of the nineteenth and early twentieth century. Seaside piers normally had no other function but to provide entertainment, and their presence confirmed the status of a resort as a successful purveyor of enjoyment. Piers continued to be built up to the First World War at a few resorts such as Minehead, which acquired a modest promenade pier. At the other end of the spectrum was the Palace Pier at Brighton, opened in 1899, which was almost a resort in its own right

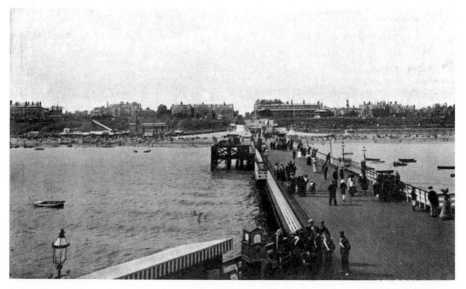

The pier at Clacton early in the twentieth century. Clacton was an 'open' resort and at this stage almost as popular as Blackpool.

The Grand Pier
and front at
Weston-super-Mare.

with its own theatre, bandstand and winter garden. Only nine new piers were built between 1900 and 1910, and these included a replacement for Great Yarmouth's popular Britannia Pier, and the impressive new Grand Pier at Weston-super-Mare. The last Edwardian pier to be built was at Fleetwood. The occasional new proposal, as at Hove, came to nothing, and a long period of conservation and development of existing structures set in.

In 1906, Morecambe's Central Pier offered dancing all day, with two bands daily; a morning promenade concert; two concert and variety entertainments daily; two sacred concerts every Sunday; steamer services to other resorts; and 'Grand Aquatic Performances and Sensational Diving into the Sea'. A similar programme continued into the interwar years, and ramshackle piers with their bandy-legged struts sometimes seemed to stagger under the weight of their indoor attractions, from which the noise of the waves could still be heard between the performances. The First World War, which, like the French Wars a century earlier, brought wealthy holidaymakers back to their own island coastline, propelled some favoured piers upmarket for a time. Thus both the Brighton piers took on high-class orchestras to meet the new demand, as fashionable promenaders reappeared in strength. But this was only a

temporary reversal of an overall downmarket trend. Orchestral music gave way to dancing in the postwar years, and then even to 'wireless concerts', while the Palace Pier's Pavilion moved over from concerts to a new use as 'a so-called Palace of Fun', with 'stalls, automatic machines and sundry other attractions for the use of the general public'. Games of chance and 'What-the-Butler-Saw' machines were essential to the profitable future of many piers.

The New Palace Pier at St Leonards was a particularly impressive example of this type of pier. It was effectively rebuilt in 1933, with a deck area more than four times that of the largest Blackpool pier. There was room for more than a thousand dancers on the sprung maple floor of its ballroom, and it had a sun lounge as well as a café. It also boasted 'the most extensive and modern range of Automatic Machines on the South Coast' as well as dodgems, skittles, darts, shooting ranges, bars, shops and kiosks. It was in fact a full-scale fairground suspended above the waves, and in 1936 it attracted a million visitors.

The only post-Second World War pier to be built was a replacement for the 1864 pier at Deal, in Kent, which had been severely damaged in the war and was demolished in 1954. The new pier (1954–57) was built entirely of reinforced concrete. Some English piers were dismantled during the Second World War amidst fears of enemy invasion. For example, half of the pier at Cleethorpes was demolished and never rebuilt; it still retains a curious stunted appearance. After the war piers gradually fell out of fashion, and many of them, such as that at Clevedon, became derelict. Fortunately, in recent years, seaside piers have joined the company of steam trains and canals as nostalgia monuments, and, in the late twentieth century, Clevedon's pier was refurbished and reopened. Many others, however, have not survived. They have been damaged by storms

A London and South Western railway postcard advertising the attractions of Swanage *c.* 1910.

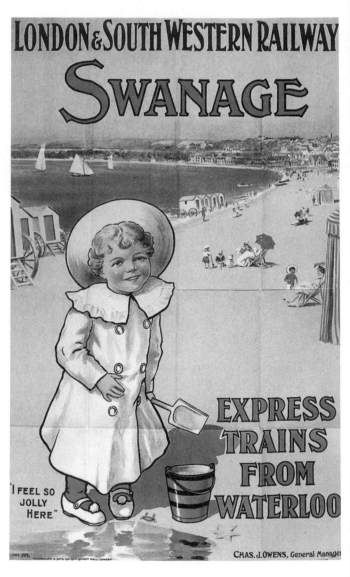

or fire, and abandoned. One curious survival is the long pier at Southport which, because of the build-up of coastal silt, now sits high and dry on top of a municipal park laid out on land created by coastal retreat. Possibly because of the protection afforded by the receding coast, Lancashire has some of the best surviving piers in England, notably the exotic structure at St Anne's-on-Sea (opened 1885) and the North Pier, Blackpool (1863).

Piers proved vulnerable to storm, fire and maritime collision, as well as to the consequences of neglect by proprietors who had come to find their upkeep an expensive liability. Of the eighty-five piers to have been built around the coasts of England and Wales, sixty-five of which existed at the system's peak in 1900, only fifty-three remained in 1976. A few were Victorian and Edwardian casualties, and three went between the wars, among which Ramsgate remained unrepaired after a First World War mine exploded against it. But a pattern of closure and demolition really began in the 1950s, when piers were beginning to feel their age and all things Victorian were still deeply unfashionable. Minehead was a direct wartime casualty in 1940, and others never recovered from being breached during the war. The standard, and widespread, postwar pier architecture involved an obsession with amusement arcades, slot machines and bingo. New pier architecture tended to be box-like and utilitarian, in contrast to the filigree and fantastical of the Victorians, while concrete often replaced or encased the characteristic wrought-iron work. Piers were not entirely finished, however; new restaurants were provided, along with bars, nightclubs and shops. In many more there were new arcades, fairground rides, and even bowling alleys. Such adaptability was controversial. The piers began to benefit from the nostalgia and heritage boom from the 1980s; but the future of many remains uncertain.

Between the Wars

Hastings with St Leonards was a conservative resort in the 1920s, and in 1926 there had been a petition to introduce a 10 mph speed limit along the sea front. At Hastings, the struggle between fishermen and local government for access to and use of the eastern Old Town beach and its surroundings can be traced through from the 1820s to beyond the Second World War, as successive attempts were made to move the fishermen further eastwards and develop their land and thus deprive them of land for boat and net storage. The local fishing industry declined steadily through the first third of the twentieth century, and, from the mid 1920s, a forceful Borough Engineer, Sidney Little, was given the brief of 'bringing the town up to date'. Little adopted Thomas Adams's proposals for a new road to clear the 'slums' of the Old Town, while using its beach for day tripper amusements. Fierce opposition from residents delayed the start of the redevelopment until 1938, just in time to leave the centre of the Old Town, with its vernacular buildings,

'derelict and devastated' during fifteen years of war and austerity. Meanwhile, the beach had acquired a new car and coach park, and part of the fishermen's quarter was lost to a boating lake, although some of the furnishings of the fishing industry were preserved by the Fishermen's Protection Society. In a final postwar push, the local authority sought to demolish all the seafront housing in the fishing quarter and replace it with an amusement park, in order to entice visitors away from the more genteel west end. This scheme was rejected in 1946, after a public outcry, and the fishermen and the remains of the Old Town were preserved, to become a much photographed and cherished feature of the town.

In the early 1930s, the town's tramways were ripped up to make way for a new promenade, built in reinforced concrete. The new front was a 'double decker', with an upper and lower walkway. The lower walkway was built in a utilitarian style, but was relieved by decoration made from different-coloured broken glass set into the concrete, and was known as 'Bottle Alley'. The glass came from a large quantity of broken bottles that Little discovered on a rubbish tip. An underground car park was also constructed as part of the development; it is still there today, quite inadequate for today's require-ments. As early as 1927, a campaign started in Hastings and St Leonards for a new outdoor pool, spearheaded by the *Hastings Observer*. A scheme was finally approved in 1931 and Little was commissioned to design the building, which, characteristically, he did in reinforced concrete; it was built on a massive scale: 330 feet by 90 feet, making it nearly as big as Blackpool's. From the air, the plan resembled a classical amphitheatre, with curved stepped terracing for spectators on one side and a curved deck for sunbathing on the other. At the centre of the pool was an impressive array of diving boards up to 30 feet high, constructed from blocks of concrete. The pool was opened to the public in June 1933. The Hastings and St Leonards *Official Handbook* for that year describes the pool's many other attractions:

> One of the novelties is a café which provides an enclosure accessible only from the bathers' deck. There are three promenades viz a spacious top walk around the pool, a second screened with Vita glass to 'bottle' the sunshine in windy or cold weather, and a third, roofed, but open to the sea. Sunbathers have two special decks all to themselves. The terraces accommodate 2000 sitting spectators ... The whole structure is of reinforced concrete, faced with squares of tinted cement, most pleasing to the eye ...

In spite of the pool's many contemporary features, it was really too big for the town. The Black Rock Pool at Brighton, built around the same time, was only half the size. As early as 1946 the town council tried to find someone to take over a lease on the pool. Eventually it was turned into a holiday camp, and was finally demolished in the 1980s. Little earned the title of 'Concrete King'. He was later to put his engineering skills with concrete to national use when

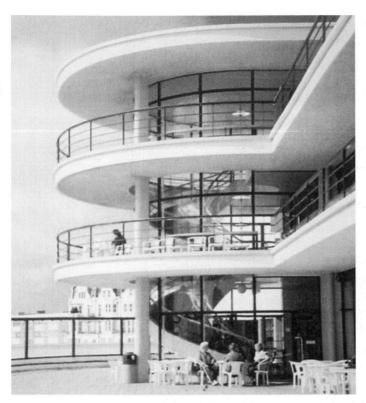

The De La Warr
Pavilion, Bexhill.

he was involved in the construction of the Mulberry floating harbour used in the D-Day landings in Normandy in 1944.

In the West Country, when Penzance extended its boundary to include Newlyn, the local authority proposed to demolish most of the village, making room for an improved coastal road to Mousehole, and to move the inhabitants to a new estate at the top of a steep hill. It took the Second World War to stave off the proposed redevelopment. At Lowestoft, however, the war applied the *coup de grâce* to a less picturesque fishing community. Here, the Victorian flint and brick terraces known as Beach Village, which had played host to many impecunious holidaymakers, were evacuated and used by the Army for streetfighting practice and then demolished, the inhabitants being rehoused on council estates. When clearance was completed, an industrial estate occupied the site of the old village.

At Scarborough, in 1938, planning consultants complained about the insensitivity of piecemeal redevelopment of parts of the 'Old Town' fishing quarter under the Housing Acts, and urged that the positive value of what remained should be safeguarded:

> The old village should be regarded not only as a collection of cottages for fishermen but also as a special feature of interest to Scarborough. As time goes on visitors to our seaside resorts are more and more attracted by the quaintness and beauty of these old relics of the fishing industry ... it is important to retain as far as possible its original character, in particular the charming character of the eighteenth-century houses which in broken outline form the façade of the harbour.[2]

The planners drew attention to preservation work at Whitby, St Ives and Plymouth, and to the popularity with visitors of old fishing villages, such as Polperro and Clovelly; and they made specific recommendations for the Old Town. They also suggested other alterations, drawing attention to:

> the character of a street of old three-storey fourteenth-century wooden houses, with the open space formed by the removal of the old buildings between

Tindall Lane and Parkins Lane made to look like an old English market place. This is a suggestion that would make the place attractive and at the same time preserve, in outward appearance at least, the character of the village.[3]

The interwar years brought new architectural styles to the seaside. The eclecticism of the late Victorians and Edwardians had produced a distinctive resort architecture, which helped to define the seaside as a desirable and distinctive location. This was replaced by the smooth lines and flowing curves of Art Deco, with a nautical theme. This was above all a development of the 1930s, and it found expression more in recreational rather than domestic architecture. A new block of flats, called Marine Court, was built at St Leonards in 1937, replacing a terrace of Victorian houses. It was described as 'a liner on land', and was inspired by the *Queen Mary* ocean liner. Immediately below Marine Court, a sun lounge was built on the lower deck of the promenade in 1937. This could seat up to a thousand people, and at the time it was a major social rendezvous.

The most impressive and enduring manifestations of the trend were the De La Warr Pavilion at Bexhill, Joseph Emberton's Pleasure Beach casino at Blackpool, and the Midland Hotel at Morecambe with its Eric Gill murals. Indeed, to the limited extent that modern architecture found favour in interwar England, it attained its greatest popularity at the seaside resort. Nautical references such as porthole windows, curved walls, sun decks and railings all entered the vocabulary of Modern architecture in the Twenties and can be found in seaside resorts throughout England in domestic, hotel and entertainment architecture. In the 1930s there were several new hotels built in the Modern style, such as the Midland Hotel in Morecambe Bay, built for the LMS Railway. This was an ambitious building, whose curved structures followed the line of the coast. Such hotels, which, unlike the earlier Edwardian hotels, did not provide for servants, appealed to the affluent, normally travelling by car. They were able to compete with the French and Italian resorts that were now attracting many wealthy British tourists.

Bournemouth had two modern hotels, the Cumberland and the Palace Court. The Cumberland was like an Aztec temple – a stepped pyramid in true Art Deco style. The Palace Court represented a significant development in hotel design. It was nine storeys high, and, as well as the main public rooms of the hotel, shops were provided on the ground floor. The upper storeys were designed as self-contained, serviced flats. The Palace Court was built in 1936 in white concrete 'liner' style, with wrap-round, curved 'suntrap' balconies, although, like the Midland, the exterior was of rendered brickwork. At five guineas for a week, the Palace Court, with its palmed garden, modern lounges, and balconies laid for afternoon tea, was the height of Thirties sophistication. An advertisement in Bournemouth's 1939 *Guide* describes it as being 'in the heart of the colourful life of Bournemouth' and describes the

hotel's extensive facilities: bridge organized every day by the social hostess, dancing to the Palace Court Hotel Band, membership of the Palace Court Club with its cocktail bar, hairdresser, costumier etc., and the Palace Court Theatre. Other new, modern hotels were built at Worthing – the Beach Hotel; Saltdean – the Ocean Hotel; Blackpool – the Manchester Hotel; and Skegness – the Ship Hotel. Osbert Lancaster observed: 'The keynote of the scheme of decoration adopted was that of a ship and every effort was made to emphasize this nautical idea ...'[4] In contrast, the new seaside semi-detached houses and bungalows, where most of the resort population expansion of this period lived, rarely displayed significant differences from their inland counterparts, with mock-Tudor prevailing over maritime motifs.

Landowners often granted landscaped parks to local authorities as amenities, as in the case of Worthing's Steyne Gardens or Southport's Hesketh Park, donated by the Reverend Charles Hesketh, who attached conditions which encouraged the development of surrounding building estates on his land. This was a common strategy. Southport's Marine Lakes and Victoria Park also predated the First World War, making the best of the sea's retreat and helping the town to lay claim to the title of 'England's Seaside Garden City', which was seen as a selling point. Bournemouth acquired the old turbary commons for conversion into public parks between 1894 and 1906, and likewise traded on a reputation for greenery and open spaces. But provision was greatly expanded between the wars and extended even to Blackpool, which had previously shown little enthusiasm for the park vogue. Stanley Park, opened in 1926, was described thus in the *Official Guide* for 1938:

> One of Blackpool's proudest possessions ... is Stanley Park – where nearly 300 acres have been transformed into a perfect paradise for lovers of nature and outdoor sport ... The picturesque Italian Garden, with its classic colonnade, guarded by two de Medici lead lions ... is the central attraction, while the floral cuckoo clock is always a source of wonder ... Stanley Park is not merely a show place, however, for it abounds in every kind of sport – bowls, tennis, putting, boating and golf.

Commercial holiday camps developed in the later 1930s. Butlins advertised the pioneer Skegness and Clacton camps as 'AN EDEN-ON-SEA and ... almost an Earthly Paradise', offering cool white buildings, glass doors, tanned faces and informality, and emphasizing that the chalets were designed like small houses. At Skegness they featured 'electric light, running water, comfortable beds with interior spring mattresses' adding up to a 'luxurious home of your own'. The camps attempted to create a fantasy world along the same lines as the cinema. The façade at Clacton was Art Deco in a stepped-pyramid style – both camps had large heated swimming pools with cascades. Ironically, the chalets, in which families slept, were designed in the

mock-Tudor style of the period. The opening of Butlins coincided with the granting of holiday pay to all workers in 1938. Butlins advertisements proclaimed: 'Holidays with pay: Holidays with play: A week's holiday for a week's wage.' By 1939 over fifteen million people in Britain had paid holidays. Although some people complained that the camps were little more than barracks, others were impressed by the privacy the chalets offered and the range of social events and entertainment available. The War Ministry took over the Butlins camps, including a third camp at Filey which had been due to open in 1940. At the end of the war, Butlins bought back the camps, and went from strength to strength in the late 1940s and 1950s.

From the late Victorian era onwards, coastal areas attracted large numbers of poor but entrepreneurial people who set up makeshift homes by the beach. Like those dispossessed peasants from the Middle Ages onwards who squatted on the edges of common land, the shanty town dwellers took possession of land which was available and not greatly valued. Many came down from London on a temporary basis, but eventually took up full-time occupation. The earliest and largest of the shanty colonies was called Bungalow Town, at Shoreham, near Brighton. By 1901 it comprised more than a hundred 'bungalows', a total that rose swiftly in the pre-1914 years to around 500, and had reached 700 by 1939. Bungalow colonies spread all along the undeveloped parts of the coast, such as at Littlestone-on-Sea, Camber Sands, between Portslade and Worthing, and then again intermittently westwards past Pagham and Selsey Bill. Some of these shanty towns were removed as part of coastal defence operations during the First World War, but others survived and were rebuilt after the war.

Shanty towns were widely condemned as ugly and wasteful of land, but the newcomers did make a notable contribution to cheap holiday homes for

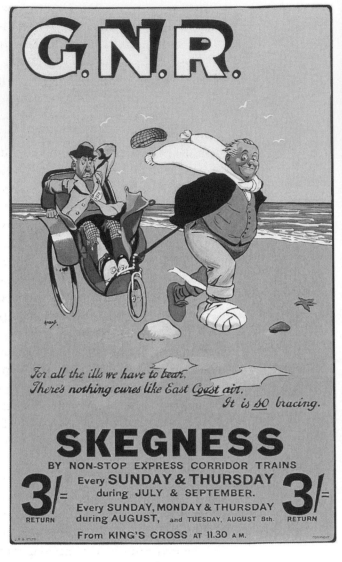

A Great Northern Railway poster boasting the 'bracing' quality of the sea and air at Skegness.

mass consumption. The favoured summer bungalow was built from two or more complete railway carriages, with all their original doors and windows. These were joined with an asbestos or corrugated iron roof, thus providing a large, multi-purpose living room, bordered by kitchen, bathroom and bedrooms in the railway compartments. A veranda was commonly added on the front. These were not incursions into areas of outstanding natural beauty as conventionally defined, but the buildings and their settings were greatly valued by occupiers and users who shared neither the aspirations of planners nor the aesthetics of the advocates of 'unspoiled' countryside. There were issues of public health and access to services, especially where there were no sewers and makeshift cesspools began to poison the land and threaten water supplies. Opposition developed during the interwar years as the emergence of a planning profession, whose ideas derived largely from the Garden City movement, was reinforced by the defenders of 'unspoiled' countryside against development of any kind. Throughout the interwar years, however, the planners' aspirations outran their powers. The Town Planning Act of 1925 allowed rural districts, within whose boundaries most of the 'bungalow towns' were developing, to prepare formal planning schemes, with a remit to preserve 'natural beauty'.

Even where emotive issues surrounding the preservation of the English countryside were involved, the opposition had to struggle with equally entrenched presumptions about the rights of property owners, who often received small rents from the squatters. In some cases, where the bungalows occupied coastal fringe land, no definitive landowner could be identified. Although it became increasingly difficult to develop new 'bungalow towns', the existing ones remained unscathed. When Canvey Island acquired its own urban district council in 1926, its controls were directed towards 'the worst properties, such as old railway carriages and bus bodies'. In 1932, Lindsey (Lincolnshire) County Council obtained an Act of Parliament to stop the extension of recreational huts and shacks along its coastal sand dunes, and by the mid 1930s it was imposing standard colour schemes and other regulations on what was already there. This was an exceptional initiative, supported by the Commons Preservation Society, which argued that these piecemeal enclosures detracted from public access and enjoyment. Nevertheless, on the eve of the Second World War, the 'bungalow towns' were less threatened by planners and redevelopment schemes than were the fishing quarters of established resorts, which were often in desirable seafront locations adjacent to modern developments. Indeed, the courts tended to treat the squatters more sympathetically than the fishing families, and where properties were compulsorily purchased it was normally at a fair price.

Even after the Town and Country Planning Act of 1947 enabled local authorities to curb the growth of 'bungalow towns', the established settlements proved difficult to uproot. Gradually, however, the premises were

upgraded, and the introduction of some basic urban services enticed owners towards a more orthodox urban environment. Some of this was being done spontaneously during the 1930s, as urban services were extended, public health regulations required increased plot sizes, and individual properties were upgraded. At Pagham, near Bognor, and Jaywick Sands, near Clacton, as at Peacehaven, there was already a recognizable road layout. The Jaywick residents in particular were eager for the local council to recognize their right to exist and provide both sea defences and the full range of urban amenities.

During the Second World War, many bungalows were destroyed for coastal defence purposes, but, as soon as restrictions on access were lifted, the owners were back, rehabilitating their property wherever possible. Further development of this kind was not going to be tolerated in an era of 'mass' holidaymaking, which could swamp the whole coastline unless controlled and directed into approved, sanitized sites. Most of the existing developments were able to survive in the long term, gradually merging into the broader conventions of seaside suburbia and losing most of their distinctiveness. The 'bungalow towns', on the coast as elsewhere, for there were riverside and rural variants, were tamed rather than suppressed, and the 'bohemian' aspects of the lifestyle that was associated with them gently withered away.

Caravan sites were also tamed and regulated in the postwar years, although few could match Sidmouth's Dunscombe Manor Farm. In 1957, was trying to resolve the incongruity of having a caravan site in what had previously sold itself as an exclusive resort by offering forty-four acres for fifty caravans, claiming that it was 'not a commercial site, but the ideal for the discerning caravanner', with 'individual toilets' and 'views, privacy, seclusion, quiet, tonic air and all the beauty that is Devon'. At the other extreme were the coasts of Lincolnshire and Flintshire; flying northwards from Skegness in 1969, Anthony Smith was amazed that 'the view was all caravans at the start,

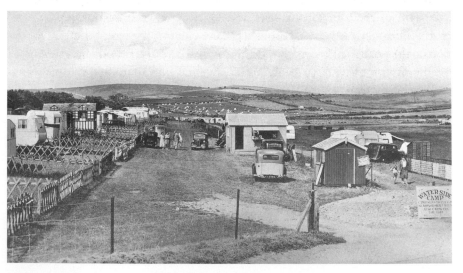

A postcard of the Waterside Caravan Camp, Bowleaze Cove, Weymouth, in 1947. Caravanning and camping, which had been popular seaside pursuits in the 1930s, blossomed in the period of austerity after 1945.

with a thousand a mile for the first twenty miles'. Most of these had been established since 1945, and containing and concentrating caravans continued to exercise the minds of planners, who were restricted by the status of static caravans as nominally temporary and portable structures that resisted building by-law restrictions. At Dungeness, for example, a single row of bungalows runs along the coastal road for several miles, separating the beach from the inhospitable interior of the promontory. The advancing line of bungalows stopped about a mile short of the Dungeness nuclear power stations.

The National Trust took steps to acquire particularly attractive stretches of coastline, and a number of other organizations and local authorities also began to protect specific areas. In East Anglia, the Holkham National Nature Reserve stretches over twelve miles in length and incorporates an extraordinary range of sand formations. It is bordered by two other reserves – Cley and Scolt Head Island. It also has a number of particularly large caravan parks as neighbours. Scolt Head Island has been a nature reserve since 1923. It is owned jointly by the National Trust and the Norfolk Naturalists Trust and is known for the colonies of terns that nest there. During the breeding season the area is closed to visitors.

Postwar Resorts

In the first post-1945 decades the English seaside retained its popularity, buoyed by extra working-class demand as holidays with pay at last became general, and sustained by restrictions on the export of currency for holidays abroad. Visitor numbers grew, but, outside Devon and Cornwall, what resident urban growth there was increasingly took the form of retirement homes, and resorts ceased to innovate in their entertainments, amenities and built environment. The single most important change in the character of a holiday by the sea in the postwar years was the growth of car ownership. In 1951, 47 per cent of holidaymakers went by train to their destinations, 27 per cent went by bus or coach, and 27 per cent by private car. By 1960, nearly half of the total number of holidaymakers went by car, and, by the end of the 1960s, nearly 70 per cent. In the 1960s, foreign holiday destinations became easier and less expensive to reach and most British seaside resorts faced a difficult period. Although holidaymakers still came, increasingly it was for day trips only, and the towns became resorts for the retired and elderly on one hand, and the boisterous and unemployed on the other. For many resorts where prospects had looked good in the 1950s, a long decline set in towards the end of the 1960s. This was accompanied by a gradual deterioration of facilities and lodgings, coarse retail developments in central locations and the spread of cheap amusement arcades.

After the Second World War, it became clear that coastal England was suffering from the equivalent of ribbon development. Bournemouth

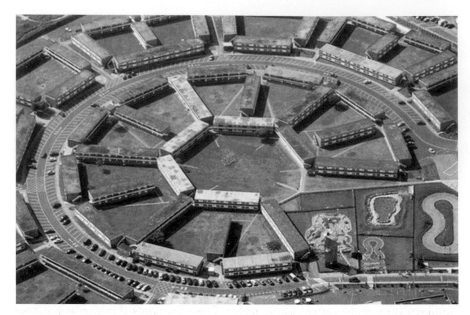

A post-Second World War Pontins Holiday Camp from the air, looking not unlike a military barracks.

swallowed the ancient boroughs of Christchurch and Poole, extending for about fourteen miles along the coast, with a population of over 300,000. Wherever possible in the south of England, there were bungalow and caravan developments along the coast. Degradation of the built environment also became an issue, as the new architecture of the 1960s onwards totally lost its seaside distinctiveness, while older emblems of seaside pleasures were demolished and redeveloped or allowed to decay. Such changes detracted from the sense that the seaside was a special, recognizable kind of place with its own landscape. Penarth's seafront was extensively redeveloped, for example, with a brutalist concrete car park, which could equally well have been in Birmingham, or anywhere, occupying a key site near the pier. The subsequent restoration of the pier pavilion to its Art Deco splendour, and the rescue of the swimming pool which faced it, salvaged important elements of the seafront townscape, but the surviving resort architecture was only an isolated group against a background of 'anywhereness'.

Another form of holiday that survived, but with reduced numbers, was the holiday camp. These enjoyed considerable success until the late 1970s, but in 1983 the Butlins camps at Clacton and Filey closed. The Clacton site is now occupied by a coach park and a housing estate. Three much modified camps survived: at Minehead, a massive holiday complex renamed 'Somerset World'; at Bognor; and the original camp at Skegness, renamed 'Funcoast World'.

Away from Blackpool, elsewhere in the 'post-industrial' North West there were further stirrings. Southport was re-emerging as a popular resort, with new private investment in its Pleasureland amusement park in 1999 featuring the Traumatizer, 'the "tallest and fastest" suspended looping coaster in Britain', and the Skycoaster, 'horizontal bungee jumping, albeit slightly more

restrained ... not for the faint hearted'. This was a remarkable development in a resort whose dominant image had become staid, upmarket and residential. In 1997, the English Tourist Board statistics for the most popular attractions not charging admission put the region's three big seaside amusement parks in first, third and fourth places, with Blackpool's Pleasure Beach drawing in an estimated 7.8 million visitors, Southport's Pleasureland 2.1 million, and Morecambe's Fronticrland 1.3 million, ahead of Blackpool Tower, which headed the North West's paying attractions with 1.2 million visitors, while Blackpool's Louis Tussaud's waxworks came sixth with 400,000. This suggested considerable resilience in the popularity of pleasures at the seaside in a region of traditional strength. Specifically seaside locations fared less well in other parts of the country, however. The Lynton and Lynmouth Cliff Railway headed the list in the South West, where it came third in the regional table with 528,198 paying customers, followed closely by Flambards Theme Park at Helston, and by Paignton Zoo. This was a long way behind the big north-western figures, suggesting a more scattered holidaymaking public with diverse tastes. The same applied in the South East, where Brighton Pavilion's 393,059 customers put it in sixth place, while the Paradise Family Leisure Park at unfashionable Newhaven came ninth with just over 300,000 visitors. Southend Pier's 350,000 visitors put it in fifth place in the east of England table. Outside the North West, commercial seaside entertainment rarely made a strong showing in terms of visitor numbers; and some of the most popular venues were theme parks whose location was only incidentally maritime. The resilient drawing power of north-western seaside attractions was not replicated in the rest of the country.

The current state of seaside pleasures at the end of the millennium is summed up by the late summer Bank Holiday weekend of 1999 at Whitby.

> Here, the west beach was quite well populated, with every kind of traditional activity on offer. But the great crush of visitors was in the narrow streets on either side of the harbour, and the preferred recreation, overwhelmingly, was shopping. The seaside resort as shopping mall was perhaps its dominant identity at the end of the century, and Clacton, with its Clacton Common themed shopping experience, or Fleetwood, with its Freeport, were among the resorts which tried to capitalize on this. For most people, most of the time, the sea was incidental.

In the early twenty-first century, it is still possible to find delightful stretches of almost deserted coastline around England – Robin Hood's Bay in North Yorkshire, Holkham Sands and Scolt Head Island in Norfolk, Spurn Head around the mouth of the Humber estuary, the Seven Sisters in Sussex, Lulworth Cove in Dorset, and stretches of the Cornish coastline. The coastline as depicted from the air in colour-photo books provides an exciting, timeless picture of a coastline empty apart from delightful fishing villages and

the odd decayed port. This portrait, however, is as partial and as misleading and unreal as the dozens of 'Village England' books with a rural countryside occupied only by thatched cottages, village greens and half-timbered pubs. They do exist, of course, but they tend to be the exception rather than the rule over much of the country. Much of this land is now protected and in the care of the National Trust or other conservation trusts. Elsewhere, the same pressures that have been eroding the rural landscape have been at work on the coast. In southern and eastern England, in particular, pressures to develop coastal locations are very powerful.

Estates of holiday and retirement homes continued to be built, and great swathes of the southern coast were developed. By the end of the century there was a semi-continuous belt of suburban development between the Isle of Thanet in Kent and Southampton. There was no grand design to so-called 'Channel Street'; instead, a string of new residential suburbs by the sea developed rapidly and coalesced as the result of the separate decisions of landowners, speculative house builders and individual households. In those gaps in the built landscape that were not protected, there were theme parks and thousands of acres of mobile homes and caravan parks.

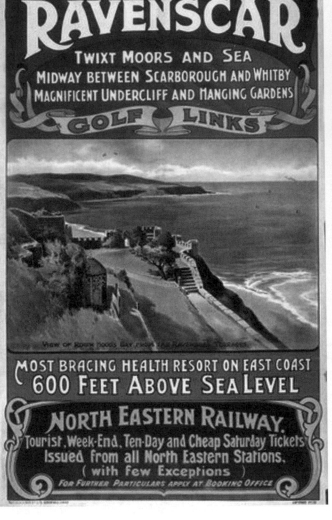

Robin Hood's Bay in Yorkshire as it was early in the twentieth century from a North Eastern Railway poster.

Brighton

Brighton was a resort which from time to time displayed characteristics of both closed and open communities. In 1841 the combined population of Brighton and Hove approached 50,000; with the coming of the railway, aristocratic visitors gave way to London middle-class trippers and holiday-makers. Thus, Brighton, 'the West End maritimized' as it was known, developed inland on speculative building plots across former open field strips.

Substandard housing was built around workshops and the new railway engineering works, which, by the late nineteenth century, employed 3000 people. By the 1860s, as many as 30,000 day visitors arrived on Whit Mondays to the 'Queen of Resorts', although Queen Victoria herself had long since forsaken Brighton for Osborne and Balmoral. Thereafter, until 1914, the town expanded largely through catering for the growing number of professional and white-collar workers taking a summer break.

Municipal guidebooks encouraged holidaymakers to become residents, extolling the virtues of living by the sea, and many newcomers did, indeed, move to the coast, often choosing new settlements such as the garden suburb of South Moulsecoomb. During the 1930s electric trains replaced steam trains between London and Brighton. Southern Railway used this development as a pretext to encourage Londoners to live by the seaside, whilst still working in the capital, by offering discounted season ticket rates. The local authorities encouraged the trend, motivated by what many councillors considered to be a prestigious growth in population and rateable value. This attitude was

The Marina at Torquay. Wealth and status tend to be now reflected through boats rather than hotels.

exemplified by Hove Corporation's lavish publicity guides in the 1930s, in which Wilhelmina Stitch told the story of a middle-class family, 'the Woodby-Happeys', who came to Hove on holiday by Pullman train only to become privileged residents in the new leafy Suburbia-by-the-Sea: 'and when they stepped forth into the bright sunshine after a grey day in London, they did indeed feel they had entered fairyland'. By 1939 the combined population of Brighton and Hove exceeded 200,000, as its industrial, service, residential and commuting functions multiplied and overtook its former leisure role in importance.

Brighton and Hove, now joined, at least physically, suffered along with most other British seaside resorts in the 1960s and 1970s. The response was to promote the resort as a venue for national and international conferences and exhibitions. The Royal Pavilion became a symbol for Brighton's new image; and the Dome concert hall – once the Prince Regent's riding stables – functioned as a major conference venue until, in 1977, the council's new Brighton Centre was opened on the seafront. The hotels in Brighton and Hove played a role not only in providing accommodation, but also in hosting conferences and exhibitions. By far the most important and impressive change at Brighton was the construction of the Marina, which lies below the chalk cliffs to the east of the city. The Marina was opened as a working harbour in 1979, enclosing an area of 126 acres, and can accommodate over 1400 boats. In addition to the harbour and the boatyard, by the time the Marina was competed early in the twenty-first century it comprised the Marina Village with quayside shops, restaurants and pubs; a multiplex cinema and bowling centre; and a superstore, a casino, car parks and extensive residential accommodation. It was a resort for the affluent in the twenty-first century, very different in kind, but perhaps not so different in character, from the fashionable Regency resort of two centuries earlier.

As Brighton's piers were allowed to decay, from the 1980s, a vigorously promoted Brighton Festival invented traditions, promoted arts-appreciating tourism and pushed the tourist trade upmarket. Brighton was remade as a resort, but one that only happened to be at the seaside. A busy dual carriageway along the front cut off the city from its shoreline, as if to underline the decreased importance of the sea to the resort. Nevertheless, the Marina, one of the largest in Britain, catered once again for the wealthy visitor who required upmarket facilities. By the end of the century, Brighton and Hove's population was a quarter of a million, and it formed part of a built-up belt along the south coast running westward through Worthing and Littlehampton to Bognor Regis, some twenty-five miles in length – an extended coastal city.

Weston-super-Mare, on the Severn estuary, although strictly speaking not a seaside resort, catered for holidaymakers from Bristol and South Wales. The most important development for Weston as a resort was the Seafront

Improvement Scheme of the 1880s, which resulted in the sea walls and two-mile promenade still in use today. About this time Weston finally gained a through railway station, when the present station and loop line into the town opened in 1884. Weston became increasingly popular with thousands of visitors, many of them day trippers on Bank Holiday trips and works outings. As the number of visitors increased so new shops opened, and private schools were set up as it became fashionable for the wealthy to send their children to seaside boarding schools. Many of these schools made particular reference in their prospectuses to the healthy air and its benefits for delicate children.

New facilities were established to entertain visitors, including indoor swimming baths, a theatre, and a library and museum in The Boulevard. On the beach, the bathing machines disappeared, as mixed bathing became acceptable. Local traders were not happy about the fact that many thousands of trippers arriving by steamer from Wales never reached the town centre because there was so much to do on Birnbeck Pier (1867). By 1900 the pier offered a theatre, alpine railway, shooting gallery, park swings, merry-go-round, tea and coffee rooms, bar, bandstand, photographic studios, switchback, waterchute, flying machine, helter-skelter, maze, bioscope, cakewalk and zigzag slide. On an average August Bank Holiday, 15,000 passengers would arrive on the steamers; it was therefore decided to build another pier in addition to Birnbeck, closer to the town centre, and in 1904 the Grand Pier opened, with a large theatre offering music hall entertainment.

Between the two world wars, the Marine Lake was built to provide a safe shallow beach; the Winter Gardens and Pavilion opened in 1927, followed in the 1930s by the open air pool, an Odeon cinema and Weston Airfield, which was officially opened in June 1936. Both Weston and Cardiff airports were close to their respective town centres, and many South Wales miners flew over to Weston on their holidays. Over the 1937 Whitsun holiday, 2555 passengers travelled on Western Airways from Weston Airport, a world record for that time. It was also about then that the first amusement arcades began to open. The Grand Pier at Weston-super-Mare acquired a massive glass-roofed pavilion at the seaward end in 1933; and these extravaganzas followed a spate of earlier initiatives at (for example) Eastbourne, Great Yarmouth, Clacton and Penarth. Such developments were concentrated in the more popular resorts, where the pier was identified as the prime site for investment in the new popular pursuits of the interwar years.

Blackpool

In 1851, Blackpool was a small seaside town. In terms of population it ranked only forty-third among English and Welsh resorts, with 2564 inhabitants. In the 1840s and 1850s, the railways brought more people right to the heart of the resort. For the most part, these working people were what became known

as trippers – staying only for the day and returning home in the evening. But it was the Wakes Weeks of the Lancashire mill towns that were responsible for Blackpool developing its extraordinary popularity. From about 1880, whole towns were shut down whilst the mill machinery was overhauled and the inhabitants decamped *en masse* to the seaside; and more often than not, they went to Blackpool. By 1901 Blackpool had almost 50,000 inhabitants, and in 1911 it ranked fifth among resorts and was by far the largest away from the south coast.

Blackpool was the open resort *par excellence*; it was hospitable to street stalls and fairgrounds, pubs and cheap eating houses, and the town centre was noisy, lively, crowded and cheerful. These characteristics helped Blackpool to attract and keep the first generation of working-class holidaymakers from its textile manufacturing hinterland. The holidaymakers encouraged investment in pleasure palaces, which provided a range of low-cost attractions, culminating in the resort's famous Tower and the Pleasure Beach at the turn of the century. By the end of the 1930s more than seven million people visited Blackpool each year. There were the great pleasure palaces, on a scale which was cumulatively unmatched elsewhere at the British seaside, from the pioneering Raikes Hall pleasure gardens and the Winter Gardens of the 1870s, to the Tower of 1894. The Tower was the ultimate enduring symbol of the popular holiday industry. It was the tallest building in England, a version of the Eiffel Tower, the Tower pleasure palace had a silhouette which became the enduring symbol of the world's biggest and brashest working-class seaside resort.

The idea of building Blackpool Tower was promoted in 1890 by a London-based organization, the Standard Contract and Debenture Corporation, which was already involved in a similar Eiffel Tower scheme at Douglas, Isle of Man. The Tower opened on Whit Monday 1894. Its distinctive super-structure soon became a landmark and a symbol of pleasure for the resort. In addition, Blackpool had *three* piers, and the Pleasure Beach at the southern extremity of the promenade, which brought the latest in American roller-coaster and other amusement technology from Coney Island, provided a distinctive flavour of its own. There was also the unofficial fairground, which appeared on the beach between the two original piers. This brought the delights of the Lancashire Wakes holidays to a seaside setting. The Pleasure Beach originated in the early 1890s, when the fortune-telling activities at the gypsy encampment on the South Shore sandhills were supplemented by fairground attractions, while the tram terminus at South Shore also attracted a fairground to a nearby vacant lot. When this was purged, after protests from neighbours in 1896, its showmen also joined the gypsies on land beyond the promenade that was unsuitable for building, until sea defences had been constructed. Here their numbers were swollen by peep shows, exhibitions, shooting galleries, hot-pea stalls and primitive mechanical rides. By 1901 the

tenancy of forty acres of sand dunes was concentrated into the hands of an Anglo-American syndicate, which bought the land outright three years later. This panorama of popular entertainment was unmatched anywhere in Britain. Blackpool's Pleasure Beach was completely redesigned in a contemporary style by the architect Joseph Emberton in the mid 1930s. The new attractions included the Great Dipper, the Grand National, the Ice Rink, the Fun House, the Indian Theatre, the Great Wheel, the Hall of Mirrors and the Water Caves. A general fascination with electric power after the First World War encouraged the famous Blackpool Illuminations, which had started in 1912 and ran for most of the interwar years, allowing the summer season to extend into autumn. The Corporation's claim that the Illuminations were 'the greatest free show on earth' might have been an exaggeration, but they kept Blackpool busy well after the end of the normal holiday season.

Distinctive lodging-house districts grew up around the railway stations, especially the tall houses in Albert Road and the neighbouring streets adjoining Central Station. Divided landownership and small, densely developed building plots generated warrens of brick-built terraced lodging houses. These were affordable as businesses for working-class people from the 'cotton towns', and provided cheap, unintimidating accommodation for visitors who might have been ill at ease in less familiar surroundings. In 1900 over one-third of the new houses had unsatisfactory drainage arrangements, and more than a quarter had insufficient yard space. But this regime produced a holiday environment that was attractive to working-class visitors. It allowed lodging houses to maximize the number of bedrooms on a site and thereby helped to keep prices low enough for the many visitors who could only just afford a seaside holiday. The unpretentious buildings in which visitors stayed were similar to the streets of their home towns. Visitors were not put off by formal and alien surroundings, and they were also able to enjoy the kind of fairground and street entertainments that were associated with popular festivals inland. Indeed, many of the showmen on the fairground circuits began to migrate to Blackpool for the season. Blackpool was welcoming to working-class visitors who might have been frightened by a regulated resort environment aimed at the middle-class market.

During the Second World War, apart from Brighton, all the east and south coast resorts were closed, and Blackpool was able to capitalize on the situation, although large numbers of servicemen were based here. This advantage was emphasized in 1940, when the Wakes holidays of the industrial towns resumed, and enough rolling stock was even made available to run twenty-nine special trains during the August Bank Holiday weekend. The move from rail to road transport after the war led to shorter stays and more day trippers; it also generated access and parking problems for guest houses. Central Station closed in the autumn of 1964, following which the site was redeveloped for shops. Meanwhile, traffic on Blackpool's roads increased by

70 per cent between 1960 and 1973, and plans were considered which would have gouged out part of the Victorian heart of the town. In the end, large-scale roadbuilding was limited to conversion of the rail route to the old Central Station to provide rapid access to the centre from the newly built M55. Parking was also provided on the old engine shed sidings. The opening of this motorway in 1975 gave a noticeable boost to the holiday season, and followed the demolition of the original North Station for retail development and its replacement by a smaller building on the site of the excursion sidings. The famous tramway system along the seafront survived to become an additional tourist attraction.

Blackpool's entertainments changed in significant ways. The resumption of the Illuminations in 1949 was warmly welcomed as a relief to postwar austerity and a sign that things were at last getting back to normal. The Pleasure Beach remained locally owned and family run, and, after a postwar hiatus, consistently led the way in innovations and growing popularity as the older pleasure palaces flagged, with six and a half million visitors per year at the end of the 1980s. The Tower, which had paid an astonishing dividend of 35 per cent in 1948, rebuilt its famous ballroom in all its original turn-of-the-century splendour after a fire in 1956, but eventually benefited from the late twentieth-century nostalgia, to match the trams. In 1961, however, overcapacity in the established live entertainment diet was reflected in the closure of the Palace next door and its replacement by Lewis's department store, reflecting the new primacy of shopping as entertainment. The key central entertainment complexes, the Tower and Winter Gardens, along with Matcham's Grand Theatre, were taken over by EMI in 1967, when a fierce local campaign had to be mounted to save the Grand from closure and demolition. Meanwhile, the three piers were taken over by Forte's entertainment subsidiary Entam between 1963 and 1967. In 1982, First Leisure took over the dominant role in Blackpool's entertainments, controlling the three piers as well as the Tower and Winter Gardens, and local entertainment programmes and initiatives came even more firmly under the scrutiny of London accountants. The waves lost their allure as awareness of the gross pollution of the Irish Sea along this coastline became more widely disseminated: an adverse report of 1988 from the Department of the Environment was being publicized as far away as Italy in the early 1990s, and the town's commercial entertainments now became dominant.

In the last decades of the twentieth century, although Blackpool suffered less than many of its competitors, its attractions began to wane. In response it moved over to embracing less distinctive, more international and specifically American pleasure styles. In particular, it looked to the profitable world of gambling for its salvation in the twenty-first century. Schemes to build a gambling centre on the lines of Las Vegas were being actively considered at the time of writing.

It seems that Blackpool still hasn't lost its ability to shock. As early as 1934 J. B. Priestley wrote: 'Its amusements are becoming too mechanised and Americanised ... It has developed a pitiful sophistication – machine made and not really English – that is much worse than the old hearty vulgarity.'[5] Recent commentators have been harsh in their verdict. Peter Jenkins writing in the *Guardian* in 1970 observed: 'Those who hate the place gain a good deal of enjoyment from its horrors. After all these years it would be a grave disappointment to discover a tolerable hotel, consume a passable meal or encounter prompt service.' Most recently of all, the best-selling American travel writer Bill Bryson described Blackpool as 'ugly, dirty and a long way from anywhere ... its sea is an open toilet, and its attractions nearly all cheap, provincial and dire'.[6] He was deeply unimpressed by the Illuminations. What all these people had in common was that they could not get away fast enough; Blackpool had no power to interest them even at an anthropological level.

In a desperate effort to survive, many of the more upmarket resorts have adopted some of Blackpool's worst excesses. A more charitable and more thoughtful assessment is provided by John Walton, who has written the definitive history of the resort:

> Blackpool epitomised all that was lively and participatory in this full-blooded, disrespectful, carnivalesque industrial popular culture in its phase of playing hard, as it worked off the pent-up emotions of a year's disciplined toil.

Blackpool as an embodiment of a rich and enjoyable popular culture, in distinctive seaside guise, carries much more conviction. It was, in many undeniable senses, Britain's and the world's first working-class seaside resort.[7]

| # *Sports and Recreations*

All fields we'll turn to sports grounds, lit at night
From concrete standards by fluorescent light:
And over all the land, instead of trees,
Clean poles and wire will whisper in the breeze.
We'll keep one ancient village just to show
What England once was when the times were slow –

John Betjeman, 'The Town Clerk's Views' [1]

I N THE FIRST PART OF THE NINETEENTH CENTURY most sports
took place in informal settings – the countryside, park, waste ground or
street. As society became increasingly urbanized, the rules which were applied
to sport tended to become more codified. The second half of the nineteenth
century saw the emergence of a whole new range of sports, complete with

A policemen's
bicycle race at Iffley
Road Stadium,
Oxford, in 1936, a
university sports
ground established
on low-lying ground
outside the city
centre. It was on this
site that Roger
Bannister was later
to become the first
man to run a mile in
under four minutes.

rules, governing bodies, and competition at all levels, including international. The move towards half-day working on Saturdays in the later nineteenth century provided an important boost for organized sports, particularly football. Added to which, specific locations were set aside for different games – and as the number of spectators increased, facilities were provided for them. Areas in municipal public parks, for example, were cordoned off and dedicated to specific sporting activities. Urban parks had been a feature of the Victorian city, and as towns and cities expanded they frequently incorporated private parks which had been overwhelmed by suburban growth. Municipal parkland for leisure and recreation was an integral part of the Edwardian town.

After 1918 there was a shift in emphasis from parks and common land to recreation grounds, often smaller in area and providing a wide range of sports facilities. The movement was accelerated by the creation of the National Playing Fields Association in 1925 and by the 1937 Physical Training and Recreation Act, which gave legislative support for local authorities to acquire and establish playing fields. By the late 1930s, for example, the London County Council could boast of 350 public cricket pitches, which were used by over a thousand teams. A parallel development, and of immense importance in terms of land use, was the growing provision of playing fields alongside schools, a development formalized by the provisions of the 1944 Education Act, which imposed on local authorities the duty to secure adequate facilities for recreation and physical training for all educational establishments under their control. Local authorities became the key providers: for example, by the mid 1960s there were 10,000 acres of sports ground in Lancashire, and in addition there were almost 10,000 acres of school playing fields.

The river at Henley during the Regatta early in the twentieth century.

Interest and participation in a wide range of sporting and exercise activities steadily increased during the twentieth century. Early in the century, for many, sports provided an escape from the hardships of living, but by the end of the century they were part of the multi-billion-pound leisure industry. Sports facilities became increasingly specialized and sophisticated; but, apart from a few great American-style superstadiums, they also became indistinguishable from other utilitarian buildings.

During the nineteenth century a number of locations became closely associated with specific sports, a

process that was cemented during the twentieth century. Horse racing was linked most obviously with Newmarket, where the countryside around the town was fashioned for the breeding and training of horses, but also with Ascot and Aintree. Croquet and tennis at Wimbledon and rowing at Henley-on-Thames had become part of the Summer Season for the upper class for one week each year, although the many club and boathouses at Henley came to form part of the permanent riverscape. As with many aspects of landscape at the beginning of the century, manifestations of sport and leisure tended to reflect the activities and interests of a small, wealthy elite. Horse racing and golf tended to be minority pastimes restricted to the well-off, as were traditional field sports.

Field Sports

Field sports had their origins in antiquity, and hunting for wild animals and birds was first reflected in the English landscape by the creation of the Royal Forests of the Norman kings. In medieval England, enclosed baronial deer parks were part of the privileges of power and wealth. The association of such activities with the aristocracy continued into the nineteenth century, when hunting with guns for pheasant and grouse became increasingly important, and fox-hunting developed into an aristocratic ritual. Until the eighteenth century hunting for hares was more popular than hunting for foxes, but, as hares became increasingly rare, fox-hunting developed in its place. Fox-hunting had been a casual affair until the eighteenth century, when what became the Quorn Hunt in Leicestershire acquired its first Master of Hounds, Hugo Meynell (1735–1808). Meynell was responsible for codifying the rules of fox-hunting, including the selective breeding of hounds and the introduction of a dress code and rules of engagement. The introduction of strict rules and etiquette was perfectly suited to the character of the landed gentry of the eighteenth and nineteenth centuries.

The rise in popularity of fox-hunting coincided almost exactly with the height of the Enclosure movement in the late eighteenth and early nineteenth centuries, when large open fields and commons were replaced by a regular pattern of hedged and walled fields. The countryside of the Quorn and the Belvoir, the Vale of Aylesbury and the Oxfordshire Windrush Valley, might have been designed with fox-hunting in mind. Fast runs were provided by large grassy fields, separated by high hedgerows, with cover for the fox provided by the many patches of woodland, scrub, gorse and spinney. The land over which the hunt went was well maintained for its purpose, and the hunts came to arrangements with local farmers to allow them to hunt over their fields. Hedges were kept in good order, gates and fences were well maintained and marginal grass gallops kept in open land. Many existing rides were widened or opened up through dense woodland, and some coverts were

improved to increase the number of foxes. During the nineteenth century, new woods and copses were planted and coverts were improved, especially with the use of gorse to make them warmer. The scattered copses, planted as refuges for foxes, were given names, many of which survive today.

Thorpe Trussels, in the Quorn county of Leicestershire, is one of the most famous fox coverts in the country. Thorpe is the name of the nearest village and Trussels is a dialect word meaning a small piece of land. When the parish of Thorpe Satchville had been enclosed in the late eighteenth century, the Enclosure Commissioners allotted ten acres of land to the poor – the land they were given was on the edge of the parish where the soil was very poor. The new owners decided to rent the land to the Quorn Hunt for £35 a year, who proceeded to plant it up as a thick fox covert. Botany Bay was another well-known covert for the Quorn Hunt, so named after the remote Australian penal settlement because it was one of the most distant coverts from the hunt kennels. In addition to specially planted coverts, there were a range of lodges erected for the hunting season. Boxes and hunting lodges proliferated in the hunting shires. One of the best known was Warwick Lodge in Melton Mowbray, named after one of Edward VII's mistresses, the Countess of Warwick, a fiercely enthusiastic hunter. Some of the wealthier hunts also created special-purpose buildings. The Cottesmore Hunt in Rutland built large stables and kennels in 1890 just outside the small town of Oakham, described by W. G. Hoskins as 'huge brick buildings, looking to me rather like a cross between a prison and a workhouse'. The Quorn Hunt erected even larger kennels and stables in 1905 at a place called Pawdy Lane: 'they speak, to me anyway, of vulgar, ostentatious Victorian England'.[2]

The coming of the railways was at first regarded as a disaster to fox-hunting. Henry Hall Dixon writing as 'The Druid' in *Sporting Life* in 1859 claimed that, by creating the railway system, 'Modern science ... has gone far to destroy the noblest pursuit which the Gods ever bestowed on mortals'. Later, it was recognized that the railways allowed 'sportsmen' to travel across the country to hunt day in, day out, and that some enthusiastic huntsmen were known to keep horses in several hunting locations. Railways actually opened hunting to more people. They brought the hunt counties within easy reach of the developing urban centres, including London. It was the urban hunters, whose number included the novelist Anthony Trollope, that took fox-hunting to greater heights of popularity in the decades leading up to the First World War. The hunts were also able to absorb other developments, such as the use of wire and barbed-wire fences and 'those inventions of the Evil One' – the motor car (according to one Master of Foxhounds), which followed a similar path from unpopularity through to popularity and necessity for committed hunters.

During the twentieth century, the growth of suburbia, the spread of trunk roads and motorways, and, latterly, the removal of hedgerows all posed serious

A hunt rider drinking from the stirrup cup at Swinbrook, Gloucestershire in the 1920s.

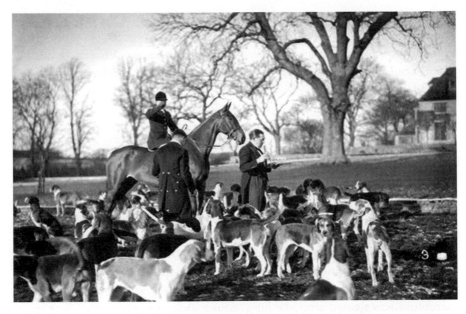

threats to hunting. Nevertheless, at the end of the twentieth century there were still almost 200 registered packs of foxhounds in Britain as a whole. Several of the large hunts still owned their own woods and coverts, specifically to manage hunting. Their main aim was to preserve the fox population by leaving dedicated areas undisturbed for foxes to live and breed in. Additionally, tracks were kept clear of unnecessary obstacles, and jumps were constructed and maintained in fences and hedges. Upper Heythrop, in Oxfordshire, home to the Heythrop Hunt, is a hunt village, with trimmed verges and manicured hedges – a closed village of a very different type. The cessation of hunting will undoubtedly be associated with further degradation of the rural landscape, but, in a logical world, legislation to ban hunting would be accompanied by measures to safeguard those areas of the landscape that hunting currently 'protects'.

The present landscape of many English moors has been frozen in time by the pastime of grouse shooting. A barometer of the popularity of shooting is provided by the number of gamekeepers, which increased from 9000 in 1851 to 23,000 in 1911. In Edwardian times, Lord Granby proclaimed that 'shooting for sport was as democratic as the omnibus'. He estimated that £3000 a week was spent in the country from London alone by shooting parties during the six months from September. Far from being democratic, however, shooting required the public to keep away altogether from the moors. Indeed, much moorland was carefully managed for the rearing of game. On Stanage Moor in Yorkshire, in the early years of the twentieth century, the Wilsons of Sheffield went so far as to employ masons to cut channels and holes into the rocks to collect water for young grouse in the breeding season, so that they would not fly off and be shot on someone

else's land. Some 108 troughs were arranged in three sequences along the boundaries of the moor. Controlled burning of sharp-edged sections of the moors over a cycle of years became a regular practice, so that young heather shoots could be produced every ten or twelve years, as heather is the staple food of grouse.

Horse Racing

Horse racing is not only a sport but also a multi-million-pound industry. Its impact on the landscape extends well beyond the facilities of the fifty or so principal racecourses in England. Large areas were given over to training horses and to stud farms dedicated to the breeding of racehorses. Point-to-point and National Hunt racing are linked with fox-hunting, but flat racing is a quite separate activity. Charles II was closely associated with the development of horse racing as a popular aristocratic sport. The royal court used to move to Newmarket during the racing season, and the Rowley Mile racecourse was named after the king, whose nickname was reputedly that of his favourite horse, Old Rowley.

Newmarket remains the headquarters of British horse racing. In addition to the racetracks – the Rowley Mile and the July Course, both of which have their own stands – there are 2500 acres of heath and woodland devoted to racing, training and breeding horses. This area incorporates 40 miles of turf gallops, 17 miles of artificial gallops and 30 miles of traffic-free walking track. Such was the success of racing at Newmarket that in 1894 a leading horse-racing figure, Colonel McCalmont, laid out a new steeplechase course

The Edwardian grandstand at Ludlow racecourse in south Shropshire. The track runs through a golf course which incorporates a number of Bronze Age burial mounds

on the heath adjacent to the main racecourse, between Cambridge Hill and Devil's Dyke. Jump-racing ceased in Newmarket in 1905 when McCalmont died, although there was a training course for hurdlers there for most of the twentieth century. The site was acquired by the Links Golf Club in 1910 and an eighteen-hole golf course created, which still occupies the site. Such was the success of Newmarket as a racing, breeding and training centre for horses that in 1902 a new railway station for passengers was built half a mile along the line to Cambridge, leaving the old station for the sole use of equine traffic.

The landscape around Newmarket is distinguished by a distinctive pattern of rectangular fields, created by downland enclosed in the eighteenth and nineteenth centuries. These fields are bounded by wide linear shelter belts of trees and subdivided into smaller tree-lined paddocks set with tree clumps. This landscape, which is characteristic of race-horse training and breeding areas, is centred on large Victorian and Edwardian houses and stable ranges. The rectilinear character of the landscape is emphasized by two stretches of ancient linear earthworks – the Devil's Dyke, which cuts cross Newmarket Heath, and Fleam Dyke, running parallel to it six miles to the south west. Although undated (possibly early Anglo-Saxon), these earthworks, which are formidably large in places, have provided prominent landscape features which have acted to provide the axis on which the man-made horse-racing landscape developed. On a smaller scale, a similar landscape, dominated by horse racing, can be found on the Berkshire Downs around Lambourn, which has been a major racehorse-training area since the early nineteenth century. Also on the chalk downlands, at Marlborough and Devizes, distinctive paddocks, enclosures and gallops, all immaculately maintained, can be found.

The popularity of horse racing increased with the development of cheap and rapid rail travel and a number of major racecourses were served by the railway. For example, the Cheltenham racecourse at Prestbury was opened in 1906 and had its own station opened in 1911. Cheltenham Racecourse station was closed for regular traffic in 1969, and during the 1970s the track was lifted. The Gloucestershire and Warwickshire Steam Railway Company restored the line and the station, however, and in 2003 public trains brought race-goers to the Cheltenham Gold Cup and other events on the racecourse. Cheltenham racecourse, Britain's premier National Hunt course, occupies a spectacular natural amphitheatre beneath Cleeve Hill, and is generally recognized as one of the most attractive venues in England. Several other courses occupy similarly attractive locations. Hereford racecourse shares its facilities with a golf club, as does that at Ludlow, twenty miles to the north. Here a fine Edwardian stand looks out on the racecourse and the golf course, and also, as it happens, on a group of Bronze Age burial mounds, each capped by a single tree, which occupy the site.

Trafford Park on the edge of Manchester was a focus for sporting activity from the late nineteenth century onwards. In this 1932 photograph there are still three major sporting venues: Old Trafford cricket ground (bottom left), Old Trafford football stadium (top left), the home of Manchester United since 1910, and the White City greyhound and speedway stadium (1928).

Golf

A golf course has been described as 'A state of nature apt to the age: a vast acreage of greenery scrupulously regulated to support a network of tiny, shallow holes'.[3] Golf became the greediest user of land for sport in the twentieth century, with almost 2000 courses in Britain as a whole, and it is estimated that one acre of land is required for every five golfers. Large areas in rural England were landscaped into golf courses: woodland was cleared (and planted), ground levelled and grassed, and hazards in the form of artificial bunkers were created. These were major operations involving large numbers of horses and men – representing the most significant deliberate concentrated landscape changes in the countryside since the parkland creations of Lancelot Brown, Humphry Repton and William Kent.

The first purpose-built golf courses were in Scotland, and most golf in England in the nineteenth century was played on common land, although a number of coastal courses were created as soon as the railways provided regular access. At this stage it was believed that sandy bunkers were essential for a successful course, and this requirement was admirably met at places such as Wentworth. London golfers playing on the commons at Wimbledon, Clapham and Mitcham had, however, to share their playing area with non-playing users of the commons. Players on Blackheath had to contend with 'gravel pits, roads, picnic parties, lamp-posts and nursemaids' prams'.[4] Additionally, when the London County Council took over responsibility for the heath early in the twentieth century, they insisted that players had to wear red coats and be preceded by a forecaddie carrying a red flag. Golf on Blackheath was eventually brought to an end during the First World War,

when the heath was taken over by the military. By that time many London golfers had already moved out to more attractive locations, such as the Kent coast. The Prince's Golf Club was founded on Mitcham Common in 1890, but there was considerable local opposition and in 1907 the villagers took legal action to secure public playing rights on the common. In the same year the Prince's Club moved to Sandwich Bay, adjacent to Royal St George's. Some London golfers found courses closer to the city. The Richmond club was started in 1891 in a park close to the village of Ham. In 1895 a course was laid out in the Home Park of Hampton Court, although bunkers were not allowed in case sheep fell into them.

The growth of the middle class and their increased mobility led to a rapid expansion in golf courses around 1900. Another reason for the increased popularity of golf at this time was the introduction of a new type of ball. In 1899 an American, Coburn Haskell, invented a ball composed of elastic wound at tension round a rubber core. The new ball was easier to hit and travelled longer distances. Greater popularity intensified the need for more playing space – land, even on the outskirts of cities, was cheap and plentiful, and very soon golfers in various neighbourhoods cooperated in the purchase or rent of hundred-acre sites, and in laying out courses. This development produced the typical suburban golf club, with a typical professional middle-class membership. Between 1890 and 1910 the number of golf clubs within a fifteen-mile radius of Charing Cross rose from nine to eighty-nine. Whereas all the pre-1890 clubs played on common land, practically all of those founded subsequently had private courses. Many of the new courses were not laid out on traditional sandy heathland but on clay soil in relatively flat meadowland or parkland. Hazards were in the form of hedges, ditches and trees – relics

A golf tournament in progress in the 1930s.

of the former agricultural landscape. Course designers also created artificial bunkers filled with imported sand.

Between the wars a number of these new courses were victim to the spread of suburbia. Raynes Park in Surrey, twelve miles from Charing Cross, provided a typical example of the effect of building development on golf. The course, laid out in 1893, was approached by walking across a field from a station which was then merely a halt. The hazards were hedges, brooks, oaks and elms, and artificial bunkers creating sandy holes in what had been a country park. The clubhouse was a modest pavilion. After thirty years, however, the golfers were made homeless. The land was sold to developers in 1923, navvies and bricklayers moved in, and within a year or two nothing remained of the course save a few acres turned into playing fields and tennis courts. The clubhouse became the pavilion of a sports club, and the newly-laid out roads were given names such as Greenway, Linkway and Fairway.

Partly in response to such losses, new courses were created further out of London, particularly in Metroland. Chorleywood was founded in 1890, Northwood in 1891, the Ellesborough club at Wendover in 1906, Harewood Downs at Chalfont St Giles in 1908 and Sandy Lodge, sited on a rare deposit of sand near Northwood in Middlesex, in 1910. The last was not directly served by the Metropolitan Railway, although a station halt was constructed for the convenience of members. After the First World War, several golf courses were constructed on the country estates that came onto the market in Metroland. In 1919 Lord Leverhulme bought Moor Park from Lord Ebury, created a golf course, and sold the surrounding land in lots for the erection of exclusive houses. The famous golf course at Wentworth was created from parkland in 1924 and in a similar fashion surrounded by an exclusive housing estate.

Some older courses were set within historic parkland. At Hawkestone Park, in Shropshire, there are two championship courses within an eighteenth-century park landscape. Golf was played here from the 1920s, and the course blended well with its historic setting. Similarly, Effingham golf course in Surrey was designed within Effingham Park in 1927 by Harry S. Colt, who worked on about 300 courses in Britain, Europe and North America. Colt was 'one of the outstanding golf architects of his day, who moved golf course design from the primitive to the classical in one generation'.[5] Colt also designed the courses at Rye (1895), Sunningdale (1922) and Edgbaston (1936). The Edgbaston course was set within a Capability Brown-designed park and, as with many such parkland courses, the former country house, in this case a classic Georgian mansion, acted as the clubhouse. Colt was responsible for designing many courses on the sandy heathlands to the west of London immediately before and after the First World War. These included Betchworth Park, Burhill, Camberley Heath and New Sunningdale in Surrey.

At the end of the century there were no less than nine golf courses located along the eight-mile stretch of the M3 from Virginia Water to Camberley. As the popularity of the sport increased, however, the location of golf courses changed and they were increasingly developed in areas of good agricultural land and close to centres of population, such as the North Oxford golf course, and became part of the 'pretend countryside' used for recreation.

New golf courses created after 1980 covered an area of land the size of Greater Manchester, and it is estimated that 1 per cent of the land area of Britain was given over to golf courses by the end of the century. Many courses date from the 1980s and 1990s, when there was a frenzy of building: between 1992 and 1996 it is estimated that there were 400 new courses. Typical of the new generation of golf courses was The Belfry, in Warwickshire, built over good agricultural land, which rapidly became an internationally famous course. Attitudes to golf courses varied and controversy over the creation of golf courses was often intense. Although golf courses catered for a relatively small number of people, ostensibly they maintained green open spaces. Many of the new courses were created, however, at the expense of ancient parkland, woodland, fields and hedges – the new landscape was antiseptic and antisocial. New golf courses, it was argued, 'rape' the environment by water abstraction, modification of natural habitats, the creation of new buildings such as clubhouses, access roads, car parks and the development of new sewerage facilities. The use of fertilizers and the regular cutting of grass inhibited natural vegetation and created a highly specialized landscape. The construction of a golf course often involves the removal of hundreds of thousands of cubic yards of material to rebuild the terrain to accommodate the construction of tees, fairways and greens. Topsoil, often with additives, is then replaced and seeded with specific varieties of grass. The grass is nurtured by the application of huge quantities of fertilizers, herbicides, fungicides and pesticides and by the construction of elaborate irrigation systems. Mowing is undertaken by sophisticated machinery so that the height of the grass is precisely controlled. Fairways, and particularly greens, are repeatedly aerated and top-dressed. The result is often in the form of a uniform, lush, soft, velvety-smooth carpet of grass.

On the other hand, golf courses in some areas did create diverse semi-natural managed habitats, replacing intensive arable agriculture. Some believe that while golf courses undoubtedly suburbanize the landscape, they are better kept than the litter-strewn fields in the urban fringe and generally richer in wildlife than cultivated land. In the case of Penn, Buckinghamshire, the proposed golf course created fears not only about its effect on the natural environment but also its likely impact on the social character of the village. There were already two adjacent golf courses on former farmland, and a planning application for a third in 1992 attracted strong objections. In the same year there were 1890 applications for new golf courses in England,

and in 1997 planning consents covered a cumulative land area of 90,000 acres.

A surge in course developments of 17 per cent nationally, but 40 per cent in the South East, over the early 1990s far outstripped the rise in the number of people playing the sport. Developers were often left with heavy losses; and, indeed, fourteen of the newly built golf courses went into receivership within five years of opening. Overdevelopment led to a proliferation of poorly located golf courses – either too close to their competitors or too far from their market. Public opinion began to be critical of the landscapes that the design consultants created, which, in the worst cases, were alien, artificial and completely insensitive to the historic landscapes they replaced. Greater care began to be taken towards the natural world, and in the 1990s English Nature joined with the Royal and Ancient Golf Club to publish guidelines about how 'golf and wildlife can exist together'.

Cricket

By the late nineteenth century, cricket had become established as the summer game in England to counter football during the winter months. Facilities were established in urban centres and three-day county championships were played between fourteen counties from 1895. The chief county grounds were all located in major towns, normally the shire capital. There were, below that level, numerous local leagues staging one-day games between villages, suburbs, factories, large stores and social institutions. Despite its urban base, cricket is still generally regarded as one of the most 'scenic' of sports. The doyen of English cricket commentators, John Arlott, wrote: 'in no other sport does winning so little affect the aesthetic, spectacular and entertainment values' and cricket 'is as much a part of the pattern of the English country as the green itself or the parish church'. In cricket the landscape is of greater importance than in any other sport. The cricketing landscape is invariably projected as a nostalgic, rustic idyll.[6]

By the early part of the twentieth century, cricket came to play an integral part in the formation of ideas about the English countryside and its history which has penetrated the national imagination. Coffee table books containing glossy photographs projecting the 'English Countryside' frequently convey a similar image, typified by Edmund Blunden's poem, 'The Season Opens':

> A tower we must have, and a clock in the tower,
> Looking over the tombs, the tithe barn, the bower;
> The inn and the mill, the forge and the hall,
> And the loamy sweet level that loves bat and ball.

The classic view is that of cricket set against a background of trees, haystacks, barns and a landscape of peace and plenty, remote from the real

world. In his much loved book *England their England*, A. G. MacDonnell claimed that the cricket ground was the essence of the *real* England, 'unspoilt by factories and financiers and tourists and hustle'. Macdonnell evocatively captured the Kentish (and English) village cricket landscape:

> It was a hot summer's afternoon. There was no wind, and the smoke from the red-roofed cottages curled slowly up into the golden haze. The clock on the flint tower of the church struck the half-hour, and the vibration spread slowly across the shimmering hedge rows ... Bees lazily drifted ... The cricket field itself was a mass of daisies and buttercups and dandelions, tall grasses and purple vetches and thistledown, and great clumps of dark red sorrel, except, of course, for the oblong patch in the centre – mown, rolled, watered – a smooth, shining emerald of grass, the pride of Fordenden, the Wicket.[7]

The wicket was a hallowed stretch of turf – in the summer of 1975, when the University Parks at Oxford were scorched yellow by a drought, it was striking that the 22 yards of the University cricket square alone was maintained in its verdant, green state. Many of the major county grounds occupy highly scenic locations. Worcester, generally thought of as one of the most attractive grounds in the world, is also one of the most photographed. The backdrop is the splendid medieval architecture of the cathedral; indeed, the Worcester ground actually belonged to the cathedral until 1976. The pavilion was built in 1898 and externally appears unchanged. Worcester developed facilities for top-level sport while ostensibly giving the impression of cricket as a meadow game. Worcester's ground lies on the Severn plain, and regular flooding introduced fishing, boating, swimming, windsurfing and even ice skating to New Road. At a professional level many English cricket

Cricket in the 1950s. Sports grounds proliferated during the second half of the century.

grounds retain, in magnified form, the landscape elements of village grounds. This cosy description of the Kent ground at Tunbridge Wells gives:

> a feeling of security and contentment. Much of this derives from the surroundings, for the ground is in a slight natural hollow and tightly enclosed all round by trees, through whose branches hardly a brick or chimney protrudes to spoil the view. And it is for one aspect of these surroundings that Tunbridge Wells is best known – the rhododendrons.[8]

Cricket landscapes are projected as being predominantly southern English in location. Cricket, like 'Constable Country', is projected as being located in and having the characteristics of 'the South Country', and can be interpreted as a construction of what is essentially English. Historically, the image of English cricket, from the village game to the sophistication of the test match, is one of quaintness, southernness, rusticity and heritage. The cricket landscape as reflected in various media can be interpreted, like the English landscape itself, as an expression of English tastes and values. The tastes which are reflected in the iconography of cricket landscapes are not necessarily those of the majority of the population, but, as with many other

The Oval cricket ground has created its own micro landscape of curving terraces and roads.

landscape predilections, 'of that minority who have been most active in creating English landscape taste and in moulding the landscape itself'.[9]

Lowenthal argued that cricket and grounds provide an acceptable form of escapism, an 'antidote to the dreadful present', a reassuring image to counter the changing English countryside itself with its increasingly mechanized farming practices and prairie-style fields. The English indignation that met the brash Australian newspaper owner Kerry Packer, when he intruded into the game in the early 1980s, was only partly because of his unashamed commercialism. What caused the greater upset was his infringement of some of the game's most holy traditions. Some of his games were played at night under floodlight, with a white ball, and the players wore colourful tracksuits – 'blasphemies' that were to be gradually accepted as normal in one-day games by the end of the century.

The Oval cricket ground at Kennington in south London has been the headquarters of Surrey Cricket Club since 1845. The site was occupied by a market garden and was originally intended as a residential double crescent or circus, as found at Bath. There was insufficient interest for the development to proceed, however, and the Oval was leased to the cricket club by the Duchy of Cornwall estate. The Oval was also host to the first football Cup Final (in 1872) as well as England's first international football games in the 1870s. The cricket ground lay at the eastern end of Vauxhall Gardens, which, since the seventeenth century, had been one of London's playgrounds; but the pleasure gardens were quickly built over and the Oval assumed the entertainment role, hosting the first 'Ashes' match between England and Australia in 1882. At the end of the nineteenth century, the ground was surrounded by trees but had no permanent seating or terracing, and there was a bowling green on the edge of the cricket ground. The pavilion was built in 1898 and was designed by A. T. Muirhead, who was also responsible for the pavilion at Old Trafford, Lancashire's cricket ground. By the outbreak of the First World War, the outer part of the ground had been terraced and wooden seats installed. By this time there were five large gasometers of the South Metropolitan Gas Company to the north of the ground, which were to provide the rather incongruous backdrop to the cricket for much of the twentieth century. Ironically, the apartment blocks of the 1920s and 1930s that surround the Oval mirror its shape, and on the north side at least form the residential crescent originally planned. In 1934 the Hobbs Gates were erected at the main entrance to honour the Surrey and England cricketer Jack Hobbs. During the Second World War the Oval was used as a prisoner of war camp, but it was restored to cricket immediately after the war. In the early 1980s the Lock and Laker stands were built to the east of the pavilion.

Most of the major county cricket grounds originated in the nineteenth century. One exception was the Rose Bowl, Hampshire's cricket ground, near Southampton. It is located on 200 acres adjacent to the M27 motorway, and

is owned by Queen's College, Oxford. In 1996 it was leased for the development of a state-of-the-art county cricket ground with additional leisure, sporting and community facilities. The Rose Bowl, which was partly funded by the Lottery Fund, incorporates a cricket academy, a hotel, a leisure centre and a golf course. The new ground is an out-of-town facility, accessible only by road, and as such is typical of so much new development.

Football

There was little organized participatory sport for the masses in the early twentieth century. Only football represented a genuinely populist sport.

> So far as the boys are concerned ... in the North the game par excellence is football. From the days when they begin to go to school this is the one game which absorbs their attention ... In courts and alleys, on vacant plots of land, on brickfields, indeed where any open space at all may be found, attempts are made to play the game.[10]

Football had developed from a variety of sources, not least the highly individual games played at public schools in the first part of the nineteenth century. The Football Association was founded in 1863, and the Football League in 1888. Soccer rapidly became a professional game, attractive both for spectators as well as players. The Rugby Football Union, founded in 1871, was in contrast a bastion of opposition to professionalism, and thus the class differences between the games were sealed.

Football, even more than cricket, relied on an urban industrial society to prosper. Schools, churches and YMCAs provided the beginnings of many clubs, such as Aston Villa, Blackburn Rovers, Bolton Wanderers and Everton; and, for example, works teams like the Newton Heath railwaymen grew into Manchester United and the Woolwich munitions workers started the Arsenal Football Club. By 1905 there were forty professional teams in the first and second divisions, based largely in the North and the Midlands. Large numbers of spectators crowded into the often basic, terraced grounds. The aggregate sum of spectators in 1901 was around two million a season. In 1900, 220 clubs entered for the Football Association Cup; over 100,000 people watched the Final between Sheffield United and Tottenham Hotspur played at the Crystal Palace. Great passions were generated by club rivalry both between and within towns and cities. Football clubs provided a personality and a sense of belonging to some communities previously regarded only as workplaces. As Simon Inglis points out: 'A football ground was in many ways as much part of a burgeoning corporation as a public library, town hall and law courts, and was certainly used by more people. Furthermore, a football ground was often the only place in a town outsiders would visit.'[11] The civic pride invested in early professional English football clubs and their stadiums was

cemented, in the main, by highly localized forms of funding and control, and by local sponsorship.

The stereotype of the footballing landscape belonged to the industrial north of England. Some of the best known artistic representations of the British football landscape are those of the Salford artist L. S. Lowry, whose paintings often incorporated representations of northern English football grounds. In *Going to the Match* the ground is sited among nineteenth-century terraced houses, factory chimneys forming a nearby horizon, with spectators striding to the ground in what appears to be the inner urban zone of a northern industrial city.

The following piece, by a *Guardian* writer as late as 1980, could only be applied to the North:

> there is a sparseness, a meanness about the ground. It is like a grey snapshot from the thirties ... the rawness of it proclaims a football town, subscribing to the male Saturday afternoon ritual which neither women's lib nor television sport has gnawed its way into.

One man in particular was associated with the design and building of football stadiums in the first part of the twentieth century – Archibald Leitch, an architect who would be far better known if he had been a designer of churches. Leitch was responsible for building a generation of football grounds to meet the large numbers of spectators attracted to the new professional game. Leitch worked on Ibrox (Glasgow Rangers), Goodison (Everton), Hillsborough (Sheffield Wednesday), Roker (Sunderland), White Hart Lane (Tottenham Hotspur), Stamford Bridge (Chelsea), Old Trafford (Manchester United) and Filbert Street (Leicester). These grounds all bore his trademark two-tier stands, with the criss-cross steelwork, pitched roof and gable. His stands at Villa Park and Highbury have been replaced. At Everton's ground, Goodison Park, in Liverpool, Leitch had to take account of existing housing when he built the Park End Stand in 1907. He simply built around the terraced housing of Goodison Road, which took a corner out of the otherwise square ground. When Manchester United moved to their new stadium at Old Trafford in 1910, the local newspaper boasted: 'The most handsomest, the most spacious and the most remarkable seen. As a football ground it is unrivalled in the world ... the home of a team who can do wonders when they are so disposed.'[12]

Rugby league and, later, greyhound racing were also followed largely by working-class spectators but enjoyed far smaller audiences, although they had their own often rudimentary edge-of-town facilities. With a shorter working day on a Saturday and cheap travel, the age of fans travelling to distant sporting fixtures arrived, with the professional football clubs' gaunt fences and grandstands, described as 'harsh new features of the urban fringe' by the commentator John Arlott. Such activities often started on common open land

or heath adjacent to towns, or were often part of an amusement park as at
Molineux (Wolverhampton Wanderers) or Villa Park (Aston Villa). As their
popularity increased, more formal grounds were created, sometimes on the
same sites, or sometimes they grew out of small municipal parks or playing
fields, which accounts for many of them being hemmed in by rows of
Victorian terraced housing. The new stadiums frequently catered for several
sports to begin with, but soon football became dominant and the exclusive
activity on most of them.

At Sheffield, the Bramall Lane stadium doubled up as a football ground
for Sheffield United and the county cricket ground for Yorkshire. Bramall
Lane lay between Bramall Lane and the London Road in the Sharrow district
of the city. Eight and a half acres of land, said to be 'free from smoke' and
used for allotments, were leased on the then edge of the city from the Duke
of Norfolk with the intention of creating a sports ground. Sheffield Cricket
Club was formed in 1854 and secured a ninety-nine-year lease for the Bramall
Lane grounds from the Duke, who stipulated that matches 'be conducted in
a respectable manner' and that there should be no 'pigeon shooting, rabbit
coursing nor any race-running for money'. The first Yorkshire county cricket
match took place in August 1855, and football was introduced in December
1862, when Sheffield FC, the oldest club in the world (formed in 1857), played
Hallam. In 1887 the ground was described in *Athletic News* as follows:

> At the top or pavilion end there is a wooden stand that would seat ... about
> 1500 spectators, whilst the side next to the lane is the place for the 6d. 'pit',
> safely and securely railed off and made in a succession of terraces so giving
> everybody an opportunity of seeing what is going on ... the proprietors have
> been recently levelling one end of the ground.

On 14 October 1878 Bramall Lane staged the first recorded floodlit match
ever played. In 1889 Sheffield United Football Club was formed as the cricket
club's resident team – they had discovered that football was more lucrative
than cricket. Before 1889 United's footballers had changed in the cricket
pavilion, but the John Street Side opposite was developed as the football
club's headquarters. The Main Stand, built at the turn of the century, was
distinguished by a tall, mock-Tudor gable in the centre of the roof. It had a
gallery with five openings, like a small house, and later became the press box,
but at the time it was also used by the growing number of cricket spectators.
As well as hosting the occasional football international, Bramall Lane was a
venue for cricket test matches. There was even a cycle track round the
perimeter. By the 1930s the football pitch was covered on its three sides. Ten
bombs hit the ground in December 1940, destroying half the John Street
Stand and its gable.

Norman Yardley and J. M. Kilburn wrote in 1952 that Bramall Lane, from
a cricket lover's point of view, had 'scarcely anything to commend it'. Their

Western Avenue
and the White City
Stadium before its
destruction in the
1980s.

further comments are ironic in light of the boast of the Duke of Norfolk's
agent that Bramall Lane had 'the advantage of being free from smoke':

> There is not a tree to be seen, and both sight and sound reflect encircling
> industry. The clatter of tramcars and the scream of a saw-mill and factory
> hooters make a background of noise to the cricket, and a brewery chimney
> periodically pours smoke and soot into the air.[13]

It was suggested that the brewery deliberately emited its foul fumes only
when Yorkshire's opponents were at the crease. The dual use of the ground
meant that there had to be an open side for the cricket, a phenomenon which
increasingly irritated the footballers, who played against teams with regular
grounds designed with terraces for spectators on all four sides. The ground
continued to be used for both sports up until 1973, when the last county
cricket game was played here. The cricket pavilion was demolished in 1982
and the cricket pitch was converted into a car park. At the end of the century
Bramall Lane, like so many of the older grounds of leading football clubs,
was surrounded by terraced housing to the east and industrial estates to the
north and west.

In the postwar era a number of football clubs disappeared altogether and their grounds with them. Accrington Stanley played their last game at Peel Park in February 1962, when they dropped out of the League for financial reasons. The ground was notorious for its sloping, narrow pitch and cramped dressing rooms. Peel Park soon declined and is now evident only in the form of a grass-covered earthwork marking the site of the old terracing. Gateshead Football Club, founded in 1899, originally known as South Shields Adelaide, first played their games at Horsley Hill Road, now a housing estate. They moved to Red Heugh Park, an elliptically shaped ground also used for greyhound racing. Gateshead were relegated from League football in 1960 and their ground disappeared with them. It is now a flat expanse of unkempt grass overlooked by tower blocks. Ironically, Gateshead Football Club, re-formed in 1977, play in one of the best grounds in the north east of England, the Gateshead International Athletics Stadium.

Perhaps the best known of the stadium casualties was the White City, to the north of Shepherd's Bush. White City was originally built to house the 1908 Olympic Games and became an important centre for various London sports until the 1980s. Adjacent to the stadium was a collection of buildings and structures created for the Franco-British Exhibition, a consequence of the Entente Cordiale of 1904. Both the exhibition and the Olympic stadium were built on a 140-acre farmland site to the west of the West London Railway, which at that date formed the boundary of the newly built up area of Notting Hill. There were forty acres of white, stuccoed buildings (from which the White City took its name), half a mile of waterways, and a Court of Honour with a lake and illuminated fountains, surrounded by Indian-style pavilions. During the First World War, palaces and other buildings were taken over by the Army for training. In 1936 the whole area was taken over by the London County Council to build blocks of council apartments. The White City Estate was not completed until after the Second World War, with blocks of flats covering over 52 acres. Only the street names, India Way, New Zealand Way and South Africa Road, remain as a reminder of the Franco-British Exhibition. The Olympic stadium itself, which housed football, greyhound racing (after 1926, when it was introduced to England) and athletics amongst other sports, was not demolished until 1984. The oval shape of the White City is still traceable in service roads which surround the massive BBC Television Centre building and car park. Wood Lane tube station, which was built to serve the Franco-British Exhibition, closed in 1959.

Following the Sheffield Hillsborough stadium disaster, in which ninety-six spectators were killed, the Taylor Report proposed that all major football stadiums in England, Scotland and Wales become all-seated by 1994–95. By implication, this meant that some clubs would have to relocate into new, purpose-built modern facilities. Some observers feared that the sport would

become increasingly distanced socially and spatially from its 'traditional' audience and be played in soulless, 'production line' concrete bowls in front of passive and affluent consumers. On the other hand, the Hillsborough disaster was seen by some as a result of a wider malaise:

> The Hillsborough disaster was the product of a quite consistent and ongoing lack of interest on the part of the owners and directors of English league clubs in the comfort, well-being and safety of their paying spectators: this particular failure within football that I am condemning is a generalized problem in English culture – the lack of regard by authority (and thereby what we now call 'service providers') for the provision of well-being and security of others.[14]

The Taylor Report, in recommending 'A totally new approach across the whole field of football [requiring] higher standards both in bricks and in human relationships', at least promised a programme, an agenda for future development in the British game, beyond the 'crisis management' which had been characteristic of its recent past. The report, combined with the restriction on development at many old grounds which were hemmed in by tightly knit housing, persuaded a number of clubs to move to new city-edge stadiums. Middlesbrough football club, for example, moved in 1995 from their ground at Ayresome Park, surrounded on all sides by terraced and semi-detached housing estates, to the Riverside Stadium, based in the old dockland area. Like so many of the relocated grounds, Riverside had extensive parking, better access roads and lay close to a railway station. Another major north-eastern football club, Sunderland, also moved premises. The team had played at Roker Park since 1898, a ground which had in part been redesigned by Archibald Leitch, but was restricted by the surrounding housing. The new site, grandly called the Stadium of Light, was on the site of the former Monkwearmouth colliery, which ceased coal production in 1993. Other teams which moved from suburban settings to new sites with more space were Stoke City in 1997, Scunthorpe United in 1988, Walsall in 1990, Derby County in 1997, Huddersfield Town in 1994 and Reading in 1998. Walsall moved from their suburban ground at Fellows Park to the Bescot Stadium, adjacent to the railway and the M6. They are planning to rebuild one of their stands, based on funding raised from renting advertising hoardings facing the ever-busy motorway. Many of the new out-of-town football grounds, such as the Kassam Stadium at Oxford, offered other recreation facilities, such as bowling and multiplex cinemas. Oxford's old stadium at the Manor Ground, in Headington, was given over to a new private hospital, forming part of a large hospital zone between the eastern bypass and inner suburban Oxford. The Kassam Stadium was built in Oxford's Green Belt, adjacent to the university's science park. By the end of the twentieth century, football had become a multi-million pound business. The stadiums of the leading Premier League clubs were the outward expressions of power and success. They were 'business'

centres: Leicester City boasted that its hospitality suites at the newly constructed Walker's Stadium constituted 'a purpose-built hotel without bedrooms'.

The Arsenal

As the professional game developed, many football clubs moved their grounds several times. Between 1886 and 1913 Arsenal, first known as Royal Arsenal and then Woolwich Arsenal, played their games at Plumstead, at one point occupying the site of a former pig farm. Initially, the workers of the Royal Arsenal put together a scratch team which played impromptu games behind the workshops where they were based (known as Dial Square FC). In 1886, reorganized under the name of Royal Arsenal, the team began playing on Plumstead Common before moving a year later to the Sportsman Ground in Plumstead village. When this pitch became too waterlogged to play on, the club moved to the nearby Manor Field in 1888 for two seasons. This ground lay adjacent to Plumstead railway station, where they roped off a pitch and brought in wagons from the nearby barracks to act as stands for spectators.

Arsenal then moved to the grand-sounding Invicta ground on Plumstead High Street, which already had a stand, terraces and dressing rooms. However, in 1893 the club returned to the Manor Field, as the Invicta ground's owner, George Weaver, of the Weaver Mineral Water Company, had decided to build houses on the site, a fate met by many football grounds occupying sites with housing potential. He built Mineral and Hector Streets on the site – traces of the old terracing survive in some of the gardens in Hector Street. During their time at the Invicta ground, Royal Arsenal turned professional – the first London club to do so – and changed their name to Woolwich Arsenal.

Until the turn of the century the club had been run essentially by working men, still closely connected with the Woolwich Arsenal. But the outbreak of the Boer War in 1899 meant more overtime for the men, and less time spent on the football club, which soon ran into debt. The ground was the principal problem: the mortgage payments were too high, and gate receipts were too low, mainly because it was a difficult site to reach from other parts of London by public transport. Arsenal played their last game at the Manor Ground on 28 April 1913. The Manor ground is now occupied by Manor Way, a round-about and Plumstead bus depot. Nothing remains to indicate that, at the beginning of the twentieth century, crowds of up to 25,000 people watched football here on a regular basis.

Henry Norris, Mayor of Fulham and a director of Fulham Football Club, was responsible for the next move. Norris was a property developer who made a fortune out of building new houses in the Fulham and Wimbledon areas. Norris decided to move the club to Highbury, despite considerable opposition

from local residents and Islington Borough Council. The new ground was located on playing fields belonging to St John's College of Divinity, leased from the Ecclesiastical Commissioners on condition that the club did not play home games on Good Friday or Christmas Day. The site's advantage was that it lay at the centre of a densely populated area, was closer to central London and, more importantly, lay next to Gillespie Road underground station (opened in 1906). No other professional football ground in London had such a facility.

Archibald Leitch was commissioned to build a stadium to accommodate the rising number of spectators as the popularity of football grew. It had one main stand on the east side and three large banks of open terracing. Highbury's stand was to be on a different scale from any of Leitch's previous designs, and became the largest in London; it was a two-tier stand with 9000 seats. The banking was raised using excavations from the underground railway. On the opening day, 6 September 1913, the ground was not complete and the pitch was not up to standard, having been raised 11 feet at the north end and lowered 5 feet at the south. When a player was injured in the first game, against Leicester Fosse, he had to be carried away on a milk cart. According to one observer, the match was played in the atmosphere of a builders' yard. By December, however, the seats were completed and conditions improved. The Arsenal, as the club was now called, went from strength to strength. After the war, it was decided to expand Division One by two clubs. Norris bargained behind the scenes, and when Chelsea, Derby and Preston joined the new First Division, Arsenal went in place of Tottenham. The whole affair had obviously been manipulated, leaving Spurs understandably very unhappy with their new neighbours. Arsenal have not left the top division since, the only club in continuous membership since 1919. Highbury soon became a focal point for football in the capital, and in 1923 it became the first English ground ever to host a full international match, when Belgium played England.

After Herbert Chapman was appointed manager, in May 1925, Arsenal enjoyed an unprecedented period of success covering most of the interwar period, during which it became England's premier football club. The 10-acre ground was purchased outright and the Ecclesiastical Commissioners were persuaded to drop their prohibition of games on Good Friday or Christmas Day. The first major redevelopment of Highbury began in 1931. In order to build up the terracing, Arsenal asked local inhabitants to bring in their rubbish. According to Arsenal legend, a coal merchant backed up too near the hole dug for the North Bank, and both his horse and cart fell in – the animal sustained so many injuries it had to be put down and buried on the site under the North Bank. The following summer, work began on the new West Stand, the most advanced and architecturally impressive grandstand ever seen in Britain, designed by the architect Claude Waterlow Ferrier. Ferrier

Arsenal's stadium at Highbury hemmed in by residential buildings on all sides.

was the designer of Trafalgar House in London's Waterloo Place, the Army and Navy Club in Pall Mall, the National Institute for the Blind and the Western Synagogue, off Edgware Road. The West Stand, completed six weeks before schedule, was the most expensive stand of its time. It used 700 tons of steel for the frame and, uniquely, had an electric lift; there were seats for 4000, plus standing room for 17,000. Chapman persuaded London Transport to rename Gillespie Road underground station after the club. The official change of title was on 5 November 1932, just in time for the opening of the West Stand. Highbury was the scene of the first radio broadcast of a football match, against Sheffield United on 22 January 1927.

When the Second World War began, the ground was requisitioned and became a first aid post and an air-raid patrol centre, with a barrage balloon flying over it. The dressing rooms became clearing stations for casualties, and a blast wall was built inside the main entrance, in the famed marble hall. A 1000-pound bomb fell on the training pitch, while five incendiary bombs destroyed the North Bank roof and damaged the pitch. Arsenal vacated Highbury and accepted refuge at White Hart Lane. Then, towards the end of the war, the college behind the Clock End was destroyed by fire; a housing estate now occupies that site.

The stadium, cut into Highbury Hill and surrounded by housing, is relatively inconspicuous. Pevsner ignored the stadium in the first edition of his volume on London covering Islington in the *Buildings of England* series (1952); but the more recent edition acknowledges the contribution of both

Plan of Arsenal's
Manor Ground at
Plumstead in the
early twentieth
century.

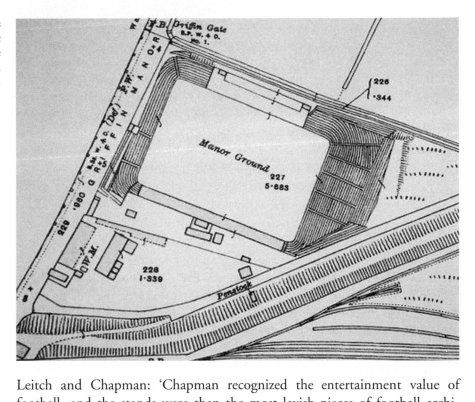

Leitch and Chapman: 'Chapman recognized the entertainment value of football, and the stands were then the most lavish pieces of football architecture ever built'.[15]

At the beginning of the twenty-first century, Arsenal were faced with many of the same problems they had a hundred years ago, but this time engendered by success, and need to move once more. The all-seater stadium for 39,000 is too small for an international club and the modern game of football. Parts of the building are now protected (any redevelopment of Highbury will have to take into account the East and West Stands, which have been listed as historic buildings), making redevelopment on the existing site difficult. Other objections to redevelopment came from the council and local residents. Consequently, Arsenal are planning to move to a new ground – Ashburton Grove.

Crystal Palace

Although most sporting activity developed out of a rural setting, as the century progressed sports took place within an increasingly artificial environment. Twentieth-century sports landscapes tended to disregard the natural or semi-natural landscape out of which they evolved – in competitive professional sport, real play and enjoyment, improvisation and spontaneity all tend to disappear. Such values are lost to the pursuit of efficiency, records and strict rules, and this was reflected in new sporting environments.

At Crystal Palace, sports activity in a parkland setting dates back to the mid nineteenth century on the site of the 1851 Great Exhibition. Below the great fountains of the exhibition, there was a cricket ground, an outdoor gymnasium, a rifle range, an archery ground and a boating lake. It was essentially a Victorian theme park with a wide range of sports, concerts and exhibitions held there. The FA Cup Final was held here between 1895 and 1914. Contemporaries claimed that Crystal Palace was more than just a venue for football matches; it had something of a picnic atmosphere and families would sit in groups under the trees, eating their sandwiches.

There were three stands at Crystal Palace, all on the north side. Two multi-span stands with decorated gables crowned with flags stood on either side of a smaller, pitched-roof construction. But the vast majority of spectators were crammed on to sloping grass banks, without any terracing or crush barriers, many of them 50 yards or more from the nearest touchline. Moreover, none of these slopes was particularly high, so that it is probable that many spectators saw little of the major games. When it was wet, the slopes turned into 'slippery banks of mud', according to an angry *Athletics News* correspondent, writing after the largest crowd ever to assemble for a football match in the world, 120,081, had struggled to see Villa versus Sunderland. 'It is not pleasant to think,' he wrote, 'that Glasgow has a far better arena for a great match than England, and that arena owned by an amateur club.' The pitch also came in for criticism. Its rich turf suffered considerable drainage problems, not helped, suggested the same newspaper, 'by galloping horses over the turf' – a reference to the other events staged at the ground, among which were rugby internationals. There is no doubt that the ground had a wonderful setting, especially with the Crystal Palace in the background and railway station only a hundred yards from the pitch. Attendances were consistently high – averaging 73,000 in twenty Finals.

On the outbreak of war in 1914 the ground was taken over as a barracks for the Navy, and consequently the 1914 Final between Burnley and Liverpool, which was the first to be watched by the King, George V, was also the last at the ground. After the war, it was used by an amateur football club, the Corinthians, until the Crystal Palace itself was destroyed by a fire in 1936 and the park went into decline. For a while it was used to stage motor racing, but after the Second World War it became the National Recreation Centre. On the exact site of the football pitch is the Crystal Palace athletics stadium, with two great cantilever stands plus additional facilities such as football on artificial turf and indoor sports. The stadium has more in common with the massive football grounds found in the United States than with traditional athletics stadiums in England. Furthermore, it could equally house football, rugby or baseball – it is a high-tech, functional building. Increasingly, the aesthetic features were replaced by industrial sporting facilities, since the National Recreation Centre was located there in 1964. The Centre was built

on the lower slopes of the exhibition site and consists of the athletics stadium, which occupies one of the great fountain basins, the largest swimming pool in London, a vast sports hall, a dry-ski slope and an eleven-storey hostel.

By the end of the twentieth century, sports and leisure facilities had become both serious commercial business and a major land-user. There was a considerable net increase in sports facilities over the century, and sport and leisure had become a significant land-user by 2000. In 1973/4 alone, some 137 leisure centres and 190 swimming pools were opened in Britain. Moreover, the nature of many sports facilities became increasingly industrial in character; sports and leisure centres were housed in large hangar-like buildings, while there was an increasing demand for all-weather tennis courts, football and hockey pitches. Between 1973 and 1977, participation in indoor sports in the UK almost doubled and continued to increase until the end of the century. Such sporting provision contributed significantly to the infilling of suburbia and green belts. In the hierarchy of urban recreation facilities, sports centres are comparable with suburban shopping centres, largely car-dependent, creating new loyalties and providing new experiences. Often, sports complexes formed part of redevelopment projects, sometimes on reclaimed land. For example, the Wapping Sports Centre occupies what was Wapping Basin; the line of the curving quays of the basin is reflected in the outline design of the 1990s sports centre.

The government permitted many leisure developments and theme parks in rural areas, and in 1992 extended the list of permissible uses of Green Belt land to include sports. At first sight the latter appeared to be an appropriate use of the rural landscape, but modern sports facilities bring with them their own problems. First, because such facilities rely heavily on car use, they need good access roads and adequate parking space, two requirements which often

A typical sports centre of the 1980s at Bicester in Oxfordshire.

Dorney Lake, Eton College. This 'Olympic' artificial rowing course lies in a bend of the River Thames between Windsor and Maidenhead.

use up as much if not more land than the sports facility itself. Secondly, many modern sports facilities need to be used round the clock and on an all-year basis; this requires floodlighting and in some cases all-weather courts and pitches, and roofing. The development of cheaper, lighter materials meant that sports halls and stadiums could be larger than in the past. The end result was normally an 'industrialization' of the area covered, often former agricultural land or open green space.

Typical of a new generation of sports facilities is the Dorney Rowing Lake in Buckinghamshire. This is a man-made, international eight-lane rowing lake, planned to be over a mile long, lying between the River Thames and the M4 motorway at Dorney, near to Eton College, which was its principal financial backer. It was excavated from the Thames river gravels, uncovering a wide range of archaeological sites in the process. Evidence of activity in the area from as early as 8000 BC has been discovered, as have remnants of what may be Bronze and Iron Age bridges, the earliest known bridges across the River Thames.

Indeed, water-based sports represented one of the fastest areas of growth during the last decades of the century. Boating marinas were developed at many resorts around the coast, often replacing more traditional seaside activities. Inland, dozens of new marinas were created on new reservoirs and aggregate quarries along the river terraces of lowland England. For example, along the short stretch of the River Thames between Windsor and Maidenhead there are more than half a dozen sailing marinas.

Wembley

Wembley, a name which became synonymous with football in the twentieth century, was in 1850 a village on the western fringes of the metropolis. Since the sixteenth century much of the land in the Wembley area had belonged to the Middlesex family of Page. Towards the end of the eighteenth century, Richard Page had employed Humphry Repton to convert some of the property into a park – Wembley Park. The park was sold eventually to John Gray, a wines and spirits dealer, to acquire for himself the status of a country squire. Gray spent considerable sums improving the park, though the growth of London was already threatening Wembley's rural isolation. In 1879 a railway line was opened by the Metropolitan Railway, and a year later Gray sold 47 acres of his property to allow the company to extend the line to Harrow. In 1889 Wembley Park changed hands again, when it was sold to the Managing Director of the Metropolitan Railway, Sir Edward Watkin, for £32,929 .

Watkin was an entrepreneur with two overwhelming ambitions: the linking of Britain to Europe through a tunnel under the English Channel, and the construction of a railway line that would connect Manchester to Paris through London and Dover. To promote the latter scheme, Watkin secured for himself membership of the boards of both the Manchester, Sheffield and Lincolnshire Railway, and the South-Eastern Railway. Watkin's Anglo-French vision had focused on the success of the Eiffel Tower at the French Exhibition of 1889. He resolved to build a bigger tower inside a spectacular funfair to be constructed at Wembley Park. In 1889 the Tower Company Ltd was

The base of the Wembley Park Tower, known as 'Watkin's Folly', before its demolition in 1907.

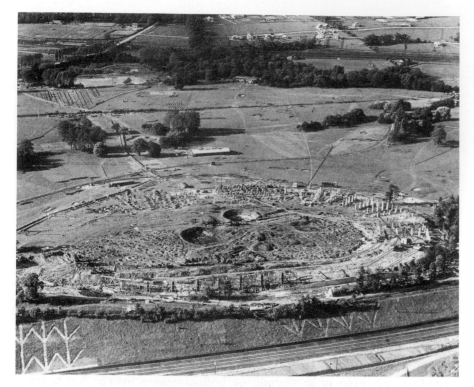

Work starting on Wembley Stadium in the early 1920s. Wembley was still a rural area at this time.

formed and a competition announced for designs for the 'Great Tower of London'. Amongst the sixty-nine plans submitted there were some extravagant proposals, including a proposal to reproduce the Tower of Pisa in granite. Generally, however, the inspiration was that of Eiffel himself, and most competitors attempted to imitate his structure. Despite the jury complaining of 'there being no single design which we could recommend as it stands for execution', the first prize was awarded for an octagonal tower of 1200 feet, 215 feet higher than the Eiffel Tower.

The tower was to be built by the International Tower Construction Company. The space inside the building was divided into restaurants, theatres, dance halls, Turkish baths, and exhibition halls for various novelties from the worlds of science and entertainment. From the outset, construction was beset by financial problems. The appeal for public subscription was unsuccessful and the entire economic burden fell on the company controlled by Watkin. Consequently, the winning design had to be modified into a less expensive one. Work began in June 1893 under the direction of Benjamin Baker, designer of the Forth Bridge and the Aswan Dam. The foundations were laid and the first level of the tower was completed in September 1895.

At the same time a large amenity park was created to contain cricket and football pitches and an artificial lake. The park opened in May 1894, and 120,000 visitors were attracted to it during 1895. Wembley soon became a

favourite recreational place for Londoners, but work on the tower stopped when its foundations shifted. Although the first level was opened to the public in the 1896 season, the number of visitors dropped dramatically. The Tower Construction Company was voluntarily closed down in 1899 – 'Watkin's Folly', as the tower had become known, only remained open until 1902, when it was declared unsafe and closed. It was demolished in 1907. The remainder of the park continued to be a popular sports venue, with football, cricket, cycling, rowing, and ice skating in winter on the artificial lake, and an athletics track built around the cricket field. More than a hundred sports clubs were using the playing fields by the end of the First World War. The Tower Construction Company became the Wembley Park Estate Company in 1906 with the aim of transforming the surroundings into a peaceful and exclusive residential area, complete with an eighteen-hole golf course.

After the First World War, a site for the British Empire Exhibition was required and Wembley became the favourite candidate. Although *The Times* maintained that Wembley was unsuitable, as it was 'some way out of London', the British Empire Exhibition bought 216 acres in Wembley Park from the Metropolitan Railway Company as a building site. The overall plan for the Exhibition was in the hands of architects John Simpson and Maxwell Ayrton, together with the engineer Sir Owen Williams, chosen for his knowledge of building in the distinguishing material of the Exhibition – reinforced concrete. This relatively new material was thought to be suitable for building quickly and at minimum cost. Each colony of the Empire was

Wembley Stadium and the Empire Exhibition in 1924.

represented by its own building, and in addition there was the Palace of Engineering, covering an area over six times that of Trafalgar Square, for the exhibition of industry. It was the largest concrete building in the world at the time. There were also the Palace of Industry, the Palace of Arts, exhibiting the development of art in the Empire from 1750, and His Majesty's Government Building, in which were represented various government ministries and official organizations. The Exhibition covered 220 acres and incorporated fifteen miles of streets.

The construction of Wembley Stadium started with the excavation of 250,000 tons of earth on the hill where 'Watkin's Folly' had stood. This formed the large hollow of the arena constructed in ellipsoidal form. 1500 tons of steel, 25,000 tons of concrete and half a million rivets were used to complete the stadium within 300 working days. The maximum measurements were 900 by 650 feet, making it twice the size of the Colosseum in Rome. The focal point of the stadium was the entrance, with its famous twin towers, 126 feet high. The twin tower motif, topped by domes and reinforced concrete flagpoles, pronounced a new style, echoed throughout the Empire from London to New Delhi. Wembley was an expression of British confidence in a decade otherwise fraught with problems. The capacity of the arena was 125,000, with 30,000 seats. The structure was tested a few days before opening by a battalion of soldiers, joined by McAlpine's workers, who marched in close formation on the terraces. Wembley staged the 1923 FA Cup Final, an organizational disaster with twice as many spectators filling the stadium as the official capacity allowed for, and a resultant invasion of the playing area.

The imperial theme was dominant at the Exhibition, which opened on St George's Day 1924. The pavilions of the colonial countries were constructed in heavy, neoclassical style, which also characterized the Government Building. 'It is', proclaimed the *Official Guide*, 'a Family Party of the British Empire – the First Family Party since the Great War, when the whole world opened astonished eyes to see that an Empire with a hundred languages and races had but one soul and mind.' There was a desire to assert the cultural integrity and the economic viability of the Empire through the Exhibition, and some of this was evident in the architecture. Contemporary opinion on the style of the buildings was mixed. Writing in the *Architectural Journal*, C. H. Reilly asked caustically of the Palaces of Engineering and Industry: 'Are they great garages or aeroplane sheds?' Others were more favourably impressed: 'Imagination is baffled by the vastness of this exhibition which is an honour to the enterprising spirit of the British race, and also the capability of British architects ...' Yet again: '[it is] a place in which an architect may be proud of his profession ... where architecture is the proven Mother of Arts.' It appears that the architects lacked experience in the use of reinforced concrete, some of which was misconceived in design terms and also poorly

executed by unskilled labour casting the concrete *in situ*. Commenting on the stadium, the critic Oscar Faber noted that 'the inside was the roughest-looking concrete job I had seen for some time'. There were a profusion of concrete bridges, lamp posts, kiosks and even roof trusses. Owen Williams, whose enthusiasm for concrete largely accounted for its use, was convinced that the Exhibition marked an important step forward in application for the new building material. He claimed that the Exhibition showed that a material that was previously regarded as a 'mysterious alternative, only to be adopted for economy' actually had a bright architectural future.

The Exhibition attracted millions of visitors in 1924, and reopened between May and October the following year, which raised the final attendance to over twenty-seven million. Nevertheless, within a few years the Exhibition site was a wasteland of derelict buildings and rubble. Two lasting memorials arose – one was the suburb of Wembley itself. Its rapid development to borough status in 1937 owed much to the infrastructure bestowed on the area through the creation of the Exhibition. The Exhibition required the reconstruction and realignment of many of the country lanes in the Wembley area, opening up for bus traffic and motor cars an area which until then had been a rural backwater. The other was the stadium, which, from its original conception as a national, indeed 'Empire', stadium, in fact became a synonym for *English* football, with its 'twin towers' an icon of Englishness.

Football became Wembley's main activity, although the Rugby League Cup Final was housed here in 1929. This was followed by other activities such as boxing and regular speedway meetings, plus the many sporting and entertainment events staged in the Empire swimming pool, which opened in 1934 and was renamed Wembley Arena in the late 1970s. The 1948 Olympic Games was another huge success for Wembley and, remarkably, was organized with just a few months' notice. Some of the formal buildings survived into the 1970s, amid general squalor and decay, but haphazard rebuilding since has ignored the scale and logic of the original arrangement, although the Wembley Conference Centre was built here in the mid 1970s. The exhibition buildings east of Olympic Way, including the Palace of Engineering, were swept away in favour of large, anonymous industrial sheds, neatly clad in ribbed aluminium, sheltering behind a motley group of taller offices along the main route.

Only a few of the buildings built for the Empire Exhibition survive. The Palestine building was moved to Glasgow, where it became a laundry; the West Africa building became a furniture factory; and other material from the site was used as part of Bournemouth Football Club's grandstand. The Palace of Industry still remains in use as a warehouse. The temple-like Palace of Arts alongside it – 'almost pagan in its sombre strength' as Betjeman called it – is now no more than a shell. Apart from the stadium, Wembley became a random collection of buildings: the Empire Pool, the Conference Centre,

squash centre, light industrial units and disused structures. Wembley Stadium itself closed at the end of 2000 and was dismantled in order to make way for a new National Sports Stadium, in which the symbolic twin towers were replaced by a massive monumental arch. The arch, once erected, was visible over much of west London; Edward Watkin's dream of a landmark tower at Wembley to equal the Eiffel Tower had, in one sense, been realized.

Theme-Park England

… never before have so many people been searching for England.

H. V. Morton, *In Search of England* (1927)

DURING THE TWENTIETH CENTURY, improvements in transport, changes in work practices, and the growth in disposable income made many previously inaccessible places more available to an increasingly large number of people. It also resulted in the conscious preservation of what was deemed popular and attractive, and the creation of what came to be termed 'theme-park' England later in the century. In *The Past is a Foreign Country*, David Lowenthal argued that the act of preservation changes the nature of that which is being preserved, and we are therefore always going to present a distorted or subtly changed version of the past.[1] Parking, interpretation centres and other visitor facilities created pressure, particularly during the summer months. By the year 2000 tourism accounted for 5 per cent of GDP, and one job in ten was related to the tourist industry.

By the end of the twentieth century, in addition to the tens of millions of British people who used leisure facilities at home, there were twenty million overseas visitors to Britain each year. The majority of overseas tourists spent most of their time in London and placed particular pressures on the capital's main historic attractions such as the Tower of London and Westminster Abbey. There was also pressure outside London on those 'honeypot' sites that were within easy reach of London – Stratford-upon-Avon, Oxford, Bath and Stonehenge. In addition to the traditional tourist centres, major new entertainments, such as the leisure parks at Alton Towers and Chessington, were established. And throughout England, as the conventional seaside holiday lost its appeal, hundreds of new museums, parks and entertainments were opened

In 1900, most people in England lived close to where they worked and, apart from those families able to afford holidays, rarely travelled away from their home area. At the beginning of the century, one inhabitant of Rottingdean in Sussex expressed a typical attitude to the outside world. It was 'regarded in a vague and uninterested way by locals as being somewhere over the hills to the north. Any town from London to Leeds, from Oxford to Edinburgh, was referred to as being "somewhere up the back o'Lewes"'.[2]

When the author, as a young boy, was taken on a trip to Lewes, some ten miles away, he and his companions were given a send-off 'worthy of a trip to Australia'. Even in the 1920s 'the villagers were often bred, baptised, book-taught, betrothed, bedded, boarded and buried all within hailing distance of the cottage which had seen their birth and many would never have occasion to travel beyond the perimeter of land that could be seen from the top of a haystack'. To Laurie Lee, growing up in the small Cotswold hamlet of Slad in the 1920s, the wooded horizon was 'the limit of our world'.[3] Like every-thing else, recreation was confined within this limited area, and the idea of providing special facilities for leisure activities, even sport, would have been seen as bizarre.

In 1927, H. V. Morton, one of the foremost English travel writers in the first half of the century, observed that it was the advent of the automobile which opened up England to tourism. He wrote:

> The remarkable system of motor coach services which now penetrate every part of the country has thrown open to ordinary people regions which even after the coming of the railway were remote and inaccessible. The popularity of the cheap motor car is also greatly responsible for this long-overdue interest in English history, antiquities, and topography. More people than in any previous generation are seeing the real country for the first time. Many hundreds of such explorers return home with a new enthusiasm, astonished that this wealth of historic, and other interest, any angle of which provides a man with an absorbing hobby for the rest of his life, should until now have been neglected at their very doors.[4]

Many people had adopted the 'absorbing hobby' long before motoring was dreamed of; the coming of the railway had encouraged an annual exodus to the coast and the development of seaside resorts. The railway had also led to the development of a number of inland spa resorts: Buxton in the Peak District, Kendal in the Lake District, Harrogate in Yorkshire, Malvern and Church Stretton in the Welsh Border hills, Cheltenham and Leamington Spa in the Midlands. As it happens, an outbreak of typhoid destroyed the reputation of Malvern's hydropathic establishment in 1905. Malvern, however, like Cheltenham, had already become a school town after Malvern College opened in 1865. Tunbridge Wells had done the same, and soon no spa or resort worth its name was without preparatory or public schools.

People both moved to live in such places and visited them to take the water or walk. Such activities were on a relatively small scale, and, although it would be a mistake to underestimate mobility in late Victorian England, it is true that most places away from cities and from the railway were rarely visited by outsiders. Tourism inside England remained restricted to the wealthy, in the same way that overseas travel was open only to a minority. Travellers in Britain tended to visit such areas as Dartmoor, the New Forest

Pre-First World War motor cars outside the Lygon Arms at Broadway in the Cotswolds, which was later to become a 'honeypot' tourist attraction.

and the Lake District, where, as early as the 1880s, Andrew Carnegie came across hotels and coaches displaying the Stars and Stripes, indicating the presence (or expectation) of American tourists.

The car was used as a means of exploring the countryside from an early date. For example, in 1904 Rudyard Kipling, an enthusiastic pioneer motorist, wrote: 'the chief end of my car, so far as I am concerned, is the discovery of England ... the car is a time machine on which one can slip from one century to another'.[5] A large number of books appeared encouraging the intrepid tourist to take to the road. In 1908 an American, John M. Dillon, wrote *Motor Days in England*, in which he complained of the lack of signposting and how he became lost in any town of size.[6] Although his passengers said that their views were sometimes spoiled by the tall hedgerows, they were enthusiastic about motor touring, claiming that it enabled them to appreciate 'real' English life and customs. In his account of *Through East Anglia in a Motor Car* (1907), J. E. Vincent also complained about the poor signposting, which was geared to the local horses and pedestrians normally travelling only a few miles a day, compared to the motorist who could expect to travel as much as twenty or thirty miles at a time. Vincent noted the changes in accommodation and how the motorist needed baths because of the dust, and wrote enthusiastically about how one old coaching inn had renamed itself a 'Motor House'. Another prolific early motoring writer was J. J. Hissey, who, in 1908, recorded how he had stopped at a hotel in Exeter and found that the yard was filled with cars. He noted with apparent approval that there was not a horse to be seen.[7] According to the 'Automobile World' of *Country Life* on the Whitsun Bank Holiday of 1913:

Thousands of motorists seemed to have made up their minds to do a tour at Whitsuntide, whatever the weather might be, and, so far as the West Country is concerned, I have never seen more traffic on the main roads nor more crowded hotels at the popular stopping-places. To sit for a few hours outside some big hostelry in any of the country towns in the West and watch the arrivals and departures afforded the best possible illustration of the change which the motor has made in the habits of a large section of the population.

During the First World War private motoring was restricted to essential users; but in the 1920s motorized tourism grew again. Many of the new tourists came from the emerging middle classes, whose strength was reflected in countless books, newspaper articles and films of the interwar years. Guide-books on touring and travel in Britain proliferated. The principal guides were Baedeker, the Blue Guide, the AA and RAC, Dunlop, Burrows, Newnes, Shell, and Black's, but there were many others and a whole library of travel books giving advice on every aspect of touring, such as John Priolean's *Car and Country: Week-End Signposts to the Open Road* (1929). The exploration and the 'rediscovery' of the countryside and its treasures, so enthusiastically embarked upon before the war, resumed with renewed vigour and with far greater numbers involved.

There was a naivety about the relationship between the car and the beauties of the English countryside which survived for much of the twentieth century, for example, in this 1920s advertisement for Jowett cars:

Have you spied the purple iris blossoming along the river bank? Have you glimpsed a bit of heaven whilst 'picnicing' by the scented pinewood? The wind's on the heath, brother; the highway is calling; there's laughter and deep breath and zestful life over there on the hills. Freedom is waiting you at the bang of your front door.

Cars were seen as a means of opening up the countryside, of enabling access to remote and beautiful places. The automobile was a means to an end and presented no sort of threat in itself – it was attractive, stylish, comfortable and fashionable. Between the wars the car was a high status symbol, which enabled the rich and successful delights that were available only on a much more restricted basis to the man in the street. In the 1930s many of the posters for Shell oil were of landmarks, historic monuments and 'inspiring landscapes'. Shell helped to promote the idealized view of rural England. Significantly, Shell won the support of pressure groups such as the Council for the Protection of Rural England, who sought to protect the countryside from urban expansion and the destruction of rural amenities by intrusions such as pylons and advertising hoardings. Most of Shell's own advertising was in the form of lorry bills, which were attached to the fleet of Shell vehicles delivering petrol and oil throughout the country. Shell users were invited to

Cheddar Gorge in
the 1930s. One of
the sites that became
popular between the
wars.

visit such landmarks as the Cerne Abbas Giant, genitalia tastefully obscured, beauty spots such as the New Forest, portrayed empty of visitors or cars, and such historic buildings as Bodiam Castle, depicted at night.

The respectability of motor touring was reinforced by the list of artists commissioned by Shell. It reads like a *Who's Who* of the British art establishment of the period – Paul Nash, Graham Sutherland, Vanessa Bell, Ben Nicholson, Rex Whistler and Edward McKnight Kauffer – who between them produced some of the finest examples of commercial art while promoting a nostalgic view of England at the same time. At this stage of the century the motor car itself was not perceived as a threat to the countryside. Buying a car meant buying into a new world. As John Lowerson has written: 'Ownership and pride in a marque identity was provided by "own brand" magazines which turned increasingly to the leisure use of cars.' Once a month throughout the late 1920s and 1930s the *Morris Owner* informed the proud owner of a new Morris Minor not only how to fix his carburettor on a lonely road, but how to find that lonely road in the first place. As the *Morris Owners' Road Book* of 1926 put it, buying a car was buying a 'modern magic carpet'. Using it took the motorist to 'the pretty villages, the old farmsteads, besides numberless quaint features to be found in our old towns [which] all reach out from those bygone centuries and captivate us with their reminiscences of ancient peace'.

Commentators were, however, not entirely oblivious to the changes that the car could bring. As early as 1907 *The Times* called attention to the fact that the car had taken possession of the Lake District and entirely altered its character, while H. V. Morton commented sadly on charabancs piling up at

Wells. George Sturt, author of *Change in the Village* (1912) maintained that, 'Where the Tripper goes, he spoils everything ...!' Later, the magazine *Nature* pointed out a consequence of the significant increase in tourism. It stated that the defect of the 1913 Act which protected ancient buildings was that it made no attempt to safeguard their character in so far as it depended on their historical or natural setting. 'It was not foreseen that a vast extension of motor traffic was at hand which would bring in its train an increase in the number of excursionists for whose entertainment and refreshment provision would be made.'[8] One observer complained:

> Kenilworth, like most other old castles, has in its old age come to the undignified state of being a sort of gigantic peep-show, with admission charged at so much a head, to the destruction of its century-gathered romance. The poetry of the land must to-day be sought for well away from the beaten track; and the beaten track, owing to the motor car, has become more beaten still. Wherever goes the road to any interesting or famous spot mentioned in the guide-book, there comes the conquering car, often hired for the day by a noisy party, and that is the worst of it.

The coming of the motor coach (or charabanc as it was known), prior to the First World War and during the interwar years, opened up the country for recreation on a previously unknown scale to the working class and enabled them to participate in the motoring age. Motor coach travel brought about a limited democratization of the countryside, a franchise that was extended to the majority in the decades after the Second World War by means of the motor car.

It is difficult to measure the spread of tourism – how many visitors were going where – but one indicator is the number of admissions to sites and buildings officially listed as ancient monuments. In 1931, quarrying, close to Hadrian's Wall, aroused considerable public disquiet and encouraged the government to introduce a Parliamentary Bill to strengthen the protection afforded to such sites. These figures show that Stonehenge, then under private ownership, had been visited by fewer than 4000 people in 1901; by 1924 the figure had risen to 60,000 and by 1929, 100,000. (In 2000 it was over two million.) The number of people visiting Whitby Abbey was 30,000 in 1924–25 and 40,000 by 1929–30. For Rievaulx Abbey the same comparison revealed a rise from 14,000 to 30,000. In a memorandum to George Lansbury, the First Commissioner for Works, the Society for the Protection of Ancient Buildings wrote:

> In the course of the last ten years public appreciation of our Ancient Buildings, which not so long ago was confined to a comparatively small part of the community, has recently become much more widespread, largely perhaps because of the increased facilities for touring the country by road.

By the 1930s, after a very lean period, more country houses were opening their doors to the public, but it was an uneven picture. John Betjeman edited a series of county guidebooks for motor tourists – the *Shell Guides*. Betjeman's sympathies were clearly more with owners and their houses than with the tourist: 'I have mentioned farms and country houses wherever they are worth looking at', he mused in the introduction to the *Shell Guide to Devon*, of which he was general editor,

> but I do not suggest that you should drive up in a motor-car and demand to see the house, be it farm or mansion. If you have not applied to see the house beforehand, drive slowly past and look longingly at it. Some tenants and proprietors gladly show their houses to visitors; others, and we can hardly blame them, are inclined to be short.[9]

The *Shell Guides* often promoted the attractions of great country houses, whether or not they could be viewed by the tourist, and in many little ways made the tourist feel like an irritant in an otherwise well-ordered countryside.

The Second World War brought about a sharp reverse in the rise both of family holidays and of motorized touring. For a while the railway resumed its place as the main means by which travellers took their holidays. Although the post-1945 recovery in motoring was, slower than after the First World War, it was all the more relentless when it began in earnest. In the post-Second World War era, with universal paid holidays and a steady increase in the standard of living for almost everyone, the impact that leisure activities had on the English landscape was profound and in some cases devastating. As car ownership increased, it became difficult to separate the essential use of the car from leisure activities. It was increasingly understood, although not by all planning authorities, that the car presented the greatest danger to the countryside. Lewis Mumford described how the motorist in search of the rural idyll was thwarted:

> In using the car to flee from the metropolis the motorist finds he has merely transferred congestion to the highway and thereby doubled it. When he reaches his destination, in a distant suburb, he finds the countryside he sought has disappeared; beyond him, thanks to the motorway, lies only another suburb, just as dull as his own.[10]

By 2000 the tourism and leisure industry in the UK had a turnover of over £35 billion, and the leisure industry accounted for about 27 per cent of consumer spending in the UK. Recreation and leisure formed an important part of the tourist industry – in 1994, earnings from recreation and leisure exceeded £10 billion. The sports industry alone employed over 500,000 people. Leisure travel increased by over one-third after 1975 and, by the end of the century, leisure accounted for over 40 per cent of all passenger mileage each year, and over 80 per cent of all leisure journeys were made by car. The

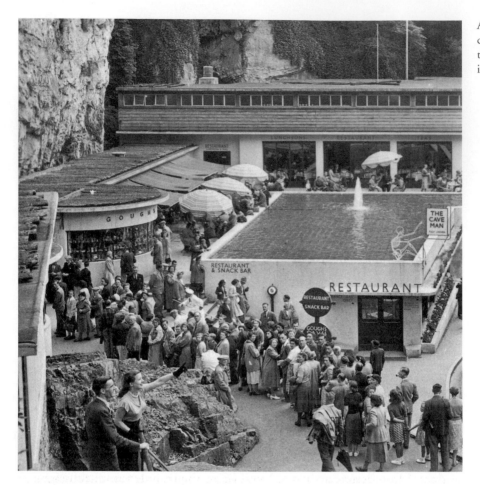

A postcard showing crowds of visitors at the Cheddar Caves in 1947.

leisure industry was responsible for significant changes in the face of the countryside, with all-weather games pitches, theme parks, golf courses, health farms, hang-gliding and war games, all providing alternative uses for rural land. After agriculture, recreational activity became the biggest source of damage to Britain's Sites of Special Scientific Interest (SSSI). Theme parks and other attractions, such as war games and mountain biking, were among the main activities responsible for environmental destruction.

There were conflicts between those who wished to use the countryside for peace and quiet and those who flew model aeroplanes, shot clay pigeons or raced motorcycles. Some of the problems, such as footpath erosion and the damage caused by sailing and water sports, were localized and heavily publicized. For example, in the early 1990s the government welcomed plans for a new Center Parcs development at Longleat, even though the scheme was within an Area of Outstanding Natural Beauty. It was claimed that it would create 750 new jobs and would not undermine the beauty of the area. The holiday village accommodated up to 3500 visitors at a time, providing short-term construction and long-term service employment. There are similar plans

for a holiday village at Alton Towers on land adjacent to the theme park. In 2000, Alton Towers covered over 600 acres, accommodating 30,000 people, 7000 cars and 400 coaches. Many leisure developments, however, were on rural land which was derelict or redundant. The Cotswold Water Park was located at a series of former gravel pits, joining them together to produce an extensive site for sailing, waterskiing and windsurfing.

The number of visitors also posed a problem and an opportunity for the great cathedrals of England, and by 2000 most of them had imposed a 'voluntary' entrance charge. This was also prompted by the need to raise the large sums of money required annually to maintain the buildings at cities such as Salisbury and Winchester. By the end of the century, over sixty million people a year visited historic monuments, including houses, churches and castles. Among the heritage sites are sixty or so designated 'historic towns'. Tourism on a large scale became part of the leisure industry. Although most British people took holidays abroad, day or weekend breaks to incorporate historic houses and monuments became commonplace.

There were a number of organizations whose 'defence' of a particular view of the countryside caused problems in the interwar period. Throughout the 1920s, the Commons, Open Spaces and Footpaths Preservation Society fought battles to prevent the sale of common land and parkland, and took on local authorities and the War Office as well as speculative builders. The Ramblers' Association kept a watching brief on closed or ploughed-up footpaths, and pressured local councils to create 'rights of way' maps for their areas.

Most spectacular of all the battles, by far the best known, and the one which opened up the whole issue of relationships between town and country, was the 'mass trespasses' in the Pennines in the early 1930s. Here organized and urban working-class rambling associations, including the Communist Party, led by the British Workers' Sports Federation, asserted the right to roam on open moorland that was private and mainly used for grouse shooting. On 24 April 1932, a group of several hundred ramblers, led by a BWSF activist, Benny Rothman, walked onto Kinder Scout from the village of Hayfield. At the top of Kinder they were met by a group of keepers and temporary wardens. 'The pushing and shoving that followed saw only a few open fights; and then they left.' On their return to Hayfield, five 'ringleaders' were arrested and were subsequently imprisoned for between two and six months. The campaign continued, however, with demonstrations and attempts at trespass elsewhere in the Peaks.

One of the most popular and widespread recreational activities is walking. It is estimated that over 100,000 people are members of the Ramblers' Association and that over 5000 belong to the Long Distance Walkers' Association. The potential impact of so many people on sensitive areas is great. For example, damage to sensitive species on popular walks can lead to soil erosion and create gullies, as along the route to Red Tarn in the Lake District. Heathlands,

chalk and limestone grasslands, and wetlands are particularly fragile, and breeding birds are also affected. In coastal areas, destruction of sand dune vegetation and the initiation of blowout dunes are a widespread problem, as at Studland in Dorset and Ainsdale in Lancashire. Blowout dunes are formed when sand dunes which have no vegetation cover to hold the sand together are eroded by winds in gale conditions. Salt marshes are also vulnerable, and trampling may lead to localized destruction of vegetation and subsequent erosion of the salt marsh. In agricultural areas there is conflict between ramblers and farmers over access to land; walkers with dogs can be even more of a nuisance, causing disturbance to sheep and fouling footpaths. Some of the long-distance walks are designed to follow historic features, such as the Offa's Dyke Walk, which follows the line of the mid Saxon earthwork in and out of Wales. A similar walk trails alongside Hadrian's Wall in Northumberland and Cumbria. There are an increasing number of other organized long-distance walks, along the Pennine Way and along the coast, for example. They are normally well, but discreetly, marked, and, although they do pose something of a threat through erosion in some places, they also open up areas of attractive landscape to the intrepid at a time when large areas of the English countryside have become increasingly inaccessible and inhospitable.

The damaging long-term competition to the canals as a means of transport from rail was exacerbated by the advent of the motor age. The canals of the Industrial Revolution survived into the twentieth century, but were progressively run down as canal traffic continued to decline. Many canals, particularly in the south of England, silted up during the late nineteenth century under railway ownership and ceased to carry commercial traffic at all. In Berkshire, commercial traffic on the Wiltshire and Berkshire Canal stopped in 1906, and the canal closed in 1914; on the Kennet and Avon Canal, traffic had all but ceased to operate by 1939. In 1911, however, in a move that went counter to the prevailing trend, Cadbury's had established a new factory at Knighton, on the Shropshire Union Canal. The factory, which produced condensed milk, moved it to the Cadbury works at Bournville, in Birmingham, by canal. Other major exceptions to the trend were the Manchester Ship Canal, completed in 1894, and the hydraulic lift at Anderton, linking the Weaver Navigation with the Trent and Mersey Canal, which had opened in 1875. On some canals, like the Oxford and the Grand Junction, barges still continued to carry appreciable quantities of long-distance traffic. Others, like the Birmingham and the Bridgewater, were increasingly used only for short-haul journeys. The atmosphere of the decaying waterways was captured by Temple Thurston, as he made one of the last journeys up the Thames and Severn Canal from Brimscombe to Sapperton in about 1910:

> For more than three miles the canal divides the wooded hills, a band of silver drawn through the valley of gold. Lock by lock it mounts the gentle incline

until it reaches the pound to Sapperton tunnel, and at the summit spreads into a wide basin before it passes into the last lock, some few hundred yards before the tunnel's mouth. The whole way from Stroud upwards is almost deserted now. We only met one barge in the whole journey. An old lady with capacious barge bonnet was standing humming quietly to herself at the tiller.[11]

During the latter half of the twentieth century, many canals found a new life catering for holidaymakers in long boats and walkers using cleared towpaths. Sections of canal, such as the Peak Forest Canal, which had been closed were reopened. The Peak Forest Canal ran from Dukinfield, on the Ashton Canal, east of Manchester, to Buxsworth Basin and Whaley Bridge, fourteen miles to the south east. Stone quarries, connected to Buxsworth by tramways, supplied most of the traffic, and as late as the 1880s up to thirty boats a day were leaving the basin. Traffic died during the 1920s, however, after which the Peak Forest Canal began a slow decline and was impassable by the 1960s. Closure seemed inevitable, but an ambitious restoration scheme using volunteer labour saved the canal, and brought about its reopening in 1974. The Peak Forest, outside Manchester's suburbs, quickly became a canal of great attraction, and the section from Marple to Whaley Bridge is still among the most scenically attractive in the country. At Marple, there are two short tunnels and a magnificent stone aqueduct over the River Goyt, with three huge arches that are over a hundred feet high. A flight of sixteen locks lifts the canal to an embankment built on to the side of the Goyt Valley. Thickly wooded, with splendid views over the valley, this embankment continues to Whaley Bridge, passing the junction with the Macclesfield Canal. At Whaley Bridge there is a terminus basin with an original stone warehouse in which goods were transhipped from boats to railway wagons for the journey across the Peaks to Cromford, along the Cromford and High Peak Railway. Although long closed, the course of the railway can be followed on foot and its inclined planes explored.

Paradoxically, the decline in importance of rail travel opened up a new form of holiday attraction: once the era of steam was well and truly over, many of the disused branch lines were transferred to enthusiasts wanting to preserve steam locomotives. Whilst people no longer wanted to make their main journey by train, they were happy to relive the days of steam with a nostalgic trip along the coast. Nostalgia for steam trains began well before the end of steam engines. John Betjeman was amongst those whose writings evoked the largely carefree image of steam transport, an image that is beautifully drawn in Edward Thomas's poem 'Adlestrop' (1915):

> Yes, I remember Adlestrop –
> The name, because one afternoon
> Of heat the express-train drew up there
> Unwontedly. It was late June.

> The steam hissed. Someone cleared his throat.
> No one left and no one came
> On the bare platform. What I saw
> Was Adlestrop – only the name.[12]

Some of these steam trains were at seaside towns, and the North Somerset
Line is notable among them. The privately owned West Somerset Railway
runs southwards from Minehead, on the Somerset coast, to Bishop's Lydeard.
At nearly twenty miles it is the longest line of its kind in the country, and
it was formed when British Rail's hundred-year-old branch between Taunton
and Minehead closed in 1971. The West Somerset Railway runs a summer
service connecting ten stations along the line. Its special attractions include
the first class Pullman dining car and the *Flockton Flyer*; the stations and the
train are frequently shown on television and in the cinema, and play a signi-
ficant role in England's thriving nostalgia industry. Preservation groups and
other enthusiasts have worked to reopen a number of other steam lines and
stations, such as the Severn Valley Railway, the Watercress Line and the
Bluebell Line, all of which have become important tourist attractions. Some
of the minor rural lines which escaped the Beeching axe are now prospering
as tourist amenities. For example, the three and a half mile steam line from
St Erth to St Ives in Cornwall carried 200,000 passengers in 2002.

Another development which ran parallel to the closing of manufacturing
industry was a dramatic increase in the number of museums. Museums such
as the STEAM Museum at Swindon, housed in the former workshops of the
Great Western Railway, the Paradise Mill Silk Museum in Macclesfield, and
the World of Glass Museum at St Helens are housed in their original
buildings on their original sites. Indeed, some of the museums are dedicated
to industries that were working well into the twentieth century, for instance,

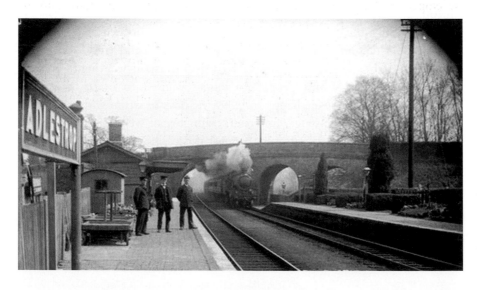

Adlestrop Station in
the Cotswolds on
the Great Western
Railway between the
wars. The station is
now closed.

Former railway track now used as a long-distance walk in the Wyre Forest, Worcestershire.

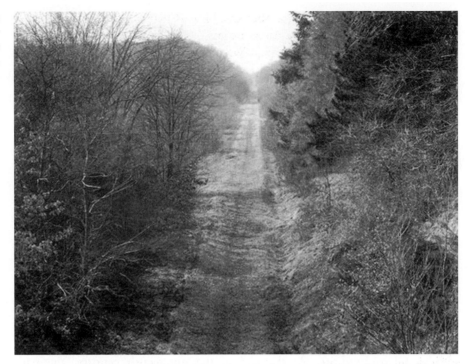

the Geevor Tin Mine in Cornwall and the Abbeydale Industrial Hamlet (steel manufacturing museum) in Sheffield. Perhaps the most exciting transformation of a former industrial landscape was at Coalbrookdale in Shropshire, on the western fringes of Telford New Town, where the Ironbridge Gorge Museum occupies part of the former Shropshire coalfield. Most notably, it was at Coalbrookdale that Abraham Darby first successfully smelted iron ore using coke as a source of fuel instead of charcoal. This led to the building of the first iron bridge, which gave its name to the small industrial town that developed in the gorge, on the banks of the River Severn. In addition to the iron working plant at Coalbrookdale, within the museum there is the Jackfield Tile Museum and the Coalport China Museum, which sits at the bottom of an inclined plane, which was an ingenious device for moving iron tub boats from the Shropshire Canal at the top of the escarpment down to the River Severn at the bottom. The Ironbridge Gorge Museum is a delight to visit and justly deserves its status as a World Heritage Site.

Partly as a result of money becoming available for capital projects through the Lottery Heritage Fund, hundreds of industrial and craft buildings have been transformed into museums or cultural centres. In some cases, such as the Liverpool, Gloucester and Bristol docks, whole urban landscapes have been transformed. So extensive was this activity that some commentators bewailed 'theme-park' England, which seemed only to look backwards.

At seaside resorts a wide range of alternative leisure activities were devised for the holidaymakers. These included permanent amusement parks, which

The docks at Gloucester, which have been restored and reopened as a museum.

previously had been seen only as itinerant funfairs. The funfair habit moved inland and there were a number of inland amusement parks such as Belle Vue in Manchester, linked to the zoo. One of the largest of these was at Shipley Glen, Bradford. At the end of the nineteenth century, the park contained a wealth of attractions including an aerial gondola ride, a big dipper and a toboggan slide. Following a fatal accident in 1900 the amusement park closed, and the park today is open common and wooded slopes; nothing remains of the Victorian fair apart from the Glen Tramway, which takes passengers up the valley side.

Following on the success of Disneyland in California, a new generation of English theme parks was developed in the last decades of the twentieth century. These parks effectively replaced the permanent or semi-permanent fairgrounds at places such as Blackpool and New Brighton, a resort which more or less died completely in the 1970s. Alton Towers, just off the M6 in Staffordshire, was the first of the new generation of entertainment parks and was opened in 1974. Alton Towers had become the main seat of the Earls of Shrewsbury in 1837. However, legal battles over the next few decades meant that in 1860 it was one of the first parks to be opened to the public on a commercial basis. In the 1890s, the 20th Earl, Charles Henry Talbot, began to develop the estate as a serious tourist attraction. He organized fêtes, illuminations and firework displays, as well as an exhibition of instruments of torture and a balloon festival. Family problems again led to financial difficulties, which were exacerbated by the First World War and eventually resulted in the Alton Towers estate being sold to a group of local businessmen. Although the contents of the house were auctioned, it continued to attract a large number of visitors up to the Second World War, when it was taken over for training by the Army. In the postwar period the house went into

decline once more, and a few fairground attractions were constructed in the park. After 1980 it was decided to develop a full-scale leisure park for the public along Disney lines, but within a distinctive English environment. Originally it was largely designed on the fairground model, but its 1000-acre site included the house and gardens, nature trails, show farm and 'adventureland', as well as restaurants and hotels. At the end of the century, Alton Tower was attracting almost three million visitors a year.

An even later attraction was Legoland Windsor, which opened in 1996 advertising itself as 'a safe, happy land-within-a-land where the imagination knows no bounds'. The park was built at a cost of £85 million on the site of the former Windsor Safari Park, itself a post-Second World War theme park, which closed in 1992. Legoland is located about thirty miles from central London, within sight of Windsor Castle, which itself attracted about 600,000 people every year. Miniland consists of Lego models of famous cities and landscapes. Legoland attracts over one and a half million visitors every year. Legoland's location just off the M25 and M4 puts it in reach of nine million families.

Center Parcs is a relatively new company in the UK and is one of the most successful leisure concepts, as compared with UK seaside resorts. It combines the concept of a theme park (based largely around water and sport) with holidays with outdoor activities such as swimming, and evening entertainment. One of the main attractions in each complex is a large indoor pool with 'rapids', 'beaches' and 'waves' in a controlled climate, which enables visitors to enjoy a family holiday at any time of the year. There are four Center Parcs in the UK: the first was opened in Sherwood Forest in 1987, followed by Elveden in Suffolk and Longleat Forest in Wiltshire in 1994, and more recently Whinfell Forest, 400 acres of pine forest on the edge of the Lake District National Park.

The Weald and Downland Open Air Museum of historic buildings.

The Center Parcs concept creates a relaxed atmosphere in a woodland setting. The sites are car-free zones and people travel around the site by bicycle or on foot. Most of the activities are centred on a dome, which contains a number of swimming pools, restaurants, play areas and shops. Other activities such as tennis, horse riding, football and badminton take place outside the dome. Sherwood Forest Center Parcs led to improving land use and habitats. At Longleat, Center Parcs created a new lake as part of the holiday complex. Center Parcs have been described as a 'suburbanised forest' and they represent the packaging of the countryside experience in an appropriate, digestible twenty-first century box.

By the end of the century, the Tussaud company was running theme parks at Chessington, Warwick Castle, Legoland and Thorpe Park as well as at Alton Towers. Such entertainments had developed out of traditional activities such as the funfair and the zoo but were carefully packaged and promoted. Although an historic English country house and park provided a pleasant backdrop for these operations, in keeping with the times they could have been anywhere – Florida, Paris or Staffordshire.

Historic Monuments

> Only in the nineteenth century did preservation evolve from an
> antiquarian, quirky, episodic pursuit into a set of national
> programmes.
>
> David Lowenthal, *The Past is a Foreign Country* (1985)

T HE IDEA THAT THE STATE had any role in the care and preservation
of historic buildings and monuments was anathema for much of the
Victorian era. Indeed, the idea that historic sites and buildings were of any
importance at all only grew slowly in the nineteenth century. During the
twentieth century, historic sites, monuments and buildings came under
unprecedented pressure, but, despite the lobbying of a range of active and
articulate preservation groups, for much of the century the historic heritage
was still regarded as a nuisance by many, particularly those involved in devel-
opment and redevelopment. In the final three decades of the twentieth
century the pendulum of public opinion moved towards the preservationists,
and systematic, but still erratically funded, programmes of conservation were
developed at local, regional and national levels.

The destruction of
London's Roman
city wall at the end
of the nineteenth
century.

In 1882 the Protection of Ancient Monuments Act was passed and began a process by which the archaeological and historical heritage became recognized as a national concern. Like the Historical Manuscripts Commission, however, the machinery put into place by the first Ancient Monuments Act was entirely voluntary. A single Inspector of Ancient Monuments was appointed, a job placed in the safe hands of General Augustus Pitt Rivers, a Tory MP, great landowner and archaeologist. Pitt Rivers was the model 'good custodian' who provided public recreation grounds and free access to the medieval monuments on his Wiltshire estate of Tollard Royal. The General provided shelters for picnics, a theatre and a bandstand in a recreation ground known as the Larmer Grounds.

As a result of the Act, fifty of the most important ancient monuments were 'scheduled' – this entitled the inspector to examine and to care for them, if the owner agreed. At first, owners of sites were reluctant to cooperate, worried that registration of an ancient monument might restrict their ability to sell the land on which it sat. Sir John Lubbock, who had campaigned vigorously for legislation himself, wavered over registering the Avebury stone circle, which lay on his estate, for precisely this reason. In the end, many owners came to the same conclusion as they had done in the case of historical manuscripts – that state inspection and preservation, if voluntary, could enhance the value of their estate. The Act was eventually extended to cover medieval buildings, but only one English medieval building was registered by a private owner. When Pitt Rivers died in 1900 he was not replaced as Inspector of Ancient Monuments. A civil servant in the Office of Works took the job on as a 'labour of love'.

In 1908 the government established a Royal Commission on Historical Monuments, whose job was to draw up a list to describe monuments and buildings of historic interest dating from before 1714. This inventory was to include inhabited buildings but, as the Commission's Secretary explained: 'Our enquiry is merely a national stocktaking ... the nation wishes to know what it has in the way of monuments, and there our functions cease.' [1] The post of Inspector of Ancient Monuments was eventually filled in 1910 by C. R. Peers, Secretary to the Society of Antiquaries.

In 1911 Tattershall Castle, a fine fifteenth-century brick castle in Lincolnshire, became the centre of a major national controversy. The owner proposed to sell and, after the National Trust had refused to pay his asking price, it appeared that the castle might be sold to the United States. Indeed, significant parts of the building had actually been broken up and removed before Lord Curzon stepped in and had the building restored and opened to the public. The castle was ultimately conveyed to the National Trust in Curzon's will. Despite strenuous efforts to draw up legislation to prevent a similar occurrence, vested landed interests weakened a new Ancient Monuments Act of 1913, which did little more than confirm and accelerate

the 'stocktaking' function of the Royal Commission. The vision of protecting the whole spectrum of historic structures through comprehensive legislation – ancient monuments, castles, country houses, moated houses, bridges, market crosses, cottages, barns – was placed on hold. The Act did establish an advisory board to the Office of Works which could schedule ancient and historical monuments even if the Royal Commission had not yet reported on them – but the impact of this scheduling was minimal. Owners were required to give notice of their intention to demolish or alter scheduled monuments, but they did not then have to receive permission from the Office of Works to do so. If government wished to prevent demolition or alteration, or to stop neglect, it could issue a Preservation Order temporarily extending government protection. The Preservation Order then had to be confirmed by Parliament and full compensation paid to the owner. Residences – including all country houses and intact castles of any age – were excluded from the working of the Act. The Act did successfully establish the principle of a national interest in all historic buildings and did provide an official foothold for experts in the form of the advisory board and the Office of Works Inspectorate.

After the 1913 Act there was no substantial legislation concerning historic monuments until the Second World War. Government powers remained strictly limited and a number of sites and many historic buildings, in particular, were damaged or destroyed with little or no protest in the interwar years. During the Second World War, historic buildings were acknowledged as appropriate objects of government care. The combination of relaxed property rights and extended planning legislation made it possible to do in 1944 what had been impossible a few years earlier – to include inhabited buildings with the ruined ancient monuments to which government action had long been confined. The German bombing raids on historic towns along with the extension of education during the war had also aroused popular interest in the traditional townscapes that were now threatened. Shortly after the Ministry of Town and Country Planning was set up in 1943, it was empowered to draw up a national inventory of historic buildings – what became known as 'listing'. In 1947 the Labour government's planning legislation allowed the Ministry to control the alteration or demolition of listed buildings, up to the point of compulsory purchase. The process of listing historic buildings was a slow one and by 1951 only 12,000 were covered, and these were mainly what could be considered elite buildings. By 1964, however, this had increased to 60,000 and by the end of the century about half a million buildings were covered. These included not only 'polite architecture' but also a wide range of vernacular and regionally characteristic buildings. A National Buildings Record (later National Monuments Record) had also been established during the war, to maintain a central supply of photographs and drawings of historic buildings. Additionally, the Royal Commission on

Historical Monuments at last had its prohibition on studying post-1714 buildings lifted. This was in part due to pressure from the Georgian Group (established in 1937), one of a number of societies established to protect relatively recent buildings. The Victorian Society was founded in 1958.

When redevelopment eventually gathered pace after the Second World War the destruction of historic buildings was still thought of as a price worth paying for new urban and suburban environments. The destruction of a number of landmark structures, notably Bunning's Coal Exchange and the neoclassical arch in front of Euston Station, both demolished in 1962, helped change the climate of opinion. By the late 1960s the Civic Trust, amongst other heritage groups, was calling for the protection of areas rather than individual sites. This led to the development of conservation areas and helped incorporate conservation firmly into the development and structure plans which followed local government reorganization in 1974. Additionally, after 1968 heritage legislation had real power – any alteration to or demolition of a listed building required planning consent. Although there were still casualties, such as the Firestone building, which was destroyed in 1980, there were far fewer of them. The presumption in favour of preservation was gaining ground rapidly and, by the end of the century, historic buildings were recognized as a valuable national asset. The Heritage Lottery Fund brought much-needed financial help to a wide range of historic building projects – three billion pounds was spent on some 1500 schemes between 1993 and 2003. The advent of Lottery money helped with the preservation and presentation of many structures and buildings which previously would have been destroyed or allowed to decay.

Attitudes to the archaeological heritage also changed in the second half of the century. The Second World War saw the development of what later became known as rescue archaeology. Prior to 1939, in most instances, non-scheduled archaeological sites discovered during the course of development tended to be destroyed without any investigation. There were a few exceptions, such as the site of the new Bodleian Library in Oxford, which was excavated for its medieval deposits prior to building in 1938. For the most part such losses were at best regarded as unfortunate. During the war, many of the new airfields were located on the sand and gravel terraces of the river systems of eastern and central England. The full extent of the archaeological wealth of these areas, which was discovered partly as a result of military aerial reconnaissance during the war, only became apparent in the postwar decades. In one instance, however, where above-ground monuments survived, there was sufficient alarm to activate an archaeological excavation. At Stanton Harcourt, in Oxfordshire, the remnants of a Neolithic henge monument survived, although it had previously been severely damaged by agricultural activity in the Middle Ages and later. The monument had been recorded by an early antiquarian, Anthony Harris, and anecdotally it is recorded that a Cabinet memo from Churchill authorized

One of the standing stones of the Devil's Quoits at Stanton Harcourt in Oxfordshire, which was destroyed by the construction of a Second World War airfield.

funds to be made available for an excavation to take place before the airfield was built. This and other excavations, funded by public money, represented the first government financial involvement in what was to become known as rescue archaeology: the investigation of archaeological sites that were to be destroyed by development in one form or another. The subsequent excavations at Stanton Harcourt revealed the location of several of the original standing stones of a monument called the Devil's Quoits, and the outline of the henge ditch. The remainder of the henge was excavated in the 1970s, prior to its destruction by gravel quarrying.

At Heathrow, the site of Shasbury Hill was a known feature of the pre-airport landscape. Gupden's *Britanniae* (1586) records that 'on the north edge of [Hounslow] Heath towards King's Arbour is a Roman camp: a simple work and not large'. The camp is mentioned again in the map of the Hundred of Isleworth drawn by Moses Glover in 1635. It is just beyond the boundary of Glover's map, but near to the River Crane, and Glover wrote: 'In this Heathe [Hounslow Heath] hath many camps bin pitched ... whereof the forme of two yet in parte remaineth not far beyond this river. By the name of Shakesbury Hilles.' The camp was mentioned in the *Victoria County History*, which recorded that 'three quarters of a mile north east of Heathrow, immediately south of the Bath Road, a small square camp about 380 feet square was extant until the autumn of 1906. It is now ploughed perfectly flat, leaving no trace.'[2] It was still significant enough, however, for it to be marked on pre-airport maps.

The excavator W. F. Grimes reported that, by 1944, the rampart and ditch had been levelled and reduced, and defied photography from the ground. The bank stood nowhere more than two feet high, its clearest indication being provided by the creep of the plough soil away from its crest, which exposed the light soil of the rampart beneath. The entrance, to the south, was barely discernible. The excavations showed that in the northern half of the enclosure there had been a group of eleven huts. This picture of a comparatively small domestic area, with a large vacant space probably used as a farmyard and enclosure for cattle, was in itself not particularly remarkable. Nevertheless, Grimes argued that this was no ordinary farm. The excavations along the west side, near the base of the bank, were of much greater significance, since they revealed the existence of a rectangular building, 37 x 32 feet in size. He interpreted as a temple, of a type earlier than anything previously recorded in this country at that time. It consisted of a central shrine, which must have had solid wooden walls, enclosed by an outer rectangle of thick wooden posts. It was probably covered by a thatched roof that extended downwards from a central ridge-pole to the outer posts. It might, he said, have had the appearance of a small Greek temple, with the stone columns replaced by wooden posts and the stone-walled sanctuary by a structure like a log cabin.

In the postwar period, it gradually became clear that there were far more buried sites in Britain than had ever been envisaged, and that aggregate working, motorways, housing, deep ploughing and airports would all take a toll on the archaeological record. The discovery of a Romano-British temple dedicated to Mithras, uncovered during the postwar reconstruction of the City of London, did much to excite the public imagination and, along with

The excavation for the Westgate Centre in Oxford in the early 1970s was accompanied by extensive rescue excavations in the western part of the city.

the television programme *Animal, Vegetable and Mineral,* raised public awareness of the value and interest in British archaeology. At the end of the century the *Time Team* programme performed much the same role. A number of large-scale excavations were undertaken from the 1960s onwards, including on urban sites at places such as London, Lincoln, Oxford and Winchester. These excavations were undertaken by contracted archaeologists paid for by the Ministry of Works (later, English Heritage). The Ministry also had care and guardianship of monuments such as Kenilworth Castle and the Tower of London, which were open to the public. The role of the Ministry of Works was taken over by the Department of the Environment in the 1970s, and then by English Heritage.

Ironically, in 2002 the plans to build the 250-acre fifth terminal at Heathrow resulted in the largest archaeological excavation ever undertaken in the United Kingdom. The excavation uncovered evidence of human activity over an 8000-year period. The excavation included the Stanwell Cursus, a two and a half mile ritual pathway, about sixty feet wide (dating to 3800 BC). The archaeologists also found evidence of field boundaries established as early as 2000 BC, some of which continued into the twentieth century. Ken Welsh, the project manager, wrote:

> The excavation revealed that the change from transient, mobile communities, where farming was carried out in short-lived clearings, to that of a settled agricultural economy with individually owned fields took place as early as 2000 BC. This is five hundred years before the accepted date.
>
> It also showed how the religious system changed under pressure from the new farming method. Land was needed so much that the cursus lost its significance and was used for growing crops. Instead, water for livestock became more difficult to get and waterholes were dug and became venerated sites – we may find many valuable objects placed in them as a sign of their importance.[3]

It was not until the 1980s, with the establishment of English Heritage, that a radically different approach to protecting and investigating the archaeological heritage was adopted. This was not in the form of the nationalization of the historic environment, although by this time large segments of it were in the hands of national and local government, the National Trust and a wide range of trusts and other heritage organizations. The new regime maintained the state's right to adjudicate on the importance of sites and monuments, but moved the financial responsibility to investigate and report on the destruction of the heritage to the developer – normally, a private company.

At the beginning of the twentieth century, only limited protection had been given to a small number of well known archaeological sites and monuments and historic buildings. By the end of the century, partly as a result of an epidemic of municipal and corporate vandalism in the interwar

Bronze Age barrows on Salisbury Plain. Only the areas of earthworks were scheduled for much of the twentieth century. As a result, ploughing left the burial mounds as isolated islands. By the end of the century a more comprehensive system of scheduling had generally been adopted.

and immediate post-Second World War decades, tens of thousands of archaeological and historic sites, monuments and buildings were safeguarded. There was a marked change in the perception of the importance of saving the past through the protection of its surviving physical remains. By the end of the century, sites protected included representatives from the industrial and technological revolutions, and monuments from the two world wars as well as the Cold War. Monuments were no longer protected in isolation; increasingly they were seen in the context of their immediate environment. There was, in other words, an understanding of the need to care for the historic landscape as a whole.

These changes were brought about by a dramatic increase in the number of known archaeological sites. Aerial photography, in particular, was able to demonstrate, through the mediums of cropmarking and soilmarking, that whole landscapes of settlements and their associated fields and tracks survive beneath the existing landscape – erased historic landscapes survive in the form of buried archaeology. Quite simply, there is far more surviving archaeological material than had been previously envisaged. This discovery came about at the same time as, and partly because of, the unprecedented threat posed to

the archaeological and historical heritage through the various forms of development and redevelopment that characterized the second half of the twentieth century. In addition to new houses, roads, quarries and intensive agricultural practice, city centres were subjected to intense developmental pressure, drawing attention to the unique archaeological heritage that they all possessed.

Gradually, a more preservationist approach was adopted. Where archaeological material was going to be destroyed, it became the developer's responsibility to provide a record of what was there. All planning proposals had to take into account not only the environmental implications but also the potential damage to the archaeology of the site or area in question. The responsibility for implementing this policy was in the hands of the local planning authorities who, through their sites and monuments records, kept a detailed archive of known archaeological data. Thus, by the end of the century, there was a system in place to monitor the impact of all proposed landscape changes on the historic environment. This situation was very different from the one operating for most of the century, when archaeology and historic buildings along with other environmental elements had been casually destroyed, often in the name of what was perceived as 'progress'. For example, parts of England are still covered in the earthworks of ridge and furrow, monuments to the last arable expansion of the Middle Ages, but the scale of destruction of this phenomenon was considerable, particularly between 1960 and 1990.

Attitudes to the country's monuments also changed. English Heritage had responsibility for the care and maintenance of a wide range of archaeological and historic monuments. Whereas for much of the century such monuments were regarded largely as the preserve of the academic elite, increasingly they

The unsightly 1970s entrance to Stonehenge still in use in 2005.

The majestic earthworks of the Iron Age hill fort at Maiden Castle, one of England's premier archaeological monuments, recorded in all its splendour from the air.

became valued for more than their intrinsic artefactual value. They were seen both as important education tools and as valuable attractions for the ever growing national and international tourist market. Preservation has many benefits for tourism. Britain's historic buildings contribute significantly 'through tourism to earnings of foreign exchange, to local employment and prosperity, and to central government taxation'. It is estimated that in 2004 tourism generated £76 billion and that it was the fifth largest employer in the country. In the borough of Greenwich a quarter of all jobs were tourist related. Visits to historic houses, ancient monuments and old churches rank first in popularity with foreign tourists; visitors contribute half the income of several cathedrals and over two-thirds of the running costs of Westminster Abbey. Building preservation in small towns and villages 'is clearly the most vital factor underpinning their income from tourism'. In addition to the honeypot sites such as Stonehenge and the Tower of London, other locations, such as Hadrian's Wall and Dover Castle, attracted very large numbers of visitors. In some places, visitor numbers actually became a danger to the

monument being visited. Stonehenge, for instance, like the Parthenon in Athens, had to be cordoned off and had to be viewed from a distance by the two million or so people who went there every year.

By the end of the twentieth century, this historic environment and its constituent elements – historic buildings, ancient monuments, relic landscape features and archaeological sites – were general recognized as being of considerable importance and value to the community as a whole. Legislation was still patchy and there remained major loopholes. It was, for example, still possible to bulldoze a thousand-year-old hedgerow with impunity, and the laws on portable antiquities still carried Victorian overtones. But the much maligned planning procedures did protect both discrete buildings, sites and monuments and, in many cases, neighbourhoods and landscape assemblages. Much remains to be done, but, after a century noted for its philistine vandalism, in this one area at least there is some room for cautious optimism.

There is, however, a real danger of debasing the past by the way use it. In the same way that historic villages are cherished and yet changed by the affluent, so the way in which we protect and present other aspects of the past has its own inherent dangers.

> If recognizing the past's difference promoted its preservation, the act of preserving made that difference still more apparent. Venerated as a fount of communal identity, cherished as a precious and endangered resource, yesterday became less and less like today. Yet its relics and residues are increasingly stamped with today's lineaments. We may fancy an exotic past that contrasts with a humdrum or unhappy present, but we forge it with modern tools. The past is a foreign country whose features are shaped by today's predilections, its strangeness domesticated by our own preservation of its vestiges.[4]

Penelope Lively observed that 'we like the past gutted and nicely cleaned up'. The filth and stench of early town life, the foraging of pigs in city streets, the din of horse-drawn vehicles on cobblestones and the terror of pain before modern anaesthesia are rarely reproduced. The past appears to best advantage in renovated relics of everyday activities: flour mills at historic reconstructions always function, printshops unfailingly turn out perfect facsimiles, medieval herb gardens seem invariably fruitful; 'nothing needs to be fixed, raked, painted: there is no dung, no puddles, no weeds'.[5] Nature's normal vicissitudes and mankind's customary tribulations seldom afflict the past as it is portrayed in Theme-Park England.

Notes

Notes to Introduction

1. The account of Stonehenge in the twentieth century is based on that in Chippindale, C., *Stonehenge Complete* (Thames & Hudson, London, 1983).
2. Le Gallienne, R., *Travels in England* (Grant Richards, London, 1900).
3. *Heritage Today*, English Heritage, November 2004.
4. Hoskins, W. G., *The Making of the English Landscape* (Hodder & Stoughton, London, 1955). Republished on numerous occasions, appearing in Penguin paperback from 1970.
5. Introduction to the 1977 edition of *The Making of the English Landscape*.
6. Aston, M., and Bond, J., *The Landscape of Towns* (J. M. Dent, London, 1976); Taylor, C., *Fields in the English Landscape* (J. M. Dent, London, 1975); Rowley, T., *Villages in the Landscape* (J. M. Dent, London, 1978); and Rackham, O., *Trees and Woodland in the British Landscape* (J. M. Dent, London, 1976).
7. Trinder, B., *The Making of the Industrial Landscape* (J. M. Dent, London, 1982).
8. Taylor, C., Introduction to and commentary on Hoskins, W. G., *The Making of the English Landscape* (Hodder & Stoughton, London, 1988 edition).

Notes to Chapter 1: The English Landscape

1. Lee, L., *Cider with Rosie* (Hogarth Press, London, 1959).
2. Hoskins, W. G., *One Man's England* (BBC Publications, London, 1976).
3. Gathorne-Hardy, F., *Lie of the Land* (CPRE, 2004).
4. Priestley, J. B., *English Journey* (Heinemann, London, 1934).

Notes to Chapter 2: The Age of the Car

1. Lee, L., *Cider with Rosie* (Hogarth Press, London, 1959).
2. *Somersetshire Archaeological and Natural History Society*, vol 44 (1898).
3. Jarrott, C., *Ten Years of Motors and Motor Racing* (Grant Richards, London, 1906).
4. Grahame, K., *The Wind in the Willows* (1908). Toad becomes obsessed with motor cars and becomes a self-confessed 'Terror of the Highway'.
5. Rackham, O., *The History of the Countryside* (J. M. Dent, London, 1986). Rackham observes that, 'The building of new main roads in the twentieth century is more than balanced by the disappearance of lesser highways'.
6. Bressey, C., and Lutyens, E., *Highway Development Survey* (HMSO, London, 1937). Bressey identified several key centres of congestion in central London. These included Oxford Circus, Holborn, Hammersmith Broadway, Angel, Archway, Cambridge Circus (which was then a roundabout, albeit a very cramped one), the Britannia junction in

Camden Town, and Elephant and Castle. To relieve these, roundabouts were suggested for all these trouble spots, and some key relief roads. These included an extension of the Embankment so that it linked Putney and the Tower, and a corresponding route on the south side. A City Loop-Way was proposed, a circular route skirting the very centre, and an Outer Circle. Also in the list was an East-West Connection, linking Western Avenue at Wood Lane with Leytonstone, via Marylebone Road and Hackney Wick.

7. Joad C. E. M., *The Horrors of the Countryside* (Hogarth Press, London, 1931).

8. Rope, H. E. G., *Forgotten England and Other Musings* (Heath Cranton, London, 1931).

9. Abercrombie, P., *The Preservation of Rural England* (1926). Abercrombie was one of the moving spirits behind the establishment of the Council for the Protection of Rural England in 1926.

10. Sharp, T., *Town and Countryside: Some Aspects of Urban and Rural Development* (Oxford University Press, London, 1932)

11. Buchanan C., *Traffic in Towns: A Study of the Long Term Problems of Traffic in Urban Areas* (HMSO, London, 1963).

12. Buchanan C., *Mixed Blessing: Motoring in Britain* (Leonard Hill, London, 1958).

13. De Botton, A., *The Art of Travel* (Hamish Hamilton, London, 2002).

14. Crosby, A. (ed.), *Leading the Way* (Lancashire County Books, Preston, 1998).

15. Anderson, R. M. C., *The Roads of England* (Ernest Benn, London, 1932).

Notes to Chapter 3: Taking Off

1. Adams, D., *The Long Dark Tea-Time of the Soul* (Pan, London, 1993). These are the opening words of the book.

2. Hudson, K., and Pettifer, J., *Diamonds in the Sky: A Social History of Air Travel* (Bodley Head, London, 1979).

3. The Victoria History of the Counties of England, *A History of the County of Middlesex*, volume ii (1911).

4. Willatts, E. C., *Middlesex and the London Region*, Report of the Land Utilization Survey (HMSO, 1937).

5. Stapleton, R. G., *The Land Now and To-Morrow* (Faber & Faber, London, 1935).

6. Roy, W., 'Account of the Measurement of a Base on Hounslow Heath', *Royal Society Philosophical Translations*, 75 (1785).

7. Maxwell G., *Highwayman's Heath: The Story in Fact and Fiction of Hounslow Heath in Middlesex* (Thomasons Ltd, Hounslow, 1935).

8. Sherwood, P., *Heathrow: 2000 Years of History* (Sutton Publishing, Stroud, 2001). Cable from Sir Richard Fairey, 7 January 1944.

9. Balfour, H., *Wings over Westminster* (Hutchinson, London, 1973).

10. Stamp, L. D., 'Land Classification and Agriculture', *Greater London Development Plan, 1944* (HMSO, London, 1944).

11. Glidewell, I. D. L., *Report of the Fourth Terminal Enquiry* (HMSO, London, 1979).

Notes to Chapter 4: London

1. Clunn H. P., *London Rebuilt* (John Murray, London, 1927).

2. Wolfe Barry, J., *Address of J. Wolfe Barry*, London Institution of Civil Engineers (London, 1896).

3. Masterman, C. F. G., *From the Abyss* (Methuen, London, 1902).

4. George Gissing's principal London novels were *Demos: A Story of English Socialism* (1886), *The Nether World* (1889) and *In the Year of the Jubilee* (1894).

5. Booth, C., *Life and Labour of the People in London,* in 17 volumes (1889–1902).

6. Besant, W., *South London* (Chatto & Windus, London, 1899).

7. Masterman, L., *C. F. G. Masterman* (Nicholson & Watson, London, 1939).

8. Massingham, H. J., *London Scene* (Cobden–Sanderson, London, 1933).

9. *The New Survey of London Life and Labour* (1934).

10. Hamilton C., *Modern England as Seen by an Englishwoman* (J. M. Dent, London, 1938).

11. Priestley, J. B., *English Journey* (Heinemann, London, 1934).

12. Ridley, J., *Edwin Lutyens* (Chatto & Windus, London, 2002).

13. These last sections of Chapter 4 are based on White, J., *London in the Twentieth Century* (Viking, London, 2002).

14. Smith, A., *The East Enders* (Secker & Warburg, London, 1961).

15. *Woolwich-Erith: A Riverside Project* (Greater London Council, 1966).

16. White, J., *London in the Twentieth Century*, chapter 2.

17. Papadakis, A. C. (ed.), *Post-Modern Triumphs in London* (Wiley Academic, New Jersey and Chichester, 1991).

18. White, J., *London in the Twentieth Century.*

Notes to Chapter 5: Towns and Industry

1. Lawrence, D. H., 'Nottingham and the Mining Country' (1939), in *Late Essays and Articles* (Cambridge University Press, Cambridge, 2004).

2. Priestley J. B., *English Journey* (Heinemann, London, 1934).

3. Freeman, T. W., *Conurbations of Great Britain* (Manchester University Press, Manchester, 1966).

4. Chapman, S., *Jesse Boot of Boots the Chemists: A Study of Business History* (Hodder & Stoughton, London, 1973).

5. Whiting, R. C., *The View from Cowley: The Impact of Industrialisation upon Oxford, 1918–1939* (Oxford University Press, Oxford, 1983).

6. Priestley J. B., *English Journey* (Heinemann, London, 1934).

7. Geddes. P., *Cities in Evolution* (Williams & Northgate, London, 1915).

8. Robson, E. R., *School Architecture* (1877; republished by Leicester University Press, Leicester, 1972).

9. Cherry, B., and Pevsner, N., *Buildings of England: London 4, North* (Penguin, Harmondsworth, 1988).

10. Gomes, M., *Picture House: Photographic Album of North-West Film and Cinema* (Manchester Metropolitan University, Manchester, 1988).

11. Buchanan, C., *Traffic in Towns* (HMSO, London, 1963).

12. Tyack, G., 'The Public Face', in Waller, P. J. (ed.), *The English Urban Landscape* (Oxford University Press, Oxford, 2000).

13. Hall, P., *Cities of Tomorrow* (Blackwell, Oxford, 1988).

14. Sharp, T., *Town and Townscape* (John Murray, London, 1968).

Notes to Chapter 6: New Towns and Garden Cities

1. Myles Wright, H., 'The Planning of Cities and Regions', *Journal of the Royal Society of Arts*, July 1966.

2. Mawson, T. H., *Bolton: A Study in Civic Art and Town Planning* (London, 1911); and Mawson, T. H., *Bolton: As It Is and As It Might Be* (1916).

3. The ideas of the Garden City were best illustrated by Ebenezer Howard in his book

Garden Cities of Tomorrow (1902), which had first appeared four years earlier under the title Tomorrow: *A Peaceful Path to Real Reform* (1898).

4. Betjeman, J., *Collected Poems* (John Murray, London, 1958).

5. Unwin, R., *Town Planning in Practice: An Introduction to the Art of Designing Cities and Suburbs* (T. Fisher Unwin, London, 1909).

6. Pevsner, N. and Neave, D., *The Buildings of England; Yorkshire: York and the East Riding* (2nd edition, Penguin, Harmondsworth, 1995).

7. Webb, W., *Garden First in Land Development* (Longmans, London, 1919).

8. Cherry, B. and Pevsner, N., *The Buildings of England; London 2: South* (Penguin, Harmondsworth, 1983)

9. Deakin, D. (ed.), *Wythenshawe: The Story of a Garden City* (Phillimore, Chichester, 1989).

10. Pevsner, N., and Richmond, I. (eds), *The Buildings of England: Northumberland* (2nd edition, Penguin, Harmondsworth, 1992).

11. Lynch, K., *Theory of Good City Form* (MIT Press, Cambridge, MA, and London, 1981).

12. Tyack, G., 'The Public Face' in Waller, P. J. (ed.), *The English Urban Landscape* (Oxford University Press, Oxford, 2000).

13. Bryson, B., *Notes from a Small Island* (Doubleday, London, 1992).

Notes to Chapter 7: Suburbia and Metroland

1. Sturt, G., *Change in the Village* (Duckworth, London, 1912). This book was first published under the authorship of George Bourne. Sturt took the name of the Surrey heathland village where he lived – The Bourne, three miles south of Farnham.

2. Massingham, H. J., 'Our Inheritance from the Past', in Williams-Ellis, C. (ed.), *Britain and the Beast* (J. M. Dent & Sons, London, 1937).

3. Priestley, J. B. (ed.), 'Britain in Danger' in *Our Nation's Heritage* (J. M. Dent, London, 1938).

4. Feiling, K., *The Life of Neville Chamberlain* (Macmillan, London, 1946).

5. Thorne, J., *Handbook to the Environs of London*, two volumes (John Murray, London, 1876).

6. Edwards, A. M., *The Design of Suburbia: A Critical Study in Environmental History* (Pembridge Press, London, 1981).

7. Orwell, G., *Coming Up for Air* (Gollancz, London, 1939).

8. Barron, P. A., *The House Desirable: A Handbook for Those Who Wish to Acquire Homes that Charm* (Methuen, London, 1929).

9. Wells, H. G., *Anticipations of the Reaction of Mechanical and Scientific Progress upon Human Life and Thought* (Methuen, London, 1902).

10. Snow, P., *Oxford Observed: Town and Gown* (John Murray, London, 1991).

11. Williams-Ellis, C. (ed.), *Britain and the Beast* (J. M. Dent & Sons, London, 1937).

12. Joad, C. E. M. *The English Counties* (Odhams, London, 1948).

13. H. G. Wells, *Experiment in Autobiography: Discoveries and Conclusions of a Very Ordinary Brain* (Gollancz, London, 1934).

14. Perkin, H., *The Age of the Automobile* (Quartet Books, London, 1976).

15. *Scott Report* (HMSO, London, 1942).

16. *Guardian*, 6 February 2004.

17. Jenkins, S., 'Urban Landscapes', in Jenkins J. (ed.), *Remaking the Landscape: The Changing Face of Britain* (Profile Books, London, 2002).

18. George Ferguson, *Guardian*, 30 June 2003.

19. Morris, W., 'The Lesser Arts of Life', in *Lectures on Art* (Macmillan, London, 1882).

Notes to Chapter 8: The Village

1. Mitford, M. R., *Our Village* (originally published in five volumes, Whitaker & Co, London, 1824–32).
2. Lees-Milne, J., *Caves of Ice* (Chatto & Windus, London, 1983).
3. Oxford, F., 'Epilogue: Elmdon in 1977', in Strathen, M., *Kinship at the Core: An Anthropology of a Village in North-West Essex in the Nineteen-Sixties* (Cambridge University Press, Cambridge, 1981).
4. Newby H., *Country Life: A Social History of Rural England* (Weidenfeld & Nicolson, London, 1987).
5. Blythe, R., *Akenfield: Portrait of an English Village* (Allen Lane, London, 1969).
6. Thompson, F., *A Country Calendar and Other Writings* (Oxford University Press, Oxford, 1979).
7. Hissey, J., J., *The Charm of the Road, England and Wales* (Macmillan, London, 1911).
8. Agricultural Economics Research Institute, *Country Planning: A Study of Rural Problems* (Oxford University Press, London, 1944).
9. Jones, S. R., *English Village Homes and Country Buildings* (B. T. Batsford, London, 1936).
10. Wild, T., *Village England: A Social History of the Countryside* (I. B. Tauris, London, 2004).
11. Aslet, C., and Heath, M., *Countryblast: How Your Countryside Needs You* (John Murray, London, 1991).
12. Wild, *Village England*.
13. Crittall, F. H., *Fifty Years of Work and Play* (Constable, London, 1934).

Notes to Chapter 9: The Countryside

1. Bryson, B., *Notes from a Small Island* (Doubleday, London, 1992).
2. Bennett A., *The City of Pleasure* (Chatto & Windus, London, 1907).
3. Mais, S. P. B., *Round About England* (Richards Press, London, 1935).
4. Lee, L., *Cider with Rosie* (Hogarth Press, London, 1959).
5. Ditchfield, P. H., *Vanishing England* (Methuen, London, 1910).
6. Sharp, T., *English Panorama* (J. M. Dent & Sons, London, 1936).
7. Hardy, T., *Tess of the d'Urbervilles* (James R. Osgood, McIlvaine & Co, London, 1891).
8. Bensusan, S. L., *Latter-Day Rural England* (Ernest Benn, London, 1927).
9. Williamson, H., *The Story of a Norfolk Farm* (Faber & Faber, London, 1941).
10. Rawding, C., *Binbrook: 1900–1939* (Workers' Educational Association, Binbrook, 1991).
11. Campbell, L. H., and Cooke, A. S. (eds.), *The Indirect Effects of Pesticides on Birds* (Joint Nature Conservation Committee, London, 1997).
12. Woodward, G., *I'll Go to Bed at Noon* (Chatto & Windus, London, 2004).
13. Shoard, M., *The Theft of the Countryside* (Temple Smith, London, 1980).
14. Blythe, R., *Akenfield: Portrait of an English Village* (Allen Lane, London, 1969).

Notes to Chapter 10: The Country House

1. Cannadine, D., *The Decline and Fall of the British Aristocracy* (Yale University Press, New Haven and London, 1990).
2. Waller, P. J., *Town, City and Nation: England, 1850–1914* (Clarendon Press, Oxford, 1983).
3. Nevill, R., *English Country House Life* (1925).

4. Mandler, P., *The Fall and Rise of the Stately Home* (Yale University Press, New Haven and London, 1997).
5. 'The Duke of Devonshire at Buxton', *The Times*, 14 June 1894.
6. 'The Democratic World', *Reynolds's Newspaper*, 24 June 1894.
7. Cannadine, *The Decline and Fall of the British Aristocracy*.
8. Howkins, A., *The Death of Rural England: A Social History of the Countryside since 1900* (Routledge, London, 2003).
9. Worsley, G., *England's Lost Houses* (Aurum Press, London, 2002).
10. *Forestry Commission Report: Croxton (Norfolk)* 1923.
11. Mandler, *The Fall and Rise of the Stately Home*.
12. Ibid.
13. Lees-Milne, J., *Another Self* (John Murray, London, 1970).
14. Lees Milne, J., *Ancestral Voices* (John Murray, London, 1975).
15. Worsley, *England's Lost Houses*.
16. Thompson, F. M. L. 'English Landed Society in the Twentieth Century, 1, Property: Collapse and Survival', *Transactions of the Royal Historical Society*, 5th series, 40 (1990).
17. Aslet, C., *The Last Country Houses* (Yale University Press, New Haven and London, 1982).
18. Ibid.

Notes to Chapter 11: Uplands and Forests

1. Bensusan, S. L., *Latter-Day Rural England* (Ernest Benn, London, 1928).
2. *Post-war Forest Policy: Report by His Majesty's Forestry Commissioners* (HMSO, London, 1943).
3. Wordsworth, W., 'Steamboats, Viaducts and Railways', *Morning Post*, 16 October 1844.
4. Morton, H. V., *In Search of England* (Methuen, London, 1927).
5. Hindle, B. P., *Roads, Tracks and their Interpretation* (B. T. Batsford, London, 1993).
6. Brontë, E., *Wuthering Heights* (T. C. Newby, London, 1847). The book was published under the pseudonym of Ellis Bell.

Notes to Chapter 12: The Landscape of War

1. Brett Young, F., 'Song of the Dark Ages', *Poems, 1916–1918* (W. Collins, London, 1919). Brett Young was stationed on Salisbury Plain between 1915 and 1918 with the Royal Army Medical Corps.
2. Wells, H. G., *War in the Air* (George Bell & Sons, London, 1908).
3. Earl Stanley Baldwin, speech in House of Commons, 30 July 1934.
4. McCauley, N. J., *Secret Underground Cities* (Pen & Sword Books, Barnsley, 1998).
5. English Heritage, *Monuments of War: The Evaluation, Recording and Management of Twentieth-Century Military Sites* (English Heritage, London, 1998).
6. O'Neil, G., *My East End* (Viking Books, London, 1999).
7. Hoskins, W. G., *Devon* (David & Charles, Newton Abbot, 1954)
8. McOmish, D., et al., *The Field Archaeology of the Salisbury Plain Training Area* (English Heritage, London, 2002).
9. Ibid.
10. Wright, P., *The Village that Died for England* (Jonathan Cape, London, 1995).
11. Bond, L., *Tyneham; A Lost Heritage* (Longmans, Dorchester, 1956).
12. Cossons, N., 'Foreword' to Barnwell, P. S. (ed.), Cocroft, W. D., and Thomas, R. J. C., *Cold War: Building for Nuclear Confrontation, 1946–1989* (English Heritage, London, 2003).

Notes to Chapter 13: The Seaside

1. Morton, H. V., *In Search of England* (Methuen, London, 1927).
2. Walton, J. K., *The British Seaside: Holidays and Resorts in the Twentieth Century* (Manchester University Press, Manchester, 2000).
3. Ibid.
4. Lancaster, O., *Progress at Pelvis Bay* (John Murray, London, 1936).
5. Priestley, J. B., *English Journey* (Heinemann, London, 1934).
6. Bryson, B., *Notes from a Small Island* (Doubleday, London, 1992).
7. Walton, J. K., *Blackpool* (Edinburgh University Press, Edinburgh, 1998).

Notes to Chapter 14: Sports and Recreations

1. Betjeman, J., *Selected Poems* (John Murray, London, 1948).
2. Hoskins, W. G., *One Man's England* (BBC Publications, London, 1976).
3. Relph, E. C., *Place and Placelessness (Research in Planning and Design)* (Routledge & Kegan Paul, London, 1976).
4. Cousins, G., *Golf in Britain: A Social History from the Beginnings to the Present Day* (Routledge, London, 1975).
5. Hawtree, F., *Colt and Co: Golf Course Architects* (Cambuc Archive, Woodstock, 1991).
6. Arlott, J., and Cardus, N., *The Noblest Game: A Book of Fine Cricket Prints* (George Harrap, London, 1969).
7. MacDonnell, A. G., *England Their England* (Macmillan, London, 1933)
8. Arlott and Cardus, *The Noblest Game.*
9. Lowenthal, D., and Prince, H., 'English Landscape Tastes', *Geographical Review,* 55 (1965).
10. Russell, C., *Social Problems in the North,* Christian Social Union Handbooks (London, 1913).
11. Inglis, S., *League Football and the Men Who Made It* (Harper Collins Willow, London, 1988).
12. *Sporting Chronicle,* Saturday, 19 February 1910.
13. Yardley, N. W. D., and Kilburn, J. M., *Homes of Sport: Cricket* (Peter Garrett, London, 1952).
14. Lord Taylor, *The Hillsborough Stadium Disaster: Inquiry Final Report (Command Paper)* (The Stationery Office Books, London, 1990).
15. Cherry, B., and Pevsner, N., *The Buildings of England: London 4: North* (Penguin, Harmondsworth, 1992).

Notes to Chapter 15: Theme-Park England

1. Lowenthal, D., *The Past is a Foreign Country* (Cambridge University Press, Cambridge, 1985).
2. Copper, B., *Early to Rise: A Sussex Boyhood* (Heinemann, London, 1976). A cottage-based view of life in Rottingdean before the first great farm sales of 1924.
3. Lee, L., *Cider with Rosie* (Hogarth Press, London, 1959).
4. Morton, H. V., Introduction to *In Search of England* (Methuen, London, 1927).
5. Filson Young, A. B., *The Complete Motorist* (Methuen, London, 1904).
6. Dillon, J. M., *Motor Days in England* (G. P. Putnam, New York, 1908).
7. Hissey, J. J., *An English Holiday with Car and Camera* (Macmillan, London, 1908).
8. *Nature* (January, 1931).

9. Watson, B., *Devon: A Shell Guide* (Faber & Faber, London, 1955).
10. Mumford, L., *The Highway and the City* (Secker & Warburg, London, 1964).
11. Thurston, E. T., *The Flower of Gloster* (William and Norgate, London, 1911).
12. Thomas E., *Collected Poems* (Selwyn Blount, London, 1920).

Notes to Chapter 16: Historic Monuments

1. Mandler, P., *The Fall and Rise of the Stately Home* (Yale University Press, New Haven and London, 1997).
2. *Victoria County History: A History of the County of Middlesex* (vol 1, 1969).
3. *www.frameworkarch.co.uk*, the website of Framework Archaeology, the archaeology consortium which undertook the excavations prior to the building of Terminal 5.
4. Lowenthal, D., *The Past is a Foreign Country* (Cambridge University Press, Cambridge, 1985).
5. Lively, P., 'Children and the Art of Memory', p. 201, *Horn Book Magazine*, 54 (1978).

Select Bibliography

Adamson, S. H., *Seaside Piers* (B. T. Batsford, London, 1977).

Aldous, T., *Goodbye Britain* (Sidgwick & Jackson, London, 1975).

Allan Patmore, J., *Recreation and Resources: Leisure Patterns and Leisure Places* (Blackwell, Oxford, 1983).

Aslet, C., and Heath, M., *Countryblast: How Your Countryside Needs You* (John Murray, London, 1991).

Aslet, C., *The Last Country Houses* (Yale University Press, New Haven and London, 1982).

Aston, M., *Interpreting the Landscape* (Batsford, London, 1985).

Aston, M., and Rowley, T., *Landscape Archaeology* (David & Charles, Newton Abbot, 1974).

Aston, M., and Bond, J., *The Landscape of Towns* (J. M. Dent and Sons, London, 1976).

Bagnall, G., *Consumption Matters* (Blackwell, Oxford, 1996).

Barker, T. C., and Gerhold, D., *The Rise and Rise of Road Transport, 1700–1990* (Cambridge University Press, Cambridge, 1993).

Barnett, A., and Scruton, R. (eds), *Town and Country* (Jonathan Cape, London, 1998).

Barnwell, P. S. (ed.), Cocroft, W. D., and Thomas, R. J. C., *Cold War: Building for Nuclear Confrontation, 1946–1989* (English Heritage, London, 2003).

Bell, C., and R., *City Fathers: The Early History of Town Planning in Britain* (Pelican Books, Harmondsworth, 1972).

Betjeman, J., *Collected Poems* (4th edn, John Murray, London, 1979).

Betjeman, J., *Ghastly Good Taste: or A Depressing Story of the Rise and Fall of British Architecture* (Chapman & Hall, London, 1933).

Binney, M., *Our Vanishing Heritage* (Arlington Books, London, 1984).

Bird, P., *The First Food Empire: A History of J. Lyons and Co.* (Phillimore, Chichester, 2000).

Black, J., *Modern British History since 1900* (Macmillan, London, 2000).

Black, J., *The Making of Modern Britain* (Sutton Publishing, Stroud, 2001).

Blythe, R., *Akenfield: Portrait of an English Village* (Allen Lane, London, 1969).

Braggs, S. and Harris, D., *Sun, Fun and Crowds* (Tempus, Stroud, 2000).

Brendon, P., *The Motoring Century* (Bloomsbury Press, London, 1997).

Bridges, J. F., *Early Country Motoring: Cars and Motorcycling in Suffolk, 1896–1940* (privately published, 1995).

Brooks, R. J., *Thames Valley Airfields in the Second World War* (Countryside Books, Newbury, 2000).

Bryson, B., *Notes from a Small Island* (Doubleday, London, 1992).

Buchanan, C., *No Way to the Airport* (Longmans, London, 1981).

Buchli, V., and Lucas, G., *Archaeologies of the Contemporary Past* (Routledge, London, 2001).

Buder, S., *Visionaries and Planners: The Garden City Movement Community* (Oxford University Press, Oxford, 1990).

Burchardt, J., *Paradise Lost: Rural Idyll and Social Change since 1800* (I. B. Tauris, London, 2002).

Burke, G., *Towns in the Making* (Edward Arnold, London, 1971).

Burnett, J., *A Social History of Housing, 1815–1970* (David & Charles, Newton Abbot, 1978).

Cannadine, D., *The Decline and Fall of the British Aristocracy* (Yale University Press, New Haven and London, 1990).

Carson, R., *Silent Spring* (Hamish Hamilton, London, 1963).

Centre for the Study of Environmental Change, *Leisure Landscapes* (Lancaster, 1994).

Charlesworth, G., *A History of British Motorways* (Thomas Telford, London, 1984).

Cherry, G. E., *Town Planning in Britain since 1900* (Blackwell, Oxford, 1996).

Chippindale, C., *Stonehenge Complete* (Thames & Hudson, London, 1983).

Clemenson, H., *English Country Houses and Estates*, (London, 1981).

Clout, H. (ed.), *The Times London History Atlas* (1991).

Collins, E. J. T. (ed.), *The Agrarian History of England and Wales*, vii, part 2, (Cambridge University Press, Cambridge, 2000).

Colls, R., *Identity of England* (Oxford University Press, Oxford, 2002).

Cosgrove, D. E., *Social Formation and Symbolic Landscape* (University of Wisconsin Press, Wisconsin, 1984).

Cosgrove, D. E., and Daniels, S., *The Iconography of Landscape* (Cambridge University Press, Cambridge, 1988).

Crawford, G., *Consuming Sport* (Routledge, London, 2004).

Cullingworth, J. B., and Nadin, V., *Town and Country Planning in Britain* (Routledge, London, 1994).

Darby, H. C., *A New Historical Geography of England after 1600* (Cambridge University Press, Cambridge, 1976).

Darley, G., *Built in Britain* (Weidenfeld & Nicolson, London, 1983).

Darley, G., *Villages of Vision* (Architectural Press, London, 1975).

Darvill, T., *Ancient Monuments in the Countryside* (English Heritage, London, 1987).

Daunton, M. (ed.), *The Cambridge Urban History of Britain*, iii, *1840–1950* (Cambridge University Press, Cambridge, 2000).

De Botton A., *The Art of Travel* (Hamish Hamilton, London, 2002).

De la Bédoyère, G., *Battles over Britain: The Archaeology of the Air War* (Tempus, Stroud, 2000).

De Wolfe, I. (ed.), *Civilia: The End of Sub Urban Man* (Architectural Press, London, 1971).

Defoe, D., *A Tour through the Whole Island of Great Britain* (J. M. Dent & Sons, London, 1962).

Ditchfield, P. H., *Vanishing England* (Methuen, London, 1910).

Dudley Stamp, L., *Man and the Land* (Collins, London, 1964).

Dudley Stamp, L., *The Land of Britain* (Longmans, Green and Co, London, 1946).

Dyos, H. J., *The Study of Urban History* (Edward Arnold, London, 1968).

Edwards, A. M., *The Design of Suburbia: A Critical Study in Environmental History* (Pembridge Press, London, 1981).

Fairbrother, N., *New Lives, New Landscapes* (Architectural Press, London, 1970).

Fines, K., *A History of Brighton and Hove* (Phillimore, Chichester, 2002).

Francis, P., *British Military Airfield Architecture* (Patrick Stephens, Sparkford, 1996).

Gardiner, V., and Mathews, H., *The Changing Geography of the United Kingdom* (3rd edn, Routledge, London, 2000).

Gelling, M., *Place-Names in the Landscape* (J. M. Dent & Sons Ltd, London, 1984).

Gilbert, D., Matless, D., and Short, B. (eds), *Geographies of British Modernity* (Blackwell, Oxford, 2003).

Girouard, M., *Town and Country* (Yale University Press, New Haven, 1992).

Graves Brown, P. (ed.), *Matter, Materiality and Modern Culture* (Routledge, London, 2000).

Grenville, J. (ed.), *Managing the Historic Rural Landscape* (Routledge, London, 1999).

Gunn, S., and Bell, R., *Middle Classes: Their Rise and Spread* (Phoenix, London, 2002).

Hall, P., *Great Planning Disasters* (Weidenfeld and Nicolson, London, 1983).

Hall, P., *Sociable Cities: The Legacy of Ebenezer Howard* (Phillimore, Chichester, 1998).

Hall, P., *Urban and Regional Planning* (3rd edn, Routledge, London, 1992).

Harrington, C. C., and Bielby, D. (eds), *Popular Culture: Production and Consumption* (Blackwell, Oxford, 2001).

Harvey, G., *The Killing of the Countryside* (Cape, London, 1997).

Hawkes, J. and Harrison, I., *Over London: A Century of Change* (Harper Collins, London, 2000).

Hawtree, F., *Colt and Co.: Golf Course Architects* (Cambuc Archive, Woodstock, 1991).

Hewison, R., *The Heritage Industry: Britain in a Climate of Decline* (Methuen, London, 1987).

Higham, R., *Bases of Air Strategy: Building Airfields for the RAF, 1914–45* (Airlife Publishing, Shrewsbury, 1998).

Hindle, B. P., *Roads, Tracks and their Interpretation* (B. T. Batsford, London, 1993).

Hissey, J. J., *Untravelled England* (Macmillan, London, 1906).

Hoggart, K., and Green, D. R. (eds), *London: A New Metropolitan Geography* (Edward Arnold, London, 1991).

Holt, R., *Sport and the British: A Modern History* (Clarendon Press, Oxford, 1989).

Hooke, D. (ed.), *Landscape: The Richest Historical Record* (Society for Landscape Studies, Amesbury, 2000).

Hoskins, W. G., *English Landscapes* (BBC Publications, London, 1973).

Hoskins, W. G., *One Man's England* (BBC Publications, London, 1976).

Hoskins, W. G., *The Making of the English Landscape* (Hodder & Stoughton, London, 1955).

Hoskins, W. G., with introduction and commentary by Taylor, C., *The Making of the English Landscape* (Hodder & Stoughton, London, 1988).

Howkins, A., *The Death of Rural England: A Social History of the Countryside since 1900* (Routledge, London, 2003).

Humphries, S., and Taylor, J., *The Making of Modern London, 1945–1985* (Sidgwick & Jackson, London, 1986).

Inglis, S., *Engineering Archie: Archibald Leitch – Football Ground Designer* (English Heritage, London, 2004).

Inglis, S., *Played in Manchester: The Architectural Heritage of a City at Play* (English Heritage, London, 2004).

Inglis, S., *The Football Grounds of England* (Willow Press, London, 1988).

Jeffrey, I., *The British Landscape, 1920–1950* (Thames & Hudson, London, 1984).

Jenkins, J. (ed.), *Remaking the Landscape: The Changing Face of Britain* (Profile Books, London, 2002).

Jenkins S., 'Urban Landscapes', in Jenkins, J. (ed.), *Remaking the Landscape: The Changing Face of Britain* (Profile Books, London, 2002).

Joad, C. E. M., *The Untutored Townsman's Invasion of the Country* (Faber & Faber, London, 1945).

Johns, E., *British Townscapes* (Edward Arnold, London, 1965).

Kidd, A., *Manchester* (3rd edn, Edinburgh University Press, Edinburgh, 2002).

Lasdun, S., *The English Park* (André Deutsch, London, 1991).

Lee, L., *Cider with Rosie* (Hogarth Press, London, 1959).

Lees-Milne, J., *People and Places* (John Murray, London, 1992).

Lees-Milne, J., *Prophesying Peace: Diaries, 1944–1945* (Michael Russell Publishing, Norwich, 2003).

Longrigg, R., *The History of Foxhunting* (Macmillan, London, 1975).

Lloyd, D. W., *The Making of English Towns* (Gollancz, Over Wallop, 1984).

Lord, E., *Investigating the Twentieth Century: Sources for Local Historians* (Tempus Publishing, Stroud, 1999).

Lowenthal, D., *The Past is a Foreign Country* (Cambridge University Press, Cambridge, 1985).

Lowenthal, D., and Prince, H., 'English Landscape Tastes', *Geographical Review*, 55 (1965).

Lyall, S., *Designing the New Landscape* (Thames & Hudson, London, 1991).

Mais, S. P. B., *Round About England* (Richards Press, London, 1935).

Mandler, P., *The Fall and Rise of the Stately Home* (Yale University Press, New Haven and London, 1997).

Marriot, L., *British Airports* (Ian Allen, Shepperton, 1993).

Mason, J., *The Townies' Guide to the Countryside* (Merlin Unwin Books, Ludlow, 2003).

Massingham H. J., *Chiltern Country* (B. T. Batsford, London, 1940).

Massingham, H. J., *English Downland* (B. T. Batsford, London, 1936).

Matless, D., *Landscape and Englishness* (Reaktion Books, London, 1998).

Meinig, D. W., *The Interpretation of Ordinary Landscapes* (Oxford University Press, Oxford, 1979).

Mingay, G. E. (ed.), *The Rural Idyll* (Routledge, London, 1989).

Morrison, K. A., *English Shops and Shopping* (English Heritage, London, 2003).

Morton, H. V., *In Search of England* (Methuen, London, 1927).

Muir, R., *The New Reading of the Landscape* (University of Exeter Press, Exeter, 2000).

Mumford, L., *The City in History* (Secker and Warburg, London, 1961).

Museum of Domestic Design and Architecture, *Little Palaces: House and Home in the Inter-War Suburbs* (Middlesex University Press, 2003).

Nagle, G., *Tourism, Leisure and Recreation* (Thomas Nelson & Sons, London, 1999).

Newby, H., *Green and Pleasant Land: Social Change in Rural England* (Hutchinson, London, 1979).

Nicholson, A., and Morter, P., *Prospects of England* (Weidenfeld & Nicolson, London, 1989).

Osborn, F. J., and Whittick, A., *The New Towns: The Answer to Megalopolis* (Leonard Hill, London, 1963) and 3rd revised edition, *The New Towns: Their Origins, Achievements and Progress* (Leonard Hill, London, 1977).

Page, S., *Urban Tourism* (Routledge, London, 1995).

Priestley, J. B., *English Journey* (Heinemann, London, 1934).

Rackham, O., *The History of the Countryside* (J. M. Dent & Sons, London, 1986).

Rackham, O., *Trees and Woodland in the British Landscape* (J. M. Dent & Sons, London, 1976).

Redford, D., *Change in the United Kingdom in the Last Thirty Years* (Hodder & Stoughton, London, 2001).

Relph, E. C., *Place and Placelessness (Research in Planning and Design)* (Routledge & Kegan Paul, London, 1976).

Relph, E. C., *The Modern Urban Landscape* (Croom Helm, London, 1987).

Robbins, K., *The British Isles, 1901–1951* (Oxford University Press, Oxford, 2002).

Roberts, R., *The Classic Slum* (Manchester University Press, Manchester, 1971).

Rowley, T., *Villages in the Landscape* (J. M. Dent & Sons, London, 1978).

Russell, D., *Football and the English* (Carnegie Publishing, Preston, 1997).

Saunders, A., *Channel Defences* (English Heritage, London, 1997).

Schofield, J., *Modern Military Matters* (Council for British Archaeology, York, 2004).

Sharp, T., *The Anatomy of the Village* (Penguin, Harmondsworth, 1946).

Sharp, T., *Town and Countryside: Some Aspects of Urban and Rural Development* (Oxford University Press, London, 1932).

Sharp, T., *Town and Townscape* (John Murray, London, 1968).

Sharp, T., *Town Planning* (Penguin Pelican, Harmondsworth, 1940).

Shoard, M., *The Theft of the Countryside* (Temple Smith, London, 1980).

Short, B., et al, *The National Farm Survey, 1941–43: State Surveillance and the Countryside in England and Wales in the Second World War* (Cabi Publishing, Wallingford, 1999).

Slack, P., and Ward, R. (eds.), *The Peopling of Britain: The Shaping of a Human Landscape* (Oxford University Press, Oxford, 2002).

Smith, G., *Taking to the Skies* (Countryside Books, Newbury, 1983).

Smith, G., *Taking to the Skies: The Story of British Aviation, 1903–1939* (Countryside Books, Newbury, 2003).

Soar, P. and Tyler, M., *Arsenal* (Hamlyn, London, 1986).

Starkie, D., *The Motorway Age* (Pergamon Press, Oxford, 1982).

Stevenson, G., *The 1930s Home* (Shire Publications, Princes Risborough, 2000).

Stevenson, J., *British Society, 1914–45* (Penguin, Harmondsworth, 1984).

Strong, R., Binney, M., and Harris, J., *The Destruction of the Country House, 1875–1975* (Thames & Hudson, London, 1974).

Tarlow, S., and West, S., *The Familiar Past? Archaeology of Later Historical Britain, 1550–1950* (Routledge, London, 1999).

Taylor, C., *Fields in the English Landscape* (J. M. Dent and Sons, London, 1975).

Taylor, C., *Parks and Gardens of Britain: A Landscape History from the Air* (Edinburgh University Press, Edinburgh, 1998).

Taylor, C., *Roads and Tracks of Britain* (J. M. Dent and Sons, London, 1979).

Taylor, S. (ed.), *The Moving Metropolis* (Laurence King Publishing, London, 2001).

Thirsk, J. (ed.), *The English Rural Landscape* (Oxford University Press, Oxford, 2000).

Thompson, F. M. L. (ed.), *The Rise of Suburbia* (Leicester University Press, Leicester, 1982).

Thorold, P., *The London Rich* (Penguin Books, Harmondsworth, 2001).

Thorold, P., *The Motoring Age: The Automobile and Britain, 1896–1939* (Profile Books, London, 2003).

Trinder, B., *The Making of the Industrial Landscape* (J. M. Dent, London, 1982).

Twentieth Century Society, *Journal of the Twentieth Century Society*, volumes 1–7 (1994–2004).

Tyack G., and Brindle, S., *Blue Guide Country Houses of England* (A. and C. Black, London, 1994).

Wade Martins, S., *Farms and Fields* (Batsford, London, 1995).

Waller P. J., *Town, City and Nation: England, 1850–1914* (Clarendon Press, Oxford, 1983).

Waller P. J. (ed.), *The English Urban Landscape* (Oxford University Press, Oxford, 2000).

Walton, J. K., *Blackpool* (Edinburgh University Press, Edinburgh, 1998).

Walton, J. K., *The British Seaside: Holidays and Resorts in the Twentieth Century* (Manchester University Press, Manchester, 2000).

Webb, M., *Architecture in Britain Today* (County Life, London, 1969).

Whetham, E. H., *The Agrarian History of England and Wales*, vii, *1914–1939* (Cambridge University Press, Cambridge, 1978).

Whiston Spirn, A., *The Language of Landscape* (Yale University Press, New Haven and London, 1998).

White, J., *London in the Twentieth Century* (Viking, London, 2001).

Whitehand, J. W. R., *The Changing Face of Cities* (Blackwell, Oxford, 1987).

Whyte, I. D., *Landscape and History since 1500* (Reaktion Books, London, 2002).

Wild, T., *Village England: A Social History of the Countryside* (I. B. Tauris, London, 2004).
Williams, R., *The Country and the City* (Hogarth Press, London, 1993).
Williams-Ellis, C. (ed.), *Britain and the Beast* (J. M. Dent & Sons, London, 1937).
Williamson, T., and Bellamy, L., *Property and Landscape* (Batsford, London, 1987).
Woodell, S. R. J. (ed.), *The English Landscape: Past, Present, and Future* (Oxford University Press, Oxford, 1985).
Worsley, G., *England's Lost Houses* (Aurum Press, London, 2002).
Wright, P., *On Living in an Old Country* (Verso, London, 1985).
Wright, P., *The Village that Died for England* (Jonathan Cape, London, 1995).

Photograph Acknowledgements

Automobile Association 33
Mick Aston 275
James Bond 44, 260, 317 and 424
Christ Church, Oxford 79
Clwyd-Powis Archaeological Trust 7, 72, 294 and 329
English Heritage (National Monuments Record) 38, 51, 116, 119 (top), 134, 139, 153, 155, 271, 278, 279, 288, 296, 324, 337, 353, 366, 369, 390, 434 and 436
Leicester University, Centre for English Local History xiii
Museum of English Rural Life 15, 30, 43, 251 and 258
National Archives 81, 100, 114, 183, 282, 313 and 427
Oxfordshire County Council, Oxfordshire Studies 2, 9, 24, 25, 125, 129, 147 (top and bottom), 200, 204, 217, 223, 226, 233, 256, 307, 316, 344, 349, 377, 381, 385, 389, 413, 415 and 431
Simmons Aerofilm 48, 65, 71, 94, 95, 102, 107, 115, 126, 187, 188, 210, 326, 395, 400, 406 and 407
Adrian Warren and Dae Sasitorn: cover photograph

Index